THE DRAMATIC WORKS IN THE BEAUMONT AND FLETCHER CANON

This is the ninth volume in the definitive series of critical, old-spelling texts of the plays in the Beaumont and Fletcher canon, in which the texts are established on modern bibliographical principles. This volume contains the texts of six plays written by Fletcher and his collaborators, Philip Massinger and William Rowley. Each play is introduced by a discussion of the text and authorship, and is accompanied by detailed textual notes, a list of press-variants, emendations of accidentals and a historical collation.

The plays are *The Sea Voyage*, *The Double Marriage*, *The Prophetess*, *The Little French Lawyer*, *The Elder Brother*, *The Maid in the Mill*.

THE
DRAMATIC WORKS IN
THE BEAUMONT AND
FLETCHER CANON

GENERAL EDITOR
FREDSON BOWERS

VOLUME IX

CAMBRIDGE
UNIVERSITY PRESS

Published by the Press Syndicate of the University of Cambridge
The Pitt Building, Trumpington Street, Cambridge CB2 1RP
40 West 20th Street, New York, NY 10011-4211, USA
10 Stamford Road, Oakleigh, Melbourne 3166, Australia

First published 1994

Printed in Great Britain at the University Press, Cambridge

*A catalogue record for this book
is available at the British Library*

Library of Congress cataloguing in publication data

Beaumont, Francis, 1584–1616.
The dramatic works in the Beaumont and Fletcher
canon.
I. Fletcher, John, 1579–1625, joint author.
II. Bowers, Fredson Thayer, ed. III. Title.
PR2420 1966 822.3 66 74421

ISBN 0 521 36188 5 hardback

CONTENTS

v

FOREWORD

These volumes contain the text and apparatus for the plays conventionally assigned to the Beaumont and Fletcher canon, although in fact Fletcher collaborated with dramatists other than Beaumont in numerous plays of the canon and some of the preserved texts also represent revision at a later date by various hands. The plays have been grouped chiefly by authors; this arrangement makes for an order that conveniently approximates the probable date of composition for most of the works.

The texts of the several plays have been edited by a group of scholars according to editorial procedures set by the general editor, who closely supervised in matters of substance as well as of detail the initially contrived form of the texts. Otherwise the individual editors have been left free to develop their concepts of the plays according to their own views. We hope that the intimate connection of one individual, in this manner, with all the different editorial processes will lend to the results some uniformity not ordinarily found when diverse editors approach texts of such complexity. At the same time, the peculiar abilities of the several editors have had sufficient free play to ensure individuality of point of view in its proper role; and thus, we hope, the deadness of compromise that may fasten on collaborative effort has been avoided, even at the risk of occasional internal disagreement.

The principles on which each text has been edited have been set forth in detail in 'The Text of this Edition' prefixed to volume 1, pp. ix–xxv, followed by an account on pp. xxvii–xxxv of the Folio of 1647. Necessary acknowledgements will be found in the present volume in each Textual Introduction.

F.B.

Charlottesville, Virginia

THE SEA VOYAGE

edited by

FREDSON BOWERS

Introduction and Textual Notes by
CYRUS HOY

TEXTUAL INTRODUCTION

The Sea Voyage (Greg, *Bibliography*, no. 656) was licensed by Sir Henry Herbert on 22 June 1622 and noted as acted at the Globe. In preparation for the Folio of 1647, where it occupies sigs. 5A1–5C2, it was entered in the Stationers' Register on or around 4 September 1646. On 30 January 1673 it was re-entered in preparation for the 1679 Folio, where it is printed in sigs. 2U2–2Y3 of the second section.

The Sea Voyage was printed at the beginning of Section 5 of the 1647 Folio, the section assigned to Edward Griffin, where it occupies sigs. 5A1 to 5C2 (5C2v is blank). The text of the play was set by the same three compositors whose work is discussed elsewhere in this volume in the Introduction to *The Double Marriage*. The spelling habits that enable an editor to identify their work are familiar from the other plays of the Beaumont and Fletcher canon printed in Griffin's shop. Compositor *A* prefers 'I'le', ''tis', ''twas', ''twill', 'doe'. Compositor *B* prefers 'Ile', 'tis', 'twas', 'twill', 'do'. Compositor *C* sets 'tis' (without apostrophe), but uses the apostrophe in ''twas' and ''twill'. It is Compositor *C* who is responsible for the distinctive form 'i'le' that occurs on sigs. A4v, B1, B1v, B2, C1v; and it is Compositor *C* who sets 'lets' (sigs. A4v, B1) while Compositors *A* and *B* set 'let's'.

Variations in the abbreviated forms of speech-prefixes also serve to differentiate compositors. Compositor *A*'s abbreviations for the speeches of Lamure are always *La-m.* Compositors *B* and *C* both designate these with the prefix *Lam.* Aminta's speeches are headed *Amin.* by Compositor *A*, *Amin.* by Compositors *B* and *C*. Morillat's speeches carry the prefix *Morill.* (or *Moril.*) when set by Compositor *A*, *Mor.* when set by Compositors *B* and *C*. Speech-prefixes for the ship's Master are chiefly *Mast.* (sometimes *Master.*) when set by Compositor *A*; *Ma.* (*Mast.* on one occasion) when set by Compositor *C*; only *Mast.* when set by Compositor *B*. Compositor *C* is responsible for the fourteen occurrences of the abbreviation *Ti.* on sigs. B2 and C1v, the most distinctive departure in the text from the *Tib.* that is the form Tibalt's speech-prefixes normally take. The abbreviations *Seba.* and *Sabast.* for the *Sebast.* that elsewhere has

3

headed Sebastian's speeches occur on sigs. C1v, C2, set by Compositor *C*.

The names of characters when fully spelled out in the dialogue or in stage-directions or occasionally in a speech-prefix of the F1 text appear in a variety of forms that sometimes suggests distinct compositorial practices, but not always. At the outset, Compositor *A* had a good deal of trouble with the name that he first sets (in the stage-direction at I.i.32.1; sig. 5A1) as *Tibalt de pont*, but which appears as *Talbat* in the first speech-prefix he sets for this character (I.i.46), and as *Tibat* in the second speech-prefix he is given (I.i.53). The variant spellings of Hippolita's name, however, seem to point to two different compositorial practices. Compositor *B* sets *Hippolita* (except for a single *Hipolita* on sig. A4 (II.ii.165)); Compositor *C* gives us the more elaborate *Hipollitta* of sig. B1v (III.i.223.1) and the even more extravagant *Hippollitta* of sig. C1v (V.iv.5.1).

Compositors *B* and *C* also appear to be responsible for the variant spellings of Rossella's name. The name occurs ten times in unabbreviated form in the F1 text: six times in stage-directions, four times in the play's dialogue. It is spelled in four different ways: *Rosella* on sig. A4 (II.ii.186.1); *Rossella* on sig. B2v (IV.ii.0.1, 28 s.d.), sig. B4v (V.i.0.1), and sig. C2 (V.iv.77); *Rossellia* on sig. B1v (III.i.223.1) and sig. C2 (V.iv.67, 88, 96); *Rossillia* on sig. C1v (V.iv.5.1). Compositor *B* set *Rosella/Rossella*, Compositor *C* set *Rossellia/Rossillia*, and on one occasion (V.iv.77) *Rossella*. The four occasions when the full form of the name appears in the play's dialogue all occur within Compositor *C*'s setting of the last thirty lines of the text (*Rossellia* at V.iv.67, 88, 96; *Rossella* at V.iv.77). Elsewhere in the text, *Rossellia* is found only once, in the stage-direction at III.i.223.1 (also set by Compositor *C*). *Rossella*, which Compositor *C* set at V.iv.77, is elsewhere to be found only in the stage-directions that Compositor *B* set at IV.ii.0.1, IV.ii.28, and V.i.0.1. It seems clear that Compositor *C* preferred a form of the name ending in *-ia*, a preference that also included the variant form *Rossillia* which occurs in the stage direction at V.iv.5.1. Since *Rossella* is found in the work of both compositors, and *Rossellia* is apparently the peculiar property of Compositor *C*, *Rossella* seems more likely to be the form that stood in the F1 manuscript. On the few occasions when the name occurs in the dialogue, the three syllables of *Rossella* fit the verse better than the four

4

syllables of *Rossellia*. *Rossella*, accordingly, is the form of the name adopted for that character's speech-prefixes in this edition.

The division of the work of the three compositors in setting the text of *The Sea Voyage* seems to be as follows:

Compositor *A*: 5A1–5A3 (I.i.o.1–II.i.79); 5C1 (V.ii.8–130)
Compositor *B*: 5A3v–5A4 (II.i.80–II.ii.219); 5B2v–5B4v (III.i.435–V.ii.7)
Compositor *C*: 5A4v–5B2 (II.ii.220–III.i.434); 5C1v–5C2 (V.ii.131–V.iv.116.1)

The Sea Voyage is the joint work of Fletcher and Massinger, and the basic nature of their collaboration is clear enough: Fletcher wrote Acts I and IV, Massinger wrote Acts II, III, and V.[1] Unlike the usual Fletcher–Massinger collaboration, however, in which the presence of the pronoun 'ye' singles out certain scenes as the work of Fletcher, while its absence suggests the work of Massinger, 'ye' is present in some degree in virtually every scene of the F1 text of *The Sea Voyage*. This suggests that the manuscript from which F1 was printed represents a version of the text that had been worked over by Fletcher, who has given the play the form in which we have it, leaving as evidence of his presence a sprinkling of his characteristic 'ye's on scenes that are strongly stamped with Massinger's verbal, syntactic and rhetorical practices. Act III provides the best example of this, where there are a number of verbal parallels with Fletcher's work, notably in some of the speeches of Tibalt, but these are present in a dramatic context that is basically Massinger's. The play as a whole exhibits a number of similarities to Massinger's own work in the early 1620s, and A. H. Cruikshank was badly wrong when he announced that the plot of *The Sea Voyage* 'does not recall [Massinger's] work in any way.'[2] Crocale's lascivious fantasies in *The Sea Voyage*, II.ii.37–70, have verbal parallels with Massinger's *The Bondman*, I.ii.7–27 and II.ii.92–100. The grotesque degradation of the shipwrecked and famished trio of would-be gentlemen (Lamure, Franville, Morillat) early in Act III of *The Sea Voyage* is of a piece with the humiliations Massinger inflicts upon other fashionable but unworthy gentlemen *in extremis* (cf., e.g., *The Maid of Honour*, III.i.75ff; *The Picture*, V.i.40ff). Finally, *The Sea Voyage* is conceived very much in the manner of two previous Fletcher–Massinger collaborations: *The Custom of the Country* and *The Double Marriage*. All three plays turn on the adventures of a loving couple exposed to the menace of another

woman who seeks to lay claim to the faithful lover.[3] The similarity of
the material of the sea scenes in *The Double Marriage* and *The Sea
Voyage* has been noted by G. E. Bentley.[4]

If, however, the F1 text leaves us in no doubt that the play contains
the work of both Fletcher and Massinger, and gives us a reasonably
clear sense of which of the play's five acts each dramatist was chiefly
responsible for, the F1 text leaves us in considerable doubt as to just
what state of the play it represents. It could possibly be a prompt-
book, though the evidence for this is not strong. There are some stage-
directions that could suggest a theatrical provenance: references to
'*above*' (I.v.12.1; II.i.63); '*Hornes within*' (II.i.52); 'this Curtaine'
(opened for a discovery scene at IV.ii.152); '*A Table furnisht*'
(V.ii.0.1); '*horrid Musicke*' (V.iv.0.1, a direction typical of Massinger,
though it can also be found in a Fletcher scene (at II.i.50) of *The
Queen of Corinth*);[5] '*An alter prepar'd*' (V.iv.5.2). But along with these
are directions that lack precision: '*beats 'em out*' (I.iv.197); '*he beats 'em
off*' (I.iv.199); '*Enter Tibalt and the rest*' (I.v.0.1); '*Enter Albert,
Tibalt, and the rest with treasure*' (III.i.396). A direction such as '*La-m.
and Franvile goes up to see the Ship*' (I.v.19.1) does not convey the sort
of detail a prompter would be likely to note.

There is some evidence to suggest that copy for F1 was not all of a
piece. The text contains no scene divisions, but Acts I, IV, and V are
conventionally headed *Actus Primus——Scæna Prima*, *Actus quar-
tus*, *Scæna prima*, and *Actus quintus*, *Scæna prima*. Acts II and III,
however, are headed simply *Actus Secundus* and *Actus Tertius*. These
are parts of the play that were basically Massinger's, but Fletcher's
additions and/or alterations to them are evident from the noticeable
occurrence in them of 'ye'. F1 copy for Acts I and IV was probably
Fletcher's foul papers. F1 copy for Acts II and III was either Fletcher's
revision of Massinger's foul papers or (more probably) a scribal
transcript of his revision of these. Act V is certainly the work of
Massinger, but it too has undergone some revision by Fletcher
(though not on the scale of Acts II and III), and it has been severely cut
(which may account for some of the numerous details of the plot that
have not been satisfactorily accounted for by the time the play ends).
The cutting could have been done either by Fletcher or by a theatrical
adapter. F1 copy for Act V is most likely to have been a scribal
transcript of this revised and abridged version of Massinger's foul
papers.

Conjectures about the state of the text of *The Sea Voyage* raise questions about the dramatists' treatment of their material. By the usual efficient standards of Fletcher and Massinger's dramatic craftsmanship, *The Sea Voyage* is a poorly organized play. The opening scene of a storm at sea ending in a shipwreck is obviously intended to launch the play with a *coup de théâtre* in the manner of Shakespeare's *Tempest*, and in the action that follows something of a Shakespearean design can be dimly discerned: the principal members of the shipwrecked party find themselves on a desolate island inhabited by persons whom they have wronged in the past; they thereby become subject to the revenge of their former victims. Much depends in this sort of plot on the revelation of the past events that have brought both parties to their present condition, and even Shakespeare's Prospero must be allowed some lengthy narrations early in *The Tempest* in the interest of dramatic exposition. In *The Sea Voyage*, the action antecedent to the play is so very complicated that explanations about who was separated from whom, by whose agency and under what circumstances and with what consequences, virtually strangle the dramatic life not only of the opening scenes but of the entire play. Motive and impulse are seldom dramatized; they are simply announced, and the resolution of the complex action that the final scenes of the play attempt is managed not by dramatic means but by extended feats of narration. The speeches of Albert (V.ii.63–83), Raymond (V.ii.86–125), Rossella (V.iv.7–49), and Sebastian (V.iv.78–96) are Massinger's dutiful efforts to give credence to the events of a dramatic plot that have not been coherently dramatized. While acknowledging the possibility that the F1 text of *The Sea Voyage* has been cut, or that it represents something less than the finished state that the play was eventually given, one ought also to be prepared to consider the possibility that in many respects the F1 text gives us the play pretty much as Fletcher and Massinger left it: one of their hastier, less considered, less considerable performances. The hand of Fletcher, here discernible throughout the play in a way uncharacteristic of most Fletcher–Massinger collaborations, may represent a salvage effort on his part. The highly irregular verse of the F1 text – which has been frequently relined in the present edition – suggests a similarly ambiguous feature about the manuscript from which the F1 text of the play was set: on the one hand, a good deal of the faulty lineation may be attributed to an indifferent scribe, or to a

manuscript made difficult for a compositor by revision and cutting; on the other hand, much of the irregular verse is inherent in the writing and is not the result of inept typesetting or of cutting for the stage. Much of the verse suggests hasty and unrevised composition.

The fact that *The Sea Voyage* is not included in the list of plays that the Lord Chamberlain protected for the King's men in August 1641 may indicate, as Bentley has suggested, that the play was not then in the company's active repertory.[6] After the restoration, however, the King's company is known to have revived *The Sea Voyage* under the title *The Storm*. Pepys, who attended the first performance of the revival on 25 September 1667 (the house 'infinitely full: the King and all the Court almost there'), pronounced it 'but so-so' and only approved of 'a most admirable dance at the end, of the ladies, in a military manner, which indeed did plese me mightily'. He returned to the theatre on the following day to show the play to his wife; his view of it remained unchanged, 'the principal thing extraordinary being the dance, which is very good'.[7] A few weeks later (7 November 1667), the rival Duke's company brought out its answer to *The Storm* when it produced Dryden and Davenant's adaptation of Shakespeare's *The Tempest*. In the Preface to *The Tempest, or the Enchanted Island*, Dryden, anxious to prove that Shakespeare's *Tempest* was worth imitating, pointed out that 'our excellent *Fletcher* had so great a value for it, that he thought fit to make use of the same Design . . . Those who have seen his *Sea-Voyage*, may easily discern that it was a Copy of *Shakespear*'s *Tempest*: the Storm, the desart Island, and the woman who had never seen a Man, are all sufficient testimonies of it.'[8] This exaggerates the similarities between the two plays, though it is probably true enough to say, as Dryden goes on to say in the Prologue to his and Davenant's *Tempest*, that

> The Storm which vanish'd on the Neighb'ring shore,
> Was taught by *Shakespear's* Tempest first to roar.[9]

The neighboring shore was, of course, the Theatre Royal in Bridges Street where the King's company's production of *The Sea Voyage*, now known as *The Storm*, had expired after a run of, apparently, only three days.[10] The play was revived briefly in the following spring. Pepys attended the performance of 25 March 1668, 'but without much pleasure, it being but a mean play compared with 'The Tempest,' at

the Duke of York's house'. All he found to commend in this and a later performance on 16 May was the actress Elizabeth Knepp, in the role of Aminta, doing 'her part of sorrow'.[11]

An adaptation of *The Sea Voyage*, titled *A Commonwealth of Women*, by Thomas D'Urfey, was performed by the United Company at the Theatre Royal in the late summer of 1685; a printed text was published in 1686.[12]

NOTES

1 Evidence for the authorial division is set forth by Cyrus Hoy in 'The shares of Fletcher and his collaborators in the Beaumont and Fletcher canon (II)', *Studies in Bibliography*, IX (1957), 153, 160–1.

2 Quoted in E. H. C. Oliphant, *The Plays of Beaumont and Fletcher* (New Haven, 1927), p. 248.

3 For the relation of *The Sea Voyage* to other Fletcher–Massinger collaborations, see Cyrus Hoy, 'Massinger as collaborator', in Douglas Howard (ed.), *Philip Massinger: A Critical Reassessment* (Cambridge, 1985), pp. 64ff.

4 *The Jacobean and Caroline Stage* (Oxford, 1956), III, 331.

5 See the Introduction to my edition of *The Double Marriage* elsewhere in the present volume (p. 102, note 6).

6 *The Jacobean and Caroline Stage*, III, 414.

7 William Van Lennep (ed.), *The London Stage 1660–1800: Part I: '1660–1700'* (Carbondale, Illinois, 1965), p. 118.

8 Maximillian E. Novak and George R. Guffey (eds.), *The Works of John Dryden* (Berkeley, 1970), X, 3.

9 *Ibid.* X, 6.

10 *Ibid.* X, 320.

11 Van Lennep, *The London Stage*, pp. 131, 136.

12 *Ibid.* p. 338.

THE PERSONS REPRESENTED IN THE PLAY

[Men]

Albert, *a French* Pirat, *in love with* Aminta.
Tibalt du Pont, *a merry Gentleman, friend to* Albert.
Master of the Ship, *an honest merry man.*
Lamure, *an usuring Merchant.*
Franville, *a vain-glorious gallant.*
Morillat, *a shallow-brain'd Gentleman.*
Boatswain, *an honest man.*
Sebastian, *a noble Gentleman of* Portugal, *Husband to* Rosellia.
Nicusa, *Nephew to* Sebastian, *both cast upon a desart Island.*
Raymond, *brother to* Aminta.
Surgeon.
Sailors.
[Gentlemen.]

Women

Aminta, *Mistress to* Albert, *a noble French* Virgin.
Rosellia, *Governess of the* Amazonian Portugals.
Clarinda, *Daughter to* Rosellia, *in love with* Albert.
Hippolita,
Crocale, } *three Ladies, Members of the Female Common-wealth.*
Juletta.

The Scene, First at Sea, then in the desart Islands.

The Principal Actors were

Joseph Taylor, John Lowin.
William Eglestone, John Underwood.
Nich. Toolie.

The Persons . . . in the Play.] *adapted from* F2; *omit* F1

10

THE SEA VOYAGE

A Tempest, Thunder and Lightning. Enter Master *and two* Saylors. I.i

Master. Lay her aloofe, the Sea grows dangerous,
How it spits against the clouds, how it capers,
And how the fiery Element frights it back!
There be devils dancing in the aire, I think;
I saw a Dolphin hang ith hornes of the moone
Shot from a wave: hey day, hey day,
How she kicks and yerks?
Down with'e main Mast, lay her at hull,
Farle up all her Linnens, and let her ride it out.
1. Saylor. Sheele never brook it Master. 10
Shees so deep laden, that sheele buldge.
Master. Hang her.
Can she not buffet with a storm a little?
How it tosses her! she reeles like a Drunkard.
2. Saylor. We have discovered the Land Sir,
Pray let's make in, shee's so drunke; else,
She may chance to cast up all her Lading.
1. Saylor. Stand in, stand in, we are all lost els,
Lost and perisht.
Master. Steer her a Star-boord there.
2. Saylor. Beare in with all the Sayle we can, see Master
See, What a clap of Thunder there is, 20
What a face of heaven, how dredfully it looks?
Master. Thou rascall, thou fearfull rogue, thou hast bin praying;
I see't in thy face, thou hast been mumbling,
When we are split you slave; is this a time,
To discourage our friends with your cold orrizons?
Call up the Boatswaine; how it storms; holla.

[*Enter* Boatswaine.]

11

Boatswaine. What shall we doe Master?
 Cast over all her lading? she will not swimme
 An houre else.
Master. The storm is lowd, 30
 We cannot heare one another, what's the coast?
Boastwaine. We know not yet; shall we make in?

 Enter Albert, Franvile, La-mure, Tibalt du-pont, Morillat.

Albert. What comfort Saylers?
 I never saw, since I have known the Sea,
 (Which has been this twenty yeers) so rude a tempest.
 In what State are we?
Master. Dangerous enough Captain,
 We have sprung five leakes, and no little ones;
 Still rage; besides her ribs are open;
 Her rudder almost spent; prepare your selves;
 And have good courages, death comes but once, 40
 And let him come in all his frights.
Albert. Is't not possible,
 To make in toth' Land? 'tis here before us.
Morillat. Here hard by Sir.
Master. Death is neerer Gentlemen.
 Yet doe not cry, let's dye like men.
Tibalt. Shal's hoyse the Boat out,
 And goe all at one cast? the more the merrier.
Master. You are too hasty Mounsieur,
 Do ye long to be ith Fish-market before your time?
 Hold her up there.

 Enter Aminta.

Aminta. O miserable Fortune, 50
 Nothing but horrour sounding in mine eares,
 No minute to promise to my frighted soule.
Tibalt. Peace woman,
 We ha storms enough already; no more howling.
Aminta. Gentle Master.
Master. Clap this woman under hatches.
Albert. Prethee speake mildly to her.

12

Aminta. Can no help?

Master. None that I know.

Aminta. No promise from your goddnesse?

Master. Am I a God? for heavens sake stoaw this woman.

Tibalt. Goe: take your gilt Prayer Booke; 60
 And to your businesse; winck and die,
 There an old Haddock stayes for ye.

Aminta. Must I dye here in all the frights, the terrors,
 The thousand severall shapes, death triumphes in?
 No friend to councell me?

Albert. Have Peace sweet Mistresse.

Aminta. No kindreds teares upon me? Oh! my country!
 No gentle hand to close mine eyes?

Albert. Be comforted,
 Heaven has the same power still, and the same mercy.

Aminta. Oh! that wave will devour me! 70

Master. Carry her down Captaine;
 Or by these hands, I'le give no more direction,
 Let the Ship sinck or swimme; we ha nere better luck,
 When we ha such stoage as these trinkets with us,
 These sweet sin-breeders; how can heaven smile on us,
 When such a burthen of iniquity
 Lies tumbling like a potion in our Ships belly?
 Exeunt [Master, Boatswain, Sailors].

Tibalt. A way with her, and if she have a Prayer,
 That's fit for such an houre, let her say't quickly,
 And seriously. *Exeunt* [Tibalt, Franvile, Lamure, Morillat]. 80

Albert. Come, I see it cleer Lady, come in,
 And take some comfort. I'le stay with ye.

Aminta. Where should I stay? to what end should I hope,
 Am I not circled round with misery?
 Confusions in their full heights dwell about me:
 O *Mounsier Albert*, How am I bound to curse ye,
 If curses could redeeme me? how to hate ye?
 You forc't me from my quiet, from my friends;
 Even from their Armes, that were as deere to me,
 As day light is, or comfort to the wretched; 90

*74 trinkets] *stet* F1–2

13

You forc't my friends from their peacefull rest,
Some your relentles sword gave their last groanes;
Would I had there been numbred; and to fortunes
Never satisfied afflictions, ye turn'd my Brother;
And those few friends I'd left like desperate creatures,
To their own feares and the worlds stubborn pitties:
Oh merciles.

Albert. Sweet Mistresse.

Aminta. And whether they are wandred to avoyd ye,
Or whether dead and no kind earth to cover 'em; 100
Was this a lovers part? but heaven has found ye,
And in his lowd voyce, his voyce of thunder,
And in the mutiny of his deep wonders,
He tels ye now, ye weepe too late.

Albert. Let these tears
Tell how I honour ye; ye know dear Lady,
Since ye were mine, how truly I have lov'd ye,
How sanctimoniously observ'd your honour;
Not one lascivious word, not one touch Lady;
No, not a hope that might not render me 110
The unpolluted servant of your Chastity;
For you I put to Sea, to seek your Brother;
Your Captain, yet your slave, that his redemption,
If he be living, where the Sunne has circuit,
May expiate your rigor, and my rashnesse.

Aminta. The Storm grows greater; what shall we do?

Albert. Let's in;
And aske heavens mercy; my strong mind yet presages,
Through all these dangers, we shall see a day yet
Shall Crown your pious hopes, and my faire Wishes.

Exeunt.

Enter Master, *Saylors, Gentlemen* [Tibalt, Lamure, Franville, [I.ii
Morillat], Boatswayne *and* Surgeon.

Master. It must all over boord.

Boastswaine. It cleers to Sea-ward.

Master. Fling o're the lading there, and let's lighten her;

2 Sea-ward.] Sympson; Sea-ward mast. F1–2 3 *Master.*] Sympson; *omit* F1–2

14

All the meat, and the Caskes, we are all gone else;
That we may finde her Leakes, and hold her up;
Yet save some little Bisket for the Lady,
Till we come to the Land.
Lamure. Must my goods over too?
Why honest Master? here lies all my money;
The money I ha wrackt by usurie, 10
To buy new Lands and Lordships in new Countryes,
'Cause I was banisht from mine own.
I ha been this twenty yeers a raising it.
Tibalt. Out with it:
The devils are got together by the eares,
Who shall have it; and here they quarrell in the clouds.
Lamure. I am undone Sir.
Tibalt. And be undone, 'tis better then we perish.
Lamure. O save one Chest of Plate.
Tibalt. A way with it, lustily Saylors; 20
It was some pawne, that he has got unjustly;
Down with it low enough, and let Crabs breed in't.
Master. Over with the Truncks too.

Enter Albert.

Albert. Take mine and spare not.
Master. We must over with all.
Franville. Will ye throw away my Lordship
That I sold, put it into clothes and necessaries,
To goe to Sea with?
Tibalt. Over with it; I love to see a Lordship sincke;
Sir you left no Wood upon't to buoy it up; 30
You might ha sav'd it else.
Franville. I am undone for ever.
Albert. Why we are all undone; would you be only happy?
Lamure. Sir you may loose too.
Tibalt. Thou liest; I ha nothing but my skinne,
And my Clothes; my sword here, and my self;
Two Crowns in my Pocket; two paire of Cards;
And three false Dice; I can swimme like a Fish,

*4 Caskes] Dyce (*after* Mason); Cakes F1–2

15

Rascall; nothing to hinder me.

Boatswaine. In with her of all hands. 40

Master. Come gentlemen, come Captain, ye must helpe all;
My life now for the Land,
'Tis high, and rocky, and full of perils.

Albert. How ever let's attempt it.

Master. Then cheer lustily my hearts.

<div align="right">*Exeunt.*</div>

<div align="center">*Enter* Sebastian *and* Nicusa. [I.iii]</div>

Sebastian. Yes 'tis a Ship, I see it now, a tal Ship;
She has wrought lustily for her deliverance;
Heavens mercy, what a wretched day has here been?

Nicussa. To still and quiet minds, that knew no misery,
It may seeme wretched, but with us 'tis ordinary;
Heaven has no Storm in store, nor earth no terror,
That can seeme new to us.

Sebastian. 'Tis true *Nicusa*;
If fortune were determin'd to be wanton,
And would wipe out the stories of mens miseries:
Yet we two living, we could crosse her purpose; 10
For 'tis impossible she should cure us,
We are so excellent in our afflictions;
It would be more then glory to her blindnes,
And stile her power beyond her pride, to quit us.

Nicusa. Doe they live still?

Sebastian. Yes, and make to harbour.

Nicusa. Most miserable men; I greive their Fortunes.

Sebastian. How happy had they been, had the Sea cover'd 'em.
They leap from one calamity to another;
Had they been drown'd, they had ended all their sorrows.
What showts of joy they make?

Nicusa. Alas poor wretches, 20
Had they but once experience of this Island,
They'd turn their tunes to waylings.

Sebastian. Nay, to curses;
That ever they set foot on such calamities.
Here's nothing but rocks and barrennes,

<div align="center">16</div>

Hunger, and cold to eat; here's no Vineyards
To cheere the heart of man, no Christall Rivers
After his labour to refresh his body,
If he be feeble; nothing to restore him,
But heavenly hopes; nature that made those remedies,
Dares not come here, nor looke on our distresses, 30
For fear she turn wilde like the place and barren.

Nicusa. O Uncle, yet a little memory
Of what we were, 'twill be a little comfort
In our calamities;
When we were seated in our blessed homes,
How happy in our kindreds, in our families,
In all our Fortunes?

Sebastian. Curse on those French Pirates, that displanted us;
That flung us from that happinesse we found there;
Constrain'd us to Sea, 40
To save our lives, honours and our riches,
With all we had, our kinsmen and our jewels,
In hope to finde some place free from such robbers,
Where a mighty storme severd our Barkes,
That, where my wife, my daughter
And my noble Ladyes that went with her,
Virgins and loving soules, to scape those Pirates——

Nicusa. They are living yet; such goodnesse cannot perish.

Sebastian. But never to me Cozen;
Never to me againe; what beares their Flag-staves? 50

Nicusa. The Armes of *France* sure;
Nay, doe not start, we cannot be more miserable;
Death is a cordial, now, come when it will.

Sebastian. They get to shore a pace, they'l flye as fast
When once they find the place; what's that which swims there?

Nicusa. A strong young man Sir, with a handsome woman
Hanging about his Neck.

Sebastian. That shewes some honour;
May thy brave charity what ere thou art,
Be spoken in a place, that may renown thee,
And not dye here.

Nicusa. The Boat it seemes turn'd over, 60

17

So forced to their shifts, yet all are landed,
They're Pirats on my life.
Sebastian. They will not rob us;
For none will take our misery for riches:
Come Cozen, let's descend and try their pitties;
If we get off, a little hope walkes with us;
If not, we shall but load this wretched Island
With the same shadows still that must grow shorter.

Exeunt.

Enter Albert, Aminta, Tibalt, Morillat, La-mure, Master, [I.iv
[Boatswain,] Franvile, Surgeon, Saylors.

Tibalt. Wet come a shore my mates, we are safe arrived yet.
Master. Thanks to heavens goodnesse, no man lost;
The Ship rides faire to, and her leakes in good plight.
Albert. The weather's turn'd more courteous; how does my deere?
Alas, how weake she is and wet?
Aminta. I am glad yet, I scapt with life;
Which certain Noble Captain, next to heavens goodnesse,
I must thanke you for, and which is more,
Acknowledge your deer tendernesse, your firme love
To your unworthy Mistresse, and recant to 10
(Indeed I must) those harsh opinions,
Those cruell unkind thoughts, I heapt upon ye;
Farther then that, I must forget your Injuries,
So farre I am tyde, and fetred to your service.
Beleeve me I will learne to love.
Albert. I thank ye Madam,
And it shall be my practise to serve.
What cheere companions?
Tibalt. No great cheere Sir, a peece of souced Bisket
And halfe a hard egge; for the Sea has taken order;
Being young and strong, we shall not surfet Captaine. 20
For mine own part, Ile Dance till I'm dry;
Come Surgeon, out with your Glister-pipe,
And stricke a Galliard.
Albert. What a brave day again;

3, 10, 30 to] *i.e.,* too (*as in* F2; *also at* III.i.21; IV.ii.221; IV.iv.35; V.i.11, 12; V.iv.99)

And what faire weather, after so fowle a storme?
Lamure. I, an't pleas'd the Master, he might ha seen
 This weather, and ha sav'd our goods.
Albert. Never think on 'em, we have our lives and healths.
Lamure. I must think on 'em, and think
 'Twas most maliciously done to undoe me.
Franville. And me to; I lost all; 30
 I han't another shirt to put upon me, nor Clothes
 But these poor raggs; I had fifteen faire sutes,
 The worst was cut upon Taffaty.
Tibalt. I am glad you ha lost, give me thy hand,
 Is thy skin whole? art thou not purl'd with scabbs?
 No Ancient monuments of madam *Venus?*
 Thou hast a suit then will pose the cunningst Taylor,
 That will never turn fashion, nor forsake thee,
 Till thy executors the wormes uncase thee,
 They take off glorious sutes *Franvile*: thou art happy, 40
 Thou art delivered of 'em; here are no Brokers;
 No *Alchymists* to turn 'em into Mettle;
 Nor Leather'd Captaine's with Ladies to adore 'em;
 Wilt thou see a dogfish rise in one of thy brave doublets,
 And tumble like a Tub to make thee merry,
 Or an old Haddock rise with thy hatcht sword
 Thou payd'st a hundred Crowns for?
 A Mermayd in a mantle of your worships,
 Or a Dolphin in your double ruffe?
Franville. Ye are merry, but if I take it thus, 50
 If I be foysted and jeer'd out of my goods——
Lemure. Nor I, I vow thee.
 Nor Master nor mate, I see your cunning.
Albert. O be not angry Gentlemen.
Morillat. Yes Sir we have reason.
 And some friends I can make.
Master. What I did Gentlemen, was for the generall safety.
 If ye ayme at me, I am not so tame.
Tibalt. Pray take my councell Gallants.
 Fight not till the Surgeon be well, 60
 Hee's damnable Sea-sick, and may spoyle all;

Besides he has lost his Fidlestick, and the best
Box of Bores grease; why doe you make such faces,
And hand your swords?

Albert. Who would ye fight with? Gentlemen?
Who has done ye wrong? for shame be better temper'd.
No sooner come to give thankes for our safeties,
But we must raise new civill Broyles amongst us,
Inflame those angry powers, to shower new vengeance on us?
What can we expect for these unmanly murmers,
These strong temptations of their holy pitties, 70
But plagues in another kind, a fuller, so dreadfull,
That the singing stormes are slumbers to it?

Tibalt. Be men and rule your minds;
If you will needs fight Gentlemen,
And thinke to raise new riches by your valours,
Have at ye, I have little else to doe now
I have said my Prayers; you say you have lost,
And make your losse your quarrell,
And grumble at my Captaine here, and the Master,
Two worthy persons; indeed too worthy for such rascals, 80
Thou Galloone gallant, and Mamon you
That build on golden mountaines, thou money Maggot;
Come all draw your swords, ye say ye are miserable.

Albert. Nay, hold good *Tibalt.*

Tibalt. Captaine, let me correct 'em;
I'le make ye ten times worse, I will not leave 'em;
For look ye, fighting is as nourishing to me as eating,
I was born quarrelling.

Master. Pray Sir.

Tibalt. I will not leave 'em skins to cover 'em;
Doe ye grumble, when ye are well ye rogues? 90

Master. Noble *Du-pont.*

Tibalt. Ye have Clothes now: and ye prate.

Aminta. Pray Gentlemen, for my sake be at peace.
Let it become me to make all friends.

Franville. You have stopt our angers Lady.

Albert. This shewes noble.

*81 Galloone] *stet* F1; *Galloon* F2 *93 Let] F2; *La-m.* Let F1

Tibalt. 'Tis well: 'tis very well: there's halfe a Bisket,
 Break't amongst ye all, and thank my bounty,
 This is clothes and Plate too; come no more quarrelling.

Enter Sebastian *and* Nicusa.

Aminta. But ha! what things are these,
 Are they humane creatures?
Tibalt. I have heard of Sea-Calves.
Albert. They are no shaddows sure, they have Leggs and Armes. 100
Tibalt. They hang but lightly on though.
Aminta. How they looke, are they mens faces?
Tibalt. They have Horse-Tayles growing to 'em, goodly long
 maines.
Aminta. Alas what sunk eyes they have!
 How they are crept in, as if they had been frighted!
 Sure they are wretched men.
Tibalt. Where are their Wardrobs?
 Looke ye *Franvile*, here are a cople of Courtiers.
Aminta. They kneele, alas poore soules.
Albert. What are ye? speake; are ye alive,
 Or wandring shaddows, that finde no peace on earth, 110
 Till ye reveale some hidden secret?
Sebastian. We are men as you are;
 Onely our miseries make us seem Monsters.
 If ever pitty dwelt in noble hearts——
Albert. We understand 'em too: pray marke 'em Gentlemen.
Sebastian. Or that heaven is pleas'd with human charity;
 If ever ye have heard the name of friendship?
 Or suffered in your selves, the least afflictions,
 Have gentle Fathers that have bred ye tenderly,
 And Mothers that have wept for your misfortunes, 120
 Have mercy on our miseries.
Albert. Stand up wretches;
 Speak boldly, and have release.
Nicusa. If ye be Christians,
 And by that blessed name, bound to releeve us,
 Convey us from this Island.
Albert. Speake; what are ye?

21

Sebastian.　As you are, Gentle born; to tell ye more,
　　Were but to number up our own calamities,
　　And turn your eyes wild with perpetuall weepings;
　　These many yeers, in this most wretched Island
　　We two have liv'd; the scorne and game of fortune:
　　Blesse your selves from it Noble Gentlemen;　　　　　　　130
　　The greatest plagues, that humane nature suffers,
　　Are seated here, wildnesse, and wants innumerable.
Albert.　How came ye hither?
Nicusa.　In a ship, as you do, and as you might have been
　　Had not heaven preserv'd ye for some more noble use;
　　Wrack't desperately; our men, and all consum'd,
　　But we two; that still live, and spin out
　　The thin and ragged threds of our misfortunes.
Albert.　Is there no meat above?
Sebastian.　　　　　　　　　　Nor meat nor quiet;
　　No summer here, to promise any thing;　　　　　　　140
　　Nor Autume, to make full the reapers hands;
　　The earth obdurate to the teares of heaven,
　　Let's nothing shoot but poysoned weeds.
　　No Rivers, nor no pleasant Groves, no beasts;
　　All that were made for mans use, flye this desart;
　　No aëry fowle dares make his flight over it,
　　It is so ominous.
　　Serpents, and ugly things, the shames of nature,
　　Roots of malignant tastes, foule standing waters;
　　Sometimes we finde a fulsome Sea-root,　　　　　　　150
　　And that's a delicate: a Rat sometimes,
　　And that we hunt like Princes in their pleasure;
　　And when we take a Toad, we make a Banquet.
Aminta.　For heavens sake let's aboord.
Albert.　D'ee know no farther?
Nicusa.　　　　　　　　　Yes we have sometimes seen
　　The shaddow of a place inhabited;
　　And heard the noyse of hunters;
　　And have attempted to finde it; so far as a River,
　　Deep, slow, and dangerous, fenced with high Rocks,
　　We have gone; but not able to atchieve that hazard,　　　160

22

Returne to our old miseries.

If this sad story, may diserve your pitties——

Albert. Ye shall aboord with us, we will relieve your miseries.

Sebastian. Nor will we be unthankfull for this benefit;

No Gentlemen, wee'le pay for our deliverance;

Look ye that plough the Seas for wealth and pleasures,

That out-runne day and night with your ambitions,

Looke on those heaps, they seeme hard ragged quarries;

Remove 'em and view 'em fully.

Master. O heaven, they are Gold and Jewels.

Sebastian. Be not too hasty, 170

Here lies another heape.

Morillat. And here another,

All perfect gold.

Albert. Stand farther off, you must not be your own carvers.

Lamure. We have shares, and deep ones.

Franville. Yes Sir, wee'le maintain't: ho fellow Saylors.

Lamure. Stand all to your freedomes; I'le have all this.

Franville. And I this.

Tibalt. You shall be hang'd first.

Lamure. My losses shall be made good.

Franville. So shall mine, or with my sword I'le do't; 180

All that will share with us, assist us.

Tibalt. Captain let's set in.

Albert. This money will undoe us, undoe us all.

Sebastian. This Gold was the overthrow of my happines;

I had command too, when I landed here,

And lead young, high, and noble spirits under me.

This cursed Gold entising 'em, they set upon their Captain,

On me that own'd this wealth, and this poor Gentleman,

Gave us no few wounds, forc'd us from our own;

And then their civill swords, who should be owners, 190

And who Lords over all, turn'd against their own lives,

First in their rage consum'd the Ship,

That poor part of the Ship that scap't the first wracke,

Next their lives by heaps; O be you wise and carefull.

Lamure. Wee'le ha more: Sirah, come show it.

Franville. Or ten times worse afflictions then thou speak'st of.

Albert. Nay, and ye will be Doggs—— *Beats 'em out.*
Tibalt. Let me come Captaine:
 This Golden age must have an Iron ending.
 Have at the bunch. *He beats 'em off. Exeunt.*
Aminta. O *Albert*; O Gentlemen; O friends. *Exit.*
Sebastian. Come noble Nephew, if we stay here, we dye; 200
 Here rides their Ship, yet all are gone toth' spoyle,
 Let's make a quick use.
Nicusa. Away deer Uncle.
Sebastian. This Gold was our overthrow.
Nicusa. It may now be our happinesse. *Exeunt.*

 Enter Tibalt *and* [Albert, *pursuing*] *the rest* [I.v]
 [Morillat, Lamure, Franville, Master, Boatswain, Surgeon, Sailors].

Tibalt. You shall have gold: yes, I'le crambe it int'ee;
 You shall be your own carvers; yes, I'le carve ye.
Morillat. I am sore, I pray heare reason.
Tibalt. I'le heare none.
 Covetous base mindes have no reason;
 I am hurt my self; but whil'st I have a Legge left,
 I will so haunt your guilded soules; how d'ee Captain?
 Ye bleed apace, curse on the causers on't;
 Ye doe not faint?
Albert. No, no; I am not so happy.
Tibalt. D'ee howle, nay, ye deserve it:
 Base greedy rogues; come, shall we make an end of 'em? 10
Albert. They are our country-men, for heavens sake spare 'em,
 Alas, they are hurt enough: and they relent now.

 Aminta *above.*

Aminta. O Captain, Captain.
Albert. Whose voyce is that?
Tibalt. The Ladies
Aminta. Look Captain, look; ye are undone: poore Captain,
 We are all undone: all, all: we are all miserable,
 Mad wilfull men; ye are undone, your ship, your Ship.
Albert. What of her?

 *197, 199 *Beats 'em out ... *He beats 'em off. Exeunt.*] stet F1–2

 24

Aminta. Shee's under Sayle and floating;
See where she flies: see to your shames, you wretches:
Those poor starv'd things, that shewed you Gold.

La-mure *and* Franvile *goes up to see the Ship.*

1. Saylor. They have cut the Cables, 20
And got her out; the tyde too has befrinded 'em.
Master. Where are the Saylors that kept her?
Boatswain. Here, here in the mutiny, to take up mony,
And left no creature, left the Boat a shoare too;
This Gold, this damn'd enticing Gold.
2. Saylor. How the wind drives her,
As if it vied to force her from our furies?
Lamure. Come back good old men.
Franville. Good honest men, come back.
Tibalt. The wind's against ye, speak lowder. 30
Lamure. Ye shall have all your Gold againe: they see us.
Tibalt. Hold up your hands, and kneele,
And houle ye blockheads; they'le have compassion on ye;
Yes, yes, 'tis very likely: ye have deserv'd it,
D'ee look like Doggs now?
Are your mighty courages abated?
Albert. I bleed apace *Tibalt.*
Tibalt. Retire Sir; and make the best use of our miseries.
They but begin now.

Enter Aminta.

Aminta. Are ye alive still?
Albert. Yes sweet.
Tibalt. Help him off Lady; and wrap him warme, in your Armes, 40
Here's something that's comfortable; off with him handsomely,
I'le come to ye straight: but vex these rascals a little.

Exeunt Albert, Aminta.

Franville. Oh! I am hungry, and hurt, and I am weary.
Tibalt. Here's a Pestle of a Portigue, Sir;
'Tis excellent meat, with soure sauce;
And here's two Chaines, suppose 'em Sausages;

Then there wants Mustar'd.
But the fearefull Surgeon will supply ye presently.

Lamure. O for that Surgeon, I shall dye else.

Tibalt. Faith, there he lies in the same pickle too. 50

Surgeon. My salves, and all my Instruments are lost;
And I am hurt, and starv'd;
Good Sir, seeke for some Hearbs.

Tibalt. Here's Hearbe gracelesse; will that serve?
Gentlemen, will ye goe to Supper!

All. Where's the meat?

Tibalt. Where's the meat? what a Veale voyce is there?

Franville. Would we had it Sir, or any thing else.

Tibalt. I would now cut your throat you Dogge, but that
I wo not doe you such a curtesie;
To take you from the benefit of starving. 60
O! what a comfort will your worship have,
Some three dayes hence? Ye things beneath pitty,
Famine shall be your harbinger;
You must not look for down-beds here, nor Hangings;
Though I could wish ye strong ones;
Yet here be many lightsome coole Star-chambers,
Open to every sweet ayre, I'le assure ye,
Ready provided for ye, and so I'le leave ye;
Your first course is serv'd, expect the second. *Exit.*

Franville. A vengeance on these Jewels. 70

Lemure. O! this cursed Gold.

 Exeunt.

Enter Albert, Aminta. [II.i]

Albert. Alas, deere soule ye faint.

Aminta. You speak the language
Which I should use to you; heaven knows, my weaknes
Is not for what I suffer in my selfe,
But to imagine what you endure, and to what fate
Your cruell Starrs reserve ye.

Albert. Doe not adde to my afflictions

*62–63 Ye things beneath pitty, | Famine shall] F2; Yea things beneath pitty shall F1
65 ones] F2; on's F1

By your tender pitties; sure we have chang'd Sexes;
You bear calamity with a fortitude
Would become a man; I like a weake girle suffer.

Aminta. O! but your wounds, 10
How fearfully they gape? and every one
To me is a Sepulchre; if I lov'd truly,
Wise men affirm that true love can doe wonders,
This bath'd in my warme teares, would soon be cur'd,
And leave no orifice behind; pray give me leave
To play the Surgeon, and bind 'em up;
The raw ayre rancles 'em.

Albert. Sweet, we want meanes.

Aminta. Love can supply all wants. [*Cuts her hair.*]

Albert. What have ye done Sweet?
Oh sacriledge to beauty: there's no haire
Of these pure locks, by which the greatest King 20
Would not be gladly bound, and love his Fetters.

Aminta. O *Albert*, I offer this sacrifice of service
To the Altar of your staid temperance, and still adore it;
When with a violent hand you made me yours,
I cursed the doer: but now I consider,
How long I was in your power? and with what honour
You entertain'd me? It being seldome seen,
That youth and heat of blood could ere prescribe
Laws to it selfe; your goodnesse is the Lethe,
In which I drown your injuries, and now live 30
Truly to serve ye: how doe you Sir?
Receive you the least ease from my service?
If you doe, I am largely recompenc'd.

Albert. You good Angels,
That are ingag'd, when mans ability failes,
To reward goodnesse: look upon this Lady
Though hunger gripes my croaking entrailes,
Yet when I kisse these rubies, me thinkes
I'm at a banquet, a refreshing banquet;
Speak my bless'd one, art not hungry?

Aminta. Indeed I could eat, to beare you company. 40

Albert. Blush unkind nature,

27

If thou hast power: or being to heare
Thy self, and by such innocence accus'd;
Must Print a thousand kinds of shames, upon
Thy various face: canst thou supply a drunkard,
And with a prodigall hand, reach choice of wines,
Till he cast up thy blessings? or a glutton,
That robbs the Elements, to sooth his palat,
And only eats to beget Appetite,
Not to be satisfied? and suffer here 50
A Virgin, which the Saints would make their guest,
To pine for hunger? ha, if my sence *Hornes within.*
Deceive me not, these notes take being
From the breath of men; confirme me my *Aminta*;
Again, this way the gentle wind conveyes it to us,
Heare you nothing?
Aminta. Yes, it seemes free hunters Musicke.
Albert. Still 'tis lowder; and I remember the Portugals
Inform'd us, they had often heard such sounds,
But ne're could touch the shore from whence it came;
Follow me, my *Aminta*: my good genius, 60
Shew me the way still; still we are directed;
When we gaine the top of this neer rising hill
We shall know further. *Exeunt, and Enter above.*
 Curteous *Zephyrus*
On his dewie wings carries perfumes to cheer us;
The ayre cleers too;
And now, we may discerne another Island,
And questionlesse, the seat of fortunate men:
O that we could arrive there.
Aminta. No *Albert*, 'tis not to be hop'd;
This envious Torrent's cruelly interpos'd; 70
We have no Vessell that may transport us;
Nor hath nature given us wing's to flye.
Albert. Better try all hazards,
Then perish here remedilesse; I feele
New vigor in me, and a spirit that dares
More then a man, to serve my faire *Aminta*;

63 Curteous] *Alb.* Curteous F1–2

28

These Armes shall be my oares, with which I'le swim;
And my zeale to save thy innocent selfe, like wings,
Shall beare me up above the brackish waves.

Aminta. Will ye then leave me?

Albert. Till now I nere was wretched. 80
My best *Aminta*, I sweare by goodnesse tis
Nor hope, nor feare, of my selfe, that invites me
To this extreame; tis to supply thy wants;
And believe me
Though pleasure met me in most ravishing formes,
And happinesse courted me to entertaine her,
I would nor eate nor sleepe till I return'd
And crown'd thee with my fortunes.

Aminta. O but your absence——

Albert. Suppose it but a dream; and as you may,
Endeavour to take rest; and when that sleep 90
Deceives your hunger with imagin'd food,
Thinke you have sent me for discovery
Of some most fortunate Continent, yet unknown,
Which you are to be Queen of.
And now ye Powers that ere heard Lovers prayers,
Or cherisht pure affection, looke on him
That is your Votary; and make it known
Against all stops, you can defend your own.

 Exeunt.

 Enter Hippolita, Crocale, Juletta. [II.ii]

Hippolita. How did we lose *Clarinda?*

Crocale. When we believ'd the Stag was spent,
And would take soyle, the sight of the blacke Lake
Which we suppos'd he chose for his last refuge,
Frighted him more then we that did pursue him.

Juletta. That's usuall;
For, death it selfe is not so terrible
To any beast of chase.

Hippolita. Since we liv'd here,
We nere could force one to it.

 80 Will] F2; Well F1 *80 *Albert.* Till] *stet* F1–2

 29

Crocale. Tis so dreadfull,
 Birds that with their pinions cleave the Ayre 10
 Dare not flie over it: when the Stag turn'd head,
 And we even tyred with labour, *Clarinda*
 As if she were made of Ayre and Fire, and had
 No part of earth in her, eagerly pursu'd him;
 Nor need we feare her safety, this place yeelds
 Not Fawnes nor Satyres, or more lustfull men;
 Here we live secure,
 And have among our selves a Common-wealth,
 Which in our selves begun, with us must end.
Juletta. I there's the misery.
Crocale. But being alone, 20
 Allow me freedome but to speake my thoughts;
 The strictnesse of our Governesse, that forbids us
 On pain of death the sight and use of men,
 Is more then tyranny: for her selfe, shee's past
 Those youthfull heats, and feeles not the want
 Of that which young mayds long for; and her daughter
 The faire *Clarinda*, though in few yeeres
 Improv'd in height and large proportion,
 Came here so young,
 That scarce remembring that she had a father, 30
 She never dreames of man; and should she see one,
 In my opinion, a would appeare
 A strange beast to her.
Juletta. Tis not so with us.
Hippolita. For my part, I confesse it, I was not made
 For this single life; nor doe I love hunting so,
 But that I had rather be the Chace my selfe.
Crocale. By *Venus* (out upon me) I should have sworn
 By *Diana*, I am of thy mind too wench;
 And though I have tane an Oath, not alone
 To detest, but never to thinke of man, 40
 Every houre something tels me I am forsworn;
 For I confesse imagination helps me sometimes,
 And that's all is left for us to feed on,
 We might starve else; for if I have any pleasure
 In this life, but when I sleep, I am a Pagan;

Then from the Courtier to the Country clown,
I have strange visions.
Juletta. Visions *Crocale?*
Crocale. Yes, and fine visions too;
And visions I hope in dreames are harmlesse,
And not forbid by our Canons; the last night 50
(Troth tis a foolish one, but I must tell it)
As I lay in my cabin betwixt sleeping and waking——
Hippolita. Upon your backe?
Crocale. How should a young mayd lie, foole,
When she would be intranc'd?
Hippolita. We are instructed; forward I prethee.
Crocale. Me thought a sweet young man
In yeeres, some twenty, with a downy chin,
Promising a future beard, and yet no red one,
Stole slylie to my cabin, all unbrac'd,
Tooke me in his armes, and kiss'd me twenty times, 60
Yet still I slept.
Juletta. Fie; thy lips run over *Crocale.*
But to the rest.
Crocale. Lord, what a man is this thought I,
To doe this to a mayd!
Yet then for my life I could not wake.
The youth, a little danted, with a trembling hand
Heav'd up the clothes.
Hippolita. Yet still you slept.
Crocale. Yfaith I did;
And when, methoughts, he was warm by my side,
Thinking to catch him, I stretcht out both mine armes;
And when I felt him not, I shreekt out,
And wak'd for anger. 70
Hippolita. Twas a pretty dream.
Crocale. I, if it had been a true one.

Enter Albert.

Juletta. But stay, what's here cast oth' shore?
Hippolita. Tis a man;

Shall I shoot him?

Crocale. No, no, tis a handsome beast;
Would we had more o'the breed; stand close wenches,
And let's heare if he can speake.

Albert. Doe I yet live?
Sure it is ayre I breathe; what place is this?
Sure something more then humane keeps residence here,
For I have past the Stygian gulph,
And touch upon the blessed shore? tis so;
This is the Elizian shade; these happy spirits, 80
That here enjoy all pleasures.

Hippolita. He makes towards us.

Juletta. Stand, or Ile shoot.

Crocale. Hold, he makes no resistance.

Albert. Be not offended Goddesses, that I fall
Thus prostrate at your feet: or if not such,
But Nymphs of *Dian's* traine, that range these groves,
Which you forbid to men; vouchsafe to know
I am a man, a wicked sinfull man; and yet not sold
So far to impudence, as to presume
To presse upon your privacies, or provoke
Your Heavenly angers; tis not for my selfe 90
I beg thus poorely, for I am already wounded,
Wounded to death, and faint; my last breath
Is for a Virgin comes as neere your selves
In all perfection, as what's mortall may
Resemble things divine. O pitty her,
And let your charity free her from that desart,
If Heavenly charity can reach to hell,
For sure that place comes neere it: and where ere
My ghost shall finde abode,
Eternally I shall powre blessings on ye. 100

Hippolita. By my life I can not hurt him.

Crocale. Though I lose my head for it, nor I.
I must pitty him and will.

Enter Clarinda.

Juletta. But stay, *Clarinda.*

32

Clarinda. What new game have ye found here, ha!
What beast is this lies wallowing in his gore?
Crocale. Keep off.
Clarinda. Wherefore, I pray? I nere turn'd
From a fell Lionesse rob'd of her whelps,
And shall I feare dead carrion?
Juletta. O but——
Clarinda. But, what ist?
Hippolita. It is infectious.
Clarinda. Has it not a name?
Crocale. Yes, but such a name from which 110
As from the divell your mother commands us flie.
Clarinda. Is it a man?
Crocale. It is.
Clarinda. What a brave shape it has in death;
How excellent would it appeare had it life!
Why should it be infectious? I have heard
My mother say I had a father,
And was not he a man?
Crocale. Questionlesse Maddam.
Clarinda. Your fathers too were men?
Juletta. Without doubt Lady.
Clarinda. And without such it is impossible
We could have been. 120
Hippolita. A sinne against nature to deny it.
Clarinda. Nor can you
Or I have any hope to be a mother
Without the helpe of men.
Crocale. Impossible.
Clarinda. Which of you then most barbarous, that knew
You from a man had being, and owe to it
The name of parent, durst presume to kill
The likenesse of that thing by which you are?
Whose Arrowes made these wounds? speake, or by *Dian*
Without distinction Ile let fly at ye all.
Juletta. Not mine.
Hippolita. Nor mine.
Crocale. Tis strange to see her mov'd thus. 130

33

Restraine your fury Maddam; had we kild him,
We had but perform'd your mothers command.
Clarinda. But if she command unjust and cruell things,
We are not to obey it.
Crocale. We are innocent;
Some storm did cast him shipwrackt on the shore,
As you see, wounded: nor durst we be Surgeons
To such your mother doth appoint for death.
Clarinda. Weake excuse; where's pity?
Where's soft compassion? cruel, and ungratefull!
Did providence offer to your charity 140
But one poore Subject to expresse it on,
And in't to shew our wants too; and could you
So carelesly neglect it.
Hippolita. For ought I know, he's living yet;
And you may tempt your mother, by giving him succour.
Clarinda. Ha, come neere I charge ye.
So, bend his body softly; rub his temples;
Nay, that shall be my Office: how the red
Steales into his pale lips! run and fetch the simples
With which my mother heald my arme 150
When last I was wounded by the Bore.
Crocale. Doe: but remember her to come after ye,
That she may behold her daughters charity.
 Exit Hippolita.

Clarinda. Now he breathes;
The ayre passing through the Arabian groves
Yeelds not so sweet an odour: prethee taste it;
Taste it good *Crocale*;
Yet I envy thee so great a blessing;
Tis not sinne to touch these Rubies, is it?
Juletta. Not, I thinke.
Clarinda. Or thus to live Camelion like? 160
I could resigne my essence to live ever thus.
O welcome; raise him up Gently. Some soft hand
Bound up these wounds; a womans haire. What fury
For which my ignorance does not know a name,
Is crept into my bosome?

Enter Hipolita [*with simples*].

But I forget
My pious work. Now if this juyce hath power,
Let it appeare; his eyelids ope: Prodigious!
Two Sunnes breake from these Orbes.

Albert. Ha, where am I? what new vision's this?
To what Goddesse doe I owe this second life? 170
Sure thou art more then mortall:
And any Sacrifice of thanks or duty
In poor and wretched man to pay, comes short
Of your immortall bounty: but to shew
I am not unthankfull, thus in humility
I kisse the happy ground you have made sacred,
By bearing of your waight.

Clarinda. No Goddesse, friend:
But made of that same brittle mould as you are;
One too acquainted with calamities,
And from that apt to pity. Charity ever 180
Findes in the act reward, and needs no Trumpet
In the receiver. O forbeare this duty;
I have a hand to meet with yours, and lips
To bid yours welcome.

Crocale. I see, that by instinct,
Though a young mayd hath never seen a man,
Touches have tittulations, and inform her.

Enter Rosella.

But here's our Governesse;
Now I expect a storme.

Rossella. Child of my flesh,
And not of my faire unspotted mind,
Un-hand this monster.

Clarinda. Monster, mother?

Rossella. Yes; 190
And every word he speakes, a Syrens note,
To drowne the carelesse hearer. Have I not taught thee

*186 tittulations] *stet* F1–2

35

The falshood and the perjuries of men?
On whom, but for a woman to shew pity,
Is to be cruell to her selfe; the soveraignty
Proud and imperious men usurpe upon us,
We conferre on our selves, and love those fetters
We fasten to our freedomes. Have we, *Clarinda*,
Since thy fathers wrack, sought liberty,
To lose it un-compeld? did fortune guide, 200
Or rather destiny, our Barke, to which
We could appoint no Port, to this blest place,
Inhabited heretofore by warlike women,
That kept men in subjection? did we then
By their example, after we had lost
All we could love in man, here plant our selves,
With execrable oathes never to looke
On man, but as a monster? and wilt thou
Be the first president to infringe those vows
We made to Heaven?
Clarinda. Heare me; and heare me with justice. 210
And as ye are delighted in the name
Of mother, heare a daughter that would be like you.
Should all women use this obstinate abstinence,
You would force upon us; in a few yeeres
The whole world would be peopled
Onely with beasts.
Hippolita. We must and will have men.
Crocale. I or wee'l shake off all obedience.
Rossella. Are ye mad?
Can no perswasion alter ye? suppose
You had my suffrage to your sute;
Can this Shipwrackt wretch supply them all? 220
Albert. Hear me great Lady?
I have fellowes in my misery, not far hence,
Divided only by this hellish River,
There live a company of wretched men
Such as your charity may make your slaves;
Imagine all the miseries mankind
May suffer under: and they groane beneath 'em.

Clarinda. But are they like to you?

Juletta. Speak they your Language?

Crocale. Are they able, lusty men?

Albert. They were good Ladyes;
 And in their May of youth, of gentle blood, 230
 And such as may deserve ye; now cold and hunger
 Hath lessen'd their perfection: but restor'd
 To what they were, I doubt not they'l appeare
 Worthy your favours.

Juletta. This a blessing
 We durst not hope for.

Clarinda. Deere Mother, be not obdurate.

Rossella. Hear then my resolution: and labour not
 To add to what i'le grant, for 'twill be fruitlesse.
 You shall appear as good angels to these wretched men;
 In a small Boat wee'l passe o're to 'em;
 And bring 'em comfort: if you like their persons, 240
 And they approve of yours: for wee'l force nothing;
 And since we want ceremonies,
 Each one shall choose a husband, and injoy
 His company a month, but that expird
 You shall no more come neer 'em; if you prove fruitful,
 The Males yee shall returne to them, the Females
 We will reserve our selves: this is the utmost,
 Yee shall 'ere obtaine:
 As yee think fit; yee may dismisse this stranger,
 And prepare to morrow for the journey *Exit.* 250

Clarinda. Come Sir, will ye walke?
 We will shew ye our pleasant Bowers,
 And something yee shall find to cheer your heart.

Albert. Excellent Lady;
 Though 'twill appear a wonder one neer starv'd
 Should refuse rest and meat, I must not take
 Your noble offer: I left in yonder desart
 A Virgin almost pind.

Clarinda. Shee's not your wife?

Albert. No Lady, but my sister (tis now dangerous
 To speak truth) to her I deeply vow'd 260

37

Not to tast food or rest, if fortune brought it me,
Till I bless'd her with my returne: now if you please
To afford me an easie passage to her,
And some meat for her recovery,
I shall live your slave: and thankfully
Shee shall ever acknowledge her life at your service.

Clarinda.　You plead so well, I can deny ye nothing;
I myselfe will see you furnisht;
And with the next Sun visit and relieve thee.

Albert.　Yee are all goodnesse——　　　　　　　　　　　　270

　　　　　　　　　　　　　　　　　　　　　　Exeunt.

　　　　Enter severally, Lamure, Franvile, Morillat.　　III.[i]

Lamure.　Oh! what a tempest have I in my stomack?
How my empty guts cry out? my wounds ake,
Would they would bleed again, that I might get
Something to quench my thirst.

Franville. O *Lamure,* the happinesse my doggs had
When I kept house at home! they had a storehouse,
A stourehouse of most blessed bones and crusts,
Happy crusts: Oh! how sharp hunger pinches me? *Exit* Franvile.

Morillat.　O my importunate belly, I have nothing
To satisfie thee; I have sought,　　　　　　　　　　10
As far as my weake legs would carry me,
Yet can find nothing: neither meat nor water;
Nor any thing that's nourishing,
My bellies grown together like an empty sachell.

　　　　　　　　　Enter Franvile.

Lamure.　How now what news?
Morillat.　Hast any meat yet?
Franville.　Not a bit that I can see;
Here be goodly quarries, but they be cruell hard
To gnaw: I ha got some mud, we'l eat it with spoons,
Very good thick mud: but it stinkes damnably;　　　20
Ther's old rotten trunks of Trees to,
But not a leafe nor blossome in all the Island.

Lamure.　How it looks?

38

Morillat. It stinkes too.

Lamure. It may be poyson.

Franville. Let it be any thing;
So I can get it down: why man,
Poyson's a princely dish.

Morillat. Hast thou no Bisket?
No crumbs left in thy pocket: here's my dublet,
Give me but three small crumbes.

Franville. Not for three Kingdoms, 30
If I were master of 'em: Oh *Lamure*,
But one poore joynt of Mutton: we ha scornd (man).

Lamure. Thou speakest of paradise.

Franville. Or but the snuffes of those healths,
We have lewdly at midnight flang away.

Morillat. Ah! but to lick the Glasses.

*Enter* Surgeon.

Franville. Here comes the Surgeon: what hast thou discovered?
Smile, smile, and comfort us.

Surgeon. I am expiring;
Smile they that can: I can find nothing Gentlemen,
Here's nothing can be meate without a miracle.
O that I had my boxes and my lints now, 40
My stupes, my tents, and those sweet helps of nature,
What dainty dishes could I make of 'em.

Morillat. Hast neer an old suppository?

Surgeon. Oh would I had sir.

Lamure. Or, but the paper where such a Cordiall
Potion or Pils hath bin entombd.

Franville. Or, the blest bladder where a cooling glister——

Morillat. Hast thou no searcloths left?
Nor any old poultices?

Franville. We care not to what it hath bin ministred. 50

Surgeon. Sure I have none of these dainties Gentlemen.

Franville. Wher's the great Wen
Thou cutst from *Hugh* the saylers shoulder?
That would serve now for a most Princely banquet.

49 poultices] F2 (pultesses); poulties F1

Surgeon. I, if we had it Gentlemen.
 I flung it over-board, slave that I was.
Lamure. A most unprovident villaine.
Surgeon. If I had any thing that were but supple now!
 I could make sallads of your shoos Gentlemen,
 And rare ones: any thing unctious. 60
Morillat. I and then we might fry the soales 'ith Sun.
 The soales would make a second dish.
Lamure. Or, souce 'em in the salt-water,
 An inner soale well souc'd.

 Enter Aminta.

Franville. Here comes the Woman;
 It may be she has meat and may relieve us,
 Let's withdraw, and marke and then be ready,
 Shee'l hide her store els, and so cozen us.
Aminta. How weary and how hungry am I,
 How feeble and how faint is all my body?
 Mine eyes like spent Lamps glowing out grow heavy, 70
 My sight forsaking me and all my spirits,
 As if they heard my passing bell go for me,
 Pull in their powers and give me up to destiny,
 Oh! for a little water: a little little meat,
 A little to relieve me ere I perish:
 I had whole floods of tears awhile that norisht me,
 But they are all consum'd for thee deere *Albert*;
 For thee they are spent, for thou art dead;
 Mercilesse fate hath swallowd thee.
 Oh——I grow heavy: sleep is a salve for misery; 80
 Heaven look on me, and either take my life,
 Or make me once more happy.
Lamure. Shee's fast asleep already,
 Why should shee have this blessing, and we wake still,
 Wake to our wants?
Morillat. This thing hath bin our overthrow,
 And all these biting mischieves that fall on us
 Are come through her means.

 83 Shee's] F2; Hee's F1

 40

Franville. True we were bound yee all know,
 For happy places and most fertill islands,
 Where we had constant promises of all things, 90
 Shee turn'd the Captaines minde,
 And must have him go in search, I know not of who,
 Nor to what end: of such a foole her brother,
 And such a coxcomb her kinsman, and we must put in every where,
 She has put us in now yfaith.
Lamure. Why should we consume thus, and starve,
 Have nothing to relieve us;
 And shee live there that bred all our miseries,
 Unrosted or unsod?
Morillat. I have read in stories———
Lamure. Of such restoring meates, we have examples; 100
 Thousand examples and allow'd for excellent;
 Women that have eate their Children,
 Men their slaves, nay their brothers: but these are nothing;
 Husbands devoured their wives (they are their chattels,)
 And of a Schoolemaster that in a time of famine,
 Powdered up all his Schollers.
Morillat. Shee's young and tydie,
 In my conscience shee'l eate delicatly;
 Just like young Porke a little lean,
 Your opinion Surgeon?
Surgeon. I think shee may be made good meat. 110
 But look we shall want Salt.
Franville. Tush, she needs no powdering.
Surgeon. I grant ye;
 But to suck out the humorous parts: by all means,
 Let's kill her in a chafe, shee'l eat the sweeter.
Lamure. Let's kill her any way: and kill her quickly,
 That we might be at our meat.
Surgeon. How if the Captaine———
Morillat. Talk not of him, hee's dead, and the rest famish'd.
 Wake her Surgeon, and cut her throate,
 And then divide her, every man his share.
Franville. Shee wakes her selfe.
Aminta. Holy and good things keep me! 120

41

What cruell dreames have I had! who are these?
O they are my friends; for heavens sake Gentlemen
Give me some food to save my life: if ye
Have ought to spare;
A little to relieve me: I may blesse yee;
For weake and wretched, ready to perish
Even now I die.

Morillat. You'l save a labour then,
You bred these miseries, and you shall pay for't;
We have no meat, nor where to have we know not,
Nor how to pull our selves from these afflictions, 130
We are starv'd too, famisht, all our hopes deluded;
Yet ere we die thus, wee'l have one deinty meale.

Aminta. Shall I be with ye Gentlemen?

Lamure. Yes mary shall yee: in our bellies Lady.
We love you well——

Aminta. What said you sir?

Lamure. Mary wee'l eat your Ladiship.

Franville. You that have buried us in this base Island,
Wee'l bury ye in a more noble Monument.

Surgeon. Will ye say your prayers, that I may perform Lady?
We are wondrous sharp set; come Gentlemen, 140
Who are for the hinder parts?

Morillat. I.

Franville. I.

Lamure. And I.

Surgeon. Be patient;
They will not fall to every mans share.

Aminta. O hear me;
Hear me ye barbarous men.

Morillat. Be short and pithy.
Our stomakes cannot stay a long discourse.

Surgeon. And be not fearfull,
For i'le kill ye daintily.

Aminta. Are ye not Christians?

Lamure. Why, do not Christians eat women?

Aminta. Eat one another? tis most impious.

Surgeon. Come come. 150

Enter Tibalt, Master, Saylors.

Aminta. Oh, help, help, help.
Tibalt. The Ladies voyce! stand off slaves,
 What do you intend villains?
 I have strength enough left me, if you abuse this soule,
 To——
Master. They would have ravisht her upon my life,
 Speak, how was it Lady?
Aminta. Forgive 'em, 'twas their hungers.
Tibalt. Ha, their hungers!
Master. They would have eaten her.
Tibalt. O dam'd villains; speak, is it true?
Surgeon. I confesse an appetite. 160
Tibalt. An appetite, i'le fit ye for an appetite.
 Are ye so sharp set that her flesh must serve you?
 Murther's a maine good service with your worships;
 Since ye would be such devils,
 Why did you not begin with one another handsomly,
 And spare the woman to beget more food on?
Aminta. Good Sir.
Tibalt. You shall grow mumey rascals;
 I'le make you fall to your brawnes and your buttocks,
 And worry one another like keen bandoggs. 170
Aminta. Good sir be mercifull.
Tibalt. You shall know what tis to be damnd Canibals.

Enter Albert.

Aminta. O my best friend!
Albert. Alas poor heart! here,
 Here's some meat and soveraigne drink to ease you,
 Sit down gentle Sweet.
Aminta. I am blest to see you.
Tibalt. Sir, not within forty foot of this food,
 If you do dogs!
All. Oh, Captain, Captain, Captain.
Albert. Ye shall have meat all of you.
Tibalt. Captain, hear me first: hark, tis so inhumane! 180

43

I would not ha the aire corrupted with it. [*Whispers.*]

Albert. O barbarous men! sit down *Dupont*,
 Good Master and honest Saylors.

Tibalt. But stand you off,
 And waite upon our charity; i'le wait on you els;
 And touch nothing but what's flung t'ee, as if you were dogs;
 If you do, i'le cut your fingers; friends
 I'le spoyle your carving.

Aminta. There wretches there.

Tibalt. Eat your meate handsomly now,
 And give Heaven thanks. 190

Albert. There's more bread.

Tibalt. See they snarle like dogs;
 Eat quietly you rascals, eat quietly.

Albert. There is drink too.

Tibalt. Come, come, i'le fill you each your cups,
 Ye shal not surfet.

Aminta. And what have you discovered?

Albert. Sweet, a paradise,
 A paradise inhabited with Angels,
 Such as you are: their pitties makt 'em angels,
 They gave me these viands, and supply'd me 200
 With these pretious drinks.

Aminta. Shall not we see 'em?

Albert. Yes, they will see you
 Out of their charities, having heard our story
 They will come, and comfort us, come presently;
 We shall no more know wants nor miseries.

Aminta. Are they all women?

Albert. All, and all in love with us.

Aminta. How!

Albert. Do not mistake: in love with our misfortunes,
 They will cherish and relieve our men. 210

Tibalt. Do you shrug now,
 And pull up your noses? you smell comfort,
 See they stretch out their Legs, like dottrels,
 Each like a new Saint *Dennis*.

<hr>

*213 stretch ... dottrels] *stet* F1–2

Albert. Deere Mistris,
 When you would name me, and the women hear,
 Call me your brother, you i'le call my sister,
 And pray observe this all——
 Why do you change colour sweet?
Aminta. Eating too much meat.
Albert. Sawcd with jealousie; 220
 Fie, fie deer saint, yfaith ye are too blame,
 Are ye not here? here fixt in my heart?
All. Hark, hark.

 Enter Rossellia, Clarinda, Crocale, Hipollitta, Juletta.

Albert. They are come, stand ready, and look nobly,
 And with all humble reverence receive 'em,
 Our lives depend upon their gentle pitties,
 And death waits on their anger.
Morillat. Sure they are Fairies.
Tibalt. Be they devils: devils of flesh and blood;
 After so long a Lent, and tedious voyage
 To me they are angels. 230
Franville. O for some Eringoes!
Lamure. Potatoes or Cantharides.
Tibalt. Peace you rogues
 That buy abilities of your 'pothecaries,
 Had I but took the diet of green Cheese,
 And Onions for a month, I could do wonders.
Rossella. Are these the Jewels you run mad for?
 What can you see in one of these
 To whom you would vouchsafe a gentle touch?
 Can nothing perswade you
 To love your selves, and place your happinesse 240
 In cold and chast embraces of each other.
Juletta. This is from the purpose.
Hippolita. We had your grant to have them as they were.
Clarinda. Tis a beauteous Creature,
 And to my selfe, I do appeare deform'd,
 When I consider her, and yet shee is

 220 Sawcd] F2; Sawce F1

 45

The strangers sister; why then should I fear?
Shee cannot prove my rivall.

Rossella. When you repent,
That you refus'd my councell, may it add
To your afflictions, that you were forwarnd; 250
Yet leap'd into the Gulfe of your misfortunes,
But have your wishes.

Master. Now she makes to us.

Aminta. I am instructed, but take heed *Albert,*
You prove not false.

Albert. Ye are your own assurance,
And so acquainted with your own perfections,
That weak doubts cannot reach you; therefore fear not.

Rossella. That you are poor and miserable men,
My eyes inform me: that without our succours,
Hope cannot flatter you to dream of safety;
The present plight you are in, can resolve you 260
That to be mercifull, is to draw near
The Heavenly essence: whether you wilbe
Thankfull, I do not question; nor demand
What country bred you, what names, what maners;
To us it is sufficient we relieve
Such as have shapes of men: and I command you,
As we are not ambitious to know
Farther of you, that on paine of death
You presume not to enquire what we are
Or whence deriv'd.

Albert. In all things we obey you, 270
And thankfully we ever shall confesse
Our selves your creatures.

Rossella. You speak as becomes you;
First then and willingly deliver up
Those weapons we could force from you.

Albert. We lay 'em down most gladly at your feet.

Tibalt. I have had many a combat with a tall wench;
But never was disarm'd before.

Rossella. And now hear comfort,

Your wants shalbe supplied, and though it be
A debt women may challenge to be sued to, 280
Especially from such they may command;
We give up to you that power, and therefore
Freely each make his choyce.
Franville. Then here I fix.
Morillat. Nay, she is mine: I eyed her first.
Lamure. This mine.
Tibalt. Stay good rascals;
 You are too forward, sir Gallant,
 You are not giving order to a Taylor
 For the fashion of a new suit;
 Nor are you in your warehouse, master Merchant,
 Stand back and give your betters leave: your betters; 290
 And grumble not; if ye do, as I love meat
 I will so swinge the salt itch out on you.
 Captaine, Master and the rest of us,
 That are brothers and good fellows: we have bin
 Too late by the ears: and yet smart for our follies;
 To end therefore all future emulation: if you please,
 To trust to my election, you shall say,
 I am not partiall to my selfe; I doubt not
 To give content to all.
All. Agreed, agreed.
Tibalt. Then but observe how learned and discreetly, 300
 I wil proceed, and as a skilfull Doctor
 In all the quirks belonging to the game,
 Read over your complexions: for you Captaine
 Being first in place and therefore first to be serv'd,
 I give my judgement thus; for your aspect
 Y'are much inclind to melancholy: and that tels me
 The sullen *Saturne* had predominance
 At your nativity, a malignant planet,
 And if not qualified by a sweet conjunction
 Of a soft and ruddy wench born under *Venus*, 310
 It may prove fatall: therefore to your armes,
 I give this rose-cheekt Virgin.

299 To] Sympson; *omit* F1–2, L 304 Being] F2; Beinst F1

47

Clarinda. To my wish;
 Till now I never was happy.
Aminta [*aside*]. Nor I accurs'd.
Tibalt. Master, you are old;
 Yet love the game, that I perceive too,
 And if not well spurd up, you may prove rusty;
 Therefore to help ye here's a *Bradamanta*,
 Or I am cosend in my calculation.
Crocale. A poore old man alloted to my share.
Tibalt. Thou wouldst have two; 320
 Nay I think twenty: but fear not wench,
 Though he be old he's tough: look on's making,
 Hee'l not fayle I warant thee.
Rossella. A merry fellow,
 And were not man a creature I detest,
 I could indure his company.
Tibalt. Here's a fayre heard of Does before me,
 And now for a barren one:
 For though I like the sport, I do not love
 To Father children: like the grand signior, 330
 Thus I walk in my Seraglio,
 And vew 'em as I passe: then draw I forth
 My handkercher, and having made my choyce,
 I thus bestow it.
Rossella. On me?
Tibalt. On you: now my choyce is made;
 To it you hungry rascals.
Albert. Excellent.
Aminta. As I love goodnesse,
 It makes me smile ith height of all my feares.
Clarinda. What a strong contention you may behold 340
 Between my Mothers mirth and anger.
Tibalt. Nay, no coynesse: be mistrisse of your word,
 I must and will enjoy you.
Rossella. Be adviz'd foole: alas I am old;
 How canst thou hope content from one that's fifty.
Tibalt. Never talke on't;
 I have known good ones at threescore and upwards;

Besides the weather's hot:
And men that have experience, fear feavers:
A temperate diet is the only physick, 350
Your Julips nor Gujacum, prunello's,
Camphire pils, nor Goord-water,
Come not neer your old woman;
Youthfull stomackes are still craving,
Though there be nothing left to stop their mouths with;
And believe me
I am no frequent giver of those bounties:
Laugh on: laugh on: good Gentlemen do,
I shall make holiday and sleep, when you
Dig in the mines till your hearts ake. 360
Rossella. A mad fellow;
Well Sir, i'le give you hearing: and as I like
Your wooing and discourse: but I must tell ye sir,
That rich widdowes look for great sums in present,
Or assurances of ample joynters.
Tibalt. That to me is easie,
For instantly i'le do it, hear me comrades.
Albert. What sayst thou *Tibalt?*
Tibalt. Why, that to woe a wench with empty hands
Is no good heraldy, therefore let's to the gold, 370
And share it equally: 'twill speak for us
More then a thousand complements or cringes,
Ditties stolne from *Petrarch* or discourse from *Ovid,*
Besides 'twill beget us respect,
And if ever fortune friend us with a Barque,
Largely supply us with all provision.
Albert. Well advis'd, defer it not.
Tibalt. Are ye all contented?
All. We are.
Tibalt. Let's away then,
Straight wee'l returne, and you shall see our riches.
 Exeunt [all except the women].

*351 Gujacum] F1; Guajacum F2 *352 Camphire pils] stet F1–2
*352 Goord-water] stet F1–2 355 there] F2; their F1
*370 heraldy] stet F1; Heraldry F2 373 Petrarch] F2; Patrick F1

Rossella. Since I knew what wonder and amazement was, 380
 I neer was so transported.
Clarinda. Why weep ye gentle mayd?
 There is no danger here to such as you;
 Banish fear: for with us I dare promise,
 You shall meet all courteous entertainment.
Crocale. We esteem our selves most happy in you.
Hippolita. And blesse fortune that brought you hither.
Clarinda. Hark in your eare;
 I love you as a friend already,
 Ere long you shall call me by a neerer name, 390
 I wish your brother well: I know you apprehend me.
Aminta. I, to my griefe I do; [*Aside.*]
 Alas good Ladies, there is nothing left me
 But thanks to pay ye with.
Clarinda. That's more
 Then yet you stand ingaged for.

 Enter Albert, Tibalt, *and the rest with treasure.*

Rossella. So soon returnd!
Albert. Hear: see the idoll of the Lapidary.
Tibalt. These Pearls for which the slavish *Negro*
 Dives to the bottome of the Sea.
Lamure. To get which the industrious Merchant 400
 Touches at either pole.
Franville. The never-fayling purchase
 Of Lordships and of honors.
Morillat. The worlds Mistris,
 That can give everything to the possessors.
Master. For which the Saylors scorn tempestuous winds,
 And spit defiance in the Sea.
Tibalt. Speak Lady: look we not lovely now?
Rossella. Yes: yes, O my Starrs
 Be now for ever blest, that have brought
 To my revenge these robbers; take your arrowes, 410
 And nayle these monsters to the earth.
Albert. What mean ye Lady?

 380 knew] F2; know F1

50

 In what have we offended?

Rossella. O my daughter!
 And you companions with me in all fortunes,
 Look on these Caskets and these Jewels,
 These were our own, when first we put to Sea
 With good *Sebastian*: and these the Pyrats
 That not alone depriv'd him of this treasure,
 But also took his life.

Crocale. Part of my present
 I well remember was mine own. 420

Hippolita. And these were mine.

Juletta. Sure, I have worne this Jewel.

Rossella. Wherefore do ye stay then,
 And not performe my command?

Albert. O Heaven!
 What cruell fate pursues us.

Tibalt. I am well enough serv'd,
 That must be offring jointures, Jewels,
 And precious stones more then I brought with me.

Rossella. Why shoote ye not?

Clarinda. Heare me deere Mother; 430
 And when the greatest cruelty, is Justice,
 Do not shew mercy: death to these starv'd wretches
 Is a reward, not punishment: let 'em live
 To undergoe the full weight of your displeasure.
 And that they may have sence to feel the torments
 They have deserv'd: allow 'm some small pittance,
 To linger out their tortures.

Rossella. Tis well counsell'd.
 And wee'l follow it.

All. Heare us speake.

Rossella. Peace dogs.
 Bind 'em fast: when fury hath given way to reason,
 I will determine of their sufferings, 440
 Which shall be horrid. Vengeance, though slow pac'd,

*437–438 *Rossella.* Tis well ... speake.] *Ros.* Tis well counsell'd. | *All.* And wee'l follow it; |
 Heare us speake. F1; *Ros.* 'Tis well counsell'd. | *All.* And wee'll follow it; | *Alb.* Hear
 us speak. F2

At length oretakes the guilty; and the wrath
Of the incensed powers will fall most sure
On wicked men, when they are most secure.

 Exeunt.

 Enter Raymond, Sebastian, Nicusa, Saylors. IV.[i]

1. Saylor. Here's nothing, sir, but poverty and hunger;
 No promise of inhabitance; neither tract of Beast,
 Nor foot of man: we have searcht
 All this Rocky desart, yet cannot discover any assurance
 Here is or hath been such men.
2. Saylor. Not a relique of any thing they wore;
 Nor marke left by 'em, either to finde reliefe,
 Or to warne others from the like misfortune.
 Believe it, these fellows are both false,
 And to get a little succour in their misery, 10
 Have fram'd this cunning tale.
Raymond. The ship, I know, is French, and own'd by Pirats,
 If not by *Albert* my arch enemy.
 You told me too there was a woman with 'em.
 A young and handsome woman.
Sebastian. There was so sir.
Raymond. And such and such young gallants.
Nicusa. We told ye true sir,
 That they had no means to quit this Island.
Raymond. And that amidst their mutiny to save your lives
 You got their ship
Sebastian. All is most certaine sir.
Raymond. Where are they then? where are these men 20
 Or woman? we are landed where your faiths
 Did assure us we could not misse their sights.
 For this news we tooke ye to our mercy,
 Reliev'd ye, when the furious Sea and famine
 Strove which should first devoure ye;
 Cloath'd, and cherisht ye; us'd ye as those
 Ye say ye are.
 Faire Gentlemen, now keep your words, and shew us
 This company, your own free pitties spoke of;

These men ye left in misery; the woman. 30
Men of those noble breedings you pretend to
Should scorn to lie, or get their food with falshood;
Come, direct us.
Sebastian. Alasse sir, they are gone,
But by what means or providence, we know not.
2. Saylor. Was not the Captain
A fellow of a fiery, yet brave nature,
A middle stature, and of brown complexion?
Nicusa. He was sir.
Raymond. 'Twas *Albert*,
And my poore wretched sister.
1. Saylor. Twas he certain, 40
I ha been at Sea with him; many times at Sea.
Raymond. Come shew us these men;
Shew us presently, and do not dally with us.
Sebastian. We left 'em here; what should we say, sir?
Here in this place.
2. Saylor The earth cannot swallow 'em;
They have no wings, they cannot fly sure.
Raymond. You told us too
Of heapes of treasure, and of sums conceald,
That set their hearts a fire; we see no such thing,
No such sign; what can ye say to purge ye? 50
What have ye done with these men?
Nicusa. We, sir?
Raymond. You sir;
For certain I believe ye saw such people.
Sebastian. By all that's good, by all that's pure and honest,
By all that's holy——
Raymond. I dare not credit ye,
Ye have so abus'd my hope, that now I hate ye.
1. Saylor. Let's put 'em in their ragged clothes again Captain,
For certain they are knaves, let's e'en deliver 'em
To their old fruitfull Farm; here let 'em walk the Island.
Sebastian. If ye do so, we shall curse your mercies.
Nicusa. Rather put us to Sea again.
Raymond. Not so. 60

Yet this Ile do, because ye say ye are Christians,
Though I hardly credit it: bring in the boat,
And all aboord again, but these two wretches;
Yet leave 'em four daies meat. If in that time,
(For I will search all nookes of this strange Island)
I can discover any tract of these men,
Alive or dead, Ile beare ye off, and honour ye;
If not, ye have found your graves; so farewell. *Exit* [*with* Sailors].

Nicusa. That goodnes dwels above, and knows us innocent,
 Comfort our lives, and at his pleasure quit us. 70

Sebastian. Come cousin, come; old time will end our story:
 But no time (if we end well) ends our glory.

 Exeunt.

 Enter Rossella, Clarinda, Crocale, Hippolita, Juletta. [IV.ii]

Rossella. Use 'em with all the austerity that may be,
 They are our slaves; turn all those pitties,
 Those tender reluctations that should become your sex,
 To stern anger; and when ye look upon 'em,
 Looke with those eyes that wept those bitter sorrows,
 Those cruelties ye sufferd by their rapines.
 Some five daies hence that blessed houre comes,
 Most happy to me, that knit this hand
 To my deare husbands,
 And both our hearts in mutuall bands. That houre Ladies—— 10

Clarinda. What of that houre?

Rossella. Why, on that houre daughter,
 And in the height of all our celebrations,
 Our deere remembrances of that deere man,
 And those that suffered with him, our faire kinsmen,
 Their lives shall fall a sacrifice to vengeance,
 Their lives that ruind his; tis a full justice.
 I will looke glorious in their bloods;
 And the most Noble spirit of *Sebastian*,
 That perisht by the pride of these French Pirates,
 Shall smile in Heaven, and blesse the hand that kild 'em. 20
 Looke strictly all unto your prisoners;
 For he that makes a scape beyond my vengeance,

Or entertaines a hope by your faire usage;
Take heed, I say, she that deceives my trust,
Again take heed: her life, and that's but light neither;
Her life in all the tortures my spirit can put on——
All. We shall be carefull.
Rossella. Do so. *Exit* Rossella.
Clarinda. You are angry mother, and ye are old too,
Forgetting what men are: but we shall temper ye. 30
How fare your prisoners, Ladies? in what forms
Do they appeare in their afflictions?
Juletta. Mine fare but poorly;
For so I am commanded: tis none of their fault.
Clarinda. Of what sort are they?
Juletta. They say they are Gentlemen, but they shew Mungrels.
Clarinda. How do they suffer?
Juletta. Faith like boyes;
They are fearfull in all fortunes; when I smile
They kneele, and beg to have that face continued; 40
And like poore slaves, adore the ground I goe on,
When I frown, they hang their most dejected heads,
Like fearfull sheephounds; shew 'em a crust of bread
Theyl Saint me presently, and skip like Apes
For a sup of Wine. Ile whip 'em like hackneys,
Saddle 'em, ride 'em, do what I will with 'em.
Clarinda. Tush, these are poore things. Have they names like
 Christians?
Juletta. Very faire names: *Franvile*, *Lamure*, and *Morillat*;
And brag of great kindreds too. They offer very handsomely,
But that I am a foole, and dare not venture. 50
They are sound too i'my conscience,
Or very neere upon't.
Clarinda. Fy, away foole.
Juletta. They tell me if they might be brought before you,
They would reveale things of strange consequence.
Clarinda. Their base poore feares.
Juletta. I, that makes me hate 'em too;
For if they were but manly to their sufferance,

29 You] F2; Your F1

55

Sure I should strain a point or two.
Clarinda. An houre hence Ile take a view of 'em,
And heare their businesse. Are your men thus too? 60
Crocale. Mine? No gentle Maddam, mine were not cast
In such base molds; afflictions, tortures,
Are names and natures of delight, to my men;
All sorts of cruelties they meet like pleasures.
I have but two; the one they call *Du-pont*,
Tibalt Du-pont; the other the ship-master.
Clarinda. Have they not lives and feares?
Crocale. Lives they have Maddam;
But those lives never linkt to such companions
As feares or doubts.
Clarinda. Use 'em Nobly; 70
And where you finde fit subjects for your pitties
Let it become ye to be courteous;
My mother will not alwaies be thus rigorous.
Hippolita. Mine are Saylors Maddam,
But they sleep soundly, and seldom trouble me,
Unlesse it be when
They dream sometimes of fights and tempests;
Then they rore and whistle for Cans of Wine,
And down they fling me; and in that rage,
(For they are violent fellows) they play such reaks. 80
If they have meat, they thank me;
If none, they heartily desire to be hangd quickly.
And this is all they care.
Clarinda. Look to 'em diligently, and where your pitties tels ye
They may deserve, give comfort.
All. We will. *Exeunt [all except* Clarinda].

 Enter Aminta.

Clarinda. Come hither, be not frighted;
Think not ye steale this liberty, for we give it,
Your tender innocence assures me, Virgin,
Ye had no share in those wrongs these men did us; 90
I finde ye are not hardned in such mischieves.

*80 play such reaks] *stet* F–2

56

Your brother was mis-led sure, foully mis-led.
Aminta [*aside*]. How much I feare these pities!
Clarinda. Certain he was, so much I pity him;
 And for your sake, whose eyes plead for him;
 Nay, for his own sake.
Aminta. Ha!
Clarinda. For I see about him;
 Women have subtill eyes, and look narrowly;
 Or I am much abusd; many faire promises:
 Nay beyond those too, many shadowed vertues.
Aminta. I think he is good.
Clarinda. I assure my selfe he will be; 100
 And out of that assurance take this comfort,
 For I perceive your feare hath much dejected ye.
 I love your brother.
Aminta. Maddam.
Clarinda. Nay, do not take it for a dreamt of favour,
 That comforts in the sleepe, and awake vanishes;
 Indeed I love him.
Aminta. Do ye indeed?
Clarinda. You doubt still, because ye feare his safety;
 Indeed he is the sweetest man I ere saw; 110
 I think the best. Ye may heare without blushes,
 And give me thanks, if ye please, for my curtesie.
Aminta. Maddam, I ever must;
 (Yet witnesse Heaven, they are hard pul'd from me.)
 Believe me, Maddam, so many imperfections I could find,
 (Forgive me Grace for lying) and such wants,
 (Tis to an honest use) such poverties,
 Both in his main proportion, and his mind too;
 There are a hundred handsomer; (I lie leudly)
 Your noble usage, Maddam, hath so bound me to ye, 120
 That I must tell ye.
Clarinda. Come tell your worst.
Aminta. He is no husband for ye.
 I think ye mean in that fayr way.
Clarinda. Ye have hit it.
Aminta. (I am sure ye have hit my heart.)

You will finde him dangerous, Maddam;
As fickle as the flying ayre, proud, jealous,
Soon glutted in your sweets, and soon forgetfull;
I could say more, and tell ye I have a brother,
Another brother, that so far excels this,
Both in the ornaments of man, and making. 130

Clarinda. If you were not his sister, I should doubt ye mainly;
Doubt ye for his love, ye deale so cunningly.
Do not abuse me, I have trusted ye with more then life,
With my first love; be carefull of me.

Amina. In what use, Maddam?

Clarinda. In this Lady,
Speak to him for me, you have power upon him;
Tell him I love him, tell him I dote on him.
It will become your tongue.

Aminta [*aside*]. Become my grave.
O fortune, O cursed fortune.

Clarinda. Tell him his liberty, 140
And all those with him; all our wealth and Jewels.
Good sister, for Ile call ye so.

Aminta. I shall Lady,
[*Aside*] Even die, I hope.

Clarinda. Here's Meat and Wine, pray take it,
And there he lies; give him what liberty you please;
But still conceald. What pleasure you shall please, sister.
He shall nere want again. Nay, see an you'l take it;
Why do you studdy thus?

Aminta. To avoyd mischiefes,
If they should happen.

Clarinda. Goe and be happy for me. [*Exit.*]

Aminta. O blind fortune;
Yet happy thus far, I shall live to see him. 150
In what strange desolation lives he here now?
Sure this Curtaine will reveale. [*Draws a Curtain.*]

Enter Albert.

Albert. Who's that? ha!
Some gentle hand, I hope, to bring me comfort.

Or if it be my death, tis sweetly shaddowed.

Aminta. Have ye forgot me sir?

Albert. My *Aminta?*

Aminta. She sir,
That walks here up and down an empty shadow,
One that for some few houres
But wanders here, carrying her own sad Coffin,
Seeking some Desart place to lodge her greifes in.

Albert. Sweet sorrow welcome, welcome noble griefe; 160
How got you this faire liberty to see me?
For sorrows in your shape are strangers to me.

Aminta. I come to counsell ye.

Albert. Ye are still more welcome;
For good friends in afflictions give good councels.
Pray then proceed.

Aminta. Pray eate first, ye shew faint;
Here's Wine to refresh ye too.

Albert. I thank ye deere.

Aminta. Drinke again.

Albert. Here's to our loves. How, turn and weepe!
Pray pledge it: this happinesse we have yet left,
Our hearts are free. Not pledge it? why,
And though beneath the axe this health were holy, 170
Why doe ye weep thus?

Aminta. I come to woe ye.

Albert. To woe me Sweet? I am woe'd and wonne already,
You know I am yours. This pretty way becomes ye.
But you would deceive my sorrows, that's your intent.

Aminta. I would I could, I should not weep, but smile.
Do ye like your Meat and Wine?

Albert. Like it?

Aminta. Do you like your liberty?

Albert. All these I well may like.

Aminta. Then pray like her that sent 'em.
Doe ye like wealth, and most unequal'd beauty? 180

Albert. Peace, indeed you'l make me angry.

Aminta. Would I were dead that aske it,
Then ye might freely like, and I forgive ye.

Albert. What like, and who? adde not more misery
 To a man that's fruitfull in afflictions.
 Who is't you would have me like? Who sent these comforts?
Aminta. I must tell.
Albert. Be bold.
Aminta. But be you temperate.
 If you be bold I die. The young fair Virgin;
 (Sorrow hath made me old.) O hearken,
 And wisely harke, the Governesse daughter: 190
 That Star that strikes this Island full of wonder,
 That blooming sweetnesse.
Albert. What of her?
Aminta. She sent it:
 And with it, it must be out, she dotes on ye,
 And must enjoy ye: else no joy must find ye.
Albert. And have you the patience to deliver this?
Aminta. A sister may say much, and modestly.
Albert. A Sister?
Aminta. Yes, that name undid ye;
 Undid us both: had ye nam'd wife, she had fear'd ye;
 And fear'd the sin she followed; She had shun'd, yea 200
 Her Virgin modesty had not touch'd at ye.
 But thinking you were free, hath kindled a fire,
 I feare will hardly be extinguisht.
Albert. Indeed I played the foole.
Aminta. O my best sir, take heed,
 Take heed of lies. Truth though it trouble some minds,
 Some wicked minds, that are both darke and dangerous:
 Yet it preserves it selfe, comes off pure, innocent,
 And like the Sunne, though never so ecclips'd,
 Must breake in glory. O sir, lie no more. 210
Albert. Ye have read me a faire Lecture,
 And put a spell upon my tongue for fayning.
 But how will you counsell now?
Aminta. Ye must study to forget me.
Albert. How?
Aminta. Be patient.

*200 shun'd, yea] stet F1–2

Be wise and patient, it concerns ye highly.
Can ye lay by our loves? But why should I doubt it?
Ye are a man, and men may shift affections,
Tis held no sin. To come to the poynt,
Ye must lose me; many and mighty reasons.

Albert. Heare me *Aminta*, 220
Have you a man that loves you to, that feeds ye,
That sends ye liberty? has this great Governesse
A noble sonne too, young, and apt to catch ye?
Am I because I am in bonds, and miserable,
My health decay'd, my youth, and strength halfe blasted,
My fortune like my wayning selfe, for this despis'd?
Am I for this forsaken? a new love chosen,
And my affections, like my fortunes wanderers?
Take heed of lying, you that chid me for it;
And shew'd how deep a sin it was, and dangerous. 230
Take heed, your selfe, you swore you lov'd me deerly;
No few, nor little oathes you swore *Aminta*,
Those seal'd with no small faith, I then assur'd my selfe.
O seek no new waies to cozen truth.

Aminta. I do not.
By Love it selfe I love thee,
And ever must, nor can all deaths dissolve it.

Albert. Why do you urge me thus then?

Aminta. For your safety,
To preserve your life.

Albert. My life I do confesse is hers, she gives it,
And let her take it back, I yeild it. 240
My love's intirely thine, none shall touch at it;
None, my *Aminta*, none.

Aminta. Ye have made me happy,
And now I know ye are mine, Fortune, I scorn thee.
Go to your rest, and Ile sit by ye;
Whilst I have time Ile be your mate, and comfort ye,
For onely I am trusted: you shall want nothing,
Not a liberty that I can steal ye.

Albert. May we not celebrate our loves *Aminta*?
And where our wishes cannot meet——

Aminta. You are wanton,
But with cold kisses Ile allay that feavor; 250
Look for no more, and that in private too.
Believe me I shall blush else.
But let's consider, we are both lost else.
Albert. Let's in, and prevent fate.

 Exeunt.

 Enter Crocale, Juletta, Tibalt, Master. [IV.iii]

Tibalt. You do well to ayre us Ladies, we shal be musty else.
 What are your wise wils now?
Crocale. You are very cranck still.
Tibalt. As cranck as a holy Friar, fed with hayl-stones.
 But do ye bring us out to baite, like Buls?
Master. Or are you weary of the charge ye are at?
 Turn us abroad again, let's jog Ladies;
 Wee are grosse, and course, unfit for your sweet pleasures.
Tibalt. Knock off our shoos, and turn's to grasse.
Crocale. You are determined
 Still to be stubborn then: it well becomes ye. 10
Tibalt. An humour Lady that contents a prisoner.
 A sullen fit sometimes serves for a second course.
Juletta. Ye may as well be kind,
 And gain our favours; gain meat, and drink,
 And lodging to rest your bones.
Tibalt. My bones have bore me thus long,
 And had their share of pains, and recreations;
 If they fayl now, they are no fayr companions.
Crocale. Are ye thus harsh to all our sex?
Master. We cannot be merry without a Fidler. 20
 Pray strike up your Tabors, Ladies.
Crocale. The fools despise us.
Juletta. We know ye are very hungry now.
Tibalt. Yes, tis very wholsome Ladies;
 For we that have grosse bodies, must be carefull.
 Have ye no piercing ayre to stir our stomacks?
 We are beholding to ye for our Ordinary.
Juletta. Why slaves, tis in our power to hange ye.

Master. Very likely.

 Tis in our powers then to be hang'd, and scorn ye. 30

 Hanging's as sweet to us, as dreaming to you.

Crocale. Come, be more courteous.

Juletta. Do, and then ye shal be pleas'd, and have all necessaries.

Tibalt. Give me some Rats-bane then.

Crocale. And why Rats-bane, Mounsier?

Tibalt. We live like vermin here, and eate up your Cheese,

 Your mouldy Cheese, that none but Rats would bite at;

 Therefore tis just that Rats-bane should reward us.

 We are unprofitable, and our Ploughs are broken;

 There is no hope of Harvest this yeere, Ladies. 40

Juletta. Ye shall have all content.

Master. I, and we'l serve your uses.

 I had rather serve hogs, there's more delight in't;

 Your greedy appetites are never satisfied;

 Just like hungry Camels, sleeping or waking

 You chew the cud still.

Crocale. By this hand we'l starve ye.

Master. Tis a Noble courtesie.

 I had as liefe ye should famish me, as founder me,

 To be jaded to death is onely fit for a hackney.

 Here be certain tarts of tar about me, 50

 And parcels of potargo in my Jerkin,

 As long as these last——

Juletta. Which will not last ever.

Tibalt. Then we'l eate one another like good fellows,

 A shoulder of his for a hanch of mine.

Juletta. Tis excellent.

Tibalt. Twill be, as we'l dresse it Ladies.

Crocale. Why sure ye are not men.

Master. Ye had best come search us,

 A Seaman is seldome without a salt Eele.

Tibalt. I am bad enough,

 And in my nature a notorious wencher;

 And yet ye make me blush at your immodesty. 60

 Tell me good Master, didst ever see such things?

Master. I could like 'em though they were lewdly given,
 If they could say no; but fie on 'em,
 They gape like Oysters.
Tibalt. Well, ye may hang, or starve us;
 But your commanding impudence shall never feare us.
 Had ye by blushing signs, soft cunnings, crept into us,
 And shew'd us your necessities: we had met your purposes,
 Supply'd your wants. We are no Saints Ladies;
 I love a good wench, as I love my life,
 And with my life I will maintain my love: 70
 But such a sordid impudence Ile spit at.
 Let's to our dens again. Come noble Master.
 You know our minds Ladies:
 This is the faith in which we'l die. *Exit* Tibalt *and Master.*
Crocale. I doe admire 'em.
Juletta. They are noble fellows,
 And they shall not want, for this.

<p align="center">*Enter* Clarinda.</p>

Crocale. But see, *Clarinda* comes.
 Farewell, Ile to my charge. [*Exit.*]
Clarinda. Bring out those prisoners now,
 And let me see 'em, and heare their businesse. 80
Juletta. I will, Maddam. *Exit.*
Clarinda. I hope she hath prevail'd upon her brother.
 She has a sweet tongue, and can describe the happinesse
 My love is ready to fling on him.
 And sure he must be glad, and certain wonder
 And blesse the houre that brought him to this Island.
 I long to heare the full joy that he labours with.

<p align="center">*Enter* Juletta, Morillat, Franvile, Lamure.</p>

Morillat. Blesse thy Divine beauty.
Franville. Mirror of sweetnesse.
Lamure. Ever springing brightnesse.
Clarinda. Nay, stand up Gentlemen, and leave your flatteries. 90
Morillat. Shee cals us Gentlemen, sure we shall have some meat
 now.

Clarinda. I am a mortall creature,
 Worship Heaven, and give these attributes
 To their Divinities. Methinks ye look but thin.
Morillat. O we are starv'd, immortall beauty.
Lamure. We are all poor starv'd knaves.
Franville. Neither liberty nor meat Lady.
Morillat. We were handsome men, and Gentlemen, and sweet men,
 And were once gracious in the eyes of beauties,
 But now we look like rogues; like poore starv'd rogues. 100
Clarinda. What would ye do if ye were to die now?
Franville. Alas we were prepar'd. If you will hang us,
 Let's have a good meale or two to die with,
 To put's in heart.
Morillat. Or if you'l drown us,
 Let's be drunk first, that we may die merrily,
 And blesse the founders.
Clarinda. Ye shal not die so hastily.
 What dare ye do to deserve my favour?
Lamure. Put us to any service.
Franville. Any bondage,
 Let's but live.
Morillat. Wee'l get a world of children, 110
 For we know, ye are hainously provided that way;
 And ye shal beat us when we offend ye;
 Beat us abundantly, and take our meat from us.
Clarinda. These are weak abject things, that shew ye poor ones.
 What's the great service ye so oft have threatned,
 If ye might see me, and win my favour?
Juletta. That businesse of discovery.
Morillat. O, Ile tell ye Lady.
Lamure. And so will I.
Franville. And I.
 Pray let me speak first.
Morillat. Good, no confusion.
 We are before a Lady that knows manners; 120
 And by the next meat I shall eate, tis certain.
 This little Gentlewoman that was taken with us——
Clarinda. Your Captains sister, she you mean?

Morillat. I, I, she's the businesse that we would open to ye.
 You are cousned in her.
⌈*Clarinda.* How, what is't you would open?
⌊*Franville.* She is no sister.
Morillat. Good sirs, how quick you are.
 She is no sister, Madam.
Franville. She is his——
Morillat. Peace I say.
Clarinda. What is she?
Morillat. Faith, sweet Lady, 130
 She is, as a man would say, his——
Clarinda. What?
Lamure. His Mistris.
Morillat. Or, as some new translators read, his——
Clarinda. O me!
Morillat. And why he should delude you thus,
 Unlesse he meant some villany? these ten weeks
 He has had her at Sea for his own proper appetite.
Lamure. His Cabin-mate, Ile assure ye.
Clarinda. No sister, say ye?
Morillat. No more then I am brother to your beauty.
 I know not why he should juggle thus.
Clarinda. Do not lie to me. 140
Morillat. If ye find me lie, Lady, hang me empty.
Clarinda. How am I fool'd!
 Away with 'em, *Juletta*, and feed 'em
 But hark ye, with such food as they have given me.
 New misery!
Franville. Nor meat, nor thanks for all this. *Exeunt.*
Clarinda. Make 'em more wretched.
 O I could burst! curse and kill now,
 Kill any thing I meet. *Juletta*, follow me,
 And call the rest along.
Juletta. We follow Maddam. 150
 Exeunt.

 Enter Albert *and* Aminta. [IV.iv]

Aminta. I must be gone now, else she may suspect me;

 *126 *Clarinda.*] Coleman; *Lam.* F1–2, L *128 sirs] *stet* F1–2

 66

How shall I answer her?
Albert. Tell her directly.
Aminta. That were too sudden, too improvident;
Fires of this nature must be put out cunningly,
They'l waste all come neere 'em else.
Farewell once more.
Albert. Farewell.
And keep my love entire.
Nay kisse me once again, me thinks we should not part.
Aminta. O be wise, sir. 10
Albert. Nay, one kisse more.
Aminta. Indeed you'r wanton; we may be taken too.

Enter Clarinda, Juletta, Crocale, Hippolita.

Clarinda. Out thou base woman. By Heaven Ile shoot 'em both.
Crocale. Nay stay, brave Lady, hold;
A sudden death cuts of a Nobler vengeance.
Clarinda. Am I made Bawd to your lascivious meetings?
Are ye grown so wise in sin?
Shut up that villaine: and sirra,
Now expect my utmost anger. Let him there starve.
Albert. I mock at your mischiefes. *Exit.* 20
Clarinda. Tie that false witch unto that Tree,
There let the savage beasts gnaw of her sweetnesse,
And Snakes embrace her beauties; tie her, and watch
That none relieve her. [Aminta *is tied to a tree.*]
Hippolita. We could wish ye better fortune Lady,
But dare not help ye.
Aminta. Be your own friends, I thank ye.
 [*Exeunt all but* Aminta.]
Now onely my last audit, and my greatest,
O Heaven, be kind unto me,
And if it be thy wil, preserve.

Enter Raymond.

Raymond. Who is this? 30
Sure tis a woman; I have trod this place,
And found much footing: now I know tis peopl'd.

15, 22 of] *i.e.,* off (*as in* F2)

Ha, let me see! tis her face.
O Heaven! turn this way mayd.
Aminta. O *Raymond*, O brother.
Raymond. Her tongue to: tis my sister; what rude hand!
Nay kisse me first, O joy! [*Unties her.*]
Aminta.. Fly, fly deere brother,
You are lost else.

<div align="center">*Enter* Juletta, Crocale, Clarinda.</div>

Juletta. A man, a man, a new man.
Raymond. What are these?
Crocale. An Enemy, an Enemy.
Clarinda. Dispatch him,
Take him off, shoot him straight. 40
Raymond. I dare not use my sword, Ladies,
Against such comely foes.
Aminta. O brother brother!
Clarinda. Away with 'em, and in darke prisons bind 'em.
One word replyd, ye die both.
Now brave mother follow thy Noble Anger,
And Ile help thee.

<div align="right">*Exeunt.*</div>

<div align="center">*Enter* Rossella, Clarinda, Crocale, Juletta, Hippolita. V.i</div>

Rossella. I am deaf to all your intreaties: she that moves me
For pity or compassion to these Pirates,
Digs up her fathers, or her brothers Tombe,
And spurns about their ashes.
Couldst thou remember what a father thou hadst once,
Twould steele thy heart against foolish pity.
By his memory, and the remembrance of his deere embraces,
I am taught, that in a Noble cause revenge is Noble;
And they shal fall the sacrifices to appease
His wandering Ghost, and my incensed fury. 10
Clarinda. The new come prisoner to?
Rossella. Him to. Yet that we may learn

<div align="center">5 hadst] F2; hast F1</div>

<div align="center">68</div>

Whether they are the same, or neere ally'd
To those that forc'd me to this cruell course,
Better their poore allowance, and permit 'em
To meet together and confer,
Within the distance of your eare; perhaps
They may discover something that may kill
Despaire in me, and be a means to save 'em
From certain ruine. 20
Crocale. That shal be my charge.
Rossella. Yet to prevent
All hope of rescue: for this new come Captain
Hath both a ship and men not far off from us,
Though ignorant to find the onely Port,
That can yeeld entrance to our happy Island,
Guard the place strongly, and ere the next Sunne
Ends his diurnall progresse, I wil be
Happy in my revenge, or set 'em free.
 Exeunt.

 Enter Crocale, Juletta, Hippolita. *A Table furnisht.* [V.ii]

Crocale. So serve it plentifully,
And lose not time to enquire the cause;
There is a main design that hangs upon this bounty.
See the Table furnisht with Wine too,
That discovers secrets which tortures cannot open:
Open the doores too of the severall prisons,
And give all free entrance into this room.
Undiscover'd I can here marke all.
 [*Exeunt* Juletta, Hippolita. Crocale *goes apart.*]
 Enter Tibalt, Master.

Here's Captain carelesse, and the tough Ship-master,
The slaves are nos'd like Vultures, how wilde they look. 10
Tibalt. Ha, the mystery of this,
Some good Hobgoblin rise and reveale.
Master. I am amazed at it: nor can I sound the intent.
Tibalt. Is not this Bread,

 69

Substantiall bread, not painted?

Master. But take heed,
 You may be poysoned.

Tibalt. I am sure I am famisht;
 And famine as the wise man says,
 Gripes the guts as much as any Minerall.
 This may be Treacle sent to preserve me
 After a long fast: or be it Vipers spittle, 20
 Ile run the hazzard.

Master. We are past all feare,
 Ile take part with ye.

Tibalt. Do: and now yfaith,
 How d'e feel your selfe? I finde great ease in't.
 What's here?
 Wine, and it be thy will; strong lusty Wine.
 Well, fooles may talke
 Of Metridate, Cordials, and Elixars.
 But from my youth this was my onely Physick.
 Here's a colour,
 What Ladies cheek, though ceruss'd over, comes neere it? 30
 It sparkles too: hangs out Diamonds.
 O my sweet heart, how I will hug thee, again, and again!
 They are poor drunkards, and not worth thy favours,
 That number thy moyst kisses in these Christals.

Master. But Mounsieur,
 Here are Suckets, and sweet dishes.

Tibalt. Tush, boys meat,
 I am past it; here's strong food fit for men:
 Nectar, old lad. Mistris of merry hearts,
 Once more I am bold with you.

Master. Take heed (man)
 Too much will breed distemper.

Tibalt. Hast thou liv'd at Sea 40
 The most part of thy life, where to be sober
 While we have Wine aboord, is capitall treason;
 And dost thou preach sobriety?

Master. Prethee forbeare,

17 famine] F2; *omit* F1

70

We may offend in it; we know not for whom
 It was provided.
Tibalt. I am sure for me: therefore footra,
 When I am full, let 'em hang me, I care not.
Master. This has been his temper ever.
 See, provoking dishes, candid Eringoes, 50
 And Potatoes.
Tibalt. Ile not touch 'em, I will drink;
 But not a bit on a march, Ile be an Eunuch rather.

 Enter Albert, Aminta, Raymond, Lamure, Morrillat, Franvile,
 severally.

Master. Who are these?
Tibalt. Marry, who you will; I keep my text here.
Albert. Raymond!
Raymond. Albert!
Tibalt. Away, Ile be drunke alone;
 Keep off rogues, or Ile belch ye into ayre;
 Not a drop here.
Aminta. Deere brother, put not in your eyes such anger;
 Those looks poyson'd with fury shot at him,
 Reflect on me. O brother looke milder, or 60
 The Christall of his temperance
 Will turn 'em on your selfe.
Albert. Sir, I have sought ye long
 To finde your pardon: you have ploughed the Ocean
 To wreak your vengeance on me, for the rape
 Of this faire virgin. Now our fortune guides us
 To meet on such hard terms, that we need rather
 A mutual pitty of our present state,
 Then to expostulate of breaches past,
 Which cannot be made up. And though it be 70
 Far from your power to force me to confesse,
 That I have done ye wrong, or such submission
 Failing to make my peace, to vent your anger;
 You being your selfe slav'd, as I to others:
 Yet for your sisters sake, her blessed sake,
 In part of recompence of what she has suffered

71

For my rash folly; the contagion
Of my black actions catching hold upon
Her purer innocence: I crave your mercy,
And wish however severall motives kept us 80
From being friends while we had hope to live,
Let death which we expect, and cannot fly from,
End all contention.
Tibalt. Drink upon't, 'tis a good motion;
Ratifie it in Wine, and tis authenticall.
Raymond. When I consider
The ground of our long difference, and look on
Our not to be avoyded miseries,
It doth beget in me I know not how
A soft religious tendernesse; which tels me, 90
Though we have many faults to answer for
Upon our own account, our fathers crimes
Are in us punisht. O *Albert,* the course
They took to leave us rich was not honest,
Nor can that friendship last, which vertue joyns not.
When first they forc'd the industrious Portugals,
From their Plantations in the happy Islands——
Crocale [aside]. This is that I watch for.
Raymond. And did omit no tyranny, which men
Inured to spoyle and mischiefe could inflict, 100
On the griev'd sufferers; when by lawlesse rapine
They reapt the harvest, which their labours sowed;
And not content to force 'em from their dwelling,
But layd for 'em at Sea, to ravish from 'em
The last remainder of their wealth; then, then,
After a long pursuit, each doubting other,
As guilty of the Portugals escape,
They did begin to quarrell, like ill men;
(Forgive me piety, that I call 'em so)
No longer love, or correspondence holds, 110
Then it is cimented with prey or profit:
Then did they turn those Swords they oft had bloodied
With innocent gore, upon their wretched selves,
And payd the forfeit of their cruelty

72

Shown to *Sebastian*, and his Collonie,
By being fatall Enemies to each other.
Thence grew *Amintas* rape, and my desire
To be reveng'd. And now observe the issue:
As they for spoyle ever forgot compassion
To women, (who should be exempted 120
From the extremities of a lawfull war)
We now, young able men, are faln into
The hands of women; that, against the soft
Tendernesse familiar to their sex,
Will shew no mercy.

 Crocale [*comes forward*].

Crocale. None, unless you shew us
 Our long lost husbands.
 We are those Portugals you talk'd of.
Raymond. Stay,
 I met upon the Sea in a tall ship
 Two Portugals, famisht almost to death.
Tibalt. Our ship by this Wine. 130
 And those the rogues that stole her,
 Left us to famish in the barraine Islands.
Raymond. Some such tale they told me,
 And something of a woman, which I find,
 To be my sister.
Crocale. Where are these men?
Raymond. I left 'em,
 Supposing they had deluded me with forg'd tales,
 In the Island where they sayd
 They had liv'd many years the wretched owners
 Of a huge masse of treasure.
Albert. The same men:
 And that the fatall muck we quarreld for. 140
Crocale. They were Portugals you say.
Raymond. So they profes'd.
Crocale. They may prove such men as may save your lives,
 And so much I am taken with faire hope,
 That I will hazard life to be resolv'd on't:

73

How came you hither?

Raymond. My ship lies by the rivers mouth,
That can convey yee to these wretched men,
Which you desire to see.

Crocale. Back to your prisons,
And pray for the successe: if they be those
Which I desire to finde, you are safe; 150
If not, prepare to die to morrow:
For the world cannot redeem ye.

Albert. How ever, we are armd for either fortune. *Exeunt.*

Tibalt. What must become of me now that I am not dismis'd?

Crocale. O sir, I purpose to have your company.

Tibalt. Take heed wicked woman, I am apt to mischiefe now.

Crocale. You cannot be so unkind, to her that gives you liberty.

Tibalt. No, I shall be too kind, that's the devil on't;
I have had store of good wine: and when I am drunk,
Joane is a Lady to me, and I shall 160
Lay about me like a Lord: I feele strange motions:
Avoid me temptation.

Crocale. Come sir, i'le help yee in.

Exeunt.

Enter Sebastian, *and* Nicusa. [V.iii]

Nicusa. What may that be that mooves upon the Lake?

Sebastian. Still it drawes neerer,
And now I plainly can descerne it.
Tis the French ship.

Nicusa. In it a woman, who seemes to invite us to her.

Sebastian. Still she cals with signes of Love to hasten to her;
So lovely hope doth still appeare:
I feele nor age nor weaknesse.

Nicusa. Though it bring death,
To us tis comfort: and deserves a meeting.
Or els fortune tyrd with what we have suffer'd, 10
And in it overcome, as it may be,
Now sets a period to our misery.

Exeunt.

Enter severally, Raymond, Albert, Aminta. *Horrid Musicke.* [V.iv]

Raymond. What dreadfull sounds are these?
Aminta. Infernall Musick,
 Fit for a bloody Feast.
Albert. It seemes prepar'd
 To kill our courages, e're they divorse
 Our soules and bodies.
Raymond. But they that fearelesse fall,
 Deprive them of their triumph.

Enter Rossillia, Clarinda, Julletta, Hippollitta, *etc.*
An alter prepar'd.

Aminta. See the furies,
 In their full Trym of cruelty.
Rossella. Tis the last
 Duty that I can pay to my dead Lord,
 Set out the Altar, I my selfe wilbe
 The Priest, and boldly do those horrid Rites 10
 You shake to think on: lead these Captaines neerer,
 For they shall have the honour to fall first
 To my *Sebastians* ashes: and now wretches,
 As I am taught already that you are,
 And lately by your free confession,
 French pirats, and the sons of those I hate,
 Even equall with the devil; hear with horror,
 What tis invites me to this cruell course,
 And what you are to suffer; no Amazons we,
 But women of *Portugall*, that must have from you 20
 Sebastian and *Nicusa*; we are they
 That groan'd beneath your fathers wrongs:
 We are those wretched women,
 Their injuries pursu'd, and overtook;
 And from the sad remembrance of our losses
 We are taught to be cruell; when we were forc'd
 From that sweet ayre we breathed in, by their rapine,

17 hear] F2; here F1

And sought a place of being; as the Seas
And winds conspird with their ill purposes,
To load us with afflictions, in a storme 30
That fell upon us; the two ships that brought us,
To seek new fortunes in an unknown world
Were severed: the one bore all the able men,
Our treasure and our Jewels; in the other,
We women were imbarq'd: and fell upon,
After long tossing in the troubled maine,
This pleasant Island: But in few moneths,
The men that did conduct us hither died,
We long before had given our husbands lost:
Remembring what we had suffred by the French, 40
We took a solemn Oath never to admit
The curs'd society of men: necessity
Taught us those arts not usuall to our sex:
And the fertile Earth yeelding abundance to us,
We did resolve thus shapt like Amazons
To end our lives; but when you ariv'd here,
And brought as presents to us our own Jewels;
Those which were boorn in the other ship,
How can ye hope to scape our vengeance?
Aminta. It boots not then to swear our inocence? 50
Albert. Or that we never forc'd it from the owners?
Raymond. Or that there are a remnant of that wrack,
 And not far off?
Rossella. All you affirme, I know,
 Is but to win time; therefore prepare your throats,
 The world shall not redeem ye: and that your cries
 May find no entrance to our eares,
 To moove pitty in any: bid lowd Musick sound
 Their fatall Knels: if ye have prayers use 'em quickly,
 To any power will own yee; but ha!

 Enter Crocale, Sebastian, Nicusa, Tibalt.

Who are these? what spectacles of misfortune? 60
Why are their looks

59 yee] F2 (ye); yea F1

76

So full of Joy and wonder?
Crocale. Oh! lay by
 These instruments of death, and welcome
 To your armes what you durst never hope to imbrace:
 This is *Sebastian*, this *Nicusa* Maddam:
 Preserv'd by miracle: look up deer sir,
 And know your own *Rossellia*: be not lost
 In wonder and amazement; or if nature
 Can by instinct instruct you what it is,
 To be blessed with the name of Father, 70
 Freely injoy it in this faire Virgin.
Sebastian. Though my miseries,
 And many years of wants, I have indur'd,
 May well deprive me of the memory
 Of all joyes past; yet looking on this building,
 This ruind building of a heavenly forme
 In my *Rossella*; I must remember,
 I am *Sebastian*.
Rossella. O my joyes!
Sebastian. And here,
 I see a perfect modell of thy selfe,
 As thou wert when thy choyce first made thee mine: 80
 These cheecks and front though wrinkled now with time
 Which art cannot restore: had equall purenesse,
 Of naturall white and red, and as much ravishing:
 Which by fayre order and succession,
 I see descend on her: and may thy vertues
 Winde into her forme, and make her a perfect dower:
 No part of thy sweet goodnesse wanting to her.
 I will not now *Rossellia* aske thy fortunes,
 Nor trouble thee with hearing mine;
 Those shall hereafter serve to make glad howers 90
 In their relation: All past wrongs forgot;
 I am glad to see you Gentlemen; but most,
 That it is in my power to save your Lives;
 You sav'd ours when we were neer starv'd at Sea, [*To* Raymond.]
 And I despaire not, for if she be mine,

74 deprive] F2; deprave F1 81 front] Dyce (*after* Mason); fronts F1–2, L–W

77

Rossellia can deny *Sebastian* nothing.

Rossella. She do's give up her selfe,
 Her power and joyes, and all, to you,
 To be discharged of 'em as to burthensome;
 Wellcome in any shape.

Sebastian. Sir in your looks, [*To* Raymond.] 100
 I read your sute of my *Clarinda*: she is yours:
 And Lady if it be in me to confirme [*To* Aminta.]
 Your hopes in this brave Gentleman,
 Presume I am your servant.

Albert. We thanke you sir.

Aminta. O Happy houre!

Albert. O my deer *Aminta*;
 Now all our feares are ended.

Tibalt. Here I fix: she's mettle,
 Steele to the back: and will cut my leaden dagger,
 If not us'd with discretion.

Crocale. You are still no changling. 110

Sebastian. Nay,
 All look cheerfully, for none shalbe
 Denyd their lawfull wishes; when a while
 We have here refresht our selves; wee'l returne
 To our severall homes; and well that voyage ends,
 That makes of deadly enemies faythfull friends.

 Exeunt.

TEXTUAL NOTES

I.i

9 Farle] A contraction of the nautical term 'Fardel' meaning 'Furl', 'To make into a bundle' (*O.E.D.*).

74 trinkets] Fletcher uses this contemptuous expression for a woman again in *The Double Marriage*, IV.iii.155.

I.ii

4 Caskes] 'Cakes', the reading of F1–2, was accepted without question by later editors until Weber, who suggested 'cates', which seems an inappropriate reading in this dramatic context. In the interest of lightening the ship by flinging overboard its lading, the cakes on board could not count for much, as J. Monck Mason wryly observed when he affirmed that 'we must surely read, and the *casks*' (*Comments on the Plays of Beaumont and Fletcher* (London, 1798), p. 315).

I.iv

81 Galloone] 'A kind of narrow, close-woven ribbon or braid, of gold, silver, or silk thread, used for trimming articles of apparel' (*O.E.D.*).

93 Let] The speech-prefix '*La-m*' that F1 places before this word is clearly an error. Lamure is not a peace-making character, and the line is a continuation of the peace-making efforts of Aminta that have begun in the preceding line. The speech-prefix for Lamure is omitted in F2.

197, 199 *Beats 'em out. ... He beats 'em off. Exit.*] The F1–2 stage-directions indicate that the mêlée that closes this scene was managed in two phases. Albert's speech at line 197 ('Nay, and ye will be Doggs——') breaks off as he descends on one group of the shipwrecked company that is in process of seizing the gold and– according to the stage-direction – '*Beats 'em out.*' Tibalt promptly joins him in his efforts to bring matters under control and – according to a second stage-direction – '*He beats 'em off.*' Just who among the motley company of Morillat, Lamure, Franville, Master, Boatswain, Surgeon and sundry Sailors is being referred to by ''em' in each case is unspecified in the F1–2 stage-directions, and it is pointless for an editor to try and designate which characters Albert '*Beats ... out*' and which ones Tibalt '*beats ... off.*' Tibalt's exit with his bunch clears the stage of all but Aminta, who then exits with her cry of 'O *Albert*; O Gentlemen; O friends', and Sebastian and Nicusa, whose brief exchange of speeches (lines 200–4) closes the scene.

I.v

62–63 Ye things beneath pitty, | Famine shall] Here F2 has made two changes in
the corresponding line in F1: emended F1 'Yea' to 'Ye', and supplied the word
'Famine', missing from F1. The F1 reading ('Yea things beneath pitty shall') makes
a vague sort of sense and might not appear suspect were it not that F2 makes the
same changes elsewhere in the text of this play. At V.ii.17, some word necessary to
the sense has clearly been omitted from F1, and again F2 supplies the word
'famine'. At V.iv.59, F1 'yea' is certainly a misreading for 'yee', and is so corrected
by F2. A similar case of F1 mistakenly printing 'yea' for 'ye' has been suggested at
IV.ii.200, but if so, the mistake went uncorrected in F2, and the case is doubtful. See
the note on that passage. As for the omission of 'Famine': the two places where the
word is missing from the F1 text are on signatures set by Compositor *A*. He was
apparently unable to read the word when he set I.v.63 (a Fletcher scene) on sig. A3,
as well as when he set V.ii.17 (a Massinger scene) on sig. C1; yet one line before this
(V.ii.16) he had managed to set the word 'famisht'. This, as my fellow-editor
Robert Kean Turner has suggested, may lend some support to the view that
Fletcher (an illegible 'famine'-writer) was at work in Massinger's fifth act of this
play, a possibility that has been discussed in the Textual Introduction.

II.i

80 *Albert.* Till] Editors from Sympson to Dyce have omitted the speech-prefix and
assigned the words 'Till now I nere was wretched' to Aminta as a continuation of
her preceding words ('Will ye then leave me?'). But the assignment of the words to
Albert in F1–2 is correct. For Aminta to follow up her question 'Will ye then leave
me?' with the words 'Till now I nere was wretched' sounds merely self-pitying.
When Albert speaks them, they define a moral dilemma: the conflict between his
sense of the need to go off and seek help, and his reluctance to leave her unprotected.

II.ii

186 tittulations] Cf. *The Bondman*, I.ii.21 (in *The Plays and Poems of Philip
Massinger*, ed. Philip Edwards and Colin Gibson (Oxford, 1976)).

III.i

213 stretch ... dottrels] The dotterel was proverbial for the stupidity with which it
allowed itself to be taken. Fuller (*The Worthies of England* (1662), p. 149) calls it 'a
Mirthmaking Bird, so *ridiculously Mimical*, that he is easily *caught* (or rather
catcheth himself) by his own *over-Active imitation*. ... As the *Fowler* stretcheth
forth his *Arms* and *Legs*, going towards the *Bird*, the *Bird* extendeth his *Legs* and
Wings approaching the *Fowler*, till surprised in the Net.' Cf. Fletcher, *Bonduca*,
IV.i.49–50: 'All other loves are meer catching of dotrels, | Stretching of legs out
onely, and trim lazinesse.'

351 Gujacum] A drug extracted from resin of the American Guaiacum tree. Massinger mentions it in *The Picture*, IV.ii.65, and in *The Emperor of the East*, IV.iii.66

352 Camphire pils] Camphire was a noted antaphrodisiac. Massinger refers to 'Camphir-Balls' in *The Guardian*, III.i.22.

352 Goord-water] rain-water. Cf. Massinger, *Believe as You List*, IV.ii.227–9: 'thou art a man of snowe | & thy father got thee in the wane of the moone | dieted with gourd water'; and *The Custom of the Country*, V.i.19 (a Massinger scene).

370 heraldy] For this variant form of 'heraldry' (from 'heraudry'), cf. the second Quarto text of Shakespeare's *Hamlet*, sigs. B2 and F3v (I.i.87; II.ii.478).

437–438 *Rossella*. Tis well ... speak.] As printed in F1, the passage consists of three half-lines each printed on a separate line, the second of which is preceded by a speech-prefix ('*All.*') that should have been printed on the third line. The result is to give Rossella only the first half of her speech ('Tis well counsell'd'), and to assign to '*All*' the second half of it ('And wee'l follow it') plus the words ('Heare us speake') that are indeed theirs. F2 retains the lineation of F1, and follows it in assigning the first two half-lines respectively to Rossella and to *All*, but unaccountably assigns the third half-line to Albert. The first two half-lines obviously comprise a speech of Rossella's. Only the third ('Heare us speake') belongs to *All*. If they were also to speak the second ('And wee'l follow it') – referring to the advice just given by Clarinda – Rossella would not make the crushing reply, 'Peace dogs' (line 438).

IV.ii

80 play such reaks] The phrase, meaning to play such mad tricks, is based on the expression 'to play rex' (alluding to the power of a king). Tilley, R96.

200 shund'd, yea] Since elsewhere in the F1 text of this play, 'yea' has been mistakenly printed for 'ye' (see the note on I.v.62–3, above, and cf. V.iv.59), Dyce considered 'yea' in the present passage to be another such error and emended to 'you' (the pronoun 'ye' is typically changed to 'you' throughout Dyce's edition). He found further support for his view that here 'yea' was a mistake for 'ye' in the fact that 'at the end of the two lines which precede this, and of the line which follows it, both the old eds. have "ye"'. One might argue with equal cogency that the very fact that lines 198, 199 and 201 end with 'ye' while line 200 ends with 'yea' suggests that here the compositor was following his copy when the line's terminal phrase departed from a pattern that is so conspicuous elsewhere. Lines ending with 'ye' are an habitual feature of Fletcher's style. But occasionally he varies it, as with the use of 'yea' at the end of the present line, a variant that is unlikely to be a printer's error. The use of 'yea' as a connective, linking and intensifying the parts in a piece of theatrical rhetoric, is an important element in the modulation of dramatic speech in late Jacobean plays. One of Arcite's speeches from Shakespeare's share of *The Two Noble Kinsmen* (V.i.34ff) provides a good example of the practise:

> Knights, Kinsemen, Lovers, yea my Sacrifices,
> ...
> ... Goe with me

Before the god of our profession: There
Require of him the hearts of Lyons, and
The breath of Tigers, yea the fearcenesse too,
Yea the speed also, to goe on, I meane . . .

'Yea' is sometimes introduced into a sequence of repeated phrases for the purpose
of transposing the discourse into a new, more decisive, more highly pitched key, as
in the present passage from *The Sea Voyage*. Later in Shakespeare's share of V.i of
The Two Noble Kinsmen, Palamon speaks (lines 118ff):

I am
To those that prate and have done, no Companion;
To those that boast and have not, a defyer;
To those that would and cannot, a Rejoycer;
Yea him I doe not love, that tells close offices
The fowlest way . . .

IV.iii

51 potargo] 'A relish made of the roe of the mullet or tunny' (*O.E.D.*, *s.v.*
'Botargo'). There are references to it in *The Elder Brother*, III.iii.25 (a Fletcher
scene), and in Massinger's *The Guardian*, II.iii.24.

126 *Clarinda*.] This speech prefix appears in F1–2 as '*Lam.*', apparently a confusion
of the abbreviation '*Clar.*' with the abbreviation for '*Lamure*'. In both Folios, the
erroneous '*Lam.*' is joined by a brace with the speech prefix '*Fran.*' in the following
line, suggesting that both characters speak simultaneously. Presumably, as soon as
Morillat says 'You are cousned in her', Franville blurts out 'She is no sister' even as
Clarinda is asking what Morillat means. Morillat's 'Good sirs, how quick you are' is
addressed to Franville (and Lamure; see below) as a rebuke, whereupon Morillat
repeats what Franville has disclosed ('She is no sister, Madam'). But Franville
continues to add his bit ('She is his——') and again is rebuked by Morillat ('Peace
I say').

128 sirs] Since Morillat is specifically addressing Franville (see the above note), it is
tempting to emend F1–2 'sirs' to 'sir', but since at least one other character
(Lamure) is present, eagerly waiting a chance (he gets it at line 131) to inform
Clarinda of Albert and Aminta's true relationship, the plural form is probably
correct.

PRESS VARIANTS IN F1 (1647)

[Copies collated: Bodl (Bodleian Library B.i.8.Art.), Camb1 (Cambridge University Library Aston a.Sel.19), Camb2 (Cambridge University Library SSS.10.8), Hoy (personal copy, Cyrus Hoy, Rochester, NY), IU (University of Illinois), MB (Boston Public Library), MnU (University of Minnesota), NcD (Duke University), NIC (Cornell University), NjP (Princeton University), ViU1 (University of Virginia 570973), ViU2 (University of Virginia 217972), WaU (University of Washington), WMU1 (University of Wisconsin-Milwaukee copy 1) WMU2 (University of Wisconsin-Milwaukee, copy 2), WMU3 (University of Wisconsin-Milwaukee, copy 3), WU (University of Wisconsin-Madison).]

SHEET 5Aii (*inner forme*)

Uncorrected: IU, WMU1
Corrected: The rest
Sig. 5A2v
 I.v.12.1 *Aminta*] *Amintta*

SHEET 5Bi (*outer forme*)

Uncorrected: Bodl
Corrected: The rest
Sig. 5B1
 III.i.121 these?] ∼ .
 III.i.185 t'ee] thee

SHEET 5Bii (*outer forme*)

Uncorrected: Bodl, ViU1
Corrected: The rest
Sig. 5B2
 III.i.312 cheekt] cheeckt
 III.i.349 experience, fear feavers] experience, fearfeavers
 III.i.358 Gentlemen] Getleman
 III.i.410 robbers; take ∧] ∼ ∧ ∼;
Sig. 5B3v
 IV.ii.212 fayning] faying
 IV.ii.239 life] lift

EMENDATIONS OF ACCIDENTALS

I.i

I.i] *Actus Primus———Scæna Prima.*
 F1–2 ~ ∧ F1–2
4 think;] ~ ∧ F1–2
5 Dolphin] *Dolphin* F1–2
10 *et seq. 1. Saylor.*] F2; ~ ∧ ~ . F1
14 *et seq. 2. Saylor.*] F2; ~ ∧ ~ . F1
15, 45 let's] F2; lets F1
17–18 Stand ... perisht.] *one line in*
 F1–2
23 see't] F2; seet F1
31 We ... coast?] F1–2 *line:* we
 another, │ What's ... coast?
32.1 *Enter ... Morillat.*] F1 *places in*
 right margin opposite lines 29–32; F2
 places following line 29
32.1 Albert, Franvile, La-mure,] F2;
 ~ ∧ ~ ∧ ~ ∧ F1

32.1 du-pont,] *de pont.* F1–2
50 *Enter* Aminta.] F1 *places in right*
 margin opposite line 46; F2 *places*
 following line 47
68–69 Be ... mercy.] F1–2 *line:* Be ...
 same │ Power ... mercy.
77.1, 80, 119.1 *Exeunt.*] *Exit.* F1–2
93–97 Would ... merciles.] F–2 *line:*
 Would ... numbred; │ And ...
 afflictions, │ Ye ... left │ Like ...
 feares │ And the ... merciles.
105–110 Let ... render me] F1–2 *line:*
 Let ... ye; │ Ye know ... mine, │
 How ... sanctimoniously │ Ob-
 serv'd ... word, │ Not one ...
 render me

I.ii

12 own.] ~ ∧ F1–2
13 twenty] F2; tweenty F1
15–16 The ... clouds.] F1–2 *line:* The
 ... it; │ And ... clouds.
30 buoy] F2; bovy F1

38 swimme] F2 (swim); swime F1
38–39 Fish, Rascall;] ~ ; ~ , F1; ~
 ∧ ~ , F2
45.1 *Exeunt.*] *Exit.* F1–2

I.iii

7–12 'Tis true ... afflictions;] F1–2
 line: 'Tis true ... determin'd │ To
 be ... stories │ Of ... living, │ We
 ... impossible │ She ... afflictions;
20–22 Alas ... waylings.] F1–2 *line:*
 Alas ... experience │ Of ...
 waylings;
22–23 curses; ... calamities.] ~

 ~ ; F1–2
32–34 O Uncle ... calamities;] F1–2
 line: O Uncle ... were, │ 'Twill ...
 calamities;
40–41 Constrain'd ... riches,] *one line*
 in F1–2
47 Pirates———] ~ . F1–2
56 woman∧] ~ . F1–2

I.iv

4 The ... deere?] F1–2 *line:* The
 courteous; | How ... deere?
4 weather's] weathers F1–2
13–14 Injuries, ... service.] ~
 ~ , F1–2
25 I,] F2; ~ ∧ F1
25 an't] F2; ant F1
25 pleas'd] F2; please'd F1
27, 28, 41, 84, 85, 89 (*twice*), 103,
 115 'em] F2; ∧ ~ F1
31 han't] hant F1; ha'n't F2
36 *Venus*] F2; Venus F1
51 goods——] ~ . F1–2
67 us,] ~ ∧ F1–2
103 They ... maines.] F1–2 *line:* They
 ... em, | Goodly ... maines.
114 hearts——] ~ ; F1–2
116 pleas'd] F1; plea'sd F1
123 blessed] F2; blesse'd F1

129 liv'd; ... fortune:] ~ : ... ~ ;
 F1–2
134 been ∧] ~ . F1–2
155–156 Yes, ... inhabited;] *one line in*
 F1–2
158 it;] ~ , F1–2
162 pitties——] ~ , F1; ~ . F2
170–171 Be ... heape.] *one line in*
 F1–2
171 another,] F2; ~ ∧ F1
176 Stand ... this.] F1–2 *line:* Stand ...
 freedomes; | I'le ... this.
186 me.] ~ , F1–2
188 own'd] F2; ow'nd F1
197 Doggs——] ~ . F1–2
197 *Beats*] F2; *beats* F1
199 *He*] F2; *he* F1
199, 204 *Exeunt.*] *Exit.* F1–2

I.v

6 d'ee] dee F1; d'ye F2
7 on't] F2; ont F1
11, 21 'em] F2; ∧ ~ F1
30 wind's] F2; winds F1
40 Help ... Armes,] F1–2 *line:* Help
 ... Lady; | And ... Armes,
42 I'le] Il'e F1; I'll F2
42.1 *Exeunt*] *Exit* F1–2

58–59 I would ... curtesie;] F1–2 *line:*
 I would ... Dogge, | But ...
 curtesie;
61–65 O! what ... ones;] F1–2 *line:* O!
 what ... hence? | Yea things ...
 harbinger; | You must ... here, |
 Nor ... strong on's;
62 pitty,] F2; ~ ∧ F1

II.i

II.i] *Actus Secundus.* F1; *Actus Secun-
 dus.* | *Scæna Prima.* F2
13 Wise] F2; Wse F1
16 'em] F2; ∧ ~ F1
38 banquet,] F2; ~ ∧ F1
39 bless'd one,] F2; blesse't one ∧
 F1
47 Till] F2; Ti l F1
63 *Exeunt,*] *Exit.* F1–2

63 Curteous] *Alb.* Curteous F1–2
78–79 And ... waves.] F1–2 *line:* And
 ... selfe, | Like ... waves.
81–84 My ... believe me] F1–2 *line:*
 My best ... goodnesse | Tis ...
 invites me | To ... believe me
88 absence——] ~ . F1–2
98.1 *Exeunt.*] *Exit.* F1–2

II.ii

2–7 When ... terrible.] F1–2 *line:*
When ... soyle, | The sight ...
suppos'd | He ... more | Then ...
him. | *Jul.* That's ... terrible
2 believ'd] F2; beliv'd F1
8–9 Since ... to it.] *one line in* F1–2
12–16 And we ... men;] F1–2 *line:*
And we ... as if | She ... Fire, |
And had ... him; | Nor ... not |
Fawness ... men;
32–33 In ... her.] *one line in* F1–2
52 waking——] ~ , F1; ~ . F2
66–67 Yfaith ... side,] *one line in* F1–2
71.1 *Enter* Albert.] F1 *places in right
margin opposite first half of line* 71;
F2 *places following line* 71
94 what's] F2; whats F1
108 but——] ~ . F1–2
121–122 Nor ... mother] *one line in*

F1–2
134–137 We are innocent ... death.]
F1–2 *line:* We are innocent ... cast
Him ... wounded: | Nor ... such |
Your ... death.
157–158 Taste ... blessing;] *one line in*
F1–2
159 these] F2; thesr F1
177–178 No ... are;] F1–2 *line:* No ...
made | Of ... are;
183–184 I ... welcome.] F1–2 *line:* I ...
yours, | And ... welcome.
190–191 Yes; ... note,] *one line in* F1–2
227 'em] F2; ʌ ~ F1
230 youth,] ~ ʌ F1–2
237 fruitlesse.] ~ , F1–2
248–249 Yee ... stranger,] F1–2 *line:*
Yee ... fit; | Yee ... stranger,
270.1 *Exeunt.*] *Exit.* F1–2

III.i

III.i] *Actus Tertius.* F1; *Actus Tertius.* |
Scæna prima. F2
9 belly,] F2; ~ ʌ F1
13 that's] F2; thats F1
36–37 Here ... us.] F1–2 *line:* Here ...
what | Hast ... us.
47 glister——] ~ ʌ F1; ~ . F2
66, 114, 115 Let's] F2; Lets F1
99 stories——] ~ . F1–2
100 Of ... examples;] F1–2 *line:* Of ...
meates, | We ... examples;
109, 118 Surgeon] *Surgeon* F1–2
116 Captaine——] ~ ? F1–2
123–124 Give ... spare;] *one line in*
F1–2
150.1 *Enter* ... Saylors.] F1 *places in
right margin opposite lines* 148–150;
F2 *places following line* 148
180–181 Captain ... it.] F1–2 *line:*
Captain ... hark, | Tis ... it.
185 t'ee,] ~ ; F1; ye; F2

219 sweet?] ~ . F1–2
223.1 *Enter* ... Juletta.] F2; F1 *places in
right margin opposite lines* 221–5
232–233 Peace ... 'pothecaries,] *one line
in* F1–2
232 rogues] F2; rouges F1
241 embraces] F2; embrases F1
275 We ... feet.] F1–2 *line:* We down |
Most ... feet.
302 game,] ~ ; F1–2
305 thus;] ~ , F1–2
307 *Saturne*] F2; Saturue F1
317 *Bradamanta*] F2; Bradamanta F1
329 sport,] ~ : F1–2
335 me?] ~ . F1–2
348–349 Besides ... feavers:] F1–2 *line:*
Besides ... men | That ... feavers:
348 weather's] weathers F1–2
351 Gujacum,] ~ ʌ F1–2
356–357 And ... bounties:] *one line in*
F1–2

370 let's] F2; lets F1
378 contented? ... are.] ~ ~ ?
 F1–2
378 Let's] Lets F1–2
379 Straight ... riches.] F1–2 *line:*
 Straight ... returne, | And ...
 riches.

379 *Exeunt.*] *Exit.* F1–2
392 I,] F2; ~ ∧ F1
396 *Enter ... treasure.*] F2; F1 *places in*
 right margin opposite lines 394–6
417 *Sebastian*] F2; Sebastian F1
429 Why ∧] F2; ~ , F1

IV.i

IV.i] *Actus quartus. Scæna prima.*] F1–2
 1 Here's] F2; Heres F1
26–27 Cloath'd ... are.] *one line in*
 F1–2
28–29 Faire ... of;] F1–2 *line:* Faire ...
 words, | And ... of;
31 to ∧] F2; ~ . F1

53 By ... honest,] F1–2 *line:* By ...
 good, | By ... honest,
54 holy——] ~ . F1–2
56 Let's] F2; Lets F1
57 let's] F2; lets F1
72.1 *Exeunt.*] *Exit.* F1–2

IV.ii

8–10 Most ... Ladies——] F1–2
 line: Most ... husbands, | And ...
 bands. | That ... Ladies.
10 Ladies——] ~ . F1–2
25 that's] F2; thats F1
26 on——] ~ . F1–2
36 They ... Mungrels.] F1–2 *line:*
 They ... Gentlemen. | But ...
 Mungrels.
36 Gentlemen,] ~ . F1–2
47 Tush ... Christians?] F1–2 *line:*
 Tush ... things. | Have ...
 Christians?
53 They ... you,] F1–2 *line:* They ...
 me | If ... you,
62 afflictions] F2; afflictons F1
75–76 But ... when] *one line in* F1–2
86 *Exeunt.*] *Exit.* F1–2
92 Your ... mis-led.] F1–2 *line:* Your
 ... sure, | Foully ... mis-led.
96 him;] ~ ∧ F1–2

98 abusd; ... promises:] ~ : ... ~ ;
 F1–2
99 those ∧ too,] ~ , ~ ∧ F1–2
114 (Yet ... me.)] ∧ ~ ... ~ . ∧
 F1–2
124 (I ... heart.)] ∧ ~ ... ~ . ∧ F1–2
136 Lady,] F2; ~ . F1
147–148 To avoyd ... happen.] *one line*
 in F1–2
150 him.] ~ , F1–2
167 Here's ... weepe!] F1–2 *line:* Here's
 ... loves. | How ... weepe!
186 Who ... comforts?] F1–2 *line:* Who
 ... like? | Who ... comforts?
192–193 She ... ye,] F1–2 *line:* She ...
 with it, | It must ... ye,
239 My ... it,] F1–2 *line:* My ... hers, |
 She ... it,
241 love's] loves F1–2
243 mine,] ~ . F1–2
249 meet——] ~ ∧ F1; ~ . F2

IV.iii

7 Wee] F1 (*catchword sig.* 5B3v); We
 F1–2 (*text*)

52 last——] ~ . F1–2
80 see] F2; seee F1

100 But ... rogues.] F1–2 *line:* But ...
 rogues; | Like ... rogues.
118 And so] F2; and so F1
121 next⌃] F2; ~ , F1
122 us——] ~ ⌃ F1; ~ . F2

123 mean?] ~ . F1–2
129, 131, 132 his——] ~ . F1–2
136 proper] F2; propes F1
146 *Exeunt.*] *Exit.* F1–2

IV.iv

12 Indeed ... too.] F1–2 *line:* Indeed
 ... wanton; | We ... too.
12.1 Crocale] F2; *Crolale* F1
13 Out ... both.] F1–2 *line:* Out ...
 woman. | By ... both.
19 Now ... starve.] F1–2 *line:* Now ...

anger. | Let ... starve.
20 I⌃] F2; ~ , F1
22–23 There ... watch] F1–2 *line:*
 There ... beasts | Gnaw ... Snakes
 | Embrace ... watch

V.i

V.i] *Actus quintus, Scæna prima.* F1–2

V.ii

10 The ... look.] F1–2 *line:* The ...
 Vultures | How ... look.
10 Vultures,] ~ ⌃ F1–2
21–26 *Master.* We ... talke] F1–2 *line:*
 Mast. We ... ye. | *Tib.* Do: ...
 selfe? | I ... here? | Wine, ... will; |
 Strong ... talke
29–30 Here's ... it?] F1–2 *line:* Here's
 ... cheek, | Though ... it?
32–33 O my ... favours,] F1–2 *line:* O
 my ... thee, | Again, ... drunkards,
 | And ... favours,
35 Mounsieur] F2; Mounsiuer F1
44 Prethee] F2; prethee F1
52.1–2 *Enter ... severally.*] F1 *places in*
 right margin opposite lines 49–54; F2
 places following line 48
54–55 Marry ... alone;] F1–2 *line:*
 Marry ... will; | I ... here. | *Alb.*
 Raymond! | *Raym.* Albert! | *Tib.*

Away ... alone;
97 Islands——] ~ . F1–2
109 'em] F2; ⌃ ~ F1
125 s.d. Crocale] *Enter Crocale.* F1–2
127 Portugals] F2; Potugals F1
139–140 The ... for.] F1–2 *line:* The ...
 muck | We ... for.
153 How ... fortune.] F1–2 *line:* How
 ... armed | For ... fortune.
153 *Exeunt.*] *Exit.* F1–2
154 What ... dismis'd?] F1–2 *line:*
 What ... now | That ... dismis'd?
155 O sir ... company.] F1–2 *line:* O sir
 ... purpose | To ... company.
156 Take ... now.] F1–2 *line:* Take ...
 woman, | I ... now.
157 You ... liberty.] F1–2 *line:* You ...
 unkind, | To ... liberty.
158 that's] F2; thats F1

V.iii

1 What ... Lake?] F1–2 *line:* What
 ... be │ That ... Lake?

5 In ... her.] F1–2 *line:* In ... woman,
 │ Who ... her,

V.iv

60 misfortune] F2; misfortun F1
77–78 In ... here,] F1–2 *line:* In ...
 Sebastian. │ *Ros.* O ... joyes! │

Seba. And here,
95 mine,] F2; ~ ? F1

HISTORICAL COLLATION

[NOTE: The following editions are collated for substantive variants: F1 (Folio 1647), F2 (Folio 1679), L (*Works*, 1711, with introduction by Langbaine), S (*Works*, 1750, ed. Sympson with assistance of Seward and Theobald), C (*Works*, 1778, ed. George Colman the Younger), W (*Works*, 1812, ed. Henry Weber), and D (*Works*, 1845, ed. Alexander Dyce, vol. VIII). Reference is made to J. Monck Mason, *Comments on the Plays of Beaumont and Fletcher* (London, 1798).]

I.i

2 how] Oh how S
17 Stand ... stand] Sland ... sland F1–2
22 rascall, thou] Rascal S
22 thou hast] thou, thou'st S
24 split] splitting S
27 Master] *omit* S
28 Cast] *Mast.* Cast S
32 yet] ye F2, L
35 this] these W
62 There] There's F2, L, S, D
63 the terrors] and Terrors F2, L, S

81 Come] *omit* S
81 cleer Lady] clear, come Lady S
84 I not] not I F2, L, S
91 from] some from S–D
99–100 whether ... whether] whither ... whither F2; whither ... whether L
99 wandred] wandering S, C
102 lowd] loudest F2, L–D
107 were] are F2, L, S
117 yet] *omit* S

I.ii

0.1 *and* Surgeon] *omit* F2, L–C
2 Sea-ward.] Sea-ward mast. F1–2; Sea-ward Master. L, C
3 *Master.*] *omit* F1–2, L
4 Caskes] Cakes F1–2, L, S, C; cates

W (*qy*); casks D (*after* Mason)
18 perish] *omit* F2, L
36 my Clothes] Clothes L, S
43 'Tis] *Boats.* 'Tis S

I.iii

11 impossible] impossible that S
15 harbour] the Harbour S
21 once] one S
38 Curse] A curse S
41 honours] Our Honours S, D

44 Where] *omit* S
45 where] bore D (*qy*)
50 beares] bear D
61 forced] forc'd 'em S; forced them W, D

90

I.iv

2 Thanks] Yes, Thanks S
2 man] Man's S
3 leakes] Leaks are S
8 which is] what's S
19 a] an S, C, W
25 pleas'd] had pleas'd S
25 seen] Foreseen S
31, 33 upon] on S
38 will never] nevere will S
53 Master] Master you S
64 swords] sword L
71 a fuller] so full S
82 money] mere Money S

93 Let] *Lam.* Let F1
97 come] *omit* S
110 wandring] are ye wandering S
122 release] relief D (*qy*)
134 and as you] and you F2, L
137 out] out here S
158 so] to F2
161 Returne] Return'd D
169 Remove 'em] Remove S, C, W
192 rage] great Rage they S
200 here] *omit* S
201 Ship, yet $_\wedge$] \sim $_\wedge$ \sim , S; \sim $_\wedge$ \sim ;
 C, W, D

I.v

19 Those] These F2, L–W
28 old] *omit* S
62 Ye] Yea F1
62 pitty] my Pity S
63 Famine] *omit* F1

64 here] there F2, L–W
65 ones] on's F1
68 for ye] for S
69 serv'd] serv'd up S

II.i

4 what] what 'tis S
6 Doe] Oh do S
13 doe wonders] do no wonders F2
14 This] These F2, L–W
38 I'm] Am S
39 not] not thou S
42 being $_\wedge$] \sim . S; \sim ! C, W
44 shames] Shame S
54 men] Man S
54–55 confirme ... us,] This way ...
 us. | Confirme ... *Aminta.* S
57 Still 'tis lowder] 'Tis louder still S
58 sounds] sound S

61 way $_\wedge$ still; still $_\wedge$] \sim ! Still, still $_\wedge$
 S–D
63 Curteous] *Alb.* Curteous F1–2,
 L–D
66 Island] Isle S
69 No *Albert*] *Albert*, no S
73 Better] 'Tis better S
80 Will] Well F1
80 *Albert.*] *omit* S–D
81 My] *Alb.* My S–D
82 nor hope] not Hope L, S, C
87 nor eate] not eat L, S

II.ii

10 Birds] The birds S, C
25 want] least want S

27 in] within S
55 prethee] pray S

68 mine] *omit* S
72 But] *omit* S
74 stand close wenches] Wenches stand close S
77 keeps ... here] here keeps Residence S
121 sinne] Sin 'tis S
132 command] strict command S
140 offer] now offer S
154 Now] See now S
160 Not, I thinke.] I think not. S
162 up] *omit* S
163 Bound] Bind L, S
165 bosome] breast S, C

175 thus] this F2; *omit* S
176 ground] Ground thus S
189 faire] fair and S
199 fathers] dear father's S
212 that] *omit* S
220 them] ye S–D
231 ye] *omit* S
232 Hath] Have D
236 labour not] don't labour S
248 shall 'ere] ever shall S
252 ye] to you S
261 to] unto S
264 meat] meat too S
269 thee] her S; ye D (*gy*)

III.i

19 we'l eat it] it we will eat S
33 *Franville.*] *omit* F2, L
47 blest] best F2, L
49 poultices] poulties F1, S; pultesses F2; poultice W, D
50 to] unto S
51 of] of all S
54 now] *omit* S
78 are] all are S
83 Shee's] Hee's F1
96 consume thus] thus Consume S
98 that] *omit* S
102 eate] Eat up S
109 Your] But what is your S
113 parts:] ~ , W, D
126 ready] ready 'las S
148 eat women?] eat, Woman ? S–D
153 do you intend] intend you S
154 me] *omit* S
158 hungers] hunger W
176 down gentle] gentle down S
177 Sir,] Stir ^ S—D
185 t'ee] ye F2, L, S
199 makt] make F2, L–D
212 pull up your noses] pull your Noses up S
215 Deere] Dearest S

216 hear] here L–W
219 do you change] change you S
220 Sawcd] Sawce F1
228 Be] Nay, be S
232 you] *omit* S
250 forwarnd] forward F1–2, L
264 what names] what your names S–D
268–269 that ... presume] that you ... presume S, C
282 to ... power] that power to you S
292 on] of S, C, W
293 Captaine] Know Captain S
299 To] *omit* F1–2, L, C,
304 first ... serv'd] to be serv'd first S
321 Nay] Nay, rather S
336 now] and now S
338 *Aminta.*] *Ros.* C
338 I] you L, S
351 Gujacum] guiacums C, W
353 neer] near to S
355 there] their F1
355 nothing] Nought S
371 equally] equal S
373 *Petrarch*] *Patrick* F1
375 Barque] Banquet L
380 *Rossella.*] *Cla.* S
380 knew] know F1

382 *Clarinda.*] omit S
384 fear] all fear S
397 Hear] Here F2, L–D
409 now] you S
409 that] now that S
420 well] will F2
421 mine] mine too S

423 command] strict command S
426 well enough serv'd] serv'd well
 enough S
438 And] *All.* And F1–2
438 *All.* Heare] Heare F1; *Alb.* Hear F2,
 L–W

IV.i

2 tract] track F2, L–D
9 it] it, Sir, S
16 ye] *omit* S
23 news] good news S
27–28 are.... Gentlemen,] ∼ , ... ∼ .

C, W, D
33 Come, direct us] Direct us, come S
50 sign] a sign S
59 shall] shall but S
66 tract] track C, W, D

IV.ii

3 Those] *omit* S
4 upon] on S
8 happy] happy once S, C
34 their] my C
51 i'] o' F2, L, C; upon S
61 No gentle Maddam] gentle Madam,
 no S
69 doubts] Doubts are S
75 soundly] sound S
80 reaks] Freaks S, C, W
84 tels] tell S–D
99 too,] two, F2; too ∧ L
105 dreamt] dream L, S
144 you please] *omit* S

148 they] they e'er S
166 to refresh ye too] too to refresh ye S
168 have yet] yet have S
170 And though] Although S–D
181 Peace,] Peace, Dear, S
187 I] I then S
200 yea] you D
217 men] man F2, L
221 to] two F2; too D
226 for this] *omit* S
234 seek] seek out S
235 By] No, by S
240 back] back again S
246 nothing] nought S

IV.iii

16 bore] borne C, W
23 are ... now] now are very hungry S
28 power] powers D (*qy*)
42 and] an S–D
45 Just ... Camels] Like hungry
 Camels just S, C
63–64 but ... Oysters] *omit* F2, L

84 ready] ready now S
102 we were] were we D (*after Heath,
 MS Notes*)
108 ye] ye all S
111 provided] unprovided F2, L, S
116 me] me but S
126 *Clarinda.*] *Lam.* F1–2, L, S

93

IV.iv

10 be wise, sir] Sir, be wise S
13 By Heaven] *omit* F2, L, S
18 villaine] villany F2, L, S
20 mock ... mischiefes] at your Mis-

chiefs mock S
22 of her sweetnesse] her Sweetnesse off S

V.i

5 hadst] hast F1
6 foolish] all foolish F2, L, S

12 Him] He F2, L–D

V.ii

8 Undiscover'd ... here] I can here
 undiscovered S
17 famine] *omit* F1
59 poyson'd with fury] with Fury
 poison'd S
65 your] you, L, S
71 your] you F2
74 your selfe slav'd] slav'd yourself D
 (*qy*)

75 your] you F2, L
94 not] sure not S
108 ill] in F2, L
112 those] these F2, L, S
119 ever] *omit* S–D
120 be] ever be S–D
123 soft] soft, | Soft S, C
132 the] these S
136 they] that they D (*qy*)

V.iii

6 to her] unto her S

V.iv

17 hear] here F1
37 few] a few S, D (*qy*)
59 yee] yea F1

74 deprive] deprave F1
81 front] fronts F1–2, L–W

THE DOUBLE MARRIAGE

edited by

CYRUS HOY

INTRODUCTION

The Double Marriage (Greg, *Bibliography*, no. 657) is a Fletcher-Massinger collaboration written and acted *c*. 1621. Such evidence as there is for the presumptive date consists in (1) the fact that the cast given in the 1679 Folio for the play, which was acted by the King's Men, does not include the name of the King's Men's most famous actor, Richard Burbage, who was buried on 16 March 1619, but does include the name of Nicholas Tooley, who was buried on 5 June 1623; (2) the view that, since the sea scenes in *The Double Marriage* are strikingly similar to those in *The Sea Voyage* (licensed for performance on 22 June 1622), it seems likely that, as G. E. Bentley puts it, 'one play exploited further the sea material which had proved popular in the other, and, since the exploitation is fuller in *The Sea Voyage*, one might reasonably guess that *The Double Marriage* immediately preceded it'; and (3) the play's apparent indebtedness to chapter 47 of Cervantes' *Don Quixote*, Part II (first published in England in 1620), where Sancho is prevented from enjoying a royal banquet by an over-zealous court physician, for its depiction of Castruchio's similar frustration in V.i.[1]

The Double Marriage draws even more explicitly on two sources that had been available in English for the past twenty-five years. R. Warwick Bond pointed out the play's use of Thomas Danett's English translation (1596) of *The Historie of Philip de Commines* (notably Book 7, chapter 11) for details concerning the tyrannous reign of the Arragonese King Ferrand of Naples.[2] Eugene Waith has shown that two of the principal ingredients of the play's extravagant plot derive from two *Controversiae* of Seneca the Elder. Of these, one (ii.5, 'The Woman Tortured by the Tyrant because of her Husband') provides the story of Juliana tortured by Ferrand to whom she refuses to betray Virolet; the other (i.6, 'The Daughter of the Pirate Chief') provides the story of Virolet and Martia. The Senecan material was available to Fletcher and Massinger in the original Latin, and in French translation; shortened versions (*Epitomes*) of the complete French text

were translated into English by Lazarus Pyott and published in 1596 in a volume titled *The Orator*.[3]

The shares of the two dramatists in *The Double Marriage* are as follows:[4]

Massinger: I; III.i; IV.ii; V.ii–iv.
Fletcher: II; III.ii–iii; IV.i, iii–iv; V.i.

There is no record of any performance of the play during the lifetime of either dramatist, but on 7 August 1641, sixteen years after Fletcher's death and in the year following Massinger's, *The Double Marriage* was considered valuable enough to be included in a list of King's Men plays 'which the Lord Chamberlain forbade the printers to publish without the company's consent'.[5] On or around 4 September 1646, it was entered in the Stationers' Register by Humphrey Robinson and Humphrey Moseley in their list of some thirty plays that were to comprise the first Beaumont and Fletcher Folio, published in the following year.

Copy for the 1647 Folio text seems to have been very close to the authors' original papers, though since the occurrence of 'ye', Fletcher's preferred form of the second-person pronoun, is by his usual standards very low (it is found only thirty-nine times in the course of the entire play), it is to be presumed that F1 was printed not from holographs but from a scribal transcript of the authors' papers. This raises the question of whether it was a transcript that had been annotated in some degree for use as a theatrical prompt-book. The connection of the play's F1 text with its authors' papers is a good deal clearer than its association with the theatre. Its source in the authors' papers (albeit a transcript of these) is never far from sight. A beginning may have been made in the work of adapting its text for stage presentation, but the evidence is inconclusive, and if the work was ever begun it was certainly never completed. Copy for the F1 text of the play could not have served as a prompt-book in the state in which it is represented in the 1647 Folio.

In the manner of plays printed from manuscripts that derive from authors' original papers, two characters in the F1 text of *The Double Marriage* seem to have received their names in the course of composition. The stage-direction at II.i.67.1 introduces Martia as the daughter of the Duke of Sesse, but her first eleven speeches are headed

'*Daugh.*' and change to '*Mart.*' only at line 192. The Page who enters
with Virolet at the beginning of the play is referred to simply as '*Boy*'
in speech-prefixes and stage-directions throughout I.i. At his next
appearance (III.iii.51), the F1 stage-direction that brings him on reads
'*Enter Boy*', but he is named ('*Lucio*') at III.iii.53, and his three
speeches that follow are so headed. When he leaves the scene at
III.iii.75.1, however, the F1 direction reads '*Ex.Boy*', and when he
returns at III.iii.90.1, F1 reads '*Enter Virolet, and Boy.*' F1 continues
to refer to him as '*Boy*' in speech-prefixes and stage-directions
throughout all his later appearances (in IV.ii, IV.iii, V.ii). Since the
play contains another 'Boy' who is never named but who appears
prominently on board Sesse's ship in II.i, a prompt-book would need
to make clear the fact that the cast contains two separate boys with
speaking-parts.

It is not always possible to account precisely for all the questionable
features of the F1 text. When, at III.ii.24–5, F1 prints the stage-
direction '*En. Citizens,* | *severally*', followed a few lines later
(III.ii.36) by the direction '*En.2.Citizens* | *at both dores, sa-* | *luting
afar off*' (both stage-directions are printed in the margin of sig. 5D4v),
is the first to be regarded as a theatrical adapter's anticipation of the
second, or does the second stage-direction represent a stage adapter's
more explicit instructions for the entrance of the citizens that has been
casually noted by the author some ten lines before? When, in II.v, it is
discovered that Martia has released her father's prisoners and fled with
them from his ship, the Gunner enters and demands 'Who knew of this
trick?' (sig. 5D3v). A few lines later (II.v.41), Martia's father, Sesse,
asks the same question: 'Who knew of this?' Are both characters to
pose it, as they have done in all previous editions of the play? Or does
the question on the Gunner's lips represent an authorial first intention
imperfectly cancelled in the copy for F1 when the author decided that
the question came more appropriately from the father of the errant
daughter (as the present edition assumes)? The issue is discussed in the
context of other problems raised by this scene in the Textual Note on
II.v.23–41. The repeated phrase a few lines later (see the footnote on
II.v.47–8) suggests that F1 copy at this point contained two versions
of another passage (here, one containing the pronoun 'you', the other
'ye'), both of which were printed.

There are in F1 a number of mis-assigned or omitted speech-

prefixes. Often the mis-assigned ones are the result of simple compositorial failure to match up the proper prefix with the proper line of dialogue, as seems to have happened, for example, at V.ii.92–3, where the mistake was caught by a proof-reader and resulted in a press-correction. There are other places, however, where speech-prefixes seem to have been omitted because there were none in the F1 copy. The six F1 lines assigned to *Sesse* on sig. 5F1v (beginning 'He's taken to the Towers strength' and ending 'What is this City up?') represent in fact a sequence of speeches spoken by the Boteswain, Sesse, and voices *'Within'* (see V.i.171–4, where 'this City' has been emended to 'the City' in the present edition). When, at II.i.7, the Boteswain hails the ship's crew below decks, and they respond with a 'Ho, ho' from *'within'*, the cries and the designation whence they've come all become part of the Boteswain's speech. Like *'within'*, *'All'* used as a speech-prefix is susceptible to being absorbed into the dialogue. Thus, at V.i.152, when everyone cries 'Liberty', F1 prints 'All Liberty, liberty, liberty' and includes the line as part of Sesse's preceding speech.

F1's stage-directions are a mixture of specific instruction (especially where off-stage sounds are concerned), descriptive detail, and permissiveness. These last two qualities seem typically authorial: e.g., '*Enter Duke of* Sesse *above and his daughter* Martia *like an Amazon*' (II.i.67.1–2); 'Pandulfo, *and* Juliana, *led by two of the* Guard, *as not yet fully recover'd*' (III.iii.0.1–2); '*Enter* Sesse, Boatswaine, Master, Gunner, . . . Citizens, *and Souldiers, as many as may be*' (V.iii.0.1–3); '*Trumpets, a peece or two go off*' (II.v.41, reiterated ('*A peece or two*') at II.v.43.1); '*One off crying Liberty and freedome*' (V.i.163.1). But the directions of specific instruction often have about them an air of professional brevity. Many of these seem to have been written in the margin of the manuscript, for they are frequently found in the margin of the F1 columns. The effect is sometimes laconic. Castruchio, fanta-sizing about the pleasures available to a king, speaks of 'the beauties, | That with variety of choyce embraces, | Renew his age' (I.ii.24–6), and in the margin F1 prints (sig. 5C4v) '*these passe o're.*' The direction at III.ii.82.1–2 that has 'Virolet, Ronvere, Ascanio, *and* Martia, | *Passing over*' is intended to give Sesse time enough to recognize his daughter, and when he has done so a marginal F1 direction marks their exit: 'Virolet *and they off againe*' (III.ii.88.1).

The words 'take away' appear in the F1 margin (sig. 5F1) during the comic scene of Castruchio's royal banquet in V.i, when servants are snatching dishes away as fast as they are placed before him. These marginal directions are a source of potential confusion, for the F1 compositors sometimes mistake them for dialogue, as when, at V.i.108, the words 'the Table taken away' (clearly a direction) are printed as part of one of Castruchio's speeches. There is another example of this on sig. 5D3, where the words 'Unbolt him', signifying the release of Virolet from his prisoner's chains, are printed at the end of Martia's speech at II.iv.126. The reverse mistake occurs in the following scene (II.v.26; sig. 5D3v), where the Sailor's off-stage cry 'She claps on all her Oares' and another off-stage cry of 'Hoy' are printed in italic in the F1 margin, in the manner of stage-directions. At least twice the marginal directions in F1 are simply wrong. Although dishes are constantly being snatched away from the table at Castruchio's disappointing feast, the words 'meat conveyed away' (sig. 5F1) can only be an error for some such direction as 'Meat brought in' (V.i.30.1), for the feast has only just begun. On sig. 5E3, the direction 'Enter Martia and Boy' is only partially accurate. Martia enters then (IV.ii.49), but the Boy (Lucio) has already been on stage for some fifteen lines. Failures such as these contribute to the impression that the F1 text of the play is a long way from a prompt-book, even one in a rudimentary state of preparation.

The stage-directions calling for specific kinds of music and musical instruments, which might be thought to provide evidence that copy for the F1 text of *The Double Marriage* derives from a manuscript that had been prepared in some measure for use in the theatre, are by no means conclusive. There are numerous instructions for flourishes from the trumpets and the cornets, a levet from the trumpet is called for at one point (II.i.67), there are directions for 'Still Musick' (I.ii.21) and 'Strange Musick' provided by 'Hoboys' (II.iv.79), and a 'horrid noyse' to which the trumpets that are called for presumably contribute (II.iv.82). But none of these need to have issued from the pen of a theatrical scribe. By 1621, Fletcher's dramatic expertise was second to none in the world of the professional London theatre, and Massinger's career as a playwright had now been under way for some half-dozen years. They would know what they wanted in the way of stage effects, and in their manuscript they would be quite capable of making their

requirements known with all the professional brevity and assurance that the F1 text displays. All of the directions for music in the F1 text of *The Double Marriage* have their parallels in other plays of the Beaumont and Fletcher canon.[6] The practised ease with which the authors call on the various musical resources of the Blackfriars company is of a piece with the assured skill with which the play's elaborate plots are shaped to provide a constantly varying sequence of stage spectacles that will utilize all the acting spaces in the Blackfriars Theatre, from the top of the tiring-house to which the ship's Boy ascends, to the trap that leads beneath the main stage, from where voices arise, and the discovery space that reveals, among other things, the bilboes. The play is notable for the number of scenes in which characters enter '*above*' to witness the action on the stage below, thereby providing multiple audiences for the dramatic enactment. This is perhaps the most sophisticated witness to the play's histrionic assurance, which extends as certainly to the directions for music as to all the other details for its stage representation. There is nothing in the directions for music that Fletcher and Massinger could not themselves have provided, and if a theatrical scribe did not provide these (and it is doubtful that he did), then it is hard to see what link exists between F1 copy and the playhouse. It seems best to describe F1 copy as simply a scribal transcript of authors' papers: certainly of Fletcher's, possibly of Massinger's as well.

The Double Marriage was printed in Section 5 of the 1647 Folio, the section assigned to Edward Griffin, where it occupies sigs. 5C3 through to 5F3v. The evidence of running-titles suggests five-skeleton work for the three quires, with five titles appearing in a sequence that in three cases (titles I, IV, and V) cut across the usual recto/verso distinction:

 I C3v, C4, E1, E2
 II D1, D2, D4, E3, E4, F2, F3
 III D1v, D3v, F2v, F3v
 IV C4v, D2v, D4v, E1v, E2v, F1
 V D3, E3v, E4v, F1v

The text of the play seems to have been set by the same three compositors whose work has been described in these volumes by the editors of other Griffin plays: *Love's Cure* (vol. III, p. 10), *The Womans Prize* (vol. IV, pp. 6–7), *The Pilgrim* (vol. VI, pp. 116–17).

Compositor *B*'s spelling preferences are the most clearly defined: e.g., 'Ile', 'tis', 'twas', 'twill', 'do' (with an occasional 'doe'), 'go' (occasional 'goe'), 'Countrey', 'Mistris', 'believe', 'shal' (sometimes 'shall'), 'wil' (sometimes 'will'). The rest of the text presents a decided contrast to these spellings: 'I'le'/'i'le'/'il'e'/'ile', ''tis', ''twas', ''twill', 'doe' (with an occasional 'do'), 'goe' (with an occasional 'go'), 'Country', 'Mistresse', 'beleeve', 'shall' (sometimes 'shal'), 'will' (sometimes 'wil').

In the part of the text that Compositor *B* did not set, two patterns of preferences are apparent: one (Compositor *A*'s), favouring 'doe' over 'do', the other (Compositor *C*'s) favouring 'do' over 'doe'. Compositor *C*'s preference is apparent in the relatively small section of the text that he set, where 'do' occurs nine times and 'doe' only three. Compositor *A*'s preference is evident throughout his three sections, where 'doe' is found a total of twenty-eight times, and 'do' but four times. While both 'doe' and 'do' will sometimes (though rarely) be found in the work of Compositor *B*, it will always be found there in the context of 'Ile', which he invariably uses; 'doe'/'do' in the work of Compositors *A* and *C* are found in the context of one or another of the 'I'le'/'i'le'/'il'e'/'ile' forms that both compositors employ on occasion.

The work of the three compositors can be identified further by their treatment of certain of the play's speech-prefixes. Headings for the Boatswain's speeches are abbreviated '*Bots.*' or '*Botes.*' by Compositor *B*. Compositor *A* uses the abbreviations '*Boats.*' or '*Boatsw.*' Compositor *C*, on first encountering the speeches of this character, heads them with a range of abbreviations that come to include '*Bote.*', '*Botes.*', '*Boat.*', '*Boats.*', ' and '*Boate.*' Though Compositor *B* heads the speeches of the Duke of Sesse indifferently as '*Ses.*' and '*Sess.*', Compositor *A* almost without exception prints them as '*Sess.*', and Compositor *C* without exception prints them as '*Ses.*' One sign of the change of compositors between the end of sig. 5D4v and the beginning of sig. 5E1 is that the catchword at the bottom of 5D4v (set by Compositor *C*) is '*Ses.*', and the first word at the top of 5E1 (set by Compositor *A*) is '*Sess.*' Within the text of the play itself, and in stage-directions, the name of the character is regularly spelled '*Sesse*', the spelling adopted for his speech-prefixes in the present edition.

The division of the work of the three compositors in setting the text of *The Double Marriage* seems to be as follows:

Compositor *A*: 5C3v-5C4v (I.i.80–I.ii.124); 5E1–5E2v (III.ii.110–IV.ii.5); 5F1–5F2v (V.i.19–V.iii.99)

Compositor *B*: 5C3 (I.i.1–79); 5D1–5D3 (I.ii.125–II.v.5); 5E3–5E4v (IV.ii.6–V.i.18); 5F3–5F3v (V.iii.100–V.iv.76)

Compositor *C*: 5D3v–5D4v (II.v.6–III.ii.109)

The Double Marriage was reprinted in the second Beaumont and Fletcher Folio in 1679. The play managed a sort of marginal existence in the Restoration theatre. In 1672 a prologue to *The Double Marriage*, apparently for a recent revival, appeared in *Covent Garden Drollery*.[7] According to John Downes, the play was among those acted by the United Companies after their union in 1682, and the United Company performed the play at Court on 6 February 1688.[8]

NOTES

1 Gerald Eades Bentley, *The Jacobean and Caroline Stage* (Oxford, 1956), III, 331.
2 R. Warwick Bond, 'On six plays in *Beaumont and Fletcher, 1679*', *The Review of English Studies*, XI (1935), 258–61.
3 Eugene M. Waith, *The Pattern of Tragicomedy in Beaumont and Fletcher* (New Haven, 1952), 94–5, 132–4, 203–4.
4 The linguistic evidence on which the following attribution is based is set forth in my 'Shares of Fletcher and his collaborators in the Beaumont and Fletcher canon (II)', *Studies in Bibliography*, IX (1957), 147, where V.ii is wrongly attributed to Fletcher. For a discussion of the two dramatists' joint work in this play, see my 'Massinger as collaborator' in Douglas Howard (ed.), *Philip Massinger: A Critical Reassessment* (Cambridge, 1985), pp. 65–6.
5 Bentley, *Jacobean Stage*, III, 330.
6 There is, for example, a direction for '*A strange Musick*' in *The Little French Lawyer* (V.i.8). '*Horrid Musicke*' is called for in *The Sea Voyage* (V.iv.0.1). For some examples from Massinger's unaided plays, see my 'Shares of Fletcher and his collaborators, (II)', p. 151, note 4.
7 Bentley, *Jacobean Stage*, III, 330.
8 Bentley, *ibid.*; William Van Lennep (ed.), *The London Stage*, Part I (1660–1700), (Carbondale, Illinois: Southern Illinois University Press, 1965), pp. 316, 362.

THE PERSONS REPRESENTED IN THE PLAY

Ferrand, *The libidinous Tyrant of* Naples.
Virolet, *A noble Gentleman, studious of his Countries freedom.*
Brissonet, ⎫
 Two honest Gentlemen, confederates with Virolet.
Camillo, ⎭
Ronvere, *A villain, Captain of the Guard.*
Villio, *A Court fool.*
Castruchio, *A court Parasite.* 10
Pandulpho, *A noble Gentleman of* Naples, *Father to* Virolet.
The Duke of *Sesse, An enemy to* Ferrand, *proscribed and turn'd Pirate.*
Ascanio, *Nephew and successor to* Ferrand
Lucio, *Page to* Virolet.
Master, ⎫
Gunner, ⎪
Boat-swain, ⎪ [*belonging to the ship of the* 20
Chirugion, ⎬ *Duke of Sesse*]
Sailors, ⎪
[Boy], ⎭
Citizens,
Guard,
Soldiers,
Servants,
[Executioners, Lawyer, Doctor].

WOMEN

Juliana, *The Matchlesse Wife of* Virolet. 30
Martia, *Daughter to the Duke of* Sesse.
[Ladies].

The Persons . . . Sharp.] *adapted from* F2; *omit* F1 14 Lucio] Boy F2

The Scene Naples.

The principal Actors were

Joseph Taylor,	*John Lowin,*
Robert Benfield,	*Rich. Robinson,*
John Underwood,	*Nich. Tooly,*
George Birch,	*Rich. Sharp.*

THE DOUBLE MARRIAGE

Enter Virolet, *and* Lucio.

Virolet. Boy.

Lucio. Sir?

Virolet. If my wife seek me, tell her that
Designes of weight, too heavy for her knowledge,
Exact my privacy.

Lucio. I shall, sir.

Virolet. Do then,
And leave me to my selfe.

Lucio. Tis a raw morning,
And would you please to interpret that for duty
Which you may construe boldnesse, I could wish
To arme your selfe against it, you would use
More of my service.

Virolet. I have heate within here,
A noble heat (good boy) to keep it off,
I shall not freeze; deliver my excuse, 10
And you have done your part.

Enter Juliana.

Lucio. That is prevented,
My Lady follows you.

Virolet. Since I must be crost then,
Let her perform that office

Lucio. I obey you. *Exit.*

Virolet. Prethee to bed; to be thus fond's more tedious
Then if I were neglected.

Juliana. Tis the fault then
Of love and duty which I would fall under,
Rather then want that care which you may challenge
As due from my obedience.

0.1, 1, 3, 4, 11, 13 *Lucio*] *Boy* F1–2 18 from] Dyce *(*Heath *conj.)*; to F1–2

107

Virolet. I confesse
This tendernesse argues a loving wife,
And more deserves my hearts best thanks then anger. 20
Yet I must tell ye Sweet, you do exceed
In your affection, if you would ingrosse me
To your delights alone.
Juliana. I am not jealous,
If my embraces have distasted you,
As I must grant you every way so worthy
That tis not in weak woman to deserve you,
Much lesse in miserable me, that want
Those graces some more fortunate are stor'd with.
Seek any whom you please, and I will study
With my best service to deserve those favours, 30
That shall yeeld you contentment.
Virolet. You are mistaken.
Juliana. No, I am patient sir, and so good morrow;
I will not be offensive.
Virolet. Heare my reasons.
Juliana. Though in your life a widdows bed receives me,
For your sake I must love it. May she prosper
That shall succeed me in it, and your ardour
Last longer to her.
Virolet. By the love I beare
First to my Countries peace, next to thy selfe
To whom compar'd, my life I rate at nothing;
Stood here a Lady that were the choyce abstract 40
Of all the beauties nature ever fashion'd,
Or Art gave ornament to, compar'd to thee,
Thus as thou art obedient and loving,
I should contemne and loath her.
Juliana. I do believe ye.
How I am blest in my assur'd beliefe?
This is unfain'd; and why this sadnesse then?
Virolet. Why *Juliana*,
Believe me, these my sad and dull retirements,
My often, nay almost continued fasts,
Sleep banisht from my eyes, all pleasures strangers, 50

Have neither root nor growth from any cause
That may arrive at woman. Shouldst thou be,
As chastity forbid, false to my bed,
I should lament my fortune, perhaps punish
Thy falshood, and then study to forget thee:
But that which like a never emptied spring,
Feeds high the torrent of my swelling griefe,
Is what my Countrey suffers; there's a ground
Where sorrow may be planted, and spring up,
Though yeelding rage and womanish despaire, 60
And yet not shame the owner.
Juliana. I do believe it true,
Yet I should think my selfe a happy woman,
If in this generall and timely mourning,
I might or give to you, or else receive
A little lawfull comfort.
Virolet. Thy discretion
In this may answer for me; look on *Naples*
The Countrey where we both were born and bred,
Naples the Paradise of *Italy*,
As that is of the earth; *Naples*, that was
The sweet retreat of all the worthiest Romans, 70
When they had shar'd the spoyles of the whole world;
This flourishing Kingdom, whose inhabitants
For wealth and bravery liv'd like petty Kings,
Made subject now to such a tyranny,
As that faire City that receiv'd her name
From *Constantine* the great, now in the power
Of barbarous Infidels, may forget her own,
To look with pity on our miseries,
So far in our calamities we transcend her.
For since this Arragonian tyrant *Ferrand*, 80
Ceaz'd on the government, there's nothing left us
That we can call our own, but our afflictions.
Juliana. And hardly those; the Kings strange cruelty,
Equals all presidents of Tyranny.
Virolet. Equals say you:

67 bred] F1(c), F2; bread F1(u) 84 Equals say] Sympson; Equall say F1–2

He has out gone, the worst compar'd to him;
Nor *Phalaris*, nor *Dionisius*,
Caligula, nor *Nero* can be mention'd;
They yet as Kings, abus'd their regall power;
This as a Marchant, all the Countries fatt,
He wholy does ingrosse unto himself; 90
Our Oyles he buyes at his own price, then sels them
To us, at dearer rates; our Plate and Jewels,
Under a fayn'd pretence of publique use,
He borrows; which deny'd, his Instruments force.
The rases of our horses, he takes from us;
Yet keeps them in our pastures; rapes of Matrons,
And Virgins, are too frequent; never man
Yet thank'd him for a pardon; for Religion,
It is a thing he dreames not of.
Juliana. I have heard,
How true it is, I know not; that he sold 100
The Bishop-prick of *Tarent* to a Jew,
For thirteene thousand Duckets.
Virolet. I was present,
And saw the money paid; the day would leave me,
Ere I could number out his impious actions;
Or what the miserable Subject suffers;
And can you entertaine in such a time,
A thought of dalliance? teares, and sighes, and groanes,
Would better now become you.
Juliana. They indeed are,
The onely weapons, our poor Sex can use,
When we are injur'd, and they may become us; 110
But for men that were born free men, of Ranck;
That would be registred Fathers of their Country;
And to have on their Tombs in Golden Letters,
The noble stile of Tyrant killers, written;
To weepe like fooles, and women and not like wise men,
To practise a redresse, deserves a name,
Which fits not me to give.
Virolet. Thy grave reproofe:

*95 The rases of our horses] *stet* F1 99 of] F2; off F1

110

If what thou dost desire, were possible
To be effected, might well argue it,
As wise as loving; but if you consider, 120
With what strong guards, this Tyrant is defended:
Ruffins, and malecontents drawne from all quarters;
That onely know, to serve his impious will;
The Citadels built by him in the neck
Of this poor City; the invincible strength,
Nature by Art assisted, gave this Castle;
And above all his feare; admitting no man
To see him, but unarm'd; it being death
For any to approach him with a weapon.
You must confesse, unlesse our hands were Canons, 130
To batter down these walls; our weake breath mines,
To blow his Forts up; or our curses lightning,
To force a passage to him; and then blast him;
Our power is like to yours, and we like you;
Weepe our misfortunes.

Juliana. Walls of Brasse resist not
A noble undertaking; nor can vice,
Raise any Bulwrack, to make good the place,
Where vertue seekes to enter; then to fall
In such a brave attempt, were such an honour;
That *Brutus*, did he live again would envy. 140
Were my dead Father in you, and my Brothers;
Nay, all the Ancestors I am deriv'd from;
As you, in being what you are, are all these;
I had rather weare a mourning Garment for you,
And should be more proud of my widdow-hood;
You dying for the freedome of this Country;
Then if I were assur'd, I should injoy
A perpetuity of life and pleasure,
With you; the Tyrant living.

Virolet. Till this minute,
I never heard thee speake; O more then woman! 150
And more to be belov'd; can I finde out
A Cabinet, to lock a secret in,
Of equall trust to thee? all doubts, and feares,

That scandalize your sex, be farre from me;
Thou shalt pertake my neer and dearest councels,
And further them with thine.
Juliana. I will be faithfull.
Virolet. Know then this day, stand heaven propitious to us,
Our liberty begins.
Juliana. In *Ferrands* death?
Virolet. 'Tis plotted love, and strongly, and beleeve it,
For nothing else could doe it; 'twas the thought, 160
How to proceed in this designe and end it,
That made strange my embraces.
Juliana. Curs'd be she,
That's so indulgent to her own delights,
That for their satisfaction, would give
A stop to such a glorious enterprize:
For me, I would not for the world, I had been
Guilty of such a crime; goe on and prosper.
Goe on my dearest Lord, I love your Honour
Above my life; nay, yours; my Prayers go with you;
Which I will strengthen with my teares: the wrongs 170
Of this poor Country, edge your sword; O may it
Peirce deep into this Tyrants heart, and then
When you return bath'd in his guilty bloud,
I'le wash you cleane with fountaines of true joy.
But who are your assistants? though I am
So covetous of your glory, that I could wish
You had no sharer in it.
 Knock.

Virolet. Be not curious.
They come, how ever you command my bosome,
To them I would not have you seene.
Juliana. I am gon Sir,
Be confident; and may my resolution 180
Be present with you. *Exit.*
Virolet. Such a Masculine spirit,
With more than womans vertues, were a dower
To waigh down a Kings fortune.

Enter Brissonet, Camillo, Ronvere.

Brissonet. Good day to you.
Camillo. You are an early stirrer.
Virolet. What new face,
 Bring you along?
Ronvere. If I stand doubted Sir,
 As by your looks I guesse it: you much injure
 A man that loves, and truly loves this Country,
 With as much zeale as you doe; one that hates
 The Prince by whom it suffers, and as deadly;
 One, that dares step as farre to gaine my freedome, 190
 As any he that breathes; that weares a sword
 As sharp as any's.
Camillo. Nay, no more comparisons.
Ronvere. What you but whisper, I dare speake aloud,
 Stood the King by; have meanes to put in act too
 What you but coldly plot; if this deserve then
 Suspition in the best, the boldest, wisest?
 Pursue your own intents, il'e follow mine;
 And if I not out-strip you——
Brissonet. Be assur'd Sir,
 A conscience like this can never be allide
 To treachery.
Camillo. Who durst speake so much, 200
 But one that is like us a sufferer,
 And stands as we affected?
Virolet. You are cozend
 And all undone; every Intelligencer
 Speakes treason with like licence; is not this
 Ronvere, that hath for many yeeres been train'd
 In *Ferrands* Schoole, a man in trust and favour,
 Rewarded too and highly?
Camillo. Grant all this,
 The thought of what he was, being as he is now;
 A man disgrac'd, and with contempt thrown off;
 Will spurre him to revenge, as swift as they, 210

That never were in favour.

Virolet. Poore and childish.

Brissonet. His regiment is cast, that is most certain;
And his command in the Castle given away.

Camillo. That on my knowledge.

Virolet. Grosser still, what shepheard
Would yeeld the poor remainder of his flock,
To a known wolfe; though he put on the habit,
Of a most faithfull dogge, and barke like one?
As this but onely talkes.

Camillo. Yes, he has meanes too.

Virolet. I know it to my griefe, weake men I know it;
To make his peace, if there were any warre 220
Between him and his Master, by betraying
Our innocent lives.

Ronvere. You are too suspitious;
And I have born too much, beyon'd my temper,
Take your own wayes, i'le leave you.

Virolet. You may stay now;
You have enough, and all indeed you fisht for;
But one word Gentlemen: have you discover'd
To him alone our plot?

Brissonet. To him and others,
That are at his devotion.

Virolet. Worse and worse:
For were he onely conscious of our purpose,
Though with the breach of Hospitable lawes, 230
In my own house, ide silence him for ever:
But what is past my help, is past my care,
I have a life to loose.

Camillo. Have better hopes.

Ronvere. And when you know, with what charge I have further'd
Your noble undertaking, you will sweare me
Another man; the guards I have corrupted:
And of the choyce of all our noblest youths,
Attir'd like virgins; such as Hermits would
Welcome to their sad cells, prepar'd a Maske;

221 by] Sympson; *omit* F1-2

114

As done for the Kings pleasure.

Virolet. For his safety 240
 I rather feare; and as a pageant to
 Usher our ruine.

Ronvere. We as Torch-bearers
 Will waite on these, but with such art and cunning;
 I have convei'd sharp poniards in the Wax,
 That we may passe, though search't through all his guards
 Without suspition, and in all his glory,
 Oppresse him, and with safety.

Camillo. 'Tis most strange.

Virolet. To be effected.

Ronvere. You are doubtfull still.

Brissonet. But we resolv'd to follow him, and if you
 Desist now *Virolet*, we will say 'tis feare, 250
 Rather then providence.

Camillo. And so we leave you.

 Exeunt [all but Virolet].

 Enter Juliana.

Juliana. To your wise doubts, and to my better councels;
 Oh! pardon me my Lord, and trust me too;
 Let me not like *Cassandra* prophesie truths,
 And never be beleiv'd, before the mischiefe:
 I have heard all; know this *Ronvere* a villaine,
 A villaine that hath tempted me, and plotted
 This for your ruine, onely to make way
 To his hopes in my embraces; at more leisure
 I will acquaint you, wherefore I conceil'd it 260
 To this last minute; if you stay you are lost,
 And all prevention too late. I know,
 And 'tis to me known onely, a darke cave
 Within this house, a part of my poor dower,
 Where you may lye conceal'd, as in the center,
 Till this rough blast be ore; where there is ayre,
 More then to keep in life; *Ferrand* will find you,
 So curious his feares are.

Virolet. 'Tis better fall

 115

Then hide my head, now 'twas thine own advice,
My friends ingag'd too.

Juliana. You stand further bound, 270
Then to weake men that have betry'd themselves,
Or to my Councell, though then just and loyall:
Your phansie hath been good, but not your judgement,
In choyce of such to side you; wil you leape
From a steep Tower, because a desperate foole
Does it, and trusts the wind to save his hazard?
There's more expected from you; all mens eyes
Are fixt on *Virolet*, to help not hurt them;
Make good their hopes and ours, you have sworn often,
That you dare credit me; and allow'd me wise 280
Although a woman; even Kings in great Actions,
Waite opportunity and so must you Sir,
Or loose your understanding.

Virolet. Thou art constant;
I an uncertain foole, a most blinde foole;
Be thou my guide.

Juliana. If I faile to direct you,
For torment or reward, when I am wretched,
May constancy forsake me.

Virolet. I've my safety.

 [*Exeunt.*]

Enter Castruchio, *and* Villio. [I.ii]

Villio. Why are you rapt thus?

Castruchio. Peace, thou art a foole.

Villio. But if I were a flatterer like your worship,
I should be wise and rich too;
There are few else that prosper, baudes excepted,
They hold an equall place there.

Castruchio. A shrew'd knave;
But O the King, the happy King!

Villio. Why happy?
In bearing a great burthen?

Castruchio. What beares he,

284 an] Sympson; am F1–2

116

That's born on Princes shoulders?
Villio. A Crownes waight,
 Which sets more heavy on his head, then the ore
 Slaves digge out of the Mines, of which 'tis made. 10
Castruchio. Thou worthily art his fool, to think that heavy
 That carryes him in the ayre; the reverence due
 To that most sacred Gold, makes him ador'd,
 His Foot-steps kist, his smiles to raise a begger
 To a Lords fortune; and when he but frownes,
 The City quakes.
Villio. Or the poor Cuckolds in it,
 Cox-combs I should say, [*aside*] I am of a foole,
 Grown a Philosopher, to heare this parasite.
Castruchio. The delicates he is serv'd with see and envy——
Villio [*aside*]. I had rather have an Onyon with a stomack, 20
 Then these without one.

 Still Musick [*within*].

Castruchio. The Celestiall Musick,
 Such as the motion of the eternall spheares
 Yeelds *Jove*, when he drinkes Nectar——
Villio [*aside*]. Here's a fine knave,
 Yet hath too many fellowes.
Castruchio. Then the beauties,

 These [*ladies*] *passe o're* [*the stage*].

 That with variety of choyce embraces,
 Renew his age.
Villio [*aside*]. Help him to croutch rather,
 And the French Cringe, they are excellent Surgeons that way.
Castruchio. O Majesty! let others think of heaven,
 While I contemplate thee.
Villio [*aside*]. This is not Atheisme,
 But Court observance.

 Flourish.

Castruchio. Now the God appears, 30

 *18 Grown] F1(u?), F2; *Vil.* Grown F1(c?)

Usher'd with earth-quakes.
Villio [*aside*]. Base Idolatry.

Enter Ferrand, Guard, Women, <i>Servants.</i>

Ferrand. These meates are poysoned, hang the Cookes;
 [*To the musicians within*] No note more, on forfeit of your fingers;
 Doe you envy me a minutes slumber,——what are these?
1. Guard. The Ladies appointed by your Majesty.
Ferrand. To the purpose, for what appointed?
1. Guard. For your graces pleasure.
Ferrand. To sucke away the little bloud is left me,
 By my continuall cares; I am not apt now,
 Injoy them first, taste of my dyet once; 40
 And your turne serv'd, for fifty Crownes a peece
 Their Husbands may redeem them.
Women. Great Sir, mercy.
Ferrand. I am deafe, why stare you? is what we command
 To be disputed? who's this? bring you the dead
 T'upbrai'd me to my face?
Castruchio. Hold Emperour;
 Hold mightiest of Kings, I am thy vassell,
 Thy Foot-stool, that durst not presume to look
 On thy offended face.
Ferrand. Castruchio rise.
Castruchio. Let not the lightning of thy eye consume me,
 Nor heare that Musicall tongue, in dreadfull thunder, 50
 That speakes all mercy.
Villio [*aside*]. Here's no flattering rogue.
Castruchio. *Ferrand,* that is the Father of his people,
 The glory of mankinde——
Ferrand. No more, no word more;
 And while I tell my troubles to my selfe,
 Be Statues without motion or voyce;
 Though to be flatter'd, is an itch to greatnesse,
 It now offends me.
Villio [*aside*]. Here's the happy man;
 But speake who dares.

51 Villio.] F2 (Vil.); Vir. F1

Ferrand [*aside*]. When I was innocent;
 I yet remember, I could eat and sleepe,
 Walke unaffrighted, but now terrible to others: 60
 My guards cannot keepe feare from me,
 It still pursues me; Oh! my wounded conscience,
 The Bed I would rest in, is stuft with thornes;
 The grounds strow'd o're with adders, and with aspicks
 Where ere I set my foot, but I am in,
 And what was got with cruelty, with blood,
 Must be defended, though this lifes a hell,
 I feare a worse hereafter.——Ha!

*Enter* Ronvere *and* Guard.

Ronvere. My Lord.
Ferrand. Welcome *Ronvere*, welcome my golden plummet
 With which I sound mine enemies depthes and angers, 70
 Hast thou discover'd——
Ronvere. All as you could wish Sir,
 The Plot, and the contrivers; was made one
 Of the conspiracie.
Ferrand. Is *Virolet* in?
Ronvere. The head of all, he onely scented me:
 And from his feare, that I plaid false is fled;
 The rest I have in fetters.
Ferrand. Death and hell.
 Next to my mortall foe the pyrat *Sesse*,
 I aym'd at him; he's vertuous, and wise,
 A lover of his freedome and his countries,
 Dangerous to such as govern by the sword, 80
 And so to me: no tract which way he went,
 No meanes to overtake him?
Ronvere. Ther's some hope left;
 But with a rough hand, to be seas'd upon.
Ferrand. What is't?
Ronvere. If any know, or where he is,
 Or which way he is fled, it is his wife;
 Her with his Father I have apprehended,
 And brought among the rest.

119

Ferrand. 'Twas wisely order'd,
 Go fetch them in, and let my executioners
 Appeare in horrour with the racke.

 Exit Ronvere [*and.* Guard].

Villio. I take it signeur, this is no time for you to flatter, 90
 Or me to foole in.
Castruchio. Thou art wise in this,
 Let's off, it is unsafe to be nere *Jove*,
 When he begins to thunder.
Villio. Good morality.

 Exeunt [Castruchio *and* Villio].

Ferrand. I that have peirc'd into the hearts of men;
 Forc'd them to lay open with my lookes,
 Secrets whose least discovery was death,
 Will rend for what concernes my life, the fortresse,
 Of a weake womans faith.

 Enter Ronvere, *Guard, Executioners with a Rack*, Camillo,
 Brissonet, Pandulfo, Juliana.

Camillo. What ere we suffer,
 The waight, that loads a Traytors heart sit ever,
 Heavy on thine.
Brissonet. As we are caught by thee, 100
 Fall thou by others.
Ronvere. Pish poor fools, your curses
 Will never reach me.
Juliana. Now by my *Virolets* life;
 Father, this is a glorious stage of murther.
 Here are fine properties too, and such spectators,
 As will expect good action, to the life;
 Let us performe our parts, and we shall live,
 When these are rotten, would we might begin once;
 Are you the Master of the company?
 Troth you are tedious now.
Ferrand. She does deride me.

 104 fine] F2; five F1

 120

Juliana. Thee and thy Power, if one poor syllable 110
 Could win me, an assurance of thy favour,
 I would not speake it, I desire to be
 The great example of thy cruelty,
 To whet which on, know *Ferrand*, I alone
 Can make discovery, where my *Virolet* is,
 Whose life, I know thou aym'st at, but if tortures
 Compell me to't, may hope of heaven forsake me;
 I dare thy worst.
Ferrand. Are we contemn'd?
Juliana. Thou art,
 Thou and thy Ministers, my life is thine;
 But in the death, the Victory shall be mine. 120
Pandulfo. We have such a Mistresse here to teach us courage,
 That cowards might learn from her.
Ferrand [*to the Executioners*]. You are slow;——

 [Juliana] *put on the rack.*

 Begin the Scene thou miserable foole
 For so I'le make thee.
Juliana. 'Tis not in thy reach;
 I am happy in my sufferings, thou most wretched.
Ferrand. So brave! Ile tame you yet, pluck harder villains;
 Is she insensible? no sigh nor groan?
 Or is she dead?
Juliana. No tyrant, though I suffer
 More then a woman, beyond flesh and blood;
 Tis in a cause so honourable, that I scorn 130
 With any sign that may expresse a sorrow
 To shew I do repent.
Ferrand. Confesse yet, and
 Thou shalt be safe.
Juliana. Tis wrapt up in my soule,
 From whence thou canst not force it.
Ferrand. I will be
 Ten daies a killing thee.
Juliana. Be twenty thousand,

114 on] F2; one F1 126 harder] Sympson; hard F1–2 133 shalt] F2; shal F1

121

My glory lives the longer.
Ronvere. Tis a miracle,
 She tires th'executioners, and me.
Ferrand. Unloose her, I am conquer'd, I must take
 Some other way; reach her my chaire, in honour
 Of her invincible fortitude.
Ronvere. Will you not 140
 Dispatch the rest?
Ferrand. When I seem mercifull,
 Assure thy selfe *Ronvere*, I am most cruel.——
 Thou wonder of thy sex, and of this Nation,
 That hast chang'd my severity to mercy,
 Not to thy selfe alone, but to thy people
 In which I do include these men, my enemies:
 Unbind them.
Pandulfo. This is strange.
Ferrand. For your intent
 Against my life, which you dare not deny,
 I onely aske one service.
Camillo. Above hope.
Ferrand. There rides a Pyrate neer, the Duke of *Sesse*, 150
 My enemy and this Countries, that in bonds
 Holds my deere friend *Ascanio*: free this friend,
 Or bring the Pyrats head; besides your pardon,
 And honour of the action, your reward
 Is forty thousand Ducates. And because
 I know that *Virolet* is as bold as wise,
 Be he your Generall; as pledge of your faith,
 That you wil undertake it, let this old man,
 And this most constant Matron stay with me;
 Of whom, as of my selfe, I wil be carefull; 160
 She shall direct you where her husband is.
 Make choice of any ship you think most useful.
 They are rig'd for you.

 Exeunt Guard, with Juliana *and* Pandulfo [*and Executioners*].

Brissonet. We with joy accept it.

Camillo. And wil proclaim King *Ferrant* mercifull.

Exeunt [Brissonet *and* Camillo].

Ronvere. The mysterie of this, my Lord? or are you
 Chang'd in your nature?
Ferrand. Ile make thee private to it.
 The lives of these weake men, and desperate woman,
 Would no way have secur'd me, had I took them;
 Tis *Virolet* I aime at; he has power,
 And knows to hurt. If they encounter *Sesse*, 170
 And he prove conquerour, I am assur'd
 They'l finde no mercy: if that they prove victors,
 I shall recover with my friend, his head
 I most desire of all men.
Ronvere. Now I have it.
Ferrand. Ile make thee understand the drift of all.
 So we stand sure, thus much for those that fall.

Exeunt.

Enter Boteswain *and* Gunner. II.i

Boteswain. Lay her before the wind; up with her Canvase
 And let her work, the wind begins to whistle;
 Clap all her streamers on, and let her dance,
 As if she were the Minion of the Ocean.
 Let her bestride the billows till they rore,
 And curle their wanton heads. Ho, below there.
Sailors (within). Ho, ho.
Boteswain. Lay her North-east, and thrust her missen out,
 The day grows faire and cleare, and the wind Courts us.
 O for a lusty saile now, to give chase to. 10
Gunner. A stubborn Barke, that wo'd but bear up to us,
 And change a broadside bravely.
Boteswain. Where's the Duke?
Gunner. I have not seen him stir to day.

1, 8 Lay] F2; Ley F1 1 her] Sympson; here F1–2
7 *Sailors (within).* Ho, ho.] Sympson; Ho, ho, within. F1–2 (*printed as part of Boteswain's
 speech*) 8 *Boteswain.*] omit F1–2

123

Boteswain. O Gunner,
 What bravery dwels in his age, and what valour?
 And to his friends, what gentlenesse and bounty?
 How long have we been inhabitants at Sea here?
Gunner. Some fourteen yeers.
Boteswain. By fourteen lives I swear then,
 This Element never nourisht such a Pirate;
 So great, so fearlesse, and so fortunate,
 So patient in his want, in Act so valiant. 20
 How many saile of wel man'd ships before us,
 As the Bonuto does the flying fish,
 Have we pursued and scowerd, that to outstrip us,
 They have been fain to hang their very shirts on?
 What Gallies have we bang'd, and sunke, and taken;
 Whose onely fraughts were fire, and stern defiance?
 And nothing spoke but Bullet in all these.
 How like old *Neptune* have I seen our Generall
 Standing ith' Poope, and tossing his steel Trident,
 Commanding both the Sea and Winds to serve him? 30
Gunner. His daughter too, which is the honour, Boteswain,
 Of all her sex; that Martiall mayd.
Boteswain. A brave wench.
Gunner. How oftentimes, a fight being new begun,
 Has she leap'd down, and took my Linstock from me,
 And crying, now fly right, fir'd all my chasers?
 Then like the Image of the warlike Goddesse,
 Her Target brac'd upon her arme, her Sword drawn,
 And anger in her eyes, leap'd up again,
 And bravely hal'd the Barke. I have wondred Botswain,
 That in a body made so delicate, 40
 So soft for sweet embraces, so much fire,
 And manly soule, not starting at a danger.
Boteswain. Her Noble father got her in his fury,
 And so she proves a souldier.
Gunner. This too I wonder at,
 Taking so many strangers as he does,

22 Bonuto] *i.e.*, Bonito, *'the striped tunny; a fish about three feet long'* (*O.E.D.*)
44 too] F2; to F1

He uses them with that respect and coolnesse,
Not making prize, but onely borrowing
What may supply his want: nor that for nothing;
But renders back what they may stand in need of,
And then parts lovingly: Where, if he take 50
His Countreyman, that should be neerest to him,
And stand most free from danger, he sure pays for't:
He drownes or hangs the men, ransacks the Barke,
Then gives her up a Bonfire to his fortune.
Boteswain. The wrongs he has receiv'd from that dull Countrey,
That's all I know has purchas'd all his cruelty.
We fare the better; cheerly, cheerly boys,
The ship runs merrily; my Captain's melancholy,
And nothing cures that in him but a Sea-fight:
I hope to meet a saile boy, and a right one. 60
Gunner. That's my hope too; I am ready for the pastime.
Boteswain. I'th mean time let's bestow a song upon him,
To shake him from his dumps, and bid good day to him.
Ho, in the hold.

Enter a Boy.

Boy. Here, here.
Boteswain. To th' main top boy.
And thou kenst a ship that dares defie us,
Here's Gold.
Boy. I am gon.

 Exit Boy.

Boteswain. Come sirs, a queint Levet,

 Trumpets [sound] a levet.

To waken our brave Generall. Then to our labour.

Enter Duke of Sesse *above and his daughter* Martia *like an Amazon.*

Sesse. I thank you loving mates; I thank you all.
 [*Gives them money*] There's to prolong your mirth, and good
 morrow to you.

Martia. Take this from me, you'r honest valiant friends; 70
 And such we must make much of. Not a sayle stirring?
Gunner. Not any within ken yet.
Boteswain. Without doubt Lady,
 The wind standing so faire and full upon us,
 We shal have sport anon. But noble Generall,
 Why are you still so sad? you take our edge off;
 You make us dull, and spirit-lesse.
Sesse. Ile tell ye,
 Because I wil provoke you to be fortunate;
 For when you know my cause, twill double arme you.
 This woman never knew it yet; my daughter,
 Some discontents she has.
Martia. Pray sir go forward. 80
Sesse. These fourteen yeeres, I have stoed it here at Sea,
 Where the most curious thought could never find it.
Boteswain. Call up the Master, and all the Mates.

 Enter below the Master *and* Saylers.

Sesse. Good morrow.
Master. Good morrow to our Generall, a good one,
 And to that Noble Lady all good wishes.
Martia. I thank you Master.
Sesse. Mark me, thus it is then;
 Which I did never think to have discovered,
 Till full revenge had wooed me; but to satisfie
 My faithfull friends, thus I cast off my burden.
 In that short time I was a Courtier, 90
 And followed that most hated of all Princes,
 Ferrant the full example of all mischiefes,
 Compel'd to follow to my soule a stranger,
 It was my chance one day to play at Chesse
 For some few Crowns, with a mynion of this Kings,
 A mean poor man, that onely serv'd his pleasures;
 Removing of a Rook, we grew to words;
 From this to hotter anger: to be short,

70, 80, 86, 99, 103, 109, 135, 146, 158, 167, 180 *Martia.*] *Daugh.* F1–2
*80 Some discontents she has.] *stet* F1–2 81 stoed] *i.e.,* stowed

I got a blow.
Martia. How, how my Noble father?
Sesse. A blow my girle, which I had soon repayd, 100
And sunk the slave for ever, had not odds
Thrust in betwixt us. I went away disgrac'd——
Martia. For honours sake not so sir.
Sesse. For that time, wench;
But calld upon him, like a Gentleman,
By many private friends; knockt at his valour,
Courted his honour hourely to repaire me;
And tho he were a thing my thoughts made sleight on,
And onely worth the fury of my footman,
Still I pursued him Nobly.
Martia. Did he escape you?
My old brave father, could you sit down so coldly? 110
Sesse. Have patience, and know all. Pursued him fairly,
Till I was laught at, scornd, my wrongs made may games.
By him unjustly wrong'd, should be all justice,
The slave protected; yet at length I found him,
Found him, when he suppos'd all had been buried;
And what I had received durst not be questioned;
And then he fell, under my Sword he fell,
For ever sunk; his poore life, like the ayre,
Blown in an empty bubble, burst, and left him,
No Noble wind of memory to raise him. 120
But then began my misery, I fled;
The Kings frowns following, and my friends dispaires;
No hand that durst relieve: my Countrey fearfull,
Basely and weakly fearfull of a tyrant;
Which made his bad wil worse, stood still and wondred,
Their vertues bedrid in e'm; then my girle,
A little one, I snatch'd thee from thy nurse,
The modell of thy fathers miseries:
And some small wealth was fit for present carriage,
And got to Sea; where I profest my anger, 130
And wil do, whilst that base ungratefull Countrey,
And that bad King, have blood or means to quench me.
Now ye know all.

Master.　　　　　We know all, and admire all;
　Go on and do all still, and still be fortunate.
Maritia.　　Had you done lesse, or lost this Noble anger,
　You had been worthy then mens empty pities,
　And not their wonders. Go on, and use your justice;
　And use it still with that fell violence
　It first appeared to you; if you go lesse,
　Or take a doting mercy to protection,　　　　　　　140
　The honour of a father I disclaim in you,
　Call back all duty, and will be prowder of
　The infamous and base name of a whore,
　Then daughter to a great Duke and a coward.
Sesse.　Mine own sweet *Martia*, no; thou knowst my nature,
　It cannot, must not be.
Martia.　　　　　　I hope it shal not.
　But why sir, do you keep alive still young *Ascanio*,
　Prince of *Rossana*, King *Ferrants* most belov'd one,
　You took two moneths agoe? Why is not he
　Flung overboord, or hang'd?
Sesse.　　　　　　Ile tell thee girle:　　　　　150
　It were a mercy in my nature now,
　So soon to break the thread of his afflictions;
　I am not so far reconcil'd yet to him
　To let him die, that were a benefit.
　Besides, I keep him as a bayt and dyet,
　To draw on more, and neerer to the King,
　I look each hour to heare of his Armados,
　And a hot welcome they shall have.
Martia.　　　　　　But hark you?
　If you were overswayed with oddes——
Sesse.　　　　　　I find you:
　I would not yield; no girle, no hope of yeelding,　　160
　Nor fling my self one houre into their mercies,
　And give the tyrant hope to gain his Kingdom.
　No, I can sink wench, and make shift to die;
　A thousand doores are open, I shal hit one.
　I am no niggard of my life, so it goe Nobly:

*148 *Rossana*] stet F1–2　　152 thread] Sympson; bed F1–2

128

All waies are equall and all houres; I care not.
Martia. Now you speak like my father.
Master. Noble General,
 If by our means they inherit ought but bangs,
 The mercy of the main yard light upon us.
 No, we can sinke too sir, and sinke low enough, 170
 To pose their cruelties, to follow us:
 And he that thinks of life, if the world go that way,
 A thousand cowards suck his bones.
Gunner. Let the worst come,
 I can unbreech a Canon, and without much help
 Turn her into the Keele; and when she has split it,
 Every man knows his way, his own prayers,
 And so good night I think.
Master. We have liv'd all with you.

 [*Enter*] Boy *atop.*

And will die with you Generall.
Sesse. I thank you Gentlemen.
Boy (above). A Sayle, a Sayle.
Master. A cheerfull sound.
Boy. A Sayle.
Boteswain. Of whence? of whence boy?
Boy. A lusty sayle.
Martia. Look right, 180
 And look again.
Boy. She plows the Sea before her,
 And fomes i'th mouth.
Boteswain. Of whence?
Boy. I ken not yet sir.
Sesse. O may she prove of *Naples.*
Master. Prove the Divell,
 We'l spit out fire as thick as she.
Boy. Hoy.
Master. Brave boy.
Boy. Of *Naples, Naples,* I think of *Naples,* Master,
 Me thinks I see the Armes.

 177.1 Boy atop] stet F1–2

 129

Master. Up, up another,
And give more certain signes.

 Exit Saylor.

Sesse. All to your businesse,
And stand but right and true.
Boteswain. Hang him that halts now.
Boy. Sh'as us in chase.
Master. We'l spare her our main top-saile,
She shall not look us long, we are no starters. 190
Down with the fore-saile too, we'l spoom before her.
Martia. Gunner, good noble Gunner, for my honour
Load me but these two Minions in the chase there;
And load 'em right, that they may bid faire welcome,
And be thine eye and level as thy heart is.

 [*Enter* Saylor *atop.*]

Gunner. Madam, Ile scratch 'em out, Ile pisse 'em out else.
Saylor (*above*). Ho.
Sesse. Of whence now?
Saylor. Of *Naples, Naples, Naples.*
I see her top flag how she quarters *Naples.*
I heare her Trumpets.
Sesse. Down, she's welcome to us.

 Exeunt Master, Boteswain, Gunner, Saylors.

Every man to his charge, man her i'th bowe wel. 200
And place your rakers right, daughter be sparing.
Martia. I sweare Ile be above sir, in the thickest,
And where most danger is, Ile seek for honour.
They have begun, harke how their Trumpets call us.
Hark how the wide mouth'd Cannons sing amongst us.
Heark how they haile; out of our shels for shame sir.

190 She] Langbaine; He F1–2 *191 spoom] *stet* F1–2
193 Minions] '*a small kind of ordnance of about 3-inch calibre*' (O.E.D.)
*193 chase] Sympson; chape F1–2 *195 eye and level] *stet* F1–2
199.1 Saylors] Dyce; *Sayl.* F1–2
201 rakers] *i.e., the guns which are to rake the enemy's vessel*
206 haile] W (Mason *conj.*); saile F1–2

Sesse. Now fortune and my cause.
Martia. Be bold and conquer.
 Exeunt.
 Charge, Trumpets and shot within.

 Enter Master, *and* Boteswain. [II.ii]

Master. They'l board us once again, they'r tuffe and valiant.
Boteswain. Twice we have blown 'em into th'ayre like fethers,
 And made 'em dance.
Master. Good boys, fight bravely, manly.

 Enter Gunner.

 They come on yet; clap in her stern, and yoke 'em.
Gunner. You shall not need, I have provision for 'em;
 Let 'em boord once again, the next is ours.
 Stand bravely to your Pikes, away, be valiant.
 I have a second course of service for 'em,
 Shall make the bowels of their Barke ake, boy.
 The Duke fights like a Dragon. Who dares be idle? 10
 Exeunt.
 Charge, Trumpets, pieces goe off.

 Enter Master, Boteswaine *following.* [II.iii]

Master. Down with 'em, stow 'em in.
Boteswain. Cut their throats,
 Tis brotherhood to fling 'em into the Sea.
 The Duke is hurt, so is his lovely daughter *Martia.*
 We have the day yet.

 Enter Gunner.

Gunner. Pox fire 'em, they have smok'd us,
 Never such plumbs yet flew.
Boteswain. They have rent the ship,
 And bor'd a hundred holes, she swims still lustily.
Master. She made a brave fight, and she shall be cur'd,
 And make a braver yet.

 9 boy] F2; hoy F1 5 yet] F1(c), F2; *omit* F1(u)
 6 she] F1(c)), F2; Yet she F1(u)

 131

Gunner. Bring us some Cans up,
 I am hot as fire.

 Enter Boy *with 3 Cans.*

Boteswain. I am sure I am none o'th coolest.
Gunner. My Cannons rung like Bels. Here's to my Mistris. 10
 The dainty Sweet brasse Minion, split their fore-mast,
 She never failed.
Master. Ye did all well, and truly,
 Like faithfull honest men.
Boteswain. But is she rich Master?

 Trumpet flourish.

 Enter Sesse, Martia, Virolet, *Saylors.*

Master. Rich for my Captains purpose howsoever,
 And we are his. How bravely now he shows,
 Heated in blood and anger?——how do you sir?
 Not wounded mortally I hope?
Sesse. No Master,
 But onely weare the livery of fury,——
 [*Aside*] I am hurt, and deep.
Master. My Mistris too?
Martia. A scratch man,
 My needle would ha done as much.——Good sir, 20
 Be provident and carefull.
Sesse. Prethee peace girle,
 This wound is not the first blood I have blusht in,——
 Ye fought all like tall men, my thanks among ye,
 That speaks not what my purse means, but my tongue, souldiers.
 Now sir, to you that sought me out, that found me,
 That found me what I am, the Tyrants Tyrant;
 You that were imp'd the weak arme to his folly,
 You are welcome to your death.
Virolet. I do expect it,
 And therefore need no complement, but waite it.
Sesse. Thou bor'st the face once of a Noble Gentleman, 30

23 Ye] F1(c), F2; You F1(u)

132

Rankt in the first file of the vertuous,
By every hopefull spirit, shewed and pointed,
Thy Countries love; one that advanc'd her honour,
Not taynted with the base and servile uses
The Tyrant ties mens soules too. Tell me *Virolet*,
If shame have not forsook thee, with thy credit——

Virolet. No more of these Racks; what I am I am.
I hope not to go free with poore confessions;
Nor if I show ill, will I seem a monster,
By making my mind prisoner; do your worst. 40
When I came out to deale with you, I cast it,
Onely those base inflictions fit for slaves,
Because I am a Gentleman——

Sesse. Thou art none.
Thou wast while thou stoodst good, th'art now a villain
And agent for the divell.

Virolet. That tongue lies.
Give me my Sword again, and stand all arm'd;
Ile prove it on ye all, I am a Gentleman,
A man as faire in honour; rate your prisoners;
How poore and like a Pedagogue it shews?
How far from Noblenesse? tis fair, you may kil's; 50
But to defame your victory with foule language——

Sesse. Go, fling him overboord; Ile teach you sirra.

Virolet. You cannot teach me to die. I could kill you now
With patience, in despising all your cruelties,
And make you choke with anger.

Sesse. Away I say.

Martia. Stay sir, h'as given you such bold language,
I am not reconcil'd to him yet, and therefore
He shall not have his wish observ'd so neerly,
To die when he please; I beseech you stay sir.

Sesse. Do with him what thou wilt.

Martia. Carry him to th'Bilboes 60
And clap him fast there, with the Prince.

Virolet. Do Lady,

39 show] F1(c), F2 (shew); strove F1(u)

133

For any death you give, I am bound to blesse you.

Exeunt Virolet, *and Saylors.*

Martia. Now to your Cabin, sir; pray lean upon me,
And take your rest, the Surgeons waite all for you.
Sesse. Thou makest me blush to see thee bear thy fortunes;
Why, sure I have no hurt, I have not fought sure?
Master. You bleed apace, Sir.
Martia. Ye grow cold too.
Sesse. I must be ruld, no leaning,
My deepest wounds scorn Crutches.
All. A brave Generall.

Flourish. Trumpets, Cornets.
Exeunt omnes.

Enter two Saylors. [II.iv]

1. Saylor. Will they not moore her?
2. Saylor. Not till we come to the Fort,
This is too weak a place for our defences,
The Carpenters are hard at worke; she swims well,
And may hold out another fight. The ship we took
Burns there to give us light.
1. Saylor She made a brave fight.
2. Saylor. She put us all in feare.
1. Saylor. Beshrew my heart did she.
Her men are gone to *Candy*, they are pepper'd,
All but this prisoner.
2. Saylor. Sure he's a brave fellow.
1. Saylor. A stubborn knave, but we have pul'd his bravery.

He discovers Virolet *and* Ascanio *in the Bilboes.*

Look how he looks now: come let's go serve his dyet, 10
Which is but bread and water.
2. Saylor. He'l grow fat on't.

Exeunt Saylors.

Ascanio. I must confesse I have endured much misery,
Even almost to the ruine of my spirit,

134

But ten times more grows my affliction,
To finde my friend here.

Virolet. Had we serv'd our Countrey,
Or honesties, as we have serv'd our follies,
We had not been here now.

Ascanio. Tis too true *Virolet.*

Virolet. And yet my end in ventring for your safety,
Pointed at more then *Ferrants* will, a base one;
Some service for mine own, some for my Nation, 20
Some for my friend; but I am rightly payd,
That durst adventure such a Noble office,
From the most treacherous command of mischiefe;
You know him now?

Ascanio. And when I neerer knew him,
Then when I waited, Heaven be witnesse with me,
(And if I lie my miseries still load me)
With what teares I have wooed him, with what prayers,
What weight of reasons I have layd, what dangers;
Then, when the peoples curses flew like storms;
And every tongue was whetted to defame him, 30
To leave his doubts, his tyrannies, his slaughters,
His fell oppressions. I know I was hated too.

Virolet. And all mankind that knew him: these confessions
Do no good to the world, to Heaven they may.
Let's study to die well, we have liv'd like coxcombs.

Ascanio. That my mis-fortune, should lose you too.

Virolet. Yes;
And not onely me, but many more, and better:
For my life, tis not this; or might I save yours,
And some brave friends I have engag'd, let me go;
It were the meritorious death I wish for, 40
But we must hang or drown like whelps.

Ascanio. No remedy?

Virolet. On my part I expect none. I know the man,
And know he has been netled to the quick too,
I know his nature.

Ascanio. A most cruell nature.

17 too] F2; to F1 27 wooed] F2; woed F1

Virolet. His wrongs have bred him up. I cannot blame him.

Ascanio. He has a daughter too, the greatest scorner,
 And most insulter upon misery.

Virolet. For those, they are toyes to laugh at, not to lead men:
 A womans mirth or anger, like a meteor
 Glides and is gone, and leaves no crack behind it; 50
 Our miseries would seem like masters to us,
 And shake our manly spirits into feavors,
 If we respected those; the more they glory,
 And raise insulting Trophies on our ruines;
 The more our vertues shine in patience.
 Sweet Prince, the name of death was never terrible
 To him that knew to live; nor the loud torrent
 Of all afflictions, singing as they swim,
 A gall of heart, but to a guilty conscience:
 Whilst we stand faire, though by a two-edg'd storm, 60
 We find untimely fals, like early Roses;
 Bent to the earth, we beare our native sweetnesse.

Ascanio. Good sir go on.

Virolet. When we are little children,
 And cry and fret for every toy comes crosse us;
 How sweetly do we shew, when sleep steales on us?
 When we grow great, but our affection greater,
 And struggle with this stubborn twin, born with us;
 And tug and pull, yet still we finde a Giant:
 Had we not then the priviledge to sleep,
 Our everlasting sleep, he would make us ideots; 70
 The memory and monuments of good men
 Are more then lives, and tho their Tombs want tongues,
 Yet have they eyes, that daily sweat their losses;
 And such a teare from stone, no time can value.
 To die both young and good, are natures curses,
 As the world says; ask truth, they are bountious blessings:
 For then we reach at Heaven, in our full vertues,
 And fix our selves new Stars, crown'd with our goodnes.

60 though] F2; but F1 62 Bent] F2; But F1
66 affection] Sympson (Seward's *emendation*); affections F1–2

136

Ascanio. You have double arm'd me.

<div align="right">*Strange Musick within, Hoboys.*</div>

<div align="right">Hark, what noyse is this?</div>
What horrid noyse is the Sea pleas'd to sing, 80
A hideous Dirg to our deliverance?
Virolet. Stand fast now.

<div align="right">*Within strange cries, horrid noyse, Trumpets.*</div>

Ascanio. I am fixt.
Virolet. We feare ye not.

<div align="center">*Enter* Martia.</div>

Let death appear in all shapes, we smile on him.
Ascanio. The Lady now.
Virolet. The face oth' Maske is alter'd.
Ascanio. What will she doe?
Virolet. Do what she can, I care not.
Ascanio. She looks on you sir.
Virolet. Rather she looks through me,
But yet she stirs me not.
Martia. Poore wretched slaves,
Why do you live? or if ye hope for mercy,
Why do not you houle out, and fill the hold
With lamentations, cries, and base submissions, 90
Worthy our scorn?
Virolet. Madam, you are mistaken;
We are no slaves to you, but to blind fortune;
And if she had her eyes, and durst be certain,
Certain our friend, I would not bow unto her;
I would not cry, nor aske so base a mercy:
If you see any thing, in our appearance,
Worthy your sexes softnes and your own glory,
Do it for that; and let that good reward it:
We cannot beg.
Martia. Ile make you beg, and bow too.

<div align="center">137</div>

Virolet. Madam for what?

Martia. For life; and when you hope it, 100
Then will I laugh and triumph on your basenesse.

Ascanio. Madam tis true, there may be such a favour,
And we may aske it too; aske it with honour;
And thanke you for that favour, nobly thank you,
Tho it be death; but when we beg a base life,
And beg it of your scorn——

Virolet. Y'are couzened woman,
Your handsomnesse may do much, but not this way;
But for your glorious hate——

Martia. Are ye so stubborn?
Death, I will make you bow.

Virolet. It must be in your bed then;
There you may worke me to humility. 110

Martia. Why, I can kill thee.

Virolet. If you do it handsomely;
It may be I can thank you, else——

Martia. So glorious?

Ascanio. Her cruelty now workes.

Martia. Yet woot thou?

Virolet. No.

Martia. Wilt thou for life sake?

Virolet. No, I know your subtilty.

Martia. For honour sake?

Virolet. I will not be a Pageant,
My mind was ever firm, and so Ile lose it.

Martia. Ile starve thee to it.

Virolet. Ile starve my selfe, and crosse it.

Martia. Ile lay thee on such miseries——

Virolet. Ile weare 'em,
And with that wantonnesse, you do your Bracelets.

Martia. Ile be a moneth a killing thee.

Virolet. Poore Lady, 120
Ile be a moneth a dying then: what's that?
There's many a Callenture outdoes your cruelty.

Martia [*aside*]. How might I do, in killing of his body,
To save his Noble mind?——Who waites there?

Enter a Saylor *with a rich Cap and Mantle.*

Saylor. Maddam.
Martia. Unbolt this man, and leave those things behind you,
 And so away.

 Exit Sailor [*after unbolting* Virolet's *chains*].

 Now put 'em on.
Virolet. To what end?
Martia. To my end, to my will.
Virolet. I will.

 [*Puts on the cap and mantle.*]

Martia. I thank you.
Virolet. Nay, now you thank me, Ile do more. Ile tell ye,
 I am a servant to your curtesie,
 And so far will be wooed: but if this triumph 130
 Be onely aym'd, to make your mischiefe glorious;
 Lady, y'ave put a richer shroud upon me,
 Which my strong mind shall suffer in.
Martia. Come hither,
 And all thy bravery put into thy carriage,
 For I admire thee.
Virolet. Whither will this woman?
Ascanio. Take heed my friend.
Martia. Look as thou scorndst my cruelty:
 I know thou doest.
Virolet. I never fear'd, nor flatter'd.
Martia. No if thou hadst, thou hadst died, and I had gloried.
 I suffer now, and thou which art my prisoner,
 Hast Nobly won the free power to despise me. 140
 I love thee, and admire thee for thy Noblenesse;
 And for thy manly sufferance, am thy servant.
Virolet. Good Lady, mock me not.
Martia. By Heaven I love thee;
 And by the soule of love, am one piece with thee.
 Thy mind, thy mind; thy brave, thy manly mind:

 *126 Now put 'em on.] *stet* F1-2

 139

That like a Rock stands all the storms of fortune,
And beats 'em roaring back they cannot reach thee:
That lovely mind I dote on, not the body;
That mind has rob'd me of my liberty:
That mind has darken'd all my bravery, 150
And into poor despis'd things, turn'd my angers.
Receive me to your love sir, and instruct me;
Receive me to your bed, and marry me:
Ile wait upon you, blesse the houre I knew you.
Virolet. Is this a new way?
Martia. If you doubt my faith,
First take your liberty; Ile make it perfect,
Or any thing within my power.
Virolet. I love you;
But how to recompence your love with marriage?
Alas, I have a wife.
Martia. Dearer then I am?
That will adventure so much for your safety? 160
Forget her fathers wrongs, quit her own honour,
Pull on her for a strangers sake, all curses?
Virolet. Shall this Prince have his freedom too?
Else all I love is gone, all my friends perish.
Martia. He shall.
Virolet. What shall I do?
Martia. If thou despise my curtesie,
When I am dead, for griefe I am forsaken,
And no soft hand left to asswage your sorrows;
Too late, but too true, curse your own cruelties.
Ascanio. Be wise; if she be true, no thred is left else,
To guide us from this laborinth of mischiefe; 170
Nor no way for our friends.
Virolet. Thus then, I take you:
I bind ye to my life, my love.
Martia. I take you,
And with the like bond tye my heart your servant;
W'are now almost at Harbour, within this houre,
In the dead watch, Ile have the long boat ready;
And when I give the word, be sure you enter,

Ile see ye furnisht both immediately,
And like your selfe; some trusty man shall wait you,
The watch Ile make mine own; onely my love
Requires a stronger vow, which Ile administer 180
Before we go.
Virolet. Ile take it to confirm you.
Martia. Go in, there are the Keys, unlock his fetters,
And arme ye Nobly both; Ile be with you presently,
And so this loving kisse.
Ascanio. Be constant Lady.

 Exeunt omnes.

Enter the Duke of Sesse *by Torchlight,* Master *and* Surgeon, *with* [II.v]
 him.

Surgeon. You grow so angry sir, your wound goes backward.
Sesse. I am angry at the time, at none of you,
That sends but one poor subject for revenge;
I would have all the Court, and all the villany
Was ever practiz'd under that foule *Ferrand,*
Tyrant and all, to quench my wrath.
Master. Be patient,
Your grace may find occasion every houre,
For certaine they will seeke you, to satisfy,
And to the full, your anger.
Sesse. Death, they dare not:
They know that I command death, feed his hunger, 10
And when I let him loose——
Surgeon. You'l never heale sir,
If these extreames dwell in you, you are old,
And burn your spirits out with this wild anger.
Sesse. Thou liest, I am not old, I am as lusty
And full of manly heat as them, or thou art.
Master. No more of that.
Sesse. And dare seek out a danger;
And hold him at the swords point, when thou tremblest
And creepest into thy box of salves to save thee.
O Master, I have had a dreadfull dream to night!

 4–6 I would ... wrath.] Stet F1–2 13 anger] F2; angers F1

 141

Me-thought the ship was all on fire, and my lov'd Daughter, 20
To save her life, leapt into th'Sea; where suddainly
A stranger snatch'd her up, and swom away with her.
Master. 'Twas but the heate o'th fight sir.
Boteswain (within). Look out, what's that?
Sailor (within). The long bote as I live.
Boteswain [within]. Ho, there, ith long Bote.
Sailor [within]. She claps on all her Oares.———Hoy!
Sesse. What noise is that?
Master. I hear sir———

 Exit Master.

Boteswain [within]. The devill or his dam; haile her agen boyes.
Sailor [within]. The long boate, ho, the long boate.
Sesse. Why, the long boate? 30
Where is the long Boate?

 Enter Boteswain.

Boteswain. She is stolne off.
Sesse. Who stole her?
O my prophetique soule!

 Enter Master.

Master. Your daughter's gone sir;
The prisoners, and six Saylors, rogues.
Sesse. Mischief, six thousand plagues sale with 'em;
They'r in her yet, make out.
Master. We have ne'r a Boate.

 Enter Gunner.

Sesse. Weigh Anchors and away.
Boteswain. We ha' no winde sir,
They'l beate us with their Oares.
Sesse. Then sinke 'em Gunner,
O sink 'em, sink 'em, sink 'em, claw 'em Gunner;
As ever thou hast lov'd me.

 *23–41 'Twas but ... Who knew of this?] *stet* F1–2
 31 *Enter* Boteswain.] F1(u); *omit* F1(c), F2

Gunner. I'le do reason,
But i'le be hangd before I hurt the Lady. 40

 Exit Gunner.

Sesse. Who knew of this?
 Trumpets, a peece or two go off.
Master. We stand all clear.
Sesse. What divel
Put this base trick into her tayle? my daughter,
And run away with rogues! I hope she's sunk,

 A peece or two [*go off*].

Or torne to pieces with the shot; rots find her,
The leprosy of whore, stick ever to her,
O she has ruind my revenge.

 Enter Gunner.

Gunner. She is gone sir,
I cannot reach her with my shot.
Sesse. Rise winds,
Blow till ye burst the aire, and swell the Seas,
That they may sink the starres, O dance her, dance her;
Shes impudently wanton, dance her, dance her, 50
Mount her upon your surges, coole her, coole her;
She runs hot like a whore, coole her, coole her;
O now a shot to sink her; come, cut Cables;
I will away, and where she sets her foote
Although it be in *Ferrants* court, ile follow her,
And such a fathers vengeance shall she suffer——
Dare any man stand by me?
Master. All, all.
Boteswain. All sir.
Gunner. And the same cup you taste——
Sesse. Cut Cables then;

41 *Trumpets,*] *Trump.* F1–2 41 divel] F1(c), F2; divels F1(u)
45 ever] F1(c), F2; over F1(u)
47–48 Rise winds, . . . aire, and] F2; Rise winds, blow till you burst the aire, │ Blow till ye burst
 the aire, and F1 48 aire,] F1(c), F2; aire sir, F1(u)

For I shall never sleep, nor know what peace is,
Till I have pluckt her heart out.

All (within). O maine there. 60

> *Exeunt.*

Florish cornets. Enter Ferrant, Ronvere, Castruchio, Villio, *and* [III.i]
> [*two*] Guard.

Ronvere. You are too gentle sir.
Ferrand. You are too carelesse:
 The creatures I have made, no way regard me:
 Why should I give you names, titles of honour,
 Rob families, to fill your private houses
 For your advancement, draw all curses on me,
 Wake tedious winter nights, to make them happy
 That for me break no slumber?
Ronvere. What we can,
 We dare doe.
Ferrand. Why is your Soveraignes life then
 (In which you live, and in whose fall your honours,
 Your wealth, your pomp, your pride and all must suffer) 10
 No better guarded? O my cruell Stars,
 That marke me out a King, raising me on
 This pinnacle of greatnesse, only to be
 The neerer blasting!
Villio [*aside*]. What think you now *Castruchio?*
 Is not this a merry life?
Castruchio. Still thou art couzend;
 It is a glorious royall discontentment;
 How bravely it becomes him!
Ferrand. To be made
 The common butt, for every slave to shoot at;
 No peace, no rest I take, but their alarams
 Beat at my heart: why do I live, or seek then, 20
 To adde a day more to these glorious troubles?
 Or to what end when all I can arrive at,
 Is but the summing up of feares and sorrowes,
 What power has my command, when from my bosom
 Ascanio my most dear, and lov'd *Ascanio,*

Was snatch'd, spite of my wil, spite of my succor,
And by mine own proud slave reteind most miserable?
And still that villain lives to nip my pleasures,
It being not within my power to reach him.
Ronvere. Time may restore all this; and would you hear 30
Whose counsell never faild you.
Ferrand. Tell me no more,
I faint beneath the burthen of my cares,
And yeild my selfe most wretched.
Ronvere. On my Knees
I beg it mighty sir, vouchsafe me hearing.
Ferrand. Speak, speak, and I thus low, such is my fortune,
Will hear what thou canst say.
Villio [*aside*]. Look but on this,
Has not a man that has but means to keep
A Hawk, a Grayhound, and a hunting Nag,
More pleasure then this King?
Castruchio. A dull foole still,
Make me a King, and let me scratch with care, 40
And see who'l have the better; give me rule,
Command, obedience, pleasure of a King,
And let the devil rore; The greatest corrosive
A King can have, is of more pretious tickling,
And handled to the height more dear delight,
Then other mens whole lives, let 'em be safe too.
Villio. Think of the mutinous people.
Castruchio. Hang the people,
Give me the pleasure, let me do all, awe all,
Enjoy their wives and states at my discretion,
And peg 'em when I please, let the slaves mumble. 50
Villio. But say they should be vex'd, and rise against thee?
Castruchio. Let 'em rise, let 'em rise: give me the bridle here,
And see if they can crack my girths: ah *Villio*,
Under the Sun, ther's nothing so voluptuous
As riding of this monster, till he founder.
Ferrand. Who's that so loud?

28 villain] F2; villains F1(c); villians F1(u) 34 mighty] F2; might F1
56 loud] F2; low F1

145

Castruchio. I am dumb: is not this rare?
Kings looks make *Pythagoreans*; is not this
A happinesse *Villio?*
Villio. Yes, [*aside*] to put to silence
A fawning sycophant.
Ferrand [*to* Ronvere]. Thou speak'st truth in all,
And mercy is a vice, when there needs rigour, 60
Which I with all severity will practise;
And since as subjects they pay not obedience,
They shall be forc'd as slaves: I wil remove
Their meanes to hurt, and with the means, my fears:
Goe you the fatall executioners
Of my commands, and in our name proclame,
That from this houre I do forbid all meetings,
All private conferences in the City:
To feast a neighbour shall be death; to talke,
As they meete in the streetes, to hold discourse, 70
By writing, nay by signes; see this perform'd,
And I wil call your cruelty, to those
That dare repine at this, to me true service.
1. Guard [*aside to* 2. Guard]. This makes for us.
2. Guard [*aside to* 1. Guard]. I now we have imployments,
If we grow not rich 'twere fit we should be beggers.

 Exit Guard.

Ferrand. Ronvere.
Ronvere. My Lord.
Castruchio [*aside to* Villio]. Thou enemy to Majesty,
What think'st thou of a King now?
Villio. As of a man
That hath power to doe ill.
Castruchio. Of a thing rather
That does divide an Empire with the Gods;
Observe but with how little breath he shakes 80
A populous City, which would stand unmov'd
Against a whirlewind.
Villio. Then you make him more

Then him that rules the winds.

Castruchio. For me I doe professe it,
 Were I offerd to be any thing on Earth,
 I would be mighty *Ferrant.*

Ferrand. Ha? who names me?
 Deliver thy thoughts slave, thy thoughts, and truly,
 Or be no more.

Castruchio. They rather will deserve
 Your favour then your fury; I admire,
 (As who does not, that is a loyall subject?)
 Your wisdom, power, your perfect happinesse, 90
 The most blest of mankind.

Ferrand. Didst thou but feele
 The weighty sorrowes, that sit on a Crown,
 Tho thou shouldst find one in the streets *Castruchio,*
 Thou wouldst not think it worth the taking up;
 But since thou art enamour'd of my fortune,
 Thou shalt ere long taste of it.

Castruchio. But one day,
 And then let me expire.

Ferrand. Goe to my wardrop,
 And of the richest things I wear, cull out,
 What thou thinkst fit: do you attend him sirra.

Villio. I warrant you, I shall be at his elbow, 100
 The foole wil never leave him.

Castruchio. Made for ever.

 Exeunt Castruchio, Villio.
 A shout within.

Ferrand. What shout is that? draw up our Guards.

Ronvere. Those rather
 Speake joy then danger.

 Enter Virolet, Ascanio, *and a Servant.*

Virolet [*to the Servant*]. Bring her to my house,
 I would not have her seen here.

 102 our] F2; *omit* F1
 103 s.p. *Virolet*] Sympson (Seward's *emendation*); *omit* F1–2

Ferrand. My *Ascanio*!
　The most desir'd of all men, let me die
　In these embraces; how wert thou redeem'd?
Ascanio. Sir, this is my preserver.
Ferrand. At more leasure,
　I will inquire the manner, and the meanes,
　I cannot spare so much time now from my
　More strickt embraces: *Virolet*, welcome too, 110
　This service weighes down your entended treason;
　You long have bin mine enemy, learn now
　To be my friend and loyall, I aske no more,
　And live as free as *Ferrant*; let him have
　The forty thousand crowns I gladly promis'd,
　For my *Ascanios* freedom, and deliver
　His Father, and his wife to him in safety.
　Something hath passed which I am sorry for,
　But 'twill not now be help'd; come my *Ascanio*,
　And reap the harvest of my winter travels. 120
　My best *Ascanio*, my most lov'd *Ascanio*.

　　　　　　　Florish Cornets. Exeunt Ferrand, Ascanio.

Virolet. My Lord, all former passages forgot,
　I am become a suitor.
Ronvere. To me *Virolet*?
Virolet. To you, yet will not beg the courtesie,
　But largely pay you for it.
Ronvere. To the purpose.
Virolet. The forty thousand crownes the King hath given me,
　I will bestow on you, if by your meanes
　I may have liberty for a divorce
　Between me and my wife.
Ronvere. Your *Juliana*?
　That for you hath indur'd so much, so nobly? 130
Virolet. The more my sorrow; but it must be so.
Ronvere. I will not hinder it: [*aside*] without a bribe,
　For mine own ends, I would have further'd this.——
　I will use all my power.

　　　　105 all men] F2; all the men F1

148

Virolet. 'Tis all I aske:
[*Aside*] Oh my curs'd fate, that ever man should hate
Himselfe for being belov'd, or be compeld
To cast away a Jewell, Kings would buy,
Tho with the losse of Crown and Monarchy!

 Exeunt.

 Enter Sesse, Master, Boatswaine, Gunner [*disguised*]. [III.ii]

Sesse. How do I look?
Master. You are so strangely alterd,
We scarce can know you, so young againe, and utterly
From that you were, figure, or any favour;
Your friends cannot discern you.
Sesse. I have none,
None but my faire revenge, and let that know me!
You are finely alterd too.
Boteswain. To please your humour,
But we may passe without disguise, our living
Was never in their element.
Gunner. This Jew sure,
That alter'd you, is a mad knave.
Sesse. O! a most excellent fellow.
Gunner. How he has mew'd your head, has rub'd the snow off, 10
And run your beard into a peak of twenty!
Boteswain. Stopt all the crannies in your face.
Master. Most rarely.
Boteswain. And now you look as plump, your eyes as sparkling,
As if you were to leap into a Ladies saddle.
Has he not set your nose awry?
Sesse. The better.
Boteswain. I think it be the better, but tis awry sure;
North and by East. I ther's the point it stands in;
Now halfe a point to th'Southward.
Sesse. I could laugh,
But that my businesse requires no mirth now;
Thou art a merry fellow.
Boteswain. I would the Jew sir, 20

9 mad] F2; made F1

149

Could steer my head right, for I have such a swimming in't,
Ever since I went to Sea first.

Master. Take wine and purg it.

Boteswain. I have had a thousand pils of Sack, a thousand;
A thousand pottle pils.

Gunner. Take more.

Boteswain. Good Doctor,
Your patient is easily perswaded.

Master. The next faire open weather me thinks this Jew,
If he were truly known to founder'd Courtiers,
And decaied Ladies, that have lost their fleeces
On every bush, he might pick a pretty living.

Boteswain. The best of all our gallants would be glad of him; 30
For if you marke their marches, they are tender,
Soft, soft, and tender; then but observe their bodies,
And you shall find 'em cemented by a Surgeon,
Or some Physitian for a year or two,
And then toth'tub again, for a new pickle.
This Jew might live a Gentile here.

Enter 2. Citizens at both dores, saluting afar off.

Sesse. What are these?
Stand close and marke.

Boteswain. These are no men, th'are motions.

Sesse. What sad and ruthfull faces!

Boteswain. How they duck!
This sencelesse, silent courtesie me thinks,
Shewes like two *Turkes*, saluting one another, 40
Upon two French porters backs.

Sesse. They are my Countrymen,
And this, some forc'd infliction from the tyrant;——
What are you? why is this? why move thus silent
As if you were wandring shadowes? why so sad?
Your tongues seald up; are yee of severall Countries?
You understand not one another?

24–25 Good . . . perswaded.] *In the margin to the right of these words,* F1 *prints s.d.* 'En. Citizens,
| *severally.', anticipating the direction at line 36, below. This marginal s.d. is omitted in* F2.
30 would] Dyce; now F1; should F2

Gunner. That's an English man,
　He lookes as though he had lost his dog.
Sesse. Your habits
　Shew ye all Neapolitanes, and your faces
　Deliver you oppressed things; speak boldly:
　Do you groan, and labor under this stiffe yoak? 50
Master. They shake their heads and weep.
Sesse. O misery!
　Give plenteous sorrow, and no tongues to shew 'em!
　This is a studied cruelty.
1. Citizen. Be gon sir,
　It seemes you are a stranger, and save your selfe.
2. Citizen. You wonder here at us, as much we wonder
　To hear you speak so openly, and boldly,
　The Kings command being publisht to the contrary;
　Tis death here, above two, to talk together;
　And that must be but common salutation neither,
　Short and so part.
Boteswain. How should a man buy mustard, 60
　If he be forc'd to stay the making of it?
1. Guard (*within*). Cleare all the streetes before the King.
1. Citizen. Get off Sir,
　And shift as we must do.

　　　　　　　　　　　　　　　Exeunt Citizens.

Sesse. I'le see his glory.
Master. Stand fast now and like men.

Flourish cornets. Enter Castruchio *like the King, in the midst of a* Gard.
　　　　　　　　　　　　　　Villio.

Castruchio. Begin the game sir,
　And pluck me down, the Row of houses there.
　They hide the view oth' hill; and sink those merchants,
　Their ships are foule and stinke.
Master. This is a sweete youth.
Castruchio. All that are taken in assemblies,

　　　　54 save] F2; *omit* F1 62 *1. Guard* (*within*).] *Within* 1. F1–2
　　　　64 *cornets*] Dyce; *colours* F1–2

　　　　　　　　　　　　151

Their houses and their wives, their wealthes are forfeit,
Their lives at your devotion. Villaines, Knaves, 70
I'le make you bow and shake, i'le make you kneele Rogues.
How brave tis to be a King?

Gunner. Here's fine tumbling.

Castruchio. No man shall sit i'th' temple neer another.

Boteswain. Nor lie with his own wife.

Castruchio. All upon paine
Of present death, forget to write.

Boteswain. That's excellent,
Carriers and foot-Posts, wil be arrant Rebels.

Castruchio. No Character, or stamp that may deliver
This mans intention, to that man i'th' Country.

Gunner. Nay, an you cut off, after my hearty commendations
Your friend and *Oliver.* No more.

Castruchio. No man smile, 80
And wear a face of mirth; that fellowes cunning,
And hides a double heart, he's your prize, smoke him.

Enter Virolet, Ronvere, Ascanio, *and* Martia, *Passing over.*

Sesse. What base abuse is this? Ha? tis her face sure,
My prisoners with her too? by heaven vild whore
Now is my time.

Master. Do what you will.

Sesse. Stay hold yet,
My Country shall be serv'd first, let her go,
Wee'l have an hour for her to make her tremble.
Now shew yourselves, and blesse you with your valors.

Virolet *and they* [Ronvere, Ascanio, Martia] *off againe.*

1. Guard. Here's a whole plump of Rogues.

Sesse. Now for your Country.

Castruchio. Away with 'em and hang 'em; no, no mercy, 90
I say no mercy.

Sesse. Be it so upon 'em.

[*They assault* Castruchio, Villio, *and* Guard.]

*80 Your friend and *Oliver.*] stet F1–2 81 cunning] F2; comming F1
84 vild] Sympson *(conj.)*; wild F1–2 89, 92 *1. Guard.*] *Guard.* F1–2

1. Guard. Treason, treason, treason.
Boteswain. Cut the slaves to giggets.
Gunner. Down with the bul-beefes.
Sesse. Hold, hold, I command you! Gods, look here.
Castruchio. A miserable thing. I am no King sir.
Sesse. Sirra, your fooles face has preserv'd your life.
 Wear no more Kings coates, you have scap'd a scouring.
Boteswain. I'st not the King?
Sesse, No, tis a prating Rascall,
 The puppy makes him mirth.
Castruchio. Yes sir, I am
 A puppy.
Boteswain. I beseech you let me hang him, 100
 I'le do't in my belt straight.
Castruchio. As you are honorable,
 It is enough you may hang me.
Gunner. I'le hang a squib at's taile
 That shall blow both his buttocks, like a petar.
Castruchio. Do any thing. But do not kill me Gentlemen.
Boteswain. Let flea him, and have him flye blowen.

Enter Citizens.

1. Citizen. Away, and save your lives.
 The King himselfe is comming on; if you stay,
 You are lost for ever; let not so much noblenesse
 Willfully perish.
Sesse. How neer?
2. Citizen. He's here behind you.
Sesse. We thank you.——Vanish! 110

Exeunt Sesse, Boatswain, [Master, Gunner], *Saylers,* Citizens.
Florish Cornets. Enter Ferand, Ronvere.

Ferrand. Double the Guards and take in men that dare,
 These slaves are frighted; where are the proud Rebels,
 To what protection fled, what villain leads 'em?
 Under our nose disturb our rest?

94 you! Gods, look] Colman; you ∧——look F1; you,——look F2
105.1 Citizens] Dyce; *Citizen* F1–2 *(on line 104)* 106 *1. Citizen.*] Dyce; *Cit.* F1–2
*110 We thank you.——Vanish!] Dyce; ~ ~ you. ∧ *vanish.* F1–2

Ronvere. We shall heare,
　For such a search I have sent, to hunt the Traytors.
Ferrand. Yet better men I say, we stand too open:
　How now *Castruchio*? how do you like our glory?
Castruchio. I must confesse, 'twas somewhat more then my match
　　Sir;
　This open glory agrees not with my body,
　But if it were ith' Castle, or some strength, 120
　Where I might have my swing——
Villio. You have been swing'd brother;
　How these delights have tickled you? you itch yet;
　Will you walke out again in pomp?
Castruchio. Good Foole——
Villio. These rogues must be rebuked, they are too sawcy,
　These premptory Knaves. Will you walk out Sir,
　And take the remnant of your Coronation?
　The people stay to see it.
Ferrand. Do not vex him;
　Ha's griefe enough in's bones; you shall to th' Citadell,
　And like my selfe command, there use your pleasure,
　But take heed to your person.
Villio. The more danger; 130
　Still the more honour Brother.
Castruchio. If I reign not then,
　And like a King, and thou shalt know it fool,
　And thou shalt feel it foole.
Villio. Fooles still are freemen,
　I'le sue for a protection, till thy reigne's out.
Ferrand. The people have abus'd the liberty
　I late allowed, I now proclaime it straighter,
　No men shall walk together, nor salute;
　For they that doe shall dye.
Ronvere. You hit the right Sir;
　That liberty cut off, you are free from practise.
Ferrand. Renew my guards.
Ronvere. I shall.
Ferrand. And keep strict watches; 140
　One houre of joy I aske.

Ronvere. You shall have many.

 Exeunt. Florish Cornets.

[*Enter*] Pandulfo, *and* Juliana, *led by two of the* Guard, *as not yet* [III.iii]
 fully recover'd.

1. Guard. You are now at liberty, in your own house Lady,
 And here our charge takes end.
Pandulfo. 'Tis now a Custome.
 We must even wooe those men deserve worst of us,
 And so we thanke your labours; there's to drinke,

 [*Gives money*]

 For that, and mischiefe are your occupations;
 And to meane well to no man, your Chief'st harvests.
2. Guard. You give liberally; we hope Sir, er't be long,
 To be ofter acquainted with your bounty,
 And so we leave you.
Pandulfo. Doe, for I dote not on ye.
Juliana. But where's my Husband? what should I do here? 10
 Or what share have I in this joy, cal'd liberty,
 Without his company? Why did you flatter me,
 And tell me he was return'd, his service honour'd?
1. Guard. He is so, and stands high in the Kings favour,
 His friends redeemd, and his own liberty,
 From which yours is deriv'd, confirm'd; his service,
 To his own wish rewarded: so fare-well Lady.

 Exeunt Guard.

Pandulfo. Go persecute the good, and hunt ye hell-hounds,
 Ye Leeches of the time, suck till ye burst slaves;
 How does my girle?
Juliana. Weake yet, but full of comfort. 20
Pandulfo. Sit down, and take some rest.
Juliana. My heart's whole Father;
 That joyes, and leaps, to heare my *Virolet*,
 My Deer, my life, has conquer'd his afflictions.
Pandulfo. Those rude hands, and that bloody will that did this.

 6 your] F2; you F1

 155

That durst upon thy tender body Print
These Characters of cruelty; heare me heaven.
Juliana. O Sir be sparing.
Pandulfo. I'le speake it, tho I burst;
And tho the ayre had eares, and serv'd the Tyrant,
Out it should goe: O heare me thou great Justice;
The miseries, that waite upon their mischiefs, 30
Let them be numberlesse, and no eye pitty
Them when their soules are loaden, and in labour,
And wounded through, and through, with guilt and horror,
As mine is now with griefe; let men laugh at 'em
Then, when their monstrous sins, like earth-quaks, shake 'em;
And those eyes, that forgot heaven would look upward,
The bloody 'larms, of the conscience beating,
Let mercy flye, and day strook into darknesse,
Leave their blind soules, to hunt our their own horrors.
Juliana. Enough, enough, we must forget deare Father; 40
For then we are glorious formes of heaven; and live,
When we can suffer, and as soon forgive.
But where's my Lord? me thinkes I have seen this house,
And have been in't before.
Pandulfo. Thine own house jewell.
Juliana. Mine, without him? or his, without my company?
I thinke it cannot be; it was not wont Father.
Pandulfo. Some businesse with the King (let it be good, heaven)
Reteines him sure.
Juliana. It must be good and noble,
For all men that he treats with taste of vertue;
His words and actions are his own; and Honour's 50
Not bought, nor compel'd from him.

Enter Lucio

Pandulfo. Here's the Boy.
He can confirme us more, how sad the child looks?
Come hither *Lucio*; how, and where's thy Master?
Juliana. Speak gentle Boy.
Pandulfo. Is he return'd in safety?

51, 75.1, 90.1 Lucio] *Boy* F1–2

156

Juliana. If not, and that thou knowest us miserable,
 Our hopes and happinesse declin'd for ever;
 Study a sorrow, excellent as thy Master,
 Then if thou canst live, leave us.
Lucio. Noble Madam,
 My Lord is safe return'd, safe to his friends, and fortune,
 Safe to his Country, entertain'd with honour, 60
 Is here within the house.
Juliana. Doe not mock me.
Lucio. But such a melancholy hangs on his mind,
 And in his eyes inhabit such sad shadowes;
 But what the cause is——
Pandulfo. Goe tell him we are here Boy,
 There must be no cause now.
Juliana. Hast thou forgot me?
Lucio. No, noblest Lady.
Juliana. Tell him I am here,
 Tell him his wife is here, sound my name to him,
 And thou shalt see him start; speake *Juliana*,
 And like the Sunne that labors through a tempest,
 How suddainly he will disperse his sadnesse! 70
Pandulfo. Goe I command thee instantly,
 And charge him on his duty——
Juliana. On his Love Boy:
 I would faine goe to him.
Pandulfo. Away, away, you are foolish.
Juliana. Beare all my service sweet Boy——
Pandulfo. Art thou here still?
Juliana. And tell him what thou wilt that shall become thee.

 Exit Lucio

Pandulfo. Ith' house; and know we are here?
Juliana. No, no, he did not;
 I warrant you he did not: could you think
 His Love had lesse then wings, had he but seen me;
 His strong affection any thing but fire
 Consuming all weak lets, and rubs before it, 80
 Till he had met my flame, and made one body?

55 us] Dyce *(Heath conj.)*; is F1–2

If ever heavens high blessings met in one man,
And there erected to their holy uses
A sacred mind, fit for their services,
Built all of polisht honour, 'twas in this man:
Misdoubt him not.
Pandulfo. I know he's truly noble;
But why this sadnesse, when the generall cause
Requires a Jubile of joy?
Juliana. I know not.
Pandulfo. Pray heaven you find it not.
Juliana. I hope I shall not:
O here he comes, and with him all my happinesse; 90

Enter Virolet, *and* Lucio.

He staies and thinks, we may be too unmannerly;
Pray give him leave.
Pandulfo. I doe not like this sadnesse.

They stand off.

Virolet [*aside*]. O hard condition of my misery!
Unheard of plagues! when to behold that woman,
That chaste and vertuous woman, that preserv'd me,
That pious wife, wedded to my afflictions,
Must be more terrible then all my dangers.
O fortune, thou hast rob'd me of my making,
The noble building of a man, demolisht,
And flung me headlong, on a sin so base 100
Man and mankind contemn; even beasts abhor it,
A sin more dull then drinke, a shame beyond it;
So foule, and farre from faith; I dare not name it,
But it will cry it self out, loud ingratitude.——
Your blessing Sir.
Pandulfo. You have it in abundance;
So is our joy, to see you safe.
Virolet. My Deere one.
Juliana [*aside*]. H'as not forgot me yet:——O take me to you Sir.
Virolet [*aside*]. Must this be added to increase my misery,
That she must weep for joy, and loose that goodnesse?——

98 me] F2; men F1

158

My *Juliana*, even the best of women, 110
Of wives the perfectest, let me speak this,
And with a modesty declare thy vertues,
Chaster then Christall, on the Scythian Clifts
The more the proud winds Court, the more the purer.
Sweeter in thy obedience, then a sacrifice;
And in thy mind a Saint, that even yet living,
Producest miracles, and women daily
With crooked and lame soules creep to thy goodnesse,
Which having toucht at, they become examples.
The fortitude of all their sex, is Fable 120
Compar'd to thine; and they that fill'd up glory,
And admiration, in the age behind us,
Out of their celebrated urns, are started,
To stare upon the greatnesse of thy spirit;
Wondring what new Martyr heaven has begot,
To fill the times with truth, and ease their stories:
Being all these, and excellent in beauty,
(For noble things dwell in the noblest buildings)
Thou hast undone thy husband, made him wretch'ed,
A miserable man, my *Juliana*, 130
Thou hast made thy *Virolet*.
Juliana. Now goodnesse keep me;
Oh! my dear Lord.
Pandulfo. She wrong you? what's the meaning?
Weep not, but speake, I charge you on obedience;
Your Father charges you; she make you miserable?
That you your self confesse.
Virolet. I doe, that kils me;
And far lesse I have spoke her, then her merit.
Juliana. It is some sinne of weaknesse, or of Ignorance?
For sure my Will——
Virolet. No, 'tis a sinne of excellence:
Forgive me heaven, that I prophane thy blessings:
Sit still; I'le shew you all.

 Exit Virolet [*and* Lucio].

Pandulfo. What meanes this madnesse? 140

118 lame] F2; tame F1

159

For sure there is no taste of right man in it;
Greives he our liberty, our preservation?
Or has the greatnesse of the deed he has done,
Made him forget, for whom, and how he did it,
And looking down upon us, scorne the benefit?
Well *Virolet* if thou beest proud, or treacherous——

Juliana. He cannot Sir, he cannot; he will shew us,
And with that reason ground his words——

Pandulfo. He comes.

Enter Virolet, Martia, Ronver [*and a* Lawyer].

What Masque is this? what admirable beauty?
Pray heaven his heart be true.

Juliana. A goodly woman. 150

Virolet. Tell me my Dear; and tell me without flattery,
As you are nobly honest, speak the truth;
What thinke you of this Lady?

Juliana. She is most excellent.

Virolet. Might not this beauty, tell me, (it's a sweet one),
Without more setting off, as now it is,
Thanking no greater Mistresse then meer nature,
Stagger a constant heart?

Pandulfo. She is full of wonder;
But yet; yet *Virolet*——

Virolet. Pray; by your leave Sir——

Juliana. She would amaze——

Virolet. O! would she so? I thanke you;
Say, to this beauty, she have all additions, 160
Wealth, noble birth——

Pandulfo. O hold there.

Virolet. All vertues,
A mind, as full of Candor as the truth is,
I, and a loving Lady.

Juliana. She must needs
(I am bound in conscience to confesse) deserve much.

Virolet. Nay, say beyond all these, she be so pious,
That even on slaves condemn'd she showre her benefits,

154 me, (it's a sweet one),] Colman; me that its a sweet one, F1; me it's a sweet one, F2

And melt their stubborn Bolts with her soft pitty,
 What thinke you then?
Pandulfo. For such a noble office,
 At these yeares, I should dote my self; take heed Boy.
Juliana. If you be he, that have received these blessings, 170
 And this the Lady: love her, honour her;
 You cannot doe too much, to shew your gratitude,
 Your greatest service will shew off too slender.
Virolet. This is the Lady; Lady of that bounty,
 That wealth, that noble name, that all I spoke of:
 The Prince *Ascanio* and my selfe, the slaves
 Redeem'd, brought home, still guarded by her goodnes,
 And of our liberties you taste the sweetnes;
 Even you she has preserv'd too, lengthen'd your lives.
Juliana. And what reward doe you purpose? it must be a maine one; 180
 If love will do it we'll all, so love her, serve her——
Virolet. It must be my love.
Juliana. Ha!
Virolet. Mine, my onely love,
 My everlasting love.
Pandulfo. How?
Virolet. Pray have patience.
 The recompence she ask'd, and I have render'd,
 Was to become her husband: then I vowed it,
 And since I have made it good.
Pandulfo. Thou durst not.
Virolet. Done Sir.
Juliana. Be what you please, this happinesse yet stayes with me,
 You have been mine; Oh my unhappy fortune.
Pandulfo. Nay, break and dye.
Juliana. It cannot yet: I must live,
 Till I see this man, blest in his new love, 190
 And then——
Pandulfo. What hast thou done? thou base one tell me,
 Thou barren thing of honesty, and honour;
 What hast thou wrought? Is not this she, looke on her,
 Look on her, with the eyes of gratitude,

187 this] Sympson *(Seward's emendation)*; his F1–2

And whipe thy false teares off; Is not this she,
That three times on the Rack, to guard thy safety,
When thou stood'st lost, and naked to the Tyrant;
Thy aged Father here, that shames to know thee,
Ingag'd ith' jawes of danger; was not this she,
That then gave up her body to the torture? 200
That tender body, that the wind sings through;
And three times, when her sinewes, crack'd and torter'd,
The beauties of her body turn'd to ruines,
Even then, within her patient heart, she lock'd thee;
Then hid thee from the Tyrant; then preserv'd thee;
And canst thou be that slave——

Martia. This was but duty;
 She did it for her Husband, and she ought it;
 She has had the pleasure of him, many an houre;
 And if one minutes paine cannot be suffer'd——
 Mine was above all these, a nobler venter, 210
 I speake it boldly, for I lost a Father,
 She has one still; I left my friends, she has many;
 Expos'd my life, and honour to a cruelty,
 That if it had seiz'd on me, racks and tortures,
 Alas, they are Triumphs to it: and had it hit,
 For this mans love, it should have shewed a triumph,
 Twise lost, I freed him; *Rossana* lost before him,
 His fortunes with him; and his friends behind him:
 Twise was I rack'd my selfe for his deliverance,
 In honour first and name, which was a torture 220
 The Hang-man never heard of; next at Sea,
 In our escape, where the proud waves took pleasure
 To tosse my little Boat up like a Bubble,
 Then like a meteor in the ayre he hung,
 Then catcht, and hugg'd him in the depth of darknesse;
 The Canon from my incensed Fathers Ship,
 Ringing our Knell, and still as we peep'd upward,
 Beating the raging surge, with fire and Bullet,

198 know thee,] F2; know thee *Tirant,* F1
212 She ... she] Sympson (*Seward's emendation*); He ... he F1–2
224 a] F2; *omit* F1 225 hugg'd] Dyce; hug F1; flung F2

And I stood fixt for this mans sake, and scorn'd it;
Compare but this.

Virolet. 'Tis too true; O my fortune! 230
That I must equally be bound to either.

Juliana. You have the better, and the nobler Lady;
And now I am forc'd, a lover of her goodnesse.
And so far have you wrought for his deliverance,
That is my Lord, so lovingly and nobly,
That now me thinks I stagger in my Title.
But how with honesty? for I am poor Lady,
In all my dutious service but your shadow,
Yet would be just; how with faire fame and credit,
I may goe off; I would not be a strumpet: 240
O my dear Sir you know――――

Virolet. O truth, thou knowest too.

Juliana. Nor have the world suspect, I fell to mischiefe.

Lawyer. Take you no care for that, here's that has don it;
A faire divorce, 'tis honest too.

Pandulfo. The devill,
Honest? to put her off.

Lawyer. Most honest Sir,
And in this point, most strong,

Pandulfo. The cause, the cause Sir?

Lawyer. A just cause too.

Pandulfo. As any is in hell, *Lawyer.*

Lawyer. For barrennesse, she never brought him children.

Pandulfo. Why art not thou divorc'd? thou canst not get 'em;
Thy neighbours, thy rank neighbours: O base jugling, 250
Is she not young?

Juliana. Woemen at more yeares Sir,
Have met that blessing; 'tis in heavens high power.

Lawyer. You never can have any.

Pandulfo. Why quick Lawyer?
My Philosophicall Lawyer?

Lawyer. The Rack has spoil'd her;
The distentions of those parts, hath stopt all fruitfulnes.

Pandulfo. O I could curse.

Juliana. And am I grown so miserable,

That mine own piety must make be wretched?
No cause against me, but my love and duty?
Farewell Sir, like obedience, thus I leave you,
My long farewell: I doe not grudge, I grieve Sir, 260
And if that be offensive, I can dye,
And then you are fairely free: good Lady love him;
You have a noble, and an honest Gentleman,
I ever found him so, the world has spoke him;
And let it be your part still to deserve him:
Love him no lesse then I have done; and serve him,
And heaven shall blesse you; you shall blesse my ashes;
I give you up the house; the name of wife,
Honour, and all respect I borrowed from him,
And to my grave I turn: one farewell more, 270
Nothing divide your Loves, not want of Children,
Which I shall pray against, and make you fruitfull;
Grow like two equall flames, rise high and glorious;
And in your honor'd age, burn out together:
To all I know, farewell.
Ronvere. Be not so grie'vd Lady;
A nobler fortune——
Juliana. Away thou parasite.
Disturbe not my sad thoughts; I hate thy greatnesse.

 [*Exit* Juliana.]

Ronvere [*aside*]. I hate not you; I am glad she's off these hinges,——
Come, let's pursue.

 Exeunt Ronvere *and* Lawyer.

Pandulfo. If I had breath to curse thee;
Or could my great heart utter; farewell villaine, 280
Thy house, nor face agen——

 Exit Pandulfo.

Martia. Let 'em all goe.
And now let us rejoyce; now freely take me,
And now embrace me *Virolet*; give the rites

257 piety] Sympson; pitty F1–2 262 are] F2; *omit* F1

164

Of a brave Husband to his love.

Virolet. I'le take my leave too.

Martia. How, take you leave too?

Virolet. The house is furnish'd for you;
You are Mistresse, may command.

Martia. Will you to bed Sir?

Virolet. As soone to hell, to any thing I hate most;
You must excuse me, I have kept my word.
You are my wife, you now enjoy my fortune,
Which I have done to recompence your bounty: 290
But to yeeld up those chaste delights and pleasures,
Which are not mine, but my first vowes——

Martia. You jeast.

Virolet. You will not find it so,——to give you those
I have divorc'd, and lost with *Juliana,*
And all fires of that nature——

Martia. Are you a Husband?

Virolet. To question hers, and satisfie your flames,
That held an equall beauty, equall bounty——
Good heaven forgive; no, no, the strict forbearance,
Of all those joyes, like a full sacrifice,
I offer to the suffrings of my first love; 300
Honour, and wealth, attendance, state, all duty,
Shall waite upon your will, to make you happy;
But my afflicted mind, you must give leave Lady;
My weary Trunk must wander.

Martia. Not enjoy me?
Goe from me too?

Virolet. For ever thus I leave you;
And how so e're I fare, live you still happy.

 Exit Virolet.

Martia. Since I am scorn'd, I'le hate thee, scorn thy gifts too;
Thou miserable fool, thou fool to pitty;
And such a rude, demolisht thing, I'le leave thee,
In my revenge: for foolish love, farewell now, 310
And anger, and the spite of woman enter,

 298 Good heaven] F2; *Vir.* Good heaven F1

That all the world shall say, that read this story,
My hate, and not my love, begot my glory.

Exit Martia.

Enter Sesse, Boatswaine, Master, Gunner IV.i
[*disguised as Switzers*].

Sesse. He that feares death, or tortures, let him leave me.
The stops that we have met with, Crown our Conquest:
Common attempts are fit for common men;
The rare, the rarest spirits. Can we be daunted?
We that have smil'd at Sea at certain ruines,
Which men on shore, but hazarded would shake at?
We that have liv'd free, in despite of fortune,
Laught at the out-stretch'd Arme of Tyranny,
As still too short to reach us, shall we faint now?
No my brave mates, I know your fiery temper, 10
And that you can, and dare, as much as men:
Calamity, that severs worldly friendships,
Could ne'r divide us, you are still the same;
The constant followers of my banisht fortunes;
The Instruments of my revenge; the hands
By which I work, and fashion all my projects.
Master. And such we will be ever.
Gunner. 'Slite Sir, Cramme me
Into a Canons mouth, and shoot me at
Proud *Ferrands* head; may onely he fall with me,
My life I rate at nothing.
Boteswain. Could I but get 20
Within my swords length of him; and if then
He scape me, may th'account of all his sinnes
Be added unto mine.
Master. 'Tis not to dye Sir,
But to dye unreveng'd, that staggers me:
For were your ends serv'd, and our Country free,
We would fall willing sacrifices.
Sesse. To rise up,
Most glorious Martyrs.
Boteswain. But the reason why

166

We weare these shapes?
Sesse. Onely to get accesse:
 Like honest men, we never shall approach him,
 Such are his feares, but thus attir'd like Switzers, 30
 And fashioning our language to our habits;
 Bold, bloody, desperate, we may be admitted
 Among his guard. But if this faile, I'le try
 A thousand others, out doe *Proteus*
 In various shapes, but I will reach his heart,
 And seale my anger on't.

 Enter Ronvere *and the Guard.*

Master. The Lord *Ronvere.*
Boteswain. Shall we begin with him?
Sesse. He is not ripe yet,
 Nor fit to fall: as you see me begin,
 With all care imitate.
Gunner. We are instructed.
Boteswain. Would we were at it once.
Ronvere. Keepe a strict watch, 40
 And let the guards be doubled; this last night
 The King had fearefull dreames.
Sesse. 'Tis a good Omen
 To our attempts.
Ronvere. What men are these? What seek you?
Sesse. Imployment.
Ronvere. Of what nature?
Sesse. We are Souldiers;
 We have seen towns and Churches set on fire;
 The Kennels runing blood, coy virgins ravish'd;
 The Altars ransack'd, and the holy reliques,
 Yea, and the Saints themselves, made lawfull spoyles,
 Unto the Conquerors: but these good dayes are past,
 And we made Beggars, by this Idle Peace, 50
 For want of action. I am Sir no stranger
 To the Government of this state, I know the King
 Needs men, that onely doe what he commands,

39 With all] F2; Withall F1

167

And search no further: 'tis the profession
Of all our Nation, to serve faithfully,
Where th'are best payed: and if you entertaine us,
I doe not know the thing you can command,
Which we'le not put in act.
Ronvere. A goodly Personage.
Master. And if you have an Enemy, or so
That you would have dispatch'd——
Gunner. They are here, can fit you. 60
Boteswain. Or if there be an Itch, though to a man——
Sesse. You shall tye our consciences in your purse-strings.
Ronvere. Gentlemen,
I like your freedome: I am now in haste,
But waite for my return. [Aside] I like the Rascals,
They may be usefull.
Sesse. We'l attend you Sir.
Ronvere. Doe; and be confident, of entertainment;
I hope ye will deserve it.

 Exeunt Ronvere *and Guard.*

Sesse. O, no doubt Sir:
Thus farre we are prosperous; we'l be his guard,
Till Tyranny and pride finde full reward. 70
 Exeunt.

 Enter Pandulfo, *and* Juliana. [IV.ii

Pandulfo. My blessing? no; a Fathers heavy curse,
Pursue, and overtake him.
Juliana. Gentle Sir——
Pandulfo. My name, and Family, end in my self
Rather then live in him.
Juliana. Deare Sir forbeare,
A fathers curses hit far off, and kill too,
And like a murthering-piece aymes not at one,
But all that stand within the dangerous level.
Some bullet may return upon your selfe too,
Though against nature, if you still go on

 58 Personage] F2; Parsonage F1

 168

In this unnaturall course.
Pandulfo. Thou art not made 10
Of that same stuffe as other women are:
Thy injuries would teach patience to blaspheme;
Yet still thou art a Dove.
Juliana. I know not malice,
But like an innocent, suffer.
Pandulfo. More miraculous!
Ile have a woman Chronicled, and for goodnesse,
Which is the greatest wonder. Let me see,
I have no sonne to inherit after me;
Him I disclaime.
What then? Ile make thy vertues my sole heire;
Thy story Ile have written, and in Gold too; 20
In prose and verse, and by the ablest doers:
A word or two of a kind step-father
Ile have put in, good Kings and Queens shal buy it.
And if the actions of ill great women,
And of the modern times too, are remembred,
That have undone their husbands, and their families,
What will our story do? It shal be so,
And I wil streight about it.

 Exit Pandulfo.

Juliana. Such as love
Goodnesse for glory, have it for reward;
I love mine for it selfe: let innocence 30
Be written on my Tomb, though ne're so humble,
Tis all I am ambitious of. But I
Forget my vows.

 Enter Lucio.

Lucio [*to* Martia *within*]. 'Fore me, you are not modest,
Nor is this Courtlike. Would you take it wel,
If she should rudely presse into your Closet,

20 too] F2; to F1
33 *Enter* Lucio] '*Enter Boy*' *after* '*Exit* Pandulfo' *(line 28)* in F1-2
33, 38, 39, 59, 62.1 *Lucio.*] *Boy.* F1-2

When from your several Boxes you choose paint,
To make a this daies face with?
Juliana. What's the matter?
Lucio [*to* Martia *within*]. Pray know her pleasure first.
Juliana. To whom speak you Boy?
Lucio. Your Ladiships pardon. That proud Lady theife,
 That stole away my Lord from your embraces, 40
 (Wrinckles at two and twenty on her cheekes for't,
 Or *Mercury* unallayed, make blisters on it)
 Would force a visit.
Juliana. And dare you deny her,
 Or any else that I call mine? No more,
 Attend her with all reverence and respect;
 The want in you of manners, my Lord may
 Construe in me for malice. I wil teach you
 How to esteem and love the beauty he dotes on;
 Prepare a banquet.

 Lucio admits Martia.

 Madam, thus my duty
 Stoops to the favour you vouchsafe your servant, 50
 In honouring her house.
Martia. Is this in scorn?
Juliana. No by the life of *Virolet*: give me leave
 To sweare by him, as by a Saint I worship,
 But am to know no further, my heart speaks that.
 My servants have been rude, and this boy (doting
 Upon my sorrows) hath forgot his duty:
 In which, that you may think I have no share,
 Sirra, upon your knees, desire her pardon.
Lucio. I dare not disobey you. [*Kneels.*]

Marita. Prethee rise,
 My anger never looks so low:——I thank you, 60
 And wil deserve it. If we may be private,
 I came to see and speak with you.
Juliana. Be gone.

 Exit Lucio.

49 Lucio *admits* Martia.] *Enter Martia and Boy.* F1–2

 Good Madam sit.
Martia. I rob you of your place then.
Juliana. You have deserv'd a better, in my bed;
 Make use of this too: Now your pleasure Lady.
 If in your breast there be a worthy pitty,
 That brings you for my comfort, you do nobly:
 But if you come to triumph in your conquest,
 Or tread on my calamities, 'twil wrong
 Your other excellencies. Let it suffice, 70
 That you alone enjoy the best of men,
 And that I am forsaken.
Martia. He the best?
 The scum and shame of mankind.
Juliana. *Virolet*, Lady?
Martia. Blest in him? I would my youth had chosen
 Consuming feavers, bed-rid age
 For my companions, rather then a thing
 To lay whose basenesse open, would even poyson
 The tongue that speaks it.
Juliana. Certainly from you
 At no part he deserves this; and I tell you,
 Durst I pretend but the least title to him, 80
 I should not hear this.
Martia. He's an impudent villaine,
 Or a malicious wretch: to you ungratefull;
 To me, beyond expression barbarous.
 I more then hate him; from you, he deserves
 A death most horrid: from me, to die for ever,
 And know no end of torments. Would you have comfort?
 Would you wash off the stain that sticks upon you,
 In being refus'd? Would you redeem your fame,
 Shipwrack'd in his base wrongs? if you desire this,
 It is not to be done with slavish suffering, 90
 But by a Noble anger, making way
 To a most brave revenge, we may call justice;
 Our injuries are equal; joyn with me then,
 And share the honour.
Juliana. I scarce understand you,
 And know I shal be most unapt to learn

To hate the man I stil must love and honour.

Martia. This foolish dotage in soft-hearted women,
Makes proud men insolent: but take your way,
Ile run another course.

Juliana. As you are noble,
Deliver his offence.

Martia. He has denied 100
The rites due to a wife.

Juliana. O me most happy,
How largely am I payd for all my sufferings?
Most honest *Virolet*, thou just performer
Of all thy promises: I call to mind now,
When I was happy in those joyes you speak of,
In a chast bed, and warranted by Law too,
He oft would swear, that if he should survive me,
(Which then I knew he wisht not) never woman
Should taste of his imbraces; this one act
Makes me again his debtor.

Martia. And was this 110
The cause my youth and beauty were contemn'd?
If I sit down here! wel——

Juliana. I dare thy worst,
Plot what thou canst, my piety shal guard him
Against thy malice. Leave my house and quickly,
Thou wilt infect these innocent walls. By vertue
I wil inform him of thy bloody purpose,
And turn it on thine own accursed head;
Believ't I wil.

 Exit Juliana.

Martia. But tis not in thy power
To hinder what I have decreed against him.
Ile set my self to sale, and live a strumpet; 120
Forget my birth, my father, and his honour,
Rather then want an instrument to help me
In my revenge.

 Enter Ronvere.

 The Captain of the guard;
 Blest opportunity courts me.
Ronvere [*aside*]. Sad and troubled?
 How brave her anger shews? how it sets off
 Her naturall beauty? under what happy star
 Was *Virolet* born, to be belov'd and sought to,
 By two incomparable women?——Noblest Lady,
 I have heard your wrongs and pity them: and if
 The service of my life could give me hope 130
 To gain your favour, I should be most proud
 To be commanded.
Martia. Tis in you, my Lord,
 To make me your glad servant.
Ronvere. Name the means.
Martia. Tis not preferment, Jewels, Gold, or Courtship.
 He that desires to reap the harvest of
 My youth and beauty, must begin in blood,
 And right my wrongs.
Ronvere. I apprehend you Madam,
 And rest assur'd tis done; I am provided
 Of instruments to fit you: To the King,
 Ile instantly present you; if I faile, 140
 He shal make good your aymes: he's lesse then man,
 That to atchieve your favour, would not doe
 Deeds, fiends would fear to put their agents to.

 Exeunt.

 Enter Virolet *Reading.* [IV.iii]

Virolet. Quod invitus facis, non est scelus. Tis an axiome,
 Now whether willingly I have departed
 With that I lov'd: with that, above her life
 Lov'd me again, crownd me a happy husband,
 Was full of children: her afflictions
 That I begot, that when our age must perish,
 And all our painted frailties turn to ashes,
 Then shal they stand and propagate our honors.
 Whether this done, and taking to protection

 143 fiends] F2; friends F1

 173

A new strange beauty, it was a useful one: 10
How, to my lust? if it be so, I am sinful;
And guilty of that crime I would fling from me.
Was there not in it this fair course of vertue?
This pious course, to save my friends, my Countrey,
That even then had put on a mourning garment,
And wept the desolation of her children?
Her noblest children? Did not she thrust me on,
And to my duty clapt the spur of honour?
Was there a way, without this woman, left me
To bring 'em off? the marrying of this woman? 20
If not, why am I stung thus? why tormented?
Or had there been a wild desire joyn'd with it,
How easily, both these, and all their beauties
Might I have made mine own? why am I toucht thus,
Having perform'd the great redemption,
Both of my friends and family? fairly done it?
Without base and lascivious ends; O Heaven,
Why am I still at war thus? why this a mischiefe,
That honesty and honour had propounded,
I, and absolv'd my tender wil, and chid me, 30
Nay then unwillingly flung me on?

 Enter Juliana, *and* Lucio.

Lucio. He's here Madam;
 This is the melancholy walk he lives in,
 And chooses ever to encrease his sadnesse.
Juliana. Stand by.

 [*Exit* Lucio.]

Virolet [*aside*]. Tis she: how I shake now and tremble?
 The vertues of that mind are torments to me.
Juliana. Sir, if my hated face shal stir your anger,
 Or this forbidden path I tread in vex you;
 My love, and faire obedience left behind me,
 Your pardon asked, I shal return and blesse you.

 31 s.d. Lucio.] *the Boy.* F1–2 31 s.p. *Lucio.*] *Boy.* F1–2
 *34 *Exit* Lucio.] *omit* F1–2

 174

Virolet. Pray stay a little, I delight to see you; 40
 May not we yet, though fortune have divided us,
 And set an envious stop between our pleasures,
 Look thus one at another? sigh and weep thus?
 And read in one anothers eyes, the Legends,
 And wonders of our old loves? be not fearful,
 Though you be now a Saint, I may adore you:
 May I not take this hand, and on it sacrifice
 The sorrows of my heart? white seale of vertue.
Juliana. My Lord, you wrong your wedlock.
Virolet. Were she here,
 And with her all severe eyes to behold us, 50
 We might do this; I might name *Juliana*,
 And to the reverence of that name, bow thus:
 I might sigh *Juliana*, she was mine once;
 But I too weak a guard for that great Treasure——
 And whilst she has a name, believe me Lady,
 This broken heart shal never want a sorrow.
Juliana. Forget her sir, your honour now commands you.
 You are anothers, keep those griefes for her,
 She richly can reward 'em. I would have spoken with you.
Virolet. What is your wil? for nothing you can aske, 60
 So ful of goodnesse are your words and meanings,
 Must be denied: speak boldly.
Juliana. I thank you sir. I come not
 To beg, or flatter, onely to be believ'd,
 That I desire: for I shal tell a story,
 So far from seeming truth, yet a most true one;
 So horrible in nature, and so horrid;
 So beyond wickednesse, that when you heare it,
 It must appeare the practice of another,
 The cast and malice of some one you have wrongd much;
 And me you may imagine, me accuse too, 70
 Unlesse you call to mind my daily sufferings;
 The infinite obedience I have born you,
 That hates all name and nature of revenge,
 My love, that nothing but my death can sever,

Rather then hers I speak of.
Virolet. *Juliana,*
 To make a doubt of what you shall deliver,
 After my full experience of your vertues,
 Were to distrust a providence; to think you can lie,
 Or being wrong'd, seek after foule repairings,
 To forge a Creed against my faith. 80
Juliana. I must do so, for it concernes your life sir;
 And if that word may stir you, heare and prosper:
 I should be dumb else, were not you at stake here.
Virolet. What new friend have I found, that dares deliver
 This loden Trunke from his afflictions?
 What pitying hand, of all that feeles my miseries,
 Brings such a benefit?
Juliana. Be wise and manly,
 And with your honour fall, when Heaven shall call you,
 Not by a Hellish mischiefe.
Virolet. Speak my blest one,
 How weak and poor I am, now she is from me? 90
Juliana. Your wife——
Virolet. How's that?
Juliana. Your wife——
Virolet. Be tender of her,
 I shal believe else——
Juliana. I must be true: your eare, sir;
 For tis so horrible, if the ayre catch it,
 Into a thousand plagues, a thousand monsters,
 It will disperse it selfe, and fright resistance.

 [*Whispers.*]

Virolet. She seeke my life with you? make you her agent?
 Another love? O speake but truth.
Juliana. Be patient,
 Deare as I love you, else I leave you wretched.
Virolet. Forward, tis well, it shal be welcome to me;
 I have liv'd too long, numbred too many daies, 100
 Yet never found the benefit of living;
 Now when I come to reap it with my service,

And hunt for that my youth and honour aimes at,
The Sunne sets on my fortune red and bloody,
And everlasting night begins to close me,
Tis time to die.

Enter Martia *and* Ronvere.

Juliana. She comes her selfe.
Ronvere. Believe Lady,
And on this Angel hand, your servant seales it,
You shal be Mistris of your whole desires,
And what ye shal command.
Martia. Ha, mynion,
My precious dame, are you there? nay go forward, 110
Make your complaints, and poure out your faind pities,
Slave-like, to him you serve: I am the same still,
And what I purpose, let the world take witnesse,
Shal be so finisht, and to such example,
Spite of your poore preventions;——my deare Gentleman,
My honourable man, are you there too?
You and your hot desire? Your mercy sir,
I had forgot your greatnesse.
Juliana. Tis not wel Lady.
Martia. Lord, how I hate this fellow now; how desperately
My stomack stands against him, this base fellow, 120
This gelded foole!
Juliana. Did you never heare of modesty?
Martia. Yes, when I heard of you and so believ'd it,——
Thou bloodlesse, brainlesse foole.
Virolet. How?
Martia. Thou despis'd foole,
Thou onely sign of man, how I contemn thee!
Thou woven worthy in a piece of Arras,
Fit onely to enjoy a wall; thou beast
Beaten to use; Have I preserv'd a beauty,
A youth, a love, to have my wishes blasted?
My dotings, and the joyes I came to offer,
Must they be lost, and sleighted by a dormouse? 130

177

Juliana. Use more respect; and woman, twill become you;
 At least, lesse tongue
Martia. Ile us all violence,
 Let him look for't.
Juliana. Dare you staine those beauties,
 Those Heavenly stamps, that raise men up to wonder,
 With harsh and crooked motions? are you she
 That overdid all ages, with your honour;
 And in a little houre dare lose this triumph?
 Is not this man your husband?
Martia. He's my halter;
 Which (having sued my pardon) I fling off thus,
 And with him all I brought him, but my anger; 140
 Which I wil nourish to the desolation,
 Not onely of his folly, but his friends,
 And his whole name.
Virolet. Tis wel, I have deservd it.
 And if I were a woman, I would raile too.
Martia. Nature nere promis'd thee a thing so Noble.
 Take back your love, your vow, I give it freely;
 I poorly scorn it; graze now where you please:
 That that the dulnesse of thy soule neglected,
 Kings sue for now. And mark me, *Virolet*;
 Thou image of a man, observe my words well. 150
 At such a bloody rate Ile sell this beauty,
 This handsomnesse thou scornst, and flingst away,
 Thy proud ungrateful life shal shake at: take your house;
 The petty things you left me give another;
 And last, take home your trinket: fare you wel, sir.
Ronvere. You have spoke like your selfe; y'are a brave Lady.

 Exeunt Ronvere *and* Martia.

Juliana. Why do you smile, sir?
Virolet. O my *Juliana*,
 The happinesse this womans scorn has given me,
 Makes me a man again; proclaimes it selfe,
 In such a generall joy, through all my miseries, 160

*155 trinket] *stet* F1–2

178

That now methinks——
Juliana. Looke to your selfe deere sir,
And trifle not with danger, that attends you;
Be joyfull when y'are free.
Virolet. Did you not heare her?
She gave me back my vow, my love, my freedom;
I am free, free as aire; and though to morrow
Her bloody wil meet with my life, and sink it,
And in her execution teare me peecemeale:
Yet have I time once more to meet my wishes,
Once more to embrace my best, my noblest, truest;
And time that's warranted.
Juliana. Good sir, forebeare it: 170
Though I confesse, equall with your desires
My wishes rise, as covetous of your love,
And to as warm alarams spur my wil to:
Yet pardon me, the Seal oth' Church dividing us,
And hanging like a threatning flame between us,
We must not meet, I dare not.
Virolet. That poore disjoynting
That onely strong necessity thrust on you,
Not crime, nor studied cause of mine: how sweetly,
And nobly I wil bind again and cherish;
How I wil recompence one deare imbrace now, 180
One free affection! how I burn to meet it!
Looke now upon me.
Juliana. I behold you willingly,
And willingly would yield, but for my credit.
The love you first had was preserv'd with honour,
The last shal not cry whore; you shal not purchase
From me a pleasure, that have equally
Lov'd your faire fame as you, at such a rate:
Your honesty and vertue must be banquerout.
If I had lov'd your lust, and not your lustre;
The glorious lustre of your matchlesse goodnesse, 190
I would compel you now to bed——forgive me,
Forgive me sir; how fondly stil I love you!

191 bed] Sympson; be! F1–2

179

Yet Nobly too; make the way straight before me,
And let but holy *Hymen* once more guide me,
Under the Ax, upon the Rack again,
Even in the bed of all afflictions,
Where nothing sings our Nuptials but dire sorrows,
With all my youth and pleasure Ile imbrace you,
Make tyranny and death stand stil affrighted,
And at our meeting soules amaze our mischiefes; 200
Til when, high Heaven defend you, and peace guide you.
Be wise and manly, make your fate your own,
By being master of a providence,
That may controle it.

Virolet. Stay a little with me,
My thoughts have chid themselves: may I not kisse you?
Upon my truth I am honest.

Juliana. I believe ye;
But yet what that may raise in both our fancies,
What issues such warm parents breed——

Virolet. I obey you,
And take my leave as from the Saint that keeps me.
I will be right again, and once more happy 210
In thy unimitable love.

Juliana. Ile pray for ye,
And when you fall I have not long to follow.

 Exeunt.

Enter Sesse, Master, Boteswaine, *and* Gunner, [IV.iv]
[*disguised as Switzers,*] *at one doore:*
Martia *and* Ronvere, *at another.*

Sesse. Now we have got free credit with the Captaine.
Master. Soft, soft, he's here again: Is not that Lady——
Or have I lost mine eyes? a salt rhume seizes 'em;
But I should know that face.

Boteswain. Make him not madder,
Let him forget the woman; steere a larboord.
Master. He wil not kill her.
Boteswain. Any thing he meets;
He's like a Hornet now, he hums, and buzzes;

Nothing but blood and horror.

Master. I would save the Lady,
For such another Lady——

Boteswain. There's the point;
And you know there want women of her mettle. 10

Master. Tis true, they bring such children now, such demilances,
Their fathers socks wil make them Christning clothes.

Gunner. No more, they view us.

Sesse. You shal play a while,
And sun your selfe in this felicity,
You shal you glorious whore; I know you still.
But I shal pick an houre when most securely——
I say no more.

Ronvere. Do you see those? those are they
Shall act your will; come hither my good fellows:
You are now the Kings. Are they not goodly fellows?

Martia. They have bone enough, if they have stout heart to it. 20

Master. Still the old wench.

Sesse. Pray Captaine, let me aske you
What Noble Lady's that? tis a rude question,
But I desire to know.

Ronvere. She is for the King, sir;
Let that suffice for answer.

Sesse. Is she so sir?——
[*Aside*] In good time may she curse it. Must I breed
Hackneys for his grace?

Ronvere. What wouldst thou do
To merit such a Ladies favour?——

Sesse. Any thing.

Ronvere. That can supply thy wants, and raise thy fortuns?

Sesse. Let her command, and see what I dare execute.
I keep my conscience here; if any man 30
Oppose her wil, and she would have him humbled,
Whole families between her and her wishes——

Master. We have seen bleeding throats sir, Cities sackt,
And infants stuck upon their Pikes.

Boteswain. Houses a fire, and handsome mothers weeping.

Sesse. Which we have heaped upon the pile like sacrifices.

Churches and Altars, Priests and all devotions,
Tumbled together into one rude Chaos.

Gunner. We know no feare sir, but want of imployment.

Sesse. Nor other faith but what our purses preach. 40
To gaine our ends we can do any thing,
And turn our soules into a thousand figures;
But when we come to do——

Martia. I like these fellowes.

Ronvere. Be ready and waite here; within this houre
Ile shew you to the King, and he shall like ye:
And if you can devise some entertainment
To fill his mirth, such as your Countrey uses,
Present it, and Ile see it grac'd.
After this Comicke Scene we shall imploy you,
For one must die.

Sesse. What is he sir? speak boldly, 50
For we dare boldly do.

Ronvere. This Ladies husband;
His name is *Virolet.*

Sesse. We shall dispatch it.

 Exeunt Martia, Ronvere.

O damned, damned thing: a base whore first,
And then a murtherer; Ile look to you.

Boteswain. Can she be grown so strange?

Sesse. She has an itch;
Ile scratch you my deare daughter, Ile so claw you;
Ile curry your hot hide; married and honour'd?
And turn those holy blessings into brothels?
Your beauty into blood? Ile hunt your hotnesse.
Ile hunt you like a traine.

Master. We did all pity her. 60

Sesse. Hang her, she is not worth mans memory;
She's false and base, and let her fright all stories.——
Wel, though thou beest mine enemy, Ile right thee,
And right thee Nobly.

Boteswain. Faith sir, since she must goe,
Let's spare as few as may be.

Sesse. We'l take all,

And like a torrent sweep the slaves before us.
You dare endure the worst?
Master. You know our hearts sir,
 And they shal bleed the last, erst we start from ye.
Gunner. We can but die, and ere we come to that,
 We shal pick out some few examples for us. 70
Sesse. Then wait the first occasion, and like *Curtius*,
 Ile leap the gulph before you, fearlesse leap it:
 Then follow me like men, and if our vertues
 May boy our Countrey up, and set her shining
 In her first state; our fair revenges taken,
 We have our Noble ends, or else our ashes.

 Exeunt.

 Enter Ascanio *and* Martia *above.* V.i

Martia. As you are Noble, keep me from discovery,
 And let me onely run a strangers fortune;
 For when the King shall find I am his daughter
 He ever holds most ominous, and hates most:
 With what eyes can he look, how entertain me,
 But with his feares and cruelties?
Ascanio. I have found you,
 Suspect not. I am bound to what you like best,
 What you intend. I dare not be so curious
 To question now; and what you are, lies hid here.

 Enter Ferand *and* Ronvere *above.*

The King comes, make your fortune, I shall joy in't. 10
Ronvere. All things are ready sir to make you merry,
 And such a King you shall behold him now.
Ferand. I long for't,
 For I have need of mirth.
Ronvere. The Lady sir.
Ferrand. Now as I am a King, a sprightly beauty,
 A goodly sweet aspect! my thanks *Ronvere*,
 My best thanks;——on your lips I seale your wishes,
 Be what you can imagine, mine, and happy.

 74 boy] *i.e.,* buoy

 183

And now sit downe and smile; come my *Ascanio*;
And let this Monarch enter.

 Enter Sesse *and* Master, Boatswain, Gunner, *and Saylors.*

Ronvere. These are the Switzers 20
 I told your grace of.
Ferrand. Goodly promising fellowes,
 With faces to keep fooles in awe, I like 'em;
 Goe guard the presence well, and doe your duties,
 To morrow I shall take a further view.
Sesse [*aside*]. You shall Sir,
 Or I shall loose my will; how the whore's mounted?
 How she sits thron'd? thou blasing muddy meteor,
 That frightest the underworld, with lustfull flashes,
 How I shall dash thy flames? away, no word more.

 Exeunt Sesse *and his company* [Master, Boatswain,
 Gunner, *Sailors*]. *Florish Cornets.*

 Enter Villio, Castruchio, Doctor, *and a* Guard [*below*].

Ferrand. Now, here he comes in glory; be merry Masters, 30

 Meat brought in.

 A Banquet too?
Ronvere. O, he must sit in State Sir!
Ascanio. How rarely he is usher'd? can he thinke now
 He is a King indeed?
Ronvere. Mark but his countenance.
Castruchio. Let me have pleasures infinite, and to the height,
 And women in abundance, many women,
 I will disport my grace,———

 Enter Ladies.

 Stand there and long for me.
 What have ye brought me here? is this a Feast
 Fit for a Prince? a mighty Prince? are these things,
 These preparations, ha?

 30.1 *Meat brought in.*] Sympson; *meat conveyed away.* F1–2

Doctor. May it please your grace?

Castruchio. It does not please my grace: where are the Marchpanes, 40
 The Custards double royall, and the subtleties?
 Why, what weak things are you to serve a Prince thus?
 Where be the delicates oth' earth and ayre?
 The hidden secrets of the Sea? am I a Plow-man,
 You pop me up with porridge? hang the Cooks.

Ferrand. O most Kingly:
 What a majestique anger.

Castruchio. Give me some wine.

Ascanio. He cooles agen now.

Castruchio. Foole, where are my Players?
 Let me have all in pomp; let 'em play some love matter,
 To make the Ladies itch,——I'le be with you anon Ladies; 50
 You black eyes, I'le be with you——Give me some wine I say,
 And let me have a Masque of Cuckolds enter:
 Of mine own Cuckolds,
 And let 'em come in, peeping and rejoycing,
 Just as I kisse their wives, and somewhat glorying.
 Some wine I say, then for an excellent night-peece,
 To shew my glory to my loves, and minions:
 I will have some great Castle burnt.

Villio. Harke you brother:
 If that be to please these Ladies, tenne to one
 The fire first takes upon your own, look to that; 60
 Then you may shew a night peece.

Castruchio. Where's this wine?
 Why shall I choak? doe yee long all to be tortur'd?

Doctor. Here Sir.

Castruchio [*tastes*]. Why, what is this? why Doctor,——

Doctor. Wine and water Sir.
 'Tis Soveraign for your heat, you must endure it.

Villio. Most excellent to coole your night-peece Sir.

Doctor. You are of a high and cholericke complexion,
 And you must have allayes.

Castruchio. Shall I have no sheere wine then?

 64 s.p. *Doctor.*] F2; *omit* F1 65 'Tis] F2; *Doct.* 'Tis F1
 66 night] F2; nigh F1

185

Doctor. Not for a world: I tender your deare life Sir;
And he is no faithfull Subject——
Villio. No, by no meanes: 70
Of this you may drinke; and never hang, nor quarter,
Nor never whip the fool, this liquors mercifull.
Castruchio. I will sit down and eat then: Kings when th'are hungry,
May eat I hope.
Doctor. Yes, but they eat discreetly.
Castruchio. Come, taste this dish, and cut me liberally;
I like sauce well.
Doctor. Fie 'tis too hot Sir:
Too deeply season'd with the spice, away with't,
You must acquaint your stomack with those diets
Are temperately nourishing.

[*Servants take away the dish.*]

Castruchio. But pray stay Doctor,
And let me have my meat agen.
Doctor. By no meanes: 80
I have a charge concerns my life.
Castruchio. No meat neither;
Doe Kings never eat Doctor?
Doctor. Very little Sir.
And that too very choice.
Villio. Your King never sleeps Brother,
He must not sleep, his cares still keep him waking.
Now he that eats and drinkes much, is a dormouse;
The third part of a wafer, is a weeks diet.
Castruchio. Appoint me something then.
Doctor. There.
Castruchio. This I feel good,
But it melts too suddainly; yet,——

[*Servants*] *take away* [*the dish*].

how, that gone too!
Ye are not mad! I charge you——
Doctor. For your health Sir,
A little quickens nature, much depresses. 90

Castruchio. Eat nothing for my health? that's new dyet;
Let me have something, something has some savour.
Why thou uncourteous Doctor, shall I hang thee?
Doctor. 'Tis better Sir then I should let you surfet;
My death were nothing.
Villio. To loose a King, were terrible.
Castruchio. Nay, then I'le carve my self, I'le stay no ceremonies.
This is a Partridge Pye, I am sure that's nourishing,
Or *Galen* is an Asse: [*Eats*] 'tis rarely season'd:
Ha Doctor have I hit right? a mark, a mark there?

 [*Servants take away the dish.*]

Villio. What ailes thy grace?
Castruchio. Retrive those Partridges, 100
Or as I am a King——
Doctor. Pray Sir be patient,
They are flowen too farre.
Villio. These are breath'd pyes an't please you,
And your hawkes are such Buzzards——
Castruchio. A King and have nothing,
Nor can have nothing!
Villio. What think you of a pudding?
A pudding Royall?
Castruchio. To be royally starv'd,——
Whip me this foole to death; he is a blockhead.
Villio. Let 'em think they whip me, as we think you a King:
'Twill be enough.
Castruchio. As for you dainty Doctor,——

 [*Servants take away the Table.*]

All gone, all snatch'd away, and I unsatisfied,
Without my wits being a King and hungry? 110
Suffer but this thy treason? I tell thee Doctor,
I tell it thee, in earnest, and in anger,
I am damnably hungry, my very grace is hungry.

104 a] Sympson; *omit* F1–2
108.1 *Servants ... Table.*] Dyce *(after* Colman*)*; F1–2 *print* 'the Table taken away' *as part of*
 Castruchio's speech on line 108 *following the words* 'dainty Doctor'

187

Villio. A hungry grace is fittest to no meale Sir.

Doctor. Some two houres hence, you shall see more: but still Sir,
 You must retaine a strict and excellent dyet.

Villio. It sharpens you, and makes your wit so poynant,
 Your very words will kill.

Doctor. A bit of Marmalade
 No bigger then a Pease——

Villio. And that well butter'd,
 The ayre thrice purified, and three times spirited, 120
 Becomes a King: your rare conserve of nothing
 Breeds no offence.

Castruchio. Am I turn'd King Camelion,
 And keep my Court ith' ayr?

Ferrand. They vex him cruelly.

Ascanio. In two dayes more they'l starve him.

Ferrand. Now the women,
 There's no food left but they.

Ascanio. They'l prove small nourishment.
 Yet h'as another stomack and a great one,
 I see by his eye.

Castruchio. I'le have mine own power here;
 Mine own Authority; I need no tutor.
 Doctor this is no dyet.

Doctor. It may be Sir.

Villio. Birlady, it may turne to a dry dyet; 130
 And how thy grace, will ward that——

Castruchio. Stand off Doctor;
 And talke to those that want faith.

Ferrand. Hot and mighty.

Ascanio. He will coole apace, no doubt.

Castruchio. Faire, plump, and red,
 A forehead high; an eye revives the dead;
 A lip like ripest fruit, inviting still.

Villio. But O, the rushy well, below the hill,
 Take heed of that, for though it never faile,
 Take heed I say, for thereby hangs a taile.

Castruchio. I'le get ye all with Childe.

Villio. With one Childe Brother,

So many men in a Blew Coat.

Castruchio.　　　　　　　　　Had I fed well,　　　　140
And drunk good store of wine, ye had been blest all,
Blest all with double Births; come kisse me greedily,
And think no more upon your foolish Husbands,
They are transitory things: a Kings flame meets you.

Doctor.　Vanish away.

　　　　　　　　　　　　　　　　　Exeunt Women.

Castruchio.　　　　　　How, they gone too? my guard there:
Take me this devill Doctor, and that foole there,
And sow 'em in a sack; bring back the women,
The lovely women, drown these rogues or hang 'em.

Ascanio.　He is in earnest Sir.

Ferrand.　　　　　　　　　In serious earnest,
I must needs take him off.

　　　　Enter Sesse, Master, Boatswain, Gunner *and Saylors.*

Sesse.　　　　　　　　Now, now be free.　　　　150
Now liberty, now Country-men, shake from ye
The Tyrants yoake.

All.　　　　　　　Liberty, liberty, liberty.

Guard.　Treason, treason, treason.

Ferrand.　We are betrayed, fly to the town, cry treason,
And raise our faithfull friends; O my *Ascanio.*

Ascanio.　Make haste, we have way enough.

Guard.　　　　　　　　　　　Treason, treason.

　　　　Exeunt Ferrand, Ascanio, [Martia, Ronvere, *above*],
　　　　　　　　　　　　　　and Guard [*below*].

Sesse.　Spare none, put all to th' sword: a vengeance shake thee;
Art thou turn'd King againe?

Castruchio.　　　　　　I am a rascall:
Spare me but this time, if ever I see King more,
Or once beleeve in King——

Sesse.　　　　　　The ports are ours,　　　　160

144 flame] Sympson *(conj.)*; fame F1–2
152 *All.* Liberty,] Langbaine; All Liberty F1–2

The treasure and the ports. Fight bravely Gentlemen;
Cry to the Town, cry liberty and honour;
Waken their persecuted soules, cry loudly,

> [Boatswain *goes*] *off crying 'Liberty and freedome.'*

We'l share the wealth among ye.
Castruchio. Doe you heare Captaine?
If ever you heare me, name a King———
Sesse. You shall not.
Castruchio. Or though I live under one, obey him———
Gunner. This rogue againe.
Sesse. Away with him good Gunner.
Castruchio. Why look ye Sir? I'le put you to no charg;
I'le never eat.
Gunner. I'le take a course, you shall not.
Come, no more words.
Castruchio. Say nothing when you kill me. 170

> *Enter* Boatswain.

Boteswain. He's taken to the Towers strength.
Sesse. Now stand sure Gentlemen.
We have him in a pen, he cannot scape us,
The rest oth' Castle's ours.
Within. Liberty, liberty.
Sesse. What is the City up?
Boteswain. They are up and glorious,
And rouling like a storm they come; their Tents
Ring nothing but liberty and freedome.
The women are in Arms too.
Sesse. Let 'em come all.
Honour and liberty.
All. Honour and liberty.

> *Exeunt.*

161 ports] Dyce; port F1–2
163.1 Boatswain *goes off crying . . . freedome.'*] *One of crying Liberty and freedome.* F1; *crying
 liberty and freedom within.* F2 171 *Boteswain.*] Sympson *(conj.)*; *Sess.* F1–2
171 *Sesse.*] Sympson *(conj.)*; *omit* F1–2 173 *Within.*] Colman; *omit* F1–2
174 *Sesse.*] Colman; *omit* F1–2 174 the] this F1–2, Langbaine

Enter Juliana.

Juliana. This womans threats, her eyes, even red with fury
 Which like prodigious meteors, foretold
 Assur'd destruction, are still before me.
 Besides I know such natures unacquainted
 With any meane, or in their love, or hatred,
 And she that dar'd all dangers to possesse him,
 Will check at nothing, to revenge the losse
 Of what she held so deare. I first discover'd
 Her bloody purposes, which she made good,
 And openly profess'd 'em; that in me 10
 Was but a cold affection; charity
 Commands so much to all; for *Virolet*
 Me thinks I should forget my Sexes weaknesse,
 Rise up, and dare beyond a womans strength;
 Then doe, not counsell: he is too secure,
 And in my judgement, 'twere a greater service
 To free him from a deadly Enemy,
 Then to get him a friend. I undertooke too,
 To crosse her plots, oppos'd my piety,
 Against her malice; and shall vertue suffer? 20
 No *Martia*, wer't thou here equally armed,
 I have a cause, spite of thy masculine breeding,
 That would assure the victory: my angell
 Direct and help me.

Enter Virolet, *like Ronvere.* [Juliana *stands aside.*]

Virolet. The State in Combustion,
 Part of the Cittadell forc'd, the treasure seiz'd on;
 The guards corrupted, arme themselves against
 Their late protected Master; *Ferrant* fled too,
 And with small strength, into the Castles Tower,
 The onely Aventine, that now is left him?
 And yet the undertakers, nay, performers, 30
 Of such a brave and glorious enterprize,
 Are yet unknown: they did proceed like men,
 I like a childe; and had I never trusted

So deep a practise unto shallow fools,
Besides my soules peace, in my *Juliana*,
The honour of this action had been mine,
In which, accurs'd, I now can claime no share.

Juliana [*aside*]. *Ronvere*! 'tis he, a thing, next to the devill
I most detest, and like him terrible;
Martia's right hand, the Instrument I feare too, 40
That is to put her bloody will into act.
Have I not will enough, and cause too mighty?
Weake womens fear, fly from me.

Virolet. Sure this habit,
This likenesse to *Ronvere* which I have studied,
Either admits me safe to my designe,
Which I too cowardly have halted after,
And suffer'd to be ravish't from my glory;
Or sincks me, and my miseries together;
Either concludes me happy.

Juliana [*aside*]. He stands musing,
Some mischiefe is now hatching: 50
In the full meditation, of his wickednesse,
I'le sink his cursed soule: guid my hand heaven,
And to my tender arm give strength and fortun,
That I may doe a pious deed all ages
Shall blesse my name for; all remembrance Crown me.

Virolet. It shall be so.

Juliana. It shall not, take that token,

 [*Stabs him.*]

And bear it to the lustfull Arms of *Martia*,
Tell her, for *Virolets* deare sake, I sent it.

Virolet. O I am happy, let me see thee,
That I may blesse the hand that gave me liberty, 60
O courteous hand, nay, thou hast done most nobly,
And heaven has guided thee, 'twas their great justice;
O blessed wound, that I could come to kisse thee!
How beautifull, and sweet thou shewest!

Juliana. Oh!

57 to] F2; *omit* F1

192

Virolet. Sighe not,
 Nor weep not Deare, shed not those soveraign Balsoms
 Into my blood; which must recover me;
 Then I shall live again, to doe a mischiefe,
 Against the mightinesse of love and vertue,
 Some base unhallowed hand shall rob thy right of.
 Help me, I faint: so.

Juliana. O unhappy wench! 70
 How has my zeale abus'd me? you that guard vertue,
 Were ye asleep? or doe you laugh at innocence?
 You suffer'd this mistake? O my deare *Virolet*!
 An everlasting curse follow that forme
 I strook thee in, his name be ever blasted;
 For his accursed shadow has betrayed
 The sweetnesse of all youth, the noblenesse,
 The honour, and the valor; wither'd for ever
 The beauty and the bravery of all mankind:
 O my dull, devils eyes.

Virolet. I doe forgive you, [*Kisses her.*] 80
 By this, and this I doe; I know you were cozend;
 The shadow of *Ronvere*, I know you aym'd at,
 And not at me; but 'twas most necessary,
 I should be struk, some hand above directed you,
 For *Juliana* could not shew her justice
 Without depriving high heaven of his glory,
 On any subject fit for her, but *Virolet*;
 Forgive me too, and take my last breath sweet one,
 This the new marriage of our soules together;
 Thinke of me *Juliana*, but not often, 90
 For feare my faults should burthen your affections,
 Pray for me, for I faint.

Juliana. O stay a little,
 A little little Sir. [*Offers to kill herself.*]

Virolet. Fye *Juliana*.

Juliana. Shall I outlive the vertue, I have murderd?

Virolet. Hold, or thou hatest my peace: give me the dagger;

69 of] F2; off F1 75 be] F2; *omit* F1 87 On] Sympson; Or F1-2
92 *Juliana*.] F1(c), F2; *Vir.* F1(u) 93 *Virolet*.] F1(c), F2; *Iul.* F1(u)

On your obedience, and your love, deliver it.
If you doe thus, we shall not meet in heaven sweet;
No guilty blood comes there; kill your intentions,
And then you conquer: there where I am going,
Would you not meet me Deare?
Juliana. Yes.
Virolet. And still love me? 100
Juliana. And still behold you.
Virolet. Live then till heaven cals you,
Then ripe and full of sweetnesse you rise Sainted,
Then I that went before you to prepare,
Shall meet and welcome you, and daily court you
With Hymnes of holy Love——I goe out,
Give me your hand, farewell, in peace farewell,
Remember me, farewell.

 Dyes.

Juliana. Sleep you sweet glasses,
An everlasting slumber Crown those Christals,
All my delight adue, farewell, Deare *Virolet*,
Deare, Deare, most Deare; O I can weep no more, 110
My body now is fire, and all consuming,
Here will I sit, forget the world, and all things,
And onely waite what heaven shall turne me to,
For now me thinkes, I should not live.

 She sits down.

 Enter Pandulfo [*with a book*].

Pandulfo. O my sweet daughter,
The worke is finisht now, I promis'd thee:
Here are thy vertues shewed, here register'd,
And here shall live for ever.
Juliana. Blot it, burne it,
I have no vertue, hatefull I am as hell is.
Pandulfo. Is not this *Virolet?*
Juliana. Aske no more questions, 120
Mistaking him, I kil'd him.

 *105 Love——I goe out,] *stet* F1–2 120 *Juliana.*] F2; *Vir.* F1

 194

Pandulfo. O my Sonne,
Nature turnes to my heart again, my deare Sonne,
Sonne of my age, would'st thou goe out so quickly?
So poorly take thy leave, and never see me?
Was this a kind stroake daughter? could you love him?
Honour his Father, and so deadly strike him?
O wither'd timelesse youth, are all thy promises,
Thy goodly growth of Honors come to this?
Doe I halt still ith' world, and trouble nature,
When her maine pieces founder, and faile daily? 130

 Enter Lucio, *and three Servants.*

Lucio. He does weep certain: what bodies that lies by him?
How doe you Sir?
Pandulfo. O look there *Lucio,*
Thy Master, thy best Master.
Lucio. Woe is me.
They have kill'd him, slaine him basely, O my Master.
Pandulfo. Well daughter well; what heart you had to do this;
I know he did you wrong; but 'twas his fortune,
And not his fault, for my sake that have lov'd you,
But I see now, you scorne me too.
Lucio. O Mistrisse?
Can you sit there, and his cold body breathlesse?
Basely upon the earth?
Pandulfo. Let her alone Boy, 140
She glories in his end.
Lucio. You shall not sit here,
And suffer him you loved——ha; good Sir come hither,
Come hither quickly, heave her up; O heaven Sir,
O God, my heart, she's cold; cold and stiffe too.
Stiffe as a stake, she's dead.
Pandulfo. She's gone, nere bend her.
I know her heart, she could not want his company:
Blessing goe with thy soule, sweet Angels shadow it:
O, that I were the third now, what a happinesse?

 130.1 Lucio] *Boy* F1–2 131 *Lucio.* He] Boy he F1; *Boy.* He F2
 133, 138, 141 *Lucio.*] *Boy.* F1–2

 195

But I must live, to see you layed in earth both,
Then build a Chapell to your memories, 150
Where all my wealth shall fashion out your storyes.
Then digge a little grave besides, and all's done.
How sweet she looks, her eyes are open smiling,
I thought she had been alive;

 [*to Lucio*] you are my charge Sir,

[*To Servants*]. And amongst you, I'le see his goods distributed.
Take up the bodies, mourn in heart my friends,
You have lost two Noble succors; follow me,
And thou sad Country, weepe this misery.

 Exeunt [*with the bodies*].

 Enter Sesse, Boatswaine, Master, Gunner [V.iii]
 [*disguised as Switzers*], Citizens, *and*
 Souldiers, as many as may be.

Sesse. Keep the Ports strongly mand, and let none enter,
 But such as are known Patriots.
All. Liberty, liberty.
Sesse. 'Tis a substantiall thing, and not a word
 You men of *Naples*, which if once taken from us,
 All other blessings leave us; 'tis a Jewell
 Worth purchasing, at the dear rate of life,
 And so to be defended. O remember
 What you have suffer'd, since you parted with it;
 And if again you wish not to be slaves,
 And properties to *Ferrands* pride and lust, 10
 Take noble courage, and make perfect what
 Is happily begun.
1. Citizen. Our great preserver,
 You have infranchis'd us, from wretched bondage.
2. Citizen. And might be known, to whom we owe our freedome,
 We to the death would follow him.
3. Citizen. Make him King,
 The Tyrant once remov'd.
Sesse. That's not my end.
 'Twas not ambition that brought me hither,

 196

With these my faithfull friends, nor hope of spoile;
For when we did possesse the Tyrants treasure,
By force extorted from you, and employed 20
To load you with most miserable thraldome,
We did not make it ours, but with it purchas'd
The help of these, to get you liberty,
That for the same price kept you in subjection.
Nor are we Switzers, worthy Country-men,
But Neapolitans; now eye me well:

 [*Removes his disguise.*]

And tho the reverend Emblems of mine age,
My Silver locks are shorne, my beard cut off,
Partaking yet of an adulterate Colour;
Tho fourteen yeares you have not seen this face, 30
You may remember it, and call to mind,
There was a Duke of *Sess*, a much wrong'd Prince,
Wrong'd by this Tyrant *Ferrand*.
1. Citizen. Now I know him.
2. Citizen. 'Tis he, long live the Duke of *Sess*.
Sesse. I thank you.
The injuries I receiv'd, I must confesse,
Made me forget the love I owed this Country,
For which I hope, I have given satisfaction,
In being the first that stir'd, to give it freedome;
And with your loves and futherance, will call back,
Long banisht peace, and plenty, to this people. 40
2. Citizen. Lead where you please, we'l follow.
1. Citizen. Dare all dangers.

 Enter Pandulf, *the Bodies of* Virolet, *and* Juliana,
 upon a Hearse [*carried by* Lucio *and Servants*].

Sesse. What solemne funeral's this?
Pandulfo. There rest a while,
And if't be possible there can be added
Wings to your swift desire of just revenge,
Hear, (if my teares will give way to my words)
In briefe a most sad story.

Sesse. Speake, what are they?
 I know thee well *Pandulfo*.
Pandulfo. My best Lord?
 As farre as sorrow will give leave, most welcome;
 This *Virolet* was, and but a Sonne of mine,
 I might say, the most hopefull of our Gentry; 50
 And though unfortunate, never Ignoble:
 But I'le speake him no further. Look on this,
 This face, that in a Savage would move pitty,
 The wonder of her Sex; and having said
 'Tis *Juliana*, Eloquence will want words
 To set out her deservings; this blest Lady
 That did indure the Rack, to save her Husband,
 That Husband, who, in being forc'd to leave her,
 Indur'd a thousand tortures; By what practise,
 I know not, (but 'twas sure a cunning one) 60
 Are made, the last I hope, but sad examples
 Of *Ferrands* Tyranny. Convey the bodies hence.

 [Exeunt Lucio *and Servants with the bodies.]*

Sesse. Expresse your sorrow
 In your revenge, not teares, my worthy Souldiers:
 That fertile earth, that teem'd so many children,
 To feed his cruelty, in her wounded wombe,
 Can hardly now receive 'em
Boteswain. We are cold,
 Cold walls shall not keep him from us.
Gunner. Were he cover'd
 With mountaines, and roome onely for a bullet
 To be sent levell at him, I would speed him. 70
Master. Let's scale this petty Towre; at Sea we are Falcons,
 And fly unto the maine top in a moment.
 What then can stop us here?
1. Citizen. We'l teare him peece-meale.
2. Citizen. Or eat a passage to him.
Sesse. Let discretion
 Direct your anger; that's a victory,
 Which is got with least losse, let us make ours such:

And therefore friends, while we hold parly here,
Raise your scalado, on the other side,
But enter'd, wreake your suffrings.

Exeunt Saylors and Souldiers.

1. Citizen. In our wrongs
There was no meane.
2. Citizen. Nor in our full revenge 80
Will we know any.
Sesse [*to* Pandulfo]. Be appeas'd good man,
No sorrow can redeem them from deaths Prison;
What his inevitable hand hath seiz'd on,
The world cannot recover. All the comfort
That I can give to you, is to see vengeance
Pour'd dreadfully upon the Authors head,
Of which their ashes may be sensible,
That have falne by him.

Sound a parly.

Enter Ferrand, Martia, Ascanio, *and* Ronvere, *above.*

Pandulfo. They appeare.
Ferrand. 'Tis not that we esteme rebellious Traytors
Worthy an answer to their proudest Sommons 90
That we vouchsafe our presence; or to exchange
One syllable with 'em: but to let such know,
Though Circled round with treason, all points bent
As to their Center at my heart, 'tis free,
Free from feare, villaines, and in this weake Tower
Ferrand commands as absolute, as when
He trod upon your necks, and as much scornes you.
And when the Sunne of Majesty shall breake through
The clouds of your rebellion, every beame
Instead of comfortable heate, shall send 100
Consuming plagues among you; and you call
That government which you term'd tyrannous
Hereafter, gentle.
Sesse. Flatter not thy selfe

79 wreake] F2 (wreak); weake F1

With these deluding hopes, thou cruell beast,
Thou art ith' toyle, and the glad Huntsman prouder,
By whom thou art taken, of his prey, then if
(Like thee) he should command, and spoile his Forrest.

Ferrand. What art thou?

Sesse. To thy horror, Duke of *Sesse.*

Ferrand. The Divel.

Sesse. Reserv'd for thy damnation.

Ferrand. Why shakes my love?

Martia. O I am lost for ever; 110
Mountains divide me from him; some kind hand
Prevent our fearfull meeting: Or lead me
To the steep rock, whose rugged brows are bent
Upon the swelling main; there let me hide me:
And as our bodies then shall be divided,
May our soules never meet.

Ferrand. Whence grows this, Sweetest?

Martia. There are a thousand furies in his looks;
And in his deadly silence more loud horror,
Then when in Hell the tortur'd and tormentors
Contend whose shreeks are greater. Wretched me! 120
It is my father.

Sesse. Yes, and I wil own her, Sir,
Till my revenge. It is my daughter, *Ferrand*;
My daughter, thous hast whor'd.

Ferrand. I triumph in it:
To know she's thine, affords me more true pleasure,
Then the act gave me, when even at the height,
I crack'd her Virgin zone. Her shame dwell on thee,
And all thy family; may they never know
A female issue, but a whore. *Ascanio*,
Ronvere, look cheerfully; be thou a man too,
And learn of me to die. That we might fall, 130
And in our ruines swallow up this Kingdom,
Nay the whol world, and make a second Chaos.
And if from thence a new beginning rise,
Be it recorded this did end with us;
And from our dust hath embryon.

Ronvere. I liv'd with you,
 And wil die with you; your example makes me
 Equally bold.
Ascanio. And I resolv'd to beare
 What ere my fate appoints me.
Sesse. They are ours,
 Now to the spoyle.
Boteswain. Pity the Lady; to all else be deaf. 140

 Exeunt.

Within. Kill, kill, kill.

 Alarum, Flourish of Trumpets. Retreat [sounded within].

 Enter Sesse *with Ferrands head, the* Citizens, [V.iv]
 Master, Boteswain, Gunner, *Souldiers, bringing in*
 Ascanio *and* Martia.

Sesse. Cruell beginnings meet with cruell ends;
 And the best sacrifice to Heaven for peace,
 Is tyrants blood: and those that stuck fast to him,
 Flesh'd instruments in his commands to mischiefe,
 With him dispatch'd
Boteswain. They are all cut off.
Sesse. Tis well.
All. Thanks to the Duke of *Sesse.*
Sesse. Pay that to Heaven,
 And for a generall joy, give generall thanks:
 For blessings nere descend from Heaven, but when
 A gratefull Sacrifice ascends from men.
 To your devotion; leave me; there's a Scene, 10
 Which I would act alone; yet you may stay,
 For wanting just spectators, twill be nothing.
 The rest forbeare me.
Citizens. Liberty, liberty, liberty.
Martia [*aside*]. I would I were as far beneath the Centre,
 As now I stand above it; how I tremble!
 Thrice happy they that dyed; I dying live
 To stand the whirlwind of a fathers fury.

 201

Now it moves toward me.

Sesse. Thou, I want a name,
By which to stile thee: All articulate sounds
That do expresse the mischiefe of vile woman, 20
That are, or have been, or shall be, are weak
To speak thee to the height. Witch, parricide,
For thou, in taking leave of modesty,
Hast kild thy father, and his honour lost;
He's but a walking shadow, to torment thee.
To leave, and rob thy father; then set free
His foes, whose slavery he did prefer
Above all treasure, was a strong defeazance
To cut off even the surest bonds of mercy.
After all this, having given up thy selfe, 30
Like to a sensuall beast, a slave to lust,
To play the whore, and then (high Heaven it racks me)
To finde out none to quench thy appetite,
But the most cruell King, whom next to Hell,
Thy father hated; and whose black imbraces
Thou shouldst have fled from, as the whips of furies;
What canst thou look for?

Martia. Death; and tis not in you
To hurt me further: my old resolution,
Take now the place of feare; in this I liv'd,
In this Ile die, your daughter.

 Enter Pandulph, *and bodies* [*of* Virolet *and* Juliana]
 borne on the Herse [*by* Lucio *and Servants*].

Pandulfo. Look but here; 40
You had, I know, a guilty hand in this;
Repent it Lady.

Martia. *Juliana* dead?
And *Virolet?*

Pandulfo. By her unwilling hand.

Martia. Fates you are equall. What can now fall on me,
That I wil shrink at? now unmov'd I dare
Look on your anger, and not bend a knee
To aske your pardon: let your rage run higher
Then billows rais'd up by a violent Tempest,

And be as that is, deafe to all intreaties:
They are dead, and I prepar'd; for in their fall 50
All my desires are sum'd up.

Sesse. Impudent too?
Die in it wretch.

Boteswain. Stay sir.

 Boteswain *kils her.*

Sesse. How dar'st thou villaine,
Snatch from my sword the honour of my justice?

Boteswain. I never did you better service sir,
Yet have been ever faithfull. I confesse
That she deserv'd to die; but by whose hand?
Not by a fathers. Double all her guilt,
It could not make you innocent, had you done it.
In me tis murder, in you twere a crime
Heaven could not pardon. Witnesse that I love you, 60
And in that love I did it.

Sesse. Thou art Noble,
I thank thee for't; the thought of her die with her.

Ascanio [*aside*]. My turn is next: since she could finde no mercy,
What am I to expect?

1. Citizen. With one voyce, sir,
The Citizens salute you, with the stile
Of King of *Naples.*

Sesse. I must be excus'd,
The burden is too heavy for my shoulder,
Bestow it where tis due. Stand forth *Ascanio,*
It does belong to you; live long and weare it,
And warn'd by the example of your Unkle, 70
Learn that you are to govern men, not beasts:
And that it is a most improvident head,
That strives to hurt the limbs that do support it.
Give buriall to the dead; for me, and mine,
We wil again to Sea, and never know,
The place, which in my birth first gave me woe.

 Exeunt.
 Flourish Trumpets.

64 *1. Citizen.*] Dyce; *Cit.* F1–2

TEXTUAL NOTES

I.i

95 The rases of our horses] F2 reads 'Races' (i.e., breed, stock). The phrase comes from Massinger's source for this passage in Thomas Danett's translation of *The History of Philip de Comines* (New York, 1967), II, 213, which is worth quoting at length for its relevance to I.i.89–102 of *The Double Marriage* (de Comines is describing the tyrannical policies of Ferrand I, King of Naples):

> Moreover, he used within his realme all trade of merchandise himselfe, so far foorth that he delivered swine to his people to feede, which they were constrained to fatte to further their sale: and if any of them happened to die, they were forced to make them good. In those places where the oile olive groweth (namely in Pouille) he and his sonne bought it all up at their owne price: and in like maner the corne yet greene upon the ground, which they sold againe as deere as was possible; and if the price thereof happened to fall, they constrained their subjects to buie it: besides that, during the time of their sale, all other were forbidden to sell. If any of their noble men were a good husband, and thought to spare some good thing for himselfe, they would foorthwith desire to borrow it; and if he made refusall, he was constrained to deliver it perforce: so that they used to take from them the races of their horses (wherewith that countrey aboundeth) and to cause them to be broken and kept to their owne use: yea and that such numbers as well of horses as of mares and colts, that they were esteemed many thousands, which also they sent to feede in divers places in the pastures of their noble men and other their subjects to their great losse and dammage. Both of them had forced many women; and as touching the Church, they had it in no reverence, neither would obey the lawes thereof, so farre foorth that they sold Bishoprikes for monie; as for example, the Bishoprike of Tarente sold to a Iew by King Ferrande for thirteene thousand ducats, to bestow upon his sonne, who (he said) was a Christian.

I.ii

18 Grown] Line 17 ('Cox-combs ... foole,') is the last line on sig. 5C4 of F1, where it is followed by the catchword 'Grown'; but line 18 ('Grown ... parasite.'), printed at the top of the first column of sig. 5C4v, is mistakenly preceded in some copies of F1 by a repetition of the speech prefix *Vil.* (omitted in F2). Sigs. 5C4 and 5C4v were both set by Compositor *A*, and it seems curious that, having set the prefix '*Vil.*' and the catchword 'Grown' in their proper places at the foot of sig. 5C4, he should have gone on to set another prefix at the head of sig. 5C4v. The

most likely explanation is that a proof-reader, correcting sig. 5C4v, wrongly added the prefix to what seemed to him an unattributed speech.

II.i

80 Some discontents she has.] 'That is, Some of my discontents have come to her knowledge, but not the cause of them' (J. Monck Mason, *Comments on the Plays of Beaumont and Fletcher* (London, 1798), p. 250.

148 *Rossana*] E. H. C. Oliphant (*The Plays of Beaumont and Fletcher* (New Haven, 1927), p. 230) wondered if this was 'a character in Fletcher's play, omitted by Massinger in revision'. He failed to recognize what the present passage makes clear: that the Prince of Rossana is the 'young *Ascanio*'. The name '*Rossana*' occurs again at III.iii.217. It appears in de Comines' *History*, where the Duc du Sesse and the Prince de Rosane are mentioned together as victims (both murdered after long imprisonment) of the cruelty of the Arragonese kings of Naples. See de Comines, II, 211–12 (trans. Danett, where the play's '*Rossana*' is given as '*Rossano*'). Historically, the Duke of Sesse and the Prince of Rossano were the same person (see R. Warwick Bond, 'On six plays in Beaumont and *1679*', *Review of English Studies*, XI (1935), 259).

177.1 Boy *atop*] The Boteswain has dispatched the boy 'To th' main top' earlier in this scene, at line 64, to serve as a look-out for other ships, and he now emerges high above the stage, on the third level of the tiring-house, in what, in the present dramatic context, would represent the crow's nest. The stage direction '*atop*' here is often compared to Shakespeare's *The Tempest*, III.iii.17, where Prospero appears '*on the top (invisible)*' to witness the action below. The staging of both scenes is discussed by Frank Kermode in his Arden Edition of *The Tempest* (New York, 1964), pp. 152–5, and by Irwin Smith in his *Shakespeare's Blackfriars Playhouse: Its History and Its Design* (New York, 1964), pp. 412–14.

191 spoon] 'to put a ship, right before the wind and sea, without any saile (and that is called spooneing afore).' Sir Henry Manwaring, *The Seaman's Dictionary*, 1644 (written in or about 1625).

193 chase] Mason (p. 250) writes in support of Sympson's emendation: 'There are in all ships of war two guns, at the least, placed in the bow, and two more in the stern, which are called the bow-chace and the stern-chace: the first are used against a vessel that is a-head; the other against a vessel that pursues.' Fletcher evidently thinks of the chase as part of the ship, a meaning acknowledged in *O.E.D.*: 'the part of the ship where the chase-ports are' (Chase, *sb*.1.6).

195 eye and level] Dyce queried 'eye as level', but 'level' here is not an adjective but a noun ('the action of aiming a gun, etc., aim' (*O.E.D.*)). Martia asks that the Gunner's eye and aim be as firm as his courage ('heart').

II.iv

126 Now put 'em on.] Following these words, F1 adds the words 'Unbolt him.', thus repeating Martia's command at the beginning of line 125. The words are omitted in F2. Colman and Weber add the stage-direction: 'Virolet *released.*'

II.v

4–6 I would ... wrath.] Mason (pp. 251–2) comments: 'What the Duke means to say is, that nothing could satisfy his wrath, but the destruction of all the court, all the villainy, and the tyrant himself.'

23–41 'Twas but ... Who knew of this?] The F1 text of this turbulent scene is troublesome, chiefly because of the way in which stage-directions and dialogue are crowded together in the margin, and because of the omission of necessary entrances and exits. In the right-hand margin beside the Master's 'Twas but the heate o'th fight sir' and the Boteswain's 'Look out, what's that?' (lines 23–4) F1 prints 'Boateswain | within & Sailor.' The Boteswain's question, the Sailor's reply, and the Boteswain's call ('Ho, there, ith long Bote') are all spoken from 'within'. Lines 25–7 are printed thus in F1:

> Bote. Ho, there, ith long Bote. *She claps on all*
> Ses. What noise is that? *Hoy.* *her Oares.*

F2 (followed by Langbaine) eliminated the problem of what to do with 'She claps on all her Oares' by omitting the words, but editors since Sympson have recognized that, though printed in the manner of a marginal stage-direction, the words in fact are part of the play's dialogue, and are spoken by the off-stage Sailor with reference to the already twice-mentioned long-boat. The cry 'Hoy' is the Sailor's equivalent to the Boteswain's 'Ho' in the previous line, and addressed like it to the long-boat's fleeing passengers (the Sailor picks up the cry at line 30). Dyce regarded 'Hoy' as a 'Cry, within, from the long-boat', but this seems improbable. The cries are all on one side, from Sesse's men, calling out in amazement after whoever it is that is making off from their ship. The escaping party in the long-boat keeps silent. F1 provides an *Exit* for the Master when he goes off to investigate (line 28.1), and brings him on again just before his speech at line 32. By line 31, the Boteswain, whose previous speeches have been heard from 'within', has re-appeared to announce that Sesse's daughter has 'stolne off.' In its uncorrected state, sig. 5D3v of F1 contained a marginal stage-direction ('En. Boate- | swain') that brought the Boteswain on stage at this point, but this stage-direction has been unaccountably omitted in the 'corrected' state of the printing. When the Gunner enters at line 35.1, F1 has him asking: 'Who knew of this trick?' It seems an odd question to come from him, and when, at line 41, Sesse (the aggrieved father) more appropriately asks 'Who knew of this?' it seems clear that the Gunner's speech is, in Colman's words, 'an accidental interpolation', it being in effect Sesse's speech of a few lines later. The Gunner's words, however, have been retained in all previous editions of the play. All these textual problems, together with the repetition noted in the footnotes to the text at II.v.47–8, indicate that copy for F1 was unusually difficult at this point.

III.i

77 King now] The F1 reading 'Kingdome' (F2: 'kingdom') is unsatisfactory in view of Villio's response ('As of a man ...') in the following line. Colman emended the F1 reading to 'King' and subsequent editors through to Dyce have followed,

though Dyce 'suspect[ed] the poet wrote "*king* now"', an emendation that seems both dramatically more appropriate and orthographically more plausible than Colman's.

III.ii

80 Your friend and *Oliver*.] For this epistolary mode of signing oneself, cf. Beaumont, *The Knight of the Burning Pestle*, II.211: 'your good friend and Humphrey'. *Oliver* presumably has reference to the proverbial 'Sweet Oliver' (Tilley, O40).

110 We thank you.——Vanish!] In both F1 and F2 the words appear thus:

We thank you. *vanish.*

The italic 'vanish' could be another of F1's laconic stage-directions, like '*take away*' and '*pass o're*', but since there is in fact a marginal stage-direction in F1 at the end of this line and the one above that clears the stage ('*Ex.Sess.Boatsw.* | *Saylers, Citizens.*'), it seems more likely that 'vanish' is spoken by Sesse as an injunction to the others to depart before the appearance of Ferrand.

IV.iii

34 *Exit* Lucio.] Though Lucio's (the Boy's) entrance with Juliana is clearly marked at IV.iii.31, and he has a speech upon his entrance, he is not heard from again in the course of this long scene, and there is no indication of when he leaves the stage. His continued presence would be awkward during the intense interview between Juliana and Virolet, and the impassioned encounter of Juliana, Virolet and Martia, and since Lucio has nothing to do after delivering his two-and-a-half-line entrance-speech, and Juliana has told him to 'Stand by', it seems best for him to exit at this point. Previous editions of the play have taken no account of the character after line 34.

155 trinket] This, as Mason (p. 254) noted, is Martia's contemptuous designation of Juliana. Cf. *The Sea Voyage*, I.i.74.

V.ii

105 Love——I goe out,] Sympson thought the dash had 'swallow'd up a Word which is requisite to complete' the sense, and imagined the passage should read: 'With Hymnes of holy Love——'fore I goe out, | Give me your hand'. Colman had 'no doubt but *Gods* was the original word for which an *hiatus* is here substituted'. Weber preferred 'God' to 'Gods', and Dyce prints 'God' in square brackets. For Colman and Weber, the added word fills the gap marked by the dash, which is not retained in their editions. Sympson and Dyce preserve the dash, but consider it to imply both a break in Virolet's final utterances, and a suppressed word which each editor, in his own way, supplies. Since a dying man might be expected to speak in broken phrases, the dash seems sufficiently accounted for here, and there seems no need to imagine that it marks the suppression of a word or phrase that an editor need attempt to provide.

PRESS VARIANTS IN F1 (1647)

[Copies collated: Hoy (personal copy of Cyrus Hoy, Rochester, N.Y.), ICN (Newberry Library), IU (University of Illinois), MB (Boston Public Library), MH (Harvard University), MnU (University of Minnesota), MWiW–C (Chapin Library, Williams College), NcD (Duke University), NIC (Cornell University), NjP (Princeton University), PSt (Pennsylvania State University), RoU (University of Rochester), ViU1 (University of Virginia copy 1), ViU2 (copy 2), WaU (University of Washington), WMU1 (University of Wisconsin-Milwaukee copy 1) WMU2 (copy 2), WMU3 (copy 3), WMU4 (copy 4), WU (University of Wisconsin-Madison).

SHEET 5Ci (*outer forme*)

Uncorrected: MH, MnU, MWiW–C, NjP, PSt, RoU, ViU1–2, WMU2, WMU4, WU
Corrected: The rest
Sig. 5C4v
 I.ii.18 *Vil.*Grown] Grown
 (*The presumed correction is in fact an error. See Textual Notes.*)

SHEET 5Cii (*inner forme*)

Uncorrected: ICN, IU, MnU, NIC, ViU1–2, WaU, WMU3
Corrected: The rest
Sig. 5C3
 I.i.67 bred] bread

SHEET 5Dii (*outer forme*)

Uncorrected: ViU2
Corrected: The rest
Sig. 5D2
 II.i.185 Naples ∧ Naples,] ~ , ~ ;
 II.i.188 true——] ~ .
 II.i.188 Bots.] *Both.*
 II.i.195 level ∧] ~ ,
 II.i.200 her i'th bowe wel] her i'th bow wel
 II.ii.1 They'l] Theyl
 II.iii.5 (yet flew] (flew
 II.iii.6 She swims] Yet she swims
 II.iii.23 Ye] You

II.iii.39 show] strove
II.iii.49 Pedagogue ∧] ~ ?
sig.5D3v
 Head-line *double*] *doble*
 II.v.11 loose——] ~ .
 II.v.21 into th'] intoth'
 II.v.31 *omit*] *En. Boate* – | *swain.*
 II.v.41 divel] divels
 II.v.45 ever] over
 II.v.48 aire,] aire sir,
 II.v.50 impudently ∧] ~ ,
 II.v.51 her, coole] ~ ∧ ~
 II.v.53 Cables;] ~ .
 II.v.55 Although ... *Ferrants* ... ile] Altho ... jerrants ... i'le
 II.v.56 suffer——] ~ .
 III.i.3 honour ∧] ~ ,
 III.i.4 houses ∧] ~ ,
 III.i.10 pomp] pamp
 III.i.23 summing] sum ming
 III.i.28 villains] villians

SHEET 5Fii (*outer forme*)

Uncorrected: Hoy, IU, MB, MnU, NcD, NIC, NjP, ViU1–2, WMU1–2, WU
Corrected: the rest
Sig. 5F2
 V.ii.92–93 *Iul.* *Vir.*] *Vir.* *Iul.*

I.i

I.i] *Actus Primus——Scæna Prima.*
 F1–2

45–46 How ... then?] F1–2 *line:* How
 ... blest │ In ... unfain'd; │ And ...
 then?

115 men,] ~ . F1–2

119 effected,] F2; ~ ? F1

125 invincible] F2; invincesible F1

143 these;] ~ . F1–2

183 Brissonet,] F2; ~ ∧ F1

185 Sir,] ~ ? F1–2

227–228 To him and ... devotion.] *one*
 line in F1–2

251.1 *Exeunt.*] *after* 'providence.' (*line*
 251) *in* F1–2

251.2 Juliana] *Julian* F1–2

277–278 There's ... them;] F1–2 *line:*
 There's ... fixt │ On ... them;

I.ii

I.ii] W; *no scene division in* F1–2, L, S, C

7 burthen?] ~ . F1–2

19 envy——) ~ , F1; ~ . F2

23 Nectar——] ~ . F1–2

23–24 Here's ... fellowes.] *one line in*
 F1–2

24 too] F2; to F1

29–30 This ... observance.] *one line in*
 F1–2

30, 31.1 *Flourish.* │ ... │ *Enter* ...
 Servants.] *Flourish* ∧ *Enter Fer-*
 rand, │ *Guard,* │ *women,* │ *Servants.*
 F1 (*in margin of lines* 31–4); '*Flour-*
 ish' *on line* 31, '*Enter* ... *Servants*'
 on line 31.1 *in* F2

30–31 Now ... earth-quakes.] *one line*
 in F1–2

32–34 These meates ... what are
 these?] F1–2 *line:* These meates ...
 hang │ The Cookes ... on │ Forfeit
 ... doe you │ Envy ... what are
 these?

34 slumber,——] ~ , ∧ F1–2

46 mightiest] F2; mightest F1

53 mankinde——] ~ . F1–2

55 voyce;] ~ , F1–2

61 me,] ~ ∧ F1–2

68 hereafter.——] ~ . ∧ F1–2

68 Ha] F2; ha F1

71 discover'd——] ~ . F1–2

79 countries,] ~ ∧ F1–2

89.1 *Exit* Ronvere] *on line* 88 *in* F1–2

91–92 Thou ... *Jove,*] *one line in* F1–2

93.1 *Exeunt*] *Exit* F1–2

98 Brissonet,] F2; ~ ∧ F1

99–100 The waight ... thine.] F1–2
 line: The waight ... Traytors │
 Heart ... thine.

101–102 Pish ... me.] F1–2 *line:* Pish
 ... will │ Never ... me.

118 contemn'd?] F2; ~ . F1

122 slow;——] ~ ; ∧ F1–2

127–128 Is she insensible ... is she
 dead?] *one line in* F1–2

132–133 Confesse ... safe.] F1–2 *line:*
 Confesse yet, │ And thou ... safe.

137 She tires ... and me.] F1–2 *line:* She
 tires th'executioners, │ And me.

142 cruell.——] ~ . ∧ F1–2

157 Generall;] ~ , F1–2

158 it,] F2; ~ ; F1

173 friend,] ~ ; F1; ~ ∧ F2

II.i

II.i] *Actus secundus. Scæna prima.* F1–2
66 Levet,] ~ . F1–2
149–150 You ... hang'd?] F1–2 *line:*
 You ... agoe? | Why ... hang'd?
179, 197 (*above*)] ∧ ~ ∧ F1–2
180–181 Look right, | And look again.]

 one line in F1–2
185 Of *Naples,*] F1(u), F2; ~ ~ ∧
 F1(c)
188 true.] F1(u), F2; ~ —— F1(c)
199.1, 207.1 *Exeunt.*] *Exit.* F1–2
207.2 *Charge,*] ~ ∧ F1–2

II.ii

II.ii] *no scene division in* F1–2, L, S, C,
 W, D
2 feathers,] ~ . F1–2

9 boy.] boy, F2; hoy ∧ F1
10 idle?] F2; ~ . F1
10.1 *Exeunt.*] *Exit.* F1–2

II.iii

II.iii] *no scene division in* F1–2, L, S, C;
 Scene II. W, D
1–2 Cut ... Sea.] *one line in* F1–2
4–5 Pox ... flew.] *one line in* F1–2
5–6 They ... lustily.] F1–2 *line:*
 They ... holes, | She ... lustily.
8–9 Bring ... fire.] *one line in* F1–2
12–13 Ye did ... men.] *one line in* F1–2
15 his. ∧ How] F2; his. —How F1
16 anger?——how] ~ ? ∧ ~ F1–2
17–18 No ... fury.] *one line in* F1–2

18 fury.——] ~ . ∧ F1–2
20 much.——Good] much ∧ ∧ good
 F1–2
22 in,——] ~ , ∧ F1–2
36 credit——] ~ . F1; ~ ? F2
43 Gentleman——] F2; ~ . F1
51 language——] ~ . F1–2
54 cruelties,] ~ . F1–2
62.1 *Exeunt*] *Exit* F1–2
65 fortunes] F2; fortuns F1

II.iv

II.iv] *no scene division in* F1–2, L, S, C;
 Scene III. W, D
17 now.] ~ ? F1–2
41 remedy?] ~ . F1–2

70 sleep,] ~ ? F1–2
97 glory,] ~ ? F1; ~ : F2
124 mind?——] ~ ? ∧ F1–2

II.v

II.v] *no scene division in* F1–2, L, S, C;
 Scene IV. W, D
4 villany ∧] ~ , F1–2
5–6 *Ferrand,* | Tyrant ∧ and all,] ~
 ∧ | ~ , ~ ~ ∧ F1–2

26 ——Hoy!] ∧ *Hoy.* F1–2
51 her;] F2; ~ ∧ F1
58 taste——] ~ . F1–2
60 (*within*)] ∧ ~ ∧ F1–2

III.i

III.i] *Actus tertius. Scœna prima.* F1–2
 0.1 *Florish cornets.] after* 'sir' (*line* 1)
 in F1–2
 0.2 Villio] F2; *Villo* F1
 3 honour,] F1(u), F2; ~ ∧ F1(c)
 76 Majesty,] ~ ? F1–2

87 deserve ∧] ~ . F1–2
101.1, 121.1 Exeunt] *Exit* F1–2
117 safety.] ~ , F1–2
129 *Juliana*] L; *Julicana* F1; *Juliano* F2
133 this.——] ~ . ∧ F1–2

III.ii

III.ii] W; *no scene division in* F1–2, L, S, C
 26 The next ... Jew,] F1–2 *line:* The next ... weather │ Me ... Jew,
 30 gallants ∧] ~ , F1–2
 37 marke.] ~ ? F1–2
 42 tyrant;——] ~ ; ∧ F1–2
 64 Castruchio] *Castrucrio* F1; *Castruccio* F2
 65 And pluck ... there.] F1–2 *line:* And pluck ... Row │ Of ... there.
 69 forfeit] F2; *foreit* F1

82.1 Ronvere] *Ronvero* F1–2
98 King?] ~ . F1–2
99–100 Yes ... puppy.] *one line in* F1–2
104 Do ... Gentlemen.] F1–2 *line:* Do ... thing. │ But ... Gentlemen.
110.2 *Florish Cornets.] after* 'Enter ... Ronvere.' *in* F1–2
110.2 Ferand,] F2; ~ . F1
121 swing——] ~ . F1–2
123 Foole——] ~ . F1–2

III.iii

III.iii] W; *no scene division in* F1–2, L, S, C
 0.2 Guard] *guard* F1–2
 47 good,] F2; ~ ∧ F1
 51 *Enter* Lucio] *after* 'sure.' (*line* 48) *in* F1–2
 70 sadnesse!] ~ ? F1–2
 72 duty——] ~ . F1–2
 74 Boy——] ~ . F1–2
 76 here?] ~ . F1–2
 90.1 *Enter ...* Lucio] *on line* 88 *in* F1–2
 92.1 *They ... off] after* 'leave.' (*line* 92) *in* F1–2
 104 ingratitude.——] ~ . ∧ F1–2
 107 yet:——] ~ : ∧ F1–2
 109 goodnesse?——] ~ ? ∧ F1–2
 146 treacherous——] ~ ∧ F1; ~ . F2
 148 words——] ~ . F1–2
 156 nature,] F2; ~ ? F1

158 *Virolet*——] ~ . F1–2
158 Sir——] ~ . F1; ~ ! F2
159 amaze——] ~ : F1–2
161 birth——] ~ . F1–2
176 Ascanio] F2; *Ascaino* F1
181 her——] ~ . F1–2
184 render'd,] F2; ~ . F1
191 then——] ~ : F1–2
206 slave——] ~ ? F1–2
209 suffer'd——] ~ ; F1–2
241 know——] ~ : F1–2
254 Lawyer?] ~ . F1–2
254 her;] ~ ∧ F1–2
259 Sir,] F2; ~ ; F1
276 fortune——] ~ . F1–2
278 hinges,——] ~ , ∧ F1–2
279 Exeunt] *Exit* F1; *Ex.* F2
279 Ronvere ∧] F2; *Ronver.* F1
281 agen——] ~ . F1; ~ , F2

292 vowes——] ~ . F1–2
293 so,——] ~ , ∧ F1–2
293 those ∧] F2; ~ ; F1

295 nature——] F2; ~ . F1
295 Husband?] F2; ~ ; F1
297 bounty——] F2; ~ . F1

IV.i

IV.i] *Actus quartus Scæna prima.* F1–2
6 shore,] ~ ; F1; ~ ∧ F2
6 at?] ~ ∧ F1; ~ : F2
20 get ∧] ~ , F1–2
35 heart,] ~ . F1–2
36 Ronvere ... *Ronvere*] F2; *Ronero ... Ronero* F1

54 search] F2; searcb F1
60 dispatch'd——] ~ . F1–2
61 man——] ~ , F1; ~ . F2
62 You ... purse-strings.] F1–2 *line:* You ... tye | Our ... purse-strings.
68 *Exeunt*] *Exit* F1–2

IV.ii

IV.ii] W; *no scene division in* F1–2, L, S, C
2 Sir——] ~ . F1–2
3 Family,] F2; ~ ; F1
5 too,] ~ . F1–2
13–14 I know ... suffer.] *one line in* F1–2
33 *Enter* Lucio] *following* '*Exit* Pan-

dulfo' (*line* 28) *in* F1–2
41 Wrinckles] F2; Wrinckes F1
54 that.] ~ ∧ F1–2
60 low:——] ~ : ∧ F1–2
60 you,] ~ . F1–2
61 it.] ~ , F1–2
128 women?——] ~ ? ∧ F1–2

IV.iii

IV.iii] W; *no scene division in* F1–2, L, S, C
11 How,] ~ ∧ F1–2
31 on?] F2; ~ . F1
70 me ∧ you] ~ , ~ F1–2
70 imagine,] ~ ∧ F1–2
73 revenge,] ~ . F1–2
91 wife—— ... wife——] ~ ~ . F1–2
91–92 Be tender ... else] *one line in* F1–2

109 Ha,] ~ ∧ F1–2
112 Slave-like,] Slave, like ∧ F1–2
115 preventions;——] ~ ; ∧ F1; ~ , ∧ F2
122 it,——] ~ , ∧ F1–2
156 You ... Lady.] F1–2 *line:* You ... selfe; | Y'are ... Lady.
188 banquerout.] ~ , F1–2
191 bed ∧ ——] be!—— F1–2
208 breed——] ~ . F1–2

IV.iv

IV.iv] W; *no scene division in* F1–2, L, S, C
9 Lady——] ~ . F1–2
11 Tis ... demilances,] F1–2 *line:* Tis

... now, | Such demilances,
24 sir?——] ~ ? ∧ F1–2
25–26 In ... grace?] F1–2 *line:* In ... it. | Must ... grace?

27 favour?——] ~ ? ∧ F1–2 52.1 *Exeunt.*] *Exit.* F1–2
44 here;] ~ ∧ F1–2 62 stories.——] ~ . ∧ F1–2

V.i

V.i] *Actus quintus, Scæna prima.* F1; 100 Partridges,] ~ . F1–2
 Actus V. | *Scæna Prima.* F2 103 Buzzards——] ~ . F1–2
17 thanks;——] ~ ; ∧ F1–2 105 starv'd,——] ~ , ∧ F1–2
18 can ∧ imagine,] ~ ; ~ ∧ F1–2 108 Doctor,——] ~ , ∧ F1–2
20 Master, Boatswain] *Mr. Bortsw.* 109 unsatisfied] F2; unsatsfied F1
 F1–2 119 Pease——] ~ . F1–2
20 Switzers ∧] ~ . F1; ~ : F2 124–125 Now ... they.] *one line in* F1–2
29.2 *Cornets.*] *Cor.* F1–2 137 faile,] ~ ∧ F1–2
36 grace,——] ~ , ∧ F1–2 140 well,] ~ . F1–2
36 *Enter Ladies.*] *one line* 35 *in* F1; 150 Sesse, ... Boatswain,] *Sess. ...*
 following line 35 *in* F2 *Boatsw.* F1–2
50 itch,——] ~ , ∧ F1–2 160, 165 King——] ~ . F1–2
51 You ... say,] F1–2 *line:* You black 160 ours,] ~ . F1–2
 ... with you | Give ... say, 161 ports. Fight] port, fight F1–2
51 you——] ~ ∧ F1; ~ . F2 166 him——] ~ . F1–2
64 Doctor,——] ~ , ∧ F1; ~ . ∧ F2 169 not.] ~ ∧ F1; ~ , F2
88 yet,——] yet, ∧ F1–2 170.1 *Enter* Boatswain.] *Enter Boatsw.*
88 *take away*] *on line* 89 *in* F1–2 (*after* 'words' (*line* 170) *in* F1–2)
89 you——] ~ : F1–2 171 strength.] ~ ; F1–2

V.ii

V.ii] W; *no scene division in* F1–2, L, S, C edness F2
8 deare.] ~ , F1–2 75 in,] F2; ~ ∧ F1
51 wickednesse] wicknesse F1; wick- 147 it:] ~ ∧ F1–2

V.iii

V.iii] W; *no scene division in* F1–2, L, S, ~ ∧ wreak ∧ F2
 C 79 wrongs ∧] ~ . F1–2
0.1 Sesse,] *Sess.* F1–2 95 feare,] F2; ~ ∧ F1
0.1 Boatswaine] F2; *Boitswaine* F1 105 Huntsman] F2; Huntsmam F1
30 fourteen] 14. F1–2 125 when] F2; When F1
32 a much] A much F1–2 128 whore.] ~ , F1; ~ ; F2
60 but] F2; bur F1 128 *Ascanio,*] ~ . F1–2
68–70 Were ... him.] F1–2 *line:* Were 140 deaf] F2; deaft F1
 ... onely for a | Bullet ... him. 141.1 *Flourish of Trumpets.*] *Flo. Trum-*
79 enter'd, wreake ∧] ~ ∧ weake, F1; *pets.* F1–2

V.iv

V.iv] D; *no scene division in* F1–2, L, S, 29 off$_\wedge$] ~ , F1–2
 C; *Scene III. continues in* W 40 *Enter ... Herse*] *after* 'look for?'
 13 Liberty,] F2; ~ $_\wedge$ F1 (*line* 37) *in* F1–2

HISTORICAL COLLATION

[This collation against the present text includes the two seventeenth-century editions
(F1, 1647; F2, 1679), and the editions of Langbaine (L, 1711), Theobald, Seward
and Sympson (S, 1750), Colman (C, 1778), Weber (W, 1812), and Dyce (D, 1843–
6), plus the commentary of J. Monck Mason (*Comments on the Plays of Beaumont
and Fletcher* (London, 1798)). Omission of a siglum indicates that the text
concerned agrees with the reading of the lemma.]

I.i

0.1, 1, 3, 4, 11, 13 *Lucio.*] *Boy.* F1–2,
 L, S, C
18 from] to F1–2, L–W
44 I do believe ye] I doe believe F2, L;
 I believe ye S; I do believe you C,
 W, D
67 bred] bread F1(u)

84 Equals say] Equall say F1–2, L
99 of] off F1
199 conscience] confidence C, W
221 by] *omit* F1–2, L
233 loose] lose F2 +
283 loose] lose L +
284 an] am F1–2, L

I.ii

1 rapt] wrapt W
9 ore] Oar F2, L, S
14 to] do S
18 Grown] *Vil.* Grown F1(c?)
24 too] to F1
25 choyce] chice F2
41 turne] turns F2, L, S, C
51 *Villio.*] *Vir.* F1
55 or] of F2

64 strow'd] strew'd F2, L–W
81 tract] track S–D
99 sit] sits F2, L, S
104 fine] five F1
114 on] one F1
120 death, the Victory] death of victory
 F2, L
126 harder] hard F1–2, L
133 shalt] shal F1

II.i

1 Lay her] Ley here F1; Lay here F2,
 L
1 with her] with your F2, L
7 *Sailors (within).* Ho, ho.] Ho, ho,
 within. F1–2, L (*printed as part of
 Boteswain's speech*)
8 Lay] Ley F1
22 Bonuto] *Bonetto* S; bonito C, W, D

27 Bullet] Bullets S
35 right, fir'd] right, and fir'd F2, L
44 too] to F1
56 has] have S–D
62 bestow] bestoy L
65 And] An S–D
70, 80, 86, 99, 103, 109, 135, 146, 158,
 167, 180 *Martia.*] *Daugh.* F1–2

81 stoed] stored F2, L, S, C; stowed
 W, D
88 wooed] woed L
139 go] do S
140 doting] dyating F2, L
149 is not he] is he not W
152 thread] bed F1–2, L

190 She] He F1–2
191 spoom] spoon S, C
193 chase] chape F1–2, L
197 Ho] Hoy C, W
199.1 Saylors] *Sayl.* F1–W
206 haile] saile F1–2, L, S, C

II.ii

5 shall] should F2, L, S

9 boy] hoy F1

II.iii

5 yet] *omit* F1(u)
6 she] Yet she F1(u)

23 Ye] You F1 (u)
39 show] strove F1 (u)

II.iv

17 too] to F1
27 wooed] woed F1
48 lead] load S
60 though] but F1
62 Bent] But F1
66 affection] affections F1–2, L

109 Death] 'Death F, C, W, D; S'Death
 S
126 Now ... on.] Now ... on. Unbolt
 him. F1
178 selfe] selves S
179 mine own] my own L–W

II.v

5–6 foule *Ferrand,* | *Tyrant*] foul
 Tyrant | *Ferrand* S, C
13 anger] angers F1
22 swom] swam F2, L–W
25 long Bote.] long-boat! ho! C
26 She ... Oares.] *printed as a stage-
 direction in* F1; *omit* F2, L; *conjec-
 tured to be part of text spoken by
 Sailor* S; *printed as such in* C, W, D
26 Hoy.] *printed in margin in italic after
 'that?'* line 27 *in* F1–2, L, S; *omit* C;
 *printed as a 'Cry, within, from the
 long-boat'* D
28 *Master.*] *omit* F2, L, S (*thus making
 the words* 'I hear sir' *part of Sesse's
 speech at line* 27, *as Mason
 conjectured*)

31 *Enter* Boteswain.] *omit* F1(c)
35.1 *Enter* Gunner.] *In* F1–2 + *the
 Gunner following his entrance asks:*
 'Who knew of this trick?' (*evidently
 an anticipation of the question asked
 at line* 41 *by Sesse, as* C, D *note*)
40 I hurt] I'll hurt F2, L
41 *Trumpets*] *Trump.* F1–2
45 divel] divels F1(u)
45 ever] over F1(u)
47–48 Rise ... Seas] Rise winds, blow
 till you burst the aire, | Blow till ye
 burst the aire, and swell the Seas F1
48 aire,] aire sir, F1(u)
53 come,] *omit* F2, L
60 O maine] Oh main F2, L; All
 o'main S (*where the phrase is*

*included as part of Sesse's preceding
speech),* C (*where the phrase is*

spoken by a 'Sailor within'); Amain
W, D

III.i

12 marke] mark'd S, C, W
28 villain] villains F1(c); villians F1(u)
34 mighty] might F1
56 loud] low F1
77 King now] Kingdome F1–2, L, S;
 king C, W, D
85 Ha?] *omit* F2, L, S

97 wardrop] Wardrobe F2+
102 our] *omit* F1
103 s.p. *Virolet*] *omit* F1–2, L
105 all men] all the men F1
126 me,] *omit* L, S
134 *Virolet.*] *Ron.* L

III.ii

9 mad] made F1
24–25 Good ... perswaded.] F1 adds
 marginal s.d.: '*En. Citizens,* |
 severally.'
26 The next faire open weather] *printed
 after* 'On every bush' (*line* 29) *in* C
29 he] *omit* S
30 would] now F1, S, C, W; should
 F2, L
36 What are] Who are L; Who're S
52 sorrow] sorrows S, C, W
54 save] *omit* F1
62 *1. Guard (within).*] *Within* I. F1–2,
 L
64 *cornets*] *colours* F1–2, L–W

81 cunning] comming F1
84 vild] wild F1–2, L, S (*conj.* vilde),
 W; vile C
86 shall] should W
88 your selves] our selves F2, L–W
89, 92 *1. Guard.*] *Guard.* F1–2, L
90 no, no mercy] shew no mercy F2, L,
 S; know no mercy C, W
94 command you! Gods, look] com-
 mand you——look here F1–2, L,
 S; command you! Heavens, look D
103 petar] petard F2, L, S, C
105.1 Citizens] *Citizen* F1–2, L–W
106 *1. Citizen.*] *Cit.* F1–2, L–W

III.iii

3 wooe] woe L, S
6 your] you F1
51 bought] brought F2, L, S
51, 75.1, 90.1 Lucio] *Boy* F1–2, L, S, C
55 us] is F1–2, L–W
71 Goe I] Go, Lucio, I Dyce (*query*)
98 me] men F1
104 it self out, loud ingratitude] it self
 out loud, Ingratitude S, C, W; itself
 out loud,——ingratitude D
118 lame] tame F1
154 tell me, (it's a sweet one),] tell me
 that it's a sweet one, F1; tell me it's a

sweet one F2, L; tell me that, it's a
sweet one S, W
182 my onely] only my S
186 Done] Done't S
187 this] his F1–2, L
198 thee,] thee *Tirant*, F1
212 She ... she] He ... he F1–2, L
224 a] *omit* F1
225 hugg'd] hug F1; flung F2, L–W
237 I am poor] I am a poor F2, L; I'm
 poor S, C
249 not thou] thou not F2, L, S
255 distentions] distention S, D

255 hath] have W
257 piety] pitty F1–2, L
262 are] *omit* F1
278 these] the S

281 all] *omit* L
285 take you] take your F2+
296 question] jest on S
298 Good] *Vir.* Good F1; Could W

IV.i

39 With all] Withall F1
54 further] farther F2, L, S

56 you] you'll S
58 Personage] Parsonage F1

IV.ii

6 aymes] aim C, W, D
20 too] to F1
33, 38, 39, 59 *Lucio.*] *Boy.* F1–2, L, C
49 Lucio *admits* Martia.] *Enter Martia and Boy*, F1–2, L; Enter Martia. S, C, W; Lucio *brings in* Martia. D

54 further] farther F2, L, S
62.1 *Lucio.*] *Boy.* F1–2, L, S, C
79 I tell] I'll tell C, W
81 impudent] impotent Mason (*conj.*)
114 thy] my L
143 fiends] friends F1

IV.iii

7 turn] turn'd F2, L
10 a useful] an useful S, C, W
30 I, and] Ay, and L–D
31 s.d. *Lucio.*] *the Boy* F1–2, L, S, C
31 s.p. *Lucio.*] *Boy* F1–2, L, S, C
33 *Exit* Lucio.] *omit* F1–2, L–D
51 *Juliana*] F2; *Julian* F1
70 accuse too] accus'd to F1

78 a] *omit* S
84 new friend] few Friends L, S
84 dares] dare L, S
86 feeles] feel D
103 aimes] aim C, W
191 bed] be! F1–2, L
206 I am honest] I am an honest L; I'm honest S, C

IV.iv

34 their] 'these', 'the', 'our' (*conj.* S); 'the iron' (*conj.* C, W, D)

68 erst] ere F1–2, C, W; e'er L, S
74 boy] buoy F2+

V.i

24 further] farther F2, L
30.1 *Meat brought in*] *meat conveyed away* F1–2, L; Servants *bring in a banquet* D
64 s.p. *Doctor.*] *omit* F1
65 'Tis] *Doct.* 'Tis F1
66 night] nigh F1
76 I like sauce] I like the sauce Mason (*conj.*)

104 a] *omit* F1–2, L, W
108–109 Doctor,—— | All gone] Doctor, the Table taken away, | All gone F1–2, L, S, W
116 a strict and excellent] an excellent and strict F2, L, S
117 poynant,] poynant, Sir F2, L, S
119 Pease] Pea S, C
125 but they] but them S, C

144 flame] fame F1–2, L, S (*conj.* 'flame')
149–150 *Ascanio. He is in earnest Sir.* | *Ferrand. In serious earnest,* | *I must needs take him off.*] *Asca.* He is in earnest Sir. | I must needs take him off. | *Fer.* In serious earnest. F2, L
150 must needs] needs must S
152 *All.* Liberty] All Liberty F1–2
161 ports F1–2, L–W
163.1 *off crying ... freedome.*] One of crying | Liberty and freedome. F1;

crying liberty and freedom within. F2, L; Some go off crying Liberty and Freedom. S, C
171 *Boteswain.*] *Sess.* F1–2, L, S (conj. '*Boteswain*')
171 *Sesse.*] omit F1–2, L, S (conj. '*Sesse*')
173 *Within.*] omit F1–2, L, S
174 *Sesse.*] omit F1–2, L, S
174 the] this F1–2, L
176 nothing but] nothing now but D (*query*)

V.ii

1 womans] woman F2, L, S; woman's C, W, D
41 into] in S
57 to] *omit* F1
69 of] off F1
75 be] *omit* F1
87 On] Or F1–2, L
92 *Juliana.*] *Vir.* F1(u)
93 *Virolet.*] *Iul.* F1(u)
105 Love——I] F1–2, L, S (*conj.*

'Love——'fore I'); love. Gods! I C; love. God! I W; love.—— [God], I D
120 *Juliana.*] *Vir.* F1
130.1 Lucio] *Boy* F1–2, L, C
131 *Lucio.* He] Boy he F1; *Boy.* He F2, L, C
132 you Sir] you do Sir F2, L
133, 138, 141 *Lucio.*] *Boy.* F1–2, L, C
135 you had] had you F2, L, S

V.iii

0.3 *as many as may be*] omit S, C, W (*printed in a footnote*), D
52 further] farther F2, L
64 Souldiers] Soldier S

71 petty] pretty S
79 wreake] weake F1
129 cheerfully] cheerfull F2
140 deaf] deaft F1

V.iv

5 all] *omit* F21, L, S
38 further] farther F2, L, S

64 *1. Citizen.*] *Cit.* F1–2, L–W

THE PROPHETESS

edited by

GEORGE WALTON WILLIAMS

TEXTUAL INTRODUCTION

The Prophetess (Greg, *Bibliography*, no. 654) was one in the list of plays by Beaumont and Fletcher entered to Humphrey Moseley in the Stationers' Register between September 4 and 15, 1646. The play was printed in the 1647 Folio, this text being the only one of authority. The 1679 Folio adds a generic subtitle: 'A Tragical History'.

Licensed as 'a new play' on 14 May 1622,[1] this work is the joint labour of Fletcher and Massinger. Dr Hoy has confirmed earlier opinions that Fletcher is the author of Acts I and III and of V.iii[–iv] and that Massinger is the author of Acts II and IV and of V.i, ii.[2] This is a distribution based, it may be noted, on shares of work, rather than on lines of the plot or on sources, such a sharing indicating a full understanding of the entire play by each author. The Folio text, as Dr Hoy has suggested, 'almost certainly derives from a Crane transcript'; as the printing of the Folio is unusually clean and free of minor errors, the Crane manuscript must have been readily legible.[3] The entire play is in verse which, with few exceptions, is correctly lined. The language of Geta and other comic figures sometimes strains the limits of iambic pentameter, but in spite of frequent irregularities it is clear from the linking part-lines that both authors thought of such speeches as part of the verse pattern of the play.

The Prophetess enjoyed a good deal of popularity on the stage in its original form, in its operatic form, and in its adaptations. It appeared in print not only in the two Folios but also in the standard collections and in a separate Quarto of 1717 printed for Jacob Tonson (a reprint of Tonson's 1711 edition of the collected works and, thus, omitted from the Historical Collation for the present edition) and in the two series, *The Select British Theatre* in 1815, as adapted by James Love (Dance), and *The London Theatre* in 1816, as altered by David Garrick. These adaptations were considerably influenced by the 1690 reworking, 'with Alterations and Additions, After the Manner of an Opera', prepared by Thomas Betterton, with music by Henry Purcell and dances by Judas Priest.[4] This 'semi-opera' (as it is termed) included most of the dialogue and added dances and instrumental and vocal

music. The text, consisting of the dialogue, songs, and directions for the dances and instrumental music, was printed in two editions (three issues) in 1690[5] and reprinted by Tonson in 1716 and in 1719, 1733 or 1734, 1736, 1758, and 1759.[6] Betterton's version is not included in the present Historical Collation, but it has been consulted regularly and has suggested some details of seventeenth-century staging that supplement the directions of the Folios.[7] The edition of the semi-opera prepared by Dr Julia Muller-van Santen in 1989 includes also the texts of the original play in exact reprint from the two Folios. Purcell's music was printed separately in 1691; it has been recently edited by Dr Muller-Van Santen for performance (1988).

The play is the second item in Section 4 of the Folio, printed by Ruth Raworth, occupying pages 4D1 through 4F3v; the evidence from the running-titles suggests two-skeleton work for the three quires, though 'Quire D exhibits a number of odd characteristics'.[8]

I D1v, D2, D3, E1v, E3v, F1v, F2v, F3v
II D2v, D3v, D4v, E2v, E4v
III D4, E2, E4, F3
IV E1, E3, F1, F2

The sort for '3' in page-numbers 31, 35, 39 (D4, E2, E4) does not fully print. Curiously enough, at III.ii.0.1(E1v) and at III.iii.0.1(E2), Fletcher's text, appears the heading '*Scœna* . . .' in place of the standard '*Scœna*'. The setting on E1v is corrected in the press to '*Scœna*'.[9]

Two variant sets of compositorial practices, identified by Dr Henning and Ms Elizabeth Hotchkiss in this section, appear in *The Prophetess*.[10]

The variant patterns are these: one compositor (*B*) setting D1–2v and E2–F2v, the other (*A*) setting D3–E2v and F3–3v (the last half of one gathering, the first half of the next). Their practices may be distinguished in these particulars in this play: *B* sets personal pronouns with '-ee', *A* with '-e'; *B* tends to set names of cities and countries and adjectives of nations (in dialogue) in roman, *A* in italic; *B* tends to set contractions without a space (''tis'), *A* with a blank space (''t is') (*A*'s blanks have been closed up to normalize text); *B* occasionally sets personal names (in stage-directions) in roman, *A* does never. This system of alternation, presumably setting by formes, is standard in the section.

Proper names usually indicate possessive case by adding '-s' or, if the word ends in '-s', by adding nothing: '*Caesars*' (IV.iv.16, E4v), '*Diocles*' (II.i.47, D3). In four instances, however, the compositor has carefully formed the possessive of a name (in italic) by adding an apostrophe and an '-s' (in roman): '*Aper*'s' (II.ii.52, D3v), '*Delphia*'s' (II.iii.44, D4; IV.ii.64, E4), '*Persian*'s' (III.i.178, E1v), text by both authors.[11] This irregularity is silently corrected. On five occasions the name of the ruler is spelled *Cesar*; as these spellings are all normalized by F2, they are normalized here with a mention in the Emendations of Accidentals.

As in *Bonduca* and *Four Plays in One*, in Section 8, also presumably set by Raworth, the lines of verse are introduced with lower-case letters (excepting those of the Chorus). As in *Bonduca* also and in *Love's Pilgrimage* (Section 8) oaths are purged in *The Prophetess*. This edition replaces the dash in the Folio with substantives that seem appropriate to the speaker and the context, at IV.v.4 giving Geta the exclamation 'pox' and at V.ii.89 giving Charinus the oath 'by the Roman gods' (both these terms appear in Betterton (1690); though why 'the Roman gods' should have been found offensive in 1647 is hard to explain).[12] Similarly, at IV.vi.92 Dioclesian is given an oath by 'Heaven' and at V.iv.5 by 'my faith'. (As it happens, these censored oaths are all set by Compositor *B*.)

The lines of the Chorus (IV.i, V.i), set in italics in the Folio, are here reduced to roman, and the English (or Augustyn) roman type used for the description of the '*Dumb Shew*' (IV.i.19.2ff.) is here reduced to standard italic. This large type is used again in the Folio for dumb shows and such like tricks in *Four Plays in One* (8D4v, 8E2v, 8F3, 8F4v) (and a larger still, Double Pica, on 8E3v, 8E4). The present edition regularizes (silently) the inconsistencies of Crane or the compositors, setting names of places in italics and adjectives of places in roman. A few nouns that seem to have had significance are retained in italic setting; others, on a few occasions set in italic – *Proscription* (I.i.70, 84; I.iii.234, 258), *Aunt* (I.ii.25; II.iii.7), *Prophetesse* (I.iii.69; III.i.163; III.iii.28), *Edile* (III.i.88; III.ii.20, 47) – are here standardized to roman, their normal setting.

Of some significance is the regular placing of mid-scene entry-directions in the text of the Folio several lines before the entry would seem actually to be appropriate. The most striking instance is at

V.iv.0.1, where the too-early placing of the entry in the dialogue of scene iii has obscured the fact (first noted by Dyce) that a new scene began with that entry. Comparable confusion obtains at III.i.117/120 where the too-early placing of the entry for Diocles admits the possibility that he and not Geta is the 'prettie youth', mocked by Drusilla (line 117). But too-early placings throughout the play, where they do not confuse, regularly frustrate the dramatic effect of the dialogue before the entering character makes an appearance. So, the 'Musick belowe', which is presumably designed to interrupt Diocles' speech at V.iv.34, is directed to sound after line 32 in the Folio, thus, by interrupting the tone or the continuity of the dialogue, vitiating the effect intended. As such locations can hardly have been desired by the authors (they appear in the work of both playwrights), they would seem to be Crane's or the book-keeper's anticipatory decisions, and they are here emended to produce, arguably, effects more dramatic. For example, the entrance of the three Persian soldiers in the heat of battle at IV.v.11 in the Folio requires that they stand by while Geta and the Guards discuss for seven lines his unwillingness to fight; this edition delays the entry until after line 17. An alternative staging that preserved the Folio locations could be conceived that would make that quiet standing humorous and contributory to the play. At line 11, the Second Guard announces that 'They come', an announcement that may indicate that they have entered or, as well, that he sees them approaching.

Two such presumed 'too-early' entry-directions are here retained, however, for it is possible that the placing is deliberate. They may be seen to create an ironic juxtaposition, providing the early entrance of a female character while her rival is being discussed (III.iii.141, 196). A third such 'too-early' placing (as in F1) allows Delphia to hear Geta's remark (V.iii.76–7) to which she then replies, but this edition argues that a 'delayed' entrance, just before she speaks, emphasizes her psychic powers, demonstrating that she had perceived the remark that she was not on stage to hear (she refers to such powers perhaps at I.ii.43–4; V.iv.48).

Three directions have been included from the Second Folio: II.ii.96; II.iii.46; IV.ii.81.

The act divisions of the Folio must reflect the intervals (with music?) of actual production. Chorus speeches separate Acts III and

IV and Acts IV and V. The exit of Drusilla two lines before the end of Act I and her entry at the beginning of Act II indicate that there was probably an interval between these two acts also. The act-divisions of the Folio are followed in the present edition as are also the scene-divisions, with one exception: after V.iii.91, the stage is clear and a new scene, iv, begins. Though the location changes to 'the Grove', no editor before Dyce created a new scene, perhaps because the part-line that concludes V.iii is completed by the part-line that opens V.iv (V.iii.91/V.iv.1).[13] Furthermore, the exit- and entry-directions for this scene-change are misplaced in the Folio. Colman relocated these directions, and Dyce first numbered a new scene. Dyce declined to give scene-numbers to the speeches of the Chorus (and to the Dumb Show) at III.i and IV.i; scenes IV.iv–vi are evidently to be imagined as a sequence of battle scenes with uninterrupted action.

The technicalities of staging *The Prophetesse* are of unusual interest, as the play offers several spectacular features. The most unexpected is the litter of the dead Numerianus which is uncovered to reveal the putrescent corpse. To represent divine retribution, '*A hand with a [thunder] Bolt appears above*' (V.iv.112); the '*Bolt*' seems to have legible text on it (lines 115–16). There is also a large property boar. The play stipulates one entry from above (II.iii.0.1–2) '*in a Throne drawn by Dragons*' and one from below (V.iv.37.1). The entry from above requires that while the throne remains elevated (lines 8, 21), the dragons should rest their wings (line 1) as if they no longer had to support it. Perhaps the group fixed themselves on a convenient scenic cloud, as they do in the engravings in the editions of Langbaine (1711) and Colman (1778), both men of the theatre.[14] At the end of this scene at line 148, the Folio exit-direction is '*Ascends throne*', which this edition interprets to mean '*Throne ascends*'; but at line 144 is the simple '*Ascend.*'. The former may be a book-keeper's preparatory note for the ascent of the throne four lines later. It may, alternatively, have some mechanical significance now lost to us. In the possibility that it does, the present edition seeks to incorporate it into the visual excitement of this scenic machinery. The entry from below at V.iv.37.1 produces '*a Spirit from the Well*' that has been brought on stage (or discovered), but the dialogue suggests that in addition to the Spirit, flowers spring 'From out the Well' (lines 38–9). One exit is enriched by Delphia's raising a mist to conceal the flight of her protégés at the conclusion of

the elaborate Dumb Show before Act IV (IV.i.19.11).[15] And one entry
may also be intended to have a similar supernatural effect; at IV.ii.81
F1 omits the entry-direction for Delphia and Drusilla; the F2 supplies
the need with the evocative 'Delphia *and* Drusilla *appear*' a direction
that, as Dyce noted, was 'suggested to the editor [printer?] by [line
79]'. But the omission in F1 may indeed suggest that the entry was not
routine but was in some way magical or mysterious.

There are also 'Musick from the Spheres' (i.e., '*above*') (II.iii.49),
'*Musick below*' (V.iv.34), a dance of a She-devil (perhaps with Geta:
III.ii.114.1), and '*A dance of Shepherds and Shepherdesses*: Pan *leading
the men*, Ceres *the maids*' (V.iv.47.1–2). Naturally enough, Betterton's
popular operatic version developed some of these suggestions; in
particular, the country dance – simple in the play of necessity and by
definition – expands in the opera into a Masque with a huge cast and
phenomenal machinery.

In response to these unusual features, the present edition has been
more generous than is standard in this series in providing stage-
directions. Professor Alan Dessen has suggested that 'Conceivably
this lightweight play could have been written primarily to exploit the
available theatrical technology'.[16]

One curiosity in the stage-directions of the Folio is the habit of
placing at the end of one scene a direction for music or alarms that
properly belongs at the beginning of the next scene, as Dyce
recognized. So at IV.iv/v the '*Flourish*' that accompanies the state exit
of Cosroe and the Persian Court from scene iv must be distinguished
from the '*Alarms*' of the battle sequence which begins in scene v,
though both directions appear on the same line concluding scene iv;[17]
and IV.v/vi the '*Flourish*' concluding scene v in the Folio pertains to
the entry '*in Triumph*' at the head of scene vi. So too at II.i/ii the '*Soft
Musick*' must surely have been intended not to accompany an
unremarkable exit from scene i but to be background for the
ceremonial entry in scene ii of the litter of the 'sick Emperour' (II.ii.1).
And as the '*Loud Musick*' at II.iii.92 was clearly intended to
accompany the entrance of Charinus at line 94, the direction should be
delayed for two lines so as to indicate that entrance. (Dyce, perhaps
correctly, left the direction at line 92, marking it '*within*'. Such a
sequence will indicate that those on stage hear the music of Charinus
approaching and so prepare to 'meet|The Emperour'; it is, however,

very difficult for an audience to hear stage dialogue over '*Loud music within*'.)

Neither Folio provides texts for the Songs at II.iii.66 or V.iv.41.1, and search has failed to disclose any originals. Betterton for the former of these provided a text clearly not by Fletcher or Massinger, and at the latter omitted the section, including the Spirit from the Well. (See Textual Note at II.iii.66.)

The list of 'Persons Represented in the Play' derives from the Second Folio. In a copy of F1 at the Perkins Library, Duke University (# 429544), a modified secretary hand of the mid-seventeenth century has supplied a list which supplements with these comments our understanding of some of the characters: Diocles, 'a Tanners sonne'; Aper, 'Genrall of the Army'; Charinus, 'brother to the murthered Prince Numerianus'; Flamen, 'a priest'.

The text of this edition has been set up from a typescript of the exemplar of the First Folio at the Harvard College Library.[18] I am, as always, indebted to Robert Kean Turner and now to James P. Hammersmith for assistance in the collation of Press Variants.[19] I have consulted the critical comments of J. Monck Mason, *Comments on the Plays of Beaumont and Fletcher* (London, 1798), John Mitford, *Cursory Notes on Various Passages in the Text of Beaumont and Fletcher* (London, 1856), and Kenneth Deighton, *Conjectural Emendations: The Old Dramatists* (Westminster, 1896).

NOTES

1 G. E. Bentley, *The Jacobean and Caroline Stage* (Oxford, 1956), III, 395.

2 Cyrus Hoy, 'The shares of Fletcher and his collaborators . . . (II)', *Studies in Bibliography*, IX (1957), 152. Hoy's 'V.iii' is divided into V.iii and iv in the present edition.

3 For the attributes of a Crane transcript, see Hoy's edition of *The Humorous Lieutenant*, this series, vol. V, pp. 297–9. It is worthy of note that Crane is guilty in that text of mistaking 'Watches' for 'martches' (III.v.49), an error which appears in the singular also in this text (III.i.181).

4 The opera in its literary and musical aspects has been exhaustively examined by Julia Johanna Gertrud Muller-van Santen in her *Producing 'The Prophetess' or*

'*The History of Dioclesian*' (Privately printed: Free University of Amsterdam, 1989; now published as Julia Muller, *Words and Music in Henry Purcell's First Semi-opera, 'Dioclesian'* (Lewiston, N.Y., 1990)). To this careful work, as to its author, I am much indebted for assistance in preparing the present edition.

5 Fredson Bowers, 'The bibliographical history of the Fletcher-Betterton play, *The Prophetess*, 1690', *The Library*, Fifth Series, XVI (September 1961), 169–75. Professor Bowers demonstrates that the first edition had two issues, the second enlarging the first and using standing type from the first issue, and a second edition used standing type from the second issue. This printing record shows that the operatic version of the play was very popular.

6 The French translation by F. G. J. S. Andrieus [*sic*] listed in the *National Union Catalogue* is evidently of *Rule a Wife* (*L'ecole des Espouseurs*), not of this play.

7 Such supplements occur at I.iii.51.1 (Geta climbing a tree); II.ii.119 (uncovering the dead body); II.iii.66 (the investing of Dioclesian); III.i.34 (the kneeling); III.i.49 (the conjuring); IV.v.20 (the addition of an Alarm); V.iv.47.1–52 (the staging of these dances). All these clarify the action intimated in the text of 1647; other directions in the semi-opera, here omitted, describe a different interpretation of that text during the reign of William and Mary. For example, where the 1647 text at III.iii.206 reads 'you have seal'd forgivenesse' we are to believe on the basis of the use of that verb elsewhere (III.iii.67; IV.ii.104) that a kiss is intended; so a few lines before, at line 193 where the Folio reads 'thus I meet it', another kiss is probably suggested, setting up the parallel of the duplicitous Diocles. At this point, however, the 1690 text reads, circumspectly, 'thus I thank you' with the direction '*Kneels*'.

8 For a complete analysis of the section see Standish Henning, 'The printers and the Beaumont and Fletcher Folio of 1647, Sections 4 and 8D–F', *Studies in Bibliography*, XXII (1969), 165–78, esp. p. 167.

The repeated use of ornaments and of standing types binds together the three plays of this Section. The second row of ornaments appears on the three titlepages (*The Maid in the Mill* (A4), *The Prophetess* (D1), *Bonduca* (F4));, the first row appears on the latter two (D1, F4). Similarly, the setting *Actus primus. Scæna prima.* and the rules above and below that setting appear at the head of the two latter plays. The act headings and rules for Acts II–V – with adjustments–reappear in the several plays: *Maid in the Mill*: B1, B3v; *Prophetess*: D3, D4v, E3v, F1v; *Bonduca*: I1v. (It is likely that some of these settings are used in more than one play.) Scene headings reappear with their rules in more than one play: '*Scaena secunda.*' in *Maid* A1v, C2 and in *Prophetess* D3; '*Scæna quarta.*' in *Prophetess* E4v and in *Bonduca* G4, H1v. It would seem that a supply of these different headings was available for use at any scene break; none of these headings carries over to *Love's Pilgrimage* in Section 8.

9 For the form '*Scœna*' see also *Rollo* (Q2), II.ii.0.1.

10 In the article cited in note 8. The compositorial assignments have been confirmed independently by my own analysis. Dr Hoy observes some of the characteristics in his edition of *Bonduca*, vol. IV (in this series), pp. 153–4. See also *Four Plays in One*, in vol. VIII, pp. 232–3.

11 Though such forms usually indicate the contraction of the verb — cf. '*Aper*'s' (I.iii.260) — they do not here; nevertheless, the correction to, e.g., '*Persian*'s' is regarded as an accidental emendation, made silently.

12 Dr van Santen shares this surprise: 'it is doubtful [that 'gods'] was the word the original author was thinking of, as it occurs throughout the play [as at V.iii.46]' (p. 294). The same deletion occurs in *The Knight of Malta*, e.g., at V.iii.46.

13 This 'scene-break' is the most conspicuous instance of both authors' tendency to place entrances in the middle of lines.

14 The engravings also change the throne to a chariot, showing thus the influence of Betterton's opera.

15 Hensman objects that the action of the Dumb Show 'could have been expressed in dialogue with greater economy of time' (p. 313). It is expressed in narrative in the lines of the Chorus (IV.i.20–47), and as it is expressed in the precise sequence of events followed in the dumb show, it is not unlikely that those lines would have been spoken to accompany the show and would not have delayed the action with needless iteration. (But — there is *Hamlet*.)

16 In correspondence: Professor Dessen has kindly read these remarks on staging and has offered many helpful suggestions.

17 Betterton removed the '*Alarms*' from the position between IV.iv and IV.v (i.e., at the beginning of Scene v) so that they should accompany the entrance of Niger at IV.v.20. But, though an '*Alarm*' is needed for Niger's entrance (see line 27.1 '*Alarm's continued.*'), one is needed also at the beginning of scene iv, as Geta has already been 'wounded' in action (lines 1–4).

18 The typescript was prepared by Ms Rebecca Sylvester to whom I extend particular thanks.

19 James P. Hammersmith, 'The proof-reading of the Beaumont and Fletcher Folio of 1647; Sections 4 and 8 D–F', *Papers of the Bibliographical Society of America*, LXXXII (1988), 585–94.

PERSONS REPRESENTED IN THE PLAY.

Charinus, *Emperour of* Rome.
Cosroe, *King of* Persia.
Diocles, *of a private Souldier elected Co-Emperour.*
Maximinian, *Nephew to* Diocles, *and Emperour by his donation.*
Volutius Aper, *Murtherer of* Numerianus, *the late Emperour.*
Niger, *a noble Souldier, servant to the Emperour.*
Camurius, *a Captain, and creature of* Aper's.
Geta, *a Jester, Servant to* Diocles, *a merry Knave.*
Flamen.
Persian Lords. 10
Senators.
Souldiers.
Suitors.
Ambassadors.
Lictors.
Shepherds.
Country-men.
[*Officers.*]
Guards.
Attendants. 20

WOMEN.

Aurelia, *Sister to* Charinus.
Cassana, *Sister to* Cosroe, *a Captive, waiting on* Aurelia.
Delphia, *a Prophetess.*
Drusilla, *Neice to* Delphia, *in love with* Diocles.
[*Chorus, Spirits. A She-devil.*]
[*In the Masque, Shepherds, Shepherdesses,* Pan, Ceres.]

The Scene Rome [*and Persia, Lumbardie*].

0.1–28 Persons ... Lumbardie].] F2; *omit* F1

232

THE PROPHETESS

Charinus. You buz into my head strange likelihoods,
 And fill mee full of doubts; But what proofes (*Niger,*)
 What certainties, that my most noble Brother
 Came to his end by murther? Tel me that,
 Assure me by some circumstance.
Niger. I will Sir.
 And as I tell you truth, so the gods prosper me.
 I have often nam'd this *Aper.*
Charinus. True, ye have done:
 And in mysterious senses I have heard ye
 Break out o'th' sudden, and abruptly,
Niger. True, Sir.
 Fear of your unbeliefe, and the Times giddinesse 10
 Made me I durst not then go farther. So your Grace please
 Out of your wonted goodnesse to give credit,
 I shall unfold the wonder.
Aurelia. Do it boldly:
 You shall have both our hearty loves, and hearings.
Niger. This *Aper* then, this too much honourd villain,
 (For he deserves no mention of a good man)
 Great Sir, give ear: This most ungratefull, spightfull,
 Above the memory of mankind mischievous,
 With his owne bloody hands——
Charinus. Take heed.
Niger. I am in, Sir;
 And if I make not good my Storie——
Aurelia. Forward: 20
 I see a Truth would break out: be not fearfull.
Niger. I say, this *Aper*, and his damn'd Ambition,
 Cut off your Brothers hopes, his life, and fortunes:
 The honourd *Numerianus* fell by him,

Fell basely, most untimely, and most treacherously:
For in his Litter, as he bore him company,
Most privately and cunningly he kill'd him;
Yet still hee fils the faithfull Souldiers ears
With stories of his weaknesse; of his life;
That he dare not venture to appear in open, 30
And shew his warlike face among the souldiers;
The tendernesse and weaknesse of his eyes,
Being not able to endure the Sun yet.
Slave that he is, he gives out this infirmitie
(Because hee would dispatch his honour too)
To arise from wantonnesse, and love of women,
And thus he juggles still.
Aurelia. O most pernitious,
Most bloody, and most base! Alas, deer Brother,
Art thou accus'd, and after death thy memory
Loaden with shames and lies? Those pious tears 40
Thou daily showerdst upon my fathers Monument,
(When in the Persian Expedition
He fell unfortunately by a stroak of thunder)
Made thy defame and sins? Those wept out eyes,
The fair examples of a noble Nature,
Those holy drops of Love, turn'd by depravers
Malitious poyson'd tongues to thy abuses?
We must not suffer this.
Charinus. It shows a truth now:
And sure this *Aper* is not right nor honest,
Hee will not now come neer me.
Niger. No, he dare not: 50
He has an inmate here, thats call'd a conscience,
Bids him keep off.
Charinus. My Brother honourd him,
Made him first Captain of his Guard, his next friend;
Then to my mother (to assure him neerer)
He made him husband.
Niger. And withall ambitious:

*46–47 depravers| ∧ Malitious ... tongues∧] ∼ (∼ ... ∼) F1–2
*53 next friend] stet F1

234

For when he trod so nigh, his false feet itch'd Sir,
To step into the State.
Aurelia. If ye beleeve, Brother,
 Aper a bloody knave (as 'tis apparant)
 Let's leave disputing, and do something Noble.
Charinus. Sister be rul'd, I am not yet so powerfull, 60
 To meet him in the field: He has under him
 The flower of all the Empire, and the strength,
 The Brittain and the Germain Cohorts; pray ye be patient.
 Niger, how stands the Souldier to him?
Niger. In fear, more Sir,
 Then love or honour: he has lost their fair affections,
 By his most covetous and greedy griping.
 Are ye desirous to do something on him,
 That all the world may know ye lov'd your Brother?
 And do it safely too, without an Army?
Charinus. Most willingly.
Niger. Then send out a Proscription, 70
 Send suddenly: And to that man that executes it,
 (I mean, that brings his head) add a fair payment,
 No common summe: then ye shall see, I fear not,
 Even from his own camp, from those men that follow him,
 Follow, and flatter him, we shall find one,
 And if he misse, one hundred that will venture it.
Aurelia. For his reward, it shall be so, deer Brother,
 So far I'll honour him that kils the villain:
 For so far runs my love to my dead Brother,
 Let him be what he will; base, old, or crooked, 80
 Hee shall have Me: Nay, which is more, I'll love him.
 I will not be denyde.
Charinus. You shall not, Sister.
 But ye shall know, my Love shall go along too:
 See a Proscription drawn; And for his recompence,
 My Sister, and half partner in the Empire:
 And I will keep my word.
Aurelia. Now ye do bravely.
Niger. And though it cost my life, I'll see it publish'd.
Charinus. Away then, for the businesse.

Niger. I am gone, Sir:
 You shall have all dispatch'd to night.
Charinus. Be prosperous.
Aurelia. And let the villain fall.
Niger. Fear nothing Madam. 90

 Exeunt [severally].

 Enter Delphia *and* Drusilla. [I.] ii

Drusilla. 'Tis true, that *Diocles* is courteous,
 And of a pleasant nature, sweet and temperate:
 His Cosen *Maximinian*, proud and bloody.
Delphia. Yes: and mistrustfull too: (my Girl) take heed,
 Although he seem to love thee, and affect
 Like the more Courtier, curious complement,
 Yet have a care.
Drusilla. You know all my affection,
 And all my heart-desires is set on *Diocles.*
 But (Aunt) how coldly he requites this courtesie,
 How dull and heavily he looks upon me, 10
 Although I woo him sometimes beyond modestie,
 Beyond a Virgins care: how still he slights me,
 And puts me still off with your Prophecie,
 And the performance of your late Prediction,
 That when he is Emperor, then he will marry me,
 Alas, what hope of that?
Delphia. Peace, and be patient,
 For though he be now a man most miserable,
 Of no rank, nor no badge of honour on him,
 Bred low and poor, no eye of favour shining:
 And though my sure Prediction of his Rising 20
 (Which can no more faile then the day or night do's,
 Nay, let him be asleep, will overtake him)
 Have found some rubs and stops, yet hear me Neece,
 And hear me with a faith, it shall come to him.
 I'll tell thee the occasion.
Drusilla. Do good Aunt:
 For yet I am ignorant.

 *8 heart-desires is] *stet* F1

 236

Delphia. Chiding him one day
 For being too neer, and sparing for a Souldier,
 Too griping, and too greedy: he made answer,
 When I am *Caesar*, then I will be liberall.
 I presently inspir'd with holy fire, 30
 And my Prophetick spirit burning in me,
 Gave answer from the gods; and this it was,
 Imperator eris Romae, cum Aprum grandem interfeceris:
 Thou shalt be Emperor, O *Diocles*,
 When thou hast kill'd a mighty Boar. From that time
 (As giving credit to my words) hee has imploy'd
 Much of his life in hunting. Many Boars
 Hideous and fierce, with his own hands he has kild too,
 But yet not lighted on the fatall one,
 Should raise him to the Empire: Be not sad Neece, 40
 Ere long he shall: Come, lets go entertain him;
 For by this time, I ghesse, he comes from hunting:
 And by my art, I find this very instant
 Some great designe's afoot.
Drusilla. The gods give good, Aunt.

 Exeunt.

 Enter Diocles, Maximinian, Geta, *with a Boar.* [I.] iii

Diocles. Lay down the Boar.
Geta. With all my heart; I am weary on't:
 I shall turn Jew, if I carry many such burthens.
 Do you think (Master) to be Emperor
 With killing Swine? ye may be an honest Butcher,
 Or allied to a seemly Family of Sowse-wives.
 Can you be such an asse, my reverend Master,
 To think these Springs of Pork will shoot up *Caesars?*
Maximinan. The fool sayes true.
Diocles. Come leave your fooling, Sirha,
 And think of what thou shalt be when I am Emperor.
Geta. Would it would come with thinking: for then o' my
 conscience 10
 I should be at least a Senator.
Maximinian. A Sowter:

 237

For that's a place more fitted to thy nature,
If there could be such an expectation.
Or say the Divel could perform this wonder,
Can such a Rascall as thou art hope for honour?
Such a log-carrying Lowt?

Geta. Yes, and bear it too,
And bear it swimmingly. I am not the first Asse, Sir,
Has born good Office, and perform'd it reverendly.

Diocles. Thou being the son of a Tiler, canst thou hope to be a
 Senator?

Geta. Thou being the son of a Tanner, canst thou hope to be an
 Emperour? 20

Diocles. Thou saist true *Geta*, there's a stop indeed;
But yet the bold and vertuous—

Geta. Ye are right, Master,
Right as a gun: For we the vertuous,
Though we be kennel-rakers, scabs, and scowndrels,
Wee the discreet and bold: and yet, now I remember it,
We Tilers may deserve to be Senators;
And there we step before you thick-skin'd Tanners,
For we are born three Stories high; no base ones,
None of your groundlings, Master.

Diocles. I like thee well,
Thou hast a good mind, as I have, to this Honour. 30

Geta. As good a mind Sir, of a simple plaisterer————
And when I come to execute my Office,
Then you shall see.

Maximinian. What?

Geta. An Officer in fury;
An Officer as he ought to be: Do you laugh at it?
Is a Senator (in hope) worth no more reverence?
By these hands I'll clap you by th'heels the first hour of it.

Maximinian. O' my conscience, the fellow beleeves.

Diocles. I, do, do *Geta*,
For if I once be Emperor————

Geta. Then will I
(For wise men must be had to prop the Republick)

Not bate ye a single ace of sound Senator.

Diocles. But what shall we do the whilst?

Geta. Kill Swine, and sowse 'em,
And eat 'em when we have bread.

Maximinian. Why didst thou run away
When the Boar made toward thee? art thou not valiant?

Geta. No indeed am I not; and 'tis for mine honour too:
I took a tree, 'tis true; gave way to the Monster;
Heark what discretion sayes, Let furie passe;
From the tooth of a mad beast, and the tongue of a slanderer
Preserve thine honour.

Diocles. Hee talks like a full Senator.
Go, take it up, and carry it in: 'tis a huge one;
We never kill'd so large a swine; so fierce too 50
I never met with yet.

Maximinian. Take heed, it stirres again;

 [*Geta climbs up.*]
How nimbly the rogue runs up: he climbs like a Squirrel.

Docles. Come down ye dunce, is it not dead?

Geta. I know not.

Diocles. His throat is cut, and his bowels out.

Geta. That's all one,
I am sure his teeth are in: and for any thing I know,
He may have pigs of his own nature in's belly.

Diocles. Come take him up I say, and see him drest,
He is fat, and will be lustie meat; away with him,
And get some of him ready for our dinner.

Geta. Shall he be rosted whole, 60
And serv'd up in a Sowce-tub? a portly service,
I'll run i'th' wheel my self.

Maximinian. Sirrah, leave your prating,
And get some piece of him ready presently,
We are weary both, and hungry.

Geta. I'll about it.
What an inundation of brewisse shall I swim in? *Exit* [*with Boar*].

Diocles. Thou art ever dull and melancholy, Cosen,
Distrustfull of my hopes.

Maximinian. Why, can ye blame me?

Do men give credit to a Juggler?
Diocles. Thou know'st she is a Prophetesse.
Maximinian. A small one,
 And as small profit to be hop'd for by her. 70
Diocles. Thou art the strangest man; how do's thy hurt?
 The boar came neer you Sir.
Maximinian. A scratch, a scratch.
Diocles. It akes and troubles thee, and that makes thee angry.
Maximinian. Not at the pain, but at the practice, Unkle,
 The butcherly base custome of our lives now:
 Had a brave enemies sword drawn so much from me,
 Or danger met me in the head o'th'Army,
 To have blush'd thus in my blood, had been mine honour.
 But to live base, like Swine-herds, and beleeve too,
 To be fool'd out with tales, and old wives dreams, 80
 Dreams, when they are drunk.
Diocles. Certain, you much mistake her.
Maximinian. Mistake her? hang her: to be made her Purveyors,
 To feed her old chaps: to provide her daily,
 And bring in Feasts, whilst shee sits farting at us,
 And blowing out her Prophecies at both ends.
Diocles. Preethee be wise: Dost thou think, *Maximinian,*
 So great a reverence, and so staid a knowledge——
Maximinian. Sur-reverence, you would say: what truth? what
 knowledge?
 What any thing but eating is good in her?
 'Twould make a fool prophecie to be fed continually: 90
 What do you get? your labour and your danger,
 Whilst she sits bathing in her larded fury:
 Inspir'd with full deep cups, who cannot prophecie?
 A Tinker, out of Ale, will give Predictions:
 But who beleeves?
Diocles. Shee is a holy *Druid.*
 A woman noted for that faith, that piety,
 Belov'd of heaven.
Maximinian. Heaven knows, I do not beleeve it.
 Indeed, I must confesse, they are excellent Jugglers;

*81 Dreams] stet F1

240

Their age upon some fools too flings a confidence.
But what grounds have they: what elements to work on? 100
Show mee but that: the sieve and sheers? a learned one.
I have no patience to dispute this Question,
'Tis so ridiculous: I think the divell do's help 'em:
Or rather, (mark me well) abuse 'em (Unkle):
For they are as fit to deal with him: these old women,
They are as jump and squar'd out to his nature——
Diocles. Thou hast a perfect malice.
Maximinian. So I would have
Against these purblind Prophets: for look ye Sir,
Old women will lie monstrously; so will the divell,
Or else he has had much wrong: upon my knowledge, 110
Old women are malicious; so is hee:
They are proud, and covetous, revengefull, lecherous;
All which are excellent attributes of the Divell.
They would at last seem holy; so would hee:
And to vail over these villanies, they would prophecie;
He gives them leave now and then to use their cunning,
Which is to kill a cow, or blast a harvest,
Make young pigs pipe themselves to death, choak poultry,
And chafe a dairy-wench into a feaver
With pumping for her butter. 120
But when he makes these Agents to raise Emperors,
When he disposes Fortune as his Servant,
And tyes her to old wives tailes——
Diocles. Goe thy wayes,
Thou art a learned Scholar, against credit.
You hear the Prophecie?
Maximinian. Yes, and I laught at it:
And so will any man can tell but twenty,
That is not blind as you are, blind and ignorant.
Do you think she knows your fortune?
Diocles. I do think it.
Maximinian. I know she has the name of a rare South-sayer:
But do you in your conscience beleeve her holy? 130
Inspired with such prophetick fire?

Diocles. Yes in my conscience.

Maximinian. And that you must upon necessity
From her words be a *Caesar?*

Diocles. If I live——

Maximinian. There's one stop yet.

Diocles. And follow her directions.

Maximinian. But do not juggle with me.

Diocles. In faith (Cosen,)
So full a truth hangs ever on her Prophecies,
That how I should think otherwise—

Maximinian. Very well Sir:
You then beleeve (for me thinks, 'tis most necessary)
She knows her own Fate?

Diocles. I beleeve it certain.

Maximinian. Dare you but be so wise to let me try it, 140
For I stand doubtfull.

Diocles. How?

Maximinian. Come neerer to me;
Because her cunning divell shall not prevent me:
Close, close, and hear; [*Whispers to him.*]
 If she can turn this destinie,
I'll be of your faith too.

Diocles. Forward, I fear not.
For if shee knows not this, sure she knows nothing.
I am so confident——

Maximinian. 'Faith so am I too,
That I shall make her Divels sides hum.

Diocles. She comes here:
Go take your stand.

Maximinian. Now holly, or you howl for't. *Goes apart.*

Diocles. 'Tis pity this young man should be so stubborn.
Valiant he is, and to his valour temperate, 150
Onely distrustfull of delayes in Fortune;
I love him deerly well.

 Enter Delphia.

Delphia. Now my Son *Diocles,*

 148 holly (*i.e.,* holy)

 242

Are yee not weary of your game to day?
And are ye well?
Diocles. Yes Mother, well and lustie:
Onely ye make me hunt for empty shadows.
Delphia. You must have patience, *Rome* was not built in one day:
And he that hopes, must give his hopes their currents.
You have kil'd a mighty Boar.
Diocles. But I am no Emperor.
Why do you fool me thus, and make me follow
Your flattering expectation hour by hour, 160
Rise early, and sleep late? to feed your appetites,
Forget my trade, my Arms? forsake mine honour?
Labour and sweat to arrive at a base memory?
Oppose my self to hazzards of all sorts,
Onely to win the barbarous name of Butcher?
Delphia. Son, you are wise.
Diocles. But you are cunning, Mother:
And with that Cunning, and the faith I give ye,
Ye lead me blindly to no end, no honour.
You find ye are daily fed, you take no labour,
Your familie at ease, they know no Market, 170
And therefore to maintain this, you speak darkly,
As darkly still ye nourish it, whilst I
Being a credulous and obsequious coxcomb,
Hunt daily, and sweat hourly, to find out
To cleer your Mystery: kill Boar on Boar,
And make your spits and pots bow with my Bounties:
Yet, I am poorer, further still——
Delphia. Be provident,
And tempt not the gods doombs: stop not the glory
They are ready to fix on ye. Ye are a fool then;
Cheerfull and gratefull takers the gods love, 180
And such as wait their pleasures with full hopes:
The doubtfull and distrustfull man Heaven frowns at.
What I have told you by my inspiration,
I tell ye once again, must and shall find ye.
Diocles. But when? or how?

167 Cunning] F2; Cannon F1 *177 am] still F1–2

243

Delphia. *Cum Aprum interfeceris.*
Diocles. I have kil'd many.
Delphia. Not the Boar they point ye:
 Nor must I reveal further, till you cleer it.
 The lots of glorious men are wrapt in mysteries,
 And so deliverd: Common and slight creatures,
 That have their Ends as open as their Actions, 190
 Easie and open fortunes follow.
Maximinian [*aside*]. I shall try
 How deep your inspiration lies hid in ye,
 And whether your brave spirit have a buckler
 To keep this arrow off, I'll make you smoak else.
Diocles. Knowing my fortune so precisely, punctually,
 And that it must fall without contradiction,
 Being a stranger of no tie unto ye,
 Me thinks you should be studied in your own,
 In your own destiny, me thinks, most perfect:
 And every hour, and every minute, Mother, 200
 So great a care should heaven have of her Ministers,
 Me thinks your fortunes both waies should appear to ye,
 Both to avoid, and take. Can the Stars now,
 And all those influences you receive into ye,
 Or secret inspirations ye make shew of,
 If an hard fortune hung, and were now ready
 To powr it self upon your life, deliver ye?
 Can they now say, Take heed?
Delphia. Ha? pray ye come hither.
Maximinian [*aside*]. I would know that: I fear your divel wil cozen
 ye,
 And stand as close as ye can, I shall be with ye. 210
Delphia. I find a present ill.
Diocles. How?
Delphia. But I scorn it.
Maximinian [*aside*]. Do ye so? do ye so?
Delphia. Yes, and laugh at it, *Diocles.*
 Is it not strange, these wild and foolish men
 Should dare to oppose the power of Destiny?
 That power the gods shake at? Look yonder, Son.

Maximinian. Have ye spide me? then have at ye.
Delphia. Do, shoot boldly.
 Hit mee and spare not, if thou canst.
Diocles. Shoot cosen.
Maximinian. I cannot; mine arm's dead, I have no feeling:
 Or if I could shoot, so strong is her arm'd vertue,
 She would catch the arrow flying.
Delphia. Poor doubtfull people, 220
 I pity your weak faiths.
Diocles. Your mercy (Mother,)
 And from this hour a deity, I crown ye. [*Kneels.*]
Delphia. No more of that.
Maximinian. O let my prayers prevail too, [*Kneels.*]
 Here like a tree, I dwell else: free me Mother,
 And greater then great Fortune, I'll adore thee.
Delphia. Be free again, and have more pure thoughts in ye.
Diocles. Now I beleeve your words most constantly,
 And when I have that power ye have promis'd to me——
Delphia. Remember then your vow: my Neice *Drusilla*,
 I mean, to marry her, and then ye prosper. 230
Dioceles. I shall forget my life else.
Delphia. I am a poor weak woman: to me no worship.[*They rise.*]

 Enter Niger, Geta.

Geta. And shall he have as you say, that kils this *Aper*?
Delphia [*to* Diocles]. Now mark and understand.
Niger. The Proscription's up,
 I'th' Market-place 'tis up, there ye may read it,
 He shall have half the Empire.
Geta. A pretty Farm i'faith.
Niger. And the Emperors Sister, bright *Aurelia*,
 Her to his wife.
Geta. Ye say well Friend; but heark ye,
 Who shall do this?
Niger. You, if ye dare.
Geta. I think so:
 Yet I could poyson him in a pot of Perry, 240

 *232.1 Geta.] Geta, *and Souldiers.* F1–2

He loves that veng'ancely: But when I have done this,
May I lie with the Gentlewoman?

Niger. Lie with her? what else man?

Geta. Yes Man, I have known
A man married, that never lay with his wife.
Those dancing dayes are done.

Niger. These are old Souldiers,
And poor, it seems. I'll try their appetites.——
'Save ye brave Souldiers.

Maximinian. Sir, ye talkt of proscriptions?

Niger. 'Tis true, there is one set up from the Emperour
Against *Volutius Aper.*

Diocles. Aper?

Delphia. Now;
Now have ye found the Boar?

Diocles. I have the meaning; 250
And blessed Mother——

Niger. He has scorn'd his Master,
And bloodily cut off by treachery
The noble Brother to him.

Diocles. He lives here Sir,
Sickly and weak.

Niger. Did you see him?

Maximinian. No.

Niger. He is murthered;
So ye shall find it mentioned from the Emperour;
And honest faithful souldiers, but believe it;
For, by the gods, you will find it so, he is murthered;
The manner how, read in the large Proscription.

Delphia. It is most true Son; and he cozens ye,
Aper's a villain false.

Diocles. I thank ye Mother, 260
And dare beleeve ye: Heark ye Sir, the recompence?
As ye related——

Niger. Is as firme as faith Sir:
Bring him alive or dead.

Maximinian. You took a fit time,
The Generall being out o'th' Towne: for though we love him not,

Yet had he known this first, you had paid for't deerly.

Diocles. 'Tis *Niger*, now I know him: honest *Niger*,
 A true sound man, and I beleeve him constantly:
 Your busines may be done, make no great hurry
 For your owne safety.

Niger. No, I am gone; I thank ye. *Exit.*

Diocles. Pray, *Maximinian*, pray.

Maximinian. I'll pray and work too. 270

Diocles. I'll to the Market place, and read the offer,
 And now I have found the Boar.

Delphia. Find your owne faith too,
 And remember what ye have vow'd.

Diocles. O Mother.

Delphia. Prosper.

 [*Exeunt, manet* Geta.]

Geta. If my Master and I do do this, there's two Emperours,
 And what a show will that make? how we shall bounce it?

 Exit.

 Enter Drusilla *and* Delphia. II.i

Drusilla. Leave us, and not vouchsafe a parting kisse
 To her that in his hopes of greatnesse lives,
 And goes along with him in all his dangers?

Delphia. I grant 'twas most inhumane.

Drusilla. O you give it
 Too mild a name: 'twas more then barbarous,
 And you a partner in't.

Delphia. I *Drusilla?*

Drusilla. Yes:
 You have blowne his swolne pride to that vastnesse,
 As he beleeves the earth is in his fadom,
 This makes him quite forget his humble Being:
 And can I hope that he, that onely fed 10
 With the imagin'd food of future Empire,
 Disdains even those that gave him Means, and life,
 To nourish such desires, when he's possest
 Of his amibitious Ends (which must fall on him,

 *274 do do] *stet* F1

 247

Or your Predictions are false) will ever
Descend to look on me?
Delphia. Were his Intents
Perfidious as the Seas or Windes, his heart
Compos'd of falshood; yet the benefit,
The greatnesse of the good he has from you,
(For what I have conferr'd, is thine, *Drusilla*) 20
Must make him firm, and thankful: But if all
Remembrance of the debts he stands engag'd for,
Finde a quick grave in his Ingratitude,
My powerful Art, that guides him to this height,
Shall make him curse the hour he ere was rais'd,
Or sink him to the center.
Drusilla. I had rather
Your Art could force him to return that ardour
To me, I bear to him; or give me power
To moderate my passions: Yet I know not,
I should repent your grant, though you had sign'd it, 30
(So well I finde he's worthy of all service)
But to believe that any check to him
In his main hopes, could yeeld content to me,
Were treason to true love, that knows no pleasure,
The object that it doats on ill affected.
Delphia. Pretty simplicity; I love thee for't,
And will not sit an idle looker on,
And see it cozen'd: dry thy innocent eyes,
And cast off jealous fears, (yet promises
Are but lip-comforts) and but fancie aught 40
That's possible in Nature, or in Art,
That may advance thy comfort, and be bold
To tell thy soul 'tis thine: therefor speak freely.
Drusilla. You new create me. To conceal from you
My virgin fondnesse, were to hide my sicknesse
From my physitian. O dear Aunt, I languish
For want of *Diocles* sight: he is the Sun
That keeps my blood in a perpetual spring:
But in his absence, cold benumming Winter

35 it] F2; is F1

248

Seizes on all my faculties. Would you binde me 50
(That am your slave already) in more fetters,
And (in the place of service) to adore you?
O bear me then (but 'tis impossible,
I fear, to be effected) where I may
See how my *Diocles* breaks thorow his dangers,
And in what heaps his honours flow upon him,
That I may meet him, in the height and pride
Of all his glories; and there (as your gift)
Chalenge him, as mine own.

Delphia. Enjoy thy wishes:
This is an easie Boon, which, at thy yeers, 60
I could have given to any; but now grown
Perfect in all the hidden mysteries
Of that inimitable Art, which makes us
Equal even to the gods, and Natures wonders,
It shall be done, as fits my skill and glory:
To break thorow bolts, and locks, a Scholars prize
For Theeves, and Pick-locks: To passe thorow an Army
Cover'd with Night, or some disguise, the practice
Of poor and needy Spies: No, my *Drusilla*,
From *Ceres* I will force her winged Dragons, 70
And in the air hung over the Tribunal
(The Musick of the Spheres attending on us)
There, as his good Star, thou shalt shine upon him,
If he prove true, and as his Angel guard him.
But if he dare be false, I, in a moment
Will put that glorious light out, with such horrour,
As if the eternal Night had seiz'd the Sun,
Or all things were return'd to the first Chaos,
And then appear like Furies.

Drusilla. I will do
What ere you shall command:

Delphia. Rest then assur'd, 80
I am the Mistris of my Art, and fear not.

 Exeunt.

*71 hung] *stet* F1

249

Soft Musick. Enter Aper, Camurius, [II.] ii
Guards, *a Litter covered.*

Aper. Your care of your sick Emperour, fellow-souldiers,
In colours to the life, doth shew your love,
And zealous duty: O continue in it.
And though I know you long to see and hear him,
Impute it not to pride, or melancholy,
That keeps you from your wishes: such State-vices
(Too too familiar with great Princes) are
Strangers to all the actions of the life
Of good *Numerianus*: Let your patience
Be the Physitian to his wounded eyes, 10
(Wounded with pious sorrow for his father)
Which Time and your strong Patience will recover,
Provided it prove constant. [Aper *bows low to the Litter.*]
1 Guard [*aside*]. If he counterfeit,
I will hereafter trust a prodigal heir,
When he weeps at his fathers Funeral.
2 Guard [*aside*]. Or a young widow, following a bed-rid husband,
(After a three yeers groaning) to the Fire.
3. Guard [*aside*]. Note his humility, and with what soft murmures
He does enquire his pleasures.
1 Guard [*aside*]. And how soon
He is instructed.
2 Guard [*aside*]. How he bows again too. 20
Aper. All your Commands (dread *Caesar*) I'll impart
To your most ready Souldier, to obey them;
So take your rest in peace.——It is the pleasure
Of mighty *Caesar* (his thanks still remembred
For your long patience, which a donative,
Fitting his State to give, shall quickly follow)
That you continue a strict Guard upon
His sacred person, and admit no stranger
Of any other Legion, to come neer him;
You being most trusted by him. I receive 30
Your answer in your silence.——[*apart*] Now *Camurius*,
Speak without flattery; Hath thy *Aper* acted

This passion to the life?

Camurius [*apart*]. I would applaud him,
 Were he saluted *Caesar*: but I fear
 These long protracted counsels will undo us;
 And 'tis beyond my reason, he being dead,
 You should conceal your self, or hope it can
 Continue undiscover'd.

Aper [*apart*]. That I have killed him,
 Yet feed these ignorant fools with hopes he lives,
 Has a main end in't. The Pannonion Cohorts 40
 (That are my own, and sure) are not come up,
 The Germane Legions waver, and *Charinus*,
 Brother to this dead dog (hells plagues on *Niger*)
 Is jealous of the murther; and I hear,
 Is marching up against me. 'Tis not safe,
 Till I have power to justifie the Act,
 To shew my self the Authour: be therefore careful
 For an hour or two (till I have fully sounded
 How the Tribunes and Centurions stand affected)
 That none come neer the Litter. If I finde them 50
 Firm on my part, I dare professe my self,
 And then live *Aper's* equal.

Camurius [*apart*]. Does not the body
 Begin to putrifie?

Aper [*apart*]. That exacts my haste:
 When, but even now, I feign'd obedience to it,
 As I had some great businesse to impart,
 The sent had almost choak'd me: be therefore curious:
 All keep at distance.

Camurius [*apart*]. I am taught my part;
 Haste you, to perfect yours. *Exit* [Aper].

1 Guard. I had rather meet
 An enemy in the field, then stand thus nodding
 Like to a rug-gown'd Watch-man.

 Enter Diocles, Maximinian, Geta.

Geta. The Watch at noon? 60

This is a new device.
Camurius. Stand.
Diocles. I am arm'd
 Against all danger.
Maximinian. If I fear to follow.
 A Cowards name pursue me.
Diocles. Now my Fate
 Guide and direct me.
Camurius. You are rude and sawcy,
 With your forbidden feet to touch this ground,
 Sacred to *Caesar* onely, and to these
 That do attend his person. Speak, what are you?
Diocles. What thou, nor any of thy faction are,
 Nor ever were: Souldiers, and honest men.
Camurius. So blunt?
Geta. Nay, you shall finde he's good at the sharp too. 70
Diocles. No instruments of craft, engines of murder,
 That serve the Emperour onely with oil'd tongues,
 Smooth and applaud his vices, play the Bauds
 To all his appetites; and when you have wrought
 So far upon his weaknesse, that he's grown
 Odious to the subject and himself,
 And can no further help your wicked ends,
 You rid him out of the way.
Camurius. Treason?
Diocles. 'Tis truth,
 And I will make it good.
Camurius. Lay hands upon 'em,
 Or kill them suddenly.
Geta. I am out at that; 80
 I do not like the sport.
Diocles. What's he that is
 Owner of any vertue worth a Roman,
 Or does retain the memory of the Oath
 He made to *Caesar*, that dares lift his sword
 Against the man that (carelesse of his life)
 Comes to discover such a horrid Treason,
 As when you hear't, and understand how long
 Y'ave been abus'd, will run you mad with fury?

I am no stranger, but (like you) a Souldier,
Train'd up one from my youth: and there are some 90
With whom I have serv'd, and (not to praise my self)
Must needs confesse they have seen *Diocles*
In the late Britain Wars, both dare and do
Beyond a common man.

1 Guard. *Diocles?*

2 Guard. I know him,
The bravest Souldier of the Empire.

Camurius. Stand:
If thou advance an inch, thou art dead. *Diocles kills*

Diocles. Die thou, *Camurius.*
That durst oppose thy self against a Truth
That will break out, though mountains cover it.

Geta. I fear this is a sucking Pigg; no Boar,
He falls so easie.

Diocles. Hear me, fellow Souldiers; 100
And if I make it not apparant to you
This is an act of Justice, and no Murther,
Cut me in pieces: I'll disperse the cloud
That hath so long obscur'd a bloody act
Nere equall'd yet: you all know with what favours
The good *Numerianus* ever grac't
The Provost *Aper?*

Guard. True.

Diocles. And that those bounties
Should have contain'd him (if he ere had learn'd
The elements of Honestie and Truth)
In loyal duty: But ambition never 110
Looks backward on desert, but with blinde haste
Boldly runs on. But I lose time. You are here
Commanded by this *Aper* to attend
The Emperours person; to admit no stranger
To have accesse to him, or come neer his Litter,
Under pretence (forsooth) his eyes are sore,
And his minde troubled: no, my friends, you are cozen'd;
The good *Numerianus* now is past
The sense of wrong or injury. [*Uncovers the Litter.*]

105 know] Langbaine (Betterton); knew F1–2

253

Guard. How? dead?

Diocles. Let your own eyes inform you.

Geta. An Emperours Cabinet? 120
Fough, I have known a Charnel-house smell sweeter.
If Emperours flesh have this savour, what will mine do,
When I am rotten?

1 Guard. Most unheard-of villany.

2 Guard. And with all cruelty to be reveng'd.

3 Guard. Who is the murtherer? name him, that we may
Punish it in his family.

Diocles. Who but *Aper?*
The barbarous and most ingrateful *Aper?*
His desperate Poniard printed on this brest
This deadly wound: hate to vow'd enemies
Findes a full satisfaction in death; 130
And Tyrants seek no farther. He (a Subject,
And bound by all the Ties of love and duty)
Ended not so; but does deny his Prince
(Whose ghost, forbad a passage to his rest,
Mourns by the Stygian shore) his Funeral-Rites.
Nay, weep not; let your loves speak in your anger;
And, to confirm you gave no suffrage to
The damned Plot, lend me your helping hands
To wreak the Parricide: and if you finde
That there is worth in *Diocles* to deserve it, 140
Make him your leader.

Guard. A *Diocles*, a *Diocles.*

Diocles. We'll force him from his Guards.

 [*Exeunt* Guards *with Litter, and body of* Camurius.]
 And now, my Stars,
If you have any good for me in store,
Shew it, when I have slain this fatal Boar.

 Exeunt.

 Enter Delphia *and* Drusilla [*descending*] [II.] iii
 in a Throne drawn by Dragons.

Delphia. Fix here, and rest a while your Sail-stretch'd wings
That have out-stript the windes: the eye of heaven

 128 this] his F1–2 134 a passage] Sympson; passage F1–2

Durst not behold your speed, but hid it self
Behinde the grossest clouds; and the pale Moon
Pluckt in her silver horns, trembling for fear
That my strong Spells should force her from her Sphere;
Such is the power of Art.

Drusilla. Good Aunt, where are we?

Delphia. Look down, *Drusilla*, on these lofty Towers
These spacious streets, where every private house
Appears a Palace to receive a King: 10
The site, the wealth, the beauty of the place,
Will soon inform thee 'tis imperious *Rome*,
Rome, the great Mistris of the conquer'd world.

Drusilla. But without *Diocles*, it is to me
Like any wildernesse we have pass'd ore:
Shall I not see him?

Delphia. Yes, and in full glory,
And glut thy greedy eyes with looking on
His prosperous successe: Contain thy self;
For though all things beneath us are transparent,
The sharpest sighted, were he Eagle-ey'd, 20
Cannot discover us: nor will we hang
Idle spectators to behold his triumph:
But when occasion shall present it self,
Do something to adde to it.

> *Enter* Diocles, Maximinian, Guards, [*holding*] Aper,
> Senators, Geta, *Officers*, (*with Litter*).

 See he comes.

Drusilla. How god-like he appears? with such a grace
[And victor's mien, as well befits one who had ruined]
The Giants that attempted to scale heaven,
When they lay dead on the Phlegrean plain,
Mars did appear to *Jove*.

Delphia. Forbear.

Diocles. Look on this,
And when with horrour thou hast view'd thy deed,
(Thy most accursed deed) be thine own judge, 30
And see (thy guilt consider'd) if thou canst

*26 The Giants] stet F1

Perswade thy self (whom thou stand'st bound to hate)
To hope or plead for mercy.
Aper. I confesse
My life's a burden to me.
Diocles. Thou art like thy name,
A cruel Boar, whose snout hath rooted up
The fruitful Vineyard of the Common-wealth:
I long have hunted for thee, and since now
Thou art in the Toyl, it is in vain to hope
Thou ever shalt break out: thou dost deserve
The Hangmans hook, or to be punished 40
More majorum, whipt with rods to death,
Or any way, that were more terrible.
Yet, since my future fate depends upon thee,
Thus, to fulfil great *Delphia's* Prophecie,
Aper (thou fatal Boar) receive the honour
To fall by *Diocles* hand. *Kills* Aper.
 Shine clear, my Stars,
That usher'd me to taste this common aire,
In my entrance to the world, and give applause
To this great work.
Delphia. Strike Musick from the Spheres. *Musick [above].*
Drusilla. O now you honour me.
Diocles. Ha? in the Air? 50
All. Miraculous.
Maximinian. This shews the gods approve
The Person, and the Act: then if the Senate
(For in their eyes I read the Souldiers love)
Think *Diocles* worthy to supply the place
Of dead *Numerianus,* as he stands
His heir, in his revenge, with one consent
Salute him Emperour.
Senators. Long live *Diocles:*
Augustus, Pater Patriae, and all Titles
That are peculiar onely to the *Caesars.*
We gladly throw upon him.
Guards. We confirm it, 60

And will defend his honour with our Swords
Against the world: raise him to the Tribunal.
1 Senator. Fetch the Imperial Robes: and as a signe
We give him absolute power of life and death,
Binde this sword to his side.
2 Senator. Omit no Ceremony
That may be for his honour.

 Song [the while they invest Diocles].
Maximinian. Still the gods
Expresse that they are pleas'd with this election.
Geta. My Master is an Emperour, and I feel
A Senators Itch upon me: would I could hire
These fine invisible Fidlers to play to me 70
At my instalment.
Diocles. I embrace your loves,
And hope the honours that you heap upon me,
Shall be with strength supported. It shall be
My studie to appear another *Atlas*,
To stand firm underneath this heaven of Empire,
And bear it boldly. I desire no Titles,
But as I shall deserve 'em. I will keep
The name I had, being a private man,
Onely with some small difference; I will adde
To *Diocles* but two short syllables, 80
And be called *Dioclesianus.*
Geta. That is fine:
I'll follow the fashion; and when I am a Senator,
I will be no more plain *Geta*, but be call'd
Lord *Getianus.*
Drusilla [apart]. He ne'er thinks of me,
Nor of your favour.
Delphia. If he dares prove false,
These glories shall be to him as a dream,
Or an inchanted banquet.

 Enter Niger.

66 Song.] stet F1 *81 *Dioclesianus] stet* F1

Niger. From *Charinus*,
 From great *Charinus*, who with joy hath heard
 Of your proceedings, and confirms your honours:
 He, with his beauteous sister, fair *Aurelia*, 90
 Are come in person, like themselves attended
 To gratulate your fortune.
Dioclesian. For thy news,
 Be thou in *France* Pro-consul: let us meet
 The Emperour with all honour, and embrace him.

 Loud Musick. Enter Charinus, Aurelia, *Attendants.*

Drusilla [apart]. O Aunt, I fear this Princesse doth eclipse
 Th'opinion of my beauty, though I were
 My self to be the judge.
Delphia [apart]. Rely on me.
Charinus. 'Tis vertue and not birth that makes us noble:
 Great actions speak great mindes, and such should govern;
 And you are grac't with both. Thus, as a Brother, 100
 A Fellow, and Co-partner in the Empire,
 I do embrace you: may we live so far
 From difference, or emulous Competition,
 That all the world may say, Although two Bodies,
 We have one Minde.
Aurelia. When I look on the Trunk
 Of dear *Numerianus*, I should wash
 His wounds with tears, and pay a sisters sorrow
 To his sad fate: but since he lives again
 In your most brave Revenge, I bow to you,
 As to a power that gave him second life, 110
 And will make good my promise. If you finde
 That there is worth in me that may deserve you,
 And that in being your wife, I shall not bring
 Disquiet and dishonour to your Bed,
 Although my youth and fortune should require
 Both to be su'd and sought to, here I yeeld
 My self at your devotion.
Dicolesian. O you gods,
 Teach me how to be thankful: you have pour'd

All blessings on me, that ambitious man
Could ever fancie: till this happie minute, 120
I nere saw beauty, or believ'd there could be
Perfection in a woman. I shall live
To serve and honour you: upon my knees
I thus receive you; and, so you vouchsafe it,
This day I am doubly married; to the Empire,
And your best-self.
Delphia [*apart*]. False and perfidious villain.
Drusilla [*apart*]. Let me fall headlong on him: O my Stars!
This I foresaw and fear'd.
Charinus. Call forth a *Flamen*. [*Exit Attendant.*]
This knot shall now be ti'd.
Delphia [*apart*]. But I will loose it,
If Art or Hell have any strength. *Thunder and Lightning.*
Charinus. Prodigious! 130
Maximinian. How soon the day's orecast?

 Enter a Flamen.

Flamen. The Signes are fatal:
Juno smiles not upon this Match, and shews too
She has her thunder.
Dioclesian. Can there be a stop
In my full fortune?
Charinus. We are too violent,
And I repent the haste: we first should pay
Our latest duty to the dead, and then
Proceed discreetly. Let's take up the body,
And when we have plac'd his ashes in his Urn,
We'll try the gods again: for wise men say,
Marriage and Obsequies do not suit one day. 140
 Senate [*with all below*] *exit.*
Delphia. So, 'tis deferr'd yet, in despite of falshood:
Comfort *Drusilla*, for he shall be thine,
Or wish, in vain, he were not. I will punish
His perjury to the height. Mount up, my birds; [*Dragons*] *Ascend.*
Some Rites I am to perform to *Hecate*,
To perfect my designes; which once perform'd,

He shall be made obedient to thy Call,
Or in his ruine I will bury all. *Ascends throne*
 [*and Exeunt*].

 Enter Maximinian (*solus*). III.i

Maximinian. What powerful Star shin'd at this mans Nativity?
 And bless'd his homely Cradle with full glory?
 What throngs of people presse and buz about him,
 And with their humming flatteries sing him *Caesar?*
 Sing him aloud, and grow hoarse with saluting him?
 How the fierce-minded Souldier steals in to him,
 Adores and courts his Honour? at his devotion
 Their lives, their vertues and their fortunes laying?
 Charinus sues, the Emperour intreats him,
 And as a brighter flame, takes his beams from him. 10
 The bless'd and bright *Aurelia*, she doats on him,
 And as the god of Love, burns incense to him.
 All eyes live on him. Yet I am still *Maximinian.*
 Still the same poor and wretched thing, his servant.
 What have I got by this? where lies my glory?
 How am I rais'd and honour'd? I have gone as far
 To woo this purblinde Honour, and have pass'd
 As many dangerous Expeditions,
 As noble, and as high; nay, in his destinie
 (Whilst 'twas unknown) have run as many hazards, 20
 And done as much; sweat thorow as many perils;
 Onely the Hang-man of *Volutius Aper*
 (Which I mistook) has made him Emperour,
 And me his slave.

 Enter Delphia *and* Drusilla [*invisible*].

Delphia. Stand still; he cannot see us,
 Till I please: mark him well, this discontentment
 I have forc'd into him, for thy cause, *Drusilla.*
Maximinian. Can the gods see this;
 See it with justice, and confer their blessings
 On him, that never flung one grain of incense
 Upon their Altars? never bow'd his knee yet; 30

And I that have march'd foot by foot, struck equally,
And whilst he was a gleaning, have been praying,
Contemning his base covetous——
Delphia. Now we'll be open.
Maximinian. Blesse me, and with all reverence. [*Kneels.*]
Delphia. Stand up, Son,
And wonder not at thy ungrateful Uncle:
I know thy thoughts, and I appear to ease 'em.
Maximinian. O mother, did I stand the tenth part to ye
Engag'd and fetter'd, as mine Uncle does,
How would I serve, how would I fall before ye?
The poorer powers we worship——
Delphia. Peace, and flatter not; 40
Necessitie and anger draws this from ye;
Of both which I will quit ye: For your Uncle
I spoke this Honour, and it fell upon him;
Fell, to his full content: he has forgot me,
For all my care; forgot me, and his vow too:
As if a dream had vanish'd, so h'as lost me,
And I him: let him now stand fast. Come hither;
My care is now on you.
Maximinian. O blessed Mother!
Delphia. Stand still, and let me work. [*She casts a spell.*]
 So now, *Maximinian,*
Go, and appear in Court, and eye *Aurelia*: 50
Beleeve, what I have done, concerns ye highly.
Stand in her view, make your addresses to her:
She is the Stayre of Honour. I'll say no more,
But Fortune is your servant: go.
Maximinian. With reverence;——
All this as holy truths——
Delphia. Believe, and prosper. *Exit* [Maximinian].
Drusilla. Yet all this cures not me; but as much credit,
As much belief from *Dioclesian*——
Delphia. Be not dejected; I have warn'd ye often:
The proudest thoughts he has, I'll humble.

40 we] F2; me F1 53 Stayre] F2 (Stair); Satyre F1

Enter Geta, Lictors, *and* Suitors, (*with Petitions*).

 [*Aside*] Who's this?
O 'tis the fool and knave grown a grave Officer: 60
Here's hot and high preferment.
Geta. What's your Bill?———
For Gravel for the *Appian* way, and Pills?——— [*Reads.*]
Is the way rheumatick?
1 Suitor. 'Tis Piles, and 't please you.
Geta. Remove me those Piles to Port *Esquiline,*
Fitter the place, my friend: you shall be paid.
1 Suitor. I thank your Worship.
Geta. Thank me when ye have it;
Thank me another way, ye are an Asse else.
I know my Office: you are for the Streets, Sir.
Lord, how ye throng! that knave has eaten Garlick;
Whip him, and bring him back. [*Exeunt some* Lictors *with him.*]
3 Suitor. I beseech your Worship; 70
Here's an old reckoning for the dung and dirt, Sir.
Geta. It stinks like thee: Away. Yet let him tarry,
His Bill shall quit his Breath. Give your Petitions
In seemly sort, and keep your hats off, decently.———
For scowring the Water-courses thorow the Cities?———[*Reads.*]
A fine periphrasis of a kennel-raker.
Did ye scour all, my friend? ye had some businesse:
Who shall scour you? you are to be paid, I take it,
When Surgeons swear you have performed your Office.
4 Suitor. Your Worship's merry.
Geta. We must be sometimes wittie, 80
To nick a knave; 'tis as useful as our gravitie.
I'll take no more Petitions; I am pester'd;
Give me some rest.
4 Suitor. I have brought the gold (and 't please ye)
About the Place ye promised.
Geta. See him enter'd.
How does your daughter?
4 Suitor. Better your Worship thinks of her.

70 your] F2; you F1

Geta. This is with the least. But let me see your daughter.
'Tis a good forward maid; I'll joyn her with ye.——
I do beseech ye, leave me.
Lictor. Ye see the Edile's busie.
Geta. And look to your Places, or I'll make ye smoke else.
Sirha, I drank a cup of wine at your house yesterday; 90
A good smart wine.
Lictor. Send him the piece, he likes it.
Geta. And ate the best wilde Boar at that same Farmors.
2 Suitor. I have half left yet: your Worship shall command it.
Geta. A bit will serve:—— give me some rest: gods help me.
How shall I labour when I am a Senator?
Delphia [*apart*]. 'Tis a fit place indeed.——'Save your Mastership;
Do you know us, Sir?
Geta. These women are still troublesom.
There be houses providing for such wretched women,
And some small Rents, to set ye a spinning.
Drusilla. Sir,
We are no Spinsters; nor, if you look upon us, 100
So wretched as you take us.
Delphia. Does your Mightinesse,
That is a great destroyer of your Memorie,
Yet understand our faces?
Geta. 'Prethee keep off, woman;
It is not fit I should know every creature.
Although I have been familiar with thee heretofore,
I must not know thee now: my place neglects thee.
Yet, because I daign a glimpse of your remembrances,
Give me your Suits, and wait me a month hence.
Delphia. Our Suits are (Sir) to see the Emperour,
The Emperour *Dioclesian*, to speak to him, 110
And not to wait on you. We have told you all, Sir.
Geta. I laugh at your simplicitie, poor women:
See the Emperour? why you are deceiv'd: now
The Emperour appears but once in seven yeers,
And then he shines not on such weeds as you are.——
Forward, and keep your State, and keep beggers from me.

 Exeunt [*Geta and his Traine*].

Drusilla. Here is a prettie youth.

Delphia. He shall be prettie,
Or I will want my will: since ye are so high, Sir,
I'll raise ye higher, or my art shall fail me.——
Stand close, he comes.

Enter Dioclesian.

Dioclesian. How am I cross'd and tortur'd? 120
My most wish'd happinese, my lovely Mistris,
That must make good my hopes, and link my greatnesse,
Yet sever'd from mine arms? Tell me, high heaven,
How have I sinn'd, that you should speak in thunder,
In horrid thunder, when my heart was ready
To leap into her brest? the Priest was ready?
The joyful virgins and the young men ready?
When *Hymen* stood with all his flames about him
Blessing the bed? the house with full joy sweating?
And expectation, like the Romane Eagle, 130
Took stand, and call'd all eyes? It was your Honour;
And ere you give it full, do you destroy it?
Or was there some dire Star? some devil that did it?
Some sad malignant Angel to mine honour?
With you, I dare not rage.

Delphia. With me thou canst not,
Though it was I. Nay, look not pale and frighted;
I'll fright thee more. With me thou canst not quarrel;
I rais'd the thunder, to rebuke thy falshood:
Look here, to her thy falshood. Now be angry,
And be as great in evil as in Empire. 140

Dioclesian. Blesse me, ye Powers.

Delphia. Thou hast full need of blessing.
'Twas I, that at thy great Inauguration,
Hung in the air unseen: 'twas I that honoured thee
With various Musicks, and sweet sounding airs:
'Twas I inspired the souldiers heart with wonder,
And made him throw himself, with love and duty,
Lowe as thy feet: 'twas I that fix'd him to thee.
But why did I all this? To keep thy honestie,

Thy vow and faith, that once forgot and slighted
Aurelia in regard, the Marriage ready,　　　　　　　150
The Priest and all the Ceremonies present.
'Twas I that thundred loud; 'twas I that threatned;
'Twas I that cast a dark face over heaven,
And smote ye all with terrour.

Drusilla.　　　　　　　　　　Yet consider,
As ye are noble, as I have deserv'd ye;
For yet ye are free: if neither faith nor promise,
The deeds of elder times may be remembred,
Let these new-dropping tears; for I still love ye,
These hands held up to heaven————

Dioclesian.　　　　　　　　　I must not pitie ye;
'Tis not wise in me.

Delphia.　　　　　How? not wise?

Dioclesian.　　　　　　　　Nor honourable.　　　　160
A Princesse is my Love, and doats upon me:
A fair and lovely Princesse is my Mistris.
I am an Emperour: consider, Prophetesse,
Now my embraces are for Queens and Princesses,
For Ladies of high mark, for divine beauties:
To look so lowe as this cheap common sweetnesse,
Would speak me base, my names and glories nothing.
I grant I made a vow; what was I then?
As she is now, of no sort (Hope made me promise)
But as I am, to keep this vow, were monstrous,　　　170
A madnesse, and a lowe inglorious fondnesse.

Delphia.　　Take heed, proud man.

Drusilla.　　　　　　　Princes may love with Titles,
But I with Truth.

Delphia.　　　　Take heed; here stands thy destinie;
Thy Fate here follows.

Dioclesian.　　　　　　Thou doating Sorceresse,
Wouldst have me love this Thing, that is not worthy
To kneel unto my Saint? to kisse her shadow?
Great Princes are her slaves; selected beauties
Bow at her beck: the mighty Persian's daughter

*170 as] (Betterton); now F1–2

265

(Bright as the breaking East, as the mid-day glorious)
Waits her commands, and grows proud in her pleasures. 180
I'll see her honour'd: some Match I shall think of,
That shall advance ye both; mean time I'll favour ye. *Exit.*
Delphia. Mean time I'll haunt thee.
 Cry not (wench) be confident,
Ere long, thou shalt more pitie him (observe me)
And pitie him in truth, then now thou seek'st him:
My Art and I are yet companions. Come, Girl.

 Exeunt.

 Enter Geta, Lictors [and *Officers*, Suitors. *A Chair*]. [III.]

Geta. I am too merciful, I finde it (friends)
 Of too soft a nature to be an Officer;
 I bear too much remorse.
1 Lictor. 'Tis your own fault, Sir;
 For look you, One so newly warm in Office
 Should lay about him blindfold, like true Justice,
 Hit where it will: the more ye whip and hang, Sir,
 (Though without cause; let that declare it self afterward)
 The more ye are admired.
Geta. I think I shall be.——
2 Lictor. Your Worship is a man of a spare body,
 And prone to anger.
Geta. Nay, I will be angry, 10
 And, the best is, I need not shew my reason.
2 Lictor. You need not, Sir, your place is without reason;
 And what you want in growth and full proportion,
 Make up in rule and rigour.
Geta. A rare Counsellor;
 Instruct me further. Is it fit, my friends,
 The Emperour my Master *Dioclesian*
 Should now remember or the Times or Manners
 That call'd him plain down *Diocles?*
1 Lictor. He must not,
 It stands not with his Royaltie.
Geta. I grant ye,

181 Match] F2; Watch F1

266

I being then the Edile *Getianus*, 20
A man of Place, and Judge, is it held requisite
I should commit to my consideration
Those Rascals of removed and ragged hours,
That with unreverend mouthes call'd me Slave *Geta?*

2 Lictor. You must forget their names; your Honour bids ye.

Geta. I do forget; but I'll hang their natures:
I will ascend my Place, which is of Justice; [*Sits in Chair.*]
And Mercy, I forget thee.

Suitor. A rare Magistrate;
Another *Solon* sure.

Geta. Bring out the offenders.

1 Lictor. There are none yet, Sir, but no doubt there will be. 30
But if you please touch some things of those natures——

Geta. And am I ready, and mine anger too?
The melancholy of a Magistrate upon me,
And no offenders to execute my fury?
Ha? no offenders, knaves?

1 Lictor. There are knaves indeed, Sir,
And we hope shortly to have 'em for your Worship.

Geta. No men to hang or whip? are you good Officers,
That provide no fuel for a Judges fury?
In this Place something must be done; this Chair, I tell ye,
When I sit down, must savour of Severitie: 40
Therefore I warn ye all, bring me lewd people,
Or likely to be lewd; twigs must be cropt too:
Let me have evil persons in abundance,
Or make 'em evil; 'tis all one, do but say so,
That I may have fit matter for a Magistrate;
And let me work. If I sit empty once more,
And lose my longing, as I am true Edile,
And as I hope to rectifie my Countrie,
You are those scabs I will scratch off from the Common-wealth:
You are those Rascals of the State I treat of, 50
And you shall finde and feel——

2 Lictor. You shall have many,
Many notorious people.

 21 is it] F2; it is F1 *36 And] (Dyce *conj.*); But F1–2

 267

Geta. Let 'em be people,
And take ye notorious to your selves. Mark me, my Lictors,
And you, the rest of my Officials;
If I be angry, as my place will ask it,
And want fit matter to dispose my Authoritie,
I'll hang a hundred of ye: I'll not stay longer,
Nor enquire no further into your offences:
It is sufficient that I finde no Criminals,
And therefore I must make some: if I cannot, 60
Suffer my self; for so runs my Commission.
Suitor. An admirable, zealous and true Justice.
1 Lictor. I cannot hold: if there be any people,
Of what degree soever, or what qualitie,
That would behold the wonderful works of Justice
In a new Officer, a man conceal'd yet,
Let 'em repair, and see, and hear, and wonder
At the most wise and gracious *Getianus.*
Geta. This qualifies a little.

Enter Delphia *and* Drusilla.

 What are these?
Delphia [*to* Drusilla]. You shall not mourn still: times of recreation, 70
To allay this sadnesse, must be sought. What's here?
A superstitious flock of senslesse people
Worshipping a signe in Office?
Geta. Lay hold on her,
And hold her fast, [*Officers seize her.*]
She'll slip thorow your fingers like an Eel else;
I know her tricks: hold her, I say, and binde her,
Or hang her first, and then I'll tell her wherefore.
Delphia. What have I done?
Geta. Thou hast done enough to undo thee;
Thou hast pressed to the Emperours presence without my warrant,
I being his key and image.
Delphia. You are an image indeed, 80
And of the coursest stuff, and the worst making
That ere I look'd on yet:

*67 'em] him F1–2

268

I'll make as good an image of an Asse.

Geta.　　Besides, thou art a woman of a lewd life.

Delphia.　　I am no whore, Sir, nor no common fame
Has yet proclaim'd me to the people, vitious.

Geta.　　Thou art to me a damnable lewd woman,
Which is as much as all the people swore it;
I know thou art a keeper of tame devils:
And whereas great and grave men of my Place　　　　　90
Can by the Laws be allow'd but one apiece,
For their own services and recreations;
Thou, like a traiterous quean, keepst twenty devils;
Twenty in ordinary.

Delphia.　　　　　Pray ye, Sir, be pacified,
If that be all: and if ye want a servant,
You shall have one of mine shall serve for nothing,
Faithful, and diligent, and a wise devil too;
Think for what end.

Geta.　　Let her alone, 'tis useful;　　*[Release her.]*
We men of business must use speedie servants:
Let me see your family.

Delphia.　　　　　Think but one, he is ready.　　　　　100

Geta.　　A devil for intelligence? No, no,
He will lye beyond all travellers. A State-devil?
Neither; he will undo me at mine own weapon,
For execution? he will hang me too.
I would have a handsom, pleasant and a fine she-devil,
To entertain the Ladies that come to me;
A travell'd devil too, that speaks the tongues,
And a neat carving devil.　　　　*Musick. [She conjures.]*

Enter a She-devil.

Delphia.　　　　　Be not fearful.

Geta.　　A prettie brown devil ifaith; may I not kisse her?

Delphia.　　Yes, and embrace her too; she is your servant.　　110
Fear not; her lips are cool enough.

Geta.　　She is marvellous well mounted; what's her name?

Delphia.　　Lucifera.

85 no whore] F2; nowhere F1

269

Geta. Come hither, *Lucifera*, and kisse me.
Delphia. Let her sit on your knee. [*She sits and kisses him.*]
Geta. The Chair turns: hey-boys:
 [*They*] *Dance.*
 Pleasant ifaith, and a fine facetious devil.
Delphia. She would whisper in your ear, and tell ye wonders.
Geta. Come; what's her name?
Delphia. *Lucifera.*
Geta. Come, *Lucie,*
 Come, speak thy minde. [*She whispers in his ear.*]
 Exeunt [*all save* Geta].
 I am certain burnt to ashes.
 I have a kinde of Glasse-house in my cod-piece.
 Are these the flames of State? I am rosted over, 120
 Over, and over-rosted. Is this Office?
 The pleasures of Authoritie? I'll no more on't;
 Till I can punish devils too, I'll quit it.
 Some other Trade now, and some course lesse dangerous,
 Or certainly I'll tyle again for two-pence.
 Exit.

 Enter Charinus, Aurelia, Cassana, [*Persian*] Ambassadors, [III.] iii
 Attendants.

Aurelia. Never dispute with me; you cannot have her:
 Nor name the greatnesse of your King; I scorn him:
 Your knees to me are nothing; should he bow too,
 It were his dutie, and my power to slight him.
Charinus. She is her woman; never sue to me;
 And in her power to render her, or keep her;
 And she, my sister, not to be compell'd,
 Nor have her own snatch'd from her.
Ambassador. We desire not,
 But for what ransom she shall please to think of;
 Jewels, or Towns, or Provinces——
Aurelia. No ransom, 10
 No, not your Kings own head, his crown upon it,
 And all the lowe subjections of his People.

 *114.1 *Dance.*] *stet.* F1

Ambassador. Fair Princes should have tender thoughts.
Aurelia. Is she too good
 To wait upon the mighty Emperours sister?
 What Princesse of that sweetnesse, or that excellence,
 Sprung from the proudest, and the mightiest Monarch,
 But may be highly blest to be my servant?
Cassana. 'Tis most true, mighty Lady.
Aurelia. Has my fair usage
 Made you so much despise me and your fortune,
 That ye grow weary of my entertainments? 20
 Henceforward, as ye are, I will command ye,
 And as you were ordain'd my prisoner,
 My slave, and one I may dispose of any way,
 No more my fair Companion:———tell your King so:
 And if he had more sisters, I would have 'em,
 And use 'em as I please. You have your Answer.
Ambassador. We must take some other way: force must compel it.
 Exeunt [Ambassadors].

 Enter Maximinian [*and stand apart*].

Maximinian. Now if thou beest a Prophetesse, and canst do
 Things of that wonder that thy tongue delivers,
 Canst raise me too: I shall be bound to speak thee: 30
 I half believe, confirm the other to me,
 And Monuments to all succeeding Ages,
 Of thee, and of thy piety—— Now she eyes me.
 Now work great power of Art: she moves unto me:
 How sweet, how fair, and lovely her aspects are?
 Her eyes are like bright Ioan flames shot thorow me.
Aurelia. O my fair friend, where have you been?
Maximinian. What am I?
 What does she take me for? Work still, work strongly.
Aurelia. Wherefore have you fled my loves and my embraces?
Maximinian. I am beyond my wits.
Aurelia. Can one poor Thunder, 40
 Whose causes are as common as his noises,

*16 Monarch] Monarchs F1–2 36 Ioan] (*i.e.,* Eoan: *pertaining to the goddess*)
*39 Wherefore] Where F1–2

Make ye defer your lawful and free pleasures?
Strike terrour to a Souldiers heart, a Monarchs?
Thorow all the fires of angry heaven, thorow tempests
That sing of nothing but destruction,
Even underneath the bolt of *Jove*, then ready,
And aiming dreadfully, I would seek you,
And flie into your arms.

Maximinian. I shall be mighty
And (which I never knew yet) I am goodly;
For certain, a most handsom man.

Charinus. Fie, sister, 50
What a forgetful weaknesse is this in ye?
What a light presence? these are words and offers
Due onely to your husband *Dioclesian*;
This free behaviour onely his.

Aurelia. 'Tis strange
That onely empty Names compel Affections:
This man ye see, give him what name or title,
Let it be nere so poor, nere so despis'd (brother)
This lovely man——

Maximinian. Though I be hang'd, I'll forward:
For (certain) I am excellent, and knew not.

Aurelia. This rare and sweet young man, see how he looks, Sir—— 60

Maximinian. I'll justle hard, dear Uncle.

Aurelia. This Thing, I say,
Let him be what he will, or bear what fortune,
This most unequall'd man, this spring of beauty
Deserves the bed of *Juno*.

Charinus. You are not mad.

Maximinian. I hope she be; I am sure I am little better.

Aurelia. O fair, sweet man!

Charinus. For shame refrain this impudence.

Maximinian. Would I had her alone, that I might seal this blessing:
Sure, sure she should not beg: If this continue,
As I hope (heaven) it will; Uncle, I'll nick ye,
I'll nick ye, by this life. Some would fear killing 70
In the pursuit now of so rare a venture;

I am covetous to die for such a Beauty.
Mine Uncle comes:

Enter Dioclesian.

 now, if she stand, I am happie.
Charinus. Be right again, for honours sake.
Dioclesian. Fair Mistris————
Aurelia. What man is this? Away. What sawcy fellow?
Dare any such base groom presse to salute me?
Dioclesian. Have ye forgot me (Fair) or do you jest with me?
I'll tell ye what I am: come, 'pray ye look lovely.
Nothing but frowns and scorns?
Aurelia. Who is this fellow?
Dioclesian. I'll tell ye who I am: I am your husband. 80
Aurelia. Husband to me?
Dioclesian. To you. I am *Dioclesian.*
Maximinian. More of this sport, and I am made, old mother:
Effect but this thou hast begun.
Dioclesian. I am he (Lady)
Reveng'd your brothers death; slew cruel *Aper*:
I am he the Souldier courts, the Empire honours,
Your Brother loves: am he (my lovely Mistris)
Will make you Empresse of the world.
Maximinian. Still excellent:
Now I see too, mine Uncle may be cozen'd.
An Emperour may suffer like another.
Well said (old mother) hold but up this miracle. 90
Aurelia. Thou lyest; thou art not he: thou a brave fellow?
Charinus. Is there no shame, no modestie in women?
Aurelia. Thou one of high and full mark?
Dioclesian. Gods, what ails she?
Aurelia. Generous and noble? Fie, thou lyest most basely.
Thy face, and all aspects upon thee, tells me
Thou art a poor Dalmatian slave, a lowe thing
Not worth the name of Romane: stand off farther.

*95 aspects ... tells] aspects ... tell F2; aspect ... tells F1

Dioclesian. What may this mean?

Aurelia. Come hither, my *Endymion*;
Come, shew thy self, and all eyes be blessed in thee.

Dioclesian. Hah? what is this?

Aurelia. Thou fair Star that I live by, 100
Look lovely on me, break into full brightnesse:——
Look, here's a face now, of another making,
Another mold; here's a divine proportion,
Eyes fit for *Phoebus* self, to gild the world with;
And there's a brow arch'd like the state of heaven;
Look how it bends, and with what radience,
As if the Synod of the gods sate under:
Look there, and wonder: now behold that fellow,
That admirable thing, cut with an ax out.

Maximinian. Old woman, though I cannot give thee recompence, 110
Yet (certainly) I'll make thy name as glorious.

Dioclesian. Is this in truth?

Charinus. She is mad, and you must pardon her.

Dioclesian. She hangs upon him: see.

Charinus. Her fit is strong now:
Be not you passionate.

Dioclesian. She kisses.

Charinus. Let her;
'Tis but the fondnesse of her fit.

Dioclesian. I am fool'd,
And if I suffer this——

Charinus. Pray ye (friend) be pacified,
This will be off anon: she goes in. *Exit* Aurelia [*with* Cassana].

Dioclesian. Sirha.

Maximinian. What say you, Sir?

Dioclesian. How dare thy lips, thy base lips——

Maximinian. I am your kinsman Sir, and no such base one:
I sought no kisses, nor I had no reason 120
To kick the Princesse from me: 'twas no manners:
I never yet compell'd her: of her courtesie
What shee bestows Sir, I am thankfull for.

Dioclesian. Be gone villain.

274

Maximinian. I will, and I will go off with that glory,
 And magnifie my fate. *Exit.*
Dioclesian. Good brother leave me,
 I am to my self a trouble now.
Charinus. I am sorry for't.
 You'll find it but a woman-fit to try ye.
Dioclesian. It may be so; I hope so.
Charinus. I am asham'd, and what I think I blush at. 130
 Exit [with Attendants].
Dioclesian. What misery hath my great Fortune bred me?
 And how far must I suffer? Poor and low States,
 Though they know wants and hungers, know not these,
 Know not these killing Fates: Little contents them,
 And with that little they live Kings, commanding
 And ordering both their Ends and Loves. O Honour!
 How greedily men seek thee, and once purchased,
 How many enemies to mans peace bringst thou?
 How many griefs and sorrows, that like sheers,
 Like fatall sheers, are sheering off our lives still? 140
 How many sad eclipses do we shine thorow?

 Enter Delphia, Drusilla *vail'd [and stand apart].*

 When I presum'd I was bless'd in this fair woman————
Delphia. Behold him now, and tell me how thou likest him.
Dioclesian. When all my hopes were up, and Fortune dealt me
 Even for the greatest and the happiest Monarch,
 Then to be cozen'd, to be cheated basely?
 By mine owne kinsman cross'd? O villain kinsman!
 Cure of my blood; because a little younger,
 A little smoother fac'd: O false, false woman,
 False and forgetfull of thy faith: I'll kill him. 150
 But can I kill her hate too? No: he wooes not,
 Nor worthie is of death, because she follows him,
 Because she courts him: Shall I kill an innocent?
 O *Diocles*! would thou hadst never known this,
 Nor surfeited upon this sweet Ambition,

 135 live ˄ Kings, commanding ˄] Sympson; live, Kings ˄ commanding, F1–2

That now lies bitter at thy heart: O Fortune,
That thou hast none to fool and blow like bubbles,
But Kings, and their Contents!
Delphia. What think ye now, Girl?
Drusilla. Upon my life, I pity his misfortune.
See how he weeps; I cannot hold.
Delphia. Away fool; 160
He must weep bloody tears before thou hast him.——
How fare ye now, brave *Dioclesian?*
What? lazie in your loves? has too much pleasure
Dull'd your most mighty faculties?
Dioclesian. Art thou there?
More to torment me? Dost thou come to mock me?
Delphia. I doe: and I do laugh at all thy suffrings.
I that have wrought 'em come to scorn thy wailings:
I told thee once, This is thy fate, this woman,
And as thou usest her, so thou shalt prosper.
It is not in thy power to turn this destiny, 170
Nor stop the torrent of those miseries
(If thou neglectst her still) shall fall upon thee.
Sigh that thou art dishonest, false of faith,
Proud, and dost think no power can crosse thy pleasures;
Thou wilt find a Fate above thee.
Drusilla. Good Aunt speak mildly:
See how he looks and suffers.
Dioclesian. I find and feel, woman,
That I am miserable.
Delphia. Thou art most miserable.
Dioclesian. That as I am the most, I am most miserable.
But didst thou work this?
Delphia. Yes, and will pursue it.
Doclesian. Stay there, and have some pity:—— fair *Drusilla.* 180
Let me perswade thy mercy, thou hast lov'd mee,
Although I know my suit will sound unjustly
To make thy love the means to lose it selfe,
Have pity on me.
Drusilla. I will do.

171 Nor] F2; not F1 *173 Sigh] *stet* F1

Delphia. Peace Neece.
 Although this softnesse may become your love,
 Your care must scorn it. Let him still contemn thee,
 And still I'll work: the same affection
 He ever shews to thee, be it sweet or bitter,
 The same *Aurelia* shall shew him; no further:
 Nor shall the wealth of all his Empire free this. 190
Doclesian [*aside*]. I must speak fair.——Lovely young maid,
 forgive me,
 Look gently on my sorrows: You that grieve too,
 I see it in your eyes, and thus I meet it. [*Kisses her.*]
Drusilla. O Aunt, I am bless'd.
Dioclesian. Be not both young and cruell,
 Again I beg it, thus.
Drusilla. Thus, Sir, I grant it. [*Kisses him.*]

 Enter Aurelia.

 He's mine own now, Aunt.
Delphia. Not yet (Girl) thou art cozen'd.
Aurelia. O my deer Lord, how have I wrong'd your patience?
 How wandred from the truth of my affections?
 How (like a wanton fool) shun'd that I lov'd most?
 But you are full of goodnesse to forgive, Sir, 200
 As I of griefe to beg, and shame to take it:
 Sure I was not my self, some strange illusion,
 Or what you please to pardon——
Dioclesian. All, my Deerest;
 All, my Delight; and with more pleasure take thee,
 Then if there had been no such dream: for certain,
 It was no more. [*Kisses her.*]
Aurelia. Now you have seal'd forgivenesse,
 I take my leave; and the gods keep your goodnesse. *Exit.*
Delphia. You see how kindnesse prospers: be but so kind
 To marry her, and see then what new fortunes,
 New joyes, and pleasures; far beyond this Lady, 210
 Beyond her Greatnesse too——
Dioclesian. I'll die a dog first.
 Now I am reconcil'd, I will enjoy her

In spight of all thy spirits, and thy witchcraft.

Delphia. Thou shalt not (fool).

Dioclesian. I will, old doating Divel;
And wert thou any thing but air and spirit,
My sword should tell thee——

Delphia. I contemn thy threatnings,
And thou know I hold a power above thee.——
Wee must remove *Aurelia*: Come.——Farewell fool,
When thou shalt see me next, thou shalt bow to me.

Dioclesian. Look, thou appear no more to crosse my pleasures. 220

 Exeunt [*severally*].

 Enter Chorus. IV.i

Chorus. So full of matter is our Historie,
Yet mix'd, I hope with sweet varietie,
The accidents not vulgar too, but rare,
And fit to be presented, that there wants
Room in this narrow Stage, and time to expresse
In Action to the life, our *Dioclesian*
In his full lustre: Yet (as the Statuarie,
That by the large size of *Alcides* foot,
Ghess'd at his whole proportion) so wee hope,
Your apprehensive judgements will conceive 10
Out of the shadow we can only shew,
How fair the body was; and will be pleas'd,
Out of your wonted goodnesse, to behold
As in a silent Mirrour, what we cannot
With fit conveniencie of time, allow'd
For such Presentments, cloath in vocall sounds.
Yet with such Art the Subject is conveigh'd,
That every Scene and passage shall be cleer
Even to the grossest understander here.

 Loud Musick.

 Dumb Shew.

Enter (at one door) [*Persian Souldiers,*] Delphia, Ambassadors, *they whisper together; they take an oath upon her hand; She circles them*

(kneeling) with her Magick rod; They rise and draw their Swords. Enter
(at the other door) Dioclesian, Charinus, Maximinian, Niger, Aurelia,
Cassana, Guard; Charinus *and* Niger *perswading* Aurelia; *She offers to*
imbrace Maximinian; Dioclesian *draws his sword, keeps off* Maximinian,
turns to Aurelia, *kneels to her, laies his sword at her feet, shee scornfully*
turns away: Delphia *gives a signe; the* Ambassadors *and Souldiers rush*
upon them, seise on Aurelia, Cassana, Charinus, *and* Maximinian;
Dioclesian *and others offer to rescue them;* Delphia *raises a Mist [and*
exit]: Exeunt [at one door] Ambassadors *and [Souldiers with their]*
Prisoners, and [at the other] the rest discontented.

The skilfull *Delphia* finding by sure proof 20
The presence of *Aurelia* dim'd the beauty
Of her *Drusilla*; and in spight of Charms,
The Emperour her Brother, Great *Charinus*,
Still urg'd her to the love of *Dioclesian*,
Deals with the Persian Legats, that were bound
For the Ransom of *Cassana*, to remove
Aurelia, Maximinian, and *Charinus*
Out of the sight of *Rome*; but takes their oathes
(In lieu of her assistance) that they shall not
On any terms, when they were in their power, 30
Presume to touch their lives: This yeelded to,
They lie in ambush for 'em. *Dioclesian*
Still mad for fair *Aurelia*, that doated
As much upon *Maximinian*, twice had kill'd him,
But that her frown restrain'd him: He pursues her
With all humilitie; but she continues
Proud and disdainfull. The sign given by *Delphia*,
The Persians break thorow, and seize upon
Charinus and his Sister, with *Maximinian*,
And free *Cassana*. For their speedy rescue, 40
Enraged *Dioclesian* draws his sword,
And bids his Guard assist him: Then too weak
Had been all opposition and resistance
The Persians could have made against their fury,
If *Delphia* by her cunning had not rais'd
A foggie mist, which as a cloud conceal'd them,
Deceiving their Pursuers. Now be pleas'd,

That your Imaginations may help you
To think them safe in *Persia*, and *Dioclesian*
For this disastre circled round with sorrow, 50
Yet mindfull of the wrong. Their future fortunes
Wee will present in Action; and are bold
In that which follows, that the Most shall say,
'Twas well begun, but the End crown'd the Play.

Exit.

Enter Dioclesian, Niger, Senators, Guards. [IV.]

Dioclesian. Talk not of comfort; I have broke my faith,
And the Gods fight against me: and proud man,
How-ever magnified, is but as dust
Before the raging whirlwind of their justice.
What is it to be great? ador'd on earth?
When the immortall Powers that are above us
Turn all our blessings into horrid curses,
And laugh at our resistance, or prevention
Of what they purpose? O the Furies that
I feel within me! whip'd on, by their angers, 10
For my tormentors. Could it else have been
In Nature, that a few poor fugitive Persians,
Unfriended, and unarmed too, could have rob'd me
(In *Rome*, the worlds *Metropolis*, and her glory;
In *Rome*, where I command, inviron'd round
With such invincible Troops that know no fear,
But want of noble Enemies) of those jewels
I priz'd above my life, and I want power
To free them, if those gods I have provok'd
Had not given spirit to the undertakers, 20
And in their deed protected 'em?
Niger. Great *Caesar*,
Your safetie does confirm you are their care,
And that how-ere their practices reach others,
You stand above their malice.
1 Senator. *Rome* in us.
Offers (as means to further your revenge)
The lives of her best Citizens,
And all they stand possess'd of.

1 Guard. Do but lead us on
With that invincible and undaunted courage
Which waited bravely on you, when you appear'd
The Minion of Conquest; Married rather 30
To glorious Victory, and we will drag
(Though all the enemies of life conspire
Against our undertakings) the proud Persian
Out of his strongest hold.
2 Guard. Be but your self,
And do not talk but doe.
3 Guard. You have hands and swords,
Limbs to make up a well proportion'd Army,
That onely want in you an Head to lead us.
Dioclesian. The gods reward your goodnesse; and beleeve,
How-ere (for some great sin) I am mark'd out
The object of their hate, though *Jove* stood ready 40
To dart his three-fold thunder, on this head,
It could not fright me from a fierce pursuit
Of my revenge: I will redeem my friends,
And with my friends mine honour; at least fall
Like to my self, a Souldier.
Niger. Now we hear
Great *Dioclesian* speak.
Dioclesian. Draw up our Legions,
And let it be your care (my much lov'd *Niger*)
To hasten the remove: And fellow-souldiers,
Your love to me will teach you to endure
Both long and tedious marches.
1 Guard. Die hee accurs'd 50
That thinks of rest or sleep, before he sets
His foot on Persian earth.
Niger. Wee know our glory:
The dignitie of *Rome*, and what's above
All can be urg'd, the quiet of your mind
Depends upon our hast.
Dioclesian. Remove to night
Five dayes shall bring me to you.
All. Happinesse
To *Caesar*, and glorious victorie. *Exeunt [all save* Dioclesian].

Dioclesian. The cheerfulnesse of my Souldiers gives assurance
 Of good successe abroad; if first I make
 My peace at home here. There is something chides me, 60
 And sharply tels me, that my breach of faith
 To *Delphia* and *Drusilla*, is the ground
 Of my misfortunes: And I must remember,
 While I was lov'd, and in great *Delphia's* grace,
 She was as my good angell, and bound Fortune
 To prosper my designes: I must appease her:
 Let others pay their knees, their vows, their prayers
 To weak imagin'd Powers; shee is my All,
 And thus I do invoke her. [*Kneels.*]
 Knowing *Delphia*,
 Thou more then woman, and though thou vouchsafest 70
 To grace the earth with thy celestiall steps,
 And taste this grossser air, thy heavenly spirit
 Hath free accesse to all the secret counsels
 Which a full Senat of the gods determine
 When they consider man: The brasse-leav'd book
 Of Fate lies open to thee, where thou read'st,
 And fashionest the destinies of men
 At thy wish'd pleasure: Look upon thy creature,
 And as thou twice hast pleased to appear
 To reprehend my falshood, now vouchsafe 80
 To see my lowe submission.

 Enter Delphia, Drusilla.

Delphia. What's thy will?
 False, and unthankfull, (and in that deserving
 All humane sorrowes) dar'st thou hope from me
 Relief or comfort?
Dioclesian. Penitence does appease
 Th'incensed Powers, and Sacrifice takes off
 Their heavie angers; thus I tender both:
 The Master of great *Rome*, and in that, Lord
 Of all the Sun gives heat and being to,
 Thus sues for mercy: Be but as thou wert,
 The Pilot to the Bark of my good fortunes, 90
 And once more steer my Actions to the Port

Of glorious honour, and If I fall off
Hereafter from my faith to this sweet Virgin,
Joyne with those Powers that punish perjury,
To make me an example, to deter
Others from being false.

Drusilla. Upon my soul
You may beleeve him: nor did he ere purpose
To me but nobly; hee made triall how
I could endure unkindnesse; I see Truth
Triumphant in his sorrow. Deerest Aunt, 100
Both credit him, and help him; and on assurance
That what I plead for, you cannot deny,
I raise him thus, and with this willing kisse
I seale his pardon. [*Kisses him.*]

Dioclesian. O that I ere look'd
Beyond this abstract of all womans goodnesse.

Delphia. I am thine again; thus I confirm our league:
I know thy wishes, and how much thou sufferst
In honour for thy friends: thou shalt repair all;
For to thy fleet I'll give a fore-right winde
To passe the Persian gulf; remove all lets 110
That may molest thy souldiers in their March
That passe by land: and destiny is false,
If thou prove not victorious: Yet remember,
When thou art rais'd up to the highest point
Of humane happinesse, such as move beyond it
Must of necessitie descend. Think on't,
And use those blessings that the gods powre on you
With moderation.

Dioclesian. As their Oracle
I hear you, and obey you, and will follow
Your grave directions.

Delphia. You will not repent it. 120

Exeunt [*severally*].

Enter Niger, Geta, Guards, *Souldiers*, [*bearing*] *Ensignes*. [IV.] iii

Niger. How do you like your entrance to the Warre?
When the whole Body of the Army moves,

*0.1 *Ensignes*] *stet* F1

283

Shews it not gloriously?

Geta. 'Tis a fine May-game:
But eating and drinking I think are forbad in't
(I mean, with leasure); wee walk on, and feed
Like hungry boyes that haste to School; or as
We carried fish to the City, dare stay no where,
For fear our ware should stink.

1 Guard That's the necessitie
Of our speedy March.

Geta. Sir, I doe love my ease,
And though I hate all Seats of Judicature, 10
I mean in the Citie, for conveniencie,
I still will be a Justice in the War,
And ride upon my foot-cloth. I hope a Captain
(And a gown'd-Captain too) may be dispens'd with.
I tell you, and do not mock me, when I was poor,
I could endure like others, cold and hunger:
But since I grew rich, let but my finger ake,
Or feel but the least pain in my great toe,
Unlesse I have a Doctor, mine own Doctor,
That may assure me, I am gone.

Niger. Come, fear not; 20
You shall want nothing.

1 Guard. We will make you fight
As you were mad.

Geta. Not too much of fighting, Friend:
It is thy trade, that art a common souldier:
We Officers, by our place, may share the spoile,
And never sweat for't.

2 Guard. You shall kil for practice
But your dozen or two a day.

Geta. Thou talkst as if
Thou wert lowsing thy self: but yet I will make danger.
If I prove one of the Worthies, so: However,
I'll have the fear of the gods before my eyes,
And doe no hurt, I warrant you. [*Exit.*]

Niger. Come, March on, 30

*4 forbad] *stet* F1 *27 make danger] *stet* F1

284

And humour him for our mirth.

1 Guard. 'Tis a fine peak-goose.

Niger. But one that fools to the Emperor, and in that,
A wise man and a Souldier.

1 Guard. True moralitie.

Exeunt.

Enter Cosroe, Cassana, *Persian Lords*; *and* Charinus, Maximinian, [IV.] iv
Aurelia (*bound*) *with Souldiers.* [*Two thrones set out.*]

Cosroe. Now by the Persian gods, most truly welcom,
Encompass'd thus with tributary kings,
I entertain you.——Lend your helping hands
To seat her by me: and thus rais'd, bow all,
To do her honour: O, my best *Cassana*,
Sister, and partner of my life and Empire,
Wee'll teach thee to forget with present pleasures
Thy late captivitie: and this proud Roman,
That us'd thee as a slave, and did disdain
A Princely Ransom, shall (if she repine) 10
Be forc'd by various Tortures, to adore
What she of late contemn'd.

Cassana. All greatnesse ever
Attend *Cosroe*: though *Persia* be stil'd
The nurse of pomp and pride; wee'll leave to *Rome*
Her native crueltie. For know *Aurelia*,
A Roman Princesse, and a *Caesars* Sister,
Though now, like me captiv'd, I can forget
Thy barbarous usage: and though thou to me
(When I was in thy power) didst shew thy self
A most insulting Tyrannesse, I to thee 20
May prove a gentle Mistris.

Aurelia. O my Stars,
A Mistris? can I live and owe that name
To flesh and bloud? I was borne to command,
Train'd up in Soveraigntie; and I, in death
Can quit the name of slave: She that scorns life,

17 now, like me,] Sympson; now, like thee F1; late, like thee F2
22 live] F2; love F1

285

May mock captivitie.

Charinus.　　　　　*Rome* will be *Rome*
When we are nothing: and her powr's the same
Which you once quak'd at.

Maximinian.　　　　　*Dioclesian* lives;
Hear it, and tremble: Lives (thou King of *Persia*)
The Master of his fortune, and his honour: 　　　　30
And though by divelish Arts wee were surpriz'd,
And made the prey of Magick and of Theft,
And not won nobly, we shall be redeem'd,
And by a Roman war; and every wrong
We suffer here, with interest, be return'd
On the insulting doer.

1 Persian.　　　　　Sure these Romanes
Are more then men.

2 Persian.　　　　　Their great hearts will not yeeld,
They cannot bend to any adverse Fate,
Such is their confidence.

Cosroe.　　　　　They then shall break.──────
Why, you rebellious wretches, dare you still 　　　　40
Contend, when the least breath, or nod of mine
Marks you out for the fire? or to be made
The prey of wolfs or vultures? The vain name
Of Roman Legions, I slight thus, and scorn:
And for that boasted bug-bear, *Dioclesian*
(Which you presume on) would he were the Master
But of the spirit, to meet me in the field,
Hee soon should find, that our immortall Squadrons,
That with full numbers ever are suppli'd,
(Could it be possible they should decay) 　　　　50
Dare front his boldest Troops, and scatter 'em,
As an high towring Falcon on her Stretches,
Severs the fearfull fowl. And by the Sun,
The Moon, the Winds, the nourishers of life,
And by this Sword, the instrument of death,
Since that you fly not humbly to our Mercy,
But yet dare hope your libertie by force;
If *Dioclesian* dare not attempt

To free you with his sword, all slavery
That crueltie can find out to make you wretched, 60
Falls heavie on you.
Maximinian. If the Sun keeps his course,
And the earth can bear his souldiers march, I fear not.
Aurelia. Or libertie, or revenge.
Charinus. On that I build too. *A Trumpet.*
Aurelia. A Roman Trumpet!
Maximinian. 'Tis: Comes it not like
A pardon to a man condemn'd?
Cosroe. Admit him.

*Enter* Niger.

The purpose of thy coming?
Niger. My great Master,
The Lord of *Rome*, (in that all Power is spoken)
Hoping that thou wilt prove a noble Enemie,
And (in thy bold resistance) worth his conquest,
Defies thee, *Cosroe.*
Maximinian. There is fire in this. 70
Niger. And to encourage thy laborious powers
To tug for Empire, dares thee to the Field,
With this assurance, If thy sword can win him,
Or force his Legions with thy barbed horse,
But to forsake their ground, that not alone
Wing'd Victory shall take stand on thy Tent,
But all the Provinces, and Kingdomes held
By the Roman Garrisons in this Eastern world,
Shall be delivered up, and hee himself
Acknowledge thee his Soveraign. In return 80
Of this large offer, he asks onely this,
That till the doubtfull Dye of War determine
Who has most power, and should command the other,
Thou wouldst intreat thy Prisoners like their births,
And not their present Fortune: and to bring 'em
(Guarded) into thy Tent, with thy best Strengths,
Thy ablest men of war, and thou thy self
Sworn to make good the place. And if he fail

287

(Maugre all opposition can be made)
In his own person to compell his way, 90
And fetch them safely off, the day is thine,
And hee (like these) thy prisoner.
Cosroe. Though I receive this
But as a Roman brave, I doe imbrace it,
And love the sender. Tell him, I will bring
My Prisoners to the field, and without ods,
Against his single force, alone defend 'em;
Or else with equall numbers. [*Exit* Niger.]
 Courage, noble Princes,
And let Posteritie record, that we
This memorable day restor'd to *Persia*,
That Empire of the world, great *Philips* son 100
Ravish'd from us, and *Greece* gave up to *Rome*.
This our strong comfort, that we cannot fall
Ingloriously, since we contend for all.

 Exeunt. Flourish.

 Alarms. Enter Geta, Guards. [IV.] v

Geta. I'll swear the peace against 'em, I am hurt,
Run for a Surgeon, or I faint.
1 Guard. Bear up man,
'Tis but a scratch.
Geta. Scoring a man ore the coxcomb
Is but a scratch with you: pox o' your occupation,
Your scurvie scuffling trade: I was told before
My face was bad enough: but now I look
Like bloody bone, and raw head, to fright children;
I am for no use else.
2 Guard. Thou shalt fright men.
1 Guard. You look so terrible now: but see your face
In the pummell of my sword.
Geta. I die, I am gone. 10
Oh my sweet physiognomy.
2 Guard. They come.
Now fight, or die indeed.

*0.1 Guards.] *Guard, Souldiers.* F1–2 4 pox] Colman;——F1–2

288

Geta. I will scape this way:
I cannot hold my sword; What would you have
Of a maim'd man?
1 Guard. Nay, then I have a goad [*They threaten him.*]
To prick you forward, Oxe.
2 Guard. Fight like a man,
Or die like a dog.
Geta. Shall I, like *Caesar* fall
Among my friends? no mercy? *Et tu Brute?*

 Enter three Persians.

You shall not have the honour of my death,
I'll fall by the Enemie first. [*They fight.*]
1 Guard. O brave, brave *Geta*;
He plaies the divell now. *Persians driven off.*

 [*Alarm.*] *Enter* Niger [*and Souldiers*].

Niger. Make up for honour, 20
The Persians shrink. The passage is laid open,
Great *Dioclesian*, like a second *Mars*,
His strong arm govern'd by the fierce *Bellona*,
Performs more then a man: His shield stuck full
Of Persian darts, which now are his defence
Against the Enemies swords, still leads the way.
Of all the Persian Forces, one strong Squadron,
 Alarm's continued.
In which *Cosroe* in his own person fights,
Stands firm, and yet unrouted: Break thorow that,
The day, and all is ours. *Retreat* [*sounded*].
All. Victory, Victory. 30
 Exeunt.

 Flourish. Enter (*in Triumph with Roman Ensignes*) *Guard,* [IV.]vi
Dioclesian, Charinus, Aurelia, Maximinian, Niger, Geta, Cosroe,
Cassana, *Persians* (*as Prisoners*): Delphia, Drusilla, *privately.*

Doclesian. I am rewarded in the Act: your freedome

 16 like] F2; lie F1 24stuck] Colman (Betterton); struck F1–2
 *30 *Retreat.*] stet F1–2

 289

To me's ten thousand Triumphs: You Sir, share
In all my Glories. And unkind *Aurelia*,
From being a Captive, still command the Victor.
Nephew, remember by whose gift you are free:——
You I afford my pitie; baser minds
Insult on the afflicted. You shall know,
Vertue and Courage is admir'd and lov'd
In Enemies: but more of that hereafter.——
Thanks to your valour; to your swords I owe 10
This wreath triumphant. Nor be thou forgot
My first poor bondman, *Geta*, I am glad
Thou art turn'd a fighter.

Geta. 'Twas against my will:
But now I am content with't.

Charinus. But imagine
What honours can be done to you beyond these,
Transcending all example; 'tis in you
To will, in us to serve it.

Niger. Wee will have
His Statue of pure gold set in the Capitol,
And he that bows not to it as a god,
Makes forfeit of his head.

Maximinian [aside]. I burst with envie; 20
And yet these honours which, conferr'd on me,
Would make me pace on air, seem not to move him.

Dioclesian. Suppose this done, or were it possible
I could rise higher still, I am a man,
And all these Glories, Empires heap'd upon me,
Confirm'd by constant friends, and faithfull Guards,
Cannot defend me from a shaking feaver,
Or bribe the uncorrupted dart of death
To spare me one short minute. Thus adorn'd
In these triumphant Robes, my body yeelds not 30
A greater shadow then it did when I
Liv'd both poor, and obscure; a swords sharp point
Enters my flesh as far; dreams break my sleep
As when I was a private man; my Passions
Are stronger tyrants on me; nor is Greatnesse

A saving Antidote to keep me from
A traitors poyson. Shall I praise my fortune,
Or raise the building of my happinesse
On her uncertain favour? or presume
She is my owne, and sure, that yet was never 40
Constant to any? should my reason fail me
(As flattery oft corrupts it) here's an example,
To speak how far her smiles are to be trusted;
The rising Sun, this morning, saw this man
The Persian Monarch, and those Subjects proud
That had the honour but to kisse his feet;
And yet ere his diurnall progresse ends,
Hee is the scorn of Fortune: But you'll say,
That shee forsook him for his want of courage,
But never leaves the bold. Now by my hopes 50
Of peace and quiet here, I never met
A braver Enemie: and to make it good,
Cosroe, *Cassana*, and the rest, be free,
And ransomlesse return.
Cosroe. To see this vertue
Is more to me then Empire; and to be
Orecome by you, a glorious victorie.
Maximinian [aside]. What a divel means he next?
Dioclesian. I know that Glory
Is like *Alcides* shirt, if it stay on us
Till pride hath mix'd it with our blood; nor can we
Part with it at pleasure: when wee would uncase, 60
It brings along with it both flesh and sinews,
And leaves us living monsters.
Maximinian [aside]. Would it were come
To my turn to put it on: I'ld run the hazzard.
Dioclesian. No, I will not be pluck'd out by the ears
Out of this glorious castle; uncompell'd
I will surrender rather: Let it suffice,
I have touch'd the height of humane happinesse,
And here I fix *Nil ultra*. Hitherto
I have liv'd a servant to ambitious thoughts,
And fading glories: what remains of life, 70

291

I dedicate to Vertue; and to keep
My faith untainted, farewell Pride and Pomp,
And circumstance of glorious Majestie,
Farewell for ever.———Nephew, I have noted,
That you have long with sore eyes look'd upon
My flourishing Fortune; you shall have possession
Of my felicitie: I deliver up
My Empire, and this Jem I priz'd above it,
And all things else that made me worth your envie,
Freely unto you. Gentle Sir, your suffrage, 80
To strengthen this: the souldiers love I doubt not;
His valour (Gentlemen) will deserve your favours,
Which let my prayers further. All is yours.
But I have been too liberall, and giv'n that
I must beg back again.

Maximinian. What am I falne from?

Dioclesian. Nay, start not: It is only the poor Grange,
The Patrimony which my Father left me,
I would be Tenant to.

Maximinian. Sir, I am yours:
I will attend you there.

Dioclesian. No, keep the Court:
Seek you in *Rome* for honour: I will labour 90
To finde content elswhere. Disswade me not,
By Heaven, I am resolv'd.———And now *Drusilla*,
Being as poor as when I vow'd to make thee
My wife: if thy love since hath felt no change,
I am ready to perform it.

Drusilla. I still lov'd
Your Person, not your Fortunes: in a cottage,
Being yours, I am an Empresse.

Delphia. And I'll make
The change most happy.

Dioclesian. Do me then the honour,
To see my vow perform'd. You but attend
My Glories to the urn; where, be it ashes, 100

92 Heaven] Colman;———F1-2

Welcome my mean estate: and as a due,
Wish Rest to me, I Honour unto you.

Exeunt.

Enter Chorus. V.i

Chorus. The War with glory ended; and *Cosroe*
(Acknowledging his fealtie to *Charinus*)
Dismiss'd in peace, returns to *Persia*:
The rest, arriving safely unto *Rome*,
Are entertain'd with Triumphs: *Maximinian*,
By the grace and intercession of his Uncle,
Saluted *Caesar*: but good *Dioclesian*,
Weary of Pomp and State, retires himself
With a small Train, to a most private Grange
In *Lumbardie*; where the glad Countrey strives 10
With Rurall Sports to give him entertainment:
With which delighted, he with ease forgets
All specious trifles, and securely tastes
The certain pleasures of a private life.
But oh Ambition, that eats into
(With venom'd teeth) true thankfulnesse, and honour,
And to support her Greatnesse, fashions fears,
Doubts, and preventions to decline all dangers,
Which in the place of safetie, prove her ruine.
All which be pleas'd to see in *Maximinian*, 20
To whom, his confer'd Soveraignty was like
A large sail fill'd full with a fore-right winde,
That drowns a smaller Bark: and hee once faln
Into ingratitude, makes no stop in mischief,
But violently runs on. Allow *Maximinian* all,
Honour, and Empire, absolute command;
Yet being ill, long great he cannot stand.

Exit.

Enter Maximinian *and* Aurelia. [V.] ii

Aurelia. Why droops my Lord, my Love, my life, my *Caesar?*
How ill this dulnesse doth comport with Greatnesse?

Does not (with open arms) your Fortune court you?
Rome know you for her Master? I my self
Confesse you for my Husband? love, and serve you?
If you contemn not these, and think them curses,
I know no blessings that ambitious flesh
Could wish to feel beyond 'em.

Maximinian. Best *Aurelia,*
The parent and the nurse to all my Glories,
'Tis not that thus embracing you, I think 10
There is a heaven beyond it, that begets
These sad retirements; but the fear to lose
What it is hell to part with: better to have liv'd
Poor and obscure, and never scal'd the top
Of hilly Empire, then to die with fear
To be thrown headlong down, almost as soon
As we have reach'd it.

Aurelia. These are Pannick terrours
You fashion to your self: Is not my Brother
(Your equall and copartner in the Empire)
Vow'd and confirm'd your friend? the souldier constant? 20
Hath not your Uncle *Dioclesian* taken
His last farewell o'th' world? What then can shake ye?

Maximinian. The thought I may be shaken: and assurance
That what we doe possesse is not our own,
But has depending on anothers favour:
For nothing's more uncertain (my *Aurelia*)
Then Power that stands not on his proper Basis,
But borrowes his foundation. I'll make plain
My cause of doubts and fears; for what should I
Conceal from you, that are to be familiar 30
With my most private thoughts? Is not the Empire
My Uncles gift? and may he not resume it
Upon the least distaste? Does not *Charinus*
Crosse me in my designes? And what is Majestie
When 'tis divided? Does not the insolent Souldier
Call my command his donative? And what can take
More from our honour? No (my wise *Aurelia,*)
If I to you am more then all the world,

As sure you are to me; as wee desire
To be secure, wee must be absolute, 40
And know no equall: when your Brother borrows
The little splendor that he has from us,
And we are serv'd for fear, not at entreaty,
We may live safe; but till then, we but walk
With heavie burthens on a sea of glasse,
And our own weight will sink us.
Aurelia. Your Mother brought you
Into the world an Emperor: you perswade
But what I would have counsell'd: Neernesse of blood,
Respect of pietie, and thankfulnesse,
And all the holy dreams of vertuous fools 50
Must vanish into nothing, when Ambition
(The maker of great minds, and nurse of honour)
Puts in for Empire. On then, and forget
Your simple Uncle; think he was the Master
(In being once an Emperor) of a Jewell,
Whose worth and use he knew not: For *Charinus*,
(No more my Brother) if hee be a stop
To what you purpose, hee to Me's a stranger,
And so to be remov'd.
Maximinian. Thou more then woman,
Thou masculine Greatnesse, to whose soaring spirit 60
To touch the stars seems but an easie flight;
O how I glory in thee! those great women
Antiquitie is proud of, thou but nam'd,
Shall be no more remembred: but persever,
And thou shalt shine among those lesser lights
To all posteritie like another *Phebe*,
And so ador'd as she is.

Enter Charinus, Niger, *Guard.*

Aurelia. Here's *Charinus*,
His brow furrow'd with anger.
Maximinian. Let him storm,
And you shall hear me thunder.
Charinus [*to* Niger]. He dispose of

295

My Provinces at his pleasure? and confer 30
Those honours (that are onely mine to give)
Upon his creatures?
Niger. Mighty Sir, ascribe it
To his assurance of your love and favour,
And not to pride or malice.
Charinus. No, good *Niger*,
Courtesie shall not fool me; he shall know
I lent a hand to raise him, and defend him,
While he continues good: but the same strength,
If pride make him usurp upon my Right,
Shall strike him to the Center.——You are well met, Sir.
Maximinian. As you make the Encounter: Sir, I hear, 80
That you repine, and hold your self much griev'd,
In that, without your good leave, I bestow'd
The Gallian Proconsulship upon
A follower of mine.
Maximinian. 'Tis true: and wonder
You durst attempt it.
Maximinius Durst, *Charinus*?
Charinus. Durst:
Again, I speak it: Think you me so tame,
So leaden and unactive, to sit down
With such dishonour? But, recall your grant,
And speedily; or by the Roman gods
Thou tripst thine own heels up, and hast no part 90
In *Rome*, or in the Empire.
Maximinian. Thou hast none,
But by permission: Alas, poor *Charinus*,
Thou shadow of an Emperor, I scorn thee,
Thee, and thy foolish threats: The gods appoint him
The absolute disposer of the Earth,
That has the sharpest sword. I am sure (*Charinus*)
Thou wear'st one without edge. When cruell *Aper*
Had kill'd *Numerianus*, thy good Brother,
(An act that would have made a trembling coward

89 gods] Colman;——F1–2 *98 good] *omit* F1–2

296

More daring then *Alcides*) thy base feare 100
Made thee wink at it: then rose up my Uncle
(For the honour of the Empire, and of *Rome*)
Against the Traitor, and among his Guards
Punish'd the treason: This bold daring act
Got him the Souldiers suffrages to be *Caesar*.
And howsoever his too gentle nature
Allow'd thee the name only, as his gift,
I challenge the succession.
Charinus. Thou art cozen'd.
When the receiver of a courtesie
Cannot sustain the weight it carries with it, 110
'Tis but a Triall, not a present Act.
Thou hast in a few dayes of thy short Reign,
In over-weening pride, riot and lusts,
Sham'd noble *Dioclesian*, and his gift:
Nor doubt I, when it shall arrive unto
His certain knowledge, how the Empire grones
Under thy Tyranny, but hee will forsake
His private life, and once again resume
His laid-by Majestie: or at least, make choice
Of such an *Atlas* as may bear this burthen, 120
Too heavie for thy shoulders.——To effect this,
Lend your assistance (Gentlemen) and then doubt not
But that this mushroom (sprung up in a night)
Shall as soon wither.—— And for you (*Aurelia*)
If you esteem your honour more then tribute
Paid to your lothsome appetite, as a Furie
Flie from his loose embraces: so farewell;
Ere long you shall hear more. *Exeunt* [Charinus *and company*].
Aurelia. Are you struck dumb,
That you make no reply?
Maximinian. Sweet, I will doe,
And after talk: I will prevent their plots, 130
And turn them on their own accursed heads.
My Uncle? good: I must not know the names
Of Pietie or Pitie. Steel my heart,

Desire of Empire, and instruct me, that
The Prince that over others would bear sway,
Checks at no Let that stops him in his way.

<div align="right">Exeunt.</div>

<div align="center">Enter three Shepherds, and two Countrymen. [V.] iii</div>

1 Shepherd. Do you think this great man will continue here?

2 Shepherd. Continue here? what else? hee has bought the great
 Farme;
A great man, with a great Inheritance,
And all the ground about it, all the woods too;
And stock'd it like an Emperor. Now, all our sports again
And all our merry Gambols, our May-Ladies,
Our evening-daunces on the Green, our Songs,
Our Holliday good cheer, our Bag-pipes now Boyes,
Shall make the wanton Lasses skip again,
Our Sheep-shearings, and all our knacks.

3 Shepherd. But heark ye, 10
We must not call him Emperor.

1 Countryman. That's all one;
He is the king of good fellowes, that's no treason;
And so I'll call him still, though I be hang'd for't.
I grant ye, he has given his honour to another man,
He cannot give his humour: he is a brave fellow,
And will love us, and we'll love him. Come hither *Ladon*,
What new Songs, and what geers?

3 Shepherd. Enough: I'll tell ye
He comes abroad anon to view his grounds,
And with the help of *Thirsis*, and old *Egon*,
(If his whorson could be gon) and *Amaryllis*, 20
And some few more o'th' wenches, we will meet him,
And strike him such new Springs, and such free welcomes,
Shall make him scorn an Empire, forget Majestie,
And make him blesse the hour he liv'd here happy.

2 Countryman. And we will second ye, we honest Carters,
We lads o'th' lash, with some blunt entertainment,
Our Teams to two pence, will give him some content,

<div align="center">20 could] i.e., cold</div>

<div align="center">298</div>

Or wee'll bawl fearfully.

3 Shepherd. Hee cannot expect now
His Courtly entertainments, and his rare Musicks,
And Ladies to delight him with their voyces; 30
Honest and cheerfull toyes from honest meanings,
And the best hearts they have. We must be neat all:
On goes my russet jerkin with blue buttons.

1 Shepherd. And my green slops I was married in; my bonnet
With my carnation point with silver tags, boyes:
You know where I won it.

1 Countryman. Thou wilt nere be old, *Alexis.*

1 Shepherd. And I shall find some toyes that have been favors,
And nose-gayes, and such knacks: for there be wenches.

3 Shepherd. My mantle goes on too I plaid young *Paris* in,
And the new garters *Amaryllis* sent me. 40

1 Countryman. Yes, yes: we'll all be handsom, and wash our faces.
Neighbour, I see a remnant of March dust
That's hatch'd into your chaps: I pray ye be carefull,
And mundifie your muzzell.

2 Countryman. I'll to th' Barbers,
It shall cost me I know what.

Enter Geta.

Who's this?

3 Shepherd. Give room, neighbours,
A great man in our State: gods blesse your Worship.

2 Countryman. Encrease your Mastership.

Geta. Thanks, my good people:
Stand off, and know your duties: as I take it
You are the labouring people of this village,
And you that keep the sheep. Stand farther off yet, 50
And mingle not with my Authoritie,
I am too mighty for your companie.

3 Shepherd. We know it Sir; and we desire your Worship
To reckon us amongst your humble servants,
And that our Country Sports, Sir,——

Geta. For your Sports, Sir,
They may be seen, when I shall think convenient,

299

When out of my discretion, I shall view 'em,
And hold 'em fit for licence. Ye look upon me,
And look upon me seriously, as ye knew me:
'Tis true, I have been a Rascall, as you are, 60
A fellow of no mention, nor no mark,
Just such another piece of durt, so fashion'd:
But Time, that purifies all things of merit,
Has set another stamp. Come neerer now,
And be not fearfull; I take off my austeritie:
And know me for the great and mighty Steward
Under this man of Honour: know ye for my vassals;
And at my pleasure, I can dispeople ye,
Can blow you and your cattell out o'th' Countrey:
But fear me, and have favour. Come, go along with me, 70
And I will hear your Songs, and perhaps like' em.

3 Shepherd. I hope you will, Sir.

Geta. 'Tis not a thing impossible.
Perhaps I'll sing my self, the more to grace ye
And if I like your women——

3 Shepherd. We'll have the best, Sir,
Handsom young Girls.

Geta. The handsomer, the better.
'May bring your wives too, 'twill be all one charge to ye;
For I must know your Families.

 Enter Delphia.

Delphia. 'Tis well said,
'Tis well said, honest friends; I know ye are hatching
Some pleasurable sports for your great Landlord:
Fill him with joy, and win him a friend to ye, 80
And make this little Grange seem a large Empire,
Set out with home-contents: I'll work his favour,
Which daily shall be on ye.

3 Shepherd. Then we'll sing daily,
And make him the best Sports.

Delphia. Instruct 'em *Geta,*
And be a merry man again.

 82 Set] Weber (Colman *conj.*); Let F1–2

Geta. Will ye lend me a divell,
That we may daunce a while?
Delphia. I'll lend thee two.
And Bag-pipes that shall blow alone.
Geta. I thank ye:
But I'll know your divels of a cooler complexion first.——
Come, follow, follow; I'll go sit and see ye.
Delphia. Do; and be ready an hour hence, and bring 'em; 90
For in the Grove you'll find him.

 Exeunt [*severally*].

 Enter Dioclesian, *and* Drusilla. [V.iv]

Dioclesian. Come *Drusilla*,
The partner of my best contents: I hope now
You dare beleeve me.
Drusilla. Yes, and dare say to ye,
I think ye now most happie.
Dioclesian. You say true (Sweet)
For by my faith, I find now by experience,
Content was never Courtier.
Drusilla. I pray ye walk on, Sir;
The cool shades of the Grove invite ye.
Dioclesian. O my Deerest!
When man has cast off his ambitious Greatnesse,
And sunk into the sweetnesse of himself;
Built his foundation upon honest thoughts, 10
Not great, but good Desires his daily servants;
How quietly he sleeps! how joyfully
He wakes again, and looks on his possessions,
And from his willing labours feeds with pleasure?
Here hangs no Comets in the shapes of Crowns,
To shake our sweet contents: nor here, *Drusilla*,
Cares, like Eclipses, darken our endeavours:
We love here without rivals, kisse with innocence,
Our thoughts as gentle as our lips; our children
The double heirs both of our forms and faiths. 20
Drusilla. I am glad ye make this right use of this sweetnesse,

 5 faith]——F1–2

 301

This sweet retirednesse.

Dioclesian. 'Tis sweet indeed (love)
And every circumstance about it, shews it.
How liberal is the spring in every place here?
The artificial Court shews but a shadow,
A painted imitation of this glory.
Smell to this flower, here Nature has her excellence:
Let all the perfumes of the Empire passe this,
The carefull'st Ladies cheek shew such a colour,
They are gilded and adulterate vanities. 30
And here in Povertie dwells noble Nature.
What pains we take to cool our wines, to allay us;
And bury quick the fuming god to quench us;
Methinks this Crystal Well—— *Musick belowe.*
 Ha! what strange musick?
'Tis underneath, sure: how it stirs and joys me?
How all the birds set on? the fields redouble
Their odoriferous sweets? Heark how the ecchoes——

Enter a Spirit from the Well.

Drusilla. See, Sir, those flowers [*Flowers rise from the Well.*]
From out the Well, spring your entertainment.

Enter Delphia.

Dioclesian. Blesse me.
Drusilla. Be not afraid, 'tis some good Angel
That's come to welcom ye.
Delphia. Go neer and hear, son.

Song [*by the Spirit*].

Dioclesian. O mother, thank ye, thank ye, this was your will.
Delphia. You shall not want delights to blesse your presence.
Now ye are honest, all the Stars shall honour ye.

Enter [Geta *with Spirits as* Pan *and* Ceres;]
Shepherds and [*Shepherdesses,*] *dancers.*

Stay, here are Countrey-shepherds; here is some sport too,
And you must grace it, Sir; 'twas meant to welcom ye;

A King shall never feel your joy. Sit down, son.

> *A dance of Shepherds and Shepherdesses;*
> Pan *leading the men,* Ceres *the maids.*

[*Enter a Spirit the while they dance, and speaks to* Delphia.]

Hold, hold, my Messenger appears:———
 leave off, friends,
Leave off a while, and breathe.
Dioclesian. What news? ye are pale, mother.
Delphia. No, I am careful of thy safety (son) 50
Be not affrighted, but sit still; I am with thee.
And now dance out your dance. [*They dance again.*]

Enter Maximinian, Aurelia, Souldiers [*and stand apart*].

 [*To* Dioclesian] Do you know that person?
Be not amaz'd, but let him shew his dreadfullest.
Maximinian. How confident he sits amongst his pleasures,
And what a chearful colour shews in's face,
And yet he sees me too, the Souldiers with me.
Aurelia. Be speedie in your work, (you will be stopt else)
And then you are an Emperour.
Maximinian. I will about it.
 [*He steps forward, after which, to a strange musick,*
 the Dancers and Spirits leave dancing and stand apart.]
Dioclesian. My Royal Cousin, how I joy to see ye,
You, and your Royal Empresse.
Maximinian. You are too kinde, Sir. 60
I come not to eat with ye, and to surfeit
In these poor Clownish pleasures; but to tell ye
I look upon ye like my Winding-sheet,
The Coffin of my Greatnesse, nay, my Grave:
For whilst you are alive———
Dioclesian. Alive, my Cousin?
Maximinian. I say, Alive.———I am no Emperour;
I am nothing but mine own disquiet.
Dioclesian. Stay, Sir.
Maximinian. I cannot stay. The Souldiers doat upon ye.
I would fain spare ye; but mine own securitie

Compels me to forget you are my Uncle, 70
Compels me to forget you made me *Caesar*:
For whilst you are remembred, I am buried.

Dioclesian. Did not I make ye Emperour, dear Cousin,
The free gift from my special grace?

Delphia. Fear nothing.

Dioclesian. Did not I chuse this povertie, to raise you?
That Royal woman gave into your arms too?
Bless'd ye with her bright beautie? gave the souldier,
The souldier that hung to me, fix'd him on ye?
Gave ye the worlds command?

Maximinian. This cannot help ye.

Dioclesian. Yet this shall ease me. Can ye be so base (Cousin) 80
So far from Noblenesse, so far from nature,
As to forget all this? to tread this Tie out?
Raise to your self so foul a monument
That every common foot shall kick asunder?
Must my blood glue ye to your peace?

Maximinian. It must, Uncle;
I stand too loose else, and my foot too feeble:
You gone once, and their love retir'd, I am rooted.

Dioclesian. And cannot this removed poor state obscure me?
I do not seek for yours, nor enquire ambitiously
After your growing Fortunes. Take heed, my kinsman, 90
Ungratefulnesse and blood mingled together,
Will, like two furious Tides——

Maximinian. I must sail thorow 'em:
Let 'em be Tides of death, Sir, I must stem up.

Dioclesian. Hear but this last, and wisely yet consider:
Place round about my Grange a Garison,
That if I offer to exceed my limits,
Or ever in my common talk name Emperour,
Ever converse with any greedie souldier,
Or look for adoration, nay, for courtesie
Above the days salute——Think who has fed ye, 100
Think (Cousin) who I am. Do ye slight my misery?
Nay, then I charge thee; nay, I meet thy crueltie.

Maximinian. This cannot serve; prepare: Now fall on, souldiers,
 And all the treasure that I have——— *Thunder and Lightning.*
1 Souldier. The earth shakes;
 We totter up and down; we cannot stand, Sir;
 Me thinks the mountains tremble too.
2 Souldier. The flashes
 How thick and hot they come? we shall be burn'd all.
Delphia. Fall on, Souldiers:
 You that sell innocent blood, fall on full bravely.
1 Souldier. We cannot stir.
Delphia [*to* Maximinian]. You have your libertie, 110
 So have you, Lady. One of you come do it.
 Do you stand amaz'd? *A hand with a Bolt appears above.*
 Look ore thy head, *Maximinian,*
 Look, to thy terrour, what over-hangs thee:
 Nay, it will nail thee dead; look how it threatens thee:
 ———The Bolt for vengence on ungrateful wretches;
 The Bolt of innocent blood:———read those hot characters,
 And spell the will of heaven. [*He kneels.*]
 Nay, lovely Lady,
 You must take part too, as spur to ambition. [*She kneels.*]
 Are ye humble? Now speak; my part's ended.
 Does all your glory shake?
Maximinian. Hear us, great Uncle, 120
 Good and great Sir, be pitiful unto us:
 Belowe your feet we lay our lives: be merciful:
 Begin you, heaven will follow. [*Thunder still.*]
Aurelia. Oh, it shakes still.
Maximinian. And dreadfully it threatens. We acknowledge
 Our base and foul intentions. Stand between us;
 For faults confess'd, they say, are half forgiven.
 We are sorry for our sins. Take from us, sir,
 That glorious weight that made us swell, that poison'd us;
 That masse of Majestie I laboured under,
 (Too heavie and too mighty for my manage) 130
 That my poor innocent days may turn again,

*104, 110 *1 Souldier.*] Colman; *Sould.* F1–2

And my minde, pure, may purge me of these curses;
By your old love, the blood that runs between us.

The hand taken in.

Aurelia. By that love once ye bare to me, by that, Sir,
That blessed maid enjoys——

Dioclesian. Rise up, dear Cousin,
And be your words your judges: I forgive ye:
Great as ye are, enjoy that greatnesse ever,
Whilst I mine own Content make mine own Empire.
Once more I give ye all; learn to deserve it,
And live to love your Good more then your Greatnesse.—— 140
Now shew your loves to entertain this Emperour,
My honest neighbours. *Geta,* see all handsom.
Your Grace must pardon us, our house is little;
But such an ample welcom as a poor man
And his true love can make you and your Empresse.
Madam, we have no dainties.

Aurelia. 'Tis enough, Sir;
We shall enjoy the riches of your goodnesse.

Souldiers. Long live the good and gracious *Dioclesian.*

Dioclesian. I thank ye, Souldiers, I forgive your rashnesse.
And Royal Sir, long may they love and honour ye. 150

Drums [sound a] march afar off.

What Drums are those?

Delphia. Meet 'em, my honest son,
They are thy friends, *Charinus* and the old Souldiers
That come to rescue thee from thy hot Cousin.
But all is well, and turn all into welcoms:
Two Emperours you must entertain now.

Dioclesian. O dear mother,
I have will enough, but I want room and glory.

Delphia. That shall be my care. Sound your pipes now merrily,
And all your handsom sports. Sing 'em full welcoms.

Dioclesian. And let 'em know, our true love breeds more stories
And perfect joys, then Kings do, and their glories. 160

[They dance. Loud Musick.] Exeunt.

F I N I S.

TEXTUAL NOTES

I.i

46–47 depravers │ Malitious ... tongues] Crane's too-ready parenthesis –
'(Malitious ... tongues)' – creates an appositive; a stronger reading results from
considering 'depravers' a genitive plural.

53 next friend] Mason saw this passage as 'describing the several gradations of
Aper's favour', and he emended: 'Made him, first, captain . . .; his friend next; Then
. . . husband' (p. 223). Weber objected to Mason's transposition of the Folio 'next
friend', but Dyce followed Mason. The Folio text without change can be
understood to signify that Numerianus made Aper his First Captain, who was his
nearest friend.

I.ii

8 heart-desires is] See Textual Note at III.iii.95.

I.iii

19–20 of ... the] F1's 'being the son a Tiler ... being son of a Tanner' is
unsatisfactory: the stichomythic pattern of lines 19 and 20 requires that the two
questions be parallel, a requirement that F2 fulfilled. A more suitable parallel might
have been based on 'being son of' as in F1 line 20, but the presence in F1 line 19 of
the word 'the' makes it unlikely that this parallel was ever intended. Had it been
intended, the omission of 'of' in the severely crowded F1 line 19 (including a
displacement to the prefix) would have been unnecessary.

81 Dreams] Dr Turner conjectures that the word should be 'Dreamd' or
'Dreampt'. This attractive suggestion is not easy to reconcile in terms of a
manuscript misreading.

114 last] Seeming holy is the culminating hypocrisy after many villainies, the last
and the worst. The F2 'least' loses this force.

177 am] The unbalanced parallel in the Folio's 'Yet I still poorer, further still',
with its two 'still' adverbs suggests that, as often, we have here a compositorial
anticipation. 'Am' seems the simplest correction.

232.1 Geta.] The *and Souldiers* that accompany Geta in F1 (and in Betterton
[1690]) must surely be an erroneous anticipation of line 247 where Niger greets
'brave Souldiers'; but the soldiers who respond there are Maximinian and Diocles:
Niger's greeting is to them, just as he promised in I.i.71–6. Niger has at some risk to
himself personally (I.i.87) posted the notice of the Proscription, and he is now
looking for volunteers. He has fallen in with Geta, but a moment's conversation
shows him that this is not the man. Niger has no body of soldiers to accompany him

307

in I.i. Bringing on some miscellaneous military blunts Diocles' moment of discovery and his later conversation with Aper's soldiers, the Guard, in II.ii. Some slight support for the unaccompanied Niger may be found in the fact that his exit is in the singular. The adjective 'old' here must carry the meaning 'former' (line 245).

274 do do] Though many editors have deleted one of these words, Dyce retains both. The repetition, with a difference, occurs also at line 37.

II.i

71 hung] Editors from Sympson to Dyce have emended to 'hang' on the basis, no doubt, of the common *u/a* misreading; but the Folio reading can be retained if the stop at the end of line 71 – the last line on the Folio page – is lightened. This change in the punctuation transfers the line from its connection with the preceding clause – 'I will force ... and ... hang' – to a connection with the succeeding clause – 'hung over the Tribunal ... There ... thou shalt shine'. The Folio reading seems preferable.

II.ii

60 *Geta*.] Betterton (1690) gave the speech to Maximinian; Colman followed, because 'we thought [Geta] the most unlikely person on the stage to make this remark'. Muller-Van Santen considers Betterton's assignment superior, since Maximinian is the 'more suspicious person' (p. 279). The reassignment provides a staging effective in its own way.

II.iii

26 The Giants] Lines 25–8 moved Sympson to write: 'This passage, for the bold Ordination of the Words, may stand in Competition with any in *Milton*, and has not its fellow, throughout the whole Collection of our Authors plays.' Dyce confessed himself 'unable to admire the "bold ordination of the words"', and the present editor suffers the same lack. He would go further and omit from the text lines 26–7 ('The Giants ... plain,'), if he could propose any reasonable explanation for their erroneous appearance in this place. In its best construction, the passage is curious, for in most accounts of the Gigantomachia Mars (Ares) is not a significant figure among the gods battling against the giants; he does not appear at all in Apollodorus (*The Library*, I.vi.1) or in Horace (*Odes* I.vi) or in Ovid (*Met.* I.150); he is present in Claudian (the unfinished *Gigantomachia*) where, though he attacks first in the battle, he is clearly less important than Minerva. Massinger's text here would seem to suggest also that after the battle, the various gods appeared before Jove to receive his thanks (?), among whom Mars presented graciousness (not a characteristic usually associated with Mars). Betterton (1690) included the lines – presumably he thought he understood them – but Muller-Van Santen notes 'the meaning remains obscure' (*Words and Music in 'Dioclesian'*, p. 280). (See also

Francis Vian, *La Guerre des Géants* (Paris, 1952), pp. 73–6, 189–90, 205–6.) In the assumption that a line has been lost, the present edition has generated a replacement between lines 25 and 26 to make a readable text.

66 *Song.*] No text appears in either Folio, and searches in manuscript materials have disclosed nothing. In the opera at this point, a *'Martial Song is sung: Trumpets and Ho-Boys joyning with them ... While they Invest him with the Imperial Robes'* (sig. D3v; Muller-Van Santen, *Words and Music in 'Dioclesian'* p. 152). The opera probably shows the staging of the play, explaining the function of the song. It makes a distinction between *'Musick'* at line 49, which is instrumental – *'A Symphony of Musick in the Air'* (D2v) – and this *'Song'*, which is vocal (as are two songs following Maximinian's lines 51–2a).

81 *Dioclesianus*] Editors have agitated themselves over the pronunciation of the name that Diocles gives himself when he becomes emperor. He tells us that he will 'adde | To *Diocles* but two short syllables, | And be called *Dioclesianus*'. Sympson, scanning the extended name as six (?) syllables, wished to emend to *'Dioclesian'*, because the Verse will run better, and because he is so call'd through the rest of the Play' – usually pronounced as four syllables. Mason concurred (p. 255). Weber argued that '-ianus' could be pronounced as two syllables, and Dyce quotes the Heath MS as agreeing. It remains odd, however, that when Geta expands his name, the first mention of it carefully gives every syllable its count (line 84). The '-ian' suffix in 'Maximinian' (or in comparable names) may scan as one syllable (I.i.24; I.ii.3; I.iii.270; II.ii.135; IV.i.27, etc.) or as two (II.ii.9, 106, 118; III.iii.162 [!]; etc.). Muller-Van Santen observes that there are 'conflicting opinions' (*Words and Music in 'Dioclesian'*, p. 281).

After this announcement of the new name, the dialogue offers the form 'Dioclesian' for the rest of the play – with one exception: at III.iii.154, the Emperor calls himself by his old name. The stage-directions continue with *'Diocles'*, except at IV.i.19.2–19.00, the direction for the Dumb Show – where both forms occur – and at IV.vi.0.2, the final triumphant entrance. Prefixes are *'Dio.'* throughout. This edition follows the pattern of the dialogue and after this scene emends to the long form of the name in stage-directions and speech-prefixes without further note, thinking with Geta that it is not fit it should remember 'the Times or Manners | That call'd him plain down *Diocles'* (III.ii.17–18). In Act V, after he has renounced his empery, the edition should logically return to the unaffected and unmodified form. However, since the Folio allows him to retain the name – though not all the addition to a king – in dialogue (V.i.7; V.ii.21, 114; V.iv.148), this edition loyally follows suit.

> The name of the friend and partner of Dioclesian, was [historically] Maximian, not Maximinian: and the measure indicates, in several parts of this play, that Maximian was the name which the Poets intended to give him ... Read Maximinian in either of these passages [III.i.13, 49], and the metre is destroyed. Yet I must acknowledge that there are other passages in which Maximinian would make better verse. (Mason, p. 222)

III.i

170 as] Editors have grappled with the problem of the Folio 'But now I am:'. Sympson and Seward agreed on 'But as I'm now'; Mason conjectured: 'But *as* now I am' which Weber adopted. An argument can be advanced that the compositor, misremembering, supplied a second 'now' to the sentence rather than a second 'as'. Betterton offered the same emendation.

III.ii

36 And] Betterton (1690) omitted the Folio 'But', and Dyce suggested the emendation 'And'.

67 'em] The sense requires the plural pronoun, not the Folio 'him'. Perhaps the compositor was deflected from the plural by the emphasis on the singular in line 66. The reverse error occurs in F2, where the later compositor set 'him' for F1 ' 'em' (IV.iv.51).

114.1 *Dance.*] The phrase 'The Chair turns' (line 114) is perhaps to be explained as referring to a chair dance, a form of dance associated with cushion dances, dating to the sixteenth century and popular at Elizabeth's Court (Iona and Peter Opie, *The Singing Game* (Oxford, 1985), pp. 190–7). Cushion dances and chair dances were designed for groups of young (and uninhibited) dancers, the purpose of the game being to assure in turn that each lady kissed each gentleman in the room, and vice versa, as he or she knelt on a cushion or took a seat on a chair in the centre of the room; no doubt, the game could also be danced by two only. (See John Playford, *The English Dancing Master* (1721), and Andrew J. Sabol (ed.), *Four Hundred Songs and Dances from the Stuart Masque* (Providence: Brown University Press, 1978), p. 608 (I am obliged to Professor Sabol for helpful correspondence on this matter).)

In the assumption that the lines refer to a chair dance, though the details are not clear, the stage-direction is made plural. The direction, furthermore, is moved up one line so that Geta's comment in line 115 describes the dance he has just had. Dyce specified, as presumably earlier editors intended, 'She-devil *dances*', but Geta is promised a dance with a Devil in V.iii.86–7 – though there he wishes to be sure that she were of 'a cooler complexion' – and it is not unlikely that he has been given that pleasure here also. At the equivalent point in the opera, seventy years later, the dance was the chair dance (Van Santen, *Words and Music in 'Dioclesian'*, pp. 183, 285). There is a chair on stage to serve as the official seat of the edile.

III.iii

16 Monarch] On the basis of a perceived compositorial tendency to supply a plural where none was intended, I have emended the Folio 'Monarchs' to the singular, in keeping with the sense of the entire passage: 'she' (line 13), 'Princesse' (15), 'servant' (17). Similarly, in this scene, 'Divels' must be 'Divel' as F2 recognized

(line 214) and 'witchcrafts' should be 'witchcraft' (line 213); and 'cunnings' (I.iii.116) and 'parts' (II.ii.57) should probably be singular.

39 Wherefore] The Folio 'Where have you' here seems to be an echo of 'where have you' two lines above (line 37), provoking the necessity of regarding 'my loves and my embraces' as terms of address directed to Maximinian and therefore requiring a comma after 'fled'. Betterton (1690), reading 'Why', removed the comma to place it after 'Love' ('loves'), though with the reading 'Why' no comma was wanted. Colman and subsequent editors removed the comma so that 'Where' had to have the meaning 'whither'. The sense of the question, however, is not 'whither' but 'wherefore', as Betterton knew, but a compositorial change from 'Wherefore' to 'Where' is more likely than one from 'Where' to 'Why' as in Betterton. Though the extra syllable of 'Wherefore' renders the line hypermetrical, Professor Bowers has indicated that the pattern is acceptable with a slurred reading.

95 aspects] Though the F1 'aspect . . . tells' is certainly defensible, the plural form of the noun, as F2 and Dyce saw, appears in the same context in line 35 of this scene. But that the noun is made plural is no mandate for changing the singular form of the verb; this particular syntax is Fletcherian:

> my affection,
> And all my heart-desires is set
> (I.ii.7–8)

> Thy face, and all aspect[s] upon thee, tells
> (III.iii.95)

(Whether the second subject is singular or plural has no bearing on the form of the verb which is to be singular in spite of the fact that the subject is double. Fletcher evidently thought of these second subjects as entirely parenthetical without reference to agreement of the following verb.)

173 Sigh] Dyce was probably correct, agreeing with Mitford (p. 25), in believing that the sense intended here is 'Since' – sighing would seem an irrelevant response in this situation – and he followed F2 in 'Sith'; but the present edition follows F1 'Sigh', since that form is listed in the *O.E.D.* as an 'erron[eous] var[iant]' of SITH, since'. A *g/t* misreading is unlikely.

IV.iii

0.1 *Ensignes*] '*Ensignes*' is ambiguous, signifying (as Dr Turner has suggested to me) either banners or banner-bearers. As the term must certainly signify the former at IV.vi.0.1, the bracketed addition here seeks to define it to mean the same.

4 forbad] We should perhaps expect here 'forbid', and assume an easy *a:i* misreading, but 'forbad' serves as a past participle in II.ii.134. Both passages are by Massinger. The form is noted as acceptable in *O.E.D.*, 5. Weber and Dyce standardized (?) to 'forbade'.

27 make danger] This rather curious English phrase is a literal translation of the Latin idiom, *facere periculum* ('to run a risk'), an idiom appearing in the plays of

Terence and Plautus and in Cicero and Caesar – standard fare for any schoolboy of the period. 'This is the fourth time that this wretched translation [meaning "I will try"] ... occurs in these plays' (Mason, p. 226). Fletcher uses it in *The Humorous Lieutenant* (IV.ii.139), *The Loyal Subject* (III.iv.50), and *The Wild-goose Chase* (I.ii.67), these being the only entries for the phrase in the *O.E.D.* (The *Prophetess* dates from 1622, contemporary with these three, which range from 1618 to 1625.) The phrase is so much a Fletcherian property that one is tempted to think that Fletcher must have supplied this passage in the Massinger section of this play. The idiom does not seem to have been used by Massinger.

IV.v

0.1 *Guards.*] The '*Souldiers*' mentioned in the Folio direction, offering additional support, throw the balance off. The context requires that the three Persians should be confronted by no more than three Romans, here Geta and these Guards. If soldiers are needed in this scene, they enter with Niger at line 20.

30 *Retreat.*] The present edition follows the Folio in the location of this direction, conceiving of the action in this manner: Niger announces that Dioclesian is leading the way against the Persians, though one squadron is yet undefeated; the Persians sound a retreat, signalling, presumably, that squadron's defeat; the Romans on stage, hearing that trumpet call, cry 'Victory' and leave the stage to join their victorious comrades. Betterton (1690), followed by Dyce, conceived another staging: after Niger's announcement, the Romans on stage cry 'Victory' and leave the stage ('*Exeunt shouting.*') to attack the undefeated squadron; '*Then a Retreat*' is sounded by the Persians (sig. H3), evidently defeated by those Romans. (The change reverses the *Exeunt* and the *Retreat*.) Presumably the Folio setting offers the preferable interpretation as it avoids the juxtaposition of a *Retreat* and a *Flourish* (at the entry of scene vi; but see Textual Introduction), and it gives the credit of the victory to Dioclesian personally, a tribute that we may suppose Massinger would have intended (if he had thought of it). Betterton avoided the musical awkwardness by following the *Exeunt* with an elaborate scene change.

V.ii

98 good] Dr Turner supports the addition of 'good' to mend the metre, noting that Numerianus has this honorific adjective prefixed to his name in II.ii.106, 118, and 'honoured' in I.i.124.

V.iv

104, 110 *1 Souldier.*] As Folio stipulates '*2 Sould.*' at line 106, it is likely that the prefix here, '*Sould.*', is also singular. The acclamation at line 148, however, also '*Sould.*', is clearly spoken by all the Soldiers on stage. This edition also makes singular the prefixes '*Amb.*' in III.iii, though 'Ambassadors' are on stage.

312

PRESS VARIANTS IN F1 (1647)

[Copies collated: Ger (private copy of Dr J. Gerritsen), Hoy (private copy of Cyrus Hoy), IU1 (University of Illinois), IU2 (University of Illinois copy 2), MB (Boston Public Library), MH (Harvard University), MnU (University of Minnesota), NcD (Duke University 429544), NIC (Cornell University), NjP (Princeton University copy 2.), PSt (Pennsylvania State University Library), ViU1 (University of Virginia), ViU2 (University of Virginia), WaU (University of Washington), Wms (private copy of G.W. Williams), WMU1 (University of Wisconsin-Milwaukee copy 1), WMU2 (University of Wisconsin-Milwaukee copy 2), WMU3 (University of Wisconsin-Milwaukee copy 3), WU (University of Wisconsin-Madison).

SHEET 4D (*outer sheet, inner forme*)

Uncorrected: IU1, MH, NcD, NIC, ViU2, WaU, WMU1, WMU3, WU
Sig. 4D1v
 I.iii.41 'em,] 'em, [Q] (*reversed quad*)

SHEET 4D (*inner sheet, inner forme*)

Uncorrected: Hoy, WMU2, WU
Sig. 4D3
 II.i.65 glory] glory [*reversed letter* 'l']
 II.i.71 and] $_a$nd

SHEET 4E (*outer sheet, inner forme*)

Uncorrected: PSt, ViU2, Wms, WMU2
Sig. 4E1v
 heading 34] 26
 III.ii.0.1 Scæna] Scœna

EMENDATIONS OF ACCIDENTALS

Persons Represented in the Play.

1–28 Charinus ... Lumbardie].] F2;
 omit F1

17 *Shepherds*] *Shepherd* F2; *omit* F1
20 *Guards*] *Guard* F2; *omit* F1

I.i

I.i] *Actus primus. Scæna prima.* F1–2
 19 hands——] ~ . F1–2

20 Storie——] ~ . F1–2
84 Proscription] *Proscription* F1–2

I.ii

I.ii] *Scæna secunda.* F1–2
 4 too:] ~ ᴀ F1; ~ , F2

25 Aunt] *Aunt* F1–2

I.iii

I.iii] *Scæna Tertia.* F1–2
 42 away] F2; a way F1
 91 danger,] ~ . F1; ~ ; F2
 92 fury:] ~ , F1–2
127 blind ᴀ as you are,] ~ , ... ~ ᴀ
 F1–2
133 *Cæsar*] F2; *Cesar* F1
133 live——] ~ , F1; ~ . F1–2
137 otherwise——] ~ . F1–2
148 *Goes apart.*] *Exit.* F1–2
152 *Enter* Delphia.] *on line below line* 145
 in F1–2

160 hour,] hour? F1–2
162 honour?] ~ , F1–2
199 perfect:] ~ , F1–2
201 Ministers,] ~ ; F1–2
228 me——] ~ . F1–2
243–244 I ... wife.] *one line in* F1–2
246 appetites.——] ~ . ᴀ F1–2
251 Mother ᴀ ——] F2; ~ . —— F1
262 related——] ~ . F1–2
274 Master ᴀ] F2; ~ , F1
275.1 *Exit.*] *Exeunt.* F1–2

II.i

II.i] *Actus Secundus Scæna Prima.* F1–2
 7 vastnesse] vastness F2; vastnes F1
31 service ᴀ] F2; ~ .) F1

71 Tribunal ᴀ] ~ ; F1–2
72 us ᴀ)] us.) F1–2

II.ii

II.ii] *Scæna secunda.* F1–2
 0.1 *Soft Musick.*] in right margin
 below *Exeunt.* in II.i.81.1 F1–2

0.2 Guards] *Guard* F1–2
23 peace.——] ~ . ᴀ F1–2
31 silence.—— ~ . ᴀ F1–2

42 *Charinus*,] ~ ∧ F1–2
43 ∧Brother ... dog∧] (~ ... ~) F1–2
43 (hells ... *Niger*)] F2; ∧ ~ ... ~ , F1
46 power∧] ~ , F1–2
58 *Exit.*] *in right margin of line 57a in*

F1–2
71 craft,] ~ : F1–2
96 *Diocles kills* Camurius.] F2; *omit* F1
134 ghost,] ~ ∧ F1–2
142 Guards] *Guard* F1–2

II.iii

II.iii] *Scæna Tertia.* F1–2
24 *Enter ... Litter).*] ~ ... ~ ∧. F1–2 (*on lines below line 22*)
24 Guards] *Guard* F1–2
46 *Kills* Aper.] F2 (*on line 45*); *omit* F1
49 *Musick.*] *in right margin of line 49a in* F1–2
57 *Senators.*] *Senat.* F1–2
60 Guards] *Guard* F1–2
87 *Enter* Niger.] *on line 85a after* favour. *in* F1–2

94.1 *Loud Musick.*] *in right margin of line 92a in* F1–2
94.1 *Enter ... Attendants.*] *on line below line 92a in* F1–2
130 *Thunder ... Lighting.*] *after* Flamen. *on line below line 130a in* F–2
131 *Enter a* Flamen.] *on line below line 130a in* F1–2
144 *Ascend.*] *in right margin of line 143 in* F1–2

III.i

III.i] *Actus Tertius. Scæna Prima.* F1–2
0.1 *solus*).] ~ .) F1–2
40 worship——] ~ . F1–2
55 truths——] ~ . F1–2
55 *Exit.*] *on line 55a beside* truths *in* F1–2
57 *Dioclesian*——] ~ . F1–2
59 *Enter ... Petitions*).] *on line below line 57 in* F1–2
59 *Petitions*).] ~ .) F1–2
61 Bill?——] ~ ? ∧ F1–2
62 Pills?——] ~ ? ∧ F1–2
74 decently.——] ~ . ∧ F1–2
75 Cities?——] ~ ? ∧ F1–2

87 ye.——] ~ . ∧ F1–2
94 serve:——] ~ : ∧ F1–2
96 indeed.——] ~ . ∧ F1–2
101 Mightinesse,] ~ ∧ F1–2
115 are.——] ~ . ∧ F1–2
116.1 *Exeunt.*] *on line below line 117a in* F1–2
118 will: ... Sir,] ~ , ... ~ : F1–2
119 me.——] ~ . ∧ F1–2
120 *Enter* Dioclesian.] *on line above line 117b in* F1–2
125 ready] F2; ~ : F1
159 heaven——] ~ . F1–2
170 am,] ~ : F1; ~ ; F2

III.ii

III.ii] *Scæna Secunda.* F1(c)–2
31 natures——] ~ . F1–2
47 Edile] *Edile* F1–2
51 feel∧——] ~ . —— F1–2

69 *Enter ... Drusilla.*] *on line below line 68 in* F1–2
82–83 That ... Asse.] *one line in* F1–2
108 She-devil] *she-devil* F1–2

315

114.1 Dance.] *on line below line* 115 *in*
F1; *on line* 115 *in* F2

117–118 Come, *Lucie . . . ashes.] one line
in* F1–2

118 Exeunt.] *on line below* Come, *Lucie
. . . ashes in lines* 117–118 *in* F1–2

122–123 on't; . . . too,] ~ , . . . ~ ;
F1–2

III.iii

III.iii] *Scæna Tertia.* F1–2

 0.1 Ambassadors] *Ambassadours*
F1–2

 8, 13, 27 *Ambassador.] Amb.* F1–2

 10 Provinces——] ~ . F1–2

 24 Companion:——] ~ : ∧ F1–2

 27.1 *Exeunt.] Exit.* F1; *Ex.* F2

 28 Prophetesse] *Prophetesse* F1–2

 33 piety ∧——] ~ . —— F1–2

 39 fled ∧] ~ , F1–2

 56 man ∧] ~ , F1–2

 58 man ∧——] ~ . —— F1–2

 60 Sir——] ~ , F1; ~ . F2

 73 *Enter* Dioclesian.] *in right margin of
lines* 71–2 *in* F1; *on line below line* 71
in F2

101 brightnesse:——] ~ : ∧ ~ ; ∧
F2

116 this——] ~ . F1–2

118 lips——] ~ ? F1–2

137 greedily] F2; geedily F1

141 eclipses] F2; ecclipses F1

142 woman——] ~ , F1–2

161 him.——] ~ . ∧ F1–2

180 pity:——] ~ : ∧ F1; ~ , ∧ F2

191 fair.——] ~ . ∧ F1–2

203 pardon——] ~ . F1–2

211 too——] ~ . F1–2

216 thee——] ~ . F1–2

217 thee.——] ~ . ∧ F1–2

218 Come.——Farewell] Come, ∧
farewell F1–2

IV.i

IV.i] *Actus Quartus. Scæna Prima.* F1–2

 1 *Chorus.] omit* F1–2

 1–19 So . . . here.] *in italic in* F1–2

 19.3 *Enter*] (*distinguished in* F1–2)

 19.3–19.14 (*at . . . discontented.*] *in
roman* F1–2)

19.8 Dioclesian] *Diocles* F1–2

19.10,13 Ambassadors] *not dis-
tinguished* F1–2

19.13 Exeunt] F2; Exeutt F1

20–54 The . . . Play.] *in italic* F1–2

54.1 *Exit.*] *in roman* F1–2

IV.ii

IV.ii] *Scæna Secunda.* F1–2

 0.1 Guards] *Guard* F1–2

 30 Conquest; married] F2; ~ : Mar-
ried F1

 57 *Cæsar*] F2; *Cesar* F1

81 *Enter . . .* Drusilla.] F2 (Delphia *and*
Drusilla *appear.*); *omit* F1

100 Triumphant] F2; triumphat F1

107 sufferst] F2; fufferst F1

IV.iii

IV.iii] *Scæna Tertia.* F1–2

 0.1 Guards] *Guard* F1–2

4 in't ∧] ~ , F1–2

5 leasure);] ~) ∧ F1–2

IV.iv

IV.iv] *Scæna quarta.* F1–2
 0.1 *Persian Lords*] Persians F1–2
 3 you.——] ~ . ∧ F1–2
 16 *Cæsars*] F2; Cesar F1

17 forget∧] F2; ~ . F1
39 break.——] ~ . ∧ F1–2
49 suppli'd] F2; supyli'd F1

IV.v

IV.v] *Scæna quinta.* F1–2
 0.1 *Alarms.*] *on line below line*
 IV.iv.103 *in* F1–2
 16 *Cæsar*] F2; Cesar F1
 17.1 *Enter ... Persians.*] *in right*

margin of line 11a *in* F1; *below line*
11a *in* F2
17.1 *three*] F2; 3 F1
20 *Persians ... off.*] *in right margin of*
line 19b *in* F1–2

IV.vi

IV.vi] *Scæna Sexta.* F1–2
 0.1 *Flourish.*] *on line below line* IV.v.30
 in F1–2
 5 free:——] ~ : ∧ F1; ~ ; ∧ F2
 7 afflicted.] ~ , F1–2

9 hereafter.——] ~ . ∧ F1–2
21 honours∧ which,] ~ , ~ ∧ F1–2
74 ever.——] ~ . ∧ F1–2
92 resolv'd.——] ~ . ∧ F1–2
100 where,] ~ ∧ F1–2

V.i

V.i] *Actus Quintus. Scæna prima.* F1–2
 1 *Chorus.*] F2; *omit* F1
 1–27 The ... stand.] *in italics in* F1–2
 16 (With ... teeth)] ∧ ~ ... ~ ∧

F1–2
16 honour,] ~ . F1–2
19 ruine.] ~ : F1–2

V.ii

V.ii] *Scæna Secunda.* F1–2
 57 (No ... Brother)] ∧ ~ ... ~ ,
 F1–2
 58 purpose,] ~ ; F1–2
 67 *Enter ... Guard.*] *on line below line*
 65 *in* F1–2

77 strength,] ~ ∧ F1–2
79 Center.——] ~ . ∧ F1–2
121 shoulders.——] ~ . ∧ F2; shoul-
 diers. ∧ F1
124 wither.——] ~ . ∧ F1–2

V.iii

V.iii] *Scæna Tertia.* F1–2
 22 strike] F2; stllke F1
 43 carefull,] F2; ~ . F1
 45 *Enter Geta.*] *on line below line* 43 *in*

F1–2
67–68 vassals;...pleasure,] ~ ,...~ ;
 F1; ~ ,...~ ∧ F2
74 women——] ~ . F1–2

77 *Enter* Delphia] *on line 75b in* F1–2
88 first.——] ~ . ∧ F1–2

91.1 *Exeunt.] in right margin of line 89
in* F1–2

V.iv

V.iv] *omit* F1–2
 0.1 *Enter ... Drusilla.] on line below
 line V.iii.89 in* F1–2
 18 innocence,] ~ ; F1–2
 33 us;] ~ , F1–2
 34 Well ∧ ——] ~ . —— F2; ~ ∧ ?
 F1
 34 *Musick belowe.] on line below line 32
 in* F1–2
 48 appears:——] ~ : ∧ F1–2
 52 *Enter ... apart].] on line below line
 51 in* F1–2

 52 person?] F2; ~ . F1
 66 Alive.——] ~ . ∧ F1–2
100 salute ∧ ——] ~ . —— F1–2
104 have——] ~ . F1–2
112 *A hand ... above.] on line below line
 111 in* F1–2
115–116 ——The ... blood:——] ∧
 ~ ... ~ : ∧ F1–2
134 that,] ~ ∧ F1–2
140 Greatnesse.——] ~ . ∧ F1–2
148 *Souldiers.] Sould.* F1–2

HISTORICAL COLLATION

[This collation against the present text includes the two seventeenth-century Folio
texts (F1, 1647; F2, 1679), and the editions of Langbaine (L, 1711), Theobald,
Seward and Sympson (S, 1750), Colman (C, 1778), Weber (W, 1812), and Dyce
(D, 1843). Omission of a siglum indicates that the text concerned agrees with the
reading of the lemma.]

I.i

46–47 depravers | Malitious … ton-
 gues ∧] ~ (~ … ~) F1 +

50 now] *omit* F2
53 next friend] friend next D

I.ii

8 heart-desires is] heart-desires are
 F2, C, W, D; heart-desire is S

23 Have] Hath F2
44 afoot] o'foot F2, C

I.iii

13 such an] any such S
19 of] *omit* F1
20 the] *omit* F1
26 to] well to S
30 a good] as good a S
37 I,] Ay, L–D; I ∧ F1
84 whilst] while F2
87 staid] stai'd F2
114 last] least F2, C, W, D

116 cunning] cunnings F1 +
123 tailes] Tales C
167 Cunning] Cannon F1, L
177 am] still F1 +
228 that] the S
232.1 Geta.] Geta, *and Souldiers.* F1 +
237 Sister] Sisters S
274 do do] do F2–C

II.i

35 it] is F1
40 lip-comforts] lip-comfort F2

40 aught] ought F2, L, S
71 hung] hang S–D

II.ii

10 his] the L, S
17 a] *omit* L
34 Were] Where L
57 part] parts F1, L, C

60 *Geta.*] *Maximinian.* C, W, D
105 know] knew F1–2
128 this] his F1 +
134 a passage] passage F1–2, L

II.iii

5 Pluckt] Pluck L
88 From ... *Charinus*] omit L

143 were not.] were. Note S

III.i

40 we] me F1
41 draws] draw W
53 Stayre] Satyre F1
70 your] you F1
74 hats] hat F2
75 Cities] *city* D (Betterton)
92 ate] eat L–W (*intended as past tense*)

120 Dioclesian] *Diocles* F1–2
147 as] at F2, C, W
170 as I am] as I'm now S; as now I am
 W; now I am F1–2, L, C, D
174 follows] followeth S
179 the mid-day] mid-day F2, C +
181 Match] Watch F1, L, S

III.ii

2 Of] And of S
21 is it] it is F1, L
36 And] But F1 +
50 I treat of] I'll tread on S

67 'em] him F1 +
85 no whore] nowhere F1
109 ifaith] i'faith F2, W, D; 'faith L, S
122 pleasures] pleasure F2, C, W

III.iii

16 Monarch] Monarchs F1 +
36 are like ... shot] like ... shoot F2,
 C, W, D
39 Wherefore] Where F1 +
95 aspects ... tells] aspect ... tells F1,
 L–W; aspects ... tell F2, D
131 great] *omit* F2

135 live Kings, commanding] live,
 Kings commanding, F1–2, L
171 Nor] Not F1
173 Sigh] Sith F2, D
213 witchcraft] witchcrafts F1 +
214 Divel] Divels F1

IV.ii

12 poor] *omit* F2

78 pleasure] pleasures F2

IV.iii

22 of] *omit* F2

IV.iv

17 now, like me,] late, like thee F2, C,
 W; now, like thee F1, L
22 live] love F1, L
41 least] last F2

42 out] or S
51 'em] him F2
61 keeps] keep F2
102 This] 'Tis S

IV.v

0.1 Guards.] *Guard, Souldiers.*] F1 + 16 like] lie F1
4 pox]———F1–2, Q, L, S 24 stuck] struck F1–2, L, S, W

IV.vi

8 is] are C+ 'Would 'twere C, W
57 a] o' F2 92 Heaven]———F1–2, Q, L, S
62 Would it were] Would't were S;

V.ii

67 so] be S 98 good] *omit* F1 +
89 gods]———F1–2, Q, L, S 108 art] are F2

V.iii

27 will] we'll L–W 58 upon] on S
46 gods] God S 82 Set] Let F1–2, Q–C
50 farther] further C, W

V.iv

5 faith]———F1–2, Q, L, S; soul C, 77 souldier] Souldiers F2
 W, D 104, 110 *1 Souldier.*] Sould. F1–2, Q, L,
15 hangs] hang F2 + S
37 ecchoes] echo's F2 113 over-hangs] hangs over S, D

THE LITTLE FRENCH LAWYER

edited by

ROBERT KEAN TURNER

TEXTUAL INTRODUCTION

The Little French Lawyer (Greg, *Bibliography*, no. 639) was one of the plays entered in September, 1646, by Robinson and Moseley to establish copyright prior to publication of the Folio of 1647. In that volume the play appears as the third in Section 1, running from sig. H2 through sig. L2 (L2v blank). The Folio of 1679, where the text was printed a second time, provides the principal actors:

Joseph Taylor	Nicholas Tooley
John Lowin	William Eccleston
John Underwood	Richard Sharpe
Robert Benfield	Thomas Holcomb

exactly the same men F2 also lists as appearing in *Women Pleased* and *The Custom of the Country*. Notably absent are the names of Richard Burbage, buried in March, 1619, and Nathan Field, probably dead by 19 May 1619. Taylor, Burbage's replacement, was a member of the King's Men by 19 May 1619. The play's first performance thus could have been as early as May, 1619, but it cannot have been much later than late May, 1623, for Tooley was buried on 5 June of that year.[1]

Section 1 of the Folio of 1647 was printed by Thomas Warren, evidently while other work was in progress. Neither the typographical evidence for the order of composition nor the spelling evidence for the distinction of the compositors is very strong; it somewhat questionably appears that the pages were set by three workmen in the following order:

Compositor	*D*	*D*	*D*	*A*	*–*	*C*	*–*	*C*	*D*	*D*	*A*	*D*	*A*	*D*
Forme	H2v:3	H2:3v		H1v:4		H1:4v		I2v:3		I2:3v		I1v:4		

Compositor	*A*	*A*	*A*	*C*	*A*	*C*	*A*	*C*	*A*	*b*	*A*+?	*?*
Forme	I1:4v		K2v:3		K2:3v		K1v:4		K1:4v		L1:2v L1v	:2

In the lineation of this edition, the compositors thus set

Compositor A: I.i.300–I.ii.50*a* (H3v); II.iii.84*b*–188 (I2); II.ii.23*b*–II.iii.84*a* (I1v); II.i.59*b*–II.ii.23*a* (I1); III.iii.58–III.iv.25 (I4v), IV.v.12*b*–IV.vi.71 (K2v); IV.iv.34*a*–IV.v.12*a* (K2); IV.i.o.1–IV.iv.33 (K1v); III.iv.26–129.1 (K1); V.i.189–V.iii.6 (L1–L1v*a*), V.iii.39±–53 (L1v*b*[2])

325

Compositor C: I.ii.50*b*–II.i.59*a* (H4–4v); IV.vi.72–V.i.188 (K3–4v)
Compositor D: I.i.79–I.i.299 (H2v–3); I.i.o.1–78 (H2); II.iii.189*a*–III.iii.57 (I2v–I4)
Compositor ?: V.iii.7–38 ± (L1v*b*¹); V.iii.54–69.1 (L2).

As in the printing of *The Mad Lover*, occasionally one or another
workman would set an entire forme rather than only one type page of
it, a factor here that led Compositor *D*, having composed I2v and I3,
to continue with the second half of the gathering rather than setting
backwards from 2v as he began to do in Quire H and as Compositor *A*
did do in Quire K. L1v was curiously divided: Compositor *A* set the
first column (V.ii.3*b*–V.iii.6) and the last part of the second (about
forty type lines, perhaps one manuscript page), and an unidentified
workman (possibly *C* or *D*, but evidence is lacking) the first part of the
second column (about thirty-five type lines, perhaps another
manuscript page) and the prologue and epilogue that occupy L2.[2]

The compositors made four or so substantive mistakes per page,
though the number now apparent may have been reduced by proof-
reading.[3] A collation of twenty-three copies of F1 turned up seven
variant formes revealing so few alterations that the variants seem to
derive from the correction of revises (see pp. 438–40), yet several of
these late-stage corrections were got wrong. At IV.vii.1 Compositor
C removed the offending space in 'enter eate' but did not correctly
replace it, for a gap opened up in 'Shal l'. Nor did he remove the first
medial 'e' in 'entereate'. And at V.ii.6 the same workman, evidently
directed to put a dash after 'beaten' to indicate change of address,
instead set a space after 'beat' and hyphenated 'en-forward'. At V.i.50*a*
more serious mix-up occurred, incorrect 'cause' being made 'coose'
rather than what seems to be the true reading, 'cousen'. Not only was
the proof-correction sometimes slipshod, typographically the work is
ordinary; a good many letters are taller than type high, and some
shorter, especially a kind of comma that often barely prints and
sometimes, one suspects, does not print at all.[4]

One feature of the text that probably originated in the printing-
house was not the compositors' responsibility. F1 lines the play
entirely as verse, correctly insofar as the main plot is concerned. But
Fletcher's comic creations, La-writ and Sampson, sometimes speak
prose, sometimes verse, and sometimes a combination of the two. For
example, V.ii, in which La-writ persuades Sampson that fighting in a
court of law is better than fighting on the field of honour, seems to be

verse with some irregular lines. In contrast, III.ii, which introduces Sampson, begins in prose despite occasional embedded pentameters. F1 makes ragged verse of it:

> *Samp.* I know Monsier *La-writ.*
> 1 *Cly.* Would he knew himselfe, Sir.
> *Samp.* He was a pretty Lawyer, a kind of pretty Lawyer,
> Of a kind of unable thing.
> 2 *Cly.* A fine Lawyer, Sir,
> And would have firk'd you up a businesse,
> And out of this Court into that. (lines 1–6)

When La-writ, the man of honour and furious duellist, arrives, however, the medium seems to change to idiomatically irregular verse that becomes more certain after Cleremont's entrance. Similarly, Sampson as his distinguished uncle's champion speaks verse with the Gentleman in IV.ii, yet when in IV.iv we again meet La-writ, he and Cleremont speak mostly prose until Sampson enters (line 30), whereupon, as though in response to Cleremont's injunction to 'Beare your selfe in your language, smooth and gently,|When your swords argue' (lines 31–2), the dialogue shifts to fairly regular verse that is sustained until Cleremont and the Gentleman leave at line 85. La-writ and Sampson, their teeth chattering, then lapse into prose that continues through their comic discomfiture in IV.vi (lines 96.1ff.), when even Champernell and Vertaigne become prose-speakers.

II.i–iii, the scenes in which La-writ is persuaded to become Cleremont's second and then triumphs over Beaupre and Verdoone, have some especially dubious sections. II.i begins with Cleremont's meeting Beaupre and Verdoone. Discussing the impending fight and Dinant's absence, they speak gentlemanly verse, and Cleremont continues to do so as he seeks help from the passers-by. When La-writ enters, pursued by his clients within, he seems initially to be speaking idiomatically irregular verse, his first line nearly linking with an incomplete line of Cleremont's:

> *Cler.*
> Cold now and treacherous?
> *La-writ.* I understand your causes.
> Yours about corne, yours about pinnes and glasses,
> Will you make me mad, have I not all the parcells?
> And his Petition too, about Bell-founding? (II.i.57–60)

Soon, however, the metre becomes more irregular, though F1 continues as verse:

> Send in your witnesses, what will you have me doe?
> Will you have me break my heart? my brains are melted;
> And tell your Master, as I am a gentleman,
> His Cause shall be the first, commend me to your Mistris,
> And tell her, if there be an extraordinary feather,
> And tall enough for her: I shall dispatch you too,
> I know your Cause, for transporting of Farthingales (II.i.60–6)

This part of the scene is typical; what at first seems to be acceptable verse again and again becomes what is clearly prose.

There is no entirely satisfactory editorial solution to the problem posed by the idiomatic verse. Earlier editors simply follow F1's lineation, but to do so subverts the convention of verse-lining employed for the speech of the romantic characters. Moreover, the questionable passages may be so only because the compositors created verse by following their copy's lineation as it had been cast-off and supplying capitals at the beginning of each line. In the circumstances it seems best to render such passages as prose, although the eye may miss some rhythmical qualities of the language that the ear can hear perfectly well.

The play's main plot has two principal movements, the first Lamira's revenge upon Dinant and Cleremont for their assault on her wedding and especially upon Dinant for his amorousness and the second the counter-revenge of Dinant upon Lamira and through her upon Champernell's entire household. As Gerard Langbaine recognized,[5] the first movement depends for general inspiration and for specific details upon Mateo Alemán's *Segunda parte de la vida de Guzman de Alfarache,* first published in Lisbon in 1604, translated into French as *Le Voleur, ou la vie de Guzman d'Alfarache* in 1620 and into English by James Mabbe as *The Rogue, or The Second Part of Guzman de Alfarache* in 1622.[6] *Guzman* provided Dinant's idea that Lamira has been married to lame old Champernell instead of to him simply because Champernell is very rich (including details of Dinant's rebuke of Vertaigne and Lamira just after the wedding (I.i.143–200), which speech is also coloured by Massinger's conception of Champernell as little better than a pirate). In the same source is found the idea for Lamira's meeting with Dinant and that of the apprehensive

Cleremont, required to share her husband's bed, discovering in the morning that he has actually spent the night with beautiful Anabell.[7] Lamira's imperilling Cleremont by sending Dinant to look for her imaginary defamer (I.iii.82–93) depends remotely on the Countess of Cellant's sending her current lover to kill his friend and predecessor lover for having impugned her reputation, a story of Bandello's taken over by Painter as Novel 24 of *The Palace of Pleasure*.[8] Champernell's secret observation of Lamira's behaviour during the assignation (III.iii–iv) is a recurring situation in the canon – e.g., Colonna's spying upon Lucinda and Miranda in *The Knight of Malta* (1616–18). Although no specific source of the second movement of the plot has been identified, its principal situation – a woman in a dark place terrified by men hideously disguised – was used in *The Queen of Corinth* (1616–17) and variants of it are found in *The Custom of the Country* and *The Knight of Malta*.

According to Cyrus Hoy's study of authorship,[9] Massinger was responsible for most of the Dinant-Lamira-Champernell plot. After introducing it in Act I, he handled the beginning of the false assignation (III.iii), and much of Dinant's 'faire reparation' (IV.v–vi.1–96 and vii, and V.i.164–287 and iii). To this half of the play, Fletcher contributed the scene in which Beaupre and Verdoone shamefacedly admit their defeat by La-writ, and Lamira, unexpectedly headstrong, defends Dinant's reputation for valour, braves her husband when he questions her honesty, and resolves to punish Dinant for attempting to seduce her (III.i); another in which Lamira berates Dinant for thinking it possible she could be unchaste, the defeated gallants are ejected from Champernell's house, and Cleremont discovers he has lain beside Anabell (III.iv); a brief transition in which the gallants, without being specific, resolve to counterattack (IV.i); an equally brief view of Champernell's household setting off on their journey (IV.iii); and the first part of the imprisonment scene in which Lamira, frightened and despondent, is broken, Anabell finally breaks, and Dinant reverses (V.i.1–163). Apart from the two merely functional scenes (IV.i and iii), Fletcher thus provided several of his specialities – a spirited woman asserts her independence, a chaste woman asserts her virtue, a spirited woman is reduced to despair by physical and mental anguish, and a rampant lecher proves to be pretending. He also wrote all the humorous story of La-writ, the little

lawyer (II.i–iii; III.ii; IV.ii, iv, and IV.vi.97–189; and V.ii).[10] As critics have noticed, the playwrights did not achieve a perfect literary union,[11] and flaws in their artistic conception are matched by discrepancies in the text, some trivial, some rather more than so. For example,

Massinger's Nurse is Lady, or Old Lady, in the only Fletcher scene in which she appears, not only in stage-directions and speech-prefixes but also in the dialogue (II.iii.178, 203).[12]

Massinger always accents *Dinant* on the second syllable, Fletcher, in the early part of the play, on the first.[13]

The dramatists disagree on how many of Dinant's friends abduct Lamira and Anabell. Massinger planned for the gang to be made up of two speakers and any convenient and appropriate number of mutes. Initially they are '*a company of* Gentlemen, *like Ruffians*' (IV.vi.8.1; Massinger), two of whom speak, although the presence of others is implied not only by the 'we' of IV.vi.23 but also by their actual capture of Beaupre and Verdoone and pretended capture of Dinant and Cleremont. The deliberate vagueness continues in Massinger's IV.vii, where again two speak but others – '*the rest*' – enter with the gallants (IV.vii.32). In Fletcher's part of V.i, there seem to be four of them (V.i.48.1) and perhaps only one speaker (V.i.55, 74, 82 and 85).[14] Massinger's two speakers are no doubt the '*two* Gentlemen' of V.i.163.2, now powerful enough to have caused the 'bloody thieves' to head for the hills (lines 180–3). The playwrights may also have somewhat different ideas about the thieves' den. To Massinger it is a cave (V.i.181, anticipated at IV.vi.95–6). The stage-direction at V.i.0.2–3, however – presumably Fletcher's – speaks of '*the Chamber doore, in which* Lamira *and* Anabell *were shut*', as though a structure of some kind was imagined.

Formerly an honourable suitor, Dinant confesses that now Lamira is married he hopes to seduce her (I.ii.30–8; Massinger). Yet it is she who guardedly suggests she will 'reward [his] love and service' (I.iii.48; Massinger) if he does not fight Beaupre. When we next meet her, however – just after the duel – she says angrily of Dinant, 'he's a

lustfull villaine, . . . and sollicites me|To my dishonour' (III.i.123–5; Fletcher), whereas, if anything, she has solicited him.

Anticipating the family's visit to their summer-house, Lamira remarks, 'My Father will be there too' (IV.iii.2; Fletcher), but Vertaigne turns out to be one of the travellers (IV.v–vi.1–96; Massinger), probably because he was needed to witness Champernell's beating La-writ out of his humour (IV.vi.96.1ff.; Fletcher). The linking of the scene's two parts is exceedingly clumsy, for the mood of the two older men is made to swing from the gravest anxiety over the kidnapping to delirious mirth over the plight of the duellist-lawyers, a comic situation that actually is not especially funny. 'I shall laugh, for all I have lost my Children,' says Vertaigne, lamer than lame Champernell (IV.vi.107). If only the main plot were concerned, there is no reason why the brigands should not have taken Vertaigne and Champernell along with the others; and Fletcher, who invented the summer-house (IV.i.1), does not consider that it is less than an ideal destination if the weather is cold enough to freeze the lawyers half to death.

To induce Anabell to elope, Fletcher's Cleremont promises her marriage with full rites – 'I have a priest too, shall be ready' (V.i.108). Massinger's Cleremont, however, has yet to find him – 'And the next Priest we meete shall warrant it [their exchange of vows] To all the world' (V.iii.53–4).

A manuscript containing such discrepancies might be foul papers, pages in Fletcher's handwriting combined with pages in Massinger's, but the linguistic data do not encourage this supposition. Although all but four occur in scenes ascribed to Fletcher, the text contains only thirty 'ye's, as opposed to 275, for example, in *The Spanish Curate*. Mr Hoy, struck by the presence in the text both of authorial and of prompter's stage-directions, concludes that the printer's copy was probably a Massinger transcript annotated for use as a prompt-book. Yet Massinger's 'customary preference of *them* to '*em* (here each form occurs 15 times)' is not exhibited.[15] So it seems more likely that the transcript of the foul papers was made by a scribe, who subsequently annotated it for prompt use or who turned the transcript over to a

prompter who did so.[16] It must have been the scribe who reduced 'plague', when used as an oath, to 'pl——', presumably because he thought it naughty. The word was not expurgated earlier in the section ('Plague o' this *Tiveria*' occurs in *The Spanish Curate*, III.ii), and it is not entirely removed here ('plague dam your whistles' was left at III.iii.106 and 'plague of all seconds' at IV.vi.97). 'Pox', purged in *The False One*, F1 *Beggars' Bush*, and *Wit at Several Weapons*,[17] was acceptable here; it is found five times.

That a prompter annotated the transcript is, as Mr Hoy observes, quite apparent.[18] Although some of the stage-directions display an authorial lack of precision, they are harmless and were allowed to stand:

Enter Cleremont, *as in the field.* (II.i.0.1; Fletcher)

Enter Monsieur la Writ *within.* (II.i.57.1; Fletcher)

Exeunt Beaupre, Verdoone *sad.* (II.ii.36; Fletcher)

Enter Champernell *privately.* (III.iii.52; Massinger)

Enter Nurse *and* Charlote, *pass 'ore the stage with pillowes, night Cloaths and such things.* (III.iii.53.2–3; Massinger)

Others, however, are clearly or probably prompter's directions:

'*Wine*' after III.iii.72 signals that a prop will be needed for '*Enter* Nurse *with Wine*' at line 81.1.

'*Recorders*' after III.iii.88 specifies the instruments for Massinger's '*Musicke*' at line 91. Cf. F1's '*Cornet*' after IV.v.13 and '*Sackbut & Troup musick*' after V.i.8.

'*The Recorders againe*' after III.iii.110 seems to be the prompter's version of an omitted direction at line 115, probably '*Musick againe*' in its authorial form.

'*Theeves peeping*' after 'us', V.i.11, warns that business is required at lines 14 and 15. The kidnappers, incidentally, are called 'thieves' only here.

Not all the problems of staging were solved, however. When Lamira fools Dinant and Cleremont, she and her would-be lover are on the main stage, as is Champernell, watching them (III.iii; Massinger). Cleremont is above, the upper stage supposedly being Champernell's bedroom. At III.iv (Fletcher) the main stage becomes another chamber into which Lamira and Dinant enter, but Fletcher, who provides no entrance for Cleremont at III.iv.62, may not have known that he is supposed to be above, though he does place Anabell and the Servants there (line 68).[19] Shortly after, Cleremont, Anabell and the Servants enter on the main stage (lines 76.1–2). Cleremont's descent, if Fletcher intended for him to descend, is not covered by dialogue and that of the others barely covered. Champernell, incidentally, enters at this point also, although if Fletcher had carried forward Massinger's idea that Champernell observes his wife, he would have entered the second chamber earlier.

In general, however, the F1 text is in reasonably good order. Entrance- and exit-directions are nearly complete and usually correctly placed; with only a few exceptions, speeches are correctly assigned; stage business not immediately clear from the dialogue is described. F1 occasionally has mistakes probably caused by confusion in the manuscript (e.g., 'Now', the word the First Gentleman gives at IV.vi.23, becomes a stage-direction in F1 and, conversely, F1 makes dialogue of a stage-direction, '*Peepe*', at V.i.14), but most of its defects seem attributable to routine printer's errors. Many of these were corrected by the editor of F2, some with a good deal of cleverness and insight. As in other plays of the canon, several of his readings suggest reference to an authoritative manuscript (e.g., 'use', I.ii.47; 'mister', II.iii.21; 'Louver', III.ii.129; 'martiall', V.ii.3), but he did not use it to supply the missing word in IV.vi.29. Rather often he sophisticated instead of correcting (e.g., III.i.63–4; III.ii.47; III.ii.148, and IV.vi.44).

Although no early records of its performance survive, the play seems to have been popular. It was in repertory in 1641, when the Lord Chamberlain forbade the publication of it and fifty-nine more King's Men plays.[20] In F1's commendatory verses it is listed among the

comedies praised by Lovelace (b3) and is singled out for commendation by Gardiner (c2) and Hills (f1v). Revived after the Restoration and performed as late as the early eighteenth century, *The Little French Lawyer* finally declined into farces (1749 and 1778) that are unconnected with the main textual tradition. The prologue, the epilogue, and the two songs were reprinted without significant change in *Poems by Francis Beaumont, Gent.* (1653) and the 'Song in the Wood' (IV.vi.1–8) in *Covent Garden Drollery* (1672). Its title there, 'The Wood Man's Song', suggests it was then performed as a solo.

In the apparatus Heath's MS notes are quoted from Dyce's edition and Coleridge's conjectures from *Marginalia*, I, ed. George Whalley, *The Collected Works of Samuel Taylor Coleridge*, vol. XII, gen. ed. Kathleen Coburn (Princeton, 1980).

NOTES

1 See Gerald Eades Bentley, *The Jacobean and Caroline Stage* (Oxford, 1967), III, 326 and 357–8. Baldwin Maxwell, *Studies in Beaumont, Fletcher, and Massinger* (Chapel Hill, 1939), pp. 89, 101–2, connects Cleremont's denunciation of duelling (I.i.11–35) with King James's anti-duelling speech before the Star Chamber in February 1617, but, as Bentley remarks, the play must be dated at least two years after that. Bertha Hensman connects the causes mentioned by La-writ at II.i.58ff. with 'the chief business of the session of Parliament during the first three months of 1620/21'. See n. 7.

2 See Turner, *The Printers and the Beaumont and Fletcher Folio of 1647: Section 1 (Thomas Warren's)* (University Microfilms, 1973), summarized in *Studies in Bibliography*, XXVII (1974), 137–56. For the composition of *The Mad Lover*, see vol. V, p. 4 in this series.

3 Press corrections of some parts of *The Little French Lawyer* have recently been examined by James P. Hammersmith, 'The proof-reading of the Beaumont and Fletcher Folio of 1647: introduction', *Publications of the Bibliographical Society of America*, LXXXII (1988), 42–4, and 'Section 1 and b', *PBSA*, LXXXII (1988), 201–27.

4 Noting all dubious appearances of this comma would have overloaded the apparatus. When a comma appears in the text, the editor saw it or a trace of it (or thought he did) in at least one of the copies of F1 consulted.

5 Langbaine, *An Account of the English Dramatic Poets* (Oxford, 1691), pp. 210–11.

6 See Jose Simon Diaz, *Bibliographia de la Literatura Hispanica*, V (Madrid, 1958), no. 722; Roméo Arbour, *L'ère baroque en France: Répertoire Chronologique . . . 1616–1628*; and *STC* no. 288.

7 See Bentley, *Jacobean and Caroline Stage*, III, 358. This particular manifestation of the bed-trick had appeared with less embellishment as Masuccio's *Novellino* 41. Bertha Hensman believes that the version of *Guzman* used by the authors was the 1620 French translation, *Le Voleur*, but the only exclusive link between the play and this version seems to be La-writ's often being called 'advocate' and the lawyer of *Le Voleur* 'advocat', whereas in the Spanish original he is 'letrado' or 'dotor' and in Mabbe 'Doctor of Law'. The playwrights needed a synonym for 'lawyer', however, and in *The Spanish Curate* (written during the summer and fall of 1622) Bartolus too is called 'advocate', in III.iii, for example. The title 'doctor', of course, would have been entirely wrong for La-writ as Fletcher conceived of him. Dr Hensman also thinks *Le Voleur* was 'the immediate source of the sub-plot' throughout as well as of the main plot through Act III. See her *The Shares of Fletcher, Field, and Massinger in Twelve Plays of the Beaumont and Fletcher Canon* (Salzburg, 1974), I, 149–71. To me there seems no question of the influence of *Guzman* on the main plot, but the connection Dr Hensman finds between it and the sub-plot (the Rogue's causing a lawyer to become very angry by making him the butt of a practical joke (*Guzman*, pt II. bk i, ch. 4) and La-writ's transformation into a rabid duellist) is very slight.

8 Bentley, III, 358.

9 Hoy, 'The shares of Fletcher and his collaborators in the Beaumont and Fletcher canon (II)', *Studies in Bibliography*, IX (1959), 150–1, 159.

10 At III.ii.190.1 Vertaigne exits, having given Cleremont leave, for the fun of it, to bring La-writ and Sampson together. Cleremont commends the president's sweet spirit in one line and in the next two wonders how he will 'contrive this matter'. Dinant then enters (line 193) and the rest of the scene (to line 202) involves Cleremont in Dinant's nocturnal visit to Lamira. The lines from Vertaigne's exit on, having nothing essential to contribute to the sub-plot, seem extraneous to III.ii, yet they are a necessary preliminary to Massinger's III.iii. Massinger may have written them, but the evidence is inconclusive. Some of his spellings appear – 'thinke' (line 192), 'goe' (193), 'dost' (195), 'breake' (199), 'freind' (202) – but they are partially offset by spellings uncharacteristic of him – 'Doest' (196), 'thing' (197), and 'hearte' (199) (see Edwards and Gibson, *Massinger*, V, 71ff.) La-writ's (Fletcher's) 'Will you have me break my heart?' (II.i.61–2), part of a full line in F1) reappears as 'Wilt thou breake my hearte?' (III.ii.199, a short line), and it seems more likely that Fletcher would repeat himself than that Massinger would repeat him.

11 Cyrus Hoy, for example, observes that Fletcher and Massinger 'are of two minds about the nature of the play they are writing'. The counter-revenge is cumbersome, the comic sub-plot weakly developed and poorly integrated with the main plot, and the characters inconsistent. See 'Massinger as collaborator: The plays with Fletcher and others', in Douglas Howard (ed.), *Philip Massinger: A Critical Reassessment* (Cambridge, 1985), pp. 55–60.

12 Frederick Gard Fleay, *A Biographical Chronicle of the English Drama* (London, 1891), I, 211. Dr Hensman (*Fletcher, Field and Massinger*, p. 165, n. 33), believes the dramatists are translating the 'reuerende Matrosne' and 'bonne Dame' of *Le*

Voleur (see n. 6). In the original the character is 'una reverenda y honorada dueña' and 'la buena dueña', translated by Mabbe as 'a very graue and reuerend Dame' and 'this good woman'. The earliest citation of 'bonne' as 'nurse' ('domestiques par les enfants') is 1708 in Paul Robert, *Dictionnaire* (Paris, 1965), but as early as the twelfth century 'dueña' meant 'nurse' ('dueña de servicio, mujer acompañante' – Joan Corominas, *Diccionario*, II (1980)).

13 Fleay, *Biographical Chronicle*, I, 211. Fletcher accented on the first syllable at II.i.3, 13, 47 and 56, and at II.iii.71 and (questionably) 73. He adopted Massinger's style at II.iii.138, 150, and 184(?) and subsequently, seven times in III.i and once in IV.iii. The sequence suggests that the first part of II.iii and the last – possibly from La-writ's exit at line 81.1, pretty certainly from the Old Lady's entrance at line 125.1 – were not written as a single composition.

14 It seems unlikely that the '*foure*' of the stage-direction means Beaupre, Verdoone, and two ruffians.

15 Hoy, 'Shares', pp. 151–2, 161.

16 That is, a MS similar to the surviving MSS of Massinger's *Parliament of Love* (ed. Philip Edwards and Colin Gibson, *The Plays and Poems of Philip Massinger* (Oxford, 1976), II, 97–179), Dekker's *The Welsh Ambassador* (ed. Fredson Bowers, *The Dramatic Works of Thomas Dekker*, IV (Cambridge, 1961), 301–404), and *The Honest Man's Fortune* (see vol. X of this edition). It might also be argued that had Massinger transcribed he would have written out at least some of the anomalies noticed above, but perhaps neither the authors nor the company insisted on perfect consistency of plot and character. See Turner, 'Collaborators at work: *The Queen of Corinth* and *The Knight of Malta*', in Bernhard Fabian and Kurt Tetzeli v. Rosador (eds.), *Shakespeare: Text, Language, Criticism: Essays in Honour of Marvin Spevack* (Hildesheim, 1987), pp. 315–33.

17 See vol. VII, p. 304 in this series.

18 Unless the prompter's direction duplicates the author's, the two cannot always be distinguished. Prompter's directions that can pretty certainly be identified have been removed from the text, but some no doubt remain.

19 It is possible, of course, that the direction Fletcher did supply was omitted in transmission.

20 See Bentley, *Jacobean and Caroline Stage*, I, 65–6, and III, 359.

PERSONS REPRESENTED IN THE PLAY.

Dinant, *a Gentleman that formerly loved, and still pretended to love* Lamira.
Cleremont, *a merry Gentleman, his Friend.*
Champernell, *a lame old Gentleman, Husband to* Lamira.
Vertaigne, *a Noble-man, and a Judge.*
Beaupre, *Son to* Vertaigne.
Verdoone, *Nephew to* Champernell.
Monsier La-writ, *a wrangling Advocate, or the Little Lawyer.*
Sampson, *a foolish Advocate, Kinsman to* Vertaigne.
Provost. 10
Gentlemen.
Clients.
Servants and Musicians.

Women.

Lamira, *Wife to* Champernell, *and Daughter to* Vertaigne.
Old Lady, *Nurse to* Lamira.
Anabell, *Niece to* Champernell.
Charlote, *Waiting Gentlewoman to* Lamira.

The Scene France.

0.1—19 Persons ... France.] based on the list in F2; *not in* F1

PROLOGUE.

To promise much, before a play begin,
And when 'tis done, aske pardon, were a sinne
Wee'll not be guilty of: and to excuse
Before we know a fault were to abuse
The writers and our selves, for I dare say
We all are foold if this be not a Playe
And such a play as shall, (so should playes doe)
Impe times dull wings, and make you merry too;
'Twas to that purpose writ, so we intend it,
And we have our wisht ends, if you commend it. 10

THE LITTLE FRENCH LAWYER

Dinant. Disswade me not.
Cleremont. It will breed a braule.
Dinant. I care not, I weare a Sword.
Cleremont. And weare discretion with it,
 Or cast it off, let that direct your arme,
 'Tis madnesse els, not valour, and more base
 Then to receive a wrong.
Dinant. Why would you have me
 Sit downe with a disgrace, and thanke the doer?
 We are not Stoicks, and that passive courage
 Is onely now, commendable in Lackies,
 Peasants, and Tradesmen, not in men of ranke, 10
 And qualitie, as I am.
Cleremont. Doe not cherish
 That daring vice, for which the whole age suffers;
 The blood of our bold youth, that heretofore
 Was spent in honourable action,
 Or to defend, or to enlarge the Kingdome,
 For the honour of our Countrey, and our Prince,
 Poures it selfe out, with prodigall expence
 Upon our Mothers lap, the Earth that bred us,
 For every trifle, and these private Duells,
 Which had their first originall from the French, 20
 (And for which, to this day, we are justly censured)
 Are banisht from all civill Governments:
 Scarce three in *Venice*, in as many yeares;
 In *Florence*, they are rarer, and in all
 The faire Dominions of the Spanish King,
 They are never heard of: Nay, those neighbour Countries,
 Which gladly imitate our other follies,

*6 Why] *stet* F1–2 22 Are] F2; And F1

And come at a deare rate to buy them of us,
Begin now to detest them.

Dinant. Will you end yet?

Cleremont. And I have heard, that some of our late Kings, 30
For the lie, wearing of a Mistris favour,
A cheate at Cards or Dice and such like causes,
Have lost as many gallant Gentlemen,
As might have met the great Turke in the field
With confidence of a glorious Victorie,
And shall we then——

Dinant. No more, for shame no more,
Are you become a Patron to? 'tis a new one,
No more on't, burn't, give it to some Orator,
To help him to enlarge his exercise,
With such a one, it might doe well, and profit 40
The Curat of the Parish, but for *Cleremont*
The bold, and under-taking *Cleremont*,
To talke thus to his friend, his friend that knowes him,
Dinant, that knowes his *Cleremont*, is absurd,
And meere Apocripha.

Cleremont. Why, what know you of me?

Dinant. Why if thou hast forgot thy selfe, I'll tell thee,
And not looke backe, to speake of what thou wert
At fifteene, for at those yeares, I have heard
Thou wast flesh'd, and enter'd bravely.

Cleremont. Well sir, well.

Dinant. But yesterday, thou wast the common second, 50
Of all that onely knew thee, thou hadst bills
Set up on every post, to give thee notice,
Where any difference was, and who were parties,
And as, to save the charges of the Law,
Poore men seeke Arbitrators, thou wert chosen
By such as knew thee not, to compound quarrells:
But thou wert so delighted with the sport,
That if there were no just cause, thou wouldst make one,
Or be engag'd thy selfe: This goodly calling

29 you end yet?] F2 (yet——); you? and yet——F1
31 Mistris favour,] F2; Mistris, feathers; F1 *37 Patron to? 'tis] *stet* F1–2
59 goodly] F2; godly F1

Thou hast followed five and twenty yeares, and studied 60
The Criticismes of contentions, and art thou
In so few houres transform'd? certaine this night
Thou hast had strange dreames, or rather visions.
Cleremont. Yes, Sir,
I have seene fooles, and fighters, chain'd together,
And the Fighters had the upper hand, and whipt first,
The poore Sotts laughing at 'em. What I have bin
It skils not, what I will be is resolv'd on.
Dinant. Why then you'll fight no more?
Claremont. Such is my purpose.
Dinant. On no occasion?
Cleremont. There you stagger me,
Some kind of wrongs there are, which flesh and blood 70
Cannot endure.
Dinant. Thou wouldst not willingly,
Live a protested coward, or be call'd one?
Cleremont. Words, are but words.
Dinant. Nor would'st thou take a blow?
Cleremont. Not from my friend, though drunke, and from an enemy,
I thinke much lesse.
Dinant. There's some hope of thee left then,
Wouldst thou heare me, behind my back disgrac'd?
Cleremont. Do you think I am a rogue? they that should do it
Had better bin borne dumbe.
Dinant. Or in thy presence
See me o're-charg'd with odds?
Cleremont. I'd fall my selfe first.
Dinant. Would'st thou endure thy Mistris be taken from thee, 80
And thou sit quiet?
Cleremont. There you touch my honour,
No French man can endure that.
Dinant. Plague upon thee,
Why dost thou talke of Peace then? that dar'st suffer
Nothing, or in thy selfe, or in thy friend
That is unmanly?
Cleremont. That I grant, I cannot:
But I'll not quarrell with this Gentleman,

*73 Words ... words.] *stet* F1–2 82 Plague] Colman; Pl——F1–2

341

For wearing stammell Breeches, or this Gamester,
For playing a thousand pounds, that owes me nothing;
For this mans taking up a common Wench
In raggs, and lowsie, then maintaining her 90
Caroached in cloth of Tissue, nor five hundred
Of such like toyes, that at no part concerne me;
Marry, where my honour, or my friend is questioned,
I have a Sword, and I thinke I may use it
To the cutting of a Rascalls throat, or so,
Like a good Christian.

Dinant. Thou art of a fine Religion,
And rather then we'll make a Schisme in friendship,
I will be of it: But to be serious,
Thou art acquainted with my tedious love-suit
To faire *Lamira?*

Cleremont. Too well Sir, and remember 100
Your presents, courtship, (that's too good a name,)
Your slave-like services, your morning musique,
Your walking three houres in the raine at midnight,
To see her at her window, sometimes laugh'd at,
Sometimes admitted, and vouchsaf'd to kisse
Her glove, her skirt, nay, I have heard, her slippers,
How then you triumph'd? Here was love forsooth.

Dinant. These follies I deny not,
Such a contemptible thing, my dotage made me,
But my reward for this——

Cleremont. As you deserv'd, 110
For he that makes a goddesse of a Puppet,
Merits no other recompence.

Dinant. This day friend,
For thou art so——

Cleremont. I am no flatterer.

Dinant. This proud, ingratefull she, is married to
Lame *Champernell.*

Cleremont. I know him, he has bin
As tall a Sea-man, and has thriv'd as well by't,
The losse of a legg and an Arme deducted, as any
That ever put from *Marseils:* you are tame,

 Plague on't, it mads me; if it were my case,
 I should kill all the family.

Dinant. Yet but now 120
 You did preach patience.

Cleremont. I then came from confession,
 And 't was enjoyn'd me three houres for a pennance,
 To be a peaceable man, and to talke like one,
 But now, all else being pardon'd, I begin
 On a new Tally: Foot doe any thing,
 I'll second you.

Dinant. I would not willingly
 Make red, thy yet white conscience, yet I purpose
 In the open street, as they come from the Temple,
 (For this way they must passe,) to speake my wrongs,
 And doe it boldly.

Cleremont. Were thy tongue a Cannon, 130
 I would stand by thee, boy, *Musick playes.*
 they come, upon 'em.

Dinant. Observe a little first.

Cleremont. This is fine fidling.

 Enter Vertaigne, Champernell, Lamira, Nurse,
 Beaupre, Verdoone.

 An Epithalamin Song at the Wedding.

 Come away, bring on the Bride,
 And place her by her Lovers side:
 You faire troope of Maides attend her,
 Pure, and holy thoughts befriend her.
 Blush, and wish, you Virgins all,
 Many such faire nights may fall.

 Chorus.

 Hymen, fill the house with joy,
 All thy sacred fires employ: 140
 Bless the Bed, with holy love,
 Now faire orbe of Beauty move.

 119 Plague] Colman; Pl——F1–2
 *132.3 An … Wedding.] *stet* F1–2 127 thy] my F1–2

Dinant. Stand by, for I'll be heard.
Vertaigne. This is strange rudenesse.
Dinant. 'Tis courtship, ballanced with my injuries,
 You all looke pale with guilt, but I will dy
 Your cheekes with blushes, if in your sear'd veines,
 There yet remaine so much of honest blood
 To make the colour; first to ye my Lord,
 The Father of this Bride, whom you have sent
 Alive into her grave——
Champernell. How? to her grave? 150
Dinant. Be patient sir, I'll speake of you anon——
 You that allowed me liberall accesse,
 To make my way with service, and approv'd of
 My birth, my person, yeares, and no base fortune:
 You that are rich, and but in this held wise too,
 That as a Father should have look'd upon
 Your Daughter in a Husband, and aim'd more
 At what her youth, and heat of blood requir'd
 In lawfull pleasures, then the parting from
 Your Crownes to pay her dowre: you that already 160
 Have one foot in the grave, yet study profit,
 As if you were assur'd, to live here ever;
 What poore end had you, in this choice? in what
 Deserve I your contempt? my house, and honours,
 At all parts equall yours, my fame as faire,
 And not to praise my selfe, the City rankes me,
 In the first file, of her most hopefull Gentry:
 But *Champernell* is rich, and needs a nurse,
 And not your gold: And add to that, he's old too,
 His whole estate in likelihood, to descend 170
 Upon your Family; Here was providence,
 I grant, but in a Nobleman, base thrift:
 No Merchants, nay, no Pirats, sell for Bondmen
 Their Countrey-men, but you, a Gentleman,
 To save a little gold, have sold your Daughter
 To worse then slaverie.

143 I'll] F2; 'twill F1 144 my] Weber (Mason *conj.*); *omit* F1–2
171 your] F2; a F1

344

Cleremont. This was spoke home indeed.

Beaupre. Sir, I shall take some other time to tell you,
That this harsh language, was delivered to
An old man, but my Father.

Dinant. At your pleasure.

Cleremont. Proceed in your designe, let me alone, 180
To answer him, or any man.

Verdoone. You presume
Too much upon your name, but may be cousin'd.

Dimant [*to* Lamira]. But for you, most unmindfull of my service,
(For now I may upbraid you, and with honour,
Since all is lost, and yet I am a gainer,
In being deliver'd from a torment in you,
For such you must have bin,) you to whom nature
Gave with a liberall hand, most excellent forme,
Your education, language, and discourse,
And judgement to distinguish; when you shall 190
With feeling sorrow, understand how wretched
And miserable, you have made your selfe,
And but your selfe, having nothing to accuse,
Can you with hope from any beg compassion?
But you will say, you serv'd your Fathers pleasure,
Forgetting that unjust commands of Parents
Are not to be obey'd, or that you are rich,
And that to wealth, all pleasures els are servants,
Yet but consider, how this wealth was purchas'd,
'Twill trouble the possession.

Champernell. You sir know 200
I got it, and with honour.

Dinant. But from whom?
Remember that, and how:——you'll come indeed
To houses bravely furnish'd, but demanding
Where it was bought, this souldier will not lie,
But answer truly, this rich cloth of Arras,
I made my prize in such a Ship, this Plate
Was my share in another; these faire Jewells,
Comming a shore, I got in such a Village,

198 pleasures] Seward; pleasure F1-2

The Maid, or Matron kill'd, from whom they were ravish'd,
The Wines you drinke, are guilty too, for this, 210
This *Candie* Wine, three Merchants were undone,
These Suckets breake as many more: In briefe,
All you shall weare, or touch, or see, is purchas'd
By lawlesse force, and you but revell in
The teares, and grones, of such as were the owners.

Champernell. 'Tis false, most basely false.

Vertaigne. Let loosers talke.

Dinant. Lastly, those joyes, those best of joyes, which *Hymen*
Freely bestowes on such, that come to tye
The sacred knot he blesses, wonne unto it
By equall love, and mutuall affection, 220
Not blindly led, with the desire of riches,
Most miserable you, shall never taste of,
This Marriage night, you'll meet a Widowes bed,
Or failing of those pleasures, all Brides looke for,
Sinne in your wish it were so.

Champernell. Thou art a Villaine,
A base, malitious slanderer.

Cleremont. Strike him.

Dinant. No,
He is not worth a blow.

Champernell. O that I had thee
In some close vault, that onely would yeild roome
To me to use my Sword, to thee no hope
To run away, I would make thee on thy knees, 230
Bite out the tongue that wrong'd me.

Vertaigne. Pray you have patience.

Lamira. This day I am to be your Soveraigne,
Let me command you.

Champernell. I am lost with rage,
And know not what I am my selfe, nor you:——
Away, dare such as you, that love the smoke
Of peace, more then the fire of glorious Warre,
And like unprofitable drones, feed on
Your grandsires laboures, (that, as I am now,

212 breake] *i.e.,* brake

346

Were gathering Bees, and fil'd their Hive, this Country,
With brave triumphant spoiles,) censure our Actions? 240
You object my prizes to me, had you seene
The horrour of a Sea-fight, with what danger
I made them mine; the fire I fearelesse fought in,
And quench'd it in mine enemies blood, which straight
Like Oyle pour'd out on't, made it burne anew;
My Deck blowne up, with noise enough to mocke
The lowdest thunder, and the desperate fooles
That boorded me, sent, to defie the tempests
That were against me, to the angrie Sea,
Frighted with men throwen ore; no victory, 250
But in despight of the foure Elements,
The Fire, the Ayre, the Sea, and sands hid in it,
To be atchiev'd; you would confesse, poore men,
(Though hopelesse, such an honourable way
To get or wealth, or honour in your selves)
He that through all these dreadfull passages,
Pursued, and overtooke them, unafrighted,
Deserves reward, and not to have it stil'd
By the base name of theft.

Dinant. This is the Courtship,
That you must looke for, Madam.

Cleremont. 'Twill doe well, 260
When nothing can be done, to spend the night with:
Your tongue is sound, good Lord, and I could wish
For this young Ladyes sake, this leg, this arme,
And there is something els, I will not name,
(Though 'tis the onely thing, that must content her)
Had the same vigour.

Champernell. You shall buy these scoffes
With your best blood, helpe me once noble anger, [*Draws.*]
(Nay stirre not, I alone must right my selfe)
And with one leg, transport me, to correct
These scandalous praters: *Falls.*
 ô that noble wounds 270

*244–245 quench'd ... anew] *stet* F1–2 248 tempests] F2; tempest F1
262 and F2; *omit* F1

Should hinder just revenge? D'ye jeere me too?
I got these, not as you doe your diseases,
In Brothells, or with riotous abuse
Of wine in Tavernes; I have one leg shot,
One arme disabled, and am honour'd more,
By loosing them, as I did, in the face
Of a brave enemy, then if they were
As when I put to Sea; you are French men onely
In that you have bin laied, and cur'd, goe to:
You mock my leg, but every bone about you, 280
Makes you good Almanack-makers, to foretell
What wether we shall have.

Dinant. Put up your Sword.

Cleremont. Or turne it to a Crutch, there't may be usefull,
And live, on the relation to your Wife,
Of what a brave man you were once.

Dinant. And tell her,
What a fine vertue, 'tis in a young Lady
To give an old man pap.

Cleremont. Or hire a Surgeon
To teach her to roule up your broken limbes.

Dinant. To make a Pultesse, and endure the sent
Of oiles, and nasty Plaisters. [*Champernell weepes.*]

Vertaigne. Fie sir, fie, 290
You that have stood all dangers of all kinds,
To yield to a rivalls scoffe?

Lamira. Shed teares upon
Your Wedding day? this is unmanly Gentleman.

Champernell. They are teares of anger: ô that I should live
To play the woman thus? All powerfull heaven,
Restore me, but one houre, that strength agen,
That I had once, to chastise in these men,
Their follies, and ill manners, and that done,
When you please, I'll yeild up the fort of life,
And doe it gladly.

Cleremont. We ha' the better of him, 300
We ha' made him crye.

*293 Gentleman] Brett *conj.*; Gentlemen F1–2

348

Verdoone. You shall have satisfaction,
 And I will doe it nobly, or disclaime me.
Beaupre. I say no more, you have a Brother, Sister,
 This is your Wedding day, we are in the streete,
 And howsoever, they forget their honour,
 'Tis fit I loose not mine, by their example.
Vertaigne. If there be Lawes in *Paris* looke to answer
 This insolent affront.
Cleremont. You that live by them,
 Study 'em for heavens sake; for my part I know not
 Nor care not what they are:——Is their ought els 310
 That you would say?
Dinant. Nothing, I have my ends,
 Lamira weepes, I have said too much I feare;
 So dearely once I lov'd her, that I cannot
 Endure to see her teares. *Exeunt* Dinant *and* Cleremont.
Champernell. See you performe it,
 And doe it like my Nephew.
Verdoone. If I faile in't
 Nere know me more,——Cousen *Beaupre.*
Champernell. Repent not
 What thou hast done, my life, thou shalt not find
 I am decrepit; in my love, and service,
 I will be young, and constant, and beleeve me,
 (For thou shall find it true, in scorne of all 320
 The scandalls these rude men have throwne upon me)
 I'le meete thy pleasures, with a young mans ardour
 And in all circumstances, of a Husband,
 Performe my part.
Lamira. Good Sir, I am your servant,
 And 'tis too late now, if I did repent,
 (Which as I am a virgin yet, I doe not)
 To undoe the knot, that by the Church is tyed;
 Onely I would beseech ye, as you have
 A good opinion of me, and my vertues,
 (For so you have pleas'd to stile my innocent weakenes,) 330
 That what hath pass'd between *Dinant* and me,

Or what now in your hearing he hath spoken,
Beget not doubts, or feares.

Champernell. I apprehend you,
You thinke I will be jealous, as I live
Thou art mistaken sweet; and to confirme it
Discourse with whom thou wilt, ride where thou wilt,
Feast whom thou wilt, as often as thou wilt,
For I will have no other guards upon thee
Then thine owne thoughts.

Lamira. I'le use this liberty
With moderation Sir.

Beaupre [*to* Verdoone]. I am resolv'd; 340
Steale off, i'le follow you.

Champernell. Come Sir, you droope,
Till you find cause, which I shall never give,
Dislike not of your son in Law.

Vertaigne. Sir, you teach me
The language I should use; I am most happy
In being so neere you. *Exeunt* Verdone *and* Beaupre.

Lamira. O my feares? good nurse
Follow my Brother unobserv'd and learne,
Which way he takes.

Nurse. I will be carefull Madam. *Exit* Nurse.

Champernell. Betweene us complements are superfluous,
One Gentlemen, th' affront we have met here
Wee'l thinke upon hereafter, 'twere unfit 350
To cherish any thought to breed unrest,
Or to our selves, or to our Nuptiall feast.

 Exeunt.

 Enter Dinant *and* Cleremont. [I.ii]

Cleremont. We shall have sport, ne'r fear't.
Dinant. What sport I prithee?
Cleremont. Why we must fight, I know it, and I long for't,
It was apparent in the fiery eye
Of young *Verdoone*, *Beaupre* look'd pale and shooke too,
Familiar signes of anger. They are both brave fellowes,

 349 One] *i.e.,* On

 350

Tride and approv'd, and I am prou'd to encounter
With men, from whom no honour can be lost,
They will play up to a man, and set him off;
When ere I goe to the field, heaven keepe me from
The meeting of an unflesh'd youth or Coward, 10
The first to get a name, comes on too hot,
The Coward is so swift in giving ground,
There is no overtaking him, without
A hunting Nag, well breath'd too.

Dinant. All this while,
 You ne'r thinke on the danger.

Cleremont. Why 'tis no more,
 Then meeting of a dousen Friends at Supper,
 And drinking hard; mischeif comes there unlook'd for,
 I am sure as suddaine, and strikes home as often;
 For this we are prepar'd.

Dinant. *Lamira* loves
 Her Brother *Beaupre* dearely.

Cleremont. What of that? 20

Dinant. And should he call me 'to account for what
 But now I speake, nor can I with mine honour
 Recant my words, that little hope is left me,
 'Ere to enjoye what (next to heaven) I long for,
 Is taken from me.

Cleremont. Why what can you hope for,
 She being now married?

Dinant. Oh my *Cleremont,*
 To you all secrets of my heart lye open,
 And I rest most secure that whatsoer'e
 I locke up there, is as a private thought,
 And will no farther wrong me; I am a Frenchman, 30
 And for the greater part, we are borne Courtiers,
 She is a woman, and how ever yet,
 No heat of service, had the power to melt
 Her frozen Chastity, time and opportunitie
 May worke her to my ends, I confesse ill ones,
 And yet I must pursue 'em: now her marriage,

6, 73 prou'd] *i.e.,* proud *22 speake] *stet* F1 26 Oh] F2; On F1

In probabilitie, will no way hurt,
But rather help me.
Cleremont.　　Sits the wind there? pray you tell me
How farr off, dwells your love from lust?
Dinant.　　　　　　　　　　Too neere,　　　　40
But prithee chide me not.
Cleremont.　　　　　　Not I, goe on boye,
I have faults my self, and will not reprehend
A crime I am not free from: for her Marriage,
I doe esteeme it (and most batchellors are
Of my opinion) as a faire protection,
To play the wanton, without losse of honour.
Dinant.　Would she make use of't so, I were most happy.
Cleremont.　No more of this: Judge now, whither I have
The guift of prophecie.

Enter Beaupre *and* Verdoone.

Beaupre.　　　　　　　Monsier *Dinant*,
I am glad to find you, Sir.
Dinant.　　　　　　　I am at your service.　　　50
Verdoone.　Good Monsieur *Cleremont*, I have long wish'd
To be knowne better to you.
Cleremont.　　　　　　My desires
Embrace your wishes Sir.
Beaupre.　　　　　　　Sir, I have ever
Esteem'd you truly noble, and professe,
I should have bin most proud, to have had the honour,
To call you Brother, but my Fathers pleasure
Denied that happinesse; I know no man lives,
That can command his passions, and therefore
Dare not condemne, the late intemperate language
You were pleas'd to use, to my Father and my Sister,　　60
Hee's old and she a woman; I most sorrie,
My honour does compell me to entreat you,
To doe me the favour, with your sword to meete me
A mile without the Citie.

Dinant. You much honour me
　In the demand, I'l gladly waite upon you.
Beaupre. O Sir you teach me what to say: the time?
Dinant. With the next Sun, if you thinke fit.
Beaupre. The place?
Dinant. Nere to the vineyard eastward from the Citie.
Beaupre. I like it well, this gentleman if you please
　Will keepe me company.
Cleremont. That is agreed on; 70
　And in my friends behalf I will attend him.
Verdoone. You shall not misse my service.
Beaupre. Good day Gentlemen.
Dinant. At your Commandement.
Cleremont. Prou'd to be your servants,

　　　　　　　　　　Exeunt Beaupre *and* Verdoone.

　I thinke there is no Nation under heaven
　That cut their enemies throates with complement,
　And such fine trickes as we doe: If you have
　Any few Prayers to say, this night you may
　Call 'em to mind and use 'em, for my self,
　As I have little to loose, my care is lesse,
　So till to morrow morning, I bequeath you, 80
　To your devotions; and those payed, but use
　That noble courage I have seene, and we
　Shall fight, as in a Castle.
Dinant. Thou art all honour,
　Thy resolution, would steele a Coward,
　And I most fortunate, in such a Friend;
　All tendernesse, and nice respect of woman,
　Be now far from me, reputation take
　A full possession of my heart, and prove
　Honour the first place holds, the second love.

　　　　　　　　　　　　　Exeunt.

　　　　　　Enter Lamira, Charlote. [I.iii]

Lamira. Sleepes my Lord still *Charlote?*
Charlote. Not to be wak'd;

353

By your Ladiships cheerefull lookes, I well perceive
That this night, the good Lord hath bin
At an unusuall service, and no wonder
If he rest after it.

Lamira. You are very bold.

Charlote. Your Creature Madam, and when you are pleas'd,
Sadnesse to me's a stranger, your good pardon
If I speake like a foole, I could have wisht,
To have taine your place to night, had bold *Dinant*
Your first and most obsequious servant tasted 10
Those delicates, which by his lethargie
As it appeares, have cloyed my Lord.

Lamira. No more.

Charlote. I am silenc'd Madam.

Lamira. Saw you my nurse this morning?

Charlote. No Madam.

Lamira. I am full of feares. *Knock within.*
 Who's that?

Charlote. She you enquir'd for.

Lamira. Bring her in, and leave me.

 Exit Charlote.

 Enter Nurse.

 Now nurse what newes?

Nurse. O Ladie dreadfull ones,
 They are to fight this morning, ther's no remedie,
 I saw my Lord your Brother, and *Verdoone*
 Take horse as I came by.

Lamira. Wher's *Cleremont?*

Nurse. I met him too, and mounted.

Lamira. Wher's *Dinant?* 20

Nurse. There's all the hope, I have staied him with a tricke,
 If I have done well, so.

Lamira. What tricke?

Nurse. I tould him,
 Your Ladiship layed your command upon him,

To attend you presently, and to confirme it,
Gave him the ring, he oft hath seene you weare,
That you bestowed on me; he waites without
Disguis'd, and if you have that power in him,
As I presume you have, it is in you
To stay or alter him.

Lamira. Have you learnt the place,
Where they are to encounter?

Nurse. Yes 'tis where 30
The Duke of *Burgundie,* met *Lewis* th' eleventh.

Lamira. Enough I will reward thee liberally,
Goe bring him in, *Exit* Nurse.
 full deare I lov'd *Dinant,*
While it was lawfull, but those fires are quenched,
I being now anothers, truth forgive me
And let dissimulation, be no crime,
Though most unwillingly, I put it on
To guard a Brothers safetie.

 Enter Dinant.

Dinant. Now your pleasure,
Though ill you have deserv'd it, you persev'd
I am still your foole, and cannot but obey 40
What ever you command.

Lamira. You speake, as if
You did repent it, and 'tis not worth my thankes then,
But there has bin a time, in which you would
Receive this as a favour.

Dinant. Hope was left then
Of recompence.

Lamira. Why I am still *Lamira,*
And you *Dinant,* and 'tis yet in my power
(I dare not say, i'll put it into act,)
To reward your love and service.

Dinant. Ther's some comfort.

Lamira. But thinke not that so low I prize my fame,

*30–31 where ... eleventh] *stet* F1–2 31 th'] F1(c)–2; *omit* F1(u)
39 persev'd] *i.e.,* perceived

To give it up to any man that refuses 50
To buy it, or with danger or performance
Of what I shall enjoine him.
Dinant. Name that danger
Be it of what horrid shape soever Ladie
Which I will shrinke at; only at this instant
Be speedie in't.
Lamira. I'll put you to the triall:
You shall not fight to day, doe you start at that?
Not with my Brother, I have heard your difference,
Mine is no *Helens* beauty, to be purchas'd
With blood and so defended; if you looke for
Favours from me, deserve them with obedience, 60
Ther's no way els to gain 'em.
Dinant. You command
What with mine honour I cannot obey
Which lies at pawne against it, and a friend
Equally deare as that, or life, engag'd,
Not for himself, but me.
Lamira. Why, foolish man,
Dare you sollicite me, to serve your lust,
In which not onely I abuse my Lord,
My father, and my family, but write whore,
Though not upon my forhead, in my conscience,
To be read howerly, and yet name your honour? 70
Yours suffers but in circumstance; mine in substance,
If you obey me, you part with some credit,
From whom? the giddy multitude; but mankind
Will censure me, and justly.
Dinant. I will loose,
What most I doe desire, rather then hazard
So deare a friend, or write my selfe a coward,
'Tis better be no man.
Lamira [aside]. This will not doe;——
Why I desire not, you should be a coward,
Nor doe I weigh my Brothers life with yours,
Meete him, fight with him, doe, and kill him fairely, 80

70–71 honour? | Yours suffers] F2; honours? Yours suffer F1

Let me not suffer for you, I am carelesse.

Dinant. Suffer for me?

Lamira. For you: my kindnesse to you,
Already brands me, with a strumpets name.

Dinant. O that I knew the wretch!

Lamira. I will not name him,
Nor give you any Character to know him;
But if you dare and instantly, ride foorth
At the west port of the City, and defend there
My reputation, against all you meete,
For two houres only, i'l not sweare *Dinant,*
To satisfie, (though sure I thinke I shall) 90
What ever you desire; if you denie this
Be desperate, for willingly, by this light,
I'l never see thee more.

Dinant. Two houres, doe you say?

Lamira. Only two houres.

Dinant. I were no Gentleman,
Should I make scruple of it; this favour armes me,
And boldly i'l performe it.

Lamira. I am glad on't. *Exit* [Dinant].
This will prevent their meeting yet, and keepe
My Brother safe, which was the marke I shott at.

 Exit.

 Enter Cleremont, *as in the field.* II.i

Cleremont. I am first i'th field, that honours gain'd of our side,
Pray Heaven I may get of as honourablie,
The houre is past, I wonder *Dinant* comes not,
This is the place, I cannot see him yet;
It is his quarrell too, that brought me hither,
And I ne'r knew him yet, but to his honour,
A firme and worthy Friend, yet I see nothing,
Nor Horse nor man; 'twould vex me, to be left here,
To th' mercy of two swords, and two approved ones;
I never knew him last.

 86 dare ∧ and instantly,] ∼ , ∼ ∼ ∧ F1–2 6 his] F2; this F1

Enter Beaupre *and* Verdoone.

Beaupre. You are well met *Cleremont.* 10

Verdoone. You are a faire Gentleman, and love your friend Sir,
What are you ready? the time has over tane us.

Beaupre. And this you know the place.

Cleremont [*aside*]. No *Dinant* yet?

Beaupre. We come not now to argue, but to doe;
We waite you Sir.

Cleremont. Ther's no time past yet, Gentlemen,
We have day enough:——i'st possible he comes not?——
You see I am ready here, and doe but stay,
Till my Friend come, walke but a turne or two,
'Twill not be long.

Verdoone. We came to fight.

Cleremont. Yee shall fight Gentlemen, 20
And fight enough, but a short turne or two,
I thinke I see him, set up your watch, wee'l fight by it.

Beaupre. That is not hee; we will not be deluded.

Cleremont. Am I bobd thus?——pray take a pipe of tobacco,
Or sing but some new ayre; by that time, Gentlemen——

Verdoone. Come draw your sword, you know the custome here Sir,
First come, first serv'd.

Cleremont. Though it be held a custome,
And practised so, I doe not hold it honest;
What honour can you both win on me single?

Beaupre. Yeild up your sword then.

Cleremont. Yeild my Sword? that's Hebrew; 30
I'll be first cut a peices; hold but a while,
I'll take the next that comes:

Enter an old Gentleman.

You are an old Gentleman?

Old Gentleman. Yes indeed am I, Sir.

Cleremont. And weare no Sword?

Old Gentleman. I need none, Sir.

Cleremont. I would you did, and had one;

30 your] F2; you F1

358

I want now such a foolish courtesie,
You see these Gentlemen——

Old Gentleman. You want a second.
In good Faith Sir, I was never handsome at it,
I would you had my Son, but hee's in *Italy*;
A proper Gentleman,——you may doe well gallants
If your quarrell be not capitall, to have more mercy, 40
The Gentleman may doe his Country——

Cleremont. Now I beseech you, Sir,
If you dare not fight, doe not stay to beg my pardon,
There lies your way.

Old Gentleman. Good morrow Gentlemen. *Exit.*

Verdoone. You see your fortune, you had better yeild your sword.

Cleremont. Pray yee stay a little,
Upon mine honestie, you shall be fought with;——
Well, *Dinant*, well,——

Enter two Gentlemen.

 these weare swords and seeme brave fellowes,——
As you are Gentlemen, one of you supply me,
I want a second now to meete these gallants,
You know what honour is.

1 Gentleman. Sir you must pardon us, 50
We goe about the same worke, you are ready for,
And must fight presently, els we were your servants.

2 Gentleman. God speed you, and good day. *Exeunt* Gentlemen.

Cleremont. Am I thus Colted?

Beaupre. Come either yeild——

Cleremont. As you are honest Gentlemen,
Stay but the next, and then i'll take my fortune,
And if I fight not like a man——Fy *Dinant*,
Cold now and treacherous?

Enter Monsieur la Writ [*speaking to those*] *within.*

La-writ. I understand your causes, yours about corne, yours
about pinnes and glasses; will you make me mad, have I not all

the parcells? and his Petition too, about Bell-founding? Send in 60
your witnesses, what will you have me doe? Will you have me
break my heart? My brains are melted; and tell your Master, as I am
a gentleman, his Cause shall be the first, commend me to your
Mistris, and tell her, if there be an extraordinary feather, and tall
enough for her: I shall dispatch you too, I know your Cause, for
transporting of Farthingales; trouble me no more, I say, againe to
you, no more vexation: bid my wife send me some puddings; I have
a Cause to run through, requires puddings, puddings enough.
Farewell.

Cleremont. God speed you, sir. 70
Beaupre. Would he would take this fellow.
Verdoone. A rare Youth.
Cleremont. If you be not hastie, sir——
La-writ. Yes, I am hastie, exceeding hastie, sir, I am going to the
Parliament, you understand this bag, if you have any businesse
depending there, be short, and let me heare it, and pay your Fees.
Cleremont. 'Faith, sir, I have a businesse, but it depends upon no
Parliament.
La-writ. I have no skill in't then.
Cleremont. I must desire you, 'tis a Sword matter, sir.
La-writ. I am no Cutler, I am an Advocate, sir. 80
Beaupre. How the thing lookes?
Verdoone. When he brings him to fight——
Cleremont. Be not so hastie, you weare a good Sword.
La-writ. I know not that, I never drew it yet, or whether it be a
Sword.
Cleremont. I must entreat you try, sir, and beare a part against these
Gentlemen, I want a second; yee seeme a man, and 'tis a noble
office.
La-writ. I am a Lawyer, sir, I am no fighter.
Cleremont. You that breed quarrells, sir, know best to satisfie.
Beaupre. This is some sport yet.
Verdoone. If this fellow should fight—— 90
La-writ. And for any thing I know, I am an arrant coward, doe not
trust me, I thinke I am a coward.
Cleremont. Try, try, you are mistaken:——

*61–62 Will ... heart?] *stet* F1–2

Walke on gentlemen, the man shall follow presently.

La-writ. Are ye mad gentleman? my businesse is within this halfe
houre.

Cleremont. That's all one, we'll dispatch within this quarter,——
There in that bottome, 'tis most convenient gentlemen.

Beaupre. Well, we'll wait, sir.

Verdoone. Why this will be a comick fight,——you'll follow? 100

Cleremont. As I am a true man.

La-writ. I cannot fight.

Cleremont. Away, away,—— *Exeunt* Beaupre, Verdone.
I know you can: I like your modesty, I know you will fight, and so
fight, with such mettall, and with such judgement, meet your
enemies fury; I see it in your eye, sir.

La-writ. I'le be hang'd then; and I charge you in the Kings name,
name no more fighting.

Cleremont. I charge you in the Kings name, play the man, which if
you doe not quickly, I begin with you, Ile make you dance, [*draws*] 110
doe you see your fiddle sticke? sweet Advocate, thou shalt fight.

La-writ. Stand farther gentleman, or I'le give you such a dust o'th'
chapps——

Cleremont. Spoke bravely, and like thy selfe; a noble Advocate:
come, to thy tooles.

La-writ. I do not say I'le fight.

Cleremont. I say thou shalt, and bravely.

La-writ. If I doe fight; I say, if I doe, but doe not depend upon't,
(and yet I have a foolish itch upon me,) what shall become of my
Writings? 120

Cleremont. Let 'em ly by, they will not run away, man.

La-writ. I may be kil'd too, and where are all my causes then? my
businesse? I will not fight, I cannot fight, my Causes——

Cleremont. Thou shalt fight, if thou hadst a thousand causes, thou art
a man to fight for any cause, and carry it with honour.

La-writ. Hum! say you so? if I should be such a coxcombe to prove
valiant now——

Cleremont. I know thou art most valiant.

*100–103 follow? *Cleremont.* As ... man. *La-writ.* I cannot fight. *Cleremont.* Away,
away,—— *Exeunt* Beaupre, Verdone.] follow. *La—w.* As ... fight. *Ex. Beaup.*
Verdone. *Cler.* Away, away, F1–2

La-writ. Doe you thinke so? I am undone for ever, if it prove so, I
tell you that, my honest friend, for ever; for I shall ne're leave 130
quarrelling. How long must we fight? for I cannot stay, nor will not
stay, I have businesse.

Cleremont. We'll do't in a minute, in a moment.

La-writ. Here will I hang my bag then, it may save my belly, I never
lov'd cold iron there.

Cleremont. You doe wisely.

La-writ. Help me to pluck my sword out then, quickly, quickly, 't
has not seen Sun these ten yeares.

Cleremont. How it grumbles? this Sword is vengeance angry.

La-writ. Now I'le put my hat up, and say my prayers as I goe; away 140
boy, if I be kill'd, remember the little Lawyer.

 Exeunt.

 Enter Beaupre. [II.ii]

Beaupre [*to* Verdoone *within*]. They are both come on, that may be a
 stubborne rascall,
Take you that ground, Ile stay here, fight bravely.

 Enter La-writ.

La-writ. To't chearfully my boyes, you'll let's have faire play? none
of your foyning tricks.

Beaupre. Come forward Monsieur;—— *Fight.*
What hast thou there? a pudding in thy belly? I shall see what it
holds.

La-writ. Put your spoone home then: nay, since I must fight, have at
you without wit, sir:——God a mercy bagg.

Beaupre. Nothing but bumbast in yee?——the rogue winkes and 10
fights.

La-writ. Now your fine fencing, sir:

 Beaupre *loses his sword*, La-writ *treads on it.*

Stand off, thou diest on point else,——I have it, I have it:——yet
further off:——I have his Sword.

Cleremont [*within*]. Then keep it, be sure you keep it.

La-writ. I'le put it in my mouth else.——Stand further off yet, and

 15 *Cleremont.*] F2; *Beau.* F1

 362

stand quietly, and looke another way, or I'le be with you.——Is
this all? I'le undertake within these two dayes to furnish any Cutler
in this Kingdome.

Beaupre. Pox, what a fortune's this? disarm'd by a puppie? a snaile? a 20
dog?

La-writ. No more o' these words Gentleman, sweet gentleman no
more, doe not provoke me, goe walke i'th' horse faire; whistle
gentleman,——

> *Enter* Cleremont, *pursued by* Verdoone.

What must I doe now?

Cleremont. Help me, I am almost breathlesse.

La-writ. With all my heart,——there's a cold py for you, sir.

Cleremont. Thou strik'st me, foole.

La-writ. Thou foole, stand further off then,——deliver, deliver.

> *He strikes up the others heeles, and takes his Sword too.*

Cleremont. Hold fast. 30

La-writ. I never faile in't——there's twelve pence, go buy you two
leaden Daggers,——have I done well?

Cleremont. Most like a gentleman.

Beaupre. And we two basely lost.

Verdoone. 'Tis but a fortune, we shall yet find an houre.

Cleremont. I shall be glad on't. *Exeunt* Beaupre, Verdoone *sad.*

La-writ. Where's my cloake, and my trinkets? or will you fight any
longer, for a crash or two?

Cleremont. I am your noble friend, sir.

La-writ. It may be so. 40

Cleremont. What honour shall I doe you, for this great courtesie?

La-writ. All I desire of ye, is to take the quarrell to your selfe, and let
me heare no more on't, I have no liking to't, 'tis a foolish matter:
and help me to put up my Sword.

Cleremont. Most willingly, but I am bound to gratifie you, and I
must not leave you.

La-writ. I tell you, I will not be gratified, nor I will heare no more
on't: take the Swords too, and doe not anger me, but leave me
quietly; for the matter of honour, 'tis at your owne disposure, and

*27 cold py] *stet* F1–2

so, and so——— *Exit* La-writ. 50
Cleremont. This is a most rare Lawyer: I am sure most valiant. Well,
 Dinant, as you satisfie me,———
 I say no more: I am loden like an Armorer.

 Exit Cleremont.

 Enter Dinant. [II.iii]

Dinant. To be dispatcht upon a sleevelesse errand?
 To leave my friend engag'd, mine honour tainted?
 These are trim things. I am set here like a Perdue,
 To watch a fellow, that has wrong'd my Mistris,
 A scurvy fellow, that must passe this way,
 But what this scurvy fellow is, or whence,
 Or whether his name be *William* or *John*,
 Or *Anthony* or *Dick*, or any thing, I know not;
 A scurvy rascally fellow I must aime at,
 And there's the office of an Asse flung on me. 10
 Sure *Cleremont* has fought, but how come off,
 And what the world shall thinke of me hereafter:
 Well, woman, woman, I must looke your rascalls,
 And loose my reputation: ye have a fine power over us.
 These two long houres I have trotted here, and curiously
 Survei'd all goers by, yet find no rascall,
 Nor any face to quarrell with:

 La-writ *sings within then Enters.*

 What's that?
 This is a rascally voice, sure it comes this way.
La-writ. *He strooke so hard the Bason broke,*
 And Tarquin *heard the sound*——— 20
Dinant. What mister thing is this? let me survey it.
La-writ. *And then he strooke his necke in two.*
Dinant. This may be a rascall, but 'tis a mad rascall,
 What an Alphabet of faces he puts on?
 Hey how it fences? if this should be the rogue,

 50 *Exit* La-writ.] F2; *omit* F1 *19–22 *He ... two.*] stet* F1–2
 *21 mister] F2 (Mister); master F1

As 'tis the likeliest rogue, I see this day——

La-writ. *Was ever man for Ladies sake? down, down.*

Dinant. And what are you good sir? *down, down, down, down.*

La-writ. What's that to you, good sir? *downe, downe.*

Dinant. A pox on you, good sir, *downe, downe, downe,* 30
You with your Buckram bag, what make you here?
And from whence come you?——I could fight with my shadow
now.

La-writ. Thou fierce man, that like sir *Lancelot* dost appear,
I need not tell thee what I am, nor eke what I make here.

Dinant. This a pretious knave,——stay, stay, good *Tristram,*
And let me aske thy mightinesse a question,
Did ye never abuse a Lady?

La-writ. Not; to abuse a Lady, is very hard, sir.

Dinant. Say you so, sir? didst thou never abuse her honour?

La-writ. Not; to abuse her honour, is impossible. 40

Dinant. Certaine this is the rascall:——What's thy name?

La-writ. My name is *Cock a two,* use me respectively,
I will be Cocke of three else.

Dinant. What's all this?
You say, you did abuse a Lady?

La-writ. You ly.

Dinant. And that you wrong'd her honour?

La-writ. That's two lyes,
Speake suddenly, for I am full of businesse.

Dinant. What art thou, or what canst thou be, thou pea-goose,
That dar'st give me the ly thus? thou mak'st me wonder.

La-writ. And wonder on, till time make all things plaine.

Dinant. You must not part so, sir, art thou a gentleman? 50

La-writ. Aske those, upon whose ruines, I am mounted.

Dinant. This is some Cavellero Knight o'th'Sun.

La-writ. I tell thee, I am as good a gentleman as the Duke;
I have atchieved——goe follow thy businesse.

Dinant. But for this Lady, sir——

La-writ. Why, hang this Lady, sir, and the Lady Mother too, sir,
what have I to do with Ladies?

*27 *Was ... sake?*] stet F1–2 *49 make all things] F2; makes all this F1

365

Enter Cleremont.

Cleremont. 'Tis the little Lawyers voice: has he got my way?
 It should be here abouts.
Dinant. Ye dry bisket rogue, I wil so swinge you for this 60
 blasphemie——[*draws.*] Have I found you out?
Cleremont. That should be *Dinants* tongue too.
La-writ. *And I defy thee, do thy worst: ô ho quoth* Lancelot *tho.* And
 that thou shalt know, I am a true gentleman, and speake according
 to the phrase triumphant, thy Lady, is a scurvy Lady, and a shitten
 Lady, and though I never heard of her, a deboshed Lady, and thou,
 a squire of low degree; will that content thee? Dost thou way-lay
 me with Ladies? A pretty sword, sir, a very pretty sword, I have a
 great mind to't.
Dinant. You shall not loose your longing, rogue.
Cleremont Hold, hold, 70
 Hold *Dinant*, as thou art a gentleman.
La-writ. As much as you will, my hand is in now.
Cleremont. I am your friend, sir: *Dinant* you draw your sword
 Upon the gentleman, preserv'd your honour:
 This was my second, and did back me nobly,
 For shame forbeare.
Dinant. I aske your mercy, sir,
 And am your servant now.
La-writ. May we not fight then?
Cleremont. I am sure you shall not now.
La-writ. I am sorry for't, I am sure I'le stay no longer then, not a jot 80
 longer: are there any more on ye afore? I will sing still, sir.
 Exit La-writ *singing*.
Dinant. I looke now you should chide me, and 'tis fit,
 And with much bitternesse, expresse your anger,
 I have deserv'd: yet when you know——
Cleremont. I thanke ye,
 Doe you thinke, that the wrong you have offred me,
 The most unmanly wrong, unfriendly wrong—
Dinant. I doe confesse——
Cleremont. That boyish sleight——

63 *ô . . . tho.*] stet F1–2 81.1 *singing*] F2; *omit* F1

Dinant. Not so, sir.

Cleremont. That poore, and base renouncing of your honour,
 Can be allaied with words?

Dinant. I give you way still.

Cleremont. Coloured with smooth excuses? Was it a friends part, 90
 A Gentlemans, a mans that weares a Sword,
 And stands upon the point of reputation,
 To hide his head, then, when his honour call'd him?
 Call'd him alowd, and lead him to his fortune?
 To halt and slip the coller? by my life,
 I would have given my life, I had never knowne thee,
 Thou hast eaten Canker-like into my judgement
 With this disgrace, thy whole life, cannot heale againe.

Dinant. This I can suffer too, I find it honest.

Cleremont. Can you pretend an excuse now may absolve you, 100
 Or any thing like honest, to bring you off?
 Ingage me like an Asse?

Dinant. Will you but heare me?

Cleremont. Expose me like a Jade, to tug, and hale through,
 Laugh'd at, and almost hooted? your disgraces,
 Invite mens Swords, and angers to dispatch me.

Dinant. If you will be patient——

Cleremont. And be abus'd still? But that I have call'd thee friend,
 And to that name, allow a Sanctuary,
 You should heare further from me, I would not talk thus:
 But henceforth stand upon your owne bottome, sir, 110
 And beare your owne abuses, I scorne my sword
 Should travell in so poore and empty quarrells.

Dinant. Ha you done yet? take your whole swinge of anger,
 I'le beare all with content.

Cleremont. Why were you absent?

Dinant. You know I am no Coward, you have seene that,
 And therefore, out of feare, forsooke you not:
 You know I am not false, of a treacherous nature,
 Apt to betray my friend (I have fought for you too);
 You know no businesse, that concern'd my state,

My kindred, or my life——

Cleremont. Where was the fault then? 120

Dinant. The honour of that Lady I adore,
Her credit, and her name: ye know she sent for me,
And with what hast.

Cleremont. What was he that traduc'd?

Dinant. The man i'th' Moone, I think, hither I was sent,
But to what end——

Cleremont. This is a pretty flim-flam.

Enter old Lady.

Old Lady. I am glad I have met you sir, I have bin seeking,
And seeking every where.

Cleremont. And now you have found him,
Declare what businesse, our Embassadour.

Old Lady. What's that to ye good man flouter?——O sir, my
Lady——

Dinant. Prethee no more of thy Lady, I have too much on't. 130

Cleremont. Let me have a little, speake to me.

Old Lady. To you sir?
'Tis more then time:——All occasions set aside sir,
Or whatsoever may be thought a businesse——

Dinant. What then?

Old Lady. Repaire to me within this houre.

Cleremont. Where?

Old Lady. What's that to you? come you, sir, when y'are sent for.

Cleremont. God a mercy *Mumpsimus,*
You may goe *Dinant,* and follow this old Fairie,
Till you have lost your selfe, your friends, your credit,
And hunny out your youth, in rare adventures, 140
I can but grieve, I have knowne you.

Old Lady. Will ye goe sir?
I come not often to you with these blessings,
You may believe that thing there, and repent it,
That dogged thing.

Cleremont. Peace touchwood.

Dinant. I will not goe:

128 what] F2; that F1 *140 hunny] *stet* F1

368

Goe bid your Lady seeke some foole, to fawne on her,
Some unexperienc'd puppie, to make sport with,
I have bin her mirth too long, thus I shake from me
The fetters she put on; thus her enchantments
I blow away like wind; no more her beauty——
Old Lady. Take heed sir, what you say.
Cleremont. Goe forward, *Dinant.* 150
Dinant. The charmes shot from her eyes——
Old Lady. Be wise.
Cleremont. Be Valiant.
Dinant. That tongue that tells faire tales to mens destructions
 Shall never wrack me more.
Old Lady. Stay there.
Cleremont. Goe forward.
Dinant. I will now heare her, see her as a woman,
 Survey her, and the power man has allowed her,
 As I would doe the course of common things,
 Unmov'd, unstruck.
Cleremont. Hold there, and I forgive thee.
Dinant. She is not faire, and that that makes her proud,
 Is not her owne, our eies bestow it on her,
 To touch and kisse her, is no blessednesse, 160
 A Sun-burnt Ethiopes lip's as soft as hers.
 Goe bid her stick some other triumph up,
 And take into her favour some dull foole,
 That has no pretious time to loose, no friends,
 No honour, nor no life; like a bold Merchant,
 A bold and banquerupt man, I have ventur'd all these,
 And split my bottome: returne this answer to her,
 I am awake againe, and see her mischiefes,
 And am not now, on every idle errand,
 And new coyn'd anger, to be hurried, 170
 And then despis'd againe, I have forgot her.
Cleremont. If this be true——
Old Lady. I am sorry, I have troubled you,
 More sorrie, that my Lady has adventur'd
 So great a favour, in so weake a mind:

*153 wrack] Weber (Seward *conj.*); rack F1–2
155 allowed her] Seward; allowed, sir F1–2

This houre you have refus'd that, when you come to know it,
Will run you mad, and make you curse that fellow,
She is not faire, nor handsome, so I leave you.

Cleremont. Stay Lady, stay, but is there such a businesse?

Old Lady. You would breake you neck 'twere yours.

Cleremont. My back, you would say.

Old Lady. But play the friends part still, sir, and undoe him, 180
'Tis a faire office.

Dinant. I have spoke too liberally.

Old Lady. I shall deliver what you say.

Cleremont. You shall be hang'd first,
You would faine be prating now; take the man with you.

Old Lady. Not I, I have no power.

Cleremont. You may goe *Dinant.*

Old Lady. 'Tis in's own will, I had no further charge, sir,
Then to tell him what I did, which if I had thought
It should have bin receiv'd so———

Cleremont. 'Faith you may,
You doe not know, how far it may concerne you.
If I perceiv'd any trick in't———

Dinant. 'Twill end there.

Cleremont. 'Tis my fault then, there is an houre in fortune, 190
That must be still observ'd: you thinke I'll chide you,
When things must be, nay, see an he will hold his head up?
Would such a Lady send with such a charge too?
Say she has plaid the foole, play the foole with her againe,
The great foole, the greater still the better,———
He shall goe with you woman.

Old Lady. As it please him,
I know the way alone else.

Dinant. Where is your Lady?

Old Lady. I shall direct you quickly.

Dinant. Well, I'll goe,
But what her wrongs, will give me leave to say———

Cleremont. We'll leave that to your selves: I shall heare from you? 200

Dinant. As soone as I come off.

Cleremont. Come on then bravely;

175 refus'd ∧ that,] Colman; ∼ , ∼ ∧ F1; ∼ ∧ ∼ ∧ F2

Farewell till then, and play the man.

Dinant. You are merry;
All I expect is scorne:———Ile lead you Lady.

Exeunt severally.

Enter Champernell, Lamira, Beaupre, Verdoone, Charlote. III.i

Beaupre. We'll venture on him.
Champernell. Out of my dores I charge thee,
See me no more.
Lamira. Your Nephew?
Champernell. I disclaime him.
He has no part in me, nor in my blood,
My Brother that kept fortune bound, and left
Conquest hereditary to his Issue
Could not beget a coward.
Verdoone. I fought, sir,
Like a good fellow, and a souldier too,
But men are men, and cannot make their fates:
Ascribe you to my Father, what you please,
I am borne to suffer———
Champernell. All disgraces wretch. 10
Lamira. Good sir be patient.
Champernell. Was there no tree,
(For to fall by a noble enemies sword,
A Coward is unworthy) nor no River,
To force thy life out backward, or to drowne it,
But that thou must survive thy infamie?
And kill me, with the sight of one I hate?
And gladly would forget?
Beaupre. Sir, his misfortune
Deserves not this reproofe.
Champernell. In your opinion;
'Tis fit you two should be of one beliefe,
You are indeed, fine gallants, and fight bravely 20
I'th' City with your tongues, but in the field
Have neither spirit to dare, nor power to doe,
Your swords, are all ledd there.

*14 or] stet F1-2

371

Beaupre. I know no duty,
 (How ever you may wreake your spleene on him,)
 That bindes me to endure this.
Champernell. From *Dinant*
 You'll suffer more; that ever cursed I,
 Should give my honour up, to the defence
 Of such a thing as he is, or my Lady
 That is all Innocence, for whom a dove would
 Assume the courage of a daring Eagle, 30
 Repose her confidence in one that can
 No better guard her. In contempt of you
 I love *Dinant*, mine enemy, nay admire him,
 His valour claimes it from me, and with justice,
 He that could fight thus, in a cause not honest,
 His sword edg'd with defence, of right and honour,
 Would pierce as deep as lightning, with that speed too,
 And kill as deadly.
Verdoone. You are as far from Justice,
 In him you praise, as equitie in the censure
 You load me with.
Beaupre. *Dinant?* he durst not meet us. 40
Lamira. How? durst not brother?
Beaupre. Durst not, I repeat it.
Verdoone. Nor was it *Cleremont*'s valour that disarm'd us,
 I had the better of him; for *Dinant*,
 If that might make my peace with you, I dare
 Write him a Coward, upon every post,
 And with the hazard of my life defend it.
Lamira. If 'twere laied at the stake, you'd loose it, Nephew.
Champernell. Came he not, say you?
Verdoone. No, but in his roome,
 There was a divell hir'd from some Magician,
 I'th' shape of an Atturney.
Beaupre. 'Twas he did it. 50
Verdoone. And his the honour.
Beaupre. I could wish *Dinant*——
 But what talke I of one that stept aside,

*29 Innocence] Seward *conj.*; Innocent F1—2

372

And durst not come?
Lamira. I am such a friend to truth,
 I cannot heare this: why doe you detract
 Thus poorely (I should say to others basely)
 From one, of such approv'd worth?
Champernell. Ha! how's this?
Lamira. From one so excellent, in all that's noble,
 Whose onely weaknesse, is excesse of courage?
 That knowes no enemies, that he cannot master,
 But his affections, and in them, the worst 60
 His love to me?
Champernell. To you?
Lamira. Yes sir, to me,
 I dare (for what is that, which Innocence dares not?)
 To you professe it, and he shun'd the Combat
 For feare, or doubt of these?——blush and repent,
 That you in thought, ere did that wrong to valour.
Beaupre. Why, this is rare.
Champernell. 'Fore heaven, exceeding rare;
 Why, modest Lady, you that sing such Encomiums
 Of your first Suiter——
Verdoone. How can ye convince us
 In our reports?
Lamira. With what you cannot answer,
 'Twas my command that staied him.
Champernell. Your command? 70
Lamira. Mine, sir, and had my will rank'd with my power,
 And his obedience, I could have sent him
 With more ease, weaponlesse to you, and bound,
 Then have kept him back, so well he loves his honour
 Beyond his life.
Champernell. Better, and better still.
Lamira. I wrought with him in private to divert him
 From your assur'd destruction, had he met you.
Champernell. In private?
Lamira. Yes, and us'd all Arts, all Charmes,
 Of one that knew her selfe the absolute Mistris

*63–64 shun'd ... these?] Weber (these!); shun'd ... these: F1; shun'd not ... these: F2

Of all his faculties

Champernell. Gave all rewards too 80
 His service could deserve? did not he take
 The measure of my sheets?

Lamira. Doe not looke yellow,
 I have cause to speake, frownes cannot fright me;
 By all my hopes, as I am spotlesse to you,
 If I rest once assur'd, you doe but doubt me,
 Or curbe me of that freedome, you once gave me——

Champernell. What then?

Lamira. I'll not alone, abuse your bed, that's nothing,
 But to your more vexation, ('tis resolv'd on,)
 I'll run away, and then try if *Dinant* 90
 Have courage to defend me.

Champernell. Impudent!

Verdoone. And on the sudden.

Beaupre. How are ye transform'd,
 From what you were?

Lamira. I was an innocent Virgin,
 And I can truly sweare, a Wife as pure
 As ever lay by Husband, and will dy so,
 Let me live unsuspected; I am no servant,
 Nor will be us'd like one: If you desire
 To keep me constant, as I would be, let
 Trust and beliefe in you, beget, and nurse it;
 Unnecessary jealousies, make more whores 100
 Then all baites els, laied to entrap our frailties.

Beaupre. There's no contesting with her, from a child
 Once mov'd, she hardly was to be appeas'd,
 Yet I dare sweare her honest.

Champernell. So I thinke too,
 On better judgement: I am no Italian
 To lock her up; nor would I be a Dutchman,
 To have my Wife, my soveraigne, to command me:
 I'll try the gentler way, but if that faile,
 Believe it, Sir, there's nothing but extreames,
 Which she must feele from me.

Beaupre. That, as you please sir. 110

Charlote. You have won the breeches, Madam, looke up sweetly,
 My Lord limpes toward you.
Lamira. You will learne more manners.
 [*Strikes her.*]
Charlote. This is a fee, for counsell that's unask'd for.
Champernell. Come, I mistook thee sweet, prethee forgive me,
 I never will be jealous: ere I cherish
 Such a mechanick humour, I'll be nothing;
 I'll say *Dinant*, is all that thou wouldst have him,
 Will that suffice?
Lamira. 'Tis well, sir.
Champernell. Use thy freedome
 Uncheck'd, and unobserv'd, if thou wilt have it,
 These shall forget their honour, I my wrongs; 120
 We'll all dote on him, hell be my reward
 If I dissemble.
Lamira. And that hell take me
 If I affect him, he's a lustfull villaine,
 (But yet no coward) and sollicites me
 To my dishonour, that's indeed a quarrell,
 And truly mine, which I will so revenge,
 As it shall fright, such as dare onely thinke
 To be adulterers.
Champernell. Use thine owne waies,
 I give up all to thee.
Beaupre. O women, women!
 When you are pleas'd, you are the least of evils. 130
Verdoone. I'll rime to't, but provokt, the worst of divells.
 Exeunt.

 Enter Monsier Sampson, *and three* Clients. [III.ii]

Sampson. I know Monsier *La-writ*.
1 Client. Would he knew himselfe, Sir.
Sampson. He was a pretty Lawyer, a kind of pretty Lawyer, of a kind
 of unable thing.
2 Client. A fine Lawyer, Sir, and would have firk'd you up a
 businesse, and out of this Court into that.
Sampson. Ye are too forward, not so fine my friends, something he

 375

could have done, but short, short.

1 Client. I know your worships favour, you are Nephew to the
Judge, Sir. 10

Sampson. It may be so, and something may be done, without
trotting i'th' durt, friends; it may be I can take him in his Chamber,
and have an houres talke, it may be so, and tell him that in's eare,
there are such courtesies: I will not say, I can.

3 Client. We know you can, sir.

Sampson. Peradventure I, peradventure no: but where's *La-writ?*
where's your sufficient Lawyer?

1 Client. He's blowne up, Sir.

2 Client. Run mad, and quarrells with the dog he meets; he is no
Lawyer of this world now. 20

Sampson. Your reason? is he defunct? is he dead?

2 Client. No, he's not dead yet, sir; but I would be loth to take a lease
on's life for two houres: alas, he is possest sir, with the spirit of
fighting, and quarrells with all people; but how he came to it———

Sampson. If he fight well, and like a Gentleman, the man may fight,
for 'tis a lawfull calling. Looke you my friends, I am a civill
Gentleman, and my Lord my Uncle loves me.

3 Client. We all know it, sir.

Sampson. I thinke he does, sir, I have businesse too, much businesse,
(turn you some forty or fifty Causes in a weeke;) yet when I get an 30
houre of vacancie, I can fight too my friends, a little does well, I
would be loth to learne to fight.

1 Client. But and't please you, sir, his fighting has neglected all our
businesse, we are undone, our causes cast away, sir, his not
appearance———

Sampson. There he fought too long, a little and fight well, he fought
too long indeed friends; but ne'r the lesse, things must be, as they
may, and there be wayes———

1 Client. We know, sir, if you please———

Sampson. Something I'll doe; goe rally up your Causes. 40

Enter La-writ, *and a* Gentleman *at the dore.*

2 Client. Now you may behold sir, and be a witnesse, whether we lie
or no.

*32 loth ... fight] *stet* F1–2 *40.1 Gentleman ... dore] *stet* F1–2

376

One that will spit as senselesse fire, as this fellow.
Cleremont. And such a man to undertake, my Lord?
Vertaigne. Nay hees too forward, these two pitch barrells
 together—— 180
Cleremont. Upon my soule no harme.
Vertaigne. It makes me smile,
Why what a stinking smother will they utter?
Yes he shall undertake Sir, as my Champion,
(Since you propound it mirth, i'll venture on it)
And shall defend my cause, but as y'ar honest
Sport not with blood.
Cleremont. Thinke not so basely, good Sir.
Vertaigne. A squire shall waite upon you from my kinsman,
To morrow morning, make your sport at full,
(You want no subject,) but no wounds.
Cleremont. That's my care.
Vertaigne. And so good day.
Cleremont. Many unto your honour, 190

 Exeunt Vertaigne *and* Gentlemen.

This is a noble fellow of a sweet spirit,
Now must I thinke how to contrive this matter,
For together they shall goe.

 Enter Dinant.

Dinant. O *Cleremont*
I am glad I have found thee.
Cleremont. I can tell thee rare things.
Dinant. O I can tell thee rarer, dost thou love me?
Cleremont. Love thee?
Dinant. Doest thou love me dearely?
Dar'st thou for my sake——
Cleremont. Any thing that's honest.
Dinant. Though it be dangerous?
Cleremont. Pox o dangerous.
Dinant. Nay wonderous dangerous?
Cleremont. Wilt thou breake my hearte?
Dinant. Along with me then.

Cleremont. I must part to morrow. 200
Dinant. You shall, you shall, be faithfull for this night
 And thou hast made thy freind.
Cleremont. Away and talke not.

 Exeunt.

 Enter Lamira *and* Nurse. [III.iii

Lamira. O Nurse welcome, where's *Dinant?*
Nurse. Hee is at my back;
 'Tis the most liberall Gentleman, this gold,
 He gave me for my paines, nor can I blame you,
 If you yeild up the fort.
Lamira. How? yeild it up?
Nurse. I know not, he that loves, and gives so largely,
 And a young Lord to boote, or I am cousend,
 May enter every where.
Lamira. Thou't make me angry.

 Enter Dinant *and* Cleremont.

Nurse. Why if you are I hope heres one will please you,
 Looke on him with my eyes,——good luck goe with you:
 Were I young for your sake——
Dinant. I thanke thee Nurse. 10
Nurse. I would be tractable, and as I am——
Lamira. Leave the roome,
 So old, and so immodest? and be carefull,
 Since whispers will wake sleeping jealousies,
 That none disturb my Lord. *Exit* Nurse.
Cleremont. Will you dispatch?
 Will you come to the matter? be not rapt thus,
 Walk in, walk in, I am your scout for once,
 You owe me the like service.
Dinant. And will pay it.
Lamira. As you respect our lives, speake not so loud.
Cleremont. Why, to it in dumb shew then, I am silenc'd.
Lamira. Be not so hasty Sir, the golden apples, 20
 Had a fell dragon for their guard, your pleasures

 4 fort] F2; for't F1 13 wake] F2 ('wake); make F1 15 Will] Till F1–2

Are to be attempted with Herculean danger,
Or never to be gotten.

Dinant. Speake the meanes.

Lamira. Thus briefely, my Lord sleepes now, and alas,
Each night he only sleepes.

Cleremont. Goe keepe her stirring.

Lamira. Now if he wake, as sometimes he does,
He only stretches out his hand and feeles,
Whether I am a bed, which being assur'd of
He sleepes againe; But should he misse me, valour
Could not defend our lives.

Dinant. Wha'ts to be done then? 30

Lamira. Servants have servile Faiths, nor have I any
That I dare trust; on noble *Cleremont*
We safely may rely.

Cleremont. What man can doe,
Command and boldly.

Lamira. Thus then, in my place,
You must lye with my Lord.

Cleremont. With an old man?
Two beards together? that's prepostrous.

Lamira. There is no other way, and though 'tis dangerous,
He having servants within call, and arm'd too,
Slaves feed to act, all that his jealousy,
And rage commands them, yet a true friend should not 40
Checke at the hazard of a life.

Cleremont. I thanke you,
I love my friend, but know no reason why
To hate my self, to be a kind of pander,
You see I am willing,
But to betray mine owne throat you must pardon.

Dinant. Then I am lost, and all my hopes defeated,
Were I to hazard ten times more for you,
You should find, *Cleremont*——

Cleremont. You shall not out doe me,
Fall what may fall, i'll do't.

Dinant. But for his beard——

39 feed] *i.e.,* fee'd

383

Lamira. To cover that you shall have my night Linnen, 50
And you dispos'd of, my *Dinant* and I,
Will have some private conference.

*Enter* Champernell *privately.*

Cleremont. Private doing,
Or i'll not venture.
Lamira. That's as we agree.

*Exeunt. Manet* Champernell.

*Enter* Nurse *and* Charlote, *pass 'ore the stage with
pillowes, night Cloaths and such things.*

Champernell. What can this Woman do, preserving her honour?
I have given her all the liberty that may be,
I will not be far off though, nor I will not be jealous,
Nor trust too much, I think she is vertuous,
Yet when I hold her best, she's but a woman,
As full of frailty as of Faith, a poore sleight woman,
And her best thoughts, but weake fortifications, 60
There may be a mine wrought. Well, let'em work then,
I shall meet with it: till the signes be monstrous,
And stick upon my head, I will not believe it,
She may be, and she may not: now to my observation.

*Stands private.*

*Enter* Dinant, *and* Lamira.

Dinant. Why do you make me stay so? if you love me——
Lamira. You are too hot, and violent.
Dinant. Why doe you shift thus
From one chamber to another?
Lamira. A little delay, sir,
Like fire, a little sprinckled ore with water,
Makes the desires burne cleare, and ten times hotter.
Dimant. Why doe you speake so lowd? I pray'e goe in 70

*53.1 *Exeunt. Manet* Champernell.] Colman; *Exeunt.* F1–2
61 mine] F2 (Mine); meane F1
70–71 in ∧ ... Mistris,] Colman; ~ ∧ ... ~ ∧ F1; ~ , ... ~ , F2

Sweet Mistris, I am mad, time steales away,
And when we would enjoy——
Lamira. Now fy, fy servant,
 Like sensuall beasts, shall we enjoy our pleasures?
Dinant. Pray doe but kisse me then.
Lamira. Why, that I will,

 [*Kisses him.*]

And you shall find anon, servant——
Dinant. Softly for heavens sake,
 You know my friend's engag'd, a little now;
 Will you goe in againe?
Lamira. Ha, ha, ha, ha.
Dinant. Why doe you laugh so lowd? pretious,
 Will you betray me? ha my friends throat cut?
Lamira. Come, come, I'le kisse thee again.
Champernell [*aside*]. Will you so? 80
 You are liberall, if you doe cozen me——

 Enter Nurse *with* Wine.

Dinant. What's this?
Lamira. Wine, wine, a draught or two.
Dinant. What does this woman here?
Lamira. She shall not hinder you.
Dinant. This might have bin spar'd,
 'Tis but delay, and time lost: pray send her softly off.
Lamira. Sit downe, and mix your spirits with Wine,
 'Twill make you another *Hercules.*
Dinant. I dare not drinke;
 Fy, what delayes you make? I dare not,
 I shall be drunke presently, and do strange things then.
Lamira. Not drink a cup with your Mistris? ô the pleasure. 90
Dinant. Lady, why this? *Musicke.*
Lamira. We must have mirth to our wine, man.
Dinant. Plague o'th' Musick.

72 servant,] F2; servant, *Wine.* F1 *76 now] now, now F1–2
*78 lowd? pretious,] *stet* F1 87 'Twill] Dyce (Mason *conj.*); I will F1–2
88 not,] F2; not, *Recorders.* F1 92 Plague] Weber; Pl——F1–2

Champernell [*aside*]. God-a-mercy Wench,
 If thou dost Cuckold me, I shall forgive thee.
Dinant. The house will all rise now, this will disturb all.
 Did you doe this?
Lamira. Peace, and sit quiet, foole,
 You love me, come, sit downe and drinke.

<p align="center">*Enter* Cleremont *above.*</p>

Cleremont. What a divell aile you?
 How cold I sweat?——— *Musick* [*still*].
 a hogs pox stop your pipes,
 The thing will wake: now, now me thinks I find
 His Sword just gliding through my throte: What's that? 100
 A vengeance choke your pipes. Are you there Lady?
 Stop, stop those rascalls; doe you bring me hither
 To be cut into minced meate? Why *Dinant?*
Dinant. I cannot doe withall; I have spoke, and spoke:
 I am betraied, and lost too.
Cleremont. Doe you heare me?
 Do you understand me? plague dam your whistles. *Musicke ends.*
Lamira. 'Twas but an over-sight, they have done, ly down.
Cleremont. Would you had done too, you know not
 In what a misery, and feare I ly.
 You have a Lady in your armes.
Dinant. I would have. 110
Champernell [*aside*]. I'le watch you, goodman Wood have.
Cleremont. Remove for heavens sake,
 And fall to that you come for.
Lamira. Ly you downe,
 'Tis but an houres endurance now.
Cleremont. I dare not, softly sweet Lady,———
 Musick againe.
 heart?
Lamira. 'Tis nothing but your feare, he sleeps still soundly,
 Ly gently downe.
Cleremont. 'Pray make an end.

 *98 pox˄] F2; ~ , F1
 115 *Musick againe.*] *The Recorders againe.* after line 110 F1–2

<p align="center"></p>

Dinant. Come, Madam.
Lamira. These Chambers are too neare.

 Exeunt Dinant, Lamira [*and* Nurse]. *Musick done.*

Champernell [*aside*]. I shall be nearer;
 Well, goe thy wayes. I'le trust thee through the world,
 Deale how thou wilt: that that I never feele, 120
 I'le never feare. Yet by the honour of a Souldiour,
 I hold thee truly Noble. How these things will looke,
 And how their bloods will curdle? play on children,
 You shall have pap anon. O thou grand foole,
 That thou knewest, but thy fortune.

 [*Exit.* Lamira *speakes lowdly within.*]

Cleremont. Peace, good Madam,
 Stop her mouth *Dinant,* it sleeps yet, 'pray' be wary,
 Dispatch, I cannot endure this misery,
 I can heare nothing more; I'le say my praiers,
 And downe againe——— *Whistle within.*
 A thousand larums, fall upon my quarter, 130
 Heaven send me off, when I ly keeping courses.
 Plague o' your fumbling *Dinant*; how I shake?
 'Tis still againe. Would I were in the Indies.

 Exit Cleremont [*above*].

 Enter Dinant, *and* Lamira *with a light.* [III.iv]

Dinant. Why doe ye use me thus? thus poorely? basely?
 Worke me into a hope, and then destroy me?
 Why did you send for me? this new way traine me?
Lamira. Madman, and fool, and false man, now Ile shew thee.
Dinant. 'Pray' put your light out.
Lamira. No I'le hold it thus,
 That all chast eyes, may see thy lust, and scorne it,
 Tell me but this, when you first doted on me,

*118 *Musick done.*] *after line* 125 F1–2 125 knewest] F2; knowest F1
*131 off,] ~ ; F1–2 132 Plague] Weber; Pl———F1–2
0.1 *with a light*] Weber; *A light within* F1–2
*4 and fool ... thee.] F2; a fool ... thee man ∧ F1(|)

And made suite to enjoy me, as your wife,
Did you not hold me honest?

Dinant. Yes, most vertuous.

Lamira. And did not that appeare, the onely lustre 10
That made me worth your love, and admiration?

Dinant. I must confesse———

Lamira. Why would you deale so basely?
So like a thiefe? a villaine?

Dinant. Peace, good Madam.

Lamira. I'le speake aloud too;———thus maliciously,
Thus breaking all the rules of honestie,
Of honour, and of truth, for which I lov'd you,
For which, I call'd you servant, and admir'd you,
To steale that jewell, purchas'd by another,
Piously set in Wedlock, even that Jewell,
Because it had no flaw, you held unvaluable? 20
Can he that has lov'd good, doat on the divell:
For he that seekes a whore, seeks but his agent?
Or am I of so vild, and low a blood,
So nurs'd in infamies———

Dinant. I doe not thinke so,
And I repent.

Lamira. That will not serve your turne, sir.

Dinant. It was your treaty drew me on.

Lamira. But it was your villany,
Made you pursue it: I drew you but to try
How much a man, and nobly you durst stand,
How well you had deserv'd the name of vertuous;
But you, like a wild torrent, mix'd with all 30
Beastly and base affections came floating on,
Swelling your poison'd billowes———

Dinant. Will you betray me?

Lamira. To all the miseries, a vext woman may.

Dimant. Let me but out,
Give me but roome, to tosse my sword about me,
And I will tell you, y'are a treacherous woman,

20 flaw] F2; flame F1 20 unvaluable] *i.e.*, invaluable
*23 vild] Dyce (Weber *conj.*); wild F1–2 23 a] F2; of F1

388

O that I had but words——

Lamira. They will not serve you.

Dinant. But two-edg'd words to cut thee; a Lady traytor?
Perish by a proud puppet? I did you too much honour,
To tender you my love, too much respected you, 40
To thinke you worthy of my worst embraces.
Goe, take your groome, and let him dally with you,
Your greasie groome; I scorne to impe your lame stock,
You are not faire, nor handsome, I lyed loudly.
This tongue abus'd you, when it spoke you beauteous.

Lamira. 'Tis very well, 'tis brave.

Dinant. Put out your light,
Your lascivious eyes, are flames enough
For fooles to find you out: a Lady plotter?
Must I begin, your sacrifice of mischiefe?
I and my friend, the first fruits of that blood, 50
You, and your honourable Husband aime at?
Crooked, and wretched you are both.

Lamira. To you, sir,
Yet to the eye of Justice, streight as Truth.

Dinant. Is this a womans love? a womans mercy?
Do you professe this seriously? doe you laugh at me?

Lamira. Ha, ha.

Dinant. Plague light upon your scornes, upon your flatteries,
Upon your tempting faces, all destructions:
A bedrid Winter hang upon your cheekes,
And blast, blast, blast, those buds of pride that paint you; 60
Death in your eyes, to fright men from these dangers,
Raise up your trophy: *Cleremont.*

[*Enter* Cleremont *above.*]

Cleremont. What a vengeance ayle you?
What dismall noise, is there no honour in you?

Dinant. *Cleremont,* we are betraied, betraied, sold by a woman,
Deale bravely for thy selfe.

57 Plague] Weber; Pl——F1–2 60 paint] F2; point F1
*63 What . . . you?] *assigned to Cleremont by* Dyce (Sympson *conj. in* Seward); *to Dinant by* F1–2
63 noise, is there ∧] F2+; ~ , ~ ~ , F1

Cleremont. This comes of rutting:
 Are we made stales to one another?
Dinant. Yes,
 We are undone, lost.
Cleremont. You shall pay for't grey-breard:
 Up, up, you sleep your last else.

 Lights above, two Servants *and* Anabell.

1 Servant. No, not yet, sir,
 Lady, looke up: would you have wrong'd this beauty?
 Wake so tender a Virgin, with rough tearmes? 70
 You weare a sword; we must entreat you leave it.
2 Servant. Fy sir, so sweet a Lady?
Cleremont. Was this my bed-fellow?
 Pray give me leave to looke, I am not mad yet,
 I may be, by and by. Did this ly by me?
 Did I feare this? is this a cause to shake at?
 Away with me for shame, I am a rascall.

 Enter Champernell, Beaupre, Verdoone. Anabel,
 Cleremont, *and two* Servants [*descend*].

Dinant. I am amaz'd too.
Beaupre. We'll recover you.
Verdoone. You walk like *Robin-good-fellow*, all the house over,
 And every man afraid of you.
Dinant. 'Tis well Lady.
 The honour of this deed, will be your owne, 80
 The world shall know your bounty.
Beaupre. What shall we doe with 'em?
Cleremont. Geld me,
 For 'tis not fit I should be a man againe,
 I am an Asse, a Dog.
Lamira [*to her kinsmen*]. Take your revenges,
 You know my Husbands wrongs, and your owne losses.
Anabell. A brave man, an admirable brave man;
 Well, well, I would not be so tried againe;
 A very handsome proper gentleman.

 *76.1 Verdoone.] Dyce; Verdoone, Lamira, F1–2 (*Laimra* F1)

Cleremont. Will you let me ly by her, but one houre more,
 And then hang me? 90
Dinant. Wee wait your malice, put your swords home bravely,
 You have reason to seeke blood.
Lamira. Not as you are Noble.
Champernell. Hands off, and give them liberty, onely disarme 'em.
Beaupre. We have done that already.
Champernell. You are welcome gentlemen,
 I am glad my house, has any pleasure for you,
 I keep a couple of Ladies here, they say faire,
 And you are young, and handsome gentlemen;
 Have you any more mind to Wenches?
Cleremont. To be abus'd too? Lady, you might have help'd this.
Anabell. Sir now 'tis past, but 't may be I may stand, 100
 Your friend hereafter, in a greater matter.
Cleremont. Never whilst you live.
Anabell. You cannot tell——
 Now sir a parting hand.
Cleremont. Downe and Roses:
 Well, I may live to see you again.——A dull rogue,
 No revelation in thee?
Lamira. Were you well frighted?
 Were your fitts, from the heart, of all colds and colours?
 That's all your punishment.
Cleremont. It might have bin all yours,
 Had not a blockhead undertaken it.
Champernell. Your swords, you must leave to these gentlemen.
Verdoone. And now, when you dare fight, 110
 We are on even Ice againe.
Dinant. 'Tis well:
 To be a Mistris, is to be a monster,
 And so I leave your house, and you for ever.
Lamira. Leave your wild lusts, and then you are a master.
Champernell. You may depart too.
Cleremont. I had rather stay here.
Champernell. Faith we shall fright you worse.
Cleremont. Not in that manner,

*112 be a Mistris] *stet* F1–2

391

There's five hundred crownes, fright me but so againe.
Dinant. Come *Cleremont*, this is the houre of foole.
Cleremont. Wiser the next shall be, or we'll to schoole.

Exeunt [Dinant *and* Cleremont].

Champernell. How coolely these hot gallants are departed? 120
Faith cousin, 'twas unconscionably done,
To ly so still, and so long.
Anabell. 'Twas your pleasure,
If 'twere a fault, I may hereafter mend.
Champernell. O, my best Wife.
Take now what course thou wilt, and lead what life.
Lamira. The more trust you commit, the more care still,
Goodnesse and vertue, shall attend my will.
Champernell. Let's laugh this night out now and count our gaines,
We have our honours home, and they their paines.

Exeunt omnes.

Enter Cleremont, Dinant. IV.i

Dinant. It holds, they will goe thither.
Cleremont. To their Summer house?
Dinant. Thither i'th' evening, and which is the most infliction,
Onely to insult upon our miseries.
Cleremont. Are you provided?
Dinant. Yes, yes.
Cleremont. Throughly?
Dinant. Throughly.
Cleremont. Basta, enough, I have your mind, I will not faile you.
Dinant. At such an houre.
Cleremont. Have I a memorie?
A Cause, and Will to doe? thoe art so sullen.
Dinant. And shall be, till I have a faire reparation.
Cleremont. I have more reason, for I scaped a fortune,
Which if I come so neare againe: I say nothing, 10
But if I sweat not in another fashion——
O, a delicate Wench.
Dinant. 'Tis certaine a most handsome one.

*6 such an houre] *stet* F1–2

392

Cleremont. And me thought the thing was angry with it self too,
 It lay so long conceald, but I must part with you,
 I have a scene of mirth, to drive this from my heart,
 And my houre is come.
Dinant. Misse not your time.
Cleremont. I dare not.
 Exeunt severally.

 Enter Sampson, *and a* Gentleman. [IV.ii]

Gentleman. I presume, sir, you now need no instruction,
 But fairely know, what belongs to a Gentleman;
 You beare your Uncles cause.
Sampson. Doe not disturbe me,
 I understand my cause, and the right carriage.
Gentleman. Be not too bloody.
Sampson. As I find my enemy;
 If his sword bite, if it bite, sir, you must pardon me.
Gentleman. No doubt he is valiant, he durst not undertake else.
Sampson. Hee's most welcome, as he is most valiant,
 He were no man for me else.
Gentleman. But say he should relent.
Sampson. Hee dies relenting, 10
 I cannot helpe it, he must die relenting,
 If he pray, praying, *ipso facto*, praying——
 Your honourable way, admits no prayer,
 And if he fight, he falls, there's his *quietus*.
Gentleman. Y'are nobly punctuall, let's retire and meet 'em,
 But still, I say, have mercy.
Sampson. I say, honour.
 Exeunt.

 Enter Champernell, Lamira, Anabell, Beaupre, [IV.iii]
 Verdoone, Charlote, *and a* Servant.

Lamira. Will not you goe sweet-heart?
Champernell. Goe? I'le fly with thee,
 I stay behind?
Lamira. My Father will be there too,

And all our best friends.

Beaupre. And if we be not merry,
We have harde lucke, Lady.

Verdoone. Faith let's have a kind of play.

Champernell. What shall it be?

Verdoone. The story of *Dinant.*

Lamira. With the merry conceits of *Cleremont,*
His fitts and Fevers.

Anabell. But I'le lie still no more.

Lamira. That, as you make the Play, 'twill be rare sport,
And how 'twill vex my gallants, when they heare it?
Have you given order for the Coach?

Charlote. Yes, Madam. 10

Champernell. My easie Nag, and padd?

Servant. 'Tis making ready.

Champernell. Where are your horses?

Beaupre. Ready at an houre, sir:
We'll not be last.

Champernell. Fy, what a night shall we have?
A roaring, merry night.

Lamira. We'll fly at all, sir.

Champernell. I'le fly at thee too, finely, and so ruffle thee,
I'le try your Art, upon a Country pallet.

Lamira. Brag not too much, for feare I should expect it,
Then if you faile——

Champernell. Thou saiest too true, we all talke,
But let's in, and prepare, and after dinner
Begin our mirthfull pilgrimage.

Lamira. He that's sad, 20
A crab-fac'd Mistris cleave to him for this yeare.

Exeunt.

Enter Cleremont, *and* La-writ. [IV.iv

La-writ. Since it cannot be the Judge——

Cleremont. 'Tis a great deale better.

La-writ. You are sure, he is his kinsman? a gentleman?

Cleremont. As arrant a gentleman, and a brave fellow, and so neare to
his blood——

La-writ.　　It shall suffice, I'le set him further off, I'le give a remove
　　shall quit his kindred, I'le lopp him.

Cleremont.　　Will ye kill him?

La-writ.　　And there were no more cosins in the world I'de kill him, I
　　do mean, sir, to kill all my Lords Kindred. For every Cause a　10
　　cousin.

Cleremont.　　How if he have no more cousins?

La-writ.　　The next a kin then, to his Lordships favour, the man he
　　smiles upon.

Cleremont.　　Why this is vengeance, horrid, and dire.

La-writ.　　I love a dire revenge:
　　Give me the man, that will all others kill,
　　And last himselfe.

Cleremont.　　You stole that resolution.

La-writ.　　I had it in a Play, but that's all one, I woo'd see it done.　20

Cleremont.　　Come, you must be more mercifull.

La-writ.　　To no Lords cosins in the world, I hate 'em; a Lords cosin
　　to me is a kind of Cocatrice, if I see him first, he dies.

Cleremont.　　A strange Antipathy, what think you of their Neeces?

La-writ.　　If I like 'em, they may live, and multiply; 'tis a cold
　　morning.

Cleremont.　　'Tis sharpe indeed; you have broke your fast?

La-writ.　　No verily.

Cleremont.　　Your valour, would have ask'd a good foundation.

La-writ.　　Hang him, I'le kill him fasting.

Enter Sampson *and the* Gentleman.

Cleremont.　　　　　　　　　　　　　Here they come,　30
　　Beare your selfe in your language, smooth and gently,
　　When your swords argue.

La-writ.　　　　　　　　　　　'Pray sir spare your precepts.

Gentleman.　　I have brought you sir——

La-writ.　　　　　　　　　　　'Tis very well, no words——
　　You are welcome, sir.

Sampson.　　　　　　　　I thanke you, sir, few words.

La-writ.　　I'le kill you for your Uncles sake.

9 I'de kill] I kil F1(|)–2　　*20 a Play] *stet* F1–2
24 *Cleremont.* A ... Antipathy, what] Seward; A ... Antipathy, | *Cler.* What F1–2

Sampson. I love you,
I'le cut your throat, for your owne sake.
La-writ. I esteeme of you.
Cleremont. Let's render 'em honest, and faire, gentleman,
Search my friend, I'le search yours.
Gentleman. That's quickly done.
Cleremont. You come with no spells, nor witchcrafts?
Sampson. I come fairely, to kill him honestly. 40
La-writ. Hang Spells, and Witchcrafts, I come to kill my Lords
Nephew like a gentleman, and so I kisse his hand.
Gentleman. This doublet is too stiffe.
La-writ. Off woo't, I hate it, and all such fortifications, feele my
skin, if that be stiffe, flea that off too.
Gentleman. 'Tis no soft one.
La-writ. Off woo't, I say: I'le fight with him, like a flead Catt.
 Put off.
Gentleman. You are well, you are well.
Cleremont. You must uncase too.
Sampson. Yes, sir. But tell me this, why should I mix mine honour 50
with a fellow, that has ne'r a lace in's shirt?
Gentleman. That's a maine point, my friend has two.
Cleremont. That's true, sir.
La-writ. Base and degenerate cousin, doest not thou know an old,
and tatter'd colours, to the enemy, is of more honour, and shewes
more ominous? This shirt, five times, victorious I have fought
under, and cut through squadrons, of your curious Cut-workes, as
I will doe through thine; shake, and be satisfied.
Cleremont. This is unanswerable.
Sampson. But may I fight, with a foule shirt? 60
Gentleman. Most certaine, so it be a fighting shirt, let it be ne'r so
foule, or lowsie, *Cæsar* wore such a one.
Sampson. Saint *Denis* then: I accept your shirt.
Cleremont. Not so forward, first you must talke, 'tis a maine point, of
the French method, talke civilly, and make your cause
Authentique.
Gentleman. No weapon must be neare you, nor no anger.
Cleremont. When you have done, then stir your resolutions, take to

37 gentleman] gentlemen F1–2

396

your Weapons bravely.

La-writ. 'Tis too cold; this for a Summer fight. 70

Cleremont. Not for a world, you should transgresse the rules.

Sampson. 'Tis peevish weather, I had rather fight without.

Gentleman. An 'twere in a river——

Cleremont. Where both stood up to th' chins——

La-writ. Then let's talke quickly, plague o' this circumstance.

Cleremont [*aside*]. Are the Horses come yet?

Gentleman [*aside*]. Yes certaine:——give your swords to us, now
 civilly.

Cleremont. We'll stand a while off;——take the things, and leave
 'em,

 You know when, and let the children play: 80
 This is a dainty time of yeare for puppies,
 Would the old Lord were here.

Gentleman. He would dy with laughter.

Cleremont. I am sorry I have no time, to see this game out,
 Away, away.

Gentleman. Here's like to be a hot fight,——
 Call when y'are fit. *Exeunt* Cleremont *and* Gentleman.

La-writ. Why look you sir, you seem to be a gentleman, and you
 come in honour of your Uncle, (boh, boh, 'tis very cold;) your
 Uncle has offer'd me some few affronts, past flesh and blood to
 beare: (boh, boh, wondrous cold.)

Sampson. My Lord mine Uncle, is an honourable man, and what he 90
 offers, (boh, boh, cold indeed,) having made choice of me, an
 unworthy kinsman, yet, take me with you: (boh, boh, pestlence
 cold,) not altogether——

La-writ. (Boh, boh,) I say altogether.

Sampson. You say you know not what then: (boh, boh,) sir.

La-writ. Sir me with your sword in your hand; you have a scurvy
 Uncle, you have a most scurvy cause, and you are (boh, boh)——

Sampson. (Boh, boh,) what?

La-writ. A shitten scurvy Cousin.

Sampson. Our Swords? our swords?——thou art a dog, and like a 100
 dog:——our swords?

La-writ. Our weapons gentlemen:——ha? where's your second?

75 plague] Weber; Pl——F1–2 *79–80 em, ... when,] *stet* F1–2

Sampson. Where's yours?

La-writ. So ho? our weapons?

Sampson. Wa, ha, ho, our weapons? our Doublets, and our weapons,——I am dead.

La-writ. Firsts? seconds? thirds?——a plague be woo' you gentlemen.

Sampson. Are these the rules of honour?——I am starv'd.

La-writ. They are gone, and we are here; what shall we do? 110

Sampson. O for a couple of faggots.

La-writ. Hang a couple of faggots; dar'st thou take a killing cold with me?

Sampson. I have it already.

La-writ. Rogues, theeves, (boh, boh,) run away with our Doublets? to fight at Buffets now, 'twere such a May-game.

Sampson. There were no honour in't, plague on't, 'tis scurvy.

La-writ. Or to revenge my wrongs at fisty-cuffes.

Sampson. My Lord, mine Uncles cause, depend on Boxes?

La-writ. Let's goe in quest, if ever we recover 'em—— 120

Sampson. I, come, our colds together, and our doublets.

La-writ. Give me thy hand; thou art a valiant gentleman. I say, if ever we recover 'em——

Sampson. Let's get into a house, and warme our hearts.

La-writ. There's ne'r a house within this mile, beat me, kick me, and beat me as I goe, and I'le beat thee too, to keepe us warme; if ever we recover 'em——kick hard, I am frozen: so, so, now I feele it.

Sampson. I am dull yet.

La-writ. I'le warme thee, I'le warme thee.——Gentlemen? rogues, theeves, theeves:——run now, I'le follow thee. 130

Exeunt.

Enter Vertaigne, Champernell, Beaupre, Verdoone, [IV.v]
Lamira, Annabell, Charlote, Nurse.

Vertaigne. Use legs, and have legs.

Champernell. You that have legs say so,
I put my one to too much stresse.

Verdoone. Your horse, sir,

107 plague] Weber; pl——F1–2 *117 plague] Weber; p——F1; pl——F2
130 run ∧ now,] Colman (now;); ~ , ~ ∧ F1–2
2 horse] F2; hrose F1(u); herse F1(c)

Will meet you within halfe a mile.

Lamira. I like
The walke so well, I should not misse my Coach,
Though it were further. *Annabell* thou art sad:
What ayles my Niece?

Beaupre. Shee's still devising, sister,
How quietly her late bed-fellow lay by her.

Nurse. Old as I am, he would have startled me,
Nor can you blame her.

Charlote. Had I ta'ne her place,
I know not, but I feare, I should ha' shreek'd, 10
Though he had never offer'd——

Anabell. Out upon thee,
Thou wouldst have taught him.

Charlote. I thinke, with your pardon,
That you wish now you had.

Anabell. I am glad, I yeild you
Such ample scope of mirth.

Vertaigne. Nay, be not angrie,
There's no ill meant: *Musicke within.*
 ha? Musique, and choice musique?

Champernell. 'Tis near us in the Grove, what courteous bounty
Bestowes it on us? my dancing daies are done;
Yet I would thanke the giver, did I know him.

Verdoone. 'Tis questionlesse, some one of your own Village,
That hearing of your purpos'd journey thither, 20
Prepares it for your entertainment, and
The honour of my Lady.

Lamira. I thinke rather,
Some of your Lordships Clyents.

Beaupre. What say you Cousin,
If they should prove your Suitors?

Verdoone. That's most likely.

Nurse. I say, if you are noble, be't who will,
Goe presently and thanke 'em: I can jump yet,
Or tread a measure.

Lamira. Like a Millers Mare.

Nurse. I warrant you, well enough to serve the Country,

*15 *Musicke within.*] *Cornet.* | *Musicke within.* after line 13 F1–2

I'le make one, and lead the way. *Exit.*
Charlote. Doe you note,
 How zealous the old Crone is?
Lamira. And you titter 30
 As eagerly as she:——come sweet, we'll follow,
 No ill can be intended.
Champernell. I ne'r fear'd yet.

 Exeunt.

 Song in the Wood [IV.vi
 [sung within].

 This way, this way, come and heare,
 You that hold, these pleasures deare,
 Fill your eares, with our sweet sound,
 Whilst we melt the frozen ground:

 This way come, make hast, ô faire,
 Let your cleare eyes gild the ayer;
 Come and blesse us, with your sight,
 This way, this way, seeke delight.

 Musicke ends. Enter a company of Gentlemen, *like Ruffians.*

1 Gentleman. They are ours, but draw them on a little further,
 From the foot-path into the neighbouring thicket, 10
 And we may do't, as safe, as in a Castle.
2 Gentleman. They follow still; the President *Vertaigne*
 Comes on a-pace, and *Champernell* limps after;
 The women, as if they had wings, and walk't
 Upon the ayre, fly to us.
1 Gentleman. They are welcome,
 We'll make 'em sport; make a stand here, all know
 How we are to proceed?
2 Gentleman. We are instructed.
1 Gentleman. One straine or two more. *Still Musick within.*

 Gentlemen [*move*] *off.*
 Enter Vertaigne, Champernell, Beaupre, Verdoone,
 Lamira, Anabell, Nurse, Charlote.

8.1 Musicke ends.] Mus. ends. after 'intended.' IV.v.32 F1–2 18 *Still*] *i.e.,* soft

 400

La-writ. I'll meet you at the Ordinary, sweet Gentlemen, and if there be a wench or two——

Gentleman. We'll have 'em.

La-writ. No handling any Duells before I come.

Gentleman. We'll have no going lesse.

La-writ. I hate a coward.

Gentleman. There shall be nothing done.

La-writ. Make all the quarrells you can devise before I come, and 50
let's all fight, there is no sport els.

Gentleman. We'll see what may be done, sir. [*Exit.*]

1 Client. Ha? Monsier *La-writ?*

La-writ. Baffled in way of businesse, my causes cast away, Judgement against us? why there it goes.

2 Client. What shall we do the whilst Sir?

La-writ. Breed new dissentions, goe hang your selves, 'tis all one to me; I have a new trade of living.

1 Client. Doe you heare what he saies Sir?

Sampson. The Gentleman, speakes finely. 60

La-writ. Will any of you fight? Fightings my occupation; if you find your selves agreev'd——

Sampson. A compleate Gentleman.

La-writ. Avant thou buckrom budget of petitions, thou spittle of lame causes;——I lament for thee, and till revenge be taken——

Sampson. 'Tis most excellent.

La-writ. There, every man chuse his paper, and his place. I'll answer ye all, I will neglect no mans busines but he shall have satisfaction like a Gentleman; the Judge may doe and not doe, hee's but a Monsieur. 70

Sampson. You have nothing of mine in your bag, Sir.

La-writ. I know not Sir, but you may put any thing in, any fighting thing.

Sampson. It is sufficient, you may heare hereafter.

La-writ. I rest your servant Sir.

Sampson. No more words Gentlemen, but follow me, no more words as you love me, the Gentlemans, a noble Gentleman. I shall doe what I can, and then——

*47 *Gentleman.* We'll ... lesse.] We'll ... lesse, F1; We'll ... else, F2
48 *La-writ.*] *omit* F1–2

Clients. We thanke you Sir.

Sampson. Not a word to disturb him, hee's a Gentleman. 80

Exeunt Sampson *and* Clients.

La-writ. No cause goe o my side? the judge cast all? and because I
was honourably employed in action, and not appear'd, pronounce?
'tis very well, 'tis well faith, 'tis well, Judge.

Enter Cleremont.

Cleremont. Who have we here? my little furious Lawyer?

La-writ. I say 'tis well, but marke the end.

Cleremont. How he is metamorphis'd? nothing of Lawyer left, not a
bit of buckrum, no solliciting face now, this is no simple
conversion:
Your servant Sir, and Friend.

La-writ. You come in time, Sir.

Cleremont. The happier man, to be at your command then. 90

La-writ. You may wonder to see me thus; but tha'ts all one, Time
shall declare; 'tis true I was a Lawyer, but I have mewd that coat, I
hate a Lawyer, I talk'd much in the Court, now I hate talking: I did
you the office of a man.

Cleremont. I must confesse it.

La-writ. And budg'd not, no I budg'd not.

Cleremont. No, ye did not.

La-writ. There's it then, one good turne requires another.

Cleremont. Most willing Sir, I am ready at your service.

La-writ [*gives him a paper*]. There read, and understand, and then 100
deliver it.

Cleremont. This is a challenge Sir.

La-writ. 'Tis very like Sir, I seldome now write Sonnets.

Cleremont [*aside*]. *O admirantis,*——
To Monsieur *Vertaigne* the president. [*Reads.*]

La-writ. I choose no foole sir.

Cleremont. Why hee's no sword man Sir.

La-writ. Let him learne, let him learne, Time that traines
Chickens up, will teach him quickly.

Cleremont. Why hee's a Judge, an old man. 110

La-writ. Never too old to be a Gentleman; and he that is a judge can

judge best what belongs to wounded honour; there are my griefes,
he has cast away my causes, in which he has bowed my reputation.
And therefore Judge, or no Judge——

Cleremont. Pray be rul'd Sir, this is the maddest thing——

La-writ. You will not carry it?

Cleremont. I doe not tell you so, but if you may be perswaded——

La-writ. You know how you us'd me, when I would not fight, doe
you remember Gentleman?

Cleremont. The Divells in him. 120

La-writ. I see it in your eyes, that you dare do it, you have a carrying
face, and you shall carry it.

Cleremont. The least is banishment.

La-writ. Be banish'd then; 'tis a friends part, wee'll meete in *Africa*,
or any corner of the earth.

Cleremont. Say he will not fight?

La-writ. I know then what to say, take you no care Sir.

Cleremont. Well, I will carry it, and deliver it, and to morrow
morning meete you in the Louver, till when, my service.

La-writ. A Judge, or no Judge? no Judge. *Exit* La-writ. 130

Cleremont. This is the prettiest Rogue, that 'ere I read of, none to
provoke tot'h field, but the old president? what face shall I put on? if
I come in earnest, I am sure to weare a paire of braceletts; this may
make some sport yet, I will deliver it; here comes the president.

Enter Vertaigne *with two* Gentlemen.

Vertaigne. I shall find time Gentlemen,
To doe your causes good,——is not that *Cleremont*?

1 Gentleman. 'Tis he my Lord?

Vertaigne. Why does he smile upon me?
Am I become ridiculous?——has your fortune Sir
Upon my son made you contemne his Father?
The glory of a Gentleman, is faire bearing. 140

Cleremont. Mistake me not my Lord, you shall not find that;
I come with no blowen spirit to abuse you,
I know your place, and honour due unto it,
The reverence to your silver age and vertue.

121 do] F2; *omit* F1 129 Louver] F2; louer F1

Vertaigne. Your face is merry still.

Cleremont. So is my businesse,
And I beseech your honour, mistake me not,
I have brought you from a wild, or rather mad man
As mad a peice——if you were wont to love mirth,
(In your young dayes, I have knowne your honour woo it,)
This may be made no little one, 'tis a challenge Sir,—— 150
Nay start not I beseech you, [*Gives him the paper.*]
 it meanes you no harme
Nor any man of honour, or understanding;
'Tis to steale from your serious houres a little laughter;
I am bold to bring it to your Lordship.

Vertaigne. 'Tis to me indeed.
Doe they take me for a sword man, at these yeares?

Cleremont. 'Tis onely worth your honours mirth, thats all Sir,
'Tad bin in me else a sawcie rudenesse.

Vertaigne. From one *La-Writ*, a very punctuall challenge.

Cleremont. But if your Lordship marke it, no great matter.

Vertaigne. I have knowne such a wrangling advocate, 160
Such a little figent thing; Oh I remember him,
A notable talking knave, now out upon him,
Has challeng'd me downe right, defied me mortally;
I doe remember too, I cast his causes.

Cleremont. Why there's the quarrell Sir, the mortall quarrell.

Vertaigne. Why what a knave is this? as y'are Gentleman
Is there no further purpose but meere mirth?
What a bold man of warre, he invites me roundly.

Cleremont. If there should be, I were no Gentleman.
Nor worthy of the honour of my kindred, 170
And though I am sure your Lordship hate my person,
Which time may bring againe into your favour,
Yet for my manners——

Vertaigne. I am satisfied,
You see Sir, I have out liv'd those daies of fighting,
And therefore cannot do him the honour to beate him my selfe;
But I have a kinsman, much of his abilitie,
His wit and carriage, for this calls him foole,

*148 peice——if] peice——of F1; piece of——F2 153 laughter] F2; laughters F1

Will wash away, there is no substance in it,
We that are expert in the game, and tough to,
Will hold you play.

1 Gentleman. This hen longs to be troden.

Enter Dinant *and* Cleremont.

Dinant. Lackey, my horse.
Cleremont. This way, I heard the cries
Of distress'd women.
2 Gentleman. Stand upon your guard. 70
Dinant. Who's here? my witty, scornfull Lady-plot,
In the hands of ruffians?
Cleremont. And my fine cold virgin,
That was insensible of man, and woman?
Dinant. Justice too,
Without a sword to guard it self?
Cleremont. And valour
With its hands bound?
Dinant. And the great Souldier dull?
Why this is strange.
Lamira. *Dinant* as thou art noble——
Anabell. As thou art valiant *Cleremont*——
Lamira. As ever
I appear'd lovely——
Anabell. As you ever hope,
For what I would give gladly——
Cleremont. Pretty conjurations.
Lamira. All injuries, a little laied behind you—— 80
Anabell. Shew your selves men, and help us.
Dinant. Though your many
And grosse abuses of me, should more move me
To triumph in your miseries then releive you,
Yet that hereafter, you may know that I,
The scorn'd and despis'd *Dinant*, know what does
Belong to honour, thus—— *Fight.*
Cleremont. I will say little,
Speake thou for me. [*Draw and fight.*]

85 scorn'd] F2; scorne F1 85 know] F2; knows F1

Champernell. 'Tis bravely fought.
Vertaigne. Brave tempers,
 To doe thus for their enemies.
Champernell. They are lost yet.
1 Gentleman. You that would rescue others, shall now feele
 What they were borne to.
2 Gentleman. Hurry them away. 90

 Exeunt. Manent Vertaigne, *and* Champernell.

Champernell. That I could follow them.
Vertaigne. I only can
 Lament my fortune, and desire of heaven
 A little life for my revenge.
Champernell. The provost,
 Shall fire the woods, but I will find e'm out,
 No cave, no rocke, nor hell shall keepe them from
 My searching vengeance.

 Enter La-writ *and* Sampson.

La-writ. O cold! o fearfull cold! plague of all seconds.
Sampson. O for a pint of burnt wine, or a sip of *aqua fortis.*
Champernell. The rogues have met with these two upon my life and
 robd 'em. 100
La-writ. As you are honourable Gentlemen, impart unto a couple of
 cold combatants———
Sampson. My Lord mine uncle, as I live?
La-writ. Pox take him; how that word, has warm'd my mouth?
Vertaigne. Why how now Cousen? Why, why and where man, have
 you bin? at a Poulters that you are cass'd thus like a rabbet? I could
 laugh now, and I shall laugh, for all I have lost my Children, laugh
 monstruously.
Champernell. What are they?
Vertaigne. Give me leave Sir, laugh more and more, never leave 110
 laughing.
Champernell. Why Sir?
Vertaigne. Why 'tis such a thing, I smell it Sir, I smell it, such a
 ridiculous thing,———

 105 why ∧] ~ ? F1-2

 404

La-writ. Do you laugh at me my Lord? I am very cold, but that
 should not be laught at.
Champernell. What art thou?
La-writ. What art thou?
Sampson. If he had his doublet and his sword by his side, as a
 Gentleman ought to have—— 120
Vertaigne. Peace Mounsier *Sampson.*
Champernell. Come hither little Gentleman.
La-writ. Base is the slave commanded: come to me.
Vertaigne. This is the little advocate.
Champernell. What advocate?
Vertaigne. The little advocate that sent me a challenge, I told you
 that my Nephew under tooke it, and what t'was like to prove: now
 you see the issue.
Champernell. Is this the little Lawyer?
La-writ. You have a sword Sir, and I have none, you have a doublet 130
 too, that keeps you warme, and makes you merry.
Sampson. If your Lordship knew the nature, and the noblenesse of
 the Gentleman, though he shew sleight here, and at what gusts of
 danger his manhood has arrived, but that mens fates are foolish, and
 often head long, over run their fortunes——
La-writ. That little Lawyer, would so pricke his eares up, and bite
 your honour by the nose——
Champernell. Say you so Sir?
La-writ. So niggle about your grave shins Lord *Vertaigne* too——
Sampson. No more sweet Gentleman, no more of that Sir. 140
La-writ. I will have more, I must have more.
Vertaigne. Out with it.
Sampson. Nay he is as brave a fellow——
Champernell. Have I caught you? *Strike him downe.*
Vertaigne. Doe not kill him, doe not kill him.
Champernell. No, no, no, I will not;——doe you peepe againe,
 downe downe proud heart.
Sampson. O valour, looke up brave friend, I have no meanes to
 rescue thee, my Kingdome for a sword.

*123 Base ... commanded] *stet* F1–2 134 but that] F2; *La-wr.* Bee't then. F1
136 *La-writ*] F2; *Sam* F1
146 *Champernell.* No ... not;——doe] F2; No ... not ∧ *Cham.* Doe F1

Champernell. I'll sword you presently, I'll claw your skin-coate too. 150
Vertaigne. Away good *Samson*, you goe to grasse els instantly.
Sampson. But doe not murder my brave friend.
Vertaigne. Not one word.
Champernell. If you doe sirra,——
Sampson. Must I goe off dishonour'd? adversity tries valour, so I
 leave thee. *Exit.*
Champernell. Are you a Lawyer Sir?
La-writ. I was, I was Sir.
Champernell. Nay never looke, your Lawyers pate is broken, and
 your litigious blood, about your eares sirra; why doe you fight and 160
 snarle?
La-writ. I was possest.
Champernell. Ile disposesse you. [*Beats him.*]
Vertaigne. Ha ha ha.
La-writ. *Et tu* Brute.
Vertaigne. Beate him no more.
Champernell. Alas Sir I must beate him, beate him into his businesse
 agen, he will be lost els.
Vertaigne. Then take your way.
Champernell. Ly still, and doe not struggle. 170
La-writ. I am patient, I never saw my blood before, it jades me,
 I have no more heart now then a goose.
Champernell. Why sirra, why do you leave your trade, your trade of
 living, and send your challenges like thunderbolts, to men of
 honour'd place?
La-writ. I understand Sir; I never understood, before your beating.
Champernell. Does this worke on you?
La-writ. Yes.
Champernell. Doe you thanke me for't?
La-writ. As well as a beaten man can. 180
Champernell. And doe you promise me, to fall close to your trade
 againe? leave brawling?
La-writ. If you will give me leave and life.
Champernell. And aske this noble man forgivenesse?
La-writ. Hartily.
Champernell. Rise then, and get you gone, and let me heare of you as
 of an Advocate new vampt; no more words, get you off quickly,

and make no murmurs, I shall pursue you else.

La-writ. I have done sweet Gentleman. *Exit.*

Vertaigne. But we forget our selves, our Friends and Children. 190

Champernell. Wee'l raise the country first, then take our fortunes.

 Exeunt.

 Enter One Gentleman *and* Lamira. [IV.vii]

1 Gentleman. Shall I entreate for what I may command?

Lamira. Thinke on my birth.

1 Gentleman. Here I am only Noble,

 A King, and thou in my dominions foole,

 A subject and a slave.

Lamira. Be not a Tyrant,

 A ravisher of honour, gentle Sir,

 And I will thinke ye such, and on my knees,

 As to my Soveraigne, pay a Subjects duty,

 With prayers and teares.

1 Gentleman. I like this humble carriage.

 I will walke by, but kneele you still and weepe too,

 It shewes well, while I meditate on the prey, 10

 Before I seize it.

Lamira. Is there no mercie, heaven?

 Enter Second Gentleman *and* Anabell.

2 Gentleman. Not kisse you? I will kisse and kisse againe.

Anabell. Savage villaine!

 My Innocence be my strength, I doe defie thee,

 Thus scorne and spit at thee; will you come on Sir?

 You are hot, there is a cooler. [*Draws a Knife.*]

2 Gentleman. A virago?

Anabell. No, lothsome Goate, more, more, I am that Goddesse,

 That here with whippes of steele, in hell hereafter,

 Scourge rape and theft.

2 Gentleman. I'll try your deity.

Anabell. My chastity, and this knife held by a Virgin, 20

 Against thy lust, thy sword and thee a Beast,

 Call on for the encounter. *Throwes her and takes her Knife.*

 189 Gentleman] Weber; Gentlemen F1–2

407

2 Gentleman. Now what thinke you?
 Are you a Goddesse?
Anabell. In me their power suffers,
 That should protect the Innocent.
1 Gentleman. I am all fire,
 And thou shalt quench it, and serve my pleasures,——
 Come partner in the spoile and the reward,
 Let us enjoy our purchase.
Lamira. O *Dinant!*
 O Heaven! o Husband!
Anabell. O my *Cleremont!*
1 Gentleman. Two are our slaves they call on, bring 'em forth
 As they are, chaind together, let them see 30
 And suffer in the object.
2 Gentleman. While we sit
 And without pitty heare 'em.

 Enter Dinant *and* Cleremont *bound,* [*guarded*] *by*
 the rest of the Gentlemen.

Cleremont. By my life,
 I suffer more for these then for my self.
Dinant. Be a man *Cleremont,* and looke upon 'em,
 As such that not alone abus'd our service,
 Fed us with hopes most bitter in digestion,
 But when love faild, to draw on further mischeif,
 The baites they laied for us were our owne honours,
 Which thus hath made us slaves to worse then slaves.
2 Gentleman. He dies. [*Offers to kill him.*]
1 Gentleman. Pray hold, give him a little respite. 40
Dinant [*to Lamira*]. I see you now beyond expression wretched,
 The wit you bragd of, foold, that boasted honour,
 As you beleev'd compass'd with walls of brasse,
 To guard it sure, Subject to be o're throwne
 With the least blast of lust.

25 shalt] F2; shall F1 30 are,] ~ ∧ F1–2
*32 *bound, by* . . . *Gentlemen.*] F2 *after* object. *line* 31; *bound. By . . . Gent.* F1(c) *after* object.; *By
 . . . Gent.* F1(u) *after line* 32 *33 these] Dyce *conj.*; thee F1–2
36 in digestion] F2; indigestion F1 39 to ∧] Dyce (Heath *conj.*); too, F1–2

Lamira. A most sad truth.
Dinant. That confidence which was not to be shaken,
In a perpetuall fever, and those favours,
Which with so strong, and Ceremonious duty
Your lover and a Gentleman long sought for,
Sought, sued, and kneeld in vaine for, must you yeild up 50
To a licentious villaine, that will hardly,
Allow you thanks for't.
Cleremont. Something I must say too,
And to you pretty one, though crying one;
To be hangd now, when these worshipful benchers please,
Though I know not their faces that condemne me,
A little startles me, but a man is nothing,
A Maydenhead is the thing, the thing all aime at;
Doe not you wish now, and wish from your heart too,
When, scarce sweet with my feares, I long lay by you,
(Those feares you and your good Aunt put upon me, 60
To make you sport) you had given a little hint,
A touch or so, to tell me I was mortall,
And by a mortall woman?
Anabell. Pray you no more.
Cleremont. If I had loos'd that virgin Zone, observe me,
I would have hired the best of all our Poets
To have sung so much and so well, in the honour
Of that nights joye, that *Ovids* afternoone,
Nor his *Corinna* should againe be mentioned.
Anabell. I doe repent, and wish I had.
Cleremont. That's comfort,
But now——
2 Gentleman. Another that will have it offer'd, 70
Compell it to be offer'd, shall enjoye it.
Cleremont. A rogue, a ruffian.
2 Gentleman. As you love your throat,——
1 Gentleman. Away with them.
Anabell. O *Cleremont*!
Lamira. O *Dinant*!
Dinant. I can but add your sorrowes to my sorrowes,

68 *Corinna*] F2; Corvina F1

409

Your feares to my feares.

Cleremont.　　　　　　To your wishes mine.
This slave may prove unable to performe,
Till I performe the taske that I was borne for.

Anabell.　Amen, amen.

1 Gentleman.　　　　Drag the slaves hence,——

[*Exeunt* Gentlemen *with* Dinant *and* Cleremont.]

　　　　　　　　　　　　　　　　for you
A while i'll locke you up here, study all wayes
You can to please me, or the deed being done,　　　　80
You are but dead.

2 Gentleman.　　　　This strong vault shall conteine you,
There thinke how many for your maydenhead
Have pin'd away, and be prepared to loose it
With penitence.

1 Gentleman.　　　No humane help can save you.

Ladyes.　Helpe, helpe?

2 Gentleman.　　　　You cry in vaine, rockes cannot heare you.
　　　　　　　　　　　　　　　　　　　[*Exeunt.*]

A Horrid noise of Musique within.　　　　　　　V.i
Enter one and opens the Chamber doore, in which Lamira
and Anabell *were shut, they in all feare* [*and exit*].

Lamira.　O Cousen how I shake, all this long night,
What frights and noises we have heard; still they encrease,
The villaines put on shapes to torture us,
And, to their Divells forme, such preparations
As if they were a hatching new dishonours,
And fatall ruine, past dull mans invention:
Goe not too far, and pray good Cousen *Anabell*,
Harke a new noise.　　　　　　　　*A strange Musick.*

Anabell.　　　　They are exquisite in mischeif.
I will goe on, this roome gives no protection,
More then the next,——what's that? how sad and hollow?　　10

*0.1 A . . . within.] *stet* F1–2　　*4 forme,] Seward; ~ ∧ F1–2
*8 *Musick.*] Dyce; *Musick.* | *Sackbut & Troup musick.* F1–2　　10 hollow?] ~ , F1–2

The sound comes to us. *Lowder.*
Lamira. Groning? or singing is it?
Anabell. The wind I think, murmuring amongst old rooms.
Lamira. Now it growes lowder, sure some sad presage
Of our fowle losse—— *Peepe.*
 looke now they peepe.
Anabell. Pox peepe 'em.
Lamira. O give them gentle language.
Anabell. Give 'em rats-bane.
 Peepe above.
Lamira. Now they are above.
Anabell. I would they were i'th Center.
Lamira. Thou art so foolish desperate.
Anabell. Since we must loose——
Lamira. Call 'em brave fellowes, Gentlemen.
Anabell. Call 'em rogues,
Rogues as they are, rude rogues, uncivill villaines.
Lamira. Look an thou woot, beware, dost thou feele the danger? 20
Anabell. Till the danger feele me, thus will I talke still,
And worse when that comes too; they cannot eate me:
This is a punishment, upon our owne prides,
Most justly laied; we must abuse brave Gentlemen,
Make 'em tame fooles, and hobby-horses, laugh and jeere at
Such men too, and so handsome and so Noble,
That howsoere we seem'd to carry it——
Woo'd 'twer to doe againe.
Lamira. I doe confesse cousen,
It was too harsh, too foolish.
Anabell. Doe you feele it?
Doe you find it now? take heed o'th punishment, 30
We might have had two gallant Gentlemen,
Proper, young, (o how it tortures me)
Two Divells now, two rascalls, two and twenty.
Lamira. O thinke not so.

11 us.] us. *Theeves peeping.* F1–2
14 losse—— *Peepe.* | looke] losse——peepe——, looke F1; loss——look F2
21 thus] F2; this F1

Anabell. Nay an we scape so modestly——
Lamira. May we be worthy any eyes, or knowledge,
 When we are used thus?
Anabell. Why not? why doe you cry?
 Are we not women still? what were we made for?
Lamira. But thus, thus basely——
Anabell. 'Tis against our wills,
 And if there come a thousand so,——
Lamira. Out on thee.
Anabell. You are a foole, what we cannot resist, 40
 Why should we greive and blush for? there be women,
 And they that beare the name of excellent women,
 Would give their whole estates, to meete this fortune.
Lamira. Harke, a new noise. *New sound within.*
Anabell. Let 'em goe on, I feare not,
 If wrangling, fighting and scratching cannot preserve me,
 Why so be it Cousen; if I be ordain'd
 To breed a race of rogues——
Lamira. They come.
Anabell. Be firme,
 They are wellcom.

Enter foure [Gentlemen] *over the stage with* Beaupre *and* Verdoone
 bound and halters about their necks.

Lamira. What mask of death is this? O my deare Brother?
Anabell. My cousen to; why now y'are glorious villaines. 50
Lamira. O shall we loose our honours?
Anabell. Let 'em goe,
 When death prepares the way, they are but Pageants;
 Why must these dye?
Beaupre. Lament your owne misfortunes,
 We perish happily before your ruines.
Anabell. Has mischeif ne'r a tongue?
1 Gentleman. Yes foolish woman,
 Our Captaines will is death.
Anabell. You dare not doe it;
 Tell thy base boisterous Captaine what I say,

50 cousen] cause F1(u); coose F1(c); Couz F2

412

Thy lawlesse Captaine that he dares not——
Doe you laugh you rogue? you pamperd rogue?

Lamira. Good Sir,
 (Good Cousen gently,) as y'are a Gentleman,—— 60
Anabell. A gentleman? a slave, a dog, the devills harbinger.
Lamira. Sir as you had a mother,——
Anabell. He a Mother?
 Shame not the name of mother, a she Beare,
 A bloody old woolfbitch, a woman Mother?
 Lookes that rude lumpe, as if he had a mother?
 Intreat him? hang him,——do thy worst, thou darst not,
 Thou dar'st not wrong their lives, thy Captaine dares not,
 They are persons of more price.
Verdoone. What ere we suffer
 Let not your angers wrong you.
Anabell. You cannot suffer.
 The men that doe this deed, must live i'th moone, 70
 Free from the gripe of Justice.
Lamira. Is it not better——
Anabell. Is it not better? let 'em goe on like rascalls
 And put false faces on; they dare not doe it;
 Flatter such scabbs of nature?
Gentleman. Woman, woman
 The next worke is with you.
Anabell. Unbind those Gentlemen,
 And put their fatall fortunes, on our neckes.
Lamira. As you have mercy doe.
Anabell. As you are monsters.
Lamira. Fright us no more with shipwrack of our honours,
 Nor if there be a guilt by us committed
 Let it endanger those.
Anabell. I say they dare not, 80
 There be a thousand gallouses, yee rogues,
 Tortures, ye bloody rogues, wheeles.
Gentleman. Away.
Lamira. Stay.
Anabell. Stay,

71–72 Is it ... Is it] F1(c)–2; It is ... It is F1(u) 81 gallouses] *i.e.*, gallows

Stay and i'll flatter too: good sweet fac'd Gentlemen,
You excellent in honesty;———o kinsmen!
O Noble kinsmen!
Gentleman. Away with 'em.
Anabell. Stay yet,

Exeunt Verdoone, Beaupre *and* Gentlemen.

The Devill and his lovely dam walke with you,———
Come fortify your self, if they doe dy,
(Which all their ruggednesse, cannot rack into me)
They cannot find an houre more Innocent,
Nor more friends to revenge 'em.

Enter Cleremont *disguis'd.*

Lamira. Now stand constant, 90
For now our tryalls come.
Cleremont. This beauties mine,
Your minute moves not yet.
Lamira. She sinkes?
Anabell. If Christian,
If any sparke of noble heate———
Cleremont [*apart to her*]. Rise Lady
And fearelesse rise, there's no dishonour meant you,
Doe you know my tongue?
Anabell. I have heard it.
Cleremont. Marke it better,
I am one that loves you, fairely, nobly loves you,
Looke on my face?
Anabell. O Sir?
Cleremont. No more words, softly,
Hearke, but hearke wisely now, understand well,
Suspect not, feare not.
Anabell. You have brought me comfort.
Cleremont. If you thinke me worthy of your Husband, 100
(I am no rogue, nor Begger,) if you dare doe thus——— [*Kisse.*]

85.1 Verdoone] F2 (Ver.); *Verta.* F1
*92–93 sinkes? | *Anabell.* If] Dyce (Heath *conj.*); sinkes if F1–2
98 now] Dyce (Heath *conj.*); how F1–2 *100 you] *stet* F1–2

Anabell. You are Mounsier *Cleremont?*
Cleremont. I am the same;
 If you dare venture, speake, if not I leave you,
 And leave you to the mercy of these villaines
 That will not wooe ye much.
Anabell. Save my reputation,
 And free me from these slaves.
Cleremont. By this kisse i'll doe it
 And from the least dishonour they dare aime at you,
 I have a priest too, shall be ready.
Anabell. You are forward.
Lamira. Is this my constant Cousen? how she whispers,
 Kisses and huggs the theif.
Anabell. You'll offer nothing? 110
Cleremont. Till all be tyed not as I am a Gentleman.
Anabell. Can you releive my Aunt too?
Cleremont. Not yet Mistris,
 But feare nothing, all shall be well, away quickly,
 It must be done i'th moment or——
Anabell. I am with yee.
Cleremont. I'll know now who sleepes by me,——keepe your
 standing. *Exeunt* Cleremont *and* Anabell.
Lamira. Well, go thy wayes, and thine own shame dwell with thee;
 Is this the constancy she shewed, the bravery?
 The deare love and the life, she owed her kinsmen?
 O brave, tongue-valiant, glorious woman?
 Is this the noble anger you arriv'd at? 120
 Are these the theeves you scornd, the rogues you rayld at?
 The scabs and scums of nature? o faire modesty,
 Excellent vertue, whither art thou fled?
 What hand of heaven is over us, when strong virgins
 Yeild to their feares, and to their feares their fortunes?
 Never beleef come neare me more, farewell wench,
 A long farewell from all that ever knew thee:
 My turne is next I am resolved,

*115 keepe your standing] *stet* F1–2
119 tongue-valiant,] Seward; tongue, valiant ˄ F1–2 *119 glorious] *stet* F1–2
*128 next ˄ ... resolved,] ~ , ... ~ ˄ F1; ~ , ... ~ , F2

Enter Dinant.

 it comes

But in a nobler shape——ha?

Dinant. Blesseyee Lady.

Lamira. Indeed Sir, I had need of many blessings, 130
 For all the houres I have had since I came here,
 Have bin so many curses. How got you liberty?
 For I presume you come to comfort me.

Dinant. To comfort you, and love you, 'tis most true,
 My bondage was as yours, as full of bitternesse
 And every hower my death.

Lamira. Heaven was your comfort.

Dinant. Till the last evening, sitting full of sadnesse,
 Wailing, sweet Mistris, your unhappy fortunes
 (Mine owne, I had the least care of,) round about me,
 The Captaine, and the company stood gaping, 140
 When I began the story of my love
 To you faire Saint, and with so full a sorrow,
 Followed each point, that even from those rude eyes,
 That never knew what pitty meant or mercy,
 Ther stole downe soft relentings, (take heed Mistris,
 And let not such unholy hearts out doe you,
 The soft plum'd god will see againe,) thus taken,
 As men transform'd with the strange tale I told
 They stood amaz'd, then bid me rise and live,
 Take liberty and meanes to see your person, 150
 And wisht me prosperous in your love; wish you so,
 (Be wise and loving Lady,) shew but you so.

Lamira. O Sir, are these fit houres, to talke of love in?
 Shall we make fooles of our afflictions?
 Can any thing sound sweetly in mine eares,
 Where all the noise of bloody horrour is?
 My Brother, and my Cousen, they are dead Sir,
 Dead, basely dead, is this an age to foole in?
 And I my self, I know not what I shall be,
 Yet I must thanke you, and if happily 160

156 is] F2; *omit* F1

416

You had asked me yesterday, when these were living,
And my feares lesse, I might have hearkned to you.
Dinant. Peace to your grief, I bind you to your word.

> *Enter* Cleremont, Anabell, Beaupre, Verdoone,
> Charlote, Nurse, *the two* Gentlemen.

Lamira. How? doe you conjure?
Dinant. Not to raise dreadfull apparitions, Madam,
But such as you would gladly see.
Lamira. My Brother,
And nephew living?
Beaupre. And both owe their lives,
To the favour of these Gentlemen.
Verdoone. Who deserve
Our service, and for us, your gracious thankes.
Lamira. Which I give freely, and become a suitour, 170
To be hereafter more familiar,
With such great worth and vertue. *Kisse.*
1 Gentleman. Ever thinke us,
Your servants Madam.
Cleremont. Why if thou wilt needs know
How we are freed, I will discover it,
And with laconick brevity, these Gentlemen
This night incountring with those out lawes that
Yesterday made us prisoners, and as we were
Attempted by 'em, they with greater courage,
(I am sure with better fortune) not alone,
Guarded themselves, but forc'd the bloody thieves, 180
Being got betweene them, and this hellish Cave,
For safety of their lives, to fly up higher
Into the woods, all left to their possession;
This sav'd your Brother, and your nephew from
The gibbet, this redeem'd me from my Chaines,
And gave my friend his liberty, this preserv'd
Your honour, ready to be lost.
Dinant [aside]. But that
I know this for a ly, and that the thieves

184 sav'd] F2; save F1

417

And gentlemen, are the same men, by my practise,
Suborn'd to this, he does deliver it 190
With such a constant brow, that I am doubtfull,
I should believe him too.
1 Gentleman. If we did well,
We are rewarded.
2 Gentleman. Thankes but takes away
From what was freely purpos'd.
Cleremont [*apart to them*]. Now by this hand,
You have so cunningly discharg'd your parts,
That while we live, rest confident you shall
Command *Dinant* and *Cleremont*; nor *Beaupre*,
Nor *Verdoone* sents it: for the Ladyes, they
Were easie to be gul'd.
1 Gentleman. 'Twas but a jest,
And yet the jest, may chance to breake our neckes 200
Should it be knowne.
Cleremont. Feare nothing.
Dinant. *Cleremont.*
Say, what successe?
Cleremont. As thou wouldst wish, 'tis done Lad,
The grove will witnesse with me, that this night,
I lay not like a blocke: but how speed you?
Dinant. I yet am in suspence, devise some meanes
To get these off, and speedily.
Cleremont. I have it,——
Come, we are dull, I thinke that the good fellowes,
Our predecessors in this place, were not
So foolish, and improvident husbands, but
'Twill yeild us meat, and wine.
1 Gentleman. Let's ransack it, 210
'Tis ours now, by the Law.
Cleremont. How say you sweet one,
Have you an appetite?
Anabell. To walke againe
I'th' Woods, if you thinke fit, rather then eate.
Cleremont. A little respite prithee; nay blush not,
You aske but whats your owne, and warrantable:

Monsiers *Beaupre*, *Verdoone*,
What thinke you of the motion?
Verdoone. Lead the way.
Beaupre. We follow willingly.
Cleremont. When you shall thinke fit,
 We will expect you. *Exeunt. Manent* Dinant *and* Lamira.
Dinant. Now be mistris of
 Your promise Lady.
Lamira. 'Twas to give you hearing. 220
Dinant. But that word hearing, did include a grant,
 And you must make it good.
Lamira. Must?
Dinant. Must, and shall,
 I will be fool'd no more, you had your tricks;
 Made properties, of me, and of my friend;
 Presum'd upon your power, and whip'd me with
 The rod of mine owne dotage: doe not flatter
 Your selfe, with hope, that any humane helpe
 Can free you; and for ayde by miracle,
 A base unthankfull woman is unworthy.
Lamira. You will not force me?
Dinant. Rather then enjoy you 230
 With your consent, because I will torment you,
 I'le make you feele the effects of abus'd love,
 And glory in your torture.
Lamira. Brother, Nephew,
 Helpe, helpe, for heavens sake.
Dinant. Teare your throat, cry lowder,
 Though every leafe, these trees beare, were an Eccho,
 And summond in your best friends to redeeme you,
 It should be fruitlesse: 'tis not that I love you,
 Or value those delights you prize so high,
 That I'le enjoy you, a French crowne will buy
 More sport, and a companion, to whom, 240
 You in your best trim, are an Ethiope.
Lamira. Forbeare me then.
Dinant. Not so, I'll do't in spite,

216 Monsiers] *Monsier*, F1–2 230 *Dinant. ...* enjoy] F2; *om. ...* enjury F1

And breake that stubborne disobedient will,
That hath so long held out, that boasted honour,
I will make equall with a common Whores;
The spring of Chastity, that fed your pride,
And grew into a River of vaine glory,
I will defile with mudd, the mudd of lust,
And make it lothsome even to goats.

Lamira. O heaven!
No pitty sir?

Dinant. You taught me to be cruell, 250
And dare you thinke of mercy? I'le tell thee foole,
Those that surpriz'd thee, were my instruments,
I can plot too, good Madam, you shall find it:
And in the stead of licking of my fingers,
Kneeling, and whining like a boy new breech'd,
To get a toy forsooth, not worth an apple,
Thus make my way, and with Authority,
Command what I would have.

Lamira. I am lost for ever: [*Kneeles.*]
Good sir, I doe confesse my fault, my grosse fault,
And yeild my selfe up, miserable guilty; 260
Thus kneeling, I confesse, you cannot study
Sufficient punishments, to load me with;
I am in your power, and I confesse againe,
You cannot be too cruell: if there be,
Besides the losse of my long guarded honour,
Any thing else to make the ballance even,
Pray put it in: all hopes, all helpes have left me;
I am girt round with sorrow, hell's about me,
And ravishment, the least that I can looke for,
Doe what you please.

Dinant. Indeed I will doe nothing, [*Raises her.*] 270
Nor touch, nor hurt you Lady, nor had ever
Such a lewd purpose.

Lamira. Can there be such goodnesse,
And in a man so injur'd?

Dinant. Be confirmed in't.
I seale it thus: [*Kisse.*]

420

I must confesse you vex'd me,
In fooling me so often, and those feares,
You threw upon me, call'd for a requitall,
Which now I have return'd, all unchast love
Dinant thus throwes away; live to man-kind,
As you have done to me, and I will honour
Your vertue, and no more thinke of your beauty. 280
Lamira. All I possesse, comes short of satisfaction.
Dinant. No complements: the terrours of this night
Imagine, but a fearfull dreame, and so
With ease forget it: for *Dinant*, that labour'd
To blast your honour, is a Champion for it,
And will protect and guard it.
Lamira. 'Tis as safe then,
As if a compleat Army undertooke it.

Exeunt.

Enter La-writ, Sampson, Clyents. [V.ii]

La-writ. Do not perswade me gentle Monsier *Sampson*,
I am a mortall man againe, a Lawyer,
My martiall part, I have put off.
Sampson. Sweet Monsier,
Let but our honours teach us———
La-writ. Monsier *Sampson*,
My honourable friend, my valiant friend,
Be but so beaten———forward my brave Clyents,
I am yours, and you are mine againe,———be but so thrasht,
Receive that Castigation with a cudgell———
Sampson. Which calls upon us for a Reparation.
La-writ. I have, it cost me halfe a crowne, I beare it 10
All over me, I beare it Monsier *Sampson*;
The oyles, and the old woman, that repaires to me,
To noint my beaten body.
Sampson. It concernes you,
You have bin swing'd.
La-writ. Let it concerne thee too;
Goe and be beaten, speake scurvy words, as I did,

3 martiall] F2; mortall F1

421

Speake to that Lion Lord, waken his anger,
And have a hundred Bastinado's, doe;
Three broken pates, thy teeth knockt out, doe *Sampson*,
Thy valiant armes and leggs beaten to Poultesses,
Doe silly *Sampson*, doe.

1 Clyent. You wrong the gentleman, 20
To put him out of his right minde thus:
You wrong us, and our Causes.

La-writ. Downe with him gentlemen,
Turne him, and beat him, if he breake our peace,———
Then when thou hast bin Lam'd, thy small guts perisht,
Then talke to me, before I scorne thy counsell,
Feele what I feele, and let my Lord repaire thee.

Sampson. And can the brave *La-writ*———

2 Clyent. Tempt him no further,
Be warn'd and say no more.

La-writ. If thou doest, *Sampson*,
Thou seest my Mirmidons, I'le let 'em loose,
That in a moment———

Sampson. I say nothing, sir, 30
But I could wish———

La-writ. They shall destroy thee wishing;
There's ne'r a man of these, but have lost ten Causes,
Dearer then ten mens lives; tempt, and thou diest:
Goe home, and smile upon my Lord, thine Uncle,
Take Money of the men thou meanest to Cozen,
Drinke Wine, and eat good meat, and live discreetly,
Talke little, 'tis an Antidote against a beating;
Keep thy hand from thy sword, and from thy Laundresse placket,
And thou wilt live long.

1 Clyent. Give eare, and be instructed.

La-writ. I find I am wiser then a Justice of Peace now, 40
Give me the wisdome that's beaten into a man,
That sticks still by him: art thou a new man?

Sampson. Yes, yes,
Thy learned precepts have inchanted me.

24 Lam'd] *i.e.*, lammed (Dyce); cf. *A King and No King* V.iii.14.
*25 me, before ∧] *stet* F1–2 *34 thine] F2; mine F1

La-writ. Goe my son *Sampson*, I have now begot thee,
 I'le send thee causes; speake to thy Lord, and live,
 And lay my share by, goe and live in peace,
 Put on new suites, and shew fit for thy place;
 That man neglects his living, is an Asse:
 Farewell; *Exit* Sampson.
 come chearly boyes, about our businesse,
 Now welcome tongue againe, hang Swords.
1 Clyent. Sweet Advocate. 50
 Exeunt.

 Enter Nurse *and* Charlote. [V.iii]

Nurse. I know not wench, they may call 'em what they will,
 Outlawes, or theeves, but I am sure, to me
 One was an honest man, he us'd me well,
 What I did, 'tis no matter, he complain'd not.
Charlote. I must confesse, there was one bold with me too,
 Some coy thing, would say rude, but 'tis no matter,
 I was to pay a Waiting womans ransome,
 And I have don't, and I would pay't againe,
 Were I taine to morrow.
Nurse. Alas, there was no hurt,
 If't be a sin, for such as live at hard meat, 10
 And keepe a long Lent in the woods, as they doe,
 To tast a little flesh——
Charlote. God help the Courtiers,
 That ly at racke and manger.
Nurse. I shall love
 A theefe the better for this while I live,
 They are men of a charitable vocation,
 And give where there is need, and with discretion,
 And put a good speed penny in my purse,
 That has bin empty twenty yeares.
Charlote. Peace Nurse,
 Fare well, and cry not rost meate, me thinkes *Cleremont.*
 And my Lady *Anabell* are in one night, 20
 Familliarly acquainted.

 *44 now] *stet* F1–2 *19 Fare well] Colman; Farewell F1–2

Nurse. I observe it,
If she has got a penny too———

 Enter Vertaigne, Champernell *and* Provost.

Charlote. No more,
My Lord Mounsier *Vertaigne*, the provost too,
Hast and acquaint my Lady. *Exeunt* Nurse *and* Charlote.
Provost. Wonderous strainge.
Vertaigne. 'Tis true Sir, on my credit.
Champernell. On mine honour.
Provost. I have bin provost-Marshall twenty yeares,
And have trussed up a thousand of these rascalls,
But so nere *Paris*, yet I never met with,
One of that Brotherhood.
Champernell. We to our cost have,
But will you search the wood?
Provost. It is beset, 30
They cannot scape us: Nothing makes me wonder,
So much as having you within their power
They let you goe; it was a Courtesy,
That French theeves use not often, I much pitty
The Gentle Ladyes, yet I know not how,
I rather hope then feare.

 Enter Dinant, Cleremont, Verdoone, Beaupre,
 Lamira, Anabell, Charlote, Nurse.

 Are these the prisoners?
Dinant. We were such.
Vertaigne. Kill me not, excesse of joy.
Champernell. I see thou livest, but hast thou had no fowle play?
Lamira. No on my soule, my usage hath bin noble,
Far from all violence.
Champernell. How were you freed? 40
But kisse me first, wee'll talk of that at leasure,
I am glad I have thee; Neice how you keepe off,
As you knew me not?
Anabell. Sir, I am where

 30 beset] F1(c)–F2; to be set F1(u)

 I owe most duty.

Cleremont. 'Tis indeed most true Sir,
 The man that should have bin your bed fellow,
 Your Lordships Bedfellow, that could not smell out
 A Virgin of sixteene, that was your foole,
 To make you merry, this poore simple fellow
 Has met the maid agen, and now she knowes,
 He is a man.

Champernell. How! is she dishonoured? 50

Cleremont. Not unlesse marriage be dishonourable,
 Heaven is a witnesse of our happy contract
 And the next Priest we meete shall warrant it
 To all the world: I lay with her in jeast,
 'Tis turn'd to earnest now.

Champernell. Is this true Neice?

Dinant. Her blushing silence grants it; nay Sir storme not,
 He is my friend, and I can make this good,
 His birth and fortunes equall hers, your Lordship
 Might have sought out a worse, we are all friends too,
 All differences end thus. Now Sir, unlesse 60
 You would raise new dissentions, make perfect
 What is so well begun.

Vertaigne. That were not manly.

Lamira. Let me perswade you.

Champernell. Well God give you joy,
 She shall not come a Begger to you Sir,
 For you Monsieur *Dinant* 'ere long i'll shew you,
 Another Neice, to this not much inferiour,
 As you shall like proceed.

Dinant. I thanke you Sir.

Champernell. Backe then to *Paris*, well that travell ends
 That makes of deadly enemies perfect friends.

 Exeunt omnes.

EPILOGUE.

Gentlemen,
I am sent forth to enquire what you decree
Of us and our Poets, they will be
This night exceeding merry, so will we
If you approve their labours. They professe
You are their patrons, and we say no lesse,
Resolve us then, for you can onely tell
Whither we have done id'ly or done well.

TEXTUAL NOTES

Persons Represented

Lamira, a lady, and Charlote, her waiting-woman, appear in *The Honest Man's Fortune* (1613); La-poop's name there possibly suggested La-writ's here. The remaining names seem to have no special significance. Anabell and Beaupre are common. Dinant, Cleremont, Champernell, Vertaigne and Verdoone derive from place names (Dinan, Clermont, Champ + Pernelle, Vertain, and Verdun). Cleremont also appears in *Philaster* and *The Noble Gentleman*, Verdon in *Rollo*.

Rather mysteriously, Massinger used the names Cleremont, Dinant, Limira and Beaupre for characters in *The Parliament of Love*, licensed on 3 November 1624 (Bentley, *Jacobean and Caroline Stage*, III, 358). They do not resemble their namesakes in *The Little French Lawyer*.

I.i

6 Why] Probably an interjection rather than an interrogative. Cf. line 68.

37 Patron to? 'tis] Seward, noting that *patron* may mean 'Pleader, or Advocate' (*O.E.D. sb.* 1.c), adds that the subject of the words following must be something like 'speech'. He suggests such an expression as 'How long | Have you been conning this Speech?' should follow 'to?' Weber and subsequent editors agree, although they believe there is merely 'an ellipsis of "speech" or "discourse"' (Dyce) rather than an omission. Brett cites 'burn't, give it' (line 38) as indicating that the idea of 'speech' is present in this line. Mason, citing I.i.120–1, recommends emending to 'parson' and Coleridge conjectures 'Patron to a new tune?' or 'Patron? 'Tis a new Tune' (*Marginalia*, p. 394). Colman, however, was on the right track when he suspected '*patron* to be a corruption of *pattern*'. It is a variant form, its meaning here being the 'design, plan' (*O.E.D.*, Pattern, *sb.* 2) of rectitude.

73 Words ... words.] Seward again thinks there has been an omission: 'After *Cleremont* has said this, which seems to assert that he would not mind being called a Coward, nor make that a Cause of Fighting, *Dinant* goes on as if he had said directly the contrary ...' The import of the absent line was 'Words are but Words, but *Coward* is a Name | I could not brook.' Later editors concur in Mason's rejection of this idea. Brett believes that F1's comma after 'Words' may mark 'a pause, or change of speech ... Perhaps a gesture made [Cleremont's] meaning evident ...' His tone did, more likely, as Coleridge recognizes: 'D. sees thro' C's gravity – & the *Actor* is to explain the "Words are but words – " is the last struggle of affected morality' (*Marginalia*, p. 395).

132.3 An ... Wedding.] Although Massinger may have planned that a song be sung as the wedding party enters and even provided a stage-direction calling for music (line 131), the lyric could have been a late addition to the text. No singer is

specified, and the title perhaps indicates where the verses were to be placed in the manuscript. The temporary absence of the lyric could explain why the prompter did not add instruments to the stage-direction as he did at III.iii.88 and elsewhere. See IV.vi.8.1 n.

244–245 quench'd ... anew] Seward notes that '*quenches*, here, must signify *to abate the Fire for a Moment*'.

293 Gentleman] Both Vertaigne's admonition (lines 290–2) – which is, in effect, 'you are being unmanly' – and Champernell's reply (lines 294–5) – which is, in effect, 'my tears are not unmanly' but then 'Oh that I am playing the woman' – suggest that Lamira addresses these words to Champernell rather than to Dinant and Cleremont. For Fletcher's similar use of 'Gentleman' as an appellative, see IV.iv.37.

I.ii

22 speake] Probably past tense. Cf. 'breake' for *brake* at I.i.212 (Brett).

I.iii

30–31 where ... eleventh] According to A. H. Bullen (in the Variorum), 'the particular reference is doubtless to the Bois de Vincennes', where Louis XI and Charles the Bold, then Count of Charolais, entered into the Treaty of Conflans. He refers to *The Memoirs of Philippe de Commynes*, I, xiv. Since the Bois de Vincennes is southeast of the centre of Paris, the locality would answer roughly to Dinant's place 'Nere to the vineyard eastward from the Citie' (I.ii.68).

II.i

61–62 Will ... heart?] Cf. Cleremont's 'Wilt thou breake my hearte?' at III.ii.199, also Fletcher's scene.

100–103 follow? *Cleremont.* As ... man. *La-writ.* I cannot fight. *Cleremont.* Away, away,—— *Exeunt* Beaupre, Verdone.] Two matters are at issue. First, Verdoone's 'you'll follow' (line 100) rather than a declaration must be a question or an adjuration in the form of a question; if so, 'As I am a true man', words not especially appropriate to La-writ, should be Cleremont's response. Secondly, as Seward first recognized, 'Away, away' is probably said by Cleremont to his antagonists, who are lingering to enjoy more of La-writ's eccentricities. Only Brett understands the words to be addressed by Cleremont to La-writ, 'scoffing at his hesitation', 'away' apparently equivalent to slang 'get away!' as an expression of disbelief.

II.ii

27 cold py] Brett notes that La-Writ 'pretends to misunderstand *help* [as 'serve'] and helps him to "cold pie."' Citing Cotgrave, the *O.E.D.* (Cold, *a*.19) defines

'cold pie' as 'the application of cold water to wake a person' (or, in this case, cold steel). Here, however, there may be a special application to swordplay since Cotgrave (*A Dictionarie of the French and English Tongues*, 1611) glosses *Porter vne chemise blanche à* as 'To giue a mornings camisado, or a cold pie for breakfast, vnto', and a *camisado* is a night attack.

II.iii

19–22 *He . . . two*.] As *R*. (Issac Reed) notes in Colman's edition, these are lines of a popular ballad. The third occurs later in the piece than the first two. In Deloney's *The Garland of Good Will* (1631) the ballad is entitled 'The Noble Acts of *Arthur* of the round Table. To the Tune of, Flying Fame [i.e., *Chevy Chase*]'; except for 'when *Tarquin*' rather than '*And* Tarquin' and 'And he stroke' rather than '*And then he strooke*', Deloney's words correspond with La-writ's (*The Works of Thomas Deloney*, ed. F. O. Mann (Oxford, 1912), pp. 324, 326). La-writ's later '*And I defy thee, do thy worst*' (line 63) exactly corresponds with the ballad (p. 325). In Percy's *Reliques of Ancient English Poetry* the ballad is called 'Sir Lancelot du Lake'; there the second and third lines are 'And Tarquin soon he spyed' and 'Forthwith he strucke', and the equivalent of line 63 is 'And I desire thee do thy worst' (ed. H. B. Wheatley (London, 1927), I, 206, 208–9). In both Deloney's and Percy's versions the phrase '*quoth* Lancelot *tho*' (II.iii.63) occurs several times, but it is his enemy Tarquin who exclaims – 'Ha, ha' in Deloney (p. 325), 'Ho, ho' in Percy (p. 208). William Chappell (*The Ballad Literature and Popular Music of the Olden Time* (London, 1859), I, 199) points out that Falstaff sings a bit of the same ballad in *2 Henry IV* (TLN 1062–3) as does Malevole in *The Malcontent* II.iii.9 (ed. G. K. Hunter).

21 mister] Seward paraphrases F1's 'What master thing is this?' as 'What Master-piece of Oddity have we here?', not an impossible interpretation; the *O.E.D.* lists several attributive uses of 'master' that lend support (e.g., 24.e: 'supremely or consummately skilled . . . wicked . . . accomplished'). He recognizes, however, that the better reading is the word derived from Old French *mestier*, which in expressions like 'what mister man' came to mean 'what kind of man' (*O.E.D., sb*.[1] 5, citing this line, emended). He evidently did not know of F2's 'Mister', as he credits Sympson with the emendation.

27 *Was . . . sake?*] Weber first pointed out that these words are from the beginning of 'The Legend of Sir Guy' ('Was ever knight . . .', Percy's *Reliques*, III, 109 and Francis James Child, *English and Scottish Ballads* (Boston, 1864), I, 63). Old Meri-thought sings 'Was never man . . .' in *The Knight of the Burning Pestle*, II, 505 ff. For further information about the ballad, see Claude M. Simpson, *The British Broadside Ballad and its Music* (New Brunswick: Rutgers University Press, 1966), pp. 283–5.

49 make all things] F2's alteration, as Dyce recognized, brings La-writ closer to quoting *A Midsummer Night's Dream*: 'But wonder on, till truthe make all things plaine' (Q1; TLN 1927). Whether the F2 editor also intended 'time' to be replaced with 'truth' is uncertain, just as it is uncertain whether F1's version did not result

from Fletcher's approximate recollection of Shakespeare's line. 'Make' for F1 'makes' is questionable because with the shorter word F2's line just gets in the measure; compare F2's 'swing' for 'swinge' at II.iii.113, a change almost certainly made to shorten the line.

63 ó . . . tho.] See note on II.iii.19–22.

98 thy] Cleremont seems to mean that the idea of Dinant's desertion has driven him mad; the disgrace has eaten into his judgement like a cancer or spreading sore. It may be, as F1 has it, that he will never be well again as long as he lives, but, since the subject of the speech is Dinant's inexcusable fault, Cleremont probably should say that he will never recover no matter what restitution Dinant makes.

103–105 Expose . . . me.] Mason (p. 146) argues that '*disgrace* is not the nominative case to the verb invite, but refers to the words tug and hale thro'. Cleremont is recapitulating the injuries he had received from Dinant; not describing the consequences of them'. He punctuates:

> Expose me like a jade, to tug and hale thro'
> (Laugh'd at, and almost hooted) your disgraces!
> Invite men's swords and daggers to dispatch me!

There is no reason why the consequences cannot be described, however, and the F1–2 punctuation indicates they are.

110 stand . . . bottome] Cleremont alludes to a proverb: 'Every tub must stand on its own bottom' (Tilley T596).

140 hunny] F2's 'Hunt away' tries to rationalize the unusual word, but *O.E.D.* recognizes 'honey' as a verb, here meaning 'to make sweet' (*v.*¹). In the sense of 'delight', the verb occurs in *The Spanish Curate*, IV.ii.7: 'I am honyed with the project' (*O.E.D.*, *v.*3).

153 wrack] Although he does not adopt the emendation, Seward cites lines 165–7 in support of it.

III.i

14 or] Seward, noting 'The Disjunctive *or* is surely improper here; for *forcing Life out backward* is . . . *drowning*', emended to 'and'. Mason comments: 'To force thy life out backward is [a] description . . . of hanging. Champernal ludicrously supposes, that the pressure of the rope must prevent life from issuing forwards, and of course force it backwards; and means to say, in other words – Could you find no tree to hang yourself on, nor any river to drown you?" In *The Lovers' Progress* the idea may be connected with sodomy: 'I shall, like an Italian, die backward, And breathe my last the wrong way' (ed. Dyce, I.i). For backward Italians dying, see Cyrus Hoy, *Introductions, Notes, and Commentaries to texts in 'The Dramatic Works of Thomas Dekker'* (Cambridge, 1980), II, 37 ff. and James T. Henke, *Courtesans and Cuckolds* (New York, 1979), p. 11.

29 Innocence] See III.i.62.

63–64 shun'd . . . these?] Because the pronoun refers to Beaupre and Verdoone, the clause should not be declarative. F2's solution ('shun'd not') makes the line

430

hypermetrical. Emending 'or' to 'nor', Dyce notes, 'In the first branch of a negative proposition our old writers frequently omit "neither"'; he cites IV.vii.67–8 as an example. It seems simpler, however, to regard the expression as a rhetorical question or exclamation, as Weber did. Brett follows F1 (substituting a full stop for the colon), but he does not comment on the meaning. 'Feare, or doubt', incidentally, seems to be redundant for emphasis, as 'doubt' probably means 'apprehension, dread, fear' (*O.E.D.*, *sb.*[1] 3).

III.ii

32 loth ... fight] I.e., sorry to have to learn to fight now (Mason).

40.1 Gentleman ... *dore*] The Gentleman appears at the door instead of fully entering to suggest that he is one of several. Cf. 'Gentlemen', line 43.

47 *Gentleman*. We'll ... lesse.] Regarding the assignment of this speech, the words are inappropriate if spoken by La-writ whether F1's 'lesse' or F2's 'else' is right as the last word. The 'We'll' indicates that the line belongs to the Gentleman because he uses the plural pronoun, whereas La-writ uses the singular.

 Regarding the variant, Colman restored 'less' because 'it is the best sense, and much more characteristick. *To go less* too, is a phrase often used by our Authors.' Weber adds that the 'phrase is still used in gambling'. The *O.E.D.* records only one sense, 'to offer or accept a lower price or less onerous conditions, take less extreme measures, etc.' (Go, *v.* 35.b), but it recognizes *to go better*, 'in certain card games, to offer a higher stake than is named in the adversary's challenge' (36); so *to go less* may be a gambling term, 35.b in a particular context. Dyce defines it as 'play for a smaller stake' (7:147). Colman is right that 'to go less' occurs frequently in the Beaumont and Fletcher plays, usually generally (*Custom of the Country*, I.i, Dyce ed. 4:395; *Four Plays in One*, 'Honour', Dyce ed. 2:486; *Honest Man's Fortune*, V.iii, Dyce ed. 3:441; *Mad Lover*, V.iv.153; and *Woman's Prize*, II.vi.97) but once in an obvious gambling metaphor – 'My rest is up, Nor will I go less' (*Elder Brother*, V.i, Dyce ed. 10:282). In Massinger the phrase occurs in its general sense in *Bashful Lover*, IV.i.89 (cited by Weber) and *City Madam*, III.ii.198; Edwards and Gibson gloss it 'accept a lower offer'. In the present case, then, though F2 yields clearer sense ('We won't go otherwise') and may correct a misreading or transposition, F1 is probably satisfactory ('We won't accept any less stringent conditions than your presence').

148 peice——if] The dash may represent either a break in the dialogue or some illegible words. The change of F1's 'of' following the dash to 'if' does not create very logical syntax, but it is closer to the F1 reading than F2's rationalization.

III.iii

53.1 *Exeunt. Manet* Champernell.] Colman seems right to recognize that Champernell would not enter at line 52 and leave almost immediately without saying or doing anything. Dyce, interpreting the entrance as a prompter's warning of Champernell's true entrance, which he places after the Nurse and Charlote pass over the stage, omits it and begins a new scene (another room in the house) after

Exeunt. F1's direction, *Enter Champ. privately*, is not in the form usually taken by anticipatory directions, however, and it is improbable that the warning rather than the operative direction should be printed. The present location is a chamber (line 67) where one may sit down (line 96) or even lie down (lines 107, 113, 117), but it is another to which the Nurse and Charlote carry the pillows and things, to which Dinant urges Lamira to retire (line 70), and in which III.iv takes place.

76 now] The F1 line in which this word appears reads 'A little now, now; Will you goe in againe¿'; it is hypermetrical, and, in contrast with line 99 where 'now, now' seems to be right, the repetition makes little sense. Editors through Seward punctuate the line as F1 does; Colman and later editors read substantially 'engag'd. A little; now, now!', but none explains. As the line is emended here, Dinant says with pained understatement, 'Be quiet, for heaven's sake; you know my friend's rather involved just now'.

78 lowd? pretious,] F2, which punctuates 'loud, Pretious?', turns 'pretious' into a term of endearment, whereas the word is actually an asseveration, as Weber recognized (*O.E.D.*, *a.* 2.b). Cf. 'heart?', line 115.

98 pox ∧] F1's comma could make the phrase an exclamation, but it probably is not. Although the *O.E.D.* does not list the term, 'hog's pox' is presumably the same as 'swine's pox', chicken pox, the basis of a curse in *The Renegado*: 'The swine's Pox ouertake you' (I.iii.164, ed. Edwards and Gibson). Cf. lines 101 and 106.

118 *Musick done.*] In F1 this direction follows Champernell's aside (lines 118–25), during which the music ought to continue. Although Champernell's 'nearer' (line 118) picks up Lamira's 'neare', Lamira's line links better with Cleremont's 'Peace, good Madam' (line 125) than those words do with Champernell's half of that line. Champernell's aside may be a second thought, the insertion of which dislocated the stage-direction. Cf. IV.vi.8.1 n.

131 off,] 'Quarter', line 130, is *O.E.D.*, *sb.* 14.c, 'A part of a[n] ... army, camp'; 'when' is the relative meaning 'on the occasion that' (6); 'lie' may carry some of its military sense 'to be encamped' (*v.*¹, 5.b); 'keep' is *v.* 14 'guard, defend'; 'courses' means 'conduct ... of a reprehensible kind' (*sb.* 21.b). Strong punctuation after 'off' is not needed, though editors retain it because, following Seward, they interpret 'courses' as 'dead bodies' and, beginning with Colman, mark a suspension after that word.

III.iv

4 and fool ... thee.] F1's superfluous 'man' may be another proof-correction gone wrong, the word being a mistake for the 'and' that should have replaced 'a'. The compositor worked hard to accommodate it in the type line; he moved the line slightly to the left of the normal indentation, spelled 'fals', introduced an ampersand, and removed several spaces. Although a corrected version of this line has not been found, F2 may have been set from one.

23 vild] Because of 'low' and 'infamies' (line 24), Weber's 'vild' seems certain. At line 30, however, 'wild' seems right.

63 What ... you?]　F1–2 assign 'What a vengeance ayle you?' (line 62) to
Cleremont and 'What ... selfe.' (lines 63–5) to Dinant, although F1 punctuates
'What dismall noise, is there, no honour in you?' and F2 'What dismall noise! is
there no honour in you?', 'What dismall noise!' evidently being Dinant's
exclamation upon Cleremont's response to his calling him. Regarding this obvious
difficulty Seward remarks, 'Either [*Din.* What dismall noise! is there ... you?] is a
Continuation of Cleremont's Speech, or some marginal Direction, as *Noises within,*
is left out; the latter seems most probable to me, the former to Mr. *Sympson.*'
Colman and Weber side with Seward, Colman supplying at line 62 the supposedly
omitted direction. Dyce, however, preferring Sympson's solution, quotes Heath's
'the line ... belongs to Cleremont, affrighted at the loudness of his friend's calling
upon him.' For a similar misassignment, see IV.iv.24. As for the punctuation,
however, it seems better that Cleremont exclaim, 'What disastrous [*O.E.D.,*
Dismal, *adj.* 3] noise! Don't you remember your obligation to keep me safe?'
76.1 Verdoone.]　Because F1 includes Lamira, who is on stage, in this direction and
provides no dialogue to cover the descent to the platform of the characters who
were above, some lines may have been omitted or the authors may not have worked
out the action completely.
112 be a Mistris]　Changing 'be' to 'have', Seward notes, '*Lamira*'s Answer plainly
shews that *Dinant* call'd himself, not her, a Monster; *i.e.* a monstrous Fool....' On
the same understanding, Sympson conjectured 'be a Mistress's', a reading in which
Brett concurs by suggesting that F1's 'Mistris' be understood as a possessive.
Actually Dinant refers to the arbitrary and capricious power a mistress has over her
lover, the power Lamira has just used to humiliate him. Lamira's reply means that
virtue will transform Dinant to a master from a servant in the amorous sense, as at
I.iii.10, III.iii.72 and 75, and III.iv.17. J.N. (John Nichols?) in Colman's edition
interprets the passage in approximately this sense, but adds that it 'may be classed
among the doubtful ones'.

IV.i

6 such an houre]　Dinant could mean 'It is unthinkable that you should fail to keep
such an appointment', but the expression may be a compositional fossil, similar to
Shakespeare's 'so many Talents' (*Timon of Athens,* TLN 992, 1002, and 1016).
Such an exact time as 'two o'clock' would fit the metre perfectly.

IV.iv

20 a Play]　The play is the anonymous *Tragedy of Nero,* in which Nero says, 'What
may I easily doe? kill thee, or him, | How may I rid you all? where is the Man | That
will all others end, and last himselfe?' (III.ii.84–6; ed. Elliott M. Hill). The identifica-
tion was made by G. B. Evans, *Modern Language Notes,* LII (1937), 406–7.
79–80 em, ... when,]　Editors from Seward through to Dyce punctuate with
dashes, possibly indicating that these words are addressed to the duellists (i.e., you
know when to call us). They seem better said to the Gentleman, however (i.e. you
know when to leave them – when they're not looking).

117 plague] Because F1 reads 'p———' rather than the usual 'pl———', Dyce emends to 'pox'. In F1, however, the type line is full.

IV.v

15 *Musicke within.*] F1 prints both Massinger's direction and the prompter's specification of the instrument, which is probably the cornett rather than the brass cornet. According to F. W. Sternfield, wind instruments such as the cornett 'were associated with entertainment, particularly with outdoor entertainment' (*Music in Shakespearean Tragedy* (London, 1963), p. 226), and authorities quoted by J. S. Manifold say of the cornett that its tone is 'incredibly pure, clear, and silvery' and that 'no other instrument can sound so like the human voice' (*The Music in English Drama* (London, 1956), p. 47).

IV.vi

8.1 *Musicke ends.*] Whether this stage-direction belongs in the text is debatable. Apparently Massinger first concluded IV.v with F1's *Mus. ends. Exeunt.* and began IV.vi with the entry of the disguised gentlemen. The song, with no indication of its singer and with a title perhaps to show where it belonged in the manuscript, was added later, but the stage-direction was not changed. See I.i.132.3 n. The music should continue to accompany the song, and, to entice the travellers, it could continue still as the gentlemen speak (lines 9–18), diminishing at line 18. 'One straine or two more' (line 18) sounds like a command, however, to which the stage-direction *Still Musick within.* is the response. It thus seems better to stop the music and then to resume it, as Massinger seems originally to have planned.

22 *Lamira. Begin.* | *1 Gentleman. And*] F1's assignment of 'Begin ... word———' entirely to Lamira is wrong because of The Second Gentleman's response. F2's solution is to omit the *Lamira* speech-prefix, thereby continuing 'Begin ... word———' to the First Gentleman, a possibility if 'Begin' may mean 'let them begin'. The F2 reading does not account for F1's *Lam.* speech-prefix, however.

23 *1 Gentleman. Now*] In F1 the stage-direction *Dance.* follows the last line of dialogue in the first column of K2v and *Now.* as a stage-direction follows the first line in the second. Colman first recognized that the word is dialogue, but he gave it to the Second Gentleman.

29–30 Nag, My legs on ... horse] F1 misreads 'on my good horse' (Weber's emendation) as 'in my good house' and at the end of line 29 erroneously adds 'my legs', evidently anticipating the words in line 30, or anticipating 'legs' at least. F2, creating a metrically deficient line 30, makes what sense it can of the unintelligible F1 passage; it does not supply the words for which 'legs' was substituted in line 29. Cyrus Hoy privately suggests 'Nag', reasoning that 'legs' in line 30 glances back to IV.v.1–2 and 'Nag' to the pad-nag (*O.E.D.*, Pad, *sb.*[2] 4: 'an easy-paced horse') of IV.iii.11.

44 yet if] F2's alteration does not cure the hypermetrical F1 line. F1's 'are,' is superfluous, perhaps an unobserved deletion.

65 their tender grissells] The pronoun refers to Vertaigne and Champernell rather than to the ladies. 'Gristle' means 'a delicate or tender person' (*O.E.D.*, *sb.* 3, citing *The Bondman*, I.iii.388).

123 Base . . . commanded] 'A parody on Pistol's exclamation, "*Base is the slave* that pays!"' *Henry V* 596 (Dyce). The universally familar lines from *Richard III* and *Julius Caesar* are parodied at IV.vi.149 and 165.

IV.vii

32 *bound, by* . . . Gentlemen.] F1(u), which puts *by* . . . *Gent.* after line 33 as though it were a separate direction, may represent a marginal addition to the entrance either by the prompter or by Massinger, who recognized that his initial statement was incomplete.

33 these] Dyce notes that F1's 'thee' would, of course, mean Anabell, but he suggests 'these' because of "em' in line 34.

V.i

0.1 A . . . within.] Evidently in the secretary hand, these words may be an addition to the manuscript, but they are not a prompter's note. Rather than 'Horrid . . . Musique', the prompter probably would have specified instruments, as he did at line 8. Fletcher probably wrote them; cf. '*Enter sixe disguis'd singing and dancing to a horrid Musick*', *The Queen of Corinth*, II.i.50.

4 forme,] Under the impression that he was restoring F's punctuation, Colman put the comma after 'devils' rather than 'form'. He understood 'to their devils' as 'besides their devils', 'like which they were disguised'. Later editors return to Seward's 'Devil's Form'. Weber paraphrases, 'The villains put on devil's forms to frighten us, and in addition to those devil's forms, put on (*i.e.* make ready) such preparations, &c.' Brett makes 'Divells' possessive plural.

8 *Musick.*] What Anabell and Lamira hear is 'sad and hollow' (line 10); it may be groaning, singing, or the wind (lines 11–12). *Sackbut and Troup musick* is the prompter's specification of the instruments he thought appropriate for this sound. Defining *troop* as 'a signal on the drum for troops to assemble in readiness for marching', *O.E.D.* (*sb.* 4) cites from 1689 Randle Holme's *Academy of Armoury* (ed. I. H. Jeayes, Roxeburgh Club, III.xix): 'The drumer is to beat all maner of beats, as a Call, a Troope, a March' Francis Grose remarks, 'At this beat the troops fall in, the roll is called, and the baggage loaded' (*Military Antiquities Respecting a History of the English Army* (London, 1812), II, 47). Andrew Sabol kindly points out that the prompter's 'musick' might mean 'consort'; if it does, his call could be for a group of one or more instrumentalists and one or more drummers, an ensemble to make an ominous music whether military or not.

 It is odd, however, that if 'sackbut' is named another instrument – 'drum' – should not be paired with it rather than a specific beat. 'Troup', then, may be an error, possibly for 'Trump'. Brass trumpets were usually employed ceremonially or to signal (e.g., '*Enter Talbot with Trumpe and Drumme, 1 Henry VI* TLN 1948) or

to produce a wild noise (e.g., '*Trumpets, Hoboyes, Drums beate, altogether*', followed by 'The Trumpets, Sack-buts, Psalteries, and Fifes, Tabors, and Symboles, and the showting Romans Make the Sunne dance', *Coriolanus* TLN 3621–4). These sounds would be inappropriate here. 'Trump', however, also means 'jew's harp' (*O.E.D.*, *sb.*[1] b), which, as Andrew Gurr writes (privately), 'would make a much more likely noise than a drum or trumpet'. In fact, Francis W. Galpin (*Old English Instruments of Music*, 4th ed., rev. Thurston Dart (New York, 1965), p. 196) mentions that in the sixteenth century a Scottish sorcerer used a jew's harp to provide music for a nocturnal dance of witches. Thus the jew's trump, or several of them, might have combined with sackbuts to produce this sad and hollow groaning.

92–93 sinkes? | *Anabell.* If] Dyce quotes Heath: 'It is evident from the reply of Cleremont that ['If Christian . . . heate———'] belong to Annabell, who is kneeling and supplicating'.

100 you] Reading 'you dare', Seward notes, 'The Word *dare* being repeated afterwards, in repeating this Question [once actually – line 103 – the 'dare' in line 101 pertaining to the kiss], and the Want of a Syllable in the Verse, seem to prove it accidentally dropt . . .' Mason proclaims the emendation 'nonsensical', which it is not unless the line is very strictly read, but, as he observes, the metre is not so defective as to require repair: a headless pentameter also occurs at line 32. Yet because this part of the text is generally regular, Seward could be right.

115 keepe your standing] 'To Lamira' (Brett). Evidently 'stay where you are' (*O.E.D.*, Keep, *v.* 33 and Standing *ppl. a.* 11).

119 glorious] In support of his change to 'vain-glorious', Seward cites V.i.246–7. Massinger wrote those lines, however, and Fletcher this.

128 next ∧ . . . resolved,] F1's punctuation causes Lamira to say, 'My turn is next. I am convinced it comes, but in a nobler shape [than that of Anabell's ravisher]'. F2 causes her to say, 'My turn is next. I am resolute. It comes' F2's interpretation is quite possible since her shocked disapproval of Anabell's apparent capitulation might strengthen her will to resist to the end. Yet, although F1's punctuation is generally unreliable, transposition of the comma creates a meaning somewhat more consistent with Lamira's earlier timidity: 'I am convinced my turn is next'. She sees a figure entering. 'It comes'

V.ii

25 me, before ∧] I.e., 'before you are so punished, I scorn' Colman and editors after him punctuate 'me; before,'.

34 thine] Retaining F1's 'mine', Brett explains that La-writ 'is sarcastically repeating Sampson's frequent phrase'. An error seems more likely, however.

44 now] In this bit of Puritan satire, La-writ plays St Paul to Samson's Corinthian, the remote allusion being to 'in Christ Jesus I have begotten you through the Gospel' (1 Cor. 4: 15), La-writ's 'learned precepts'. The reading, however, could possibly be 'new', in which case the underlying text would perhaps be 'Thou art my Sonne: this day have I begotten thee' (Ps. 2:7). In Shakespeare honours are 'new begot' (*1 Henry VI*, TLN 89).

V.iii

19 Fare well] Colman notes, 'The proverb proves, as well as the sense, that we should read, *fare well*' rather than F1's 'Farewell', to which Weber adds, 'To cry roast meat . . . [means] to boast of any thing you have, so that another shall take it from you'. Weber reads 'Farewell', however, evidently missing Colman's point, which, I take it, is that 'dine well' (i.e., enjoy yourself to the fullest) is consonant with the 'roast meat' of the proverb. Cf. *The Scornful Lady*, V.iv.72: 'Cannot you fare well, but you must cry rost-meat?'

PRESS VARIANTS IN F1 (1647)

[Copies collated: Bodl (Bodleian Library B.i.8.Art.), Camb[1] (University Library Cambridge, Acton a.Sel.19), Camb[2] (SSS.10.8), CLU (University of California, Los Angeles, collated by L. A. Beaurline), CLU–C (University of California, Los Angeles, Clark Memorial Library, collated by Beaurline), Hoy (private copy of Cyrus Hoy), ICN (Newberry Library), IU[1] (University of Illinois 822/B38/1647), IU[2] (q822/B38/1647 cop. 2), MB (Boston Public Library), MnU (University of Minnesota), NcD (Duke University), NIC (Cornell University), NjP (Princeton University Ex 3623.1/1647q cop. 2), PSt (Pennsylvania State University), ViU[1] (University of Virginia 570973), ViU[2] (217972), WaU (University of Washington), WMU[1] (University of Wisconsin-Milwaukee cop. 1), WMU[2] (cop. 2), WMU[3] (cop. 3), WMU[4] (cop. 4), WU (University of Wisconsin-Madison).]

SHEET 1 H1 (*outer forme*)

Uncorrected: Camb[1], ICN, IU[2], MnU, NjP, WMU[1], WMU[3]
Sig. 1H4v
 I.iii.73 whom? ... multitude;] whom; ... multitude?
 89 *Dinant*] *Dinanet*
 II.i.25 Gentlemen——] Gentlemen
 30 then] *broken* n
 56 man——Fy *Dinant*,] man? Fy *Dinant*,——

SHEET 1 H1 (*inner forme*)

Sig. 1H4
Uncorrected: Camb[1], ICN, IU[2], MnU, NjP, WMU[3]
First-stage corrected: Bodl, NcD, NIC, PSt, ViU[2], WaU, WMU[1–2,4]
 I.iii.11 delicates] dedicates
 31 *Lewis* th' eleventh] *Lewis* eleventh
 Second-stage corrected: Camb[2], CLU, CLU–C, Hoy, IU[1], MB, ViU[1], WU
 I.iii.4 unufuall] unfuall
 Note: The 's' of the catchword 'Favours' rides below the line in all uncorrected and first-stage corrected copies. It has disappeared in all second-stage corrected copies. Probably not a deliberate change.

SHEET 1 I1 (*outer forme*)

Uncorrected(?): IU[2], MB, NIC
Sig. 1I1
 II.i.80 fir.] fir. [*quad*]

SHEET 1 Ii (*inner forme*)

Sig. 1I4

In some copies the comma following 'jealoufies' (III.iii.13) *prints heavily; the shoulder takes ink and the* 's' *is partially obscured. In others the* 's' *prints normally but the comma imperfectly, so as to resemble a full stop.*

SHEET 1 Iii (*outer forme*)

Sig. 1I2
Uncorrected: Camb¹, CLU, ICN, IU¹, MB, MnU, NcD, NIC, NjP, PSt, ViU², WaU, WMU¹

 II.iii.98 againe] agiine
 170 new] now
Sig. 1I3v
Uncorrected: Camb¹, CLU, ICN, IU¹, MB, MnU, NcD, NIC, NjP, PSt, ViU², WaU, WMU¹
First-stage corrected: Hoy, ViU¹, WMU²

 III.ii.81 goe ... fide?] goe? ... fide
 92 mewd] Meud
 118 us'd] us d
 149 woo] wo
 150 Sir,——] Sir,
 161 thing] thiing
Second-stage corrected: Bodl, Camb², CLU–C, IU², WMU³⁻⁴, WU
 pg. no. 62] 50

SHEET 1 Ki (*inner forme*)

Uncorrected: CLU, NcD, PSt
Sig. 1K4

 V.i.50 coofe] caufe
 71 Is it not better?] It is not better
 72 Is it] It is

SHEET 1 Kii (*outer forme*)

Uncorrected: WMU¹, WMU³
Sig. 1K2

 IV.iv.100 Swords? our fwords?] Swords, our fwords,
 101 fwords?] fwords.
 104 weapons?] weapons,
 107 Firfts? feconds? thirds?] Firfts, feconds, thirds,
 107–108 yougentlemen] you gentlemen
 120 in queft] inqueft
 IV.v.2. herfe] hrofe

Sig. 1K3v

 IV.vii.1 Shal l I entereate] Shall I enter eate
 13 vill aine] villanie
 16 hot,] hot
 22 encounter.] encounter?
 22 you?] you,
 32 *Enter ... bound.By the reſt of the Gent.* ... life, [*after* object., *line* 31]]
 Enter ... bound. ... life, *By the reſt of the Gent.* [*By ... Gent.* flush right]
 72 ruffian] ruffican

SHEET 1 L (*inner forme*)
(*a single sheet*)

Uncorrected: Camb¹⁻², CLU–C, IU², MnU, NIC, NjP, WaU

Sig. 1L1v

 V.ii.6 beat en-forward] beaten forward
 24 Lam'd,] Lam'd
 V.iii.16 diſcretion,] diſcretion
 22 too] to
 30 is befet] is to be fet
 32 you] you,

Sig. 1L2

 V.iii.66 Neice, to this] Neice to this,

Epi. 8 id'ly] *idly*

EMENDATIONS OF ACCIDENTALS

[(|) *indicates the reading occurs in a line that fills the measure.*]

Prologue

8 *too;*] ~ ∧ F1; ~ . F2 9 *it,*] ~ ∧ F1–2

I.i

I.i] *Actus Primus. Scena Prima.*
10 Tradesmen] F2; Tradesemen F1
12 suffers;] ~ ∧ F1; ~ . F2
18 us,] ~ ∧ F1–2
20 French,] ~ ; F1; ~ ∧ F2
22 Governments:] F2; ~ ∧ F1
54 Law,] ~ ; F1; ~ ∧ F2
78 presence∧] F2; ~ ? F1
100 *Lamira?*] F2; ~ . F1
101 (that's ... name,)] ∧ ~ ... ~ , ∧
 F1–2
102 musique,] ~ ; F1–2
107 How ... forsooth.] F1–2 *line:* How
 ... triumph'd? | Here ... forsooth.
125 Tally:] ~ , F1–2
131 *Musick playes.*] *after* boldly. *line*
 130 F1–2
138.1 Chorus.] F2; ~ , F1
150 grave——] ~ . F1–2
151 anon——] ~ , F1; ~ ∧ F2
173 Bondmen∧] F2; ~ . F1
184–187 (For ... bin,)] ∧ ~ ... ~ , ∧
 F1–2
190 distinguish;] ~ ∧ F1; ~ , F2
202 how:——] ~ : ∧ F1–2
212 more:] F2; ~ , F1
212 In] in F1–2
217 *Hymen*] F2; Hymen F1
226–227 No, ... blow.] *one line* F1–2
234 you:——] ~ : ∧ F1–2
238–240 (that ... spoiles,)] ∧ ~ ...

~ , ∧ F1–2
239 Country,] ~ ∧ F1–2
248 boorded] Boorded F1–2
248–249 sent, ... me,] F2; ~ ∧ ... ~
 ∧ F1
252 it,] ~ ∧ F1–2
253 atchiev'd; ... confesse,] ~ , ... ~
 ∧ F1–2
255 honour∧ ... selves)] ~) ... ~ ;
 F1–2 +
258 stil'd] F2; stil d F1
272 doe∧ your diseases,] ~ , ~ ~ ∧
 F1–2
278 onely∧] ~ , F1–2
303 more,] F2; ~ ∧ F1
310 are:——] ~ , ∧ F1; ~ . ∧ F2
314 *Exeunt* Dinant] F2; *Exiunt.Dionant*
 F1
316 more,——] ~ , ∧ F1–2
316 *Beaupre*] F2; *Beupre* F1
320–321 (For ... me)] ∧ ~ ... ~ ∧
 F1–2
327 tyed;] ~ ∧ F1; ~ . F2
328 have∧] F2; ~ , F1
330 (For ... weakenes,)] ∧ ~ ... ~ ,
 ∧ F1–2
340 resolv'd;] ~ ∧ F1; ~ . F2
342 give,] F2; ~ ∧ F1
343 you] F2; You F1
345 feares?] ~ ∧ F1; ~ ! F2

I.ii

1 ne'r] F2; ner F1
2–3 for't,...eye∧] F2; ~ ∧ ... ~ , F1
5 fellowes,] ~ ∧ F1–2
6–8 encounter∧ ... lost,...off;] ~ ~ ∧ ...,F1; ~ ∧ ... ~ ;... ~ . F2
18 often;] ~ , F1–2
19 loves] Loves F1–2
24 heaven)...for,∧] F2; ~ ∧ ... ~ ,) F1
30 me;] ~ , F1; ~ . F2
48–49 No ... prophecie.] F1–2 *line:* No ... now, | Whither ...

48 this:] ~ , F1; ~ . F2
49 *Dinant,*] F2; ~ . F1
54 professe,] ~ . F1; ~ ∧ F2
57 happinesse;] ~ , F1; ~ . F2
60 Sister,] F2; ~ ∧ F1
61 woman;] ~ , F1–2
61 sorrie] F2; sortie F1
64 me∧] F2; ~ . F1
67 place?] F2; ~ . F1
73.1 *Exeunt ...* Verdoone.] *after line* 72 F1–2
84 resolution] F2; resoultion F1
85 Friend;] F2; ~ , F1

I.iii

1 *Charlote?*] F2; *Carlote.* F1
1 wak'd;] ~ ∧ F1; ~ . F2
6 pleas'd,] ~ ∧ F1(|)–2
16 newes?] F2; ~ . F1
17 remedie,] ~ ∧ F1; ~ . F2
18 *Verdoone*∧] F2; ~ . F1
22 well,] ~ ∧ F1–2
22 ∧tould] F2; 'tould F1
25 ring,] ring' F1; ~ ∧ F2
45 *Lamira,*] F2; ~ . F1
47 (I ... act,)] ∧ ~ ... ~ , ∧ F1–2

49 prize] F2, przie F1
59 blood∧ ... defended;] ~ , ... ~ ∧ F1; ~ , ... ~ , F2
64 life,] F2; ~ ∧ F1
67 onely∧] F2; ~ , F1
77 doe;——] ~ ; ∧ F1–2
82 you:] ~ ∧ F1–2
91 desire;] ~ , F1–2
96 i'l] F2 (I'll); il' F1
98.1 *Exit*] *Exeunt* F1–2

II.i

II.i] *Actus Secundus. Scena Prima.*
1 field, ... side,] F2; ~ ∧ ... ~ ∧ F1(|)
9 th'] F2; th∧ F1
9 ones;] ~ ∧ F1; ~ . F2
11 Sir,] ~ ∧ F1(|); ~ . F2
12 ready? ... us.] F2; ~ ∧ ... ~ ? F1
15 Sir. ... yet,] ~ , ... ~ . F1; ~ ~ ∧ F2
16 enough:—— ... not?——] ~ : ∧ ... ~ ? ∧ F1–2
21 two,] F2; ~ ∧ F1

24 thus?—— ... tobacco,] ~ , ∧ ... ~ ? F1; ~ ?∧ ... ~ , F2
26 Sir,] F2; ~ ∧ F1(|)
32 comes:] ~ , F1; ~ . F2
32 Gentleman?] F2; ~ . F1
33–43 *Old Gentleman*] Gent F1–2
34 none, Sir.] F2; ~ ; ~ , F1
35 courtesie,] ~ ∧ F1; ~ . F2
36 Gentlemen——] ~ ; F1; ~ ? F2
44 You ... sword.] F1–2 *line:* You ... fortune, | You ... sword.
46–47 with;—— ... well,——] ~ ;

442

ʌ ... ~ , ʌ F1–2 +

47 *Enter two* Gentlemen.] *after line* 45
F1–2

47 fellowes,——] ~ ʌ ʌ F1(|); ~ .
ʌ F2

48 me,] ~ ʌ F1; ~ . F2

51 for,] ~ ; F1–2

53 *Exeunt* Gentlemen] *Exit Gent* F1–2

57 treacherous?] ~ , F1; ~ . F2

58–69 I ... Farewell.] F1–2 *line:* I ...
causes, | Yours ... glasses; | Will
... parcells? | And ... founding? |
Send ... doe? | Will ... melted; |
And ... gentleman, | His ... Mis-
tris, | And ... feather, | And ...
too, | I ... Farthingales; | Trouble
... you, | No ... puddings; | I ...
puddings, | Puddings enough. |
Farewell.

58 causes,] ~ . F1–2

59 glasses;] ~ , F1–2

66 Farthingales;] ~ ʌ F1–2

72 sir——] ~ . F1–2

73–77 Yes ... Parliament.] F1–2 *line:*
Yes ... hastie, | Exceeding ...
Parliament, | You ... businesse |
Depending ... it, | And ... Fees. |
'Faith ... businesse, | But ...
Parliament.

79 I ... sir.] F1–2 *line:* I ... you, | 'Tis
... sir.

80 I ... sir.] F1–2 *line:* I ... Cutler, | I
... sir.

81 fight——] ~ . F1–2

82 Be ... Sword.] F1–2 *line:* Be ...
hastie, | You ... Sword.

83–84 I ... Sword.] F1–2 *line:* I ...
that, | I ... Sword.

84 Sword.] ~ —— F1–2

85–87 I ... office.] F1–2 *line:* I ... part
| Against ... second; | Yee ...
office.

90 fight——] ~ . F1–2

91–92 And ... coward.] F1–2 *line:*
And ... coward, | Doe ... coward.

93–94 Try ... presently.] F1–2 *line:*
Try ... gentlemen, | The ...
presently.

93 mistaken:——] ~ : ʌ F1–2

95–96 Are ... houre.] F1–2 *line:* Are
... gentleman? | My ... houre.

97–98 That's ... gentlemen.] F1–2
line: That's all one, | We'll ...
bottome, | 'Tis ... gentlemen.

97 quarter,——] ~ , ʌ F1–2

100 fight,——] ~ , ʌ F1–2

103–106 Away ... sir.] F1–2 *line:*
Away, away,—— | I ... modesty,
| I ... mettall, | And ... fury; | I ...
sir.

103 away,——] ~ , ʌ F1–2

107–108 I'le ... fighting.] F1–2 *line:* I'le
... then; | And ... fighting.

109–111 I ... fight.] F1–2 *line:* I ...
man, | Which ... you, | Ile ...
sticke? | Sweet ... fight.

112–113 Stand ... chapps——] F1–2
line: Stand ... gentleman, | Or ...
chapps——

112 gentleman,] F2; ~ . F1

114–115 Spoke ... tooles.] F1–2 *line:*
Spoke bravely, | And ... Advocate:
| Come ... tooles.

114 selfe;] ~ , F1–2

116–120 If ... Writings?] F1–2 *line:* If
... fight; | I ... upon't, | And ...
me,) | What ... Writings?

119 (and ... me,)] ʌ ~ ... ~ , ʌ
F1–2

121 Let ... man.] F1–2 *line:* Let ... by, |
They ... man.

122–123 I ... Causes——] F1–2 *line:* I
... too, | And ... businesse? | I ...
Causes——

124–125 Thou ... honour.] F1–2 *line:*
Thou ... causes, | Thou ... cause, |
And ... honour.

126–127 Hum! ... now——] F1–2
line: Hum! ... should | Be ...
now——

129–132 Doe ... businesse.] F1–2 *line:*
Doe ... so? │ I ... so, │ I ... ever; │
For ... quarrelling. │ How ... stay,
│ Nor ... businesse.

133 minute,] *Comma does not print in
some copies of* F1.

134–135 Here ... there.] F1–2 *line:*
Here ... belly, │ I ... there.

137–138 Help ... yeares.] F1–2 *line.*
Help ... quickly; │ 'T ... yeares.

139 How ... angry.] F1–2 *line:* How it
grumbles? │ This ... angry.

140–141 Now ... Lawyer.] F1–2 *line:*
Now ... up, │ And ... boy, │ If ...
Lawyer.

II.ii

2 Take ... bravely.] F1–2 *line:* Take
... ground, │ Ile ... bravely.

3–4 To't ... tricks.] F1–2 *line:* To't
... play? │ None ... tricks.

3 play?] ∼ , F1–2

5 Mounsieur;——] ∼ ; ∧ F1–2

6–7 What ... holds.] F1–2 *line:* What
... belly? │ I ... holds.

8–9 Put ... bagg.] F1–2 *line:* Put ...
then: │ Nay ... sir:—— │ God ...
bagg.

9 sir:——] ∼ : ∧ F1–2

10–11 Nothing ... fights.] F1–2 *line:*
Nothing ... yee? │ The ... fights.

10 yee?——] ∼ ? ∧ F1–2

12.1 La-writ] F2; *La.writ* F1

13–14 Stand ... Sword.] F1–2 *line:*
Stand ... else,—— │ I ... off:——
│ I ... Sword.

13 else,——] ∼ , ∧ F1–2

13–14 it:—— ... off:——] ∼ : ∧
... ∼ : ∧ F1–2

16–19 I'le ... Kingdome.] F1–2 *line:*
I'le ... else.—— │ Stand ...
quietly, │ And ... you.—— │ Is ...
dayes │ To ... Kingdome.

16 else.——] ∼ . ∧ F1–2

17 you.——] ∼ . ∧ F1–2+

20–21 Pox ... dog?] F1–2 *line:* pup-
pie? │ A

22–24 No ... gentleman,——] F1–2
line: No ... Gentleman, │ Sweet ...
me, │ Goe ... gentleman,

24 gentleman,——] ∼ , ∧ F1–2

27 heart,——] ∼ , ∧ F1–2

29 Thou ... deliver.] F1–2 *line:* Thou
... then,—— │ Deliver, deliver.

29 then,——] ∼ , ∧ F1–2

31–32 I ... well?] F1–2 *line:* I ...
in't—— │ There's ... Daggers,
—— │ Have ... well?

31 in't——] ∼ ∧ F1; ∼ , F2

32 Daggers,——] ∼ , ∧ F1–2

35 'Tis ... houre.] F1–2 *line:* 'Tis ...
fortune, │ We ... houre.

36 *Exeunt* Beaupre,] *Ex. Beau.*
F1–2+

37–38 Where's ... two?] F1–2 *line:*
Where's ... trinkets? │ Or ... two?

41–53 What ... Armorer.] F1–2 *line:*
What ... you, │ For ... courtesie? │
All ... ye, │ Is ... on't, │ I ...
matter: │ And ... Sword. │ Most
willingly, │ But ... you. │ I ...
gratified, │ Nor ... too, │ And ...
quietly; │ For ... disposure, │ And
... so—— │ This ... Lawyer: │ I
... me,—— │ I ... Armorer.

43 on't,] F2; ∼ ∧ F1

43 matter:] ∼ , F1–2

49 quietly;] ∼ , F1 (?); ∼ . F2

50 so——] ∼ , F1; ∼ . F2

52 me,——] ∼ , ∧ F1–2

53.1 *Exit* ∧ F2; ∼ . F1

II.iii

9 fellow‿] F2; ~ . F1
18 voice,] F2; ~ ‿ F1
20 *sound*——] ~ . F1–2
30 you, good‿] ~ ‿ ~ , F1; ~ ‿
 ~ ‿ F2
32 you?——] ~ ? ‿ F1–2
35 knave,——] ~ , ‿ F1–2
39 Say ... honour?] F1–2 *line:* Say ...
 sir? | Didst ... honour.
41 rascall:——] ~ : ‿ F1–2
44 Lady?] ~ ; F1; ~ . F2
45 honour?] ~ . F1–2
47 pea-goose] pea-| goose F1–2
56–57 Why ... Ladies?] F1–2 *line:*
 Why ... sir, | And ... Ladies?
60–61 Ye ... out?] F1–2 *line:* Ye ...
 rogue, | I ... blasphemie—— |
 Have ... out?
63–69 *And* ... to't.] F1–2 *line: And* ...
 tho. | And ... gentleman, | And ...
 triumphant, | Thy ... shitten Lady,
 | And ... Lady, | And ... thee? |
 Dost ... sir, | A ... to't
63 *And ... worst:*] roman F1–2
65 triumphant,] ~ ; F1–2

76–77 I ... now.] *one line* F1–2
80–81 I ... sir.] F1–2 *line:* I ... then, |
 Not ... afore? | I ... sir.
80 for't,] F2; ~ ‿ F1(|)
82 'tis] F2; 'Tis F1
84 know——‿] ~ ——. F1–2
106 patient——] ~ . F1–2
107 still?] ~ : F1–2
118–120 (I ... too); ... life——] ‿ ~
 ... ~ ‿; ... ~ . F1–2
121 adore,] F2; ~ ‿ F1
129–132 flouter?—— ... Lady——
 ... time:—— F1–2 *omit dashes*
145 her,] F2; ~ ‿ F1
149 wind;] ~ , F1–2
149 beauty——] F2; ~ . F1
165 life;] ~ , F1–2
189 in't——] ~ . F1–2
192 nay, see‿] ~ ‿ ~ , F1–2
195 better,——] ~ , ‿ F1–2 +
199 say——] ~ . F1–2
200 you?] ~ . F1–2
201 off.] ~ —— F1–2
203 scorne:——] ~ : ‿ F1–2

III.i

III.i] *Actus tertius. Scena prima.*
 0.1 Charlote] F2 (Charlotte); *Chailote*
 F1
 1–2 Out ... more.] *one line* F1–2
 10 suffer——] ~ . F1–2
 18 opinion;] ~ , F1–2
 39 censure‿] F2; ~ , F1
 49 divell‿ ... Magician,] ~ , ... ~
 ‿ F1–2
 61 me?] ~ . F1–2
 61 Yes‿ sir,] ~ , ~ ‿ F1; ~ , ~ ,
 F2

62 not?)] ~ ‿) F1–2
64 these?——] ~ : ‿ F1–2
81 deserve?] ~ ; F1–2
83 speake, ... me;] ~ ; ... ~ , F1–2
89 ('tis resolv'd on,)] ‿ ~ ~ ~ , ‿
 F1–2
89 resolv'd] F2; resov'd F1
92 sudden.] ~ —— F1–2
96 unsuspected;] ~ , F1–2
116 humour,] F2; ~ ; F1
120 wrongs;] ~ ‿ F1; ~ . F2

445

III.ii

3–14 He ... can.] F1–2 *line:* He ...
Lawyer, | Of ... thing. | A ... Sir, |
And ... businesse, | And ... that. |
Ye ... forward, | Not ... done, |
But short, short. | I ... favour, |
You ... Sir. | It ... so, | And ...
friends; | It ... Chamber, | And ...
so, | And ... courtesies: | I ... can.

3 Lawyer, ... kind ∧] F2; ~ ~ ,
F1

16–17 Peradventure ... Lawyer?] F1–
2 *line:* Peradventure ... *La-writ?* |
Where's ... Lawyer?

19–27 Run ... me.] F1–2 *line:* Run ...
meets; | He ... now. | Your reason?
| Is ... dead? | No ... sir; | But ...
houres: | Alas ... fighting, | And
... it—— | If ... Gentleman, |
The ... calling. | Looke ... Gentle-
man, | And ... me.

19–20 quarrells ∧ ... Lawyer ∧] F2;
~ , ... ~ , F1

29–38 I ... wayes——] F1–2 *line:* I
... businesse, | (Turn ... weeke;) |
Yet ... vacancie, | I ... well, | I ...
fight. | But ... sir, | His ...
businesse, | We ... sir, | His not
appearance—— | There ... long, |
A ... friends; | But ... may, | And
... wayes——

29 businesse ∧] business ∧ F1(|)–2

30 (turn ... weeke;)] ∧ ~ ... ~ ; ∧
F1–2

35 appearance——] ~ . F1–2

36 long, a little ∧] F2; ~ ∧ ~ ~ , F1

41–42 Now ... no.] F1–2 *line:* Now
... sir, | And ... no.

43–44 I'll ... two——] F1–2 *line:*
Gentlemen, | And

50–51 Make ... els.] F1–2 *line:* Make
... quarrells | You ... fight, | There
... els.

54–55 Baffled ... goes.] F1–2 *line:*

Baffled ... businesse, | My ... us? |
Why ... goes.

57–58 Breed ... living.] F1–2 *line:*
Breed ... selves, | 'Tis ... living.

57 selves,] ~ ∧ F1–2

61–62 Will ... agreev'd——] F1–2
line: Will ... occupation; | If ...
agreev'd——

61 occupation;] ~ ∧ F1–2

62 agreev'd——] ~ ; F1; ~ . F2

64–65 Avant ... taken——] F1–2
line: Avant ... petitions, | Thou ...
thee, | And ... taken——

65 causes;——] ~ ; ∧ F1–2

67–70 There ... Monsieur.] F1–2 *line:*
There ... place. | I'll ... busines |
But ... Gentleman; | The ...
Monsieur.

67 There,] F2; ~ ∧ F1

69 Gentleman;] ~ , F1–2

72–73 I ... thing.] F1–2 *line:* I ... Sir,
| But ... thing.

76–79 No ... then——] F1–2 *line:*
No ... Gentlemen, | But ... love
me, | The ... Gentleman. | I ...
then——

76 Gentlemen,] ~ ∧ F1–2

80.1 *Exeunt*] *Exit* F1; *Ex.* F2

81–83 No ... Judge.] F1–2 *line:* No ...
all? | And ... action, | And ... well,
| 'Tis ... Judge.

84 Who ... Lawyer?] F1–2 *line:* Who
... here? | My ... Lawyer?

85 I ... end.] F1–2 *line:* I ... well, |
But ... end.

86–88 How ... conversion:] F1–2 *line:*
How ... metamorphis'd? | Nothing
... buckrum, | No ... now, | This
... conversion:

86 left,] F2; ~ ∧ F1

88 conversion:] ~ ∧ F1; ~ . F2

91–94 You ... man.] F1–2 *line:* You
... one, | Time ... Lawyer, | But

... Lawyer, | I ... talking: | I ... man.

91 one,] F2; ~ ∧ F1

92 coat,] F2; ~ ∧ F1

93 talking:] ~ ∧ F1; ~ , F2

98 There's] F2; Ther's F1 (|)

103 'Tis ... Sonnets.] F1–2 *line:* 'Tis ... Sir, | I ... Sonnets.

104 *admirantis,*——] ~ , ∧ F1–2

108–109 Let ... quickly.] F1–2 *line:* Let ... learne, | Time ... quickly.

111–114 Never ... Judge——] F1–2 *line:* Never too old | To ... judge | Can ... honour; | There ... causes, | In ... reputation. | And ... Judge——

111 old ∧] F2; ~ . F1

112 griefes,] F2; ~ ∧ F1

114 Judge——] ~ , F1; ~ . F2

115 Pray ... thing——] F1–2 *line:* Pray ... Sir, | This ... thing——

116 it?] ~ , F1; ~ . F2

117 perswaded——] ~ ∧ F1(|); ~ . F2

118–119 You ... Gentleman?] F1–2 *line:* You ... fight, | Doe ... Gentleman?

121–122 I ... it.] F1–2 *line:* it, | You

121 it,] F2; ~ ∧ F1

124–125 Be ... earth.] F1–2 *line:* Be banish'd then; | 'Tis ... *Africa,* | Or ... earth.

126 fight?] ~ , F1; ~ . F2

127 say,] F2; ~ ∧ F1

128–129 Well ... service.] F1–2 *line:* Well ... it, | And ... Louver, | Till ... service.

130 Judge?] ~ , F1–2

131–134 This ... president.] F1–2 *line:* This ... of, | None ... president? | What ... earnest, | I ... braceletts; | This ... it; | Here ... president.

132 president?] ~ ; F1–2

134 it;] ~ ∧ F1; ~ , F2

136 good,——] ~ , ∧ F1–2

136 *Cleremont?*] F2; ~ . F1

138 ridiculous?——] ~ ? ∧ F1–2

145 businesse] bussinesse F1; business F2

146 not,] F2; ~ ∧ F1

149 (In ... it,)] ∧ ~ ... ~ ∧ ∧ F1 (|); ∧ ~ ... ~ , ∧ F2

152 understanding;] ~ ∧ F1; ~ , F2

153 laughter;] F2; ~ ∧ F1(|)

156 mirth,] F2; ~ ∧ F1

163 mortally;] ~ ∧ F1–2

165 there's] F2; ther's F1(|)

166 y'are ∧] F2; ~ ? F1

174 liv'd] F2; li'v'd F1

175 therefore ... selfe;] F2; therfore ... ~ ∧ F1(|)

176 abilitie,] F2; ~ ∧ F1

179 Lord?] F2; ~ , F1

180 together——] ~ ∧ F1; ~ . F2

184 (Since ... it)] ∧ ~ ... ~ ∧ F1; ∧ ~ ... ~ , F2

189 (You ... subject,)] ∧ ~ ... ~ , ∧ F1–2 +

190.1 *Exeunt* Vertaigne] *Exit* Vertaine F1; *Ex.* Vertaign F2

195 O ... me?] F1–2 *line:* O ... rarer, | Dost ... me?

196 dearely?] F2; ~ ∧ F1

197 sake——] ~ ? F1–2

198 dangerous?] F2; ~ ∧ F1

199 dangerous?] ~ . F1–2

III.iii

1 back;] ~ ∧ F1; ~ . F2

2 Gentleman,] *Comma does not print in some copies of* F1

6 cousend,] F2; ~ ∧ F1

8 one] F2; on F1(|)

9 eyes,—— ... you:] ~ , ∧ ... ~ ∧ F1; ~ , ∧ ... ~ : F2

10 sake ∧ ——] F2; ~ .—— F1

15 matter?] ~ ˄ F1–2

24 briefely,] F2; ~ ˄ F1

34 then,] ~ ˄ F1–2

37 dangerous,] F2; ~ ˄ F1(|)

46 defeated,] F2; ~ ˄ F1

53.2 Charlotte] F2 (Charlotte); *Char-loth* F1

53.3 pillowes,] F2; ~ ˄ F1

55 be,] F2; ~ ˄ F1

56 jealous,] F2; ~ ˄ F1

71 Mistris,] F2; ~ ˄ F1

74–77 Why ... againe?] F1–2 *line:* Why ... servant—— | Softly ... engag'd, | A ... againe?

75 servant——] ~ . F1–2

80–81 Will ... me——] F1–2 *line:* Will ... liberall, | If ... me——

98 sweat?——] ~ ? ˄ F1–2+

104–106 I... whistles.] F1–2 *line:* I ... withall; | I ... too. | Doe ... me? | Plague ... whistles.

108 Would ... not] F1–2 *line:* Would ... too, | You know not.

108 too,] ~ . F1–2

110 have.] ~ —— F1–2

111 Wood] F2; wood F1

125 fortune.] ~ —— F1–2

131 when] F2; When F1

III.iv

0.1 Dinant,] F2; ~ . F1 (?)

0.1 Lamira ˄] ~ . F1; ~ : F2

4 false] F2; fals F1 (|)

14 too;——] ~ ; ˄ F1–2

18 another,] F2; ~ ˄ F1

20 unvaluable?] ~ : F1–2

21–22 divell: ... agent?] ~ ? ... ~ : F1–2+

24 infamies——] ~ ? F1–2

37 words——] ~ ! F1–2

57 flatteries,] F2; ~ ˄ F1(|)

61 dangers,] ~ . F1; ~ : F2

62 trophy:] ~ ˄ F1; ~ , F2

66–67 Yes ... lost.] *one line:* F1–2

72–74 Was...me?] F1–2 *line:* Was ... looke, | I ... by. | Did ... me?

73 looke] look F1(|)–2

78 over,] F2; ~ ˄ F1(|)

93 disarme 'em] disarm'em F1(|); disarm 'em F2

100 but ˄] F2; ~ , F1

102–103 You ... hand.] *one line:* F1–2

104–105 again.—— ... thee?] ~ . ˄ ... ~ . F1–2

124 my] F2; My F1

128 gaines] gains F1(|)–2

IV.i

IV.i] *Actus quarti. Scena Prima.*

5 will] F2; wil F1(|)

7 sullen.] ~ —— F1–2

13 too,] ~ ˄ F1–2(|)

IV.ii

5–9 As ... else.] F1–2 *line:* As ... bite, | If ... me. | No ... valiant, | He ... else. | Hee's ... welcome, | As ... else.

12 praying——] ~ , F1–2

14 *quietus*] F2; quietus F1

IV.iii

11 padd?] ~ . F1–2

12–13 Ready ... last.] *one line* F1–2

IV.iv

0.1 Cleremont,] F2; ~ . F1

4–7 As ... him.] F1–2 *line:* As ... fellow, | And ... blood—— | It shall suffice, | I'le ... remove | Shall ... him.

9–11 And ... cousin.] F1–2 *line:* And ... him, | I ... kindred. | For ... cousin.

10 Lords] F2; Lotds F1

12 cousins?] F2; ~ . F1

13–14 The ... upon.] F1–2 *line:* The favour, | The ... upon.

20 I ... done.] F1–2 *line:* I ... one, | I ... done.

22–24 To ... Antipathy,] F1–2 *line:* To ... em; | A ... Cocatrice, | If ... dies. | A strange Antipathy,

25–26 If ... morning.] F1–2 *line:* If ... em, | They ... morning.

27 fast?] F2; ~ . F1

33 words——] ~ , F1–2

41–42 Hang ... hand.] F1–2 *line:* Hang ... Witchcrafts, | I ... gentleman, | And ... hand.

44–45 Off ... too.] F1–2 *line:* Off ... it, | And ... skin, | If ... too.

47 Off ... Catt.] F1–2 *line:* Off ... say: | I'le ... Catt.

47 Off ∧] F2; ~ , F1

50–51 Yes ... shirt?] F1–2 *line:* Yes, sir. | But ... honour | With ... shirt?

54–58 Base ... satisfied.] F1–2 *line:* Base ... know | An ... enemy, | Is ... ominous? | This ... under, | And ... Cut-workes, | As ... satisfied.

58 thine;] ~ , F1–2

61–62 Most ... one.] F1–2 *line:* Most ... shirt, | Let ... one.

64–66 Not ... Authentique,] F1–2 *line:* Not ... talke, | 'Tis ... method, | Talke ... Authentique.

68–69 When ... bravely.] F1–2 *line:* When ... resolutions, | Take ... bravely.

70 'Tis ... fight.] F1–2 *line:* 'Tis ... cold; | This ... fight.

72 'Tis ... without.] F1–2 *line:* 'Tis peerish weather; | I ... without.

73 river——] ~ . F1–2

74 chins——] ~ . F1–2

75 Then ... circumstance.] F1–2 *line:* Then ... quickly, | Plague ... circumstance.

77 certaine:——] ~ : ∧ F1–2

79 off;——] ~ ; ∧ F1–2

84 fight,——] ~ , ∧ F1–2

85 *Exeunt*] *Ex.* F1–2

86–93 Why ... altogether——] F1–2 *line:* Why ... gentleman, | And ... cold;) | Your ... affronts, | Past ... cold.) | My ... man, | And ... indeed,) | Having ... kinsman, | Yet ... cold,) | Not altogether——

87 (boh ... cold;) 89 (boh ... cold.) 91 (boh ... indeed,) 92–93 (boh ... cold,) 94 (Boh, boh,) 95 (boh, boh,) 97 (boh, boh)—— 108 (Boh, boh,) 115 (boh, boh,)] *omit parens* F1–2

90 Lord ∧] ~ , F1–2

93 altogether——] ~ . F1–2

96–97 Sir ... boh)——] F1–2 *line:* Sir ... hand; | You ... cause, | And ... boh)——

97 are (boh, boh)——] are——boh, boh. ∧ F1–2

100–101 Our ... swords?] F1–2 *line:* Our ... swords?—— | Thou ... swords?

100 swords?——] ~ ? ∧ F1–2

101 dog:——] ~ : ∧ F1–2+

102 gentlemen:——] ~ : ∧ F1–2

102 where's] F2; wher's F1(|)

105–108 Wa ... gentleman.] F1–2 *line:* Wa ... weapons? | Our ... dead. |

Firsts ... gentlemen.
106 weapons,——] ~ , ∧ F1–2
107 thirds?——] ~ ? ∧ F1–2
108 honour?——] ~ ? ∧ F1–2
112–113 Hang ... me?] F1–2 *line:* Hang ... faggots; | Dar'st ... me?
115–116 Rogues ... May-game.] F1–2 *line:* Rogues ... Doublets? | To ... May-game.
120 'em——] ~ . F1–2
122–123 Give ... 'em——] F1–2 *line*

as verse: Give ... gentleman. | I ... 'em——
125–127 There's ... it.] F1–2 *line:* There's ... me, | Kick ... too, | To ... 'em—— | Kick ... it.
129–130 I'le ... thee.] F1–2 *line:* I'le ... Gentlemen? | Rogues, ... thee.
129 thee,] F2; ~ ∧ F1
129 Gentlemen?] F2; ~ , F1
130 theeves:——] ~ : ∧ F1–2

IV.v

0.1 Champernell,] F2; ~ ∧ F1
0.2 Annabell,] F2; ~ . F1
16 Grove,] ~ ∧ F1; ~ ; F2
19 Village,] F2; ~ . F1 (?)

23 Cousin,] F2; ~ ? F1
25 will,] F2; ~ ; F1
31 she:——] ~ : ∧ F1–2

IV.vi

8.1 *Musicke*] Mus. F1; *Musick* F2
9 further,] ~ ∧ F1(|)–2
12 President∧] F2; ~ , F1
17 proceed?] ~ . F1–2
22 *Dance.*] *after* instructed. *line* 23 F1–2
23 We are] F2; Weare F1
24 we] F2; We F1
52 me,] F2; me,, F1
60 Neece,] F2; ~ . F1
71–72 Lady-plot,... ruffians?] ~ ? ... ~ , F1; ~ ∧ ... ~ ? F2
74–75 And ... bound?] *one line* F1–2
77 Cleremont∧——] F2; ~ .—— F1
77–78 As ... lovely——] *one line* F1–2
80 you——] ~ ∧ F1; ~ . F2
83 you,∧] ~ ,—— F1–2
84 I,] ~ ∧ F1–2
85 does∧] F2; ~ . F1
90.1 *Exeunt*] *Exit* F1; *Ex* F2
91–92 I ... heaven] *one line* F1–2
98–102 O ... combatants——] F1–2

line: O ... sip | Of *aqua fortis.* | The ... two | Upon ... 'em. | As ... Gentlemen, | Impart ... comba-tants——
102 combatants——] ~ , F1; ~ . F2
103 Lord∧ mine uncle,] ~ , ~ ~ ∧ F1–2
103 live?] ~ , F1; ~ . F2
104–108 Pox ... monstruously.] F1–2 *line:* Pox take him; | How ... mouth? | Why ... Cousen? | Why ... Poulters | That ... now, | And ... Children, | Laugh monstruously.
104 him; how] him. How F1–2
104 warm'd] F2; warm,d F1
105 have] F2; bave F1
110–111 Give ... laughing.] F1–2 *line:* Give ... Sir, | Laugh ... laughing.
113–114 Why ... thing,——] F1–2 *line:* Why ... it, | Such ... thing, ——
115–116 Do ... at] F1–2 *line:* Do ... Lord? | I ... at.

119–120 If ... have——] F1–2 *line:* If
 ... doublet | And ... have——
119–120 doublet ‸ ‸ ... have——] ~
 . —— ... ~ ‸ F1; ~ . —— ...
 ~ . F2
126–128 The ... issue.] F1–2 *line:* The
 ... challenge, | I ... it, | And ...
 issue.
130–137 You ... nose——] F1–2 *line:*
 You ... Sir, | And ... too, | That
 ... merry. | If ... knew | The ...
 Gentleman, | Though ... danger |
 His ... arrived, | But that | Mens
 ... foolish, | And | fortunes—— |
 That ... up, | And ... nose——
132 knew ‸] F2; ~ . F1
135 fortunes——] ~ , F1; ~ . F2
137 nose——] ~ . F1–2
139 too——] ~ ‸ F1; ~ . F2
143 fellow ‸ ——] ~ . —— F1–2
146 not;——doe] ~ ‸ ‸ Doe F1; ~ ,
 ‸ Do F2
148–151 O ... instantly.] F1–2 *line:* O
 valour, | Looke ... thee, | My ...
 sword. | I'll ... presently, | I'll ...

too. | Away good *Samson,* | You
 ... instantly.
155–156 Must ... thee.] F1–2 *line:* Must
 ... dishonour'd? | Adversity ...
 thee.
159–161 Nay ... snarle?] F1–2 *line:*
 Nay ... broken, | And ... sirra; |
 Why ... snarle?
159 broken,] F2; ~ ‸ F1(|)
160 sirra;] ~ , F1–2
167–168 Alas ... els.] F1–2 *line:* Alas
 ... him, | Beate ... els.
171–176 I ... beating.] F1–2 *line:* I am
 patient, | I ... me, | I ... goose. |
 Why ... living, | And ... thunder-
 bolts, | To ... place? | I understand
 Sir; | I ... beating.
176 Sir;] ~ , F1–2
181–182 And ... brawling?] F1–2 *line:*
 And ... me, | To ... brawling?
182 brawling?] F2; ~ ‸ F1
186–188 Rise ... else.] F1–2 *line:* Rise
 ... you | As ... words, | Get ...
 murmurs, | I ... else.
188 murmurs,] F2; ~ ‸ F1

IV.vii

0.1 One] *one* F1–2
1 entreate] F2 (entreat); entereate
 F1(c); enter eate F1(u)
2 Noble,] F2; ~ . F1
4 Tyrant,] F2; ~ ; F1
11.1 Second] *second* F1–2
12 Not ... againe.] F1–2 *line:* Not
 kisse you? | I ... againe.
15 Sir?] F2; ~ , F1
17 more, more,] F2; ~ , ~ ‸ F1
18 steele, ... hereafter,] ~ ‸ ... ~ ‸
 F1–2
21 Beast,] F2; ~ . F1
22 *takes* ‸] F2; ~ . F1
25 pleasures,——] ~ , ‸ F1–2+
30 together,] F2; ~ ‸ F1

32 *bound, by*] bound. *By* F1; *bound by* F2
38 us ‸] ~ ; F1; ~ , F2
46 shaken,] ~ ‸ F1–2
54 please,] F2; ~ ‸ F1(|)
59 When, ... you,] ~ ‸ ... ~ ‸
 F1–2
60–61 (Those ... sport)] ‸ ~ ... ~
 ‸ F1–2+
66 much ‸ ... well,] ~ , ... ~ ‸
 F1–2
70 now ‸ ——] F2; ~ . —— F1
77 that] F2; thar F1
78 hence,——] ~ , ‸ F1–2
79 here,] F2; ~ ‸ F1
81 you,] F2; ~ ‸ F1

V.i

V.i] *Actus Quinti. Scena Prima.*
0.1 within.] ~ , F1–2
2 heard;] ~ ∧ F1; ~ , F2
2 encrease,] F2; ~ ∧ F1(|)
4 And,] ~ ∧ F1–2
6 invention:] ~ ∧ F1; ~ . F2
10 next,——] ~ , ∧ F1–2
13 lowder, ... presage] F2; ~ ∧ ... ptesage F1
16 i'th] F2 (i'th'); i th F1
17 loose——] ~ . F1–2
22 me:] ~ ∧ F1; ~ . F2
27 it——] F2; ~ ∧ F1
30 o'th] F2 (o'th'); ot'h F1
32 Proper, young, (o ... me)] ~ ∧ ~ , ∧ ~ ... ~ ∧ F1; ~ , ~ , ∧ ~ ... ~ ! F2
33 rascalls, ... twenty.] ~ ∧ ... ~ ∧ F1; ~ , ... ~ —— F2
36 cry?] F2; ~ ! F1
42 women,] ~ ∧ F1–2
45 me,] F2; ~ ∧ F1(|)
47 rogues∧——] ~ .—— F1–2
48.2 *bound*∧] F2; ~ , F1 (?)
49 Brother?] ~ ∧ F1(|); ~ . F2
52 Pageants;] ~ ∧ F1; ~ . F2
53 misfortunes,] F2; ~ ∧ F1
56 it;] ~ ∧ F1; ~ . F2
58 not——] ~ ; F1–2
60 (Good Cousen gently,)] ∧ ~ ~ ~ , ∧ F1–2
62 mother,——] ~ , ∧ F1–2 +
63 Beare,] ~ ∧ F1–2
66 him,——] ~ , ∧ F1–2
67 Captaine] Captain F1(|)–2
67 not,] F2; ~ ∧ F1(|)
70 moone,] ~ ∧ F1–2
71 better——] ~ ? F1–2
74 nature?] F2; ~ , F1
78 honours,] ~ ∧ F1(|)–2
82 rogues,] F2; ~ ∧ F1
82 Away] F2; A way F1
83 Gentlemen,] F2; ~ ∧ F2

84 honesty;——] ~ ; ∧ F1–2
85 yet,] ~ ∧ F1; ~ . F2
85.1 *Exeunt*] Exit F1; *Ex.* F2
86 you,——] ~ , ∧ F1–2
88 (Which ... me)] ∧ ~ ... ~ ∧ F1; ∧ ~ ... ~ , F2
91 mine,] F2; ~ ∧ F1
93 heate∧——] ~ .—— F1–2
95–96 better, ... nobly loves you,] F2; ~ ∧ ... ~ ~ ∧ F1
97 softly,] ~ ∧ F1–2
101 (I ... Begger,)] ∧ ~ ... ~ ∧ ∧ F1; ∧ ~ ... ~ , ∧ F2
102 *Cleremont?*] ~ , F1; ~ . F2
102 same;] ~ ∧ F1; ~ , F2
107 you,] F2; ~ ∧ F1
110 You'll] F2 (You'l); You 11 F1
110 nothing?] ~ ∧ F1; ~ . F2
111 Till ... Gentleman.] F1–2 *line:* Till ... tyed | Not ... Gentleman.
112 Mistris,] F2; ~ . F1
113–114 nothing, ... well, ... quickly, ... or——] F2; F1 *omit punc.*
115 me,——] ~ , ∧ F1–2
115.1 *Exeunt.*] Exit. F1; *Ex.* F2
116 thee;] ~ ? F1; ~ . F2
117 shewed, the bravery?] F2; ~ ∧ ~ ~ ∧ F1
119 brave,] ~ ∧ F1–2
121 scornd,] *Comma does not print in some copies of F1.*
127 thee:] F2; ~ ∧ F1
128 My ... comes] F1–2 *line:* My ... next, | I ... comes
129 shape——] ~ , F1–2
131 since] F2; sincc F1
137 sadnesse,] F2; ~ ∧ F1
139 (Mine ... of,)] F2; ∧ ~ ... ~ , ∧ F1
141 love∧] F2; ~ , F1
144 mercy,] F2; ~ ∧ F1
145–147 (take ... againe,)] ∧ ~ ... ~ , ∧ F1–2 +

149 amaz'd,] F2; ~ ∧ F1
151 love;] ~ , F1–2
152 (Be ... Lady,)] ∧ ~ ... ~ , ∧ F1–2
159 be,] F2; ~ ∧ F1
163.1–2 Cleremont, ... Charlote,] F2; ~ ∧ ... ~ ∧ F1
166–167 My ... living?] *one line* F1–2
171 familiar,] ~ . F1; ~ ∧ F2
179 fortune)] F2; ~ ∧ F1
183 possession;] ~ ∧ F1–2
186 liberty,] F2; ~ ∧ F1
187 honour,] ~ ∧ F1–2
190 this,] F2; ~ ∧ F1
197 *Cleremont*;] F2; ~ , F1

201 *Cleremont*,] F2; ~ . F1
206 it,——] ~ , ∧ F1–2
219 *Exeunt. Manent*] *Ex. Manent*, F1; *Ex. Man.* F2
228 you; ... miracle,] ~ , ... ~ ; F1; ~ , ... ~ ∧ F2
231 consent, ... you,] ~ ∧ ... ~ ; F1; ~ , ... ~ ; F2
241 trim,] ~ . F1; ~ ∧ F2
266–267 even, ... in:] ~ : ... ~ , F1; ~ , ... ~ , F2
268 hell's] F2; hell's F1
274 you vex'd] F2; youvex'd F1
277–278 return'd; ... away,] ~ , ... ~ ; F1–2

V.ii

4 us——] ~ . F1–2
6 beaten——forward] beaten ∧ forward F1(u); beat en-forward F1(c); beaten, forward F2
7 againe,——] ~ , ∧ F1–2
8 cudgell——] ~ . F1–2

23 peace,——] ~ , ∧ F1–2
30–31 I ... wish——] *one line* F1–2
41 man,] ~ ∧ F1–2
45 live,] F2; ~ . F1
49 *Exit* ∧] F2; ~ . F1

V.iii

1 call 'em ... will] F2; call'em ... wil F1(|)
11 Lent ∧ ... woods,] ~ , ... ~ ∧ F1–2
12 flesh——] ~ , F1; ~ . F2
22 too——] ~ . F1–2
22–23 Vertaigne, ... *Vertaigne*,] F2; ~ ∧ ... ~ ∧ F1
24 *Exeunt*] *Exit* F1; *Ex.* F2
28 *Paris*, yet ∧] ~ ∧ ~ , F1; ~ ∧

~ ∧ F2
30 wood?] F2; ~ ∧ F1
31 us:] ~ , F1–2
38 play?] F2; ~ ∧ F1(|)
40 freed?] F2; ~ , F1
45 fellow,] ~ ∧ F1–2
55 Neice?] F2; ~ ∧ F1
56 not,] F2; ~ ∧ F1(|)
59 worse,] F2; ~ ∧ F1
61 dissentions,] F2; ~ ∧ F1

[Included are substantive and semi-substantive differences from the present text. Changes from 'ye' to 'you' and vice versa made by editions after F2 are ignored, and only the originator of a conjectural reading never adopted into the text is acknowledged. The + sign indicates the agreement of all editions after the one to which the reading is attributed and − (minus) indicates exceptions to this. No substantive variants were found in *Poems: By Francis Beaumont, Gent.* (1653). The sigla are:

F1 *Comedies and Tragedies* (1647).

F2 *Fifty Comedies and Tragedies* (1679).

L *Works* (1711), intro. by Gerard Langbaine the younger.

S *Works* (1750), edited by Theobald, Seward, and Sympson (*The Little French Lawyer* by Seward).

C *Works* (1778) edited by George Colman the younger.

M J. Monck Mason, *Comments on the Plays of Beaumont and Fletcher* (London, 1798).

W *Works* (1812), edited by Henry Weber.

D *Works* (1843–6), edited by Alexander Dyce.

V *The Little French Lawyer*, edited by Cyril Brett, Variorum Edition, vol. IV (London, 1912).

I.i

1–2 Disswade ... Sword.] Disswade ... care not, | I ... Sword. Bullen *conj. in* V

22 Are] And F1

29 you∧ end yet?] you? and yet——F1; you∧ end yet——F2, L, S

31 Mistris' favour,] Mistris, feathers; F1

37 Patron to] pattern too C *conj.*; parson too M *conj.*; Patron to a new tune *or* Patron? 'Tis a new Tune Coleridge *conj.*

59 goodly] godly F1

80 be] to be L, S

82 Plague] Pl——F1–2, L, S

91 Caroached∧] ∼ , C+ (−V)

93 friend] Friend's S+

119 Plague] Pl——F1–2, L, S

127 thy] my F1+

132 fine] a fine W

132.2 Verdoone] Verdone; *Musicians* W, D

132.3 An ... Wedding] *An Epithalamium*. SONG at the Wedding F2, V; SONG at the Wedding L, S; SONG D

143 I'll] 'twill F1

144 my] *omit* F1+ (−W, D)

171 your] a F1

198 pleasures] pleasure F1–2

222 miserable∧ you,] ∼ ∧ ∼ ∧ F2, L, S, C, W; ∼ , ∼ ∧ D

245 out] *omit* S *conj.*

248 tempests] tempest F1

262 and] *omit* F1

283 be] by F2

293 Gentleman] Brett *conj.*, Gentlemen F1+

324 part] parts F1, C, W

I.ii

2 I long] long W
21 account] an account L, S

26 Oh] On F1
47 use] rise F1

I.iii

0.1 I.iii] ACT II. SCENE I. S, C
5 rest] rests S, C, W
11 delicates] dedicates F1(u)
31 'th] omit F1(u), W
39 persev'd] perceive F2 +
51 or performance] of performance

F2 + (− D, V)
70–71 honour? Yours suffers]
honours? Yours suffer F1; honours?
Yours suffers W
86 dare ∧ and instantly,] ∼ , ∼ ∼ ∧
F1–2, L, S; ∼ , ∼ ∼ , C, W, D, V

II.i

0.1 II.i] SCENE II. S, C
6 his] this F1
30 your] you F1
38–39 Italy; ... Gentleman,——] ∼
, ... ∼ ;∧ F1–2, L, S
40 your] you F1
57.1 Enter ... within.] within after
speech-prefix La-Writ, line 58, and
Enter La-Writ. after line 69 C, W,
D
100–103 follow? Cleremont. As ... man.

La-writ. I cannot fight. Cleremont.
Away, away,—— Exeunt Beaupre,
Verdone.] follow. La-w. As ...
fight. Ex. Beaup. Verdone. Cler.
Away, away, F1 + ('Away, away,'
addressed to the gentlemen S, C, W,
D)
106 enemies] Enemy's L +
115 come,] ∼ ∧ F2, L, S
140 say] saw L

II.ii

2.1 Enter La-writ.] after line 1 C, W
15 Cleremont.] Beau. F1
20 a fortune's] fortunes F2 + (− D,

V)
50 Exit La-writ.] omit F1

II.iii

21 mister] master F1, L
39 never] never yet S
38, 40 Not;] ∼ ∧ W
48 dar'st] durst S, C, W
49 make all things] makes all this F1,
C, W, V
63 tho] tho' C; though W
82 singing] omit F1
98 thy] my F1

100 an excuse] a 'scuse S
103–104 through, Laugh'd ... hooted?
your disgraces,] ∼ (∼ ... ∼) ∼
∼ ! Mason conj., W +
113 Ha∧] Ha, F1
113 swinge] swing F2, L, C, D
128 what] that F1
128 our] old Sympson conj., S
140 hunny] Hunt away F2, L

153 wrack] rack F1 + (− W, D)
155 allowed her] allowed, sir F1–2, L
170 anger] Danger S *conj*
170 hurried] honeyed Sympson *conj.*, S;

hurried to her D *conj.*
175 refus'd ∧ that,] ∼ , ∼ ∧ F1, L, S;
 ∼ ∧ ∼ ∧ F2
195 the greater] and the greater S

III.i

14 or] and S, C
29 Innocence] Innocent F1 +
63–64 shun'd ... or ... these?] shun'd
 ... or ... these: F1, V; shun'd not
 ... or ... these: F2, L, S, C; shunn'd

... nor ... these. D
69 our] your F2, L, S
81 deserve] desire W
83 me] me, Sir S, C

III.ii

4 unable] an unable S
9 Nephew] a nephew W
47–48 *Gentleman. ... La-writ.*] *omit*
 F1 +
47 lesse] else F2, L, S
64 spittle] Splitter S
81 and] *omit* S
93 I talk'd] Talk'd L, S
97 ye] you F2 + (− V)
104 *admirantis,*] *omit* Anon. *conj.*, S
121 do] *omit* F1

125 corner] part F2, L, S
129 Louver] louer F1
147 mad man] Mad-man F2, L, S, C
148 peice——if] peice——of F1;
 peice of——F2 +
153 laughter] laughters F1
171 hate] hates F2 +
173 my] the F2 + (− D, V)
177 carriage] Courage F2, L, S
177 calls] call F2, L, S, C
188 your] you F2, L, S

III.iii

4 fort] for't F1
13 wake] make F1
15 Will] Till F1 +
18 our] your L, S
19 to] do F2 + (− D, V)
39 feed] fed F2 + (− D, V)
52 *Enter* Champernell *privately.*] *omit*
 D
53.1 *Exeunt. Manet* Champernell.]
 Exeunt F1 + (− C, W)
53.2 SCENE IV. *marked by* D, V *before*
 Nurse's *entrance.*
53.3 *things.*] things. | *Enter* Champer-
 nell. D, V
61 mine] meane F1, V
70 pray'e] pray L, S, C

70–71 in ∧ ... Mistris,] ∼ ∧ ... ∼ ∧
 F1; ∼ , ... ∼ , F2, L, S, W; ∼ ; ...
 ∼ , D, V
72 servant,] servant, *Wine.* F1, V
74 but ∧] not ∧ F2, L; not; S
76 engag'd, a little now;] engag'd, A
 little now, now; F1–2, L, S;
 engaged. A little; now, now! C +
77 you] ye F2, L
78 lowd? pretious,] ∼ , ∼ ? F2, L, S,
 C; ∼ ? ∼ ! W, D
87 'Twill] I will F1–2, L, S, C, W
88 not,] F2; not, *Recorders.* F1, V
92 Plague] Pl——F1–2, L, S
98 pox ∧] ∼ , F1
106 dam] damn C, W, D

115 *Musick againe.*] *The Recorders
 againe.* after line 110 F1 +
115 heart] God's heart C, W; hark C
 conj.
117 end.] end. [*Exit above.*] D
118 *Musick done.*] after line 125 F1 +
121 feare. Yet∧] fear∧ yet: D
123 bloods] blood F2, L, S

125 knewest] knowest F1
125 *Cleremont.* Peace] *Re-enter* Clere-
 mont *above.* | *Cleremont.* Peace D
130 larums] Alarms F2, L
130 quarter] quarters F2 + (−V)
131 off,] ∼ ; F1 +
131 courses] Coarses S + (−V)
132 Plague] Pl——F1 + (−C, W, D)

III.iv

III.iv] III.iii *continues* W; SCENE V. D,
 V
 0.1 *with a light*] *A light within.* F1–2,
 L, S, C, V
 1 ye] you F2 + (−V)
 4 and fool ... thee.] a fool ... thee
 man∧ F1
 4 thee] thee man F1
 5 No] Nay F2 + (−D, V)
 20 flaw] flame F1
 23 vild] wild F1 + (−D)
 23 a] of F1
 28 you] thou F2, L, S
 47 Your] For your S; Your own D
 conj.
 57 Plague] Pl——F1 + (−C, W, D)

 60 paint] point F1
 62 you?] you? *Noises within.* S *conj.*, C,
 W
 63 What ... you?] *assigned to* Dinant
 F1 + (−D, V)
 63 noise, is there∧] ∼ , ∼ ∼ , F1; ∼
 ∧ ∼ ∼ ? D, V
 76.1 Verdoone.] Verdoone, Lamira
 F1 + (−D)
 76.1 Anabel,] *omit* W
 92 Not∧] ∼ , C, W, D
 97 handsome∧] ∼ , F2, L, S
 104 rogue,∧] ∼ !——W
 112 be a Mistris] have a Mistress S; be a
 Mistress's Sympson *conj.*; be a
 mistress' V *conj.*

IV.i

 5 enough] *omit* Sympson *conj.*, S

IV.ii

 11 die] dies F2

IV.iii

 9 And] Any W

 13 Fy] Hey S; Fly S *conj.*, C, W

IV.iv

 9 I'de] I F1 +
 24 *Cleremont.* A strange Antipathy,
 what] A strange Antipathy, | *Cler.*

 What F1–2, L
 36 of] *omit* S
 37 gentleman] gentlemen F1 +

457

47.1 *Put off.*] *omit* F2 + (− V)
75 plague] Pl——F1–2, L, S
79–80 em, ... when,] ~ —— ... ~
—— S + (− V)
81 yeare] fear W
107 Firsts? seconds? thirds] First,

second, third F2 + (− D, V)
107 plague] pl——F1–2, L, S
117 plague] p——F1; pl——F2, L, S,
V; pox D
130 run ∧ now,] ~ , ~ ∧ F1–2, L, S

IV.v

2 horse] hrose F1(u); herse F1(c)
6 devising] musing F2, L, S, C

15 *Musicke within.*] *Cornet.* | *Musicke
within.* F1 + (− D)

IV.vi

1 *way, come* ∧] ~ ∧ ~ ∧ ~ F2, L, S;
~ ∧ ~ , C, W, D
8.1 *Musicke ends.*] '*Mus. ends.*' *after
intended.* IV.v.32 F1 +
18 *Still Musick*] *Music continues* C, W;
Music D
19 misse; ... businesse,] ~ , ... ~ ,
F1–2, L, S; ~ ∧ ... ~ ; V
20 *Musick ... Dance.*] *omit* C, W, D
22 *Lamira.* Begin. | *1 Gentleman.* And]
Lam. Begin, and F1; Begin, and
F2 +
22 *Dance.*] *after* instructed. *line* 23
F1 +
23 *1 Gentleman.* Now.] *without speech-
prefix,* '*Now.*' *as stage-direction after*
fairely——F1; *omit* F2, L, S; *conti-
nued to 2 Gentleman* C
29–30 my Nag, My legs on ... horse]
my legs, My legs in ... house F1;
my legs, Or ... Horse F2, L, S, C;
My legs on ... horse W +

31 to] too, F1–2, L
44 yet if] yet are, if F1; yet if you are
F2 +
55 suck'd ∧ I knew] suck'd ∧ I know
F1; suck'd, I know F2 +
85 scorn'd] scorne F1
85 know] knows F1
90 them] then L
91 can ∧] ~ . V
105 why ∧] ~ ? F1–2, L, S; ~ ——
C +
133 gusts] Justs S
134 but that] *La-writ.* Bee't then. F1
136 *La-writ*] *Sam* F1
144 *Strike*] *Strikes* F2 + (− V)
146 *Champernell.* No ... not;——doe]
No ... not. *Cham.* Doe F1
146 No, no, no] No, no L, S
184 noble man] nobleman C +
189 Gentleman] Gentlemen F1 +
(− W, D)

IV.vii

10 meditate] mediate L
12 will kisse] will L, S
25 shalt] shall F1
30 are,] ~ ∧ F1 +
32 *bound, by ... Gentlemen.*] '*bound.
By ... Gent.*' *after* object. *line* 31
F1(c) + ; '*By... Gent.*' *after line* 32

F1(u)
33 these] thee F1 +
36 in digestion] indigestion F1
39 to ∧] too, F1 + (− D, V)
40–41 *1 Gentleman ... Dinant*] *Din.
... om.* V
68 *Corinna*] Corvina F1

458

V.i

0.2 *Chamber*] omit F2 + (− D, V)

0.2 *in*] *within* S

0.3 *exit.*] *exit. Enter Lamira* and *Annabell.* D

1 shake, ... night,] ~ ∧ ... ~ ! F2, L, S, C; ~ ! ... ~ , M *conj.*

4 Divells ∧ forme,] ~ ∧ ~ ∧ F1–2, L; ~ , ~ ∧ C

4 Divells] Devil's S, W, D; devils' V

8 *Musick.*] *Musick.* | *Sackbut and Troup musick.* F1 + (− D)

10 hollow?] ~ , F1 +

11 *Lowder.*] omit L, S

11 us.] us. *Theeves peeping.* F1 + (− D)

14 losse—— Peepe. | looke] losse— —peepe——, looke F1; loss—— look F2, L, S

20 woot,] ~ ∧ F2 + (− V)

21 thus] this F1

29 It] I F2, L, S

39 thousand ∧ so,——] ~ , ~ ∧ —— —C; ~ , ~ . ∧ W, D

50 cousen] cause F1(u); coose F1 (c); Couz F2 +

58 not] not do it S, C

71–72 Is it ... Is it] It is ... It is F1(u)

74 *Gentleman*] 2 *Gent* W, D

82 *Gentleman*] 2 *Gent* W, D; 1 *Gent* V

85 *Gentleman*] *First Gent* D, V

85.1 Verdoone] *Verta.* F1

88 their] that W

92–93 sinkes? | *Anabell.* If] sinkes if F1–2, L, S, C, W

97 softly,] ~ ∧ W

98 now] how F1–2, L, S, C, W

100 you] you dare S, C

114 or] omit L, S

116 ways] way F2, L, S, C

119 tongue-valiant,] tongue, valiant ∧ F1–2, L

119 glorious] and vain-glorious S, C

124 of] O F2, L, S

126 Never ∧ beleef ∧] ~ , ~ , C, W

128 next ∧ ... resolved,] ~ , ... ~ ∧ F1; ~ , ... ~ , F2, L, S; ~ ; ... ~ . C, W, D, V

156 is] omit F1

172 *Kisse*] *Kisses them* W; *The two Gentlemen kiss Lamira* D

175 these] Those V

184 sav'd] save F1

193 takes] take C, W

216 Monsiers ∧] *Monsier,* F1–2; Monsieur ∧ L +

230 *Dinant.* ... enjoy] omit ... enjury F1

V.ii

3 martiall] mortall F1

10 have] have it W

10–11 beare it ∧ ...me,] ~ ~ , ... ~ ∧ C, W, D, V

21 put] try to put S, C, W

34 thine] mine F1, V

35 Cozen] Cousin F2

46 my] thy V *conj.*

49 chearly] chearily F2, L, S

V.iii

19 Fare well] Farewell F1 + (− C, D)

25 On] O F2

27 And] and I V

30 beset] to be set F1(u)

37 *Vertaigne.*] *Verd.* F2, L, S

53 it] omit V

THE ELDER BROTHER

edited by

FREDSON BOWERS

TEXTUAL INTRODUCTION

The Elder Brother (Greg, *Bibliography*, no. 515) first appears in surviving records of performances in 1635; John Greene saw it in February of that year and Sir Humphrey Mildmay on 25 April (G. E. Bentley, *Jacobean and Caroline Stage*, I, 110). However, Professor Bentley agrees with Fleay that Fletcher must have composed the play 'in January 1624/5, or shortly thereafter' since the reference to 'blew *Neptune* courting of an Iland,|Where all the perfumes and the pretious things|That waite upon great Nature are laid up . . .' (IV.iii.53–5) fits 'precisely the action in Jonson's *Neptune's Triumph* . . . prepared for Twelfth Night 1623/4' and 'reused in *The Fortunate Isles and Their Union*, which was performed at court 9 January 1624/5 and published about the same time' (III, 334–5). Because the theatres were closed on account of plague from late March 1625, until December, the play could not have been acted until after Fletcher's death in August 1625, which sad event is alluded to in both the Prologue and the Epilogue. Greg was convinced that Fletcher 'left the play unfinished at his death, and that it was completed by Massinger at some date probably not much before 1637' (*Variorum*, II, 3). Professor Bentley, on the other hand, finds it 'impossible to believe that so valuable a commodity as a Fletcher play – and one which was to prove so popular as this one – would have been left unexploited for ten years or so by the canny King's men'; he points out that the division of labour between Massinger (Acts I and V) and Fletcher (II–IV) is normal and 'offers no evidence at all that Massinger finished what Fletcher left incomplete' (III, 335). The linguistic evidence, however, convinced Cyrus Hoy that the text is 'a Fletcherian original, the first and last acts of which have been virtually rewritten by Massinger' (*Studies in Bibliography*, IX, 154), and if the play were in fact first produced in the mid 1620s it is perhaps odd that no evidence of performance at that time has come to light. This edition therefore accepts Mr Hoy's opinion, assuming that Massinger's work was done a few years earlier than Greg thought. The early history of the text seems to resemble that of *A Very Woman* (for which see vol. VII, pp. 642–5, of this series).

The Elder Brother was performed at Court on 5 January 1637 and that performance very likely triggered its entry in the Stationers' Register on 24 March 1637 and its first edition (Q1) in the same year, printed by Felix Kingston for John Waterson and John Benson, who had jointly entered for the copy. A second edition (Q2), also dated 1637, reprints Q1; Greg labels it a piracy of uncertain date but before 1661, when a later edition (Q4) used it as copy. In 1650–1 a third edition (Q3), calling itself the second and advertising that it was corrected and emended, was published by Humphrey Moseley. As Greg observes, 'This edition was printed from [Q1] but, as implied on the title, the text was revised from some other source. It may be earlier than [Q2].' A fourth edition (Q4) was printed without publisher's name in 1661, part of a series of 'fraudulent or suspicious reprints issued by Francis Kirkman and his associates about this year', in Greg's words. In 1678 Q5, lined as prose, was printed by Thomas Newcombe for Dorman Newman and (possibly) Thomas Cockerill. The seventeenth-century publishing history is concluded by the play's appearance in the 1679 Beaumont and Fletcher Folio (F2). Q2 was typeset directly from Q1, Q3 from an annotated copy of Q1, Q4 from Q2, Q5 from Q4, and F2 from Q5.

A manuscript (British Library MS Egerton 1994), speculatively dated 1630–40, is described by Greg (*Dramatic Documents from the Elizabethan Playhouses*, pp. 334–7). This consists of twenty-eight leaves (in poor condition) containing the text of the play followed by three short poems in the same hand. Greg characterizes the hand as 'not markedly professional, but probably that of a scribe'. If it is scribal work, the transcript is remarkably careless and free, with many verbal substitutions for what were probably the readings of its source. Nevertheless, since it is clearly a favour copy for a person of some importance, the likelihood of that person's having copied the play himself is minimal, although he must have provided the copyist with the three poems that conclude the manuscript. The date may actually be *circa* 1635, when the first evidence of the play's performance appears.

Nothing can be more speculative than an attempt to reconstruct the copy for an early play text represented in multiple versions; nevertheless, some few propositions may be stated about *The Elder*

Brother. Despite wide variation in many readings, MS and Q1 are closer to each other than either is to the Q3 text. Q3, 'corrected and emended', taps into a slightly different tradition. Some of the Q3 variants, such as the hypermetrical interjection at IV.iv.79, must come from some manuscript copy, as must a number of the Q3 single-word variants, but other differences were caused by carelessness or haste, especially in V.ii, the final scene, when the scribe, eager to finish his work, did not trouble to reproduce accurately the variant readings of his MS source. Thus a certain amount of inadvertent as well as intentional 'improvement' of the text originated with the annotator responsible for the Q3 variations from its copy, Q1.

The origin and authority of these variants then come in question. Although there is no demonstrable influence of a prompt-book on the Q3 readings, the odds are long that the variants derive from collation with the 1635 prompt-book (probably in its 1637 form, if that differed). It was Humphrey Moseley who published Q3, and Moseley, having collected copy for his 1647 Folio, in 1651 would have had available such a prompt-book as those from which a number of the F1 texts descend. Moreover, since the Q3 text differs in various particulars from the text behind MS and Q1, these versions could not have derived from the prompt-book (as one would scarcely have expected) but from Massinger's manuscript or an intermediate transcript of his papers made in preparation for the prompt-book. For example, if a copy of the play were loaned by the King's Men for the transcribing of the favour MS, it would probably not have been the prompt-book that was allowed to leave the theatre. If this loan manuscript, having served as the original of the favour manuscript, then reached Waterson and Benson, perhaps even by direct sale from the company eager to take advantage of the publicity aroused by the Court performance, it would most naturally have become the copy for Q1. On this hypothesis, such of the Q3 variants as are authentic would have originated with revisions made either in a pre-prompt-book manuscript or else with the copying of that manuscript into the prompt-book. These alterations may have been Massinger's or the company scribe's, but they cannot in any way have been Fletcher's, as this stemma shows:

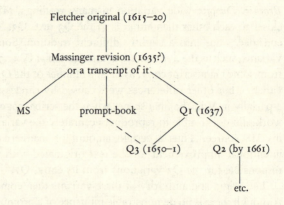

Thus not all Q3 variation from Q1 need be Massinger's. Since the base copy for MS and the source of the Q3 annotations differ, it follows that agreement of Q3 and MS against Q1 exposes a Q1 reading of lesser authority or a downright error. Agreement of Q3 and Q1 against MS is less significant owing to the strong possibility that the Q3 annotator missed some variants in the copy he was collating and thus perpetuated the Q1 reading. When unique MS readings seem indubitably superior, concurrence of Q1 and Q3 is probably due to a slip by the annotator. Agreement of MS and Q1 against Q3 reveals either a Q3 printer's error, the annotator's unauthoritative marking of his copy, or else a genuine Massinger revision of his own work or of the underlying Fletcher text.

Although Massinger's major revision was confined to Acts I and V, it may be expected that he would alter the Act II–IV text whenever he preferred some word or phrase of his own. It is this general but limited working-over of copy that is referred to in the Textual Notes as the 'revision' of the text. The copy for Acts I and V seems to have contained Massinger's relatively sweeping revision of the Fletcher original, and this revision must be differentiated from whatever textual variation resulted from the preservation of Fletcher's own work within the revision of Acts I and V.

The following editorial situation results. Q1 becomes the copy-text since MS is in various degrees corrupt. Since the present edition endeavours to recover as much of Fletcher's text as possible, it attempts to distinguish in the Q3 variants between those deriving

from Fletcher's original and those deriving from Massinger's alterations. The concurrence of MS with Q1 against Q3 is useful in this process, being taken generally as identifying Massinger's later 'revision' both of his own text in Acts I and V and of Fletcher's in Acts II–IV. The agreement also exposes errors made in the annotation or during the course of printing. In these circumstances the Q3 variant is ordinarily rejected. Correspondingly, the agreement of MS and Q3 against Q1, which occurs less frequently, has generally been taken to expose an unauthoritative reading in Q1. But if the annotator failed to alter the Q1 copy when the prompt-book differed, Q3 preserves the unauthoritative Q1 reading. Then the MS variant would be authoritative were it not that the validity of the unique MS readings generally appears to be low. Hence in only a few cases has it been possible to accept a MS reading on the grounds that a Q1 reading of no or low authority went unchanged. Mostly these are obvious readings. But a few unique lines from MS have been accepted when there was more reason to believe that Q1 was wrong (and Q3 did not correct) than that the MS was the inventing text. Such an occurrence comes, for example, in V.ii.35 (see the Textual Note) where eyeskip – as hypothesised also in IV.iv.56 – is probable.

As a general rule Q1 is carefully printed. Either the copyist or the printer styled the text differently in some respects from the usual commercial play quarto. For example, until in the latter part of the play when he reverted to normality, he omitted '*Enter*' in opening stage-directions and in the European manner merely listed the names of the characters, the initial speech-prefix wanting but the speech identifiable as that of the first-named. In the entrance-directions the names are in small capitals with a heading capital, a departure from the popular convention of italics. Either the copy had few stage-directions or the copyist omitted them. Since Q3 supplies no further directions, unique directions in MS have been introduced into this edition.

The copy-text is Q1, the Henry E. Huntington Library copy of that edition having been compared with the British Library copy. No press-variants were found. The Huntington Library copy of Q3 was used. British Library MS Egerton 1994 was consulted in microfilm.

THE SPEAKERS OF THE PLAY

LEWIS, *a Lord.*
MIRAMONT, *a Gentleman.*
BRISAC, *a Justice, brother to* Miramont.
CHARLES, *a Scholar.* } *Sonnes to* Brisac.
EUSTACE, *a Courtier.*
EGREMONT, } *two Courtiers, Friends to* Eustace.
COWSY,
ANDREW, *Servant to* Charles.
COOKE, } *Servants to* Brisac.
BUTLER,
PRIEST.
NOTARY.
SERVANTS.
OFFICERS.

ANGELLINA, *Daughter to* Lewis.
SYLVIA, *her Woman.*
LILLY, *Wife to* Andrew.
LADIES.

[Scene: France]

Lectori.

Would'st thou all wit, all Comicke art survay?
Reade here and wonder; FLETCHER *writ the Play.*

Prologue.

But that it would take from our modesty,
To praise the Writer, or the Comedie,
Till your faire suffrage crowne it: I should say,
Y'are all most welcome to no vulgar Play;
And so farre we are confident: And if he
That made it, still lives in your memory;
You will expect what we present to night,
Should be judg'd worthy of your eares and sight.
You shall heare Fletcher *in it; his true straine,*
And neate expressions; living he did gaine 10
Your good opinions; But now dead commends
This Orphan to the care of noble friends:
And may it raise in you content and mirth,
And be receiv'd for a legitimate birth.

 Your grace erects new Trophies to his fame,
 And shall to after times preserve his name.

THE ELDER BROTHER.
A COMEDIE.

Lewis. Nay, I must walke you farther.
Angellina. I am tyr'd Sir,
 And nere shall foot it home.
Lewis. Tis for your health;
 The want of exercise takes from your beauties,
 And sloth dries up your sweetnesse: That you are
 My onely Daughter and my heire, is granted;
 And you in thankfulnesse must needs acknowledge,
 You ever finde me an indulgent Father,
 And open handed.
Angellina. Nor can you taxe me, Sir,
 I hope, for want of duty to deserve
 These favours from you.
Lewis. No, my *Angellina*, 10
 I love and cherish thy obedience to me,
 Which my care to advance thee, shall confirme;
 All that I aime at, is to winne thee from
 The practise of an idle foolish state
 Us'd by great Women, who thinke any labour,
 (Though in the service of themselves) a blemish
 To their faire fortunes.
Angellina. Make me understand Sir,
 What 'tis you point at.
Lewis. At the custome how
 Virgins of wealthy families, waste their youth;
 After a long sleepe, when you wake, your woman 20
 Presents your breakfast, then you sleepe againe,
 Then rise, and being trimm'd up by others hands,
 Y'are led to dinner, and that ended, either
 To Cards or to your Couch (as if you were

*24 Couch] *stet* Q1

471

Borne without motion): After this to Supper,
And then to bed; And so your life runnes round
Without variety or action Daughter.
Sylvia [*aside*]. Here's a learned Lecture!
Lewis. From this idlenesse
Disease both in body and in minde
Grow strong upon you; where a stirring nature 30
With wholsome exercise guards both from danger:
I'de have thee rise with the Sunne, walke, daunce, or hunt,
Visite the groves and springs, and learne the vertues
Of Plants and Simples: Doe this moderately,
And thou shalt not with eating chalke, or coales,
Leather and oatmeale, and such other trash,
Fall into the greene sicknesse.
Sylvia. With your pardon
(Were you but pleas'd to minister it) I could
Prescribe a remedy for my Ladies health,
And her delight too, farre transcending those 40
Your Lordship but now mention'd.
Lewis. What is it *Sylvia?*
Sylvia. What is't? A noble Husband; In that word,
A noble Husband, all content of Woman
Is wholly comprehended; He will rowse her,
As you say, with the Sunne, and so pipe to her,
As she will daunce, ne're doubt it, and hunt with her,
Upon occasion, untill both be weary;
And then the knowledge of your Plants and Simples,
As I take it, were superfluous; A loving,
And but adde to it a gamesome Bedfellow, 50
Being the sure Physician.
Lewis. Well said Wench.
Angellina. And who gave you Commission to deliver
Your verdict, Minion?
Slyvia. I deserve a fee,
And not a frowne, deare Madam; I but speake
Her thoughts, my Lord, and what her modesty
Refuses to give voyce to; Shew no mercy
To a Maidenhead of fourteene, but off with't:

Let her loose no time Sir; fathers that deny
Their Daughters lawfull pleasures, when ripe for them,
In some kindes edge their appetites to taste of 60
The fruit that is forbidden.
Lewis. Tis well urg'd,
And I approve it; no more blushing Girle,
Thy woman hath spoke truth, and so prevented
What I meant to move to thee: There dwelles neere us
A Gentleman of blood, Monsieur *Brisac*,
Of a faire state, sixe thousand Crownes *per annum*,
The happy Father of two hopefull Sonnes,
Of different breeding; Th'elder, a meere Scholar,
The younger, a queint Courtier.
Angellina. Sir, I know them
By publique fame, though yet I never saw them; 70
And that oppos'd antipathy betweene
Their various dispositions, renders them
The generall discourse and argument;
One part inclining to the Scholar *Charles*,
The other side preferring *Eustace*, as
A man compleat in Courtship.
Lewis. And which way
(If of these two you were to chuse a husband)
Doth your affection sway you?
Angellina. To be plaine, Sir,
(Since you will teach me boldnesse) As they are
Simply themselves, to neither; Let a Courtier 80
Be never so exact, Let him be blest with
All parts that yeeld him to a Virgin gracious,
If he depend on others, and stand not
On his owne bottomes, though he have the meanes
To bring his Mistresse to a Masque, or by
Conveyance from some great ones lippes, to taste
Such favour from the kings; or grant he purchase,
Precedency in the Country, to be sworne
A servant Extraordinary to the Queene;

*59 pleasures] MS, Q3; pleasure Q1–2 *60 kindes] *stet* Q1
*84 bottomes] *stet* Q1

473

Nay, though he live in expectation of 90
Some huge preferment in reversion; If
He want a present fortune, at the best
Those are but glorious dreames, and onely yeeld him
A happinesse in *posse*, not in *esse*;
Nor can they fetch him silkes from th' Mercer; nor
Discharge a Taylors bill; nor in full plenty
(Which still preserves a quiet bed at home)
Maintaine a family.

Lewis. Aptly consider'd,
And to my wish, but what's thy censure of
The Scholar?

Angellina. Troth (if he be nothing else) 100
As of the Courtier; all his Songs, and Sonnets,
His Anagrams, Acrosticks, Epigrammes,
His deepe and Philosophicall discourse
Of natures hidden secrets, makes not up
A perfect husband; he can hardly borrow
The Starres of the Celestial crowne to make me
A tire for my head; nor *Charles* Waine for a Coach,
Nor *Ganimede* for a Page, nor a rich gowne
From *Juno's* Wardrobe, nor would I lye in
(For I despaire not once to be a mother) 110
Under heavens spangled Canopy, or banquet
My guests and Gossips with imagin'd Nectar,
Pure *Orleans* would doe better; no, no, father,
Though I could be well pleas'd to have my husband
A Courtier, and a Scholar, young, and valiant,
These are but gawdy nothings, If there be not
Something to make a substance.

Lewis. And what's that?
Angellina. A full estate, and that said, I've said all,
And get me such a one with these additions,
Farewell Virginity, and welcome wedlocke. 120
Lewis. But where is such one to be met with Daughter?
A blacke Swan is more common, you may weare
Grey tresses ere we finde him.
Angellina. I am not

So punctuall in all ceremonies, I will bate
Two or three of these good parts, before Ile dwell
Too long upon the choice.
Sylvia. Onely, my Lord, remember
That he be rich and active, for without these,
The others yeeld no rellish, but these perfect;
You must beare with small faults, Madam.
Lewis. Merry Wench,
And it becomes you well; Ile to *Brisac*, 130
And try what may be done; ith' meane time, home,
And feast thy thoughts with th' pleasures of a Bride.
Sylvia. Thoughts are but airy food Sir, let her taste them.

 Exeunt.

 [*Enter*] ANDREW, COOKE, BUTLER. I.ii

Andrew. Unload part of the Library, and make roome
For th'other dozen of Carts, Ile straight be with you.
Cooke. Why, hath he more bookes?
Andrew. More than ten Marts send over.
Butler. And can he tell their names?
Andrew. Their names? he has 'em
As perfect as his *pater noster*, but that's nothing,
'Has read them over leafe by leafe three thousand times;
But here's the wonder, though their weight would sinke
A Spanish Carracke, without other ballast,
He carryeth them all in his head, and yet
He walkes upright.
Butler. Surely he has a strong braine. 10
Andrew. If all thy pipes of wine were fill'd with bookes
Made of the barkes of trees, or mysteries writ
In old moth-eaten vellam, he would sip thy Celler
Dry, and still be thirsty; Then for's Diet,
He eates and digests more Volumes at a meale,
Than there would be Larkes (though the sky should fall)
Devowr'd in a moneth in *Paris*; yet feare not

133.1 *Exeunt.*] MS; *omit* Q1–3 0.1 ANDREW] MS, Q3; *omit* Q1
3 Why,] F2; ~ ∧ Q1–3, MS 14 Dry] MS, Q3; Quite dry Q1–2

Sonnes oth' buttry, and kitchin, though his learn'd stomacke
Cannot b'appeas'd, hee'll seldome trouble you,
His knowing pallat contemnes your blacke Jackes, *Butler*,　　20
And your Flagons, and *Cooke* thy boyl'd, thy roast, thy bak'd.
Cooke.　　How liveth he?
Andrew.　　　　　　　Not as other men doe,
　　Few Princes fare like him; He breakes his fast
　　With *Aristotle*, dines with *Tully*, takes
　　His watering with the Muses, suppes with *Livie*,
　　The walkes a turne or two in *via lactea*,
　　And (after six houres conference with the starres)
　　Sleepes with old *Erra Pater*.
Butler.　　　　　　This is admirable.
Andrew.　　I'le tell you more hereafter, here's my old Master
　　And another old ignorant Elder, Ile upon 'em.　　30

Enter BRISAC, LEWIS.

Brisac.　　What *Andrew*? welcome, where's my *Charles*? speake
　　Andrew,
　　Where didst thou leave thy Master?
Andrew.　　　　　　　　Contemplating
　　The number of the sands in the high way,
　　And from that, purposes to make a judgement
　　Of the remainder in the Sea; He is Sir,
　　In serious study, and will lose no minute
　　Nor out of's pace to knowledge.
Lewis.　　　　　　　This is strange.
Andrew.　　Yet he hath sent his duty Sir before him
　　In this faire manuscript.
Brisac.　　　　　　What have we heere?
　　Pothookes and Andirons!
Andrew.　　　　　　I much pitie you,　　40
　　It is the Syrian Character, or the Arabicke,
　　Would'ee have it said, so great and deepe a Scholar
　　As Master *Charles* is, should aske blessing
　　In any Christian Language? Were it Greeke,
　　I could interpret for you, but indeed

*20 pallat] MS; stomacke Q1–3

476

I'm gone no farther.

Brisac. And in Greeke you can
Lie with your smug wife *Lilly*.

Andrew. If I keepe her
From your French dialect, as I hope I shall Sir,
Howere she is your Laundresse, she shall put you
To th' charge of no more soape than usuall 50
For th' washing of your sheets.

Brisac. Take in the knave,
And let him eat.

Andrew. And drinke too, Sir?

Brisac. And drinke too, Sir,
And see your Masters Chamber ready for him.

Butler. Come Doctor *Andrew*, without Disputation
Thou shalt commence ith' Celler.

Andrew. I had rather
Commence on a cold bak'd meat.

Cooke. Thou shalt ha't, Boy.

Exeunt [Butler, Cooke, Andrew].

Brisac. Good Monsieur *Lewis* I esteeme my selfe
Much honour'd in your cleare intent, to joyne
Our ancient families, and make them one,
And 'twill take from my age and cares to live 60
And see what you have purpos'd put in act,
Of which your visite at this present is
A hopefull Omen; I each minute expecting
Th'arrivall of my Sonnes; I have not wrong'd
Their Birth for want of meanes and education,
To shape them to that course each was addicted;
And therefore that we may proceed discreetly,
Since what's concluded rashly seldome prospers,
You first shall take a strict perusall of them,
And then from your allowance, your faire daughter 70
May fashion her affection.

Lewis. Monsieur *Brisac*,
You offer faire, and nobly, and Ile meet you
In the same line of honour, and I hope,

Being blest but with one daughter, I shall not
Appeare impertinently curious,
Though with my utmost vigilance and study,
I labour to bestow her to her worth;
Let others speake her forme, and future fortune
From me descending to her; I in that
Sit downe with silence.
Brisac. You may my Lord securely, 80
Since fame alowd proclaimeth her perfections,
Commanding all mens tongues to sing her praises;
Should I say more, you well might censure me
(What yet I never was) a Flatterer. *Trampling.*
What trampling's that without of Horses?

Enter BUTLER.

Butler. Sir my young Masters are newly alighted. [*Exit.*]
Brisac. Sir now observe their severall dispositions.

Enter CHARLES.

Charles. Bid my Subsiser carry my Hackney to the Buttry,
And give him his bever; it is a civill
And sober beast, and will drinke moderately, 90
And that done, turne him into the quadrangle.
Brisac. He cannot out of his University tone.

Enter EUSTACE, EGREMONT, COWSY.

Eustace. Lackey, take care our Coursers be well rubb'd,
And cloath'd, they have outstripp'd the winde in speed.
Lewis. I marry Sir, there's metall in this young fellow!
What a sheepes looke his elder brother has!
Charles. Your blessing, Sir? [*Kneeles.*]
Brisac. Rise *Charles*, thou hast it.
Eustace. Sir, though it be unusuall in the Court,
(Since 'tis the Countries garbe) I bend my knee, [*Kneeles.*]
And doe expect what followes.
Brisac. Courtly begg'd. 100
My blessing! take it.

Eustace. Your Lordships vow'd adorer:——— *To* Lewis.
　　What a thing this brother is! yet Ile vouchsafe him
　　The new Italian shrug——How clownishly
　　The book-worme does returne it.
Charles. I'm glad y'are well.

　　　　　　　　　　　　Plucks out a book and reades.

Eustace.　Pray you be happy in the knowledge of
　　This paire of accomplish't Monsieurs.
　　They are Gallants that have seene both Tropicks.
Brisac.　I embrace their loves.
Egremont. Which wee'll repay with service.
Cowsy.　And will report your bounty in the Court.
Brisac.　I pray you make deserving use on't first: 110
　　Eustace give entertainment to your friends,
　　What's in my house is theirs.
Eustace. Which wee'l make use of;
　　Let's warme our braines with halfe a dozen healths,
　　And then hang cold discourse, for wee'll speake fire-works.

　　　　　　　　　　Exeunt [Eustace, Egremont, Cowsy].

Lewis.　What at his booke already?
Brisac. Fye, fye, *Charles.*
　　No houre of interruption?
Charles. *Plato* differs
　　From *Socrates* in this.
Brisac. Come lay them by;
　　Let 'em agree at leasure.
Charles. Mans life Sir, being
　　So short, and then the way that leades unto
　　The knowledge of our selves, so long and tedious, 120
　　Each minute should be precious.
Brisac. In our care
　　To manage worldly businesse, you must part with
　　This bookish contemplation, and prepare
　　Your selfe for action; to thrive in this age,

104.1 *Plucks ... reades.*] MS; *reades.* Q1–3 *108 service] MS, Q3; servulating Q1–2
*121 our] *stet* Q1

Is held the palme of learning; you must study
To know what part of my land's good for th' plough,
And what for pasture, how to buy and sell
To the best advantage, how to cure my Oxen
When they're oregrowne with labour.
Charles. I may doe this
From what I've read Sir; for what concernes tillage? 130
Who better can deliver it than *Virgil*
In his *Georgicks?* and to cure your heards,
His *Bucolicks* is a masterpeece; but when
He does describe the Commonwealth of Bees,
Their industry and knowledge of the hearbs,
From which they gather honey, with their care
To place it with *decorum* in the Hive,
Their government among themselves, their order
In going forth and comming loaden home,
Their obedience to their King, and his rewards 140
To such as labour, with his punishments
Onely inflicted on the slothfull Drone,
I'm ravished with it, and there reape my harvest,
And there receive the gaine my Cattell bring me,
And there finde wax and honey.
Brisac. And grow rich
In your imagination, heyday, heyday,
Georgicks, and *Bucolicks*, and Bees! Art mad?
Charles. No Sir, the knowledge of these guard me from it.
Brisac. But can you finde among your bundle of bookes,
(And put in all your Dictionaries that speake all tongues) 150
What pleasures they enjoy, that doe embrace
A well shap'd wealthy Bride? Answer me that.
Charles. Tis frequent Sir in story, there I read of
All kinde of vertuous and vitious women,
The ancient Spartan Dames, and Roman Ladyes,
Their beauties, and deformities, and when
I light upon a *Portia* or *Cornelia*,
Crown'd with still-flourishing leaves of truth and goodnesse,
With such a feeling I peruse their fortunes,

*133 *Bucolicks*] stet Q1

480

As if I then had liv'd, and freely tasted 160
Their ravishing sweetnesse; at the present loving
The whole sexe for their goodnesse and example.
But on the contrary when I looke on
A *Clytemnestra* or a *Tullia*,
The first bath'd in her husbands blood; The latter,
Without a touch of piety, driving on
Her Chariot ore her fathers breathlesse trunke;
Horrour invades my faculties; and comparing
The multitudes o' th' guilty, with the few
That did dye Innocents, I detest, and loathe'm 170
As ignorance or Atheisme.
Brisac. You resolve then
Nere to make payment of the debt you owe me.
Charles. What debt, good Sir.
Brisac. A debt I paid my father
When I begat thee, and made him a Grandsire,
Which I expect from you.
Charles. The children Sir,
Which I will leave to all posterity,
Begot and brought up by my painefull studies,
Shall be my living issue.
Brisac. Very well,
And I shall have a generall collection
Of all the quiddits from *Adam* to this time 180
To be my grandchilde.
Charles. And such a one I hope Sir,
As shall not shame the Family.
Brisac. Nor will you
Take care of my estate.
Charles. But in my wishes,
For know Sir, that the wings on which my Soule
Is mounted, have long since borne her too high
To stoope to any prey, that soares not upwards.
Sordid and dunghill mindes compos'd of earth,
In that grosse Element fixe all their happinesse;
But purer spirits, purg'd and refin'd, shake off

165 latter] Q2–3, MS; later Q1

That clog of humane frailty; give me leave 190
T'enjoy my selfe, that place that does containe
My Bookes (the best Companions) is to me
A glorious Court, where howrely I converse
With the old Sages and Philosphers,
And sometimes for variety, I conferre
With Kings and Emperours, and weigh their Councels,
Calling their Victories (if unjustly got)
Unto a strict accompt, and in my phancy,
Deface their ill plac'd Statues; Can I then
Part with such constant pleasures, to imbrace 200
Uncertaine vanities? No, be it your care
T'augment your heape of wealth; It shall be mine
T'encrease in knowledge.——Lights there for my study. *Exit.*

Brisac. Was ever man that had reason thus transported
From all sense and feeling of his proper good?
It vexes me, and if I found not comfort
In my young *Eustace*, I might well conclude
My name were at a period!

Lewis. Hee's indeed Sir,
The surer base to build on.

Enter EUSTACE, EGREMONT, COWSY, *and* ANDREW.

Brisac. *Eustace.*
Eustace. Sir.
Brisac. Your eare in private. [*Speake apart.*]
Andrew. I suspect my master 210
Has found harsh welcome, hee's gone supperlesse
Into his study; could I finde out the cause,
It may be borrowing of his bookes, or so,
I shall be satisfi'd.

Eustace. My duty shall Sir,
Take any form you please, and in your motion
To have me married, you cut off all dangers
The violent heats of youth might beare me to.

Lewis. It is well answer'd.

Eustace. Nor shall you my Lord,

*196 Councels] *stet* Q1

482

Nor your faire Daughter ever finde just cause
To mourne your choice of me; the name of husband 220
Nor the authority it carries in it
Shall never teach me to forget to be
As I am now her servant, and your Lordships,
And but that modesty forbids, that I
Should sound the Trumpet of my owne deserts,
I could say my choice manners have beene such,
As render me lov'd and remarkable
To th' Princes of the blood.

Cowsy. Nay to the King.

Egremont. Nay to the King and Councell.

Andrew [*aside*]. These are Court admirers,
And ever eccho him that beares the bagge, 230
Though I be dull ey'd, I see through this jugling.

Eustace. Then for my hopes——

Cowsy. Nay certainties.

Eustace. They stand
As faire as any mans. What can there fall
In compasse of her wishes which she shall not
Be suddenly possess'd of? Loves she titles?
By th' grace and favour of my princely friends,
I am what she would have me.

Brisac. He speakes well,
And I beleeve him.

Lewis. I could wish I did so.
Pray you a word Sir, Hee's a proper Gentleman,
And promises nothing, but what's possible. 240
So farre I will goe with you, Nay I adde,
He hath wonne much upon me, and were he
But one thing that his brother is, the bargaine
Were soone strucke up.

Brisac. What's that my Lord?

Lewis. The heire.

Andrew [*aside*]. Which he is not, and I trust never shall be.

Brisac. Come, that shall breed no difference, you see
Charles has giv'n ore the World; Ile undertake,

*222 never] MS; ever Q1–3 225 Trumpet] MS; Trumpe Q1–3

And with much ease, to buy his birthright of him
For a dry-fat of new bookes; nor shall my state
Alone make way for him, but my elder brothers, 250
Who being issuelesse, t'advance our name,
I doubt not will adde his; Your resolution?
Lewis. Ile first acquaint my daughter with the proceedings,
On these tearmes I am yours, as she shall be,
Make you no scruple, get the writings ready,
She shall be tractable; to morrow we will hold
A second conference: Farewell noble *Eustace,*
And you brave Gallants.
Eustace. Full increase of honour
Wait ever on your Lordship.
Andrew [*aside*]. The Gowt rather
And perpetuall Meagrim.
Brisac. You see *Eustace,* 260
How I travaile to possesse you of a fortune
You were not borne to, be you worthy of it,
Ile furnish you for a Suitor; visite her
And prosper in't.
Eustace. Shee's mine Sir, feare it not:
In all my travailes, I nere met a Virgin
That could resist my Courtship.——— If this take now,
 [*Apart to* Cowsy, Egremont.]
W'are made for ever, and will revell it.
 Exeunt. [*Manet* Andrew.]
Andrew. In tough welsh parsly, which in our vulgar Tongue
Is strong hempen halters; My poore Master cooz'nd,
And I a looker on! If we have studied 270
Our majors, and our minors, antecedents,
And consequents, to be concluded coxcombes,
W'have made a faire hand on't. I'm glad I h've found
Out all their plots, and their conspiracies,
This shall t'old Monsieur *Miramont,* one, that though
He cannot reade a Proclamation, yet
Dotes on learning, and loves my Master *Charles*

*249 dry-fat] *stet* Q1
*266 If] F2 (*preceded by a space*); *Eust.* If Q1–2; *Egre.* If MS; *Bri.* If Q3

484

For being a Scholar. I heare hee's comming hither,
I shall meet him, and if he be that old
Rough teasty blade he alwayes us'd to be, 280
Hee'll ring 'em such a peale as shall goe neere
To shake their belroome, peradventure, beat'm,
For he is fire and flaxe, and so have at him.

 Exit.

 [*Enter*] MIRAMONT. BRISAC. II.i

Miramont. Nay brother, brother.
Brisac. Pray Sir be not moved,
 I meddle with no businesse but mine owne,
 And in mine owne 'tis reason I should governe.
Miramont. But know to governe then, and understand Sir,
 And be as wise as y'are hasty; though you be
 My brother and from one bloud sprung, I must tell yee
 Heartely and home too——
Brisac. What Sir?
Miramont. What I grieve to finde,
 You are a foole, and an old foole, and that's two.
Brisac. Wee'l part 'em, if you please.
Miramont. No they're entail'd to 'em;
 Seeke to deprive an honest noble spirit, 10
 Your eldest sonne Sir, and your very Image,
 (But hee's so like you that he fares the worse for't)
 Because he loves his booke and doates on that,
 And onely studies how to know things excellent,
 Above the reach of such course braines as yours,
 Such muddy fancies, that never will know farther
 Then when to cut your Vines, and cozen Merchants,
 And choake your hide-bound Tenants with musty harvests.
Brisac. You goe too fast.
Miramont. I'm not come to my pace yet,
 Because h'has made his study all his pleasure, 20
 And is retyr'd into his Contemplation,
 Not medling with the dirt and chaffe of nature,

That makes the spirit of the minde mud too,
Therefore must he be flung from his inheritance?
Must he be dipossess'd, and Monsieur gingle boy
His younger brother——

Brisac. You forget your selfe.

Miramont. Because h'has been at Court and learn'd new Congees,
And how to speake a tedious peece of nothing,
To vary his face as Seamen doe their Compasse,
To worship images of gold and silver, 30
And fall before the she Calves of the Season,
Therefore must he jumpe into his brothers land?

Brisac. Have you done yet, and have spake enough
In praise of learning, Sir?

Miramont. Never enough.

Brisac. But brother doe you know what learning is?

Miramont. It is not to be a Justice of Peace, as you are,
And palter out your time ith' penall Statutes,
To heare the curious Tenets controverted
Betweene a Protestant Constable, and a Jesuit Cobler,
To picke naturall Philosophie out of bawdry 40
When your Worship's pleas'd to correctifie a Lady,
Nor 'tis not the maine morall of blinde Justice
(Which is deepe learning) when your worships Tenants
Bring a light cause, and heavie Hennes before yee,
Both fat and feesible, a Goose or Pig,
And then you sit like equity with both hands
Weighing indifferently the state oth' question.
These are your quodlibets, but no learning Brother.

Brisac. You are so parlously in love with learning,
That I'de be glad to know what you understand, brother, 50
I'me sure you have read all *Aristotle.*

Miramont. Faith no,
But I beleeve, I have a learned faith Sir,
And that's it makes a Gentleman of my sort,
Though I can speake no Greeke I love the sound on't,
It goes so thundering as it conjur'd Devils;
Charles speakes it loftily, and if thou wert a man,

*27 Congees] MS; tongues Q1-3 43 worships] MS, Q3; worship Q1-2

486

Or had'st but ever heard of *Homers Iliads*,
Hesiod, and the Greeke Poets, thou would'st runne mad,
And hang thy selfe for joy th'hadst such a Gentleman
To be thy sonne; O he has read such things 60
To me!
Brisac. And you doe understand'm brother.
Miramont. I tell thee no, that's not materiall; the sound's
 Sufficient to confirme an honest man:
 Good brother *Brisac*, do's your young Courtier
 That weares the fine cloathes, and is the excellent Gentleman,
 (The Traveiler, the Souldier, as you thinke too)
 Understand any other power than his Tailor?
 Or knowes what motion is, more than an Horse-race?
 What the Moone meanes, but to light him home from Tavernes?
 Or the comfort of the Sunne is, but to weare slash't clothes in? 70
 And must this peece of ignorance be popt up,
 Because't can kisse the hand, and cry sweet Lady?
 Say it had beene at *Rome*, and seene the Reliques,
 Drunke your *Verdea* wine, and ridde at *Naples*,
 Brought home a box of *Venice* treacle with it,
 To cure young wenches that have eaten ashes:
 Must this thing therefore——
Brisac. Yes Sir, this thing must,
 I will not trust my land to one so sotted,
 So growne like a disease unto his studie;
 He that will fling off all occasions 80
 And cares, to make him understand what state is,
 And how to governe it, must by that reason,
 Be flung himselfe aside from managing:
 My younger boy is a fine Gentleman.
Miramont. He is an asse, a peece of ginger-bread,
 Gilt over to please foolish girles and puppets.
Brisac. You are my elder brother——
Miramont. So I had need,
 And have an elder wit, thou'd'st shame us all else,
 Goe too, I say, *Charles* shall inherit.
Brisac. I say no,
 Unlesse *Charles* had a soule to understand it, 90

Can he manage six thousand Crownes a yeere
Out of the metaphysicks? or can all
His learn'd Astronomy looke to my Vineyards?
Can the drunken old Poets make up my Vines?
(I know they can drinke'm) or your excellent humanists
Sell'm the Merchants for my best advantage?
Can History cut my hay, or get my Corne in?
And can Geometrie vent it in the market?
Shall I have my sheepe kept with a *Jacobs* staffe now?
I wonder you will magnifie this mad man, 100
You that are old and should understand.

Miramont. Should, sai'st thou,
Thou monstrous peece of ignorance in office!
Thou that hast no more knowledge than thy Clerke infuses,
Thy dapper Clerke larded with ends of Latin,
And he no more than custome of offences;
Thou unreprieveable Dunce! that thy formall bandstrings,
Thy ring nor pomander cannot expiate for,
Do'st thou tell me I should? Ile pose thy Worship
In thine owne Library an Almanacke,
Which thou art dayly poring on to picke out 110
Dayes of iniquity to cozen fooles in,
And full Moones to cut Cattell; do'st thou taint me,
That have runne over story, Poetry,
Humanity?

Brisac. As a cold nipping shadow
Does ore the eares of Corne, and leave 'em blasted;
Put up your anger, what Ile doe Ile doe.

Miramont. Thou shalt not doe.

Brisac. I will.

Miramont. Thou art an Asse then,
A dull old tedious Asse, th'art ten times worse
And of lesse credit than Dunce *Hollingshead*
The Englishman, that writes of snowes and Sheriffes. 120

Enter LEWIS.

Brisac. Well take your pleasure, here's one I must talke with.
Lewis. Good day Sir.

Brisac. Faire to you Sir.

Lewis. May I speake w'yee?

Brisac. With all my heart, I was waiting on your goodnesse.

Lewis. Good morrow Monsieur *Miramont*.

Miramont. O sweet Sir,
Keepe your good morrow to coole your Worships pottage,
[*Aside.*] A couple of the worlds fooles met together
To raise up dirt and dunghils.

Lewis. Are they drawne?

Brisac. They shall be ready Sir, within these two houres,
And *Charles* set his hand.

Lewis. Tis necessary,
For he being a joint purchaser, though your state 130
Was got by your owne industrie, unlesse
He seale to the Conveyance, it can be
Of no validity.

Brisac. He shall be ready,
And doe it willingly.

Miramont [*aside.*] He shall be hang'd first.

Brisac. I hope your daughter likes.

Lewis. She loves him well Sir,
Young *Eustace* is a bait to catch a woman,
A budding spritely fellow, y'are resolv'd then,
That all shall passe from *Charles*.

Brisac. All all, hee's nothing,
A bunch of bookes shall be his patrimony,
And more than he can manage too.

Lewis. Will your brother 140
Passe over his land too, to your sonne *Eustace?*
You know he has no heire.

Miramont. He will be flead first,
And horse-collers made of's skin!

Brisac. Let him alone,
A wilfull man; my state shall serve the turne, Sir.
And how does your Daughter?

Lewis. Ready for the houre,
And like a blushing Rose that staies the pulling.

Brisac. To morrow, then's the day.

Lewis. Why then to morrow
 Ile bring the Girle, get you the Writings ready.
Miramont. But harke you Monsieur, have you the vertuous
 conscience
 To helpe to robbe an heire, an Elder Brother 150
 Of that which nature and the Law flings on him?
 You were your fathers eldest sonne, I take it,
 And had his Land, would you had had his wit too,
 Or his discretion to consider nobly,
 What 'tis to deale unworthily in these things;
 You'll say hee's none of yours, hee's his sonne,
 And he will say, he is no sonne to inherit
 Above a shelfe of Bookes; Why did he get him?
 Why was he brought up to write and reade and know things?
 Why was he not like his father, a dumbe Justice? 160
 A flat dull peece of flegme, shap'd like a man,
 A reverend Idoll in a peece of arras?
 Can you lay disobedience, want of manners,
 Or any capitall crime to his charge?
Lewis. I doe not,
 Nor doe not weight your words, they bite not me, Sir;
 This man must answer.
Brisac. I have don't already,
 And giv'n sufficient reason to secure me:
 And so good morrow brother to your patience.
Lewis. Good morrow Monsieur *Miramont.*
Miramont. Good nightcaps
 Keepe your braines warme, or Maggots will breed in'm. 170
 [*Exeunt* Brisac, Lewis.]
 Well *Charles*, thou shalt not want to buy thee bookes yet,
 The fairest in thy study are my gift,
 And the University *Lovaine* for thy sake,
 Hath tasted of my bounty, and to vexe
 Th'old doting foole thy father, and thy brother,
 They shall not share a *Solz* of mine betweene 'em;
 Nay more, Ile give thee eight thousand Crownes a yeere,
 In some high straine to write my Epitaph.
 Exit.

 162 arras] MS; auras Q1–3 176 'em] MS; them Q1–3

[*Enter*] EUSTACE, EGREMONT, COWSY. II.ii

Eustace. How doe I looke now to my elder Brother;
 Nay, 'tis a handsome Suite.
Cowsy. All courtly, courtly.
Eustace. Ile assure ye Gentlemen, my Tailor has travail'd,
 And speakes as lofty language in his bills too,
 The cover of an old Booke would not shew thus.
 Fye, fie, what things these Academicks are,
 These book-wormes, how they looke!
Egremont. Th'are meere Images,
 No gentle motion nor behaviour in 'em.
 They'll prattle yee of *primum mobile*,
 And tell a story of the state of Heaven, 10
 What Lords and Ladies governe in such houses,
 And what wonders they doe when they meet together,
 And how they spit snow, fire, and haile like a Jugler,
 And make a noise when they are drunke, which we call Thunder.
Cowsy. They are the sneaking'st things, and the contemptiblest;
 Such small beere braines, but aske 'em any thing
 Out of the Element of their understanding,
 And they stand gaping like a roasted Pig;
 Doe they know what a Court is or a Councell,
 Or how th'affaires of Christendome are manag'd? 20
 Doe they know any thing but a tyr'd hackney?
 And they cry absurd as the Horse understood 'em.
 They have made a fine youth of your elder brother,
 A pretty peece of flesh.
Eustace. I thanke'm for it,
 Long may he study to give me his state.
 Saw you my Mistresse?
Egremont. Yes, shee's a sweet young woman,
 But be sure you keepe her from learning.
Eustace. Songs she
 May have, and reade a little unbak'd Poetry,
 Such as the Dablers of our time contrive,
 That has no weight nor wheele to move the minde, 30
 Nor indeed nothing but an empty sound;

3 travail'd] *i.e.* traveled *as in* MS 23 fine] MS, Q3; faire Q1–2

She shall have cloathes but not made by Geometrie,
Horses and Coach but of no immortall race;
I will not have a Scholar in mine house
Above a gentle Reader, They corrupt
The foolish women with their subtle problems:
Ile have my house call'd Ignorance, to fright
Prating Philosophers from enterteinment.

Cowsy. It will doe well, love those that love good fashions,
Good clothes and rich, they invite men to admire'm, 40
That speake the lispe of Court, Oh 'tis great learning!
To ride well, daunce well, sing well, or whistle Courtly,
Th'are rare endowments; that have seene farre Countries
And can speake strange things, though they speake no truths,
For then they make things common. When are you marryed?

Eustace. To morrow, I thinke; we must have a Masque Boyes,
And of our owne making.

Egremont. Tis not halfe an houres worke,
A *Cupid* and a fiddle, and the thing's done,
But let's be handsome, shall's be Gods or Nymphs?

Eustace. What, Nymphs with beards?

Cowsy. That's true, wee'll bee Knights then, 50
Some wandring Knights, that light here on a sudden.

Eustace. Let's goe, let's goe, I must goe visite, Gentlemen,
And marke what sweet lips I must kisse to morrow.

 Exeunt.

 [*Enter*] COOKE, ANDREW, BUTLER. II.iii

Cooke. And how do's thy Master?

Andrew. Is at's booke, peace Coxcombe,
That such an unlearn'd tongue as thine should aske for him!

Cooke. Do's he not studie conjuring too?

Andrew. Have you
Lost any plate, *Butler?*

Butler. No, but I know
I shall to morrow at dinner.

Andrew. Then to morrow
You shall be turn'd out of your place for't; we meddle

 *¹ thy] MS; my Q1–2

 492

With no spirits oth' Buttry, they taste too small for us;
Keepe me a pye *in folio*, I beseech thee,　　　　　[*To* Cooke.]
And thou shalt see how learnedly Ile translate him;
Shall's have good cheere to morrow?

Cooke.　　　　　　　　　　Ex'llent good cheere *Andrew.* 10

Andrew.　The spight on't is, that much about that time,
I shall be arguing, or deciding rather,
Which are the Males and Females of red Herrings,
And whether they be taken in the red Sea onely,
A question found out by *Copernicus*,
The learned Motion-maker.

Cooke.　　　　　　　　I marry, *Butler*,
Here are rare things; a man that look'd upon him,
Would sweare he understood no more than we doe.

Butler.　Certaine, a learned *Andrew*.

Andrew.　　　　　　　　I've so much on't,
And am so loaden with strong understanding,　　　　　20
I feare, they'll runne me mad; here's a new instrument,
A metamaticall glister to purge the Moone with,
When she is laden with cold flegmaticke humours,
And here's another to remove the Starres,
When they grow too thicke in the Firmament.

Cooke.　O heavens! why doe I labour out my life
In a beefe-pot? and onely search the secrets
Of a Sallad; and know no farther!

Andrew.　　　　　　　　They are not
Reveal'd to all heads; These are farre above
Your Element of Fire, *Cooke.* I could tell you　　　　　30
Of *Archimides* glasse to fire your coales with,
And of the Philosophers turfe that nere goes out;
And *Gilbert Butler*, I could ravish thee,
With two rare inventions.

Butler.　　　　　　　What are they *Andrew?*

Andrew.　The one to blanch thy bread from chippings base,
And in a moment, as thou would'st an Almond,
The Sect of the Epicurians invented that;

*10 Ex'llent ⋏] *Ex*'Lent, Q1–2; Ex'Lent, Q3; Excellent ⋏ MS, F2
35 thy] MS; your Q1–3

493

The other for thy trenchers, that's a strong one,
To cleanse you twenty dozen in a minute,
And no noise heard, which is the wonder *Gilbert*, 40
And this was out of *Plato's* new *Idea's*.

Butler. Why what a learned Master do'st thou serve *Andrew?*

Andrew. These are but the scrapings of his understanding, *Gilbert*;
With gods and goddesses, and such strange people
He deales, and treats with in so plaine a fashion,
As thou do'st with thy boy that drawes thy drinke,
Or *Ralph* there with his kitchin boyes and scalders.

Cooke. But why should he not be familiar and talke sometimes,
As other Christians doe, of hearty matters,
And come into the Kitchin, and there cut his breakfast? 50

Butler. And then retyre to the Buttry and there eat it,
And drinke a lusty bowle, my younger Master
That must be now the heire will doe all these,
I and be drunke too; These are mortall things.

Andrew. My Master studies immorality.

Cooke. Now thou talk'st
Of immortality, how do's thy wife *Andrew?* My old Master
Did you no small pleasure when he procur'd her
And stock'd you in a farme. If he should love her now,
As he hath a Colts tooth yet, what sayes your learning
And your strange instruments to that my *Andrew?* 60
Can any of your learned Clerkes avoid it?
Can ye put by his Mathematicall Engine?

Andrew. Yes, or Ile breake it; thou awaken'st me,
And Ile peepe ith' Moone this moneth but Ile watch for him.
My Master rings, I must goe make him a fire,
And conjure ore his bookes.

Cooke. Adieu good *Andrew*,
And send thee manly patience with thy learning.

Exeunt.

[*Enter*] CHARLES. II.iv

Charles. I have forgot to eate and sleepe with reading,
And all my faculties turne into studie,
Tis meat and sleepe, what need I outward garments,

When I can cloathe my selfe with understanding,
The Starres and glorious Planets have no Tailors,
Yet ever new they are and shine like Courtiers,
The seasons of the yeere finde no fond parents,
Yet some are arm'd in silver Ice that glisters,
And some in gawdy greene come in like Masquers,
The Silke-worme spinnes her owne suite and her lodging,　　　10
And has no aide nor partner in her labours;
Why should we care for any thing but knowledge,
Or looke upon the world but to contemne it?

Enter ANDREW.

Andrew.　　Would you have any thing?
Charles.　　　　　　　　　　　　*Andrew*, I finde
There is a stie growne ore the eye oth' Bull,
Which will goe neere to blinde the Constellation.
Andrew.　　Put a gold-ring in's nose, and that will cure him.
Charles.　　*Ariadne's* crown's awry too, two maine starres
That held it fast are slipp'd out.
Andrew.　　　　　　　　　　　Send it presently
To *Gallatteo* the Italian Star-wright,　　　20
Hee'll set it right againe with little labour.
Charles.　　Thou art a pretty Scholar.
Andrew.　　　　　　　　　　　I hope I shall be,
Have I swept your bookes so often to know nothing?
Charles.　　I heare thou art marryed.
Andrew.　　　　　　　　　　It hath pleas'd your father
To match me to a maide of his owne choosing,
I doubt her constellation's loose too, and wants nailing,
And a sweet farme he has given us a mile off Sir.
Charles.　　Marry thy selfe to understanding, *Andrew*,
These women are *Errata* in all Authours,
They're faire to see to, and bound up in vellam,　　　30
Smoothe, white and cleare, but their contents are monstrous;
They treat of nothing, but dull age and diseases.
Thou hast not so much wit in thy head, as there is
On those shelves *Andrew*.

　　　　23 Have I ... nothing?] *stet* Q1

Andrew. I thinke I have not Sir.

Charles. No, if thou had'st thould'st nere have warmed a woman
In thy bosome, they're Cataplasmes made oth' deadly sinnes,
I nere saw any yet but mine owne mother,
Or if I did, I did regard them, but
As shadowes that passe by of under Creatures.

Andrew. Shall I bring you one? Ile trust you with my owne wife; 40
I would not have your brother goe beyond ye,
Th'are the prettiest naturall Philosphers to play with.

Charles. No, no, th'are opticks to delude mens eyes with,
Does my younger brother speake any Greeke yet, *Andrew*?

Andrew. No, but he speakes high Dutch, and that goes as daintily.

Charles. Reach me the bookes downe I read yesterday,
And make a little fire, and get a manchet,
Make cleane those instruments of brasse I shew'd ye,
And set the great Sphere by, then take the foxe tayle
And purge the bookes from dust, last take your *Lilly*, 50
And get your part ready.

Andrew. Shall I goe home Sir?
My wives name is *Lilly*, there my best part lyes, Sir.

Charles. I meane your Grammar, O thou dunderhead!
Would'st thou be ever in thy wives *Syntaxis*?
Let me have no noise, nor nothing to disturbe me,
I am to finde a secret.

Andrew. So am I too,
Which if I doe finde, I shall make some smart for't.

Exeunt.

[*Enter*] LEWIS, ANGELLINA, SYLVIA, NOTARY *and Servants.* III.i

Lewis. This is the day my daughter *Angellina*,
The happy day that must make you a fortune,
A large and full one, my great care has wrought it,
And yours must be as great to entertaine it,
Young *Eustace* is a Gentleman at all points,
And his behaviour affable and courtly,
His person excellent; I know you finde that,

*35 warmed] Q3; married Q1–2, MS 48 ye] MS; you Q1–3
 0.1 *and Servants*] MS; *omit* Q1–3 2 day] MS, Q3; *omit* Q1–2

496

I reade it in your eyes, you like his youth,
Young handsome people should be match'd together,
Then followes handsome Children, handsome fortunes, 10
The most part of his fathers state, my Wench,
Is ti'd in joynture, that makes up the harmony,
And when y'are marryed hee's of that soft temper,
And so farre will be chain'd to your observance,
That you may rule and turne him as you please.
What, are the writings drawne on our side, Sir?
Notary. They are, and here I have so fetter'd him,
That if the Elder Brother set his hand to,
Not all the power of Law shall ere release him.
Lewis [*aside*]. These Notaries are notable confident Knaves, 20
And able to doe more mischiefe than an Army:——
Are all your Clauses sure?
Notary. Sure as proportion,
They may turne Rivers sooner than these Writings.
Why did you not put all the lands in, Sir?
Lewis. Twas not condition'd.
Notary. If it had been found,
It had been but a fault made in the Writing,
If not found, all the Land.
Lewis [*aside*]. These are small Devills
That care not who has mischiefe, so they make it;
They live upon the meere scent of dissension.——
Tis well, 'tis well, Are you contented Girle? 30
For your will must be knowne.
Angellina. A husband's welcome,
And as an humble wife Ile entertaine him
No soveraignty I aime at, 'tis the mans Sir,
For she that seekes it, killes her husbands honour:
The Gentleman I have seene, and well observ'd him,
Yet finde not that grac'd excellence you promise,
A pretty Gentleman, and he may please too,
And some few flashes I have hear'd come from him,
But not to admiration, as to others;

Hee's young, and may be good, yet he may make it, 40
And I may helpe, and helpe to thanke him also.
It is your pleasure I should make him mine,
And't has been still my duty to observe you.
Lewis. Why then let's goe, and I shall love your modesty.
To horse, and bring the Coach out. *Angellina*,
To morrow you will looke more womanly.
Angellina. So I looke honestly, I feare no eyes, Sir.

 Exeunt.

 [*Enter*] BRISAC, ANDREW, COOKE, [BUTLER,] LILLY. III.ii

Brisac. Waite on your Master, he shall have that befits him.
Andrew. No inheritance, Sir?
Brisac. You speake like a foole, a coxecombe,
He shall have annuall meanes to buy him bookes,
And finde him cloathes and meat, what would he more?
Trouble him with Land? 'tis flat against his nature:
I love him too, and honour those gifts in him.
Andrew. Shall Master *Eustace* have all?
Brisac. All, all, he knowes how
To use it, hee's a man bred in the world,
T'other ith' heavens: my masters, pray be wary,
And serviceable, and *Cooke* see all your sawces 10
Be sharpe and poynant in the pallat, that they may
Commend you, looke to your roast and bak'd meates handsomely,
And what new kickshawes and delicate made things——
Is th' musicke come?
Butler. Yes Sir, th'are here at breakfast.
Brisac. There will be a Masque too, you must see this roome cleane,
And *Butler* your doore open to all good fellowes,
But have an eye to your plate, for there be Furies:
My *Lilly* welcome, you are for the linnen,
Sort it, and see it ready for the Table,
And see the bride-bed made, and looke the cords be 20
Not cut asunder by the Gallants too,
There be such knacks abroad; [*apart*] harke hither, *Lilly*,
To morrow night at twelve a clocke, Ile suppe w'ye,

 *40 may make] MS, Q3; must make Q1–2 *19 see] *stet* Q1

 498

Your husband shall be safe, Ile send ye meate too,
Before I cannot well slip from my company.

Andrew. Will ye so, will you so, Sir? Ile make one to eate it,
I may chance make you stagger too.

Brisac. No answer, *Lilly*?

Lilly. One word about the linnen; [*apart*] Ile be ready,
And rest your worships still.

Andrew. And Ile rest w'yee,
You shall see what rest 'twill be: Are ye so nimble: 30
A man had need have ten paire of eares to watch you.

Brisac. Waite on your Master, for I know he wants ye,
And keepe him in his study, that the noise
Doe not molest him:——I will not faile my *Lilly*——
Come in, sweet hearts——all to their severall duties.

 Exeunt (Andrew *stay on*).

Andrew. Are you kissing ripe, Sir? Double but my farme
And kisse her till thy heart ake; these smocke vermin,
How eagerly they leape at old mens kisses,
They licke their lippes at profit, not at pleasure;
And if't were not for th' scurvie name of Cuckold, 40
He should lye with her, I know shee'll labour at length
With a good Lordship. If he had a wife now,
But that's all one, Ile fit him: I must up
Unto my Master, hee'll be mad with studie.

 Exit.

Noyse. [*Enter*] CHARLES. III.iii

Charles. What noise is in this house, my head is broken
Within a Parenthesis, in every corner
As if the earth were shaken with some strange Collect,
These are stirres and motions, What Planet rules this house?

 Enter ANDREW.

Who's there?

*35 sweet hearts] *stet* Q1 35.1 (Andrew *stay on*)] MS; *omit* Q1–3
 0.1 *Noyse.*] MS; *omit* Q1–3 *2 Within a Parenthesis] *stet* Q1
 3 Collect] *i.e.*, Collicke *as in* MS

Andrew. Tis I Sir, faithfull *Andrew.*

Charles. Come neere,
And lay thine eare downe, hear'st no noise?

Andrew. The Cookes
Are chopping hearbs and mince meat to make pies,
And breaking Marrow-bones——

Charles. Can they set them againe?

Andrew. Yes, yes, in brothes and puddings, and they grow stronger
For th'use of any man.

Charles. What squeaking's that? 10
Sure there is a massacre.

Andrew. Of Pigs and Geese Sir,
And Turkeys for the spit. The Cookes are angry Sir,
And that makes up the medly.

Charles. Doe they thus
At every dinner? I nere mark'd them yet,
Nor know who is a Cooke.

Andrew. Th'are sometimes sober,
And then they beat as gently as a Tabor.

Charles. What loades are these?

Andrew. Meate, meate, Sir, for the Kitchin,
And stinking fowles the Tenants have sent in,
They'll nere be found out at a generall eating,
And there's fat Venison, Sir.

Charles. What's that?

Andrew. Why Deere, 20
Those that men fatten for their private pleasures,
And let their Tenants starve upon the Commons.

Charles. I've read of Deere, but yet I nere eate any.

Andrew. There's a Fishmongers boy with Caviar Sir,
Anchoves and Potargo, to make ye drinke.

Charles. Sure these are moderne, very moderne meates,
For I understand 'em not.

Andrew. No more do's any man
From Caca merda or a substance worse,
Till they be greas'd with oyle, and rub'd with onions,
And then, flung out of doores, they are rare Sallads. 30

25 Potargo] i.e., botargo, *a relish made of fish roe*
*30 then, flung] Dyce; ~ ∧ ~ Q1-5, F2

Charles. And why is all this, prithee tell me *Andrew?*
 Are there any Princes to dine here to day?
 By this abundance, sure there should be Princes;
 I've read of entertainment for the gods
 At halfe this charge, will not sixe dishes serve 'em?
 I never had but one, and that a small one.
Andrew. Your Brother's married this day, hee's married,
 Your younger brother *Eustace.*
Charles. What of that?
Andrew. And all the friends about are bidden hither,
 There's not a dogge that knowes the house but comes too. 40
Charles. Married? to whom?
Andrew. Why to a dainty Gentlewoman,
 Young, sweet, and modest.
Charles. Are there modest women?
 How doe they looke?
Andrew. O you'ld blesse your selfe to see them.
 [*Aside.*] He parts with's booke, he nere did so before yet.
Charles. What do's my father for 'em?
Andrew. Gives all his Land,
 And makes your brother heire.
Charles. Must I have nothing?
Andrew. Yes, you must study still, and hee'll maintaine you.
Charles. I am his elder brother.
Andrew. True, you were so,
 But he has leap'd ore your shoulders, Sir.
Charles. Tis well,
 Hee'll not inherit my understanding too? 50
Andrew. I thinke not, hee'll scarce finde Tenants to let it
 Out to.
Charles. Harke, harke.
Andrew. The Coach that brings the faire Lady.

Enter LEWIS, ANGELLINA, [SYLVIA,] *Ladies,* NOTARY, *Servants.*

Andrew. Now you may see her.
Charles. Sure this should be modest;
 But I doe not truly know what women make of it,

48 elder] MS, Q3; eldest Q1–2 52.1 *Servants.*] MS; &c. Q1–3

Andrew; she has a face lookes like a story,
The story of the Heavens lookes very like her.
Andrew. She has a wide face then.
Charles. She has a Cherubins,
Cover'd and vail'd with wings of modest blushes.
Eustace be happy whiles poore *Charles* is patient.
Get me my booke againe, and come in with me. 60
 Exeunt [Charles, Andrew].

Enter BRISAC, EUSTACE, EGREMONT, COWSY, MIRAMONT.

Brisac. Welcome sweet Daughter, welcome noble brother,
And you are welcome Sir, with all your writings,
Ladies most welcome; What? my angry brother!
You must be welcome too, the feast is flat else.
Miramont. I come not for your welcome, I expect none,
I bring no joyes to blesse the bed withall,
Nor songs, nor Masques to glorifie the Nuptialls,
I bring an angry minde to see your folly,
A sharpe one too, to reprehend you for it.
Brisac. You'll stay and dine though?
Miramont. All your meate smelles musty, 70
Your Table will shew nothing to content me.
Brisac. Ile assure you, here's good meate.
Miramont. But your sawce is scurvie,
It is not season'd with the sharpnesse of discretion.
Eustace. It seemes your anger is at me, dear Uncle.
Miramont. Thou art not worth my anger, th'art a boy,
A lumpe o'thy fathers lightnesse, made of nothing
But anticke cloathes and cringes, looke in thy head,
And 'twill appeare a football full of fumes
And rotten smoke; Lady, I pitie you,
You are a handsome and a sweet young Lady, 80
And ought to have a handsome man yoak'd t'yee,
An understanding too, this a Gincracke,
That can get nothing but new fashions on you,
For say he have a thing shap'd like a childe,

58 wings of] MS; *omit* Q1–3 65 come not] MS, Q3; am not come Q1–2
72 assure] MS, Q3; answer Q1–2

Twill either prove a tumbler or a Tailor.

Eustace. These are but harsh words Uncle.

Miramont. So I meane 'em,
Sir, you play harsher play w'your elder brother.

Eustace. I would be loth to give you——

Miramont. Doe not venter,
Ile make your wedding-cloathes fit closer t'ee then;
I but disturbe you, Ile goe see my nephew. 90

Lewis. Pray take a peece of rosemary.

Miramont. Ile weare it,
But for the Ladies sake, and none of yours,
May be Ile see your table too. *Exit.*

Brisac. Pray doe, Sir.

Angellina. A mad old Gentleman.

Brisac. Yes faith, sweet daughter,
He has been thus his whole age to my knowledge,
He has made *Charles* his heire, I know that certainly,
Then why should he grudge *Eustace* any thing?

Angellina. I would not have a light head, nor one laden
With too much learning, as they say, this *Charles* is,
That makes his booke his Mistresse: [*aside*] Sure, there's something 100
Hid in this old mans anger, that declares him
Not a meere Sot.

Brisac. Come shall we goe and seale, brother?
All things are ready and the Priest is here,
When *Charles* has set his hand unto the Writings,
As he shall instantly, then to the Wedding,
And so to dinner.

Lewis. Come, let's seale the booke first,
For my daughters Joynture.

Brisac. Let's be private in't, Sir.

 Exeunt.

Enter CHARLES, MIRAMONT, ANDREW. III.iv

Miramont. Nay, y'are undone.

Charles. Hum.

Miramont. Ha'ye no greater feeling?

Andrew. You were sensible of the great booke, Sir,

When it fell on your head, and now the house
Is ready to fall, Doe you feare nothing?
Charles. Will
He have my bookes too?
Miramont. No, he has a booke,
A faire one too to reade on, and reade wonders,
I would thou hadst her in thy studie Nephew,
And 'twere but to new string her.
Charles. Yes, I saw her,
And me thought 'twas a curious peece of learning,
Handsomely bound, and of a dainty letter. 10
Andrew. He flung away his booke.
Miramont. I like that in him,
Would he had flung away his dulnesse too,
And spake to her.
Charles. And must my brother have all?
Miramont. All that your father has.
Charles. And that faire woman too?
Miramont. That woman also.
Charles. He has enough then.
May I not see her sometimes, and call her Sister?
I will doe him no wrong.
Miramont. This makes me mad,
I could now cry for anger; these old fooles
Are the most stubborne and the wilfullest Coxcombs.
Farewell, and fall to your booke, forget your brother, 20
You are my heire, and Ile provide y'a wife:
Ile looke upon this marriage though I hate it. *Exit.*

Enter BRISAC.

Brisac. Where is my sonne?
Andrew. There Sir, casting a figure
What chopping children his brother shall have.
Brisac. He do's well; How do'st *Charles?* still at thy booke?
Andrew. Hee's studying now Sir, who shall be his father.
Brisac. Peace you rude Knave.——Come hither *Charles*, be merry.
Charles. I thanke you, I am busie at my booke, Sir.
Brisac. You must put your hand my *Charles*, as I would have you,
Unto a little peece of parchment here, 30

504

Onely your name, you write a reasonable hand.

Charles. But I may doe unreasonably to write it,
 What is it Sir?

Brisac. To passe the Land I have, boy,
 Unto your younger brother.

Charles. Is't no more?

Brisac. No, no, 'tis nothing, you shall be provided for,
 And new bookes you shall have still, and new studies,
 And have your meanes brought in without the care, boy,
 And one still to attend you.

Charles. This shewes your love father.

Brisac. I'm tender to you.

Andrew [*aside*]. Like a stone, I take it.

Charles. Why father, Ile goe downe, an't please you let me, 40
 Because Ide see the thing they call the Gentlewoman,
 I see no women but through contemplation,
 And there Ile doe't before the company,
 And wish my brother fortune.

Brisac. Doe I prithee.

Charles. I must not stay, for I have things above
 Require my study.

Brisac. No thou shalt not stay,
 Thou shalt have a brave dinner too.

Andrew. Now has he
 Orethrowne himselfe for ever; I will downe
 Into the Celler, and be starke drunke for anger.

 Exeunt.

Enter LEWIS, ANGELLINA, [SYLVIA,] EUSTACE, PRIEST, *Ladies*, III.v
 COWSY, NOTARY, MIRAMONT.

Notary. Come let him bring his sonnes hand, and all's done.
 Is yours ready?

Priest. Yes, Ile dispatch ye presently,
 Immediately, for in truth I am a hungry.

Eustace. Doe, speake apace, for we beleeve exactly:
 Doe not we stay long Mistris?

Angellina. I finde no fault, Sir,

*33 boy] MS; Sir Q1–3 *44 And ... prithee.] *stet* Q1–3
*2 Is yours ready?] *stet* Q1 5 Sir,] MS, Q3; *omit* Q1–2

505

Better things well done than want time to doe 'em.
Uncle, why are you sad?

Miramont. Sweet smelling blossome, [*Speakes apart.*]
Would I were thine Uncle to thine owne content,
Ide make thy husbands state a thousand better,
A yearely thousand, thou hast mist a man, 10
(But that he is addicted to his study,
And knowes no other Mistresse than his minde)
Would weigh downe bundles of these empty kexes.

Angellina. Can he speake, Sir?

Miramont. Faith yes, but not to women:
His language is to heaven, and heavenly wonder,
To Nature, and her darke and secret causes.

Angellina. And does he speake well there?

Miramont. O, admirably,
But hee's too bashfull to behold a woman,
Theres none that sees him, nor he troubles none.

Angellina. He is a man?

Miramont. Yes, and a cleare sweet spirit. 20

Angellina. Then conversation me thinkes——

Miramont. So thinke I too,
But it is his rugged fate, and so I leave you.

Angellina. I like thy noblenesse.

Eustace. See, my mad Uncle
Is courting my faire Mistresse.

Lewis. Let him alone,
There's nothing that allayes an angry minde
So soone as a sweet beauty; hee'l come to us.

Enter BRISAC, CHARLES.

Eustace. My father's here, my brother too! that's a wonder,
Broke like a spirit from his Cell.

Brisac. Come hither,
Come neerer *Charles*, 'Twas your desire to see
My noble Daughter, and the company, 30
And give your brother joy, and then to seale boy.
You doe like a good brother.

6 'em] MS; them Q1–3 8 Uncle ⌃ ... content,] *stet* Q1

Lewis. Marry do's he,
 And he shall have my love for ever for't.
 Put to your hand now.
Notary. Here's the Deed Sir, ready.
Charles. No, you must pardon me a while, I tell ye, [*Lookes at her.*]
 I am in contemplation, doe not trouble me.
Brisac. Come, leave thy study, *Charles.*
Charles. Ile leave my life first;
 I study now to be a man, I've found it.
 Before, what man was, was my Argument.
Miramont. I like this best of all, he has taken fire, 40
 His dull mist flies away.
Eustace. Will you set to your hand brother?
Charles. No, brother no, I have no time for poore things,
 I'm taking th'height of that bright Constellation.
Brisac. I say, you trifle time, sonne.
Charles. I will not seale, Sir,
 I am your eldest, and Ile keepe my birthright,
 For heaven forbid I should become example;
 Had ye shew'd me Land onely, I had deliver'd it,
 And been a proud man to have parted with it;
 Tis dirt and labour; Doe I speake right Uncle?
Miramont. Bravely my boy, and blesse thy tongue.
Charles. Ile forward, 50
 But you have open'd to me such a treasure,
 I finde my minde free, heaven direct my fortune.
Miramont. Can he speake now? Is this a sonne to sacrifice?
Charles. Such an inimitable peece of beauty,
 That I have studied long, and now found onely,
 That Ile part sooner with my soule of reason,
 And be a plant, a beast, a fish, a flie;
 And onely make the number of things up
 Than yeeld one foot of Land, if she be ty'd to't.
Lewis. He speakes unhappily.
Angellina. And me thinkes bravely, 60
 This the meere Scholar?

39 my] MS, Q3; but my Q1–2 *41 set to your hand] MS, Q3 (too); write Q1–2
*47 Had ye ... Land onely] Had y'onely ... Land Q1–2; Had yee' shew'd me Land Q3; If you
 had ... Land onely MS

Eustace. You but vexe your selfe brother,
 And vexe your studie too.
Charles. Goe you and studie,
 For'ts time young *Eustace*, you want both man and manners,
 I've studied both, although I made no shew on't,
 Goe turne the Volumes over I have read,
 Eate and digest 'em, that they may grow in thee,
 Weare out the tedious night with thy dimme Lampes
 And sooner loose the day than leave a doubt,
 Distill the sweetnesse from the Poets Spring,
 And learne to love, Thou know'st not what faire is, 70
 Traverse the stories of the great Heroes,
 The wise and civill lives of good men walke through;
 Thou hast seene nothing but the face of Countries,
 And brought home nothing but their empty words:
 Why should'st thou weare a Jewell of this worth?
 That has no worth within thee to preserve her.

 Beauty cleere and faire,
 where the aire
 Rather like a perfume dwelles,
 Where the violet and the rose 80
 Their blew veines and blush disclose,
 And come to honour nothing else.

 Where to live neere,
 and planted there,
 Is to live, and still live new,
 Where to gaine a favour is
 More than life, perpetuall blisse,
 Make me live by serving you.

 Deare againe backe recall,
 to this light, 90
 A stranger to himselfe and all;
 Both the wonder and the story
 Shall be yours, and eke the glory.
 I am your servant, and your thrall.

*81 *and*] MS; *in* Q1–3 *87 *life*] MS; *light* Q1–3

Miramont. Speake such another Ode, and take all yet.
 What say ye to the Scholar now?
Angellina. I wonder;
 Is he your brother, Sir?
Eustace. Yes, would he were buried,
 I feare hee'l make an asse of me, a younker.
Angellina. Speake not so softly Sir, 'tis very likely.
Brisac. Come leave your finicall talke, and let's dispatch, *Charles.* 100
Charles. Dispatch? What?
Brisac. Why the land.
Charles. You are deceiv'd, Sir,
 Now I perceive what 'tis that woes a woman,
 And what maintaines her when shee's woo'd. Ile stop here.
 A wilfull poverty nere made a beauty,
 Nor want of meanes maintain'd it vertuously:
 Though land and monies be no happinesse,
 Yet they are counted good Additions.
 That use Ile make, He that neglects a blessing,
 Though he want present knowledge how to use it,
 Neglects himselfe; May be I have done you wrong Lady, 110
 Whose love and hope went hand in hand together,
 May be my brother, that has long expected
 The happy houre and blest my ignorance:
 Pray give me leave Sir, I shall cleare all doubts.
 Why did they shew me you? Pray tell me that?
Miramont [*aside*]. Hee'l talke thee into a pension for thy knavery.
Charles. You happy you, why did you breake unto me?
 The rosie fingred morne nere broke so sweetly:
 I am a man and have desires within me,
 Affections too, though they were drown'd a while, 120
 And lay dead, till the Spring of beauty rais'd them,
 Till I saw those eyes, I was but a lumpe,
 A Chaos of confusednesse dwelt in me;
 Then from those eyes shot Love, and he distinguisht,
 And into forme he drew my faculties;
 And now I know my Land, and now I love too.
Brisac. We had best remove the maide.
Charles. It is too late Sir,

*98 younker] Theobald; younger Q1–F2 118 fingred] Q3; sugred Q1–2; *omit* MS

I have her figure here. Nay frowne not *Eustace*,
There are lesse worthy soules for younger brothers,
This is no forme of silke but sanctity, 130
Which wilde lascivious hearts can never dignifie.
Remove her where you will, I walke along still,
For like the light we make no separation;
You may sooner part the billowes of the Sea,
And put a barre betwixt their fellowships,
Than blot out my remembrance, sooner shut
Old time into a den, and stay his motion,
Wash off the swift houres from his downy wings,
Or steale eternity to stop his glasse,
Than shut the sweet Idea I have in me. 140
Roome for an elder brother, pray give place, Sir.
Miramont. 'Has studied duell too, take heed, hee'l beat thee.
 [*Aside.*] 'Has frighted the old Justice into a fever;
 I hope hee'l disinherit him too for an asse;
 For though he be grave with yeeres, hee's a great baby.
Charles. Doe not you thinke me mad?
Angellina. No certaine, Sir,
 I have heard nothing from you but things excellent.
Charles. You looke upon my clothes and laugh at me,
 My scurvie clothes!
Angellina. They have rich linings Sir.
 I would your brother——
Charles. His are gold and gawdy. 150
Angellina. But touch 'em inwardly, they smell of Copper.
Charles. Can ye love me? I am an heire, sweet Lady,
 However I appeare a poore dependant;
 Can you love with honour? I shall love so ever:
 Is your eye ambitious? I may be a great man.
 Is't wealth or lands you covet? my father must dye.
Miramont. That was well put in, I hope hee'll take it deeply.
Charles. Old men are not immortall, as I take it,
 Is it, you looke for, youth and handsomnesse?
 I doe confesse my brother's a handsome Gentleman, 160

*144 I ... asse;] *stet* Q1
154 Can ... honour?] MS, Q3; Love you with honour. Q1–2

510

But he shall give me leave to lead the way Lady.
Can you love for love, and make that the reward?
The old man shall not love his heapes of gold
With a more doting superstition,
Than Ile love you; The young man his delights,
The merchant when he ploughs the angry sea up
And sees the mountaine billowes falling on him,
As if all Elements, and all their angers
Were turn'd into one vow'd destruction;
Shall not with greater joy imbrace his safety. 170
Wee'll live together like two wanton Vines,
Circling our soules and loves in one another,
Wee'll spring together and wee'll beare one fruit,
One joy shall make us smile, and one griefe mourne,
One age goe with us, and one houre of death
Shall shut our eyes, and one grave make us happy.

Angellina. And one hand seale the match, Ime yours for ever.

Lewis. Nay, stay, stay, stay.

Angellina. Nay certainly, 'tis done Sir.

Brisac. There was a contract.

Angellina. Onely conditionall,
That if he had the Land, he had my love too; 180
This Gentleman's the heire, and hee'll maintaine it.
Pray be not angry Sir, at what I say; [*To* Eustace.]
Or if you be, 'tis at your owne adventure.
You have the outside of a pretty Gentleman,
But by my troth your inside is but barren;
Tis not a face I onely am in love with,
Nor will I say your face is excellent,
A reasonable hunting face to court the winde with;
Nor th'are not words unlesse they be well plac'd too,
Nor your sweet Dam-mees, nor your hired verses, 190
Nor telling me of Cloathes, nor Coach and horses,
No nor your visits each day in new suites,
Nor your blacke patches you weare variously,
Some cut like starres, some in halfe Moones, some Lozenges,
(All which but shew you still a younger brother.)

Miramont. Gramercy Wench, thou hast a noble soule too.

Angellina. Nor your long travailes, nor your little knowledge,
 Can make me doate upon you. Faith goe study,
 And gleane some goodnesse, that you may shew manly,
 Your brother at my suite Ime sure will teach you, 200
 Or onely study how to get a wife Sir,
 Y'are cast farre behinde, 'tis good you should be melancholy,
 It shewes like a Gamester that had lost his money,
 And 'tis the fashion to weare your arme in a skarfe Sir,
 For you have had a shrewd cut ore the fingers.
Lewis. But are y'in earnest?
Angellina. Yes, beleeve me father,
 You shall nere choose for me, y'are old and dimme Sir,
 And th' shadow of the earth ecclips'd your judgement,
 Y'have had your time without controwle deare father,
 And you must give me leave to take mine now Sir. 210
Brisac. This is the last time of asking, Will you set your hand too?
Charles. This is the last time of answering, I will never.
Brisac. Out of my doores.
Charles. Most willingly.
Miramont. He shall Jew,
 Thou of the Tribe of *Man-y-asses*, Coxcombe,
 And never trouble thee more till thy chops be cold, foole.
Angellina. Must I be gone too?
Lewis. I will never know thee.
Angellina. Then this man will, what fortune he shall runne, father,
 Bee't good or bad, I must partake it with him.

Enter EGREMONT.

Egremont. When shall the Masque beginne?
Eustace. Tis done already,
 All, all, is broken off, I am undone friend, 220
 My brother's wise againe, and has spoil'd all,
 Will not release the land, has wonne the Wench too.
Egremont. Pox, could he not stay till th' Masque was past? w'are
 ready.

*197 nor your little] *stet* Q1 203 like] MS, Q3; likes Q1–2
211 too] *i.e.* to *as in* Q2 *213–214 Jew, ... -asses,] *stet* Q1
*223 Pox,] MS (pox ∧); *omit* Q1–3

512

What a skirvie trick's this?
Miramont. O you may vanish,
 Performe it at some Hall, where the Citizens wives
 May see't for sixe pence a peece, and a cold supper.
 Come let's goe *Charles*, And now my noble Daughter,
 Ile sell the tiles off my house ere thou shalt want Wench.
 Rate up your dinner Sir, and sell it cheape,
 Some younger brother will take't up in commodities. 230
 Send you joy, Nephew *Eustace*, if ye study the Law,
 Keepe your great pippin-pies, they'l goe farre with yee.
Charles. Ide have your blessing.
Brisac. No, no, meet me no more,
 Farewell, thou wilt blast mine eyes else.
Charles. I will not.
Lewis. Nor send not you for Gownes.
Angellina. Ile weare course flannell first.
Brisac. Come let's goe take some counsell.
Lewis. Tis too late.
Brisac. Then stay and dine, It may be we shall vexe 'em.
 Exeunt.

 Enter BRISAC, EUSTACE, EGREMONT, COWSY. IV.i

Brisac. Nere talke to me, you are no men but Masquers,
 Shapes, shadowes, and the signes of men, Court bubbles,
 That every breath or breakes or blowes away,
 You have no soules, no metall in your bloods,
 No heat to stirre ye when ye have occasion,
 Frozen dull things that must bee turn'd with leavers,
 Are you the Courtiers and the travail'd Gallants?
 The spritely fellowes, that the people talke of?
 Ye have no more spirit than three sleepy sops.
Eustace. What would ye have me doe, Sir?
Brisac. Follow your brother, 10
 And get ye out of doores, and seeke your fortune,
 Stand still becalm'd, and let an aged Dotard,
 A haire-brain'd puppy, and a bookish boy,
 That never knew a blade above a penknife,

 228 off] MS; of Q1-3

And how to cut his meat in Characters
Crosse my designe, and take thy owne Wench from thee,
In mine owne house too? Thou despis'd poore fellow!
Eustace. The reverence that I ever bare to you Sir,
Then to my Uncle, with whom't had been but sawcinesse
T'have been so rough——
Egremont. And we not seeing him 20
Strive in his owne cause, that was principall,
And should have led us on; thought it ill manners
To beginne a quarrell here.
Brisac. You dare doe nothing.
Doe you make your care the excuse of your cowardlinesse?
Three boyes on hobby-horses with three penny halberts,
Would beate you all.
Cowsy. You must not say so.
Brisac. Yes,
And sing it too.
Cowsy. You are a man of peace,
Therefore we must give way.
Brisac. Ile make my way
And therefore quickly leave me, or Ile force you;
And having first torne off your flaunting feathers, 30
Ile trample on 'em; and if that cannot teach you
To quit my house, Ile kicke ye out of my gates;
You gawdy glow-wormes carrying seeming fire,
Yet have no heat within ye.
Cowsy. O blest travaile!
How much we owe thee for our power to suffer?
Egremont. Some spleenative youths now that had never seene
More than their Country smoake would grow in choler.
It would shew fine in us.
Eustace. Yes marry would it,
That are prime Courtiers, and must know no angers,
But give thankes for our injuries, if we purpose 40
To hold our places.
Brisac. Will you finde the doore?
And finde it suddenly; you shall lead the way, Sir,
With your perfum'd retinew, and recover

The now lost *Angellina*, or build on it,
I will adopt some beggers doubtful issue,
Before thou shalt inherit.
Eustace. Wee'll to councell,
And what may be done by mans wit or valour
Wee'll put in execution.
Brisac. Doe, or never
Hope I shall know thee. *Exeunt* [Eustace, Egremont, Cowsy].

Enter LEWIS.

Lewis. O Sir, have I found you?
Brisac. I never hid my selfe, whence flowes this fury? 50
With which as it appeares, you come to fright me.
Lewis. I smell a plot, a meere conspiracy
Among ye all to defeate me of my daughter,
And if she be not suddenly delivered,
Untainted in her reputation too,
The best of *France* shall know how I am juggled with.
She is my heire, and if she may be ravisht
Thus from my care, farewell Nobility,
Honour and bloud are meere neglected nothings.
Brisac. Nay then, my Lord, you goe too farre, and taxe him 60
Whose innocency understands not what feare is.
If your unconstant daughter will not dwell
On certainties, must you thenceforth conclude,
That I am fickle? What have I omitted,
To make good my integrity and truth?
Nor can her lightnesse, nor your supposition
Cast an aspersion on me.
Lewis. I am wounded
In fact, nor can words cure it: doe not trifle,
But speedily, once more I doe repeat it,
Restore my daughter as I brought her hither, 70
Or you shall heare from me in such a kinde,
As you will blush to answer. *Exit.*
Brisac. All the world
I thinke conspires to vexe me, yet I will not

72 *Exit.*] MS; *omit* Q1–3

515

Torment my selfe, some spritefull mirth must banish
The rage and melancholy which hath almost choak'd me,
T'a knowing man 'tis physicke, and 'tis thought on,
One merry houre Ile have in spight of fortune,
To cheare my heart, and this is that appointed,
This night Ile hugge my *Lilly* in mine armes,
Provocatives are sent before to cheare me; 80
We old men need 'em, and though we pay deare
For our stolne pleasures, so it be done securely
The charge much like a sharpe sawce gives 'em relish.
Well honest *Andrew*, I gave you a farme,
And it shall have a beacon to give warning
To my other Tenants when the Foe approaches;
And presently, you being bestowed elsewhere,
Ile graffe it with dexterity on your forehead;
Indeed I will, *Lilly* I come, poore *Andrew*.

Exit.

Enter MIRAMONT, ANDREW. IV.ii

Miramont. Doe they chafe roundly?
Andrew. As they were rubb'd with soape, Sir,
And now they sweare alowd, now calme again,
Like a ring of bells, whose sound the winde still alters,
And then they sit in councell what to doe,
And then they jarre againe what shall be done;
They talke of Warrants from the Parliament,
Complaints to the King, and forces from the Province,
They have a thousand heads in a thousand minutes,
Yet nere a one head worth a head of garlicke.
Miramont. Long may they chafe, and long may we laugh at 'em, 10
A couple of pure puppies yoak'd together.
But what sayes the young Courtier Master *Eustace*,
And his two warlike friends?
Andrew. They say but little,
How much they thinke I know not, they looke rufully,
As if they had newly come from a vaulting house,
And had beene quite shot through 'tweene winde and water
By a she Dunkirke, and had sprung a leake, Sir.

Certaine my master was too blame.

Miramont. Why *Andrew?*

Andrew. To take away the Wench oth' sudden from him,
And give him no lawfull warning, he is tender, 20
And of a young girles constitution, Sir,
Ready to get the greene sicknesse with conceit;
Had he but tane his leave in travailing Language,
Or bought an Elegie of his condolement,
That th' world might have tane notice, he had been
An Asse, 'thad been some favour.

Miramont. Thou saist true,
Wise *Andrew*, but those Scholars are such things
When they can prattle.

Andrew. Very parlous things Sir.

Miramont. And when they gaine the liberty to distinguish
The difference 'twixt a father and a foole, 30
To looke below and spie a younger brother
Pruning and dressing up his expectations
In a rare glasse of beauty, too good for him:
Those dreaming Scholars then turne Tyrants, *Andrew*,
And shew no mercy.

Andrew. The more's the pitie, Sir.

Miramont. Thou told'st me of a tricke to catch my brother,
And anger him a little farther, *Andrew*.
It shall be onely anger I assure thee,
And a little shame.

Andrew. And I can fit you, Sir;
Harke in your eare.

Miramont. Thy wife?

Andrew. So I assure ye: 40
This night at twelve a clocke.

Miramont. Tis neat and handsome;
There are twenty Crownes due to thy project *Andrew*.
I've time to visit *Charles*, and see what Lecture
He reades to his Mistresse. That done, Ile not faile
To be with you.

Andrew. Nor I to watch my Master.

 Exeunt.

517

[Enter] ANGELLINA, SYLVIA *with a taper.* IV.i⟩

Angellina. I'me worse than ere I was, for now I feare,
 That that I love, that that I onely dote on;
 He followes me through every roome I passe,
 And with a strong set eye he gazes on me,
 As if his sparke of innocence were blowne
 Into a flame of lust; Vertue defend me.
 His Uncle too is absent, and 'tis night;
 And what these opportunities may teach him——
 What feare and endlesse care 'tis to be honest!
 To be a maide, what misery, what mischiefe! 10
 Would I were rid of it, so it were fairely.
Sylvia. You need not feare that, will you be a childe still?
 He followes you, but still to looke upon you,
 Or if he did desire to lye with ye,
 Tis but your owne desire, you love for that end;
 Ile lay my life, if he were now a bed w'ye,
 He is so modest, he would fall a sleepe straight.
Angellina. Dare you venter that?
Sylvia. Let him consent, and have at ye,
 I feare him not, he knowes not what a woman is,
 Nor how to finde the mysterie men aime at. 20
 Are you afraid of your owne shadow, Madam?
Angellina. He followes still, yet with a sober face;
 Would I might know the worst, and then I were satisfied.
Sylvia. You may both, and let him but goe with ye.

Enter CHARLES.

Charles. Why doe you flie me? what have I so ill
 About me or within me to deserve it?
Angellina. I am going to bed Sir.
Charles. And I am come to light ye;
 I am a maide, and 'tis a maidens office;
 You may have me to bed without a scruple,
 And yet I am chary too who comes about me. 30
 Two Innocents should not feare one another.

24.1 *Enter* Charles.] MS; *omit* Q1–3

Sylvia. The Gentleman sayes true. Plucke up your heart, Madam.
Charles. The glorious Sunne both rising and declining
 We boldly looke upon, even then sweet Lady,
 When like a modest bride he drawes nights curtaines,
 Even then he blushes too, men should behold him.
Angellina. I feare he will perswade me to mistake him.
Sylvia. Tis easily done, if you will give your minde to't.
Angellina. Pray ye to your bed.
Charles. Why not to yours, deare Mistresse?
 One heart and one bed.
Angellina. True Sir, when 'tis lawfull: 40
 But yet you know——
Charles. I would not know, forget it;
 Those are but sickly loves that hang on Ceremony,
 Nurst up with doubts and feares, ours high and healthfull,
 Full of beleefe, and fit to teach the Priest;
 Love should seale first, then hands confirme the bargaine.
Angellina. I shall be an Heretique if this continue.——
 What would you doe a bed? you make me blush, Sir.
Charles. Ide see you sleepe, for sure your sleepes are excellent:
 You that are waking such a noted wonder,
 Must in your slumbers prove an admiration: 50
 I would see your dreames too, if 'twere possible;
 Those were rich showes.
Angellina [aside]. I am becomming Traitor.
Charles. Then like blew *Neptune* courting of an Iland,
 Where all the perfumes and the pretious things
 That waite upon great Nature are laid up,
 Ide clip ye in mine armes, and chastly kisse ye,
 Dwell in your bosome like your dearest thoughts,
 And sigh and weepe.
Angellina [aside]. I've too much woman in me.
Charles. And those true teares falling on your pure Chrystalls
 Should turne to armelets for great Queenes t'adore. 60
Angellina. I must be gone.
Charles. Doe not, I will not hurt ye;

36 blushes too,] MS (~ ~ ∧), Q3; blushes that Q1–2
51 see] MS, Q3; behold Q1–2 56 ye ... ye] MS, Q3; it ... it Q1–2

519

This is to let you know, my worthiest Lady,
Y'have clear'd my minde, and I can speake of love too;
Feare not my manners, though I never knew
Before these few houres what a beauty was,
And such a one that fires all hearts that feele it;
Yet I have read of vertuous temperance,
And studied it among my other secrets,
And sooner would I force a separation
Betwixt this spirit, and the case of flesh, 70
Than but conceive one rudenesse against chastity.

Angellina. Then we may walke.

Charles. And talke of any thing,
Any thing fit for your eares; and my language,
Though I was bred up dull I was ever civill;
Tis true, I have found it hard to looke on you,
And not desire, Twill prove a wise mans taske,
Yet those desires I have so mingled still
And tempered with the quality of honour,
That if you should yeeld, I should hate you for't.
I am no Courtier of a light condition, 80
Apt to take fire at every beautious face,
That onely serves his will and wantonnesse,
And lets the serious part of life runne by
As thin neglected sand. Whitenesse of name,
You must be mine; why should I robbe my selfe
Of that that lawfully must make make me happy?
Why should I seeke to cuckold my delights?
And widow all those sweets I aime at in you?
Wee'll loose our selves in *Venus* groves of mirtle,
Where every little bird shall be a *Cupid*, 90
And sing of love and youth, each winde that blowes
And curles the velvet leaves shall breed delights,
The wanton springs shall call us to their bankes,
And on the perfum'd flowers woe us to tumble,
Yet wee'll walke by untainted of their pleasures,
And as they were pure Temples wee'll talke in 'em.

*94 woe us to tumble] Q3; wee'll feast our senses Q1–2; woe us to't MS
96 'em] MS; them Q1–3

Angellina. To bed, and pray then, we may have a faire end
 Of our faire loves; would I were worthy of you,
 Or of such parents that might give you thankes:
 But I am poore in all but in your love. 100
 Once more, good night.
Charles. A good night t'yee, and may
 The deaw of sleepe fall gently on you, sweet one,
 And locke up those faire lights in pleasing slumbers;
 No dreames but chaste and cleare attempt your fancie,
 And breake betimes sweet morne, I've lost my light else.
Angellina. Let it be ever night when I lose you.
Sylvia. This Scholar never went to a Free-Schoole, hee's so simple.

Enter a SERVANT.

Servant. Your brother with two Gallants is at doore, Sir,
 And they're so violent, they'l take no deniall.
Angellina. This is no time of night——
Charles. Let 'em in Mistresse. 110
Servant. They stay no leave; Shall I raise the house on 'em Sir?
Charles. Not a man, nor make no murmur of't, I charge ye.
 [*Exit* Servant.]

Enter EUSTACE, EGREMONT, COWSY [*drawne*].

Eustace. Th'are here, my Uncle absent, stand close to me.——
 How doe you brother with your curious story?
 Have you not read her yet sufficiently?
Charles. No, brother, no, I stay yet in the Preface;
 The stile's too hard for you.
Eustace. I must entreat her.
 Shee's parcell of my goods.
Charles. Shee's all when you have her.
Angellina. Hold off your hands, unmannerly, rude Sir;
 Nor I, nor what I have depend on you. 120
Charles. Doe, let her alone, she gives good counsell; doe not
 Trouble your selfe with Ladies, they are too light;
 Let out your land, and get a provident Steward.
Angellina. I cannot love ye, let that satisfie you;

Such vanities as you are to be laught at.
Eustace. Nay, then you must goe, I must claime my owne.
Both. Away, away with her.

<div align="right">*She strikes off* Eustace's *hat.*</div>

Charles. Let her alone,
Pray let her alone, and take your coxcombe up:
Let me talke civilly a while with you brother,
It may be on some tearms I may part with her. 130
Eustace. O, is your heart come downe? what are your tearmes, Sir?
Put up, put up. [*To* Egremont, Cowsy.]
Charles. This is the first and chiefest,

<div align="right">*Snatches away his his sword.* [*They draw again.*]</div>

Let's walke a turne; now stand off fooles, I advise ye,
Stand as farre off as you would hope for mercy:
This is the first sword yet I ever handled,
And a sword's a beauteous thing to looke upon,
And if it hold, I shall so hunt your insolence:
Tis sharpe I'me sure, and if I put it home,
Tis ten to one I shall new pinke your Sattins:
I finde I have spirit enough to dispose of it, 140
And will enough to make ye all examples;
Let me tosse it round, I have the full command on't:
Fetch me a native Fencer, I defie him;
I feele the fire of ten strong spirits in me.
Doe you watch me when my Uncle is absent?
This is my griefe, I shall be flesht on Cowards;
Teach me to fight, I willing am to learne.
Are ye all gilded Flies, nothing but shew in ye?
Why stand ye gaping? who now touches her?
Who calles her his, or who dares name her to me? 150
But name her as his owne? who dares looke on her?
That shall be mortall too; but thinke, 'tis dangerous.
Art thou a fit man to inherit land,
And hast no wit nor spirit to maintaine it?
Stand still thou signe of man, and pray for thy friends,

<div align="center">126 my] MS, Q3; mine Q1–2</div>

Pray heartily, good prayers may restore ye.

Angellina. But doe not kill 'em Sir.

Charles. You speake too late, Deare,
 It is my first fight, and I must doe bravely,
 I must not looke with partiall eyes on any;
 I cannot spare a button of these Gentlemen; 160
 Did life lye in their heele *Achilles* like,
 Ide shoot my anger at those parts and kill 'em.
 Who waits within?

[*Enter* SERVANT.]

Servant. Sir.

Charles. View all these, view 'em well,
 Goe round about 'em and still view their faces,
 Round about yet, See how death waites upon 'em,
 For thou shalt never view 'em more.

Eustace. Pray hold, Sir.

Charles. I cannot hold, you stand so faire before me,
 I must not hold, 'twill darken all my glories.
 Goe to my Uncle, bid him poste to the King, [*To* Servant.]
 And get my pardon instantly, I have need on't. 170

Eustace. Are you so unnaturall?

Charles. You shall dye last Sir,
 Ile talke thee dead, thou art no man to fight with.
 Come, will ye come? me thinkes I've fought whole battailes.

Cowsy. We have no quarrell to you, that we know on, Sir.

Egremont. Wee'll quit the house and aske ye mercy too:
 Good Lady, let no murther be done here;
 We came but to parly.

Charles. How my sword
 Thirsts after them? stand away Sweet.

Eustace. Pray Sir,
 Take my submission, and I disclaime for ever.

Charles. Away ye poore things, ye despicable Creatures! 180
 Doe you come poste to fetch a Lady from me,
 From a poore Schoole-boy that ye scorn'd of late?
 And grow lame in your hearts when you should execute?
 Pray take her, take her, I am weary of her;

What did ye bring to carry her?

Egremont. A Coach and foure horses.

Charles. But are they good?

Egremont. As good as *France* can shew Sir.

Charles. Are you willing to leave those, and take your safeties?
 Speake quickly.

Eustace. Yes with all our hearts.

Charles. Tis done then:
 Many have got one horse, I've got foure by th' bargaine.

Enter MIRAMONT.

Miramont. How now, who's here?

Servant. Nay now, y'are gone without baile. 190

Miramont. What, drawne my friends? Fetch me my two-hand
 sword;
 I will not leave a head on your shoulders, Wretches.

Eustace. In truth Sir, I came but to doe my duty.

Both. And we to renew our loves.

Miramont. Bring me a blanket.
 What came they for?

Angellina. To borrow me a while, Sir;
 But one that never fought yet has so curried,
 So bastinado'd them with manly carriage,
 They stand like things *Gorgon* had turn'd to stone:
 They watch'd your being absent, and then thought
 They might doe wonders here, and they have done so; 200
 For by my troth, I wonder at their coldnesse,
 The nipping North or frosts never came neere them,
 St. *George* upon a Signe would grow more sensible:
 If the name of honour were for ever to be lost,
 These were the most sufficient men to doe it
 In all the world, and yet they are but young,
 What will they rise to? They're as full of fire
 As a frozen Glo-wormes taile, and shine as goodly;
 Nobility and patience are match'd rarely
 In these three Gentlemen, they have right use on't; 210
 They'll stand still for an houre and be beaten.
 These are the Anagrammes of three great Worthies.

Miramont. They will infect my house with cowardize,
If they breathe longer in it; my roofe covers
No baffl'd Monsieurs, walke and aire your selves;
As I live, they stay not here, white liver'd wretches!
Without one word to aske a reason why,
Vanish, 'tis the last warning, and with speed,
For if I take ye in hand I shall dissect ye,
And reade upon your flegmaticke dull carcases. 220
My horse againe there: I have other businesse,
Which you shall heare hereafter and laugh at it.
Good night *Charles*, faire goodnesse to you deare Lady.
Tis late, 'tis late.
Angellina. Pray Sir be carefull of us.
Miramont. It is enough, my best care shall attend ye.

 Exeunt.

 Enter ANDREW. IV.iv

Andrew. Are you come old Master? very good, your horse
Is well set up, but ere ye part Ile ride you
And spurre your reverend Justiceship such a question,
As I shall make the sides o' your reputation bleed,
Truely I will. Now must I play at Bo-peepe———
A banquet———well, Potatoes and Eringoes,
And as I take it, Cantharidies,———Excellent,
A priapisme followes, and as Ile handle it,
It shall, old lecherous Goate in authority.
Now they beginne to bill; how he slavers her. 10
Gramercy *Lilly*, she spits his kisses out,
And now he offers to fumble she falles off,
(That's a good Wench) and cries faire play above boord.
Who are they in the corner? As I live,
A covey of Fidlers; I shall have some musicke yet
At my making free oth' Company of Horners;
There's the comfort, and a song too! He beckons for one———
Sure 'tis no Anthem nor no borrowed rhymes
Out of the Schoole of vertue; I will listen——— *A Song.*
This was never penn'd at *Geneva*, the note's too spritely. 20

 219 ²ye] MS; you Q1–2

 525

So, so, the musicke's paid for, and now what followes?
O that Monsieur *Miramont* would but keepe his word,
Here were a feast to make him fat with laughter,
At the most 'tis not sixe minutes riding from his house,
Nor will he breake I hope——

[*Enter* MIRAMONT.]

 O are you come Sir?
The prey is in the net and wee'll breake in
Upon occasion.
Miramont. Thou shalt rule me *Andrew.*
O th'infinite fright that will assaile this Gentleman!
The quarterns, tertians, and quotidians
That will hang like Sergeants on his worships shouldiers! 30
The humiliation of the flesh of this man!
This grave austere man will be wondred at.
How will those solemne lookes appeare to me,
And that severe face, that spake chaines and shackles?
Now I take him in the nicke, ere I've done with him,
He had better have stood betweene two panes of wainscot
And made his recantation in the market,
Than heare me conjure him.
Andrew. He must passe this way,
To th'onely bed I have, he comes, stand close.

[*Enter* BRISAC, LILLY.]

Brisac. Well done, well done, give me my nightcap. So, 40
Quicke, quicke, untrusse me; I will trusse and trounce thee;
Come Wench a kisse betweene each point; kisse close;
It is a sweet Parenthesis.
Lilly. Y'are merry Sir.
Brisac. Merry I will be anon, and thou shalt feele it,
Thou shalt my *Lilly.*
Lilly. Shall I aire your bed, Sir?
Brisac. No, no, Ile use no warming pan but thine, Girle;
That's all; Come kisse me againe.
Lilly. Ha' ye done yet?

 26 wee'll] MS (weel); will Q1–3 35 I've] MS (I have); I' Q1, Q3; I ∧ Q2

Brisac. No, but I will doe, and doe wonders, *Lilly.*
 Shew me the way.
Lilly. You cannot misse it, Sir;
 You shall have a Cawdle in the morning, for 50
 Your worships breakfast.
Brisac. How, ith' morning *Lilly?*
 Th'art such a witty thing to draw me on.
 Leave fooling, *Lilly*, I am hungry now,
 And th'hast another Kickshaw, I must taste it.
Lilly. Twill make you surfet, I am tender of you,
 And for your healths and credits sake must tell you
 Y'have all y'are like to have.
Andrew. Can this be earnest?
Miramont. It seemes so, and she honest.
Brisac. Have I not
 Thy promise *Lilly?*
Lilly. Yes, and I have performed
 Enough to a man of your yeares, this is truth, 60
 And you shall finde Sir, you have kist and tows'd me,
 Handled my legge and foote, what would you more, Sir?
 As for the rest, it requires youth and strength,
 And th' labour in an old man would breed Agues,
 Sciaticaes, and Cramps; you shall not curse me,
 For taking from you what you cannot spare, Sir:
 Be good unto your selfe, y'have tane already
 All you can take with ease; you are past threshing,
 It is worke too boisterous for you, leave
 Such drudgery to *Andrew.*
Miramont. How she jeeres him? 70
Lilly. Let *Andrew* alone with his owne tillage,
 Hee's tough, and can manure it.
Brisac. Y'are a queane,
 A scoffing jeering queane.
Lilly. It may be so, but
 I'me sure, Ile nere be yours.
Brisac. Doe not provoke me,
 If thou do'st, Ile have my Farme againe, and turne

*56 And ... you] MS; *omit* Q1–3

527

Thee out a begging.

Lilly. Though you have the will,
And want of honesty to deny your Deed, Sir,
Yet I hope *Andrew* has got so much learning
From my young Master, as to keepe his owne;
At the worst, Ile tell a short tale to the Judges, 80
For what grave ends you sign'd your Lease, and on
What tearmes you would revoke it.

Brisac. Whore, thou dar'st not.
Yeeld or Ile have thee whipt; How my bloud boiles,
As if 'twere ore a furnace!

Miramont. I shall coole it.

Brisac. Yet gentle *Lilly*, pitie and forgive me,
Ile be a friend t'ye, such a loving bountifull friend——

Lilly. To avoid suites in Law, I would grant a little,
But should fierce *Andrew* know it, what would become
Of me?

Andrew. A whore, a whore.

Brisac. Nothing but well, Wench,
I will put such a strong bit in his mouth 90
As thou shalt ride him how thou wilt, my *Lilly*.
Nay, he shall hold the doore, as I will worke him,
And thanke ye for the Office.

Miramont. Take heed *Andrew*,
These are shrewd temptations.

Andrew. Pray you know
Your Cue, and second me Sir; By your Worships favour.

[*Comes forward.*]

Brisac. *Andrew*!

Andrew. I come in time to take possession
Of th'office you assigne me; hold the doore,
Alas 'tis nothing for a simple man
To stay without when a deepe understanding
Holds conference within, say with his wife: 100
A trifle Sir, I know I hold my farme
In Cuckolds Tenure; you are Lord o'the soyle Sir,
Lilly is a Weft, a Stray, shee's yours, to use Sir,

I claime no interest in her.

Brisac. Art thou serious?
Speake honest *Andrew* since thou hast oreheard us,
And winke at small faults, man; I'me but a pidler,
A little will serve my turne, thou'lt finde enough
When I've my belly full; wilt thou be private
And silent?

Andrew. By all meanes, Ile onely have
A Ballad made of't, sung to some lewd Tune, 110
And the name of it shall be *The Justice Trap*,
It will sell rarely with your Worships name,
And *Lillies* on the toppe.

Brisac. Seeke not the ruine
O' my reputation, *Andrew.*

Andrew. Tis for your credit,
Monsieur *Brisac* printed in capitall letters,
Then pasted upon all the posts in *Paris.*

Brisac. No mercy, *Andrew?*

Andrew. O, it will proclaime you
From th' Citie to the Court, and prove sport royall.

Brisac. Thou shalt keepe thy Farme.

Miramont. He does afflict him rarely.

Andrew. You trouble me. Then his intent arriving, 120
(The vizard of his hypocrisie pull'd off)
To the Judge criminall——

Brisac. O, I am undone.

Andrew. Hee's put out of Commission with disgrace,
And held uncapable of bearing Office
Ever hereafter. This is my revenge,
And this Ile put in practice.

Brisac. Doe but heare me.

Andrew. To bring me backe from my Grammar to my Horne-
 booke,
It is unpardonable.

Brisac. Doe not play the Tyrant;
Accept of composition.

Lilly. Heare him, *Andrew.*

111 *The*] Theobald; *omit* Q1–F2

529

Andrew. What composition?

Brisac. Ile confirme thy farme, 130
 And adde unto't an hundred acres more
 Adjoyning to it.

Andrew. Umh, This mollifies,
 But y'are so fickle, and will againe deny this,
 There being no witnesse by.

Brisac. Call any witnesse,
 Ile presently assure it.

Andrew. Say you so,
 Troth there's a friend of mine Sir, within hearing,
 That is familiar with all that's past,
 His testimony will be authenticall.

Brisac. Will he be secret?

Andrew. You may tye his tongue up,
 As you would doe your purse-strings. [*Miramont comes forward.*]

Brisac. *Miramont.*

Miramont. Ha, ha, ha. 140

Andrew. This is my witnesse. Lord how you are troubled?
 Sure, y'have an ague, you shake so with choler;
 Hee's your loving brother Sir, and will tell no body
 But all he meets, that you have eate a snake,
 And are growne young, gamesome, and rampant.

Brisac. Caught thus?

Andrew. If he were one that would make jests of you,
 Or plague ye with making your religious gravity
 Ridiculous to your neighbours, Then you had
 Some cause to be perplex'd.

Brisac. I shall become
 Discourse for Clownes and Tapsters.

Andrew. Quicke, *Lilly*, quicke. 150
 Hee's now past kissing, betweene point and point.
 He swounds, fetch him some Cordiall—— Now put in Sir.

Miramont. Who may this be? sure this is some mistake:
 Let me see his face, weares he not a false beard?
 It cannot be *Brisac* that worthy Gentleman,
 The pillar and the patron of his Country;
 He is too prudent and too cautelous,

132 Umh] Umb Q1–F2; Ump MS

Experience hath taught him t'avoid these fooleries,
He is the punisher and not the doer,
Besides hee's old and cold, unfit for women; 160
This is some Counterfeit, he shall be whipt for't,
Some base abuser of my worthy brother.

Brisac. Open the doores, will y'imprison me? are ye my Judges?

Miramont. The man raves! This is not judicious *Brisac*:
Yet now I thinke on't, a'has a kinde of dog looke
Like my brother, a guilty hanging face.

Brisac. Ile suffer bravely, doe your worst, doe, doe.

Miramont. Why, it's manly in you.

Brisac. Nor will I raile nor curse,
You slave, you whore, I will not meddle with you,
But all the torments that ere fell on men, 170
That fed on mischiefe, fall heavily on you all. *Exit.*

Lilly. You have giv'n him a heat, Sir.

Miramont. He will ride you
The better, *Lilly*.

Andrew. Wee'll teach him to meddle with Scholars.

Miramont. He shall make good his promise t'encrease thy Farme,
 Andrew,
Or Ile jeere him to death, feare nothing *Lilly*,
I am thy Champion. This jeast goes to *Charles*,
And then Ile hunt him out, and Monsieur *Eustace*
The gallant Courtier, and laugh heartily
To see 'em mourne together.

Andrew. Twill be rare, Sir.

 Exeunt.

[*Enter*] EUSTACE, EGREMONT, COWSY. V.i

Eustace. Turn'd out of doores and baffled!

Egremont. We share with you
In the affront.

Cowsy. Yet beare it not like you
With such dejection.

Eustace. My Coach and horses made
The ransome of our cowardize.

Cowsy. Pish, that's nothing,

531

Tis *Damnum reparabile*, and soone recover'd.
Egremont. It is but feeding a suitor with false hopes,
And after squeeze him with a dozen of oathes.
You are new rigg'd, and this no more remembred.
Eustace. And does the Court that should be the example
And Oracle of the Kingdome, reade to us 10
No other doctrine?
Egremont. None that thrives so well
As that, within my knowledge.
Cowsy. Flatt'ry rubbes out,
But since great men learne to admire themselves,
Tis something crest-falne.
Egremont. To be of no Religion,
Argues a subtle morall understanding,
And it is often cherisht.
Eustace. Piety then,
And valour, nor to doe nor suffer wrong,
Are there no vertues?
Egremont. Rather vices, *Eustace*;
Fighting! What's fighting? It may be in fashion,
Among Provant swords, and buffe-jerkin men: 20
But w'us that swimme in choise of silkes and Tissues;
Though in defence of that word reputation,
Which is indeed a kinde of glorious nothing,
To lose a dramme of bloud must needs appeare
As coarse as to be honest.
Eustace. And all this
You seriously beleeve?
Cowsy. It is a faith,
That we will die in, since from the blacke guard
To the grimme Sir in office, there are few
Hold other Tenets.
Eustace. Now my eyes are open,
And I behold a strong necessity 30
That keepes me knave and coward.
Cowsy. Y'are the wiser.
Eustace. Nor can I change my Copy, if I purpose
To be of your society?
Egremont. By no meanes.

Eustace. Honour is nothing with you?
Cowsy. A meere bubble,
 For what's growne common is no more regarded.
Eustace. My sword forc'd from me too, and still detein'd,
 You thinke's no blemish?
Egremont. Get me a battoone,
 Tis twenty times more courtlike, and lesse trouble.
Eustace. And yet you weare a sword.
Cowsy. Yes, and a good one,
 A Millan hilt, and a Damasco blade, 40
 For ornament, no use the Court allowes it.
Eustace. Wil't not fight of it selfe?
Cowsy. I nere tri'd this,
 Yet I have worne as faire as any man,
 I'me sure I've made my Cutler rich, and paid
 For severall weapons, Turkish and Toledo's,
 Two thousand Crownes, and yet could never light
 Upon a fighting one.
Eustace. Ile borrow this,
 I like it well.
Cowsy. Tis at your service Sir,
 A lath in a velvet scabberd will serve my turne.
Eustace. And now I have it, leave me, y'are infectious, 50
 The plague and leprosie of your basenesse spreading
 On all that doe come neere you, such as you
 Render the Throne of Majesty, the Court,
 Suspected and contemptible, you are Scarabes
 That batten in her dung, and have no pallats
 To taste her curious viands, and like Owles
 Can onely see her night deformities,
 But with the glorious splendor of her beauties
 You are strucke blinde as Moles, that undermine
 The sumptuous building that allow'd you shelter: 60
 You sticke like running ulcers on her face,
 And taint the purenesse of her native candor,
 And being bad servants cause your masters goodnesse
 To be disputed of; make you the Court
 That is the abstract of all Academies,

*64 make you] *stet* Q1

To teach and practice noble undertakings
(Where courage sits triumphant crown'd with Lawrell,
And wisedome loaded with the weight of honour)
A Schoole of vices?

Egremont. What sudden rapture's this?

Eustace. A heavenly one that raising me from sloth and ignorance, 70
(In which your conversation long hath charm'd me)
Carries me up into the aire of action,
And knowledge of my selfe; even now I feele
But pleading onely in the Courts defence,
(Though farre short of her merits and bright lustre)
A happy alteration, and full strength
To stand her Champion against all the world,
That throw aspersions on her.

Cowsy. Sure hee'll beat us,
I see it in his eyes.

Egremont. A second *Charles*;
Pray looke not Sir so furiously.

Eustace. Recant 80
What you have said, ye Mungrils, and licke up
The vomit you have cast upon the Court,
Where you unworthily have had warmth and breeding,
And sweare that you like Spiders, have made poyson
Of that which was a saving antidote.

Egremont. We will sweare any thing.

Cowsy. We honour the Court
As a most sacred place.

Egremont. And will make oath,
If you enjoyne us to't, nor knave nor foole,
Nor Coward living in it.

Eustace. Except you two,
You Rascals!

Cowsy. Yes, we are all these, and more, 90
If you will have it so.

Eustace. And that untill
You are againe reform'd and growne new men,
You nere presume to name the Court, or presse

69 vices?] Greg; ~ . Q1–F2

Into the Porters Lodge but for a penance,
To be disciplin'd for your roguery, and this done
With true contrition——

Both. Yes Sir.

Eustace. You againe,
 May eat scraps and be thankfull.

Cowsy. Here's a cold breakfast
 After a sharpe nights walking.

Eustace. Keepe your oathes,
 And without grumbling vanish.

Both. We are gone, Sir.

 Exeunt [Egremont, Cowsy.]

Eustace. May all the poorenesse of my spirit goe with you, 100
 The fetters of my thraldome are fil'd off:
 And I at liberty to right my selfe,
 And though my hope in *Angellina*'s little,
 My honour (unto which compar'd shee's nothing)
 Shall like the Sunne disperse those lowring Clouds,
 That yet obscure and dimme it; not the name
 Of brother shall divert me, but from him,
 That in the worlds opinion ruin'd me,
 I will seeke reparation, and call him
 Unto a strict accompt. Ha! 'tis neere day, 110
 And if the Muses friend, rose-cheek'd *Aurora*,
 Invite him to this solitary grove,
 As I much hope she will, he seldome missing
 To pay his vowes here to her, I shall hazard
 To hinder his devotions—— The doore opens.

 Enter CHARLES.

 Tis he most certaine, and by's side my sword,
 Blest opportunity.

Charles. I have oreslept my selfe,
 And lost part of the morne, but Ile recover it:
 Before I went to bed, I wrote some notes
 Within my Table-booke, which I will now consider. 120
 Ha! What meanes this? What doe I with a sword?

 535

Learn'd *Mercurie* needs not th'aide of *Mars*, and innocence
Is to it selfe a guard, yet since armes ever
Protect arts, I may justly weare and use it,
For since 'twas made my prize, I know not how
I'me growne in love with't, and cannot eate nor study,
And much lesse walke without it: but I trifle,
Matters of more weight aske my judgement.

Eustace. None Sir,
Treate of no other Theme, Ile keepe you to it,
And see y'expound it well.

Charles. *Eustace!*

Eustace. The same Sir, 130
Your younger brother, who as duty bindes him,
Hath all this night (turn'd out of doores) attended,
To bid good morrow t'ye.

Charles. This not in scorne,
Commands me to returne it, Would you ought else?

Eustace. O much, Sir, here I end not, but beginne;
I must speake to you in another straine,
Than yet I ever us'd, and if the language
Appeare in the delivery rough and harsh,
You (being my Tutor) must condemne your selfe,
From whom I learn'd it.

Charles. When I understand 140
(Bee't in what stile you please) what's your demand,
I shall endeavour in the selfe same phrase
To make an answer to the point.

Eustace. I come not
To claime to your birthright, 'tis your owne,
And 'tis fit you enjoy it, nor aske I from you
Your learning and deepe knowledge; (though I am not
A Scholar as you are) I know them Diamonds
By your sole industry, patience and labour
Forc'd from steepe rockes and with much toile attended,
And but to few, that prize their value granted, 150
And therefore without rivall freely weare them.

Charles. These not repin'd at (as you seeme t'enforme me)

The motion must be of a strange condition,
If I refuse to yeeld to't, therefore *Eustace*,
Without this tempest in your lookes propound it,
And feare not a deniall.

Eustace. I require then,
(As from an enemy and not a brother)
The reputation of a man, the honour,
Not by a faire warre wonne when I was waking,
But in my sleepe of folly ravish'd from me, 160
With these, the restitution of my sword,
With large acknowledgement of satisfaction,
My Coach, my Horses, I will part with life,
Ere lose one haire of 'em, and what concludes all,
My Mistresse *Angellina*, as she was
Before the musicall Magicke of thy tongue
Inchanted and seduc'd her. These perform'd,
And with submission, and done publiquely,
At my Fathers and my Uncles intercession
(That I put in too) I perhaps may listen 170
To tearmes of reconcilement; but if these
In every circumstance are not subscrib'd to,
To th' last gaspe I defie thee.

Charles. These are strict
Conditions to a brother.

Eustace. My rest is up,
Nor will I goe lesse.

Charles. I'me no Gamester, *Eustace*,
Yet I can guesse your resolution stands
To winne or lose all; I rejoyce to finde ye
Thus tender of your honour, and that at length
You understand what a wretched thing you were,
How deepely wounded by your selfe, and made 180
Almost incureable in your owne hopes,
The dead flesh of pale cowardise growing over
Your festred reputation, which no balme
Or gentle unguent ever could make way to,
And I am happy, that I was the Surgeon,

164, ¹211 'em] MS; them Q1–3 *175 goe] MS; give Q1–3

537

That did apply those burning corrosives
That render you already sensible
O'th' danger you were plung'd in, teaching you,
And by a faire gradation, how farre
And with what curious respect and care 190
The peace and credit of a man within,
(Which you nere thought till now) should be preferr'd
Before a gawdy outside; pray you fixe here,
For so farre I goe with you.

Eustace. This discourse
Is from the subject.

Charles. Ile come to it brother,
But if you thinke to build upon my ruines,
You'll finde a false foundation, your high offers
Taught by the masters of dependancies,
That by compounding differences 'tweene others
Supply their owne necessities, with me 200
Will never carry't; As you are my brother,
I would dispence a little, but no more
Than honour can give way to; nor must I
Destroy that in my selfe I love in you,
And therefore let not hopes nor threats perswade you,
I will descend to any composition,
For which I may be censur'd.

Eustace. You shall fight then.

Charles. With much unwillingnesse with you, but if
There's no evasion———

Eustace. None.

Charles. Heare yet a word,
As for the sword and other fripperies, 210
In a faire way send for 'em, you shall have 'em,
But rather than surrender *Angellina*,
Or heare it againe mention'd, I oppose
My breast unto lowd thunder, cast behinde me
All ties of Nature.

Eustace. She detein'd, I'me deafe
To all perswasion.

*192 nere] Q2; were Q1, Q3, MS

538

Charles. Guard thy selfe then *Eustace,*
 I use no other Rhetoricke. *They fight.*

 Enter MIRAMONT.

Miramont. Clashing of swords
 So neere my house? brother oppos'd to brother!
 Here is no fencing at halfe-sword, hold, hold,
 Charles, Eustace.
Eustace. Second him, or call in more helpe, 220
 Come not betweene us, Ile not know nor spare you;——
 D'ye fight by th' booke?
Charles. Tis you that wrong me, off Sir,
 And suddenly Ile conjure downe the spirit
 That I have raised in him.
Eustace. Never *Charles,*
 Till thine, and in thy death, be doubled in me.
Miramont. I'me out of breath, yet trust not too much to't boyes,
 For if you pawse not suddenly, and heare reason——
 Doe, kill your Uncle, doe, but that I'me patient,
 And not a cholericke old teasty foole,
 Like your father, Ide daunce a matachin with you, 230
 Should make you sweat your best blood for't, I would,
 And it may be I will. *Charles* I command thee,
 And *Eustace* I entreat thee, th'art a brave Sparke,
 A true tough metal'd blade, and I beginne
 To love thee heartily, give me a fighting Courtier,
 Ile cherish him for example; in our age
 Th'are not borne every day.
Charles. You of late Sir,
 In me lov'd learning.
Miramont. True, but take me w'ye, Charles,
 Twas when young *Eustace* wore his heart in's breeches,
 And fought his battailes in Complements and Cringes, 240
 When's understanding wav'd in a flaunting feather,
 And his best contemplation look'd no further
 Than a new fashion'd doublet, I confesse then
 The lofty noise your Greeke made onely pleas'd me,

 217 *They fight.*] MS; *omit* Q1–3

 539

But now hee's turn'd an *Oliver* and a *Rowland*,
Nay the whole dozen of peeres are bound up in him;
Let me remember, when I was of his yeeres
I did looke very like him, and did you see
My picture as I was then, you would sweare
That gallant *Eustace*, (I meane, now he dares fight) 250
Was the true substance and the perfect figure.
Nay, nay, no anger, you shall have enough *Charles*.
Charles. Sure Sir, I shall not need addition from him.
Eustace. Nor I from any, this shall decide my interest,
Though I am lost to all deserving men,
To all that men call good, for suffering tamely
Insufferable wrongs, and justly sleighted,
By yeelding to a minute of delay
In my revenge, and from that made a stranger
Unto my fathers house and favour, orewhelm'd 260
With all disgraces, yet I will mount upward,
And force my selfe a fortune, though my birth
And breeding doe deny it.
Charles. Seeke not *Eustace*,
By violence what will be offered to you,
On easier composition; though I was not
Allied unto your weaknesse, you shall finde me
A brother to your bravery of spirit,
And one that not compell'd to't by your sword,
(Which I must never feare) will share with you,
In all but *Angellina*.
Miramont. Nobly said *Charles*, 270
And learne from my experience, you may heare reason
And never maime your fighting; [*to* Eustace] for your credit
Which you thinke you have lost, spare *Charles*; and swinge me,
And soundly, three or foure walking velvet cloakes
That weare no swords to guard 'em, yet deserve it,
Thou art made up againe.
Eustace. All this is lip-salve.
Miramont. It shall be Hearts-ease, *Eustace*, ere I've done;
As for thy fathers anger, now thou dar'st fight,
Nere feare't, for I've the dowcets of his gravity

Fast in a string, and will so pinch and wring him, 280
That spight of his authority, thou shalt make
Thine owne conditions with him.

Eustace. Ile take leave
A little to consider.

> [*Enter* ANDREW *with a broken head.*]

Charles. Here comes *Andrew.*
Miramont. But without his Comicall and learned face,
 What sad disaster, *Andrew?*
Andrew. You may reade Sir,
 A Tragedy in my face.
Miramont. Art thou in earnest?
Andrew. Yes, by my life Sir, and if now you helpe not,
 And speedily by force or by persuasion,
 My good old Master (for now I pitie him)
 Is ruin'd for ever.
Charles. Ha, my father!
Andrew. He Sir. 290
Miramont. By what meanes? speake.
Andrew. At the suite of Monsieur *Lewis,*
 His house is seiz'd upon, and he in person
 Is under guard, (I saw it with these eyes Sir)
 To be convey'd to *Paris,* and there sentenc'd.
Miramont. Nay, then there is no jesting.
Charles. Doe I live,
 And know my father injur'd?
Andrew. And what's worse Sir,
 My Lady *Angellina*——
Eustace. What of her?
Andrew. Shee's carryed away too.
Miramont. How?
Andrew. While you were absent,
 A crew of Monsieur *Lewis* friends and kinsmen
 By force brake in at th' backe part of the house 300
 And tooke her away by violence; faithfull *Andrew,*
 (As this can witnesse for him) did his best,
 In her defence, but 'twould not doe.

Miramont. Away,
 And see our horses sadled, 'tis no time
 To talke, but doe: *Eustace*, you now are offer'd
 A spatious field, and in a pious warre
 To exercise your valour, here's a cause,
 And such a one, in which to fall is honourable,
 Your duty and reverence due to a fathers name
 Commanding it; but these unnaturall jarres 310
 Arising betweene brothers (should you prosper)
 Would shame your victory.
Eustace. I would doe much Sir,
 But still my reputation!
Miramont. *Charles* shall give you
 All decent satisfaction; nay, joyne hands,
 And heartily; why this is done like brothers;
 And old as I am, in this cause that concernes
 The honour of our family, Monsieur *Lewis*
 (If reason cannot worke) shall finde and feele
 There's hot blood in this arme, Ile lead you bravely.
Eustace. And if I follow not, a Cowards name 320
 Be branded on my forehead.
Charles. This spirit makes you
 A sharer in my fortunes.
Miramont. And in mine,
 Of which (*Brisac* once freed, and *Angellina*
 Againe in our possession) you shall know
 My heart speakes in my tongue.
Eustace. I dare not doubt it, Sir.
 Exeunt.

 Enter LEWIS, BRISAC, ANGELLINA, SYLVIA, *Officers.* V.ii

Lewis. I'me deafe to all perswasion.
Brisac. I use none,
 Nor doubt I, though a while my innocence suffers,
 But when the King shall understand how falsely
 Your malice hath inform'd him, he in justice
 Must set me right againe.
 307 your] MS, Q3; you Q1–2

Angellina. Sir, let not passion
So farre transport you as to thinke in reason,
This violent course repaires, but rather ruines
That honour you would build up, you destroy
What you would seeme to nourish; if respect
Of my preferment or my reputation 10
May challenge your paternall love and care,
Why doe you, now good fortune has provided
A better husband for me than your hopes
Could ever fancy, strive to robbe me of him?
In what is my lov'd *Charles* defective, Sir?
Unlesse deepe learning be a blemish in him,
Or well proportion'd limbs be mulcts in Nature,
Or what you onely aim'd at, large revenewes,
Are on the sudden growne distastfull to you?
Of what can you accuse him?

Lewis. Of a rape 20
Done to mine honour, which thy ravenous lust
Made thee consent to.

Sylvia. Her lust! you are her father.

Lewis. And you her Bawd.

Sylvia. Were you ten Lords, 'tis false,
The purenesse of her chaste thoughts entertaine not
Such spotted instruments.

Angellina. As I have a soule Sir——

Lewis. I am not to be alter'd, to sit downe
With this disgrace would argue me a Peasant,
And not borne noble: all rigour that the Law
And that encrease of power by favour yeelds,
Shall be with all severity inflicted; 30
You have the Kings hand for't; no Bayle will serve,
And therefore at your perils Officers, away with 'em.

Brisac. This is madnesse.

Lewis. Tell me so in open Court,
And there Ile answer you.——

7 rather ruines ∧] Q3; ruines it; Q1–2; ruines rather ∧ MS
8 up, you destroy ∧] MS; ~ ∧ ~ ~ ; Q1–2; ~ : ~ ~ ∧ Q3
*15 lov'd] MS (Lo'ud); Lord Q1–2; Love Q3 *21 mine] MS; *omit* Q1–2; thy Q3

Will you doe what you are sworne too? [*To Officers.*]

 Enter MIRAMONT, CHARLES, EUSTACE, ANDREW.

Miramont. Well overtaken.

Charles. Ill if they dare resist.

Eustace. He that advances
 But one step forward dies.

Lewis. Shew the kings Writ.

Miramont. Shew your discretion, 'twill become you better.

Charles. Y'are once more in my power, and if againe [*To* Angellina.]
 I part with you, let me for ever lose you. 40

Eustace. Force will not do't nor threats, [*to* Brisac] accept this
 service
 From your despair'd of *Eustace.*

Andrew. And beware
 Your reverend Worship never more attempt
 To search my *Lilly-pot*, you see what followes.

Lewis. Is the Kings power contemn'd?

Miramont. No, but the torrent
 O'your wilfull folly stopp'd. And for you, good Sir,
 If you would but be sensible, what can you wish
 But the satisfaction of an obstinate will,
 That is not indear'd to you? rather than
 Be cross'd in what you purpos'd, you'll undoe 50
 Your daughters fame, the credit of your judgement,
 And your old foolish neighbour; make your states,
 And in a suite not worth a Cardecue,
 A prey to Advocates, and their buckram Scribes,
 And after they have plum'd ye, returne home
 Like a couple of naked Fowles without a feather.

Charles. This is a most strong truth Sir.

Miramont. No, no, Monsieur,
 Let us be right Frenchmen, violent to charge,
 But when our follies are repell'd by reason,
 Tis fit that we retreat and nere come on more: 60
 Observe my learned *Charles*, hee'll get thee a Nephew

*35 Will ... too?] MS; *omit* Q1–F2 *40 you] MS; thee Q1–3
*49 indear'd] *stet* Q1

On *Angellina* shall dispute in her belly,
And sucke the Nurse by Logicke: and here's *Eustace*,
He was an Asse, but now is growne an *Amadis*;
Nor shall he want a Wife, if all my land
For a joynture can effect it: Y'are a good Lord,
And of a gentle nature, in your lookes
I see a kinde consent, and it shewes lovely;
And doe you heare old Foole? but Ile not chide,　　　[*To* Brisac.]
Hereafter like me, ever doate on learning,　　　　　　　　　　　　70
The meere beleefe is excellent, 'twill save you;
And next love valour though you dare not fight
Your selfe, or fright a foolish Officer, young *Eustace*
Can doe it to a haire. And to conclude,
Let *Andrew's* Farme b'encreas'd, that is your penance,
You know for what, and see you rut no more,
You understand me, So embrace on all sides.
　　Ile pay those Billmen, and make large amends;
　　Provided we preserve you still our friends.

　　　　　　　　　　　　　　　　　　　　　　　　Exeunt.

Epilogue.

Tis not the hands, or smiles, or common way
Of approbation to a well-lik'd Play,
We onely hope; But that you freely would
To th'Authour's memory, so farre unfold,
And shew your loves and liking to his wit,
Not in your praise, but often seeing it;
That being the grand assurance that can give
The Poet and the Player meanes to live.

FINIS.

*69 Foole? but] *stet* Q1

TEXTUAL NOTES

I.i

24 Couch] MS clearly reads 'couch' like Q1, and therefore Q3 'coach' is, as Greg remarks, ingenious but unnecessary. At first sight 'coach' seems the superior reading, the idea being that travel by coach on social calls, and thus without movement of the body as in walking, in Lewis' notion is as slothful as the other ways of passing the day that he has described – that is, without bodily activity. However, the syntax does not encourage this reading, the 'as if' indeed quite discouraging it. Thus 'Borne without motion' must mean 'as if you had been born incapable of movement', not 'carried along and so without movement' in a carriage.

59 pleasures] The agreement of MS and Q3 in the plural establishes its authority over Q1 singular 'pleasure', especially in view of I.i.131–2: 'ith' meane time, home, | And feast thy thoughts with th' pleasures of a Bride' as in Q1, although Q3 here has 'pleasure'.

60 kindes] The Qq plural seems acceptable as against MS singular if the meaning is 'in various ways', although the MS, Q3 plural 'pleasures' could have contaminated the singular 'kind'. The singular in I.ii.154 'All kinde of vertuous and vitious women' is not an exact parallel; moreover, MS here has 'kindes'.

84 bottomes] As Greg remarks, the authority of Q1, Q3 and MS is overwhelming despite the unusual plural.

I.ii

20 pallat] Although Greg follows Q1–3 'stomacke' here, he remarks that MS 'pallat' is perhaps preferable on account of the 'learn'd stomacke' two lines earlier in line 18. Contamination in Q1 and oversight by the Q3 annotator could account for the reading. For 'pallat', see III.ii.11 and V.i.55.

108 service] Q1 'servulating' must be authorial; it is equally clear that the later copy behind MS and Q3 reads 'service'. This latter could be a simple sophistication but it is at least as plausible to conjecture that in the working-over of the manuscript copy behind Q1, 'servulating' (while initially a satire on affected Court language) was taken as being too learned a word and hence insufficiently distinguished from Charles's academic jargon. It is noteworthy that the two courtiers do not speak such affected language elsewhere.

121 our] Dyce's emendation to 'your' is superficially attractive in view of the 'you ... Your selfe' that follows. But the agreement of MS with Q1, Q3 should be authoritative, and Brisac's generalized 'our' repeats Charles's generalization 'our selves' in line 120.

133 Bucolicks] These contain nothing relative to the doctoring of cattle. However, as Greg points out, the Bucolics and Georgics 'were commonly classed together, and

546

the author would not be likely to discriminate very nicely.'

196 Councels] This is the spelling of Q1, Q3, although MS, Q2, have 'Counsells'. Greg notes that 'councel' (i.e., council) and 'counsel' (advice) are always distinguished in Q1 and hence he takes it that Charles means that he criticizes the king's advisers. This interpretation is more precise than the usage warrants. A council is indeed a meeting of advisers, but the king would normally preside at any formal meeting and would greatly influence the decisions taken. The point may be a fine one, but it would seem that Charles likes to criticize not the king's advisers as individuals but the formal meetings and decisions of the king's councillors, the king participating and therefore responsible for accepting the ultimate decision. The emphasis is on the decisions made.

222 never] The retention of the obvious error 'ever' in Q3 from Q1 indicates the possibilities for such slips by the Q3 annotator and serves to cast some doubt on the authority of the concurrence of these two texts.

249 dry-fat] The agreement in this reading of Q1 and MS establishes the authority of the original but does not answer the question whether Q3 'shelfe' is a revision or a sophistication. For 'a shelfe of Bookes' see Miramont in II.i.158, but whether there is a connection with the Q3 reading in I.ii.249 is moot. In doubt one may choose the harder reading and retain Q1, MS 'dry-fat', partly because it is metrically superior but mainly because the examples of Q3 divergence from MS, Q1 are all suspect, with only a few corrections of what appear to be common errors.

266 If] That Q1 faithfully repeats its copy in the repetition of Eustace as a speech-prefix is suggested by the absurd guess of Q3 assigning Brisac; correspondingly, it throws suspicion on the MS assignment to Egremont as only a more intelligent speculation. If the error stood in copy, it was later matched by the repetition of the Notary's prefix at III.i.25 where there can be no question of a substitute. Eustace is the most logical and natural speaker, and no need exists to hypothesize anyone else.

II.i

9 to 'em] This is a difficult crux. For Q1–2 ''em' MS ('you') and Q3 agree in 'ye', a powerful consideration, and a reading adopted by all editors. On the other hand, Miramont's estate and fortune does not seem to be entailed, judging by his confidence that he can leave it where he pleases, first to Charles and then, as he finally decides, to Eustace. Hence 'ye' is inappropriate since Miramont has not in fact entailed his estate to his next of kin, Brisac, who would then necessarily inherit. Some sense can be made of Q1 ''em', although with difficulty. Brisac suggests as a compromise that he should pass over the entail to Charles for his own estate and bequeath it to Eustace, whereas if he pleases Miramont can leave his to Charles. But Miramont is unwilling to see Brisac's estate forfeited by Charles and responds that it is entailed to them. This must mean to Charles and then, Charles dying without issue, the entail would pass to Eustace. The problem of Miramont's saying that his (or Brisac's) estate is entailed to 'ye' seems difficult to solve despite MS, Q3 agreement.

27 Congees] Although Greg retains Qq 'tongues', he remarks that 'tongues' may be a printer's error. Indeed it is probably a misreading which the Q3 annotator

overlooked rather than a revision. However, the hypothesis of misreading is not positively required since the possibility also exists that 'Congees' is a revision of original 'tongues' not repeated in Q3 owing to carelessness in the collation.

II.iii

1 thy] Although Andrew is in a sense on loan to Charles from his father, he is established as Charles' servant by line 42: 'Why what a learned Master do'st thou serve *Andrew?*' This should take precedence over the Butler's 'my younger Master' in line 52 in a different context. The servants would regard the two sons as their masters, of course, but the ambiguity of the Cook's opening speech is apparent. It follows that MS 'thy' is required and Q1, Q3 'my' is another example of Q3 repeating a Q1 error.

10 Ex'llent] The authority of MS 'Excellent' here may not be very strong, and it is true that the full form could scarcely have given rise to the Q1 mystifying '*Ex*'Lent' – a real misunderstanding. A forced pun on the season of Lent is most improbable in context and would represent the only example of the servants' punning. Perhaps the unusual apostrophe and the radical contraction threw off the Q1 compositor, a hypothesis making the reconstruction 'Ex'llent' a trifle better than the conventional 'Exc'llent'.

II.iv

35 warmed] Uneasy as one may be at any hypothesis involving double misreading of their copy by the scribes behind Q1 and MS to produce 'marryed' here, such another case does occur at III.v.118 when 'fingred', unintelligible to MS, was misread as 'sugred' by Q1 and was also corrected by Q3. The ease with which Q3 could correct both obviously bad readings without necessary reference to copy suggests the possibility that in each case the Q1, MS mistake resulted not from misreading but from an actual error in the original.

III.i

39 as to others;] This is a difficult crux, with the exact meaning in dispute. Following Mason, Dyce placed the Q1 semicolon after 'admiration' and read 'as to others' with a comma, meaning 'as to his other qualities'. This is possible although somewhat strained in context. (Earlier, Theobald's guess 'as from others' was pure desperation.) Greg preferred the MS variant 'admiration as in others', interpreting it as 'they do not move to admiration as in the case of others', which presumably means that Angelina found others' 'flashes' superior to Eustace's. This reading is not so 'irresistible' as Greg labelled it nor does the Q1 punctuation necessarily enforce it as he suggested. In such small matters MS departs from Q1 so frequently as to cast any minor variant's authority in doubt. The case, thus, hinges on the meaning of 'as to others'. The Dyce transposition of the punctuation is possible but is not encouraged by MS 'admiration as in others,', which rejects any stop after

'admiration'. If we follow Q1 it is possible to take it that Angelina is less astonished than others by Eustace's flashes of wit; in other words, she thinks less of him than do other people who have remarked him. This same sense might just possibly fit the MS reading as well.

40 may make] The crux continues in this passage, an indication that the writing is contorted. The problem is not helped by the Q1 reading 'must make it' as against the more authoritative agreement of MS and Q3 in 'may make it'. Presumably 'make it' refers to 'good' and would mean 'make himself good'. Greg paraphrases as 'even yet he may make good the promise in him', which perhaps makes the best of a bad job. The difficulty continues, nevertheless, with 'And I may helpe, and helpe to thanke him also', for which earlier editors have offered unsatisfactory emendations. The word play in 'I may helpe . . .' may withstand precise dissection. The general sense probably is something like 'when he makes himself good I shall benefit as well and appreciate the results as they affect me'. Just possibly Angelina is suggesting that Eustace's maturation will be appreciated by others, who will thank him, in which thanks she will join. Greg's paraphrase is no doubt close to the mark: 'I may help to the formation of a good disposition in him, and in the end join in the praise of his goodness'.

III.ii

19 see] Q3 'set' is such an indifferent reading that it is unlikely to be supported as a revision against Q1, MS 'see'; moreover, the case for further revision in Q3 after MS is not to be established here. Dyce points out the possible anticipation of the 'see' in line 20, but common error in Q1 and MS is difficult to demonstrate.

35 sweet hearts] Although MS reads in the singular, as if Brisac were addressing Lily, editors agree that Q1 'hearts' is right and that Brisac is speaking in the plural. Dyce remarks that '*sweet heart* was often applied to the male sex' but does not identify who is being addressed. Greg takes it that Brisac is speaking to his servants. This is more probable than that he is calling offstage to some early arrivals and then ordering his servants to attend them. The case may seem to be clinched by the use of the theatrical 'Come in' for leaving the stage, especially when in III.iii.60 Charles orders Andrew before their exeunt to 'come in with me.' Theatrical language is charmingly used in V.i.115 when Eustace remarks of Charles' entrance into a 'solitary grove' that 'The doore opens.'

III.iii

2 Within a Parenthesis] This phrase has puzzled editors. Theobald took it to be a marginal note crept into the text, and subsequent editors up to Dyce omitted it. Greg seized on Theobald's explanation as an 'astounding piece of nonsense' but nevertheless thinks the phrase is an interpolation. He notes not only that MS omits the words but also that it places a round bracket after 'broken' though 'the scribe has forgotten to begin it before *my*.' Greg adds that 'the omission of the interpolation has necessitated some re-division of the lines'. In fact, this difference

in lining from Q1 is not editorial but is drawn from MS, which divides 'broken | In every … shaken | with … motions, | What … there? | *And.* Tis … Andrew: | *Char.* Come … noyse?' This is tolerable verse up to line 5 where Andrew's response does not link to form a pentameter with Charles's 'Come neere', whereas Q1's lining is good metre for the whole passage, an important point that casts doubt on the authority for omitting 'Within a parenthesis'. Dyce provides the answer by noting that a passage from Lyly's *Sapho and Phao* indicates that the phrase as associated with the head meant horns: 'It is true, and the same time did Mars make a full point, that Vulcans head was made a Parenthesis.' Very likely this application was part of the use of 'parenthesis' to make an obscene movement of bowing the legs as if suffering from venereal disease. In IV.iv.43 'it is a sweet Parenthesis' seems to mean that Brisac is enjoying his presumed cuckolding of Andrew.

30 then, flung] Dyce added a comma after 'then' without comment but Greg will not allow that the sense is improved and he suggests that the passage is perhaps corrupt. Nevertheless, the comma may seem to make satisfying sense: 'flung out of doores' is then parenthetical, the meaning being that after all the preparation of an obnoxious substance the result would be a very fine salad if it were thrown out of the door and never eaten.

III.iv

33 boy] One should be cautious about adopting a unique MS variant, but – as Greg saw – this emendation from MS for Q1 'Sir' is certainly advisable. Nowhere else in the play does Brisac address Charles as 'Sir' and it would indeed be inappropriate. His familiar address, 'boy', comes a few lines later in line 37. Cf. also III.v.31.

44 And … prithee.] MS omits 'And … fortune.' and adds the metrical 'twill be tenne times better' after 'prithee'. We have here what may be a Massinger revision of the Fletcher original, but which one is which is slightly moot. However, III.v.29–31 with its 'And give your brother joy' seems to refer back to Charles' 'And wish my brother fortune' and so to suggest that this is the original.

III.v

2 Is yours ready?] It is difficult to ignore the unique MS assignment of this line to Eustace since the natural assumption is that the Priest's reply 'Yes, Ile dispatch ye presently' would be addressed to his interlocutor. On the other hand, Eustace's 'Doe, speake apace' is perhaps not the normal response to such an exchange. On the whole, and with some misgiving, it may seem better to take it that the Notary – who is fancying himself in charge and seeing that all things are ready – would continue his fussiness about detail and turn from Lewis to the Priest. The Priest's 'ye' need not be addressed directly to Eustace but instead to the Notary, who is in charge of the business. Then Eustace would chime in to encourage the Priest. It is not likely that speech-prefix problems in this passage led to Q3's omission of the Notary's address to the Priest, the Priest's reply, and the first line of Eustace's encouragement, 'Doe … exactly'. All are of a piece, indicating that the cut was an

intentional one, probably to remove any suggestion of religious satire such as provoked the cuts in *Barnavelt*.

41 set to your hand] The agreement of MS and Q3 underlines the revisory nature of this variant for Q1 'write'; it is odd only in that it substitutes a hypermetrical for Q1's regular line.

47 Had ye shew'd me Land onely] The one relative certainty is that the annotator of Q3 removed 'onely' from Q1's 'Had y'onely shew'd me Land', as is shown by his leaving the Q1 apostrophe 'y'' in his version: 'Had yee' shew'd me Land'. The rest is speculative. Both MS ('If you had shew'd me Land onely') and Q1 attest to the authority of 'onely' in the line but not to its position; hence the simplest way to account for the Q3 form is to take it that the 'onely' was placed later in the annotator's copy, as it was in MS, and that he overlooked it, the more particularly since it makes a rather rough line in MS. The failure of Q3 to alter Q1 'Had y'' in favour of MS 'If you had', although his attention had been drawn to the line, provides as much evidence as we are likely to have that the MS variant is more likely to be unauthoritative than not. The reconstructed line in the present text, then, combines what appear to be the more authoritative features of Q1 with both MS and Q3.

81 *and*] As Greg remarks, 'The MS. happily puts an end to the nonsense which has been written concerning this passage', this in reference to much editorial speculation whether blue veins can form a blush etc. MS clearly, if uniquely, assigns the blue veins to the violet and the blush to the rose, as one would expect. Mason had originally proposed the '*and*' and Dyce had queried it, but the change was not made before the discovery of MS.

87 *life*] MS '*life*' for Q1, Q3 '*light*' seems correct. Ordinarily Fletcher uses 'light' or 'lights' to signify Angelina's eyes, as in IV.iii.103, and at III.v.90 '*light*' is the light shed upon him by those eyes. Some vague sort of sense could be forced into Q1, Q3 '*light*' in Charles' ode but '*life*' is definitely superior. To be near the beloved is to live and daily to live anew; but to receive a favour from her is to surpass life by a translation to eternal bliss.

98 younker] The concurrence of Q1–3 and MS in 'younger' can be defended with some strain as meaning 'a true younger brother, which is to say an ass' but Theobald's emendation to 'younker' has the right ring, and the case may be substantially clinched by Greg's note that 'younker' could be spelled 'younger', as in *1 Henry IV*, III.iii.75 and *Merchant of Venice*, II.vi.14, meaning a raw youth, a gull. It may be a form of modernization, then, to emend to 'younker' although taking it that 'younger' is only the variant spelling. At least, emendation removes possible confusion, since, as Greg points out, Eustace could be lamenting that 'he will leave me in the position of a younger brother after all.' Although possible, this latter does not fit well after 'asse', whereas 'younker' (or 'younger') does.

144 I ... asse] The absence of this line in Q3 is more likely the result of Q3 compositorial eyeskip owing to two lines beginning "Has' than of deliberate omission, although the possibility of a deliberate deletion by the annotator, misinterpreting 'disinherit him' as applying to Brisac (not Eustance) and attempting to reject nonsense, cannot be overlooked.

197 nor your little] MS 'and your little' has something to be said for it on the analogy of 'Coach and horses' in line 191. That is, it is arguable whether (like 'Coach and horses') the two parts are not linked instead of being discrete: 'your little knowledge despite your long travels'. But the case is not certain enough to disturb the Q1 reading with its comma.

213–214 Jew, . . . -asses,] The omission of this offensive epithet is another case of Q3 censorship, for which see III.v.2–4.

223 Pox] That the expletive 'pox' is present both in MS and in Q3, although wanting in Q1, shows its authority. The problem is that in Q3 it is assigned to Eustace (line 222) in the form, 'pox on't has got . . .' where it is hypermetrical if metre includes such expletives, which it sometimes does not, although usually it does when the expletive is at the beginning of a line. The MS assignment of simple 'Pox' to Egremont seems more natural in context and causes no metrical problem.

IV.iii

94 woe us to tumble] Q1 'wee'll feast our senses' may be a delicate censoring of the line, but at any rate it must yield in authority to MS and Q3, whether original or revised. The key reading shared by MS and Q3 is 'woe us to'. Whether the author wrote 'to't' as in MS or 'to tumble' as in Q3 is not to be determined. The sexuality of the line apparently caused some second thoughts in Q1 (on the part of the scribe?), since it clashes with Charles' innocence, especially in the blunt MS version.

101 A . . . may] For whatever reason (a skip in the common copy?) MS and Q3 omit this part-line completing a pentameter. The metrics form the strongest argument for rejecting MS, since in this play Fletcher's linking of part-lines is invariable. However, the Q3 annotator saw that something was wrong since he seems to have attempted to repair the pentameter by omitting 'on you, sweet one' from the following line, thus forcibly linking 'The deaw . . . gently' to complete 'Once more, good night.'

IV.iv

56 And . . . you] Whether or not this line is authentic – MS being the sole authority – poses a problem. Although there may be a very slight gap in continuity in the Q1, Q3 version, the transition from 'tender of you' to 'Y'have all' is not so abrupt as to lead a scribe to invent a bridging line. On the other hand, if the line is authorial an uncomfortable double error must be posited: the Q3 annotator would have ignored his copy to adopt the Q1 mistake. The alternative is no more attractive: a revision written in the margin and over-looked either by Q1 or by Q3. It would be simpler, of course, to regard the line in MS as an invention, but MS does not seem to invent lines. Both the present line and the MS reading at V.ii.35 seem to be authentic.

79 owne;] Q3's interpolation of Andrew's 'I warrant thee Wench', appears to be a Massingerian gag. Unlike other part-lines, it does not link to form a pentameter.

V.i

64 make you] Since the speech closes in line 69 with a full stop after 'vices', the inversion caused editors difficulty and they responded by adopting the Q2, Q4–5, F2 sophistication 'you make'. It was left to Greg to see that the sentence is not declarative but interrogative and to authenticate Q1, Q3 by simply placing a query after 'vices'.

149 attended] For some obscure reason Qq 'attended' seems here to have caused a problem, which was solved neither by MS 'ascended' (very ingenious but contextually unsound) nor by Langbaine *et al.* up to Greg emending to 'attain'd', which is otiose. 'Attended' in the sense of 'accompanied by' is perfectly satisfactory.

175 goe] This is a difficult crux to adjudicate. MS 'goe' for Q1, Q3 'give' was coincidentally adopted by Langbaine and Theobald, followed by Weber and Dyce, and, as Greg remarks, its evidence in MS is strong even though 'give' is possible. Much depends upon 'go less' in relation to 'My rest is up', a gaming phrase for 'my stake is on the table'. Here *O.E.D.* is useful by glossing the phrase 'go less' as 'offer or accept a lower price' (vb. 35b), as in Massinger's *Maid of Honour*, III.i: 'It is too little, yet, | Since you have said the word, I am content, | But will not goe a gazet lesse.' Particularly pertinent is 36: 'to risk, adventure (a certain sum), to stake, wager', with its quotation from Jonson's *Volpone*, III.v: 'Like your wanton gam'ster at primero, | Whose thought had Whisper'd to him, not goe lesse.' These examples encourage the adoption of MS 'goe' over Q1, Q3 suspect 'give'.

192 nere] The shared error 'were' in Q1 and MS – an easy handwriting misreading – would appear to support the several other examples as indicating a common or closely connected source for both texts, a source that was not original authorial manuscript but a transcript, since double independent misreading is unlikely. The concurrence of Q3 with Q1 seems to be simply another oversight by the annotator. The Q2 source for the emendation is unauthoritative, but the emendation is inevitable whatever its source.

V.ii

15 lov'd] All three authorities have readings that are acceptable: 'Lord' for Q1, 'Lo'ud' (i.e., 'Lov'd') for MS, and 'Love' for Q3 correcting Q1. Q1 'Lord' is the least probable reading in view of the agreement of MS and Q3 in forms of 'Love'. The decision, then, must be between 'Lov'd' and 'Love'. In this respect the Q1 form with its final *d* is easier to explain as a misreading of MS 'Lo'ud' than of Q3 'Love'. This observation, which also weighed with Greg, may slightly tip the scales in favour of MS despite the more general attractiveness of Q3 and the possibility that 'e' could be misread as 'd'.

21 mine] The Q1 omission of the pronoun is metrically deficient and may be regarded as an error, despite the temptation to assign the divergent substitutions of MS ('mine') and Q3 ('thy') as guesses to fill in a gap in the copy. Of the two, one can argue for MS 'mine' as more appropriate for the constant emphasis on self shown by

the choleric noble Lewis, who takes the upset of his plans as a personal affront. This is certainly the only reason why he objected to Angelina's choice.

35 Will ... too?] It is possible but not easy to believe that this line, unique to MS, is an address to the Officers present in the original but skipped by the Q1 compositor and overlooked by the Q3 annotator. The main reason is that the addition makes 'And there I'll answer you.———' an uncharacteristic short line instead of the natural first half of 'Well overtaken.' This metrical irregularity alone makes one suspicious of 'Will ... too?' as an intruder which had been later added to the copy underlying Q1 and so was not set. It seems equally difficult to take it that the addition was a gag inserted by the scribe of the MS. (Unlike the unique intrusion in Q3 of hypermetrical '*Bri.* Your brother Sir' in line 69 below.) The MS scribe was very careless and inclined to paraphrase but not to invent in this manner. Theatrically the line is apt since it reflects some reluctance on the part of the Officers to obey Lewis' order (line 32) 'away with 'em', a reluctance he may have observed (or anticipated) when he felt impelled to threaten them 'at your perils' before 'away with 'em.' The line agrees, then, with theatrical pertinence and with Lewis' general impatience and choler as a character. The main problem centres on the textual transmission. As reconstructed hypothetically, one layer of revision was made to the original (Q1) as evidenced by the common readings of MS and Q3 that are not simple corrections of Q1. In this case one is forced to believe that the absence of the line in Q3 was due to the annotator's oversight, even though it occurs in an area where he was especially active although mainly in an unauthoritative manner.

40 you] Since Q1–3 'you ... thee' in the same line is awkward, and since Charles nowhere else addresses Angelina except as 'you', MS 'you' is here better than Q1 'thee'. This is not the sort of minor variant that the Q3 annotator was inclined to pick up.

49 indear'd] Editors have not been happy with this MS, Q1–3 reading and have preferred Langbaine's emendation of 'tender'd', which – as Greg remarks while accepting it – is clever. The joint reading of all three authorities is not to be ignored without better reason, however. The sense appears to be clear enough: 'Except for the satisfaction of your obstinate will, what can you wish from what is offered you that is not to your liking?'

69 Foole? but] The Q3 interjection '*Bri.* Your brother Sir' is difficult to explain as authorial revision in view of the general lack of authority in Q3's unique readings as against the agreement of MS with Q1. The Q3 addition interrupts Miramont's concluding speech to little purpose unless it could be thought that the speech was overly lengthy without some interjection. Brisac's words are either a mild protest ('don't heap scorne on your brother in public') or else ironic ('if I'm a fool, don't forget you are my brother'). That they were not in the original composition may be shown not only by their absence from MS as well as Q1 but also by their failure to link without creating a dangling part-line 'but Ile not chide'. If authoritative the speech would need to have been added by Massinger in revising his own work. It may be a matter of opinion whether the insertion leads as naturally to Miramont's 'but Ile not chide' as does his starting on another tirade and then pulling himself up short.

EMENDATIONS OF ACCIDENTALS

Prologue

5 *confident:*] Q4; ~ ; Q1–3

I.i

I.i] *Actus* I. *Scœna* I. Q1 ±
25 motion):] ~)∧ Q1–5, MS, F2
42–43 word, | A noble] word, a |
 Noble Q1–3; husband, | In that

word a noble husband MS
58 Sir;] Q2; ~ , Q1
92 want] MS; Want Q1–3
130 well;] Q2; ~ , Q1

I.ii

I.ii] *Actus* I. *Scœna* II. Q1 ±
4 Their] Q3; their Q1–2, MS
17 *Paris;*] ~ , Q1–5, MS, F2
18 oth'] Q2; oth' the Q1
19 appeas'd, hee'll] MS; appeas'd;
 Hee'll Q1–3 ±
54 *Andrew,*] Q3; ~ ∧ Q1–2, MS
93 Lackey,] Q2; ~ . Q1
101 adorer:——] ~ : ∧ Q1–4; ~ . ∧
 MS, Q5, F2
101 *To*] MS; *to* Q1–3

108 Which] MS, Q3; which Q1–2
186 upwards.] MS, Q2; ~ , Q1
203 knowledge.——] ~ ∧ —— Q1–
 5, F2; ~ : ∧ MS
209 *Enter . . .* ANDREW.] Q3; *all italic in
 right mrgn* Q1–2, MS
232 hopes——] ~ . Q1, Q3, MS, F2;
 ~ : Q2
240 what's] MS; what is Q1–3
273 on't.] F2; ~ , Q1, Q3, MS; ~ ; Q2
278 Scholar.] MS; ~ , Q1, Q3; ~ ; Q2

II.i

II.i] *Actus* 2. *Scœna* I. Q1 ±
5 hasty;] ~ , Q1–F2
7 too——] ~ . Q1–F2; ~ ∧ MS
8 that's] MS, Q2–3; that'ts Q1
8 two.] MS, Q2–3; ~ ∧ Q1
26 brother∧——] Q4; ~ ? ——
 Q1–3; ~ : ∧ MS
77 therefore——] ~ ? —— Q1–F2;

~ ∧ ∧ MS
79 studie;] Q2; ~ , Q1, Q3; ~ . MS
87 brother——] ~ . Q1–F2; ~ ∧
 MS
115 blasted;] ~ , Q1–F2; ~ . MS
165 Sir;] Q4; ~ , Q1–3; ~ . MS
169 nightcaps] MS; ~ - | ~ Q1–3

II.ii

II.ii] *Actus* II. *Scœna* II.

26 shee's] MS, Q3; shees Q1–2

II.iii

II.iii] *Actus* II. *Scœna* III. Q3 ± (*Scœna*
 II. Q1)
 10 morrow?] Q2; ~ . Q1, Q3, MS

21 mad;] ~ , Q1–4, MS; ~ . Q5–F2
30 Fire, *Cooke.*] F2; ~ , ~ , Q1, Q3;
 ~ . ~ , Q2; ~ ‸ ~ ‸ MS

II.iv

II.iv] *Actus* II. *Scœna* IV. Q1 ±

20 -wright,] Q4; ~ ‸ Q1–3, MS

III.i

III.i] *Actus* 3. *Scœna* 1. Q1 ±
 7 excellent;] ~ , Q1–F2; ~ ‸ MS
 16 What,] ~ ‸ Q1–F2, MS
 21 Army:——] ~ : ‸ Q1–5; ~ · ‸

MS, F2
27 found,] Q4; ~ ‸ Q1–3, MS
29 dissension.——] ~ . ‸ Q1–F2,
 MS

III.ii

III.ii] *Actus* III. *Scœna* II. Q1 ±
 34 him:——] ~ : ‸ Q1–F2; ~ , ‸

MS
35 hearts——] ~ , Q1–F2; ~ ‸ MS

III.iii

III.iii] *Actus* III. *Scœna* III. Q1 ±

88 you——] ~ . Q1–F2, MS

III.iv

III.iv] *Actus* III. *Scœna* IV. Q1 ±
 1 Hum] Q3; hum Q1–2, MS
 27 Knave.——] ~ ‸ —— Q1–F2;
 ~ , ‸ MS

27 merry.] MS, Q2; ~ , Q1
28 you,] MS, Q2; ~ ‸ Q1, Q3
37 care,] Q5; ~ ‸ Q1–4, MS

III.v

III.v] *Actus* III. *Scœna* V. Q1 ±
 9 thousand ‸ better,] Q5; ~ , ~ ‸
 Q1–3; ~ ‸ ~ ‸ MS, Q4
 20 man? MS; ~ , Q1–3
 98 me,] MS; ~ ‸ Q1–3
 116 ‸ *Mir.* Hee'l ... knavery. ‸] (~

. ~ ... ~ ‸) Q1–5; (~ . ~ ...
 ~ .) F2
99, 178, 183, 202, 204 'tis] Q5; ‸ ~
 Q1–4, MS
161 Lady.] MS; ~ , Q1–3

IV.i

IV.i] *Actus* 4. *Scœna* 1. Q1 ±
 42 suddenly;] Q5; ~ , Q1–4; ~ . MS;

~ ? F2
43 perfum'd] Q2; perfumd' Q1, Q3;

perfumd MS
56 *France*] F2; France Q1–3
76 (*twice*) 'tis] F2; ∧ ~ Q1–3, MS
82 securely∧] MS; ~ : Q1, Q3; ~ ;

Q2
89 will, *Lilly*∧] ~ ∧ ~ , Q1–4, MS;
~ , ~ , Q5, F2

IV.ii

IV.ii] *Actus IV. Scæna II.*] Q1 ±

IV.iii

IV.iii] *Actus IV. Scæna III.*] Q1 ±
9 'tis] Q5; ∧ ~ Q1–4, MS
46 continue.——] ~ . ∧ Q1–F2, MS
107.1 *Enter a* SERVANT.] *in right mrgn*
Q1 *opposite lines* 108–9

113 me.——] ~ . ∧ Q1–F2, MS
167–168 hold, ... hold,] Q3; ~ ∧ ...
~ ∧ Q1, MS; ~ , ... ~ ∧ Q2
185 her?] Q3; ~ ; Q1–2

IV.iv

IV.iv] *Actus IV. Scæna IV.* Q1 ±
9 shall,] Q3; ~ ∧ Q1–2, MS
121 (The ... off)] MS; ∧ ~ ... ~ ∧

Q1–3
122 criminall——] ~ . Q1–F2, MS

V.i

V.i] *Actus 5. Scæna 1.* Q1 ±
11 doctrine?] MS; ~ . Q1, Q3; ~ ! Q2
18 vertues?] Q2; ~ . Q1, Q3; ~ ! Q2
26 beleeve?] MS; ~ . Q1–3
33 society?] ~ . Q1–F2; ~ ∧ MS
37 blemish?] ~ . Q1–F2, MS
53 Court,] Q5; ~ ∧ Q1–4, MS
54 Scarabes] MS; Scarabee's Q1–3
60 shelter:] ~ , Q1–F2; ~ . MS
69 vices?] ~ . Q1–F2, MS
96 contrition——] ~ . Q1–F2, MS
111 friend,] MS; ~ ∧ Q1–3
115.1 *Enter* CHARLES.] Q1 *all italic in*
right mrgn; MS *in left mrgn*

168–169 publiquely, ... intercession∧]
F2; ~ ∧ ... ~ , Q1–3; ~ ∧ ...
~ ∧ MS
181 incureable∧ ... hopes,] Q4; ~ , ...
~ ∧ Q1, Q3; ~ , ... ~ , Q2; ~
∧ ... ~ ∧ MS
193 outside;] Q2; ~ , Q1, Q3, MS
217 *Enter* MIRAMONT.] Q1 *all italic in*
right mrgn; MS *in left mrgn*
221 you;——] ~ ; ∧ Q1–F2; ~ . ∧
MS
289–290 him) | Is] MS; Q1–3 *line:* him)
is |

V.ii

V.ii] *Actus V. Scæna II.* Q1 ±
9 nourish;] ~ , Q1–F2; ~ ∧ MS
18 at,] Q2; ~ ∧ Q1, Q3, MS
25 Sir——] ~ . Q1–F2; ~ ∧ MS

34 you.——] ~ . ∧ Q1–F2, MS
35 *Enter* ... ANDREW.] Q1 *all italic in*
right mrgn; MS *centred*
73 ∧young] MS, Q3; 'young Q1–2

557

HISTORICAL COLLATION

[NOTE: The following editions are herein collated for substantives: Q1 (1637), Q2 ('1637' but later), Q3 (1651), Q4 (1661), Q5 (1678), F2 (1679), L (*Works*, 1711, ed. Gerard Langbaine the Younger and others), S (*Works*, 1730, ed. Sympson, Seward and Theobald), C (*Works*, 1778, ed. George Colman the Younger), W (*Works*, 1812, ed. Henry Weber), D (*Works*, ed. Alexander Dyce, rev. ed. 1877), V (*Variorum Beaumont and Fletcher*, ed. W. W. Greg, 1905)].

Prologue

MS *omit*

3 *your*] you Q2

5 *And*] *omit* Q5

6 *lives*] live Q3

I.i

14 idle foolish] foolish idle MS
24 Couch] Coach Q3, D
29 in … in] of … of Q3, C
33 vertues] vertue F2
36 Leather … trash,] *omit* MS
43 A] *omit* MS
43 Woman] women C, W
59 pleasures] pleasure Q1–2, Q4–5, L
60 kindes] kind MS, S, C, D, V; kind's W
64 meant] proposed MS
66 state] Estate F2

76 way] may Q2
84 bottomes] bottom Q2, D
84 the] *omit* Q3
87 kings] King Q4–5, F2
88 Country] Court Q4–5, F2
104 makes] make S–D
107 *Charles*] *Charles's* Q5, F2, L–C
117 make] make up Q3
121 such] such a MS, Q4–5, F2
129 Wench] wenches MS
132 pleasures] pleasure Q3

I.ii

3 Why,] ~ ∧ Q1–4, MS
12 ¹of] with L
12–13 writ | In] S, C *line:* writ in |
14 Dry] Quite dry Q1–2, Q4–5, F2, L+
20 pallat] stomacke Q1–5, F2, L–V
37 out of's pace] ought of space C (*qy*)
42 'ee] you MS, F2, L–D
48–49 ∧ as … Sir, … Laundresse,] ∧
 ~ … ~ ; … ~ , Q5, F2, L; (~

 … ~) … ~ , S; (~ … ~ , …
 ~) C, W
52 Sir? … Sir,] *omit* S
56 a] *omit* W
56.1 *Exeunt.*] *omit* MS, F2
61 put] but Q2, Q4–5, F2
66 addicted] addicted to MS
74 but] *omit* MS
84 (What … Flatterer.] *omit* MS
84 *Trampling.*] *omit* Q1–5, F2, L–V

88 to the Buttry] S-W *line:* to | the
 Buttry
93 Lackey] Hoe Lackey Q3
97a *Charles.* Your blessing Sir?] *omit*
 MS
99 Countries] Courtiers Q1–5, F2
104.1 *Plucks ... reades.*] reades. Q1–5,
 F2, L-V
106–107 This ... Tropicks.] D *lines:*
 This ... Gallants | That ...
 Tropicks.
108 loves] love Q2, Q4–5, F2, L, S, W
108 service] servulating Q1–2, C, W, V
110 make ... first:] first make use of it ∧
 MS
111 your] you Q2
114.1 *Exeunt*] exit cum Socijs MS
116 interruption] intermission MS
116–117 *Plato ... this.*] *one line in* C
117 them] it MS
119 then] *omit* MS
119 unto] to MS
121 our] your D
125 palme] blame Q2, Q4–5, F2
128 advantage] Vantage S
129 oregrowne] oreworne MS; o'er-
 done S; oregone C
144 And ... me,] *omit* MS
148 guard] guards Q4–5, F2
151 pleasures] pleasure Q2, Q4–5, W
154 kinde] kindes MS
165 husbands] husband F2
165 latter] later Q1
175 you] thee MS
178–179 Very ... collection] *one line in*
 C

180 from ... time] to this time from
 Adam MS
181 grandchilde.] ~ ? MS
182–183 Nor ... estate.] *one line in* S
188 all] *omit* MS
196 Councels] Counsells MS, Q2, Q4–
 5, L-D
209 *Eustace.*] ~ ? MS
210 Your eare] You are L
219 Nor] For Q4–5, F2
222 never] ever Q1–5, F2, L-W
224 And ... I] *omit* MS
225 Trumpet] Trumpe Q1–3
234 In] in the MS
238 so] sir MS
239 Sir] *omit* MS
240 promises] promise Q4–5
241 will] would W
242 upon] *omit* MS
249 dry-fat] shelfe Q3, D
261 travaile] travel F2, S
266 If] *Eust.* If Q1–2, Q4–5, D; *Egre.*
 If MS; *Bri.* If Q3; *Cowsy.* If S, C
266 this] *omit* Q2; it Q4–5, F2, W
267 ever, and] ~ . *Cowsy.* And MS
267 *Exeunt*] (exeunt all but And) MS
269 poore] *omit* MS
270 a] *omit* MS
274 all] *omit* MS
276 Proclamation, yet] S, C, D *line:*
 Proclamation, | Yet
279 meet] meet with S
280 always us'd] was wont MS
281 Hee'll ring 'em] Ile ring him Q1–5,
 F2, V
281–282 shall ... shake] will shake MS

II.i

4 know] how Q1–2, L
9 to 'em] ye MS (you), Q3, L-D
23 of] and Q3
27 Congees] tongues Q1–5, F2, L-V
28 peece] speech Q3
34 Sir] *omit* MS

35 But brother] *omit* MS
43 worships] worship Q1
45 feesible] feeble Q4–5, F2
46 you] you'll Q4–5, F2
52 beleeve,] ~ ∧ F2
54 on't] of't F2

61 brother] *omit* MS
68 knowes] know C–D
75 box] pox Q2
86 and] *omit* Q2, Q4–5, F2
91 Can] Why can S
98 vent] vend Q5, F2
99 with a *Jacobs*] with [*illegible*] MS
112 taint] taunt D
115 the] *omit* W
120 snowes] Shows Q5, F2, S–D
121 here's] he's W
121 I] that I W

127 raise] build MS
129 set] to set S
130, 144 state] Estate Q5, F2
140 too] to L
141 too] *omit* Q4–5, F2
146 the] *omit* MS
162 arras] auras Q1–3
170 your] *omit* Q2, Q4–5, F2
173 University *Lovaine*] University of *Louvain* Q5, F2; *Louvain* University S
176 'em] them Q1–5, F2, L–V

II.ii

1 to] *omit* Q2, Q4–5, F2
3 travail'd] traveled MS, Q5, F2, L, S, W
4 bills] Bill MS
8 No ... 'em.] *omit* MS
8 gentle] genteel S, C
14 which] that MS
22 And] And then L
23 fine] faire Q1–2, Q4–5, F2, L–W

27–28 Songs she | May have, and] *one line in* MS; Songs ... have | And D, V
34 mine] my MS, Q5, F2
43 that] that they Q2, Q4–5, F2, L, S; they that W
49 shall's] shall MS
53 must] shall MS

II.iii

1 thy] my Q1–F2
1 Is] He's Q5, F2
3 *Cooke.*] *Gilbert* (Butler) D
7 spirits] spirit Q4–5, F2
10 Ex'llent ∧] *Ex*'Lent, Q1; Ex'Lent Q3; Ex. *Lent* Q2, Q4; Exc'llent Q5, V; Excellent MS, F2, L–W
13 and] or Q2, Q4–5, F2
22 metamaticall] mathematical Q4–5, F2, L–V
34 What] But what Q3

35 thy] your Q1–5, F2, L–V
35 from] for Q3
37 The ... that;] *omit* MS
52 younger] young Q3; to my young Q2, Q4–5, F2
53 will] he'll Q5, F2
55–56 Now ... immortality] *one line in* L–W
58 farme] fame Q3
62 ye] you MS

II.iv

10 The] And W
10 ²her] *omit* Q4–5, F2
15 stie] flie Q2, Q4–5, F2, L
18 awry] away Q2, Q4–5, F2

20 *Gallatteo*] Galileo S–V
23 Have I ... nothing?] I have not ... nothing. Q3
25 maide] Mate S

30 to] too L
30 vellam] monstrous MS
31 their] *omit* MS
34 those] these S
35–36 No ... sinnes] S–V *line:* No ...
 had'st │ Thou'dst bosome, │
 They're ... sins
35 have] *omit* Q2, Q4–5, F2

35 warmed] marryed Q1–2, Q4–5, F2,
 MS, L
37 mine] my MS
38 did regard] not regarded Q3
48 ye] you Q1–5, F2, L–C
54 be ever] ever be Q3
56 secret] secrett out MS
57 I doe] you Q2; I Q4–5, F2

III.i

0.1 *and Servants*] *omit* Q1–5, F2,
 L–V
2 day] *omit* Q1–2, Q4–5, F2
3 great] *omit* Q5, F2
10 followes] follow S–D
11 state] Estate Q5, F2, L
16 our] your Q5, F2
24 Why] *Not.* Why Q1–2, Q4; *Lew.*
 Why Q5, F2
24 lands] land MS
25a *Lewis.*] *Not.* Q5, F2

25b *Notary.*] *omit* Q5, F2
34 killes] kill S
39 admiration, ... others;] ~ ; ... ~ ,
 D
39 ²to] in MS, V; from S
40 may make] must make Q1–2, Q4–
 5, F2, L, C, W; must make him so S
41 helpe to] for help S; help'd too,
 C–D
43 And't has] And thats MS

III.ii

10 all] *omit* MS
11 Be ... poynant] all poynant and
 sharpe MS
12–13 handsomely, ... delicate] *omit*
 MS
15 this] the MS
18 welcome,] ~ ∧ Q4–5, F2
19 see] set Q3, C–D
20 be] they be MS
22 abroad] *omit* MS
25 well] *omit* MS

27 chance] chance to C
34 molest] trouble MS
35 hearts] heart MS
35.1 (Andrew *stay on*)] *omit* Q1, Q4–5,
 F2, L–V
36 Sir? ... farme] make but my farme
 as much more MS
40 And] he can doe her no harme and
 MS
41 shee'll] she would MS

III.iii

0.1 *Noyse.*] *omit* Q1, Q4–5, F2, L–V
1–5 What ... there?] S, C, W, V *line:*
 What ... broken, │ In every ...
 shaken │ With ... motions. │ What
 ... there?
1 What] What a Q2, Q4–5, F2, W, D

1 in this house] this Q3, C
2 Within a Parenthesis] With several
 noises and F2, L; *omit* S–W, V
3 the] *omit* MS
3 Collect] Cholicke L–V
5 faithfull] tis faithfull MS

6 hear'st] hearest thou MS
10 squeaking's] speaking's Q2, Q4–5, F2
12 spit] spit sir MS
12 Sir] too MS; Sirs Q2, Q4–5, S
13 And] omit MS
13 up] omit MS
23 read] red Q2
24 There's] And there's Q3
25 ye] em MS
37 this day] to day Q3
42 Young, ... modest] omit MS
43 you'ld] you'll Q4–5, F2
45 What] and what MS
45 'em] him MS
48 elder] eldest Q1–2, Q4–5, F2, L

49 Sir] now sir MS
51–52 I ... to.] I thinke not Q3; one line in W–V
52.1 Servants.] om. Q1, Q4–5, F2, L–V
57 wide] very wide Q3
58 wings of] omit Q1–5, F2, L–D
65 come not] am not come Q1–2, Q4–5, F2, L, D; am not W
69 one too,] omit MS
72 assure] answer Q1–2, Q4–5, F2
75 Thou] Thee C
76 lightnesse] likenesse Q3
82 An] And L
87 harsher play] omit MS
103 here] here too MS

III.iv

2 sensible] most sensible S
2–3 of ... fell] When the great book, Sir, | Fell Q3
3 head] head sir MS
8 to] omit MS
10 dainty] daintily Q2
13 spake] speak Q2, Q4; spoke F2
15 then] omit MS
19 most stubborne and] most stubbornst MS
21 y'a wife] a wife for you MS

25 do'st] doest thou MS
25 still] what still still MS
33 boy] Sir Q1–5, F2, L–D
35 for] studies Q3; omit MS
36 studies] for Q3
37 the] your MS; thy Q2, Q4–5, F2, S–D
42 women] woman MS, Q4–5, F2
44 And ... fortune.] omit MS
44 prithee.] ∼ , twill be tenne times better. MS

III.v

0.1 Ladies,] omit MS
2–4 Is ... exactly:] omit Q3
2 Is] Eust. Is MS
3 a] omit S
5 Doe not] Eust. Doe not Q3
5 Sir,] omit Q1–2, Q4–5, F2, L–V
6 'em] them Q1–5, F2, L–V
8 thine] thy MS; mine D (Mason)
15 wonder] Wonders S
20 Yes] Faith yes Q2, Q4–5, F2, W
21 too,] omit Q2 (not inked), Q4–5, F2, W

31 to] omit MS
39 was, was] was MS
39 my] but my Q1–2, Q4–5, F2, L–W, V
41 set to your hand] write Q1–2, Q4–5, F2, L–V
44 sonne] omit MS
47 Had ... onely] Had y'onely shew'd me Land Q1–2, Q4–5, F2, L–V; If you had ... Land onely MS
59 one] to one Q4–5, F2
63 For] omit S

63 'ts] 'tis MS, Q3, F2
63 both] *omit* Q3, C, W
64 although] though MS
66 'em] thee Q1–5, F2, L–V
67 Lampes] Lampe Q2, Q4–5, F2, W, D
71 great] greatest L, S
81 *Their*] *The* Q2–5, F2
81 *and*] *in* Q1–5, F2, L–D
83 *neere*] *but near* S
84 *and*] *omit* S
85 *Is*] *Is still* S
87 *life*] *light* Q1–5, F2, L–D
88 *Make*] *O! Make* S
88 *live*] *love* MS
89 *backe*] *omit* S
93 *and eke*] *still and the* MS
94 *am*] *omit* MS
96 ye] you MS
98 younker] younger Q1–F2, L
102 a] *omit* L
109 present] a present Q2, Q4–5, F2
118 fingred] sugred Q1–2, Q4–5, F2
124 eyes] lights MS
131 hearts] heats D
137 stay] stop Q3
143 a] *omit* MS
144 I ... asse;] *omit* Q3
150 gold] gay Q3

154 Can ... honour?] Love you with honour. Q1–2, Q4–5, F2, L, S, W, D
156 lands] land L, S
159 Is it] What is't S
159 you] your MS
161 he] you MS
165 Ile] I S
167 falling] faidling Q2
168 ¹all] all the Q5, F2
176 shut] close Q3, C, W
178 stay, stay, stay] stay stay MS
185, 193 your] you Q2
191 and] nor MS
197 your long] you long Q2
197 nor] not Q2
202 farre] *omit* S, C
203 like] likes Q1–2
206 are y'] art thou MS
213–214 Jew, ... asses,] *omit* Q3
219 beginne] begins Q2
220 friend] friends Q3
222 has wonne] pox on't has got Q3
223 Pox,] *omit* Q1–5, F2, L–V
228 off] of Q1–5, F2, L–V
230 't] *omit* MS
231 ye] you Q3, F2
233 No, no] No, no, no MS

IV.i

9 Sops] sots Q3, S–D
16 thy] thine Q2, Q4–5, F2
17, 79 mine] my MS
19 but] *omit* MS
24 cowardlinesse] Cowardise F2
31 trample] tramble Q2
37 More than their] but their owne MS

37 their] thy Q2, Q4–5, F2
38a would] will Q2, Q4–5, F2
38b *Eustace.*] *Cowsy.* D (*qy*), V (*qy*)
43 recover] cover Q2, Q4–5, F2
52 a meere] meer Q2, Q4–5, F2
76 on] one S–W

IV.ii

13 warlike] noble warlike MS
15 had newly come] come newly MS
18 too] to L

22 get the] fall into a MS
23 in travailing] innavailing Q2, Q4; in availing Q5, F2

24 bought] brought S
27 those] these Q2, Q4–5, F2
29 they] *omit* Q2, Q4–5, F2
30 'twixt] between MS

32 Pruning] Pruning up Q2, Q4–5, F2
34 Those] These S
35 more's] more S, C
35 Sir] *omit* MS

IV.iii

4 strong] strange Q3
5 his] a C, W
24 You] Ye Q5, F2
24 both] know both S
24 and] *omit* S–W
29 You] *Ang.* You Q2, Q4–5, F2
36 too] that Q1–2, Q4–5, F2, L–V
39 bed] bed, Sir Q2
40 and] *omit* Q3
42 Ceremony] Ceremonies Q5, F2
43 high and] *omit* MS
45 should] shall Q2, Q4–5, F2
45 hands] hand Q3
46 an] a MS
47 ¹you] *omit* Q3
50 slumbers] slumber Q2, Q4–5, F2
51 see] behold Q1–2, Q4–5, F2, L–V
55 Nature] *omit* MS
56 ye … ye] it … it Q1–2, Q4–5, F2, L, S
56 mine] my Q2, Q4–5, F2
59 Chrystalls] crystal V (*qy*)
60 adore] weare Q3
72 thing] *omit* F2
77 still] Mistris Q3, C
79 yeeld … for't.] consent now I should hate you. Q3
81 face] sparkle Q3; favour MS
83 of life] *omit* Q2, Q4–5, F2
84 sand. … name,] ∼ , … ∼ . S
86 that that] that which Q3
94 woe us to tumble] woe us to't MS; wee'll feast our senses Q1–2, Q4–5, F2, L, S, W–V
95 their] these MS
96 'em] them Q1–5, F2, L–V
98 were] where Q2
100 in your love] your affections Q3, C,

W
101 A … may] *omit* MS, Q3
102 on you, sweet one] *omit* Q3
108 is] are MS
109 take no deniall] not be kept out Q3
110 time] fit time Q5, F2
110 of] for MS
111 Sir] *omit* Q1–5, F2, L–V
112 charge] command MS
112.1 *Enter … COWSY.*] *omit* MS
115 yet] ore Q3
118 ¹Shee's] *Char.* shee is MS
126 my] mine Q1–2, Q4–5, F2, L, S, W–V
131 downe? what] S *lines:* down? | What
132.1 *Snatches away*] strikes out MS
133 turne; now] S *lines:* turn | Now
145 Doe] What, do S
150 to me] *omit* MS
152 but] to Q3, C
152 'tis] is Q3, C
154 no] neither MS
155 man] a man Q5, F2
165 upon] on MS
172 talke] take Q3, Q5, F2
175, 180 ye] you MS
177 came] came here S
180 things, ye] slight Q3, C
185 What … her?] *omit* MS
185 ye] you Q5, F2
189.1 *Enter MIRAMONT.*] *omit* MS
190 *Servant.*] *Eust.* MS
190 y'are] you are MS
193 truth] troth Q2, Q4–5, F2
194 me] in MS
196 that] who Q3, C
196 curried] frighted um Q3, C

202 frosts] frost Q2, Q4–5, F2, W, D
206 young] young neither MS
208 taile] ratle Q2, Q4; rattle Q5, F2
210 right] the right MS

219 ²ye] you Q1–5, F2, L, S, D
222 hereafter and] and hereafter MS
222 it] *omit* MS
223 you] your Q5, F2

IV.iv

2 ye] you F2
2 you] *omit* MS
4 I] *omit* D
8 and as] and still too as Q3
9 lecherous] *omit* MS
13 That's a] *omit* MS
15–16 yet | At] S *lines:* yet at |
16 Horners] Horn'd Ones S
19 *A Song.*] *omit* MS
21 So, so,] *omit* MS
23 feast] feast for him MS
26 wee'll] will Q1–5, F2, L, S (*qy*)
30 Sergeants] servants MS
34 spake] speak Q2–4; speaks Q5, F2
35 I've] I' Q1; I Q2, Q4–5, F2; I have MS, L, D
40 So] and so MS
47 Come] and come MS
54 must] must needs MS
54 it] of MS
56 And … you] *omit* Q1–5, F2, L–V
57 Can] And can Q2, Q4–5, F2
57 earnest] in earnest S
60 truth] truth sir MS
64 Agues] Aches S, C
79 owne;] owne. *And*. I warrant thee Wench. | *Lil.* At Q3, C, W
86 a friend] such a friend MS
86 bountifull] and bountifull MS
87–88 little, | But] little. | *And*. A Whore, a Whore. | *Lil.* But Q3

93 ye] thee Q1–5, F2, L–V
94–95 know | Your Cue, and] D *lines:* know your cure | And
95 Cue … me Sir] cue Sir | And second me MS
100 within … wife] conference with his wife within Q3
102 In] by Q5, F2
108 wilt] Andrew wilt MS
111 *The*] *omit* Q1–5, F2
121 pull'd] poll'd Q2
122 O] *omit* MS
131 unto't] to it MS
132 Umh] Umb Q1–5, F2; Ump MS; Umph S; Hum C–V
136 Sir] *omit* MS
142 an ague] got an ague that MS
143 Hee's] Here's Q5, F2
147 plague] torment Q3
160 women] woman Q2, Q4–5, F2, W, D
162 worthy] *omit* MS
163 ye] you MS, Q3, V
165 a'has] he has MS; h'has F2
168 it's] this MS
171 fed] feed S, W
172–173 He … *Lilly*.] *one line in* S
173 Scholars] us Scholars Q3, C, W
174 promise … Farme, *Andrew*,] promise Andrew to increase thy farme MS

V.i

3 made] *omit* S
5 and soone] a losse and easily MS
6 It is] tis MS
7 dozen] dozen or 2 MS
12 within] on MS

12 rubbes] rules MS
12 out] on S–W
13 learne] learnt MS
17 nor suffer] and suffer Q5, F2
18 there] they Q2, Q4–5, F2

20 Provant] Prevant L
37 thinke's] think 'tis Q4–5, F2
41 ornament, no use∧] ~ ∧ ~ ~ ,
 MS; ~ , not use∧ Q3, L, S (~ ;),
 C–D
55 That ... pallats] *omit* MS
64 make you] you make Q2, Q4–5, F2,
 S, W, D
69 vices?] ~ . Q1–5, F2, L–D
85 antidote.] antidote, or——MS
119–120 some ... -booke] downe in my
 table-booke some notes W
124 justly] *omit* MS
126 nor] or MS
128 None] Now Q1–2, Q4–5, F2, L
133 bid ... t'ye] bid you good morrow
 MS
133 not] not done MS
149 attended] ascended MS; attain'd
 L–D
155 Without] What MS
164, ¹211 'em] them Q1–5, F2, L–V
167 These] this MS
175 goe] give Q1–5, F2, C, D, V
188 teaching] in teaching Q2–5, F2
192 nere] were MS, Q3
202 would] will Q5, F2
205 nor] or Q5, F2
217 I] Ile MS; In L

217 *They fight.*] *omit* Q1–5, F2
219 hold, hold.] hold hold hold, MS
225 Till] 'Tis Q4–5, F2
230 Like your father] as your father is
 MS; Like to your Father S
237–238 Sir ... lov'd] in me Sir loved
 MS
246 Nay ... bound] *omit* MS
250 gallant] *omit* MS
251 and] and that MS
252 Nay, nay] nay MS
253 Sir] *omit* MS
256 To ... good,] *omit* MS
260 Unto] to MS
275 no swords] Swords not S; not
 swords C
275 yet] and so MS
280 Fast] *omit* MS
280 and] I Q2, Q4–5, F2
280 him,] him if he rebell MS
285 may] my F2
285–286 reade Sir ... face.] read ... face
 sir MS
296 what's] that is MS
307 your] you Q1–2
308 And ... one,] *omit* MS
315 why] why so MS
316 old] as old Q5, F2
316 I] *omit* MS

V.ii

1 perswasion] perswasions Q2, Q4–
 5, F2
3 falsely] false Q2, Q4–5, F2
7 rather ruines] ruines it; Q1–2, Q4–
 5, F2, L
8 up, you destroy∧] ~ ∧ ~ ~ ;
 Q1–2, Q4–5, F2, L; ~ : ~ ~ ∧
 Q3, S–V
10 reputation] patern Q2–4; pattern
 Q5, F2
12 good] *omit* Q3
15 lov'd] Lord Q1–2, Q4–5, F2, L, S;
 Love Q3, C–D

21 mine] *omit* Q1–2, Q4–5, F2, C, W;
 thy Q3; my L, S, D
22 thee] the Q2
23 you] thou Q3
24 entertaine] entertains Q2, Q4–5,
 F2, S–D
35 Will ... too?] *omit* Q1–5, F2, L–V
36 Ill] Kill Q3, C, W
40 ²you] thee Q1–5, F2, L–V
49 indear'd] tender'd L–V
50 what] that MS
52 states] Estates F2
53 And] *omit* Q3

64 now is growne] is MS

66 it] *omit* Q5, F2

69 old] you old MS

69 Foole?] Foole? | *Bri.* Your brother
 Sir. *Mir.* But Q3, C, W

75 *Andrew's* ... b'] Andrew have his

 farme MS

76 see you] *omit* MS

78 those] the MS

79 preserve ... our] continue still good
 Q3

THE MAID IN THE MILL

edited by

FREDSON BOWERS

TEXTUAL INTRODUCTION

The Maid in the Mill (Greg, *Bibliography*, no. 653) was entered (as 'Maid of the Mill') in the *Stationers' Register* about 4 September 1646 for publication in 1647 in the first Beaumont and Fletcher Folio, where it occupied sigs. 4A1–4C4, pp. 1–23. (Sig. C4v, p. [24] was blank.) It was re-entered on 30 January 1673 and printed in the Second Folio, 1679, sigs. P3v–S2, pp. 118–139 [Section 2]. A cast of characters, wanting in the First Folio, was prefixed in the Second, along with the names of the principal actors: Joseph Tailor, John Lowin, John Underwood, William 'Rowly', John Thomson, Robert Benfield, and Tho. Polard.

The date of composition is approximated by the entry for licensing in Herbert's Office Book on 29 August 1623: 'a new Comedy, called, *The Maid in the Mill*; written by Fletcher, and Rowley'. It was shortly after acted at Court on 29 September 1623 and on 1 November and 26 December. On 7 August 1641 the play was included in the list of the King's Men's plays prohibited from publication by the Lord Chamberlain the Earl of Essex.[1] Dr Cyrus Hoy has assigned to Fletcher Acts I, III.ii–iii and V.ii.1–222 (to the entrance of Antonio). To William Rowley he assigns Acts II, III.i, IV, V.i, and V.ii.223–end.[2]

Hoy believes that the printer's copy was a transcript by the scribe Ralph Crane, chiefly on the evidence of the profusion of round brackets, especially to indicate the vocative, and the general preservation of the characteristic Fletcherian 'ye'; but subsequent research by Professor T. H. Howard-Hill questions the value of these vocative parentheses as the most reliable way to identify Crane's work.[3] Though vocative parentheses are plentiful in this text, other characteristics of Crane's work are not.[4] Furthermore, Crane is not usually associated with the preparation of prompt-books, yet that the copy was in fact the prompt-book is indicated by the direction in the First Folio, sig. 4A2v, filling a space at the end of Act I and at the foot of the second column: '*Six Chaires placed at the Arras.*' The chairs were to be used for Don Julio and his guests as spectators at the

country-sports masque (see II.ii.104).[5] (The placing of the chairs here, some 275 lines before they are required, would seem to indicate that the division between Act I and Act II was an interval, used to facilitate the mechanics of the performance. If so, it is the only such indication of an interval in the text.) It is possible that the presence of two complementary stage-directions for the fight at IV.iii.46.1–48 indicate a book-holder's addition (line 48) to an original authorial direction (lines 46.1–2). (In the present edition, the two are consolidated.)

> *Enter 2. Gentlemen with weapons drawn, they set upon* Mar—
> tin: Antonio *pursues them out in rescue of* Martin.
>
> *Mar.* Come, Land, land, you must clamber by the cliffe, 47
> Here are no staires to rise by.
> *Ant.* I, are you there? *fight and Exeunt.*

With these two exceptions, the directions do not otherwise suggest a prompt-book origin.

One direction seems authorial: '*Enter* Franio *out of breath.*' (III.ii.72).

The play is the first item in Section 4 of the Folio, printed by Ruth Raworth. The evidence from the running-titles suggests regular two-skeleton work for the three quires, the titles for both recto and verso being 'The Maid in the Mill.' The page-number '2' on A1v (page 2) reappears on page 6 on A3v (both times with running-title 'I'), an error that demonstrates that the outer sheet, inner forme, preceded the inner sheet, outer forme, through the press and that therefore, the printing of the formes was from outer to inner – at least in gathering A – rather than the other way around as we should have expected. Such a scheme almost necessitates a setting by formes. The first title to be set ('IV') was used for A4v in the first forme to be printed off and was then transferred from that verso position to appear in a recto setting in gatherings B and C.

I	A1v	A3v	B1v	B2v	C1v	C2v
II	A2v	B3v	B4v	C3v		
IV	A4v					

| III | A3 | A4 | B1 | B2 | C1 | C2 |
| IV | A2 | B3 | B4 | C3 | C4 | |

The compositors of Raworth's section have been identified by Professor Standish Henning who finds his Compositor *B* responsible

for the setting of most of the play.⁶ According to his analysis, based primarily on the identification of type-cases, Compositor *B* set A1– 4v, B1 and B4v, C1 and C3–4v, D1–2v; Compositor *A* set D3–4v. He suggests also, though with no certainty, that a third compositor, *C*, assisted by setting B1v–4 and C1v–2v. Since Compositor *C* appears nowhere else in the section, as Professor Henning admits, the work of these pages may actually be that of Compositor *A*, from whose characteristics Compositor *C*'s differ only slightly. Such an assumption would bring the division of stints in this play into line with the normal pattern found in the rest of the section, a system of setting by half-quires alternating by compositor (with Compositor *B*, not in normal sequence, setting B1 and B4v–C1).

The copy-text First Folio print is relatively clean. The Second Folio text made some shrewd guesses in certain needed emendations but these are without authority.

A minor problem in editing this play concerns the variety of the spellings used for the names of Ismenia, Martine, and Tirso (as they are denominated here). In Fletcher's I.i, ii, iii the invariable form for the heroine is *Ismena*; thereafter she appears only in Rowley's scenes where the form is *Ismenia* throughout (except for *Ismena* once at II.ii.137.1). This being the form in the source, *Gerardo*, a romance translated from the Spanish of Don Gonzalo de Céspedes y Meneses, *Ismenia* is adopted in the present text. For the hero's friend, *Martine* is the form in Fletcher's I.ii and I.iii and in Rowley's II.ii and IV.i. Curiously, in the opening scene, I.i, Fletcher denominates this character *Martin* (although switching to *Martine* in I.ii), and he is also *Martin* in Rowley's IV.ii, IV.iii, and V.ii. The two forms are not mixed in any scene. Whether the anomaly was caused by cross-wires in the communication of the two dramatists or by some other mistake is subject only to speculation, but it has seemed preferable to adopt *Martine* in the present text, as it is the form in the source. Utter confusion reigns in the case of *Tirso* (as he is in the source). In Fletcher's I.i he is *Terʒo*, in Rowley's II.ii.92 he is *Tirsa*, in Fletcher's III.ii.0.1 he is *Tersa*. Bustofa confused him in IV.i.56 as *Tarso*, and Antonio repeated *Tarso* in the next line (the latter use could be compositorial regularisation and not authorial). In Fletcher's V.ii.124.2 he is *Terso* with the speech-prefix *Ter.*, but the prefix changes to *Tir.* in Fletcher's V.ii.206, in the same scene, confirmed by

Tir. in Rowley's V.ii.306 in the continuation. This last evidence is strong for the regularised *Tirso* in the present text, the more especially since it is the source form. The variant forms of these three names have been regularized silently.[7]

One other silent adjustment has been made in the text. As was customary in the period, a terminal round bracket often takes the place of other punctuation, as in I.i.20, 'some dream (*Ismenia*)' ending a sentence. In such cases when the omitted point is a full stop, the stop has been silently supplied, but the provision of other punctuation is noted in the Emendations of Accidentals. Moreover, too frequently for notation, when original punctuation is used in connection with the round bracket, such marks are almost invariably placed inside the bracket, a misplacement by syntactical logic although customary in the period. Hence in order to remove a source of occasional confusion for the modern reader, such pointing has been silently placed where it would be found in the present day. Thus at I.i.103 'It shall (Cosen.)' is silently emended to '(Cosen).', and so throughout in similar instances.

The speeches of Bustofa, except the verse-lines of his role of Paris in the 'Sports' and his jingles at V.ii.493–502, 513–16, are prose, though printed as verse in F1.[8] As nothing useful is to be gained by recording the details of such erroneous mislining, this edition reduces the verse to prose without further notice. In IV.ii and occasionally in V.ii some prose speeches are set correctly as prose in F1.

Another irregularity of lineation seems to affect V.ii, where Songs 2 and 5 are preceded and followed by part-lines that together seem to make (passable) decasyllabics. The same thing occurs at II.ii.133, where Antonio's line interrupts a verse line. In these instances, the following part-line is indented (as if it were concluding a line of verse) but the two part-lines are counted individually in the line-numbering of the scene.[9]

The song 'Come follow me (you Country-Lasses)' at II.i.143–9, 168–74) survives in one music manuscript (Drexel 4041, nos. 22, 23, New York Public Library) which differs substantively from the Folio text only in completing the refrain: 'Com follow mee Com follow mee'. On the basis of this evidence, the refrain at line 149 is emended to conform to the musical pattern.[10] The second song of the play, Florimel's salacious 'Now having leisure, and a happy wind' (V.ii. 1–99) appears in truncated form – 'Songs' 2, 4 and 5 only – in Harleian

MS 3991 in the British Library as 'How long shall I pine for love'. One emendation is admitted to the text from this version (see Textual Note to V.ii.25).

The only press variants are those resulting from typographical adjustments made during the course of printing.[11]

NOTES

1 G. E. Bentley, *The Jacobean and Caroline Stage*, I (Oxford, 1941), 112.

2 Cyrus H. Hoy, 'The shares of Fletcher and his collaborators in the Beaumont and Fletcher canon', *Studies in Bibliography*, XIII (1960), 96–7.

3 Trevor H. Howard-Hill, 'Ralph Crane's parentheses,' *N&Q*, N.S. XII (1965), 334–40.

4 Virginia Haas, 'Ralph Crane: A status report,' *AEB*, N.S. III (1989), 3–15.

5 Dr. R. K. Turner points out that the direction is a 'space-filler,' and he wonders 'if more of them in the MS were edited out.'

6 Standish Henning, 'The printers and the Beaumont and Fletcher Folio of 1647, Sections 4 and 8D–F', *Studies in Bibliography*, XXII (1969), 165–78. Professor Henning credits Ms Elizabeth Hotchkiss with the bulk of the spelling-tests. For observations on the repetition of act/scene headings and of rules in the three plays of Section 4, see also the Textual Introduction to *The Prophetess*, above, p. 230.

7 Other oddities in naming might be mentioned. At II.ii.104 one of the three 'Gentlemen' come to see Don Julio's 'Sports' is named 'Philippo'. This third Don is included in the F2 list of 'Persons Represented', but the choice of name is awkward, as it is also the name of the King. Rowley has forgotten that he will want to use this common name later in the play. The character Lisauro disappears in the general conclusion of V.ii although his cousin Tirso, who otherwise appears with him, has a small part. Possibly doubling problems – or simple inadvertence – caused this anomaly.

8 Though these jingles might seem to be songs (and are so regarded by some editors), that they are printed in roman suggests that they were not designed to be sung: the actor who played Bustofa could not sing.

9 Something of the same sort of lining seems to have taken place in *A Very Woman* (see vol. VII, p.647) at I.i.140–6 and perhaps at III.v.110–19.

10 John P. Cutts, *La musique de scène de la troupe de Shakespeare* (Paris, 1971), pp. 185–6. As the manuscript provides distinct musical settings for the two stanzas of this song, Cutts regards the two stanzas as constituting two songs.

11 The facts are listed in J. P. Hammersmith, 'The proof-reading of the Beaumont and Fletcher Folio of 1647: Sections 4 and 8 D–F', *PBSA*, LXXXII (1988), 593.

THE PERSONS REPRESENTED IN THE PLAY

MEN

Don Philippo, *King of* Spain.
Otrante, *A Spanish Count, in love with* Florimell.
Julio, *A Noble Man, Uncle to* Antonio.
Bellides, *Father to* Ismenia, *Enemy to* Julio.
Lisauro, *Brother to* Ismenia, Bellides *Son.*
Tirso, *Kinsman to* Lisauro, *and friend to* Bellides.
Antonio, *In love with* Ismenia, *an enemy to* Bellides.
Martine, *Friend to* Antonio, *and his secret Rival.*
Gerasto, *Servant to* Otrante. 10
Pedro, }
Moncado,} *Two Courtiers.*
Gostanzo,}
Giraldo, } *Three Gentlemen, Friends to* Julio.
Philippo,}
Vertigo, *A French Taylor.*
Two Lords, *Attending the King in progress.*
Franio, *A Miller, supposed Father to* Florimell.
Bustofa, Franio *his Son, a Clown.* 20
Pedro, *a Songster.*
Constable.
Officers.
Servants.

WOMEN

Ismenia, *Daughter to* Bellides, *Mistriss of* Antonio.
Aminta, *Cousen to* Ismenia, *and her private competitrix in* Antonio's *love.*
Florimell, *Supposed Daughter to* Franio, *Daughter to* Julio, *stolen from him as a child.*
Gillian, Franio *the Millers Wife.* 30
Countrey Wenches.

The Scene Spaine.

1–32 *adapted from* F2; *omit* F1

THE MAID IN THE MILL.

Enter Lisauro, Tirso, Ismenia, *and* Aminta.

Lisauro. Let the Coach go round, wee'l walk along these Meadows:
 And meet at Port again: Come my fair Sister,
 These cool shades will delight ye.
Aminta. Pray be merry,
 The Birds sing as they meant to entertain ye,
 Every thing smiles abroad: methinks the River
 (As he steals by) curles up his head, to view ye:
 Every thing is in Love.
Ismenia. You would have it so.
 You that are fair, are easie of belief, Cosen,
 The Theame slides from your Tongue.
Aminta. I fair, I thank ye:
 Mine's but shadow when your Sun shines by me. 10
Ismenia. No more of this, you know your worth (*Aminta*).
 Where are we now?
Aminta. Hard by the Town (*Ismenia*).
Tirso. Close by the Gates.
Ismenia. 'Tis a fine Ayre.
Lisauro. A delicate;
 The way so sweet and even, that the Coach
 Would be a tumbling trouble to our pleasures:
 Methinks I am very merry.
Ismenia. I am sad.
Aminta. You are ever so when we entreat ye (Cosen).
Ismenia. I have no reason: such a trembling here
 Over my heart methinks.
Aminta. Sure you are a fasting,
 Or not slept well to night; some dream (*Ismenia*)? 20
Ismenia. My dreams are like my thoughts, honest, and innocent,
 Yours are unhappy; who are these that coast us?

Enter Antonio *and* Martine.

You told me the walk was private.

577

Tirso. 'Tis most commonly.

Ismenia. Two proper men: it seems they have some busines,
 With me none sure; I do not like their faces;
 They are not of our Company?

Tirso. No Cosen:
 Lisauro, we are dog'd.

Lisauro. I find it (Cosen).

Antonio. What handsome Lady?

Martine. Yes, shee's very handsom.
 They are handsome both.

Antonio. *Martine*, stay; we are cosened.

Martine. I will go up; a woman is no wild-fire. 30

Antonio. Now by my life she is sweet: Stay good *Martine*,
 They are of our enemies; the House of *Bellides*,
 Our mortal enemies.

Martine. Let 'em be devills,
 They appear so handsomly, I will go forward;
 If these be enemies, I'le ne'er seek friends more.

Antonio. Prethee forbear; the Gentlewomen——

Martine. That's it (man)
 That moves me like a Gin. 'Pray ye stand off. Ladies——

Lisauro. They are both our enemies: both hate us equally;
 By this fair day our mortal foes.

Tirso. I know 'em,
 And come here to affront: how they gape at us? 40
 They shall have gaping-work. [*Draw.*]

Ismenia. Why your swords, Gentlemen?

Tirso. 'Pray ye stand you off, Cosen,
 And good now leave your whistling, we are abus'd all:
 Back, back I say.

Lisauro. Go back.

Antonio. We are no doggs Sir,
 To run back on command.

Tirso. Wee'l make ye run, Sir.

Antonio. Having a civil charge of handsom Ladies,
 We are your servants: pray ye no quarrel Gentlemen.

37 moves] F2; mopes F1
37 off. ‸ Ladies——] Coleman (~ .—— ~ ——); ~ ‸ ‸ ~ : F1–2

There's way enough for both.

Lisauro. Wee'l make it wider.

Antonio. If you will fight, arm'd from this Saint; have at ye. [*Fight.*]

Ismenia. O me unhappy, are ye Gentlemen? 50
Discreet, and Civil, and in open view thus?

Aminta. What will men think of us? nay you may kill us;
Mercy o' me: through my petticoat; what bloody gentlemen!
Make way through me, ye had best, and kill an innocent.
 [*Stands between them.*]

Ismenia. Brother, why Cosen: by this light Ile die too:
 [*Joins her.*]

This Gentleman is temperate: be you merciful:
Alas, the Swords.

Aminta. You had best run me through the belly,
'Twill be a valiant thrust.

Ismenia. I faint amongst ye.

Antonio. 'Pray ye be not fearful: I have done (sweet Lady)
My sword's already aw'd, and shall obey ye: [*Leaves off.*] 60
I come not here to violate sweet beauty,
I bow to that.

Ismenia. Brother, you see this gentleman,
This Noble Gentleman——

Lisauro. Let him avoid then,
And leave our Walk.

Antonio. The Lady may command Sir,
She bears an eye more dreadful then your weapon.

Ismenia. What a sweet nature this man has? dear brother,
Put up your sword.

Tirso. Let them put up and walk then.

Antonio. No more loud words: there's time enough before us:
For shame put up, do honour to these beauties.

Martine. Our way is this, we will not be denyde it. 70

Tirso. And ours is this, we will not be cross'd in it.

Antonio. What ere your way is (Lady) 'tis a fair one;
And may it never meet with rude hands more,
Nor rough uncivil Tongues.

Ismenia. I thank ye Sir,

*54–55 Make ... | *Ismenia.* Brother,] *Ism.* Make ... | Brother, F1–2

Indeed I thank ye nobly: *Exeunt* [Antonio, Martine].
 A brave Enemie,
Here's a sweet temper now: This is a man (Brother)
This Gentleman's anger is so nobly seated,
That it becomes him: Yours proclaim ye Monsters.
What if he be our House-Foe? we may brag on't:
We have ne'er a friend in all our House so honourable: 80
I had rather from an Enemie, my Brother,
Learn worthy distances and modest difference,
Then from a race of empty friends, loud nothings:
I am hurt between ye.
Aminta. So am I, I fear too:
 I am sure their swords were between my leggs; deer Cosen
 Why look ye pale? where are ye hurt?
Ismenia. I know not,
 But here me-thinks.
Lisauro. Unlace her gentle Cosen.
Ismenia. My heart, my heart, and yet I blesse the Hurter.
Aminta. Is it so dangerous?
Ismenia. Nay, nay, I faint not.
Aminta. Here is no blood that I find, sure 'tis inward. 90
Ismenia. Yes, yes, 'tis inward: 'twas a subtle weapon,
 The hurt not to be cur'd I fear.
Lisauro. The Coach there.
Aminta. May be affright.
Ismenia. *Aminta*, 'twas a sweet one,
 And yet a cruel.
Aminta. Now I find the wound plain:
 A wondrous handsome Gentleman.
Ismenia. Oh no deeper:
 Prethee be silent (wench) it may be thy case.
Aminta. You must be searched: the wound will rancle Cosen;
 And of so sweet a nature.
Ismenia. Deer *Aminta*:
 Make it not sorer.
Aminta.. And on my life admires ye.
Ismenia. Call the Coach, Cosen. 100

*96 case] F2; cause F1

580

Aminta. The Coach, the Coach.

Tirso. 'Tis ready, bring the Coach there.

Lisauro. Well my brave enemies, we shall yet meet ye,
And our old hate shall testifie.

Tirso. It shall (Cosen).

Exeunt.

Enter Antonio *and* Martine. [I.]ii

Antonio. Their swords, alas, I weigh 'em not (deer Friend)
The indiscretion of the Owners blunts 'em;
The fury of the House affrights not me,
It spends it self in words: (Oh me *Martine*)
There was a two edg'd eye, a Lady carried
A weapon that no valour can avoyd,
Nor Art (the hand of Spirit) put aside.
O Friend, it broke out on me like a bullet
Wrapt in a cloud of fire: that point (*Martine*)
Dazled my sence, and was too subtle for me, 10
Shot like a Comet in my face, and wounded
(To my eternal ruine) my hearts valour.

Martine. Methinks she was no such peece.

Antonio. Blaspheme not Sir,
She is so far beyond weak commendation,
That impudence will blush to think ill of her.

Martine. I see it not, and yet I have both eies open,
And I could judge: I know there is no beauty
Till our eies give it 'em, and make 'em hansom;
What's red and white, unles we do allow 'em?
A green face else; and me-thinks such an other. 20

Antonio. Peace thou leud Hereticke; Thou judge of beauties?
Thou hast an excellent sense for a signe-post (Friend);
Dost thou not see? Ile swear thou art stone blind else,
As blind as ignorance: when she appear'd first
Aurora breaking in the east, and through her face,
As if the Hours and Graces had strew'd Roses,
A blush of wonder flying; when she was frighted
At our uncivil swords, didst thou not mark

23 stone] Sympson; soon F1–2

How far beyond the purity of snow
The soft wind drives, whitenes of innocence, 30
Or any thing that bears Celestial palenes,
She appear'd o'th sodain? Didst thou see her tears
When she intreated? O thou Reprobate!
Didst thou not see those orient tears flow'd from her,
The little Worlds of Love? A sett (*Martine*)
Of such sanctified Beads, and a holy heart to love
I could live ever a Religious Hermite.
Martine. I do beleeve a little, and yet me-thinks
She was of the lowest stature.
Antonio. A rich Diamond
Set neat and deep; Natures chief Art (*Martine*) 40
Is to reserve her Modells curious,
Not cumbersome and great; and such a one
For fear she should exceed, upon her matter
Has she fram'd this; Oh 'tis a spark of beauty,
And where they appear so excellent in little,
They will but flame in great; Extension spoils 'em:
Martine learn this, the narrower that our eies
Keep way unto our object, still the sweeter
That comes unto us: Great bodies are like Countries,
Discovering still, toyle and no pleasure finds 'em. 50
Martine. A rare Cosmographer for a small Island.
Now I believe she is handsom.
Antonio. Believe heartily,
Let thy belief, though long a coming, save thee.
Martine. She was (certain) fair.
Antonio. But heark ye (Friend *Martine*)
Do not believe your self too far before me,
For then you may wrong me, Sir.
Martine. Who bid ye teach me?
Do you show me meat, and stitch my lips (*Antonio*)?
Is that fair play?
Antonio. Now if thou shouldst abuse me,
And yet I know thee for an arrant Wencher,
A most immoderate thing; thou canst not love long. 60
Martine. A little serves my turn, I fly at all games,

But I believe.

Antonio. How if we never see her more?
 Shee is our enemie.

Martine. Why are you jealous then?
 As far as I conceive she hates our whole House.

Antonio. Yet (good *Martine*)——

Martine. Come, come, I have mercy on ye:
 You shall enjoy her in your dream (*Antonio*)
 And I'll not hinder: though now I perswade my self——

Antonio. Sit with perswasion down, and you deal honestly:
 I will look better on her.

 Enter Aminta *with a Letter.*

Martine. Stay, who's this, Friend?

Antonio. Is't not the other Gentlewoman?

Martine. Yes a Letter. 70
 She brings no challenge sure: if she do (*Antonio*)
 I hope shee'l be a Second too; I am for her.

Aminta. A good houre Gentlemen.

Antonio. You are welcom Lady;
 'Tis like our late rude passage has powr'd on us
 Some reprehension.

Aminta. No, I bring no anger,
 Though some deserv'd it.

Antonio. Sure we were all too blame, Lady;
 But for my part (in all humility
 And with no little shame) I ask your pardons,
 Indeed I wear no sword to fright sweet beauties.

Aminta. You have it, and this Letter; pray ye Sir view it, 80
 And my Commission's done. [*Reads.*]

Martine. Have ye none for me Lady?

Aminta. Not at this time.

Martine. I am sorry for't; I can read too.

Aminta. I am glad: but Sir, to keep you in your exercise,
 You may chance meet with one ill written.

Martine. Thank ye,
 So it be a womans, I can pick the meaning,
 For likely they have but one end.

Aminta. You say true Sir. *Exit.*

Antonio. *Martine*, my wishes are come home and loaden,
Loaden with brave return: most happy, happy:
I am a blessed man: where's the Gentlewoman?

Martine. Gone, the spirit's gone: what news?

Antonio. 'Tis from the Lady; 90
From her we saw: from that same miracle,
I know her Name now: read but these three lines;
Read with devotion, friend, the lines are holy.

Martine *reads.*

I dare not chide ye in my letter (Sir)
'Twill be too gentle: If you please to look me
In the West-street, and find a fair Stone window,
Carved with white Cupids; there Ile entertain ye:
Night and discretion guide ye.
Call me Ismenia.

Antonio. Give it me again: Come, come, fly, fly, I am all fire.

Martino. There may be danger.

Antonio. So there is to drink 100
When men are thirsty, to eat hastily
When we are hungry: so there is in sleep, Friend,
Obstructions then may rise, and smother us,
We may die laughing, choked: even at devotions,
An Apoplexie, or a sodain Palsey
May strike us down.

Martine. May be a train to catch ye.

Antonio. Then I am caught: and let Love answer for it.
'Tis not my folly, but his infamy,
And if he be adored, and dare do vild things.

Martine. Well, I will go.

Antonio. She is a Lady, Sir, 110
A Maid, I think, and where that holy spell
Is flung about me, I ne're fear a villany,
'Tis almost night: away friend.

Martine. I am ready,
I think I know the house too.

104 choked: ... devotions,] Coleman; ~ , ... ~ : F1–2 ±

Antonio. Then we are happy.

 Exeunt.

 Enter Ismenia *and* Aminta. [I.]iii

Ismenia. Did you meet him?

Aminta. Yes.

Ismenia. And did you give my Letter?

Aminta. To what end went I?

Ismenia. Are ye sure it was he?
Was it that Gentleman?

Aminta. Do you think I was blind?
I went to seek no Carrier, nor no Midwife.

Ismenia. What kind of man was he? thou maist be deceived Friend.

Aminta. A man with a nose on's face: I think he had eies too,
And hands: for sure he took it.

Ismenia. What an answer?

Aminta. What questions are these to one that's hot and troubled?
Do you think me a Babe? am I not able (Cosen)
At my years and discretion, to deliver 10
A Letter handsomly! is that such a hard thing?
Why every wafer-woman will undertake it:
A Sempsters girle, or a Taylors wife will not misse it:
A Puritane Hostesse (Cosen) would scorn these questions.
My legges are weary.

Ismenia. I'll make 'em well again.

Aminta. Are they at Supper?

Ismenia. Yes, and I am not well,
Nor desire no company: look out, 'tis darkish.

Aminta. I see nothing yet: assure your self, *Ismenia*,
If he be a man he will not misse.

Ismenia. It may be he is modest,
And that may pull him back from seeing me; 20
Or has made some wild construction of my easinesse:
I blush to think what I writ.

Aminta. What should ye blush at?
Blush when you act your thoughts, not when you write 'em;
Blush soft between a pair of sheets, sweet Cosen.
Though he be a curious carried Gentleman, I cannot think

He's so unnatural to leave a woman,
A young, a noble, and a beauteus woman,
Leave her in her desires: Men of this age
Are rather prone to come before they are sent for.
Hark, I hear somthing; up to th' Chamber, Cosen, 30
You may spoil all else.

Enter [at one side] Antonio and Martine.

Ismenia. Let me see, they are Gentlemen;
It may be they.
Aminta. They are they: get ye up,
And like a Load-star draw him.
Ismenia. I am shamefac'd. *Exeunt.*
Antonio. This is the street.
Martine. I am looking for the house:
Close, close, pray ye close: here?
Antonio. No, this is a Merchants;
I know the man well.
Martine. And this a Pothecaries: I have lain here many times
For a loosenes in my Hilts.
Antonio. Have ye not past it?
Martine. No sure:
There is no house of mark that we have scaped yet.
Antonio. What place is this?
Martine. Speak softer: 'may be spies; 40
If any, this, a goodly window too,
Carv'd fair above, that I perceive: 'tis dark,
But she has such a lustre.
Antonio. Yes *Martine,*
So radiant she appears.
Martine. Else we may misse, Sir:
The night growes vengeance black, 'pray heaven she shine clear:

Enter Ismenia *and* Aminta *above with a Taper.*

Hark, hark, a window, and a candle too.
Antonio. Step close, 'tis she: I see the cloud disperse,
And now the beautious Planet.

33 Load-star] Sympson (*qy*), Coleman; Land-star F1–2 42 fair] Sympson; far F1–2

586

Martine. Hah, 'tis indeed,
 [*Aside*] Now by the soul of love a divine Creature.
Ismenia. Sir, Sir——
Antonio. Most blessed Lady.
Ismenia. 'Pray ye stand out. 50
Aminta. You need not fear, there's no body now stirring.
Martine [*aside*]. Beyond his commendation I am taken,
 Infinite strangely taken.
Aminta [*aside*]. I love that Gentleman,
 Methinks he has a dainty nimble body:
 I love him heartily.
Ismenia. 'Tis the right Gentleman:
 But what to say to him: Sir——
Aminta. Speak.
Antonio. I wait still,
 And will do till I grow an other Pillar,
 To prop this house, so it please you.
Ismenia. Speak softly,
 And 'pray ye speak truly too.
Antonio. I never lyde, Lady.
Ismenia. And don't think me impudent to ask ye, 60
 I know ye are an Enemie, speak low,
 But I would make ye a friend.
Antonio. I am friend to beauty;
 Ther's no handsomnesse I dare be foe too.
Ismenia. Are ye married?
Antonio. No.
Ismenia. Are ye betrothed?
Antonio. No, neither.
Ismenia. Indeed (fair Sir)?
Antonio. Indeed (fair sweet) I am not.
 Most beauteous Virgin, I am free as you are.
Ismenia. That may be Sir, then ye are miserable,
 For I am bound.
Antonio. Happy the bonds that hold ye;
 Or do you put them on your self for pleasure?
 Sure they be sweeter far then libertie: 70

58 prop] F2; propt F1

There is no blessednesse but in such bondage:
Give me that freedom (Madam) I beseech ye,
(Since you have question'd me so cunningly)
To ask you whom you are bound to, he must be certain
More then humane, that bounds in such a beauty:
Happy that happy chain, such links are heavenly.

Ismenia. 'Pray ye do not mock me, Sir.

Antonio. 'Pray ye (Lady) tell me.

Ismenia. Will ye beleeve, and will ye keep it to ye?
And not scorn what I speak?

Antonio. I dare not (Madam)
As Oracle what you say, I dare swear to. 80

Ismenia. I'll set the candle by: for I shall blush now;
Fy, how it doubles in my mouth? it must out,
'Tis you I am bound to.

Antonio. Speak that word again,
I understand ye not.

Ismenia. 'Tis you I am bound to.

Antonio. Here is another gentleman.

Ismenia. 'Tis you Sir.

Aminta. He may be lov'd too.

Martine [aside]. Not by thee, first curse me.

Ismenia. And if I knew your name.

Antonio. *Antonio* (Madam).

Ismenia. *Antonio,* take this kisse, 'tis you I am bound to.

Antonio. And when I set ye free, may heaven forsake me,
Ismenia.

Ismenia. Yes, now I perceive ye love me, 90
You have learnd my name.

Antonio. Hear but some vows I make to ye:
Hear but the protestations of a true love.

Ismenia. No, no, not now: vowes should be cheerful things,
Done in the cleerest light, and noblest testimony:
No vow (deer Sir) tye not my fair belief
To such strict termes: those men have broken credits,
Loose and dismembred faiths (my deer *Antonio*)
That splinter 'em with vows: am I not too bold?
Correct me when you please.

Antonio. I had rather hear ye,
For so sweet Musick never struck mine eares yet: 100
Will you believe now?
Ismenia. Yes.
Antonio. I am yours.
Aminta. Speak lowder,
If ye answer the Priest so low, you will lose your wedding.
Martine [*aside*]. Would I might speak, I would holloa.
Antonio. Take my heart,
And if it be not firm and honest to you,
Heaven——
Ismenia. Peace, no more: I'll keep your heart, and credit it.
Keep you your word: when will you come again (Friend)?
For this time we have wooed indifferently,
I would fain see ye, when I dare be bolder.
Antonio. Why any night: onely (deer noble Mistris)
Pardon three daies: my Uncle *Julio* 110
Has bound me to attend him upon promise,
Upon expectation too: we have rare sports there,
Rare Countrey sports, I would you could but see 'em.
Dare ye so honour me?
Ismenia. I dare not be there,
You know I dare not, no, I must not (friend).
Where I may come with honourable freedom——
Alas, I am ill too; wee in love——
Antonio. You flowt me.
Ismenia. Trust me I do not: I speak truth, I am sickly,
And am in Love; but you must be Physician.
Antonio. I'll make a plaister of my best affection. 120
Ismenia. Be gone, we have supp'd, I hear the people stir,
Take my best wishes: give me no cause (*Antonio*)
To curse this happy night.
Antonio. I'll lose my life first,
A thousand kisses.
Ismenia. Take ten thousand back again.
Martine. I am dumb with admiration:——shall we goe Sir? *Exeunt.*
Ismenia. Dost thou know his Uncle?

*101 *Aminta.*] Dyce; *Ism.* F1–2

Aminta. No, but I can ask, Cosen.

Ismenia. I'll tell thee more of that, come let's to bed both,
 And give me handsom dreams, Love, I beseech thee.

Aminta. 'Has given ye a handsom subject.

Ismenia. Pluck to the windows.

 Exeunt.

 Enter Bustofa [*with a paper*]. II.i

Bustofa [*reads*]. The thundring Seas, whose watry fire washes the
 whiting mops:
 The gentle Whale whose feet so fell flies ore the Mountain tops.

Franio [*within*]. Boy. *Within* Franio.

Bustofa. The thundring——

Franio [*within*]. Why boy *Bustofa.*

Bustofa. Here I am——the gentle whale——

 Enter Franio.

Franio. Oh, are you here Sir? where's your sister?

Bustofa. The gentle whale flies ore the mountain tops.

Franio. Where's your sister (man)?

Bustofa. Washes the whiting-Mops. 10

Franio. Thou ly'st, she has none to wash! mops?
 The Boy is half way out of his wits, sure:
 Sirrha, who am I?

Bustofa. The thundring Seas——

Franio. Mad, stark mad.

Bustora. Will you not give a man leave to con?

Franio. Yes, and fesse too, ere I have done with you Sirrha.
 Am I your father?

Bustofa. The question is too hard for a child, ask me any thing that I
 have learn'd, and I'll answer you. 20

Franio. Is that a hard question? Sirrha, am not I your Father?

Bustofa. If I had my mother-wit I could tell you.

Franio. Are you a thief?

Bustofa. So far forth as the son of a Miller.

Franio. Will you be hang'd?

 2 Mountain] Dyce; Mountains F1–2
 11 wash! mops?] Sympson (~ . ~ ?); ~ ∧ ~ ? F1–2

Bustofa. Let it go by eldership. The gentle Whale———
Franio. Sirrha, lay by your foolish study there,
 And beat your brains about your owne affaires: or———
Bustofa. I thank you; you'ld have me goe under the sails and beat
 my brains about your mill? a naturall Father you are.——— 30
Franio. I charge you go not to the sports to day:
 Last night I gave you leave, now I recant.
Bustofa. Is the wind turn'd since last night?
Franio. Marry is it Sir, go no farther then my Mill;
 There's my command upon you.
Bustofa. I may go round about then as your Mill does! I will see your
 Mill gelded, and his Stones fryde in steaks, ere I deceive the
 Countrey so: have I not my part to study? How shall the sports go
 forward, if I be not there?
Franio. They'll want their fool indeed, if thou bee'st not there. 40
Bustofa. Consider that, and go your self.
Franio. I have fears (Sir) that I cannot utter,
 You go not, nor your Sister: there's my charge.
Bustofa. The price of your golden thumb cannot hold me.
Franio. I, this was sport that I have tightly lov'd, [*Horns within.*]
 I could have kept company with the Hounds.
Bustofa. You are fit for no other company yet.
Franio. Run with the Hare; and bin in the whore's tayl 'yfaith.
Bustofa. That was before I was born; I did ever mistrust I was a
 Bastard, because *Lapis* is in the singular number with me. 50

Enter Otrante *and* Gerasto.

Otrante. Leave thou that gun (*Gerasto*) and chase here,
 Do thou but follow it with my desires,
 Thou'lt not return home emptie.
Gerasto. I am prepard
 (My Lord) with advantages: and see
 Yonder's the subject I must work upon.
Otrante. Her Brother? 'tis, methinks it should be easie:
 That grosse compound cannot but diffuse
 The soul in such a latitude of ease,

*56 Brother? 'tis,] *stet* F1

591

As to make dull her faculties, and lazie:
What wit above the least can be in him, 60
That Reason ties together?
Gerasto. I have prov'd it, Sir,
And know the depth of it: I have the way
To make him follow me a hackney-pace,
With all that flesh about him; yes, and dragge
His Sister after him: This baytes the old one, [*Horns within.*]
Rid you him, and leave me to the other.
Otrante. 'Tis well: *Exit* [*Gerasto*].
 O *Franio*, the good day to you;
You were not wont to hear this musick standing:
The Beagle and the Bugle ye have lov'd,
In the first rank of Huntsmen. 70
Bustofa. The doggs cry out of him now.
Franio. Sirrha, leave your barking, I'll bite you else.
Bustofa. Curre, Curre.
Franio. Slave, do'st call me dog?
Otrante. Oh fie Sir, he speaks
Latine to you, he would know why you'll bite him.
Bustofa. *Responde cur*; You see his understanding (my Lord).
Franio. I shall have a time to curry you for this:
But (my Lord) to answer you, the daies have been
I must have footed it before this Horn-pipe,
Though I had hazarded my Mill a fire, 80
And let the stones grinde empty: but those dancings
Are done with me: I have good will to it still.
And that's the best I can do.
Otrante. Come, come, you shall be hors'd:
Your company deserves him, though you kil him,
Run him blind, I care not.
Bustofa. Hee'll do't o' purpose (my Lord) to bring him up to the
Mill.
Franio. Do not tempt me too far (my Lord).
Otrante. There's a foot i'th' stirrop: I'll not leave you now:
You shall see the Game fall once again. 90
Franio. Well (my Lord) I'll make ready my leggs for you,
And try 'em once a horsback: sirra, my charge, keep it. *Exit.*

Bustofa. Yes, when you pare down your dish for conscience sake,
when your thumb's coyn'd into *bone et legalis*, when you are a true-
man, Miller.

Otrante. What's the matter *Bustofa?*

Bustofa. My Lord; if you have ere a drunken Jade that has the
staggers, that will fall twice the height of our Mill with him: set him
o'th' back on him: a galled Jennet that will winch him outo'the
saddle, and breake one on's neckes, or a shank of him (there was a 100
fool going that way, but the Asse had better lucke); or one of your
brave Barbaries, that would passe the Straites, and run into his
owne Countrey with him; the first Moor he met, would cut his
throat for Complexions sake: there's as deadly feud between a Moor
and a Miller, as between black and white.

Orante. Fie, Fie, this is unnaturall *Bustofa,*
Unlesse on some strong cause.

Bustofa. Be Judge (my Lord). I am studied in my part: the Julian-
Feast is to day: the Countrey expects me; I speak all the dumb
shews: my sister chosen for a Nimph.——The gentle Whale 110
whose feet so fell:——Cry mercy, that was some of my part: But
his charge is to keep the Mill, and disappoint the Revels.

Otrante. Indeed, there it speaks shrewdly for thee; the Country
expecting.

Bustofa. I, and for mine own grace too.

Otrante. Yes, and being studied too: and the main Speaker too.

Bustofa. The main? Why all my Speech lies in the main, and the dry
ground together:——The thundring seas, whose, &c.

Otrante. Nay, then thou must go, thou'lt be much condmn'd else.
But then o'th other side, obedience. 120

Bustofa. Obedience? But speak your conscience now (my Lord).
Am not I past asking blessing at these yeers? Speak as you'r a Lord,
if you had a Miller to your father.

Otrante. I must yeeld to you (*Bustofa*), your reasons
Are so strong, I cannot contradict: This I think,
If you go, your sister ought to go along with you.

Bustofa. There I stumble now: shee is not at age.

Otrante. Why? shee's fifteen, and upwards.

Bustofa. Thereabouts.

Otrante. That's womans ripe age; as full as thou art 130

At one and twenty: shee's manable, is she not?

Bustofa. I think not: poor heart, she was never tryde in my conscience. 'Tis a coy thing; she will not kisse you a clown, not if he would kisse her——

Otrante. What, man?

Bustofa. Not if he would kisse her, I say.

Otrante. Oh, 'twas cleanlier, then I expected: well Sir.
I'll leave you to your own, but my opinion is,
You may take her along: [*aside*] this is half way:
The rest (*Gerasto*) and I hunt my prey.—— 140

Bustofa. Away with the old Miller (my Lord) and the mill strikes sail presently. *Exit* [Otrante].

Enter Pedro, *with* Gerasto [*called* Diego] *blind, singing.*

Song.

Gerasto. *Come follow me (you Country-Lasses)*
And you shall see such sport as passes:
You shall dance, and I will sing;
Pedro hee shall rub the string:
Each shall have a loos-bodied gown
Of green; and laugh till you lie down.
Come follow me, come follow me.

Enter Florimell.

Bustofa. O sweet *Diego*, the sweetest *Diego*: stay, Sister *Florimell*. 150

Florimell. What's that, Brother?

Bustofa. Didst not hear *Diego*? Hear him, and thou'lt be ravish'd.

Florimell. I have heard him sing, yet unravish'd, Brother.

Bustofa. You had the better luck (Sister). I was ravish'd by mine own consent: Come away: for the Sports.

Florimell. I have the fear of a Father on me (Brother).

Bustofa. Out: the theef is as safe as in his mill; hee's hunting with our great Land-lord the Don *Otrante*. Strike up *Diego*.

Florimell. But say he return before us, Where's our excuse?

Bustofa. Strike up *Diego*. Hast no strings to thy apron? 160

Florimell. Well, the fault lie upon your head (Brother).

Bustofa. My faults never mount so high (girl), they rise but to my

*140 The rest] *stet* F1 149 come follow me.] NYPL; &c. F1; come follow, &c. F2.

594

middle at most. Strike up *Diego*.

Gerasto. Follow me by the ear, I'll lead thee on (*Bustofa*) and pretty
 Florimell thy Sister: oh that I could see her.

Bustofa. Oh *Diego*, there's two pities upon thee; great pitie thou art
 blinde; and as great a pitie thou canst not see.

<div align="center">*Song.*</div>

Gerasto. You shall have Crowns of Roses, Daysies,
 Buds, where the honey-maker grazes:
 You shall taste the golden thighs, 170
 Such as in Wax-Chamber lies.
 What fruit please you, taste, freely pull,
 Till you have all your bellies full.
<div align="center">Come follow me, &c.</div>

Bustofa. O *Diego*, the Don was not so sweet when hee perfum'd the
 Steeple.

<div align="right">*Exeunt.*</div>

<div align="center">*Enter* Antonio *and* Martine.</div> <div align="right">[II.]ii</div>

Martine. Why, how now (Friend) thou art not lost agen?

Antonio. Not lost? why, all the world's a wildernesse:
 Some places peopled more by braver beasts
 Then others are: But faces, faces (man)
 May a man be caught with faces?

Martine. Without wonder.
 'Tis odds against him: May not a good face
 Lead a man about by the nose? 'las
 The nose is but a part against the whole.

Antonio. But is it possible that two faces
 Should be so twin'd in form, complexion, 10
 Figure, aspect? that neither wen, nor mole,
 The table of the brow, the eyes lustre,
 The lips cherry; neither the blush nor smile
 Should give the one distinction from the other?
 Do's Nature work in molds?

Martine. Altogether.
 We are all one mold, one dust.

Antonio. Thy reason's moldie.

<div align="center">169 grazes] Sympson; gazes F1–2 10 twin'd] *i.e.,* twinned</div>

I speak from the Form, thou the Matter.
Why? was't not ever one of Natures Glories,
Nay, her great peece of wonder, that amongst
So many millions millions of her works 20
Shee left the eye distinction, to cull out
The one from other; yet all one name, the face?

Martine. You must compare 'em by some other part
Of the body, if the face cannot do't.

Antonio. Didst ask her name?

Martine. Yes, and who gave it her,
And what they promis'd more, besides a spoon,
And what Apostles picture; she is christend too,
In token wherefore she is call'd *Isabella*,
The daughter of a Country plow-swain by:
If this be not true, shee lyes.

Antonio. She cannot; 30
It would be seen a blister on her lip,
Should falshood touch it, it is so tender:
Had her name held, 't had been *Ismenia*,
And not another of her name.

Martine. Shall I speek?

Antonio. Yes, if thou'lt speak truth: Is she not wondrous like?

Martine. As two garments of the same fashion,
Cut from the same piece: yet if any excell,
This has the first; and in my judgement 'tis so.

Antonio. 'Tis my opinion.

Martine. Were it the face
Where mine eyes should dwell, I would please both 40
With this, as soon as one with the other.

Antonio. And yet the other is the case of this.
Had I not look'd upon *Ismenia*,
I nere had staid beyond good-morrows time
In view of this.

Martine [*aside*]. Would I could leave him here,
'Twere a free passage to *Ismenia*:
I must now blow, as to put out the fire
Yet kindle't more.———You not consider Sir,

*40 eyes] Sympson; eye F1—2

596

The great disparitie is in their bloods,
Estate and fortunes: there's the rich beauty 50
Which this poore homelinesse is not endow'd with;
There's difference enough.

Antonio. The least of all.
Equalitie is no rule in Loves Grammar:
That sole unhappinesse is left to Princes
To marry blood: we are free disposers,
And have the power to equalize their bloods
Up to our own; wee cannot keep it back,
'Tis a due debt from us.

Martine. I Sir, had you
No Father nor Unkle, nor such hinderers,
You might do with your self at your pleasure; 60
But as it is——

Antonio. As it is; 'tis nothing:
Their powers will come too late, to give me back
The yesterday I lost.

Martine. Indeed, to say sooth,
Your opposition from the other part
Is of more force; there you run the hazzard
Of every hour a life, had you supply;
You meet your deerest enemy in love
With all his hate about him: 'Twill be more hard
For your *Ismenia* to come home to you,
Then you to go to Country *Isabell.* 70

Antonio. Tush; 'tis not fear removes me.

Martine. No more: Your Unkle.

Enter Julio.

Julio. Oh, the good hour upon you Gentlemen:
Welcome Nephew; Speak it to your friend Sir,
It may be happier receiv'd from you,
In his acceptance.

Antonio. I made bold, Uncle,
To do it before; and I think he beleeves it.

Martine. 'Twas never doubted, Sir.

*72 Julio.] Stet F1

597

Julio. Here are sports (Dons)
 That you must look on with a loving eye,
 And without Censure, 'lesse it be giving
 My country neighbours loves their yeerly offrings 80
 That must not be refus'd; though't be more pain
 To the Spectator, then the painfull Actor,
 'Twill abide no more test then the tinsell
 We clad our Masks in for an hours wearing,
 Or the Livery lace sometimes on the cloaks
 Of a great Dons Followers: I speak no further
 Then our own Country, Sir.
Martine. For my part, Sir,
 The more absurd 't shalbe, the better welcom.
Julio. You'll find the guest you look for: I heard Cousen,
 You were at *Toledo* th'other day.
Antonio. Not late, Sir. 90
Julio. O fie! must I be plainer? You chang'd the point
 With *Tirso* and *Lisauro*, two of the Stock
 Of our Antagonists, the *Bellides*.
Antonio. A meer proffer, Sir; the prevention
 Was quick with us: we had done somewhat else:
 This Gentleman was ingag'd in't.
Julio. I am
 The enemie to his foe for it: that wild-fire
 Will crave more then fair water, to quench it
 I suspect. Whence it will come I know not.
Antonio. I was about a gentle reconcilement, 100
 But I do fear I shall goe back agen.
Julio. Come, come; The Sports are coming on us:

Enter two or three Gentlemen.

 Nay, I have more guests to grace it: Welcome
 Don *Gostanƺo, Giraldo, Philippo*: Seat, seat all. *Musick.*

Enter a Cupid.

Cupid. Love is little, and therefore I present him,
 Love is a fire, therefore you may lament him.
Martine. Alas poor Love, who are they that can quench him?

Julio. He's not without those members, fear him not.
Cupid. Love shoots, therefore I bear his bow about.
 And Love is blind, therefore my eyes are out. 110
Martine. I never heard Love give reason for what he did before.

Enter Bustofa (*for* Paris).

Cupid. Let such as can see, see such as cannot: behold,
 Our goddesses all three strive for the ball of gold:
 And here fair *Paris* comes, the hopefull youth of Troy,
 Queen *Hecub's* darling-son, King *Priams* onely joy.
Martine. Is this *Paris?* I should have taken him for *Hector* rather.
Bustofa. *Paris* at this time: Pray you hold your prating.
Antonio. *Paris* can be angry.
Julio. Oh, at this time
 You must pardon him; he comes as a Judge.
Martine. Gods mercy on all that looks upon him, say I. 120
Bustofo. The thundring seas whose watry fires washes the
 whiting-Mops,
 The gentle Whale, whose feet so fell, flies ore the mountain tops,
 No roares so fierce, no throats so deep, no howls can bring such
 fears
 As *Paris* can, if Garden from he call his Dogs and Bears.
Martine. I, those they were that I feard all this while.
Bustofa. Yes *Jack-an-Apes*——
Martine. I thank you, good *Paris.*
Bustofa. You may hold your peace, and stand further out o'th' way:
 then the lines will fall where they light.
 Yes *Jack-an-Apes* he hath to sport, and faces make like mirth, 130
 Whilst bellowing buls, the horned beasts, do tosse from ground to
 earth:
 Blind Bear there is, as *Cupid* blind——
Antonio. That Bear would be whip'd for losing of his eyes.
Bustofa. be whipped man may see,
 But we present no such content, but Nimphs such as they be.

*120 Gods mercy] Colman (God's); —— Mercy F1–2
124 Garden] *i.e.,* Paris Garden on the Bankside
*128–129 way: then ∧] ~ ∧ ~ : F1–2 *130 sport] Weber; sports F1–2
132 Blind] F2; Bloud F1 134 be whipped] *i.e.,* be-whipped

Antonio. These are long lines.

Martine.. Can you blame him, leading Buls and Bears in 'em?

Enter Shepherd singing, with Ismenia [*calling herself* Isabella],
Aminta, Florimell, (*as* Juno, Pallas, Venus), *and three* [Countrey
Wenches *as*] *Nymphs attending.*

Bustofa. Go *Cupid* blind, conduct the dumb, for Ladies must not
 speak here:
 Let shepherds sing with dancing feet, and cords of musick break
 here.

 Song.

Now Ladies fight, with heels so light, by lot your luck must fall, 140
Where *Paris* please, to do you ease, and give the golden Ball.

 Dance.

Martine. If you plaid *Paris* now *Antonio.*
 Where would you bestow it?

Antonio. I prethee, Friend,
 Take the full freedome of thought, but no words.

Martine. 'Protest there's a third, which by her habit
 Should personate *Venus,* and by consequence
 Of the Story, receive the honours prize:
 And were I a *Paris,* there it should be.
 Doe you note her?

Antonio. No; mine eye is so fixed,
 I cannot move it. 150

Cupid. The dance is ended; Now to judgment *Paris.*

Bustofa. Here *Juno,* here: but stay, I do espy
 A pretty gleeke comming from *Pallas* eye:
 Here *Pallas,* here: yet stay agen: methinks
 I see the eye of lovely *Venus* winks:
 Oh close them both: shut in those golden eyne,
 And I will kisse those sweet blind cheeks of thine.
 Juno is angry: yes, and *Pallas* frowns,
 Would *Paris* now were gone from *Ida's* downs.
 They both are fair, but *Venus* has the Mole, 160
 The fairest hair, and sweetest dimple hole:
 To her, or her, or her, or her, or neither;
 Can one man please three Ladies altogether?

No, take it *Venus*, tosse it at thy pleasure,
Thou art the *lovers* friend beyond his measure.
Julio. *Paris* has done what man can do, pleas'd one,
Who can do more?

Enter Gerasto, (*as* Mars).

Martine. Stay, here's another person.
Gerasto. Come lovely *Venus*, leave this lower Orbe,
And mount with *Mars*, up to his glorious Spheare.
Bustofa. How now, what's he? 170
Florimell. I'm ignorant what to do, Sir.
Gerasto. Thy silver-yoke of Doves are in the Team,
And thou shalt fly thorough *Apollo's* Beam:
I'le see thee seated in thy golden Throne,
And hold with *Mars* a sweet conjunction. *Exit* [*with* Florimell].
Bustofa. Ha? what fellow's this? 'has carried away my sister *Venus*:
he never rehears'd his part with me before.
Julio. What follows now Prince *Paris*?
Florimell (*within*). ——Help, help, help.
Bustofa. Hue and cry, I think Sir, this is *Venus* voice, mine owne 180
sister *Florimells*.
Martine. What, is there some Tragick-Act behind?
Bustofa. No, no, altogether Comical; *Mars* and *Venus* are in the old
conjunction it seems.
Martine. 'Tis very improper then, for *Venus*
Never cryes out when she conjoynes with *Mars*.
Bustofa. That's true indeed: they are out of their parts sure, it may
be 'tis the Book-holders fault: Ile go see.—— *Exit.*
Julio. How like you our Countrey Revells, Gentlemen?
All Gentlemen. Oh, they commend themselves, Sir.
Antonio. Me-thinks now 190
Juno and *Minerva* should take revenge on *Paris*,
It cannot end without it.
Martine. I did expect
Insteed of *Mars*, the Storm-Gaoler *Eolus*,
And *Juno* proffring her *Deiopeia*
As satisfaction to the blustring god,

176 fellow's] F2; follows F1

To send his Tossers forth.

Julio. It may so follow,
Lets not prejudice the History.

Enter Bustofa.

Bustofa. Oh, oh, oh, oh.

Julio. So, here's a Passion towards.

Bustofa. Help, help, if you be Gentlemen; my Sister, my *Venus*; 200
shee's stolne away.

Julio. The story changes from our expectation.

Bustofa. Help, my father the Miller will hang me els: god *Mars* is a
bawdy Villain: he said she should ride upon Doves: shee's horss'd,
shee's horss'd whether she will or no.

Martine. Sure I think hee's serious.

Bustofa. Shee's horss'd upon a double Gelding, and a Stone-horse in
the breech of her: the poor wench cries help, and I cry help, and
none of you will help.

Julio. Speak, is it the show, or dost thou bawle? 210

Bustofa. A pox on the Ball: my Sister bawls, and I bawl: either bridle
horse and follow, or give me a halter to hang my self: I cannot run
so fast as a hogge.

Julio. Why, follow me, I'le fill the Countrey with pursuit
But I will find the Thief: my House thus abus'd?

Bustofa. 'Tis my house that's abus'd, the Sister of my flesh and
blood: oh, oh. *Exeunt* [Julio, Gentlemen, Bustofa].

1 Wench. 'Tis time we all shift for our selves if this be serious.

2 Wench. However I'le be gone.

3 Wench. And I. *Exeunt* [*three Wenches*]. 220

Antonio. You need not fright your beauties, pretty souls,
With the least pale complexion of a fear.

Martine. *Juno* has better courage: and *Minerva* more discreet.

Ismenia. Alas my courage was so counterfeit
It might have been struck from me with a feather,
Juno ne'er had so weak a presenter.

Aminta. Sure I was ne'er the wiser for *Minerva*,
That I find yet about me.

[Antonio *whispers* Ismenia.]

*214 Why,] Sympson; Wie ∧ F1; *omit* F2

Ismenia. My dwelling Sir?
 'Tis a poor Yeomans roof, scarce a league off,
 That never sham'd me yet.
Antonio. Your gentle pardon: 230
 I vow my erring eyes had almost cast you
 For one of the most mortal Enemies
 That our Family has.
Ismenia. I'me sorry Sir,
 I am so like your foe: 'twere fit I hasted
 From your offended sight.
Antonio. Oh, mistake not,
 It was my error, and I do confesse it:
 You'l not beleeve you're welcome; nor can I speak it;
 But there's my friend can tell you, pray hear him.
Martine. Shall I tell her Sir? I'me glad of the employment.
 [*They walk apart.*]

Antonio. A kinswoman to that beauty?
Aminta. A kin to her, Sir, 240
 But nothing to her Beauty.
Antonio. Do not wrong it, 'tis not far behind her.
Aminta. Her hinder parts are not far off, indeed, Sir.
 [*They walk apart.*]

Martine. Let me but kisse you with his ardour now,
 You shall feel how he loves you.
Ismenia. Oh forbear:
 'Tis not the fashion with us, but would you
 Perswade me that he loves me?
Martine. I'le warrant you
 He dies in't: and that were witnes enough on't.
Ismenia. Love me Sir? can you tell me for what reason?
Martine. Fy, will ye ask me that which you have about you? 250
Ismenia. I know nothing Sir.
Martine. Let him find it then;
 He constantly beleeves you have the thing
 That he must love you for: much is apparent,
 A sweet and lovely beauty.
Ismenia. So Sir; 'Pray you

237 you're] F2 (you'r); your F1

603

Show me one thing: Did he nere love before?
(I know you are his bosome-Counsellor.)
Nay then I see your answer is not ready:
I'le not beleeve you if you study farther.

Martine. Shall I speak truth to you?

Ismenia. Or speak no more.

Martine. There was a smile thrown at him, from a Lady 260
 Whose deserts might buy him treble, and lately
 He receiv'd it, and I know where he lost it,
 In this face of yours: I know his heart's within you.

Ismenia. May I know her name?

Martine. In your ear you may
 With vow of silence. *[They walk apart.]*

Aminta. Hee'l not give over Sir:
 If he speak for you, hee'l sure speed for you.

Antonio. But that's not the answer to my question.

Aminta. You are the first in my virgin-conscience
 That ere spoke Love to her:——oh, my heart!

Antonio. How doe you?

Aminta. Nothing Sir: but would I had a better face. 270
 How well your pulse beats.

Antonio. Healthfully, does it not?

Aminta. It thumps prettily, methinks. *[They walk apart.]*

Ismenia. Alack, I hear it.
 With much pitie: how great is your fault too,
 In wrong to the good Lady?

Martine. You forget
 The difficult passage hee has to her,
 A hell of feud's between the Families.

Ismenia. And that has often Love wrought by advantage
 To peacefull reconcilement.

Martine. There impossible.

Ismenia. This way 'tis worser; 't may seed again in her
 Unto another generation: 280
 For where (poor Lady) is her satisfaction?

Martine. It comes in me; to be truth, I love her
 (I'll go no farther for comparison)
 As deer as hee loves you.

Ismenia. How if shee love not?

Martine. Tush: be that my pains: You know not what art I have
 Those wayes.

Ismenia. Beshrow you, you have practis'd upon me.
 Well, speed me here, and you with your *Ismenia.*

Martine [*to* Antonio]. Go, the condition's drawn, ready dated,
 There wants but your hand to't. [Antonio, Ismenia *walk apart.*]

Aminta. Truly you have taken great pains, Sir. 290

Martine. A friendly part, no more (sweet Beuty).

Aminta. They are happy, Sir, have such friends as you are.
 But do you know you have done well in this?
 How will his Allyes receive it? shee (though I say't)
 Is of no better Blood then I am.

Martine. There I leave it, I'm at farthest that way. [*Walk apart.*]

Ismenia. You shall extend your vows no larger now.
 My heart calls you mine own: and that's enough.
 Reason, I know, would have all yet conceal'd.
 I shall not leave you unsaluted long 300
 Either by pen or person. You may discourse *Antonio.*
 With me, when you think y'are alone, I shall
 Be present with you.

Ismenia. Come Cosen, will you walk? [*They return.*]

Aminta. Alas, I was ready long since: in conscience
 You would with better will yet stay behind.

Ismenia. Oh Love, I never thought thou'dst bin so blind.

 Exeunt [Ismenia, Aminta].

Martine. You'll answer this Sir?

Antonio. If ere't be spoke on:
 I purpose not to propound the question.

 Enter Julio.

Julio. 'Tis true the poor knave said: some Ravisher,
 Some of Lusts Blood-hounds have seiz'd upon her: 310
 The Girle is hurried, as the divell were with 'em
 And help'd their speed.

Martine. It may not be so ill, Sir.
 A well prepared Lover may do as much

 605

In hot blood as this, and perform't honestly.
Julio. What? steale away a virgin 'gainst her will?
Martine. It may be any mans case; despise nothing:
 And that's a thiefe of a good quality,
 Most commonly hee brings his theft home again,
 Though with a little shame.
Julio. There's a charge by't
 Faln upon mee: *Paris* (the Millers son) 320
 Her brother, dares not venture home again
 Till better tidings follow of his sister.
Antonio. Y'are the more beholding to the mischance, Sir:
 Had I gone a Boot-haling, I should as soon
 Have stolne him, as his sister: Marry then,
 To render him back in the same plight he is
 May be costly: his flesh is not maintain'd with little.
Julio. I think the poor knave will pine away,
 Hee cries all to be pitied yonder.
Martine. 'Pray you Sir, let's go see him: I should laugh 330
 To see him cry sure.
Julio. Well, you are merry, Sir.
 Antonio, keep this charge; I have fears
 Move me to lay it on you: 'Pray forbear
 The wayes of your enemies, the *Bellides.*
 I have reason for my Injunction, Sir. *Exit.*

 Enter Aminta (*as a Page with a Letter*).

Antonio. To me, Sir? from whom?
Aminta. A friend, I dare vow, Sir,
 Though on the enemies part: the Ladie *Ismenia.*
Martine. Take heed: blush not too deep; let me advise you
 In your Answer, 't must be done heedfully.
Antonio. I should not see a masculine in peace 340
 Out of that house.
Aminta. Alas: I' am a child, Sir,
 Your hates cannot last till I wear a sword.
Antonio. Await me for your answer. [*Exit with* Aminta.]
Martine. Hee must see her,
 To manifest his shame: 'tis my advantage;

While our blood's under us, wee keep above:
But then we fall when we do fall in love.

<p style="text-align:right">Exit.</p>

<p style="text-align:center">Enter Julio and Franio.　　　　　　　III.i</p>

Franio. My Lord, my Lord, your house hath injur'd me,
　　Rob'd me of all the joys I had on earth.
Julio.　Where wert thou brought up (fellow)?
Franio.　　　　　　　　　　　　In a Mill.
　　You may perceive it by my loud exclaimes,
　　Which must rise higher yet.
Julio.　　　　　　　Obstreperous Carle.
　　If thy throats tempest could ore-turn my house,
　　What satisfaction were it for thy child?
　　Turn thee the right way to thy journies end.
　　Wilt have her where she is not?
Franio　　　　　　　　Here was she lost,
　　And here must I begin my footing after;　　　　　10
　　From whence, untill I meet a pow'r to punish,
　　I will not rest: You are not quick to grief,
　　Your hearing's a dead sense. Were yours the losse,
　　Had you a daughter stoln, perhaps be-whor'd,
　　(For to what other end should come the thiefe?)
　　You'ld play the Miller then, be loud and high.
　　But being not a sorrow of your own,
　　You have no help nor pitie for another.
Julio.　Oh, thou hast op'd a sluce was long shut up,
　　And let a flood of grief in; a buried grief　　　　　20
　　Thy voice hath wak'd again: a grief as old
　　As likely t'is, thy child is; friend, I tell thee,
　　I did once lose a daughter.
Franio.　　　　　　Did you Sir?
　　Beseech you then, how did you bear her losse?
Julio.　With thy grief trebled.
Franio.　　　　　　　But was she stolne from you?
Julio.　Yes, by devouring theeves, from whom cannot
　　Ever returne a satisfaction:
　　The wild beasts had her in her swathing clothes.

<p style="text-align:center">607</p>

Franio. Oh much good do 'em with her.

Julio. Away tough churle.

Franio. Why, she was better eaten then my child, 30
Better by beasts then beastly men devoured,
They took away a life, no honour from her:
Those beasts might make a Saint of her, but these
Will make my child a devil: but was she, Sir,
Your onely daughter?

<div align="center">Enter Gillian.</div>

Julio. I ne'r had other (Friend).

Gillian. Where are you (man)? your busines lies not here,
Your daughter's in the Pownd, I have found where.
'Twill cost you deer her freedom.

Franio. I'll break it down,
And free her without pay: horse-locks nor chains
Shall hold her from me. [Gillian *whispers him.*]

Julio. I'll take this relief,
I now have time to speak alone with grief. *Exit.* 40

Franio. How? my Land-lord? hee's Lord of my Lands
But not my Cattel: I'll have her again (*Gill*).

Gillian. You are not mad upon the sudden now?

Franio. No *Gill*, I have been mad these five hours:
I'll sell my Mill, and buy a Roring *Meg*,
I'll batter down his house, and make a Stewes on't.

Gillian. Will you gather up your wits a little
And hear me? the King's neer by in progresse,
Here I have got our supplication drawn, 50
And there's the way to help us.

Franio. Give it me (*Gill*),
I will not fear to give it to the King:
To his own hands (God blesse him) will I give it,
And he shall set the Law upon their shoulders,
And hang 'em all that had a hand in it.

Gillian. Where's your Son?

Franio. He shall be hang'd in flitches:
The dogs shall eat him in Lent, there's Cats-meat

*46 *Meg*] Dyce; *omit* F1–2 56 flitches] F2; flotches F1

And Dogs-meat enough about him.

Gillian. Sure the poor girle is the Counts whore by this time.

Franio. If she be the Counts whore, the whores Count 60
 Shall pay for it: He shall pay for a new Maiden-head.

Gillian. You are so violous: this I'm resolv'd,
 If she be a whore once, I'll renounce her:
 You know, if every man had his right,
 She's none of our child, but a meer foundling
 (And I can guesse the owner for a need too),
 We have but fosterd her.

Franio. *Gill*, no more of that,
 I'll cut your tongue out if you tell those tales. [*Trumpets.*]
 Hark, hark, these Toaters tell us the King's coming:
 Get you gone; I'll see if I can find him. 70

 Exeunt.

 Enter Lisauro, Tirso, Pedro *and* Moncado. [III.ii]

Lisauro. Do's the King remove to day?

Tirso. So saies the Harbengers,
 And keeps his way on to *Valentia*,
 There ends the progresse.

Pedro. He hunts this morning Gentlemen,
 And dines i'th' fields: the Court is all in readinesse.

Lisauro. *Pedro*, did you send for this Tailor? or you *Moncado*?
 This light french demi-launce that follows us.

Pedro. No, I assure ye on my word, I am guiltlesse,
 I owe him too much to be inward with him.

Moncado. I am not quit I am sure: there is a reckoning
 Of some four scarlet cloaks, and two lac'd suits 10
 Hangs on the file still, like a fearful Comet
 Make me keep off.

Lisauro. I am in too Gentlemen,
 I thank his faith, for a matter of three hundred.

Tirso. And I for two, what a devil makes he this way?
 I do not love to see my sins before me.

Pedro. 'Tis the vacation, and these things break out
 To see the Court, and glory in their debtors.

 69 Toaters] *i.e.,* tooters, trumpeters

Tirso. What do you call him? for I never love
 To remember their names that I owe money to,
 'Tis not gentill, I shun 'em like the plague ever. 20
Lisauro. His name's *Vertigo*: hold your heads, and wonder,
 A French-man, and a founder of new fashions:
 The Revolutions of all shapes and habits
 Run madding through his brains.
Moncado. He is very brave.
Lisauro. The shreds of what he steals from us, beleeve it,
 Makes him a mighty man: he comes, have at ye.

Enter Vertigo

Vertigo. Save ye together, my sweet Gentlemen,
 I have been looking——
Tirso. Not for money Sir?
 You know the hard time.
Vertigo. Pardon me sweet (Signior)
 Good faith the least thought in my heart, your love Gentlemen, 30
 Your love's enough for me: Money? hang money:
 Let me preserve your love.
Lisauro. Yes marry shall ye,
 And we our credit, you would see the Court?
Moncado. He shall see every place.
Vertigo. Shall I i'faith Gentlemen?
Pedro. The Cellar, and the Buttry, and the Kitchin,
 The Pastry, and the Pantry.
Tirso. I, and taste too
 Of every Office: and be free of all too:
 That he may say when he comes home in glory——
Vertigo. And I will say, i'faith, and say it openly,
 And say it home too: Shall I see the King also? 40
Lisauro. Shalt see him every day: shalt see the Ladies
 In their French clothes: shalt ride a hunting with 'em,
 Shalt have a Mistris too: [*apart*] we must fool hansomly
 To keep him in belief we honour him,
 He may call on us else.
Pedro. A pox upon him.

42 'em] Dyce; him F1–2

Let him call at home in's owne house for salt butter.
Vertigo. And when the King puts on a new suit——
Tirso. Thou shall see it first,
And desect his dublets, that thou maist be perfect.
Vertigo. The Wardrobe I would fain view, Gentlemen,
Fain come to see the Wardrobe.
Lisauro. Thou shall see it, 50
And see the secret of it, dive into it:
Sleep in the Wardrobe, and have Revelations
Of fashions five yeer hence.
Vertigo. Ye honour me,
Ye infinitely honour me.
Tirso. Any thing i'th' Court Sir,
Or within the compasse of a Courtier.
Vertigo. My wife shall give ye thanks.
Tirso. You shall see any thing,
The privatst place, the stool, and where 'tis emptied.
Vertigo. Ye make me blush, ye pour your bounties, Gentlemen,
In such abundance.
Lisauro. I will show thee presently
The order that the King keeps when he comes 60
To open view; that thou maist tell thy Neighbours
Over a shoulder of mutton, thou has seen somthing,
Nay, thou shalt present the King for this time——
Vertigo. Nay, I pray Sir.
Lisauro. That thou maist know what State there do's belong to it;
Stand there I say, and put on a sad countenance,
Mingled with height: be cover'd, and reserved;
Move like the Sun, by soft degrees, and glorious,
Into your order (Gentlemen) uncover'd,
The King appears; [*aside*] Wee'l sport with you a while Sir,
I am sure you are merry with us all the year long (Tailor)—— 70
Move softer still, keep in that fencing leg, Monsieur;
Turne to no side.

Enter Franio *out of breath.*

Tirso. What's this that appears to him?
Lisauro. 'Has a petition, and he looks most lamentably,

Mistake him, and we are made.

Franio. This is the King sure,
 The glorious King, I know him by his gay clothes.

Lisauro. Now bear your self that you may say hereafter——

Franio. I have recover'd breath, I'll speak unto him presently,
 May it please your gracious majesty to consider
 A poor mans case?

Vertigo. What's your will Sir?

Lisauro. You must accept, and read it. 80

Tirso. The Tailor will run mad upon my life for't.

Pedro. How he mumps and bridles: he will ne'er cut clothes again.

Vertigo. And what's your grief?

Moncado. He speaks i'th' nose like his goose.

Franio. I pray you read there; I am abus'd and frumpt Sir,
 By a great man that may do ill by authority;
 Poor honest men are hang'd for doing lesse Sir:
 My child is stolne, the Count *Otrante* stole her;
 A pretty child she is, although I say it,
 A hansom mother, he means to make a whore of her,
 A silken whore, his knaves have filch'd her from me; 90
 He keeps lewd knaves, that do him beastly offices:
 I kneel for Justice. Shall I have it Sir?

Enter King Philippo, *and* Lords.

Philippo. What Pageant's this?

Lisauro. The King:
 Tailor, stand off, here ends your apparition:
 Miller, turn round, and there addresse your paper,
 There, there's the King indeed.

Franio. May it please your Majesty——

Philippo. Why didst thou kneel to that fellow?

Franio. In good faith Sir,
 I thought he had been a King he was so gallant:
 There's none here wears such gold.

Philippo. So foolishly, 100
 You have golden busines sure; because I am homely
 Clad, in no glittring suit, I am not look'd on:

Ye fools that wear gay clothes love to be gap'd at,
What are you better when your end calls on you?
Will gold preserve ye from the grave? or jewells?
Get golden minds, and fling away your Trappings;
Unto your bodies minister warm rayments,
Wholsom and good; glitter within and spare not:
Let my Court have rich souls, their suits I weigh not:
And what are you that took such State upon ye? 110
Are ye a Prince?

Lisauro. The Prince of Tailors, Sir,
We owe some money to him, and't like your Majesty.

Philippo. If it like him, would ye owde more, be modester,
And you lesse sawcy Sir: and leave this place:
Your pressing iron will make no perfect Courtier:
Go stitch at home, and cozen your poor neighbours,
Show such another pride, I'll have ye whipt for't,
And get worse clothes, these but proclaim your fellony.
And what's your paper?

Franio. I beseech you read it.

Philippo. What's here? the Count *Otrante* task'd for a base villany, 120
For stealing of a maid?

1 Lord. The Count *Otrante*?
Is not the fellow mad Sir?

Franio. No, no, my Lord,
I am in my wits, I am a labouring man,
And we have seldom leisure to run mad,
We have other businesse to employ our heads in,
We have little wit to lose too: if we complain,
And if a heavie lord lie on our shoulders,
Worse then a sack of meal, and oppresse our poverties,
We are mad straight, and whoop'd, and tyde in fetters,
Able to make a horse mad as you use us: 130
You are mad for nothing, and no man dare proclaim it,
In you a wildnesse is a noble trick,
And cherishd in ye, and all men must love it:
Oppressions of all sorts, sit like new clothes,
Neatly and hansomly upon your Lordships:

129 whoop'd] Weber; whop'd F1–2

And if we kick when your honours spur us,
We are knaves and Jades, and ready for the Justice.
I am a true Miller.

Philippo. Then thou art a wonder.

2 Lord. I know the man reputed for a good man,
An honest and substantial fellow.

Philippo. He speaks sence, 140
And to the point: Greatnesse begets much rudenesse.
How dare you (Sirrha) 'gainst so main a person,
A man of so much Noble note and honour,
Put up this base complaint? Must every Pesant
Upon a sawcy will affront great Lords!
All fellows (Miller)?

Franio. I have my reward, Sir,
I was told one greatnesse would protect another,
As beams support their fellowes; now I find it:
If't please your Grace to have me hang'd, I am ready,
'Tis but a Miller, and a Thief dispatch'd: 150
Though I steal bread, I steal no flesh to tempt me.
I have a wife, and't please him to have her too,
With all my heart: 'twill make my charge the lesse Sir,
She'll hold him play a while: I have a Boy too,
He is able to instruct his Honours hoggs,
Or rub his Horse-heels: when it please his Lordship
He may make him his slave too, or his bawd:
The boy is well bred, can exhort his Sister:
For me, the prison, or the Pillory,
To lose my goods, and have mine ears cropt off: 160
Whipt like a Topp, and have a paper stuck before me,
For abominable honestie to his owne daughter,
I can endure, Sir: the Miller has a stout heart,
Tough as his Toal-pin.

Philippo. I suspect this shrewdly,
Is it his daughter that the people call
The Millers fair maid?

2 Lord. It should seem so Sir.

Philippo. Be sure you be i'th' right, Sirrha.

Franio. If I be i'th' wrong Sir,

614

Be sure you hang me, I will ask no curtesie:
Your Grace may have a daughter, think of that Sir,
She may be fair, and she may be abused too: 170
A King is not exempted from these cases:
Stolne from your loving care.
Philippo. I do much pity him.
Franio. But heaven forbid she should be in that venture
That mine is in at this hour: I'll assure your Grace
The Lord wants a water-mill, and means to grind with her:
Would I had his stones to set, I would fit him for it.
Philippo. Follow me (Miller) and let me talk with ye farther,
And keep this private all upon your loyalties:
To morrow morning, though I am now beyond him,
And the lesse lookt for, I'll break my fast with the good Count. 180
No more, away, all to our sports, be silent.
 Exeunt [Philippo, Franio, Lords].
Vertigo. What Grace shall I have now?
Lisauro. Choose thine owne grace,
And go to dinner when thou wilt, *Vertigo,*
We must needs follow the King.
Tirso. You heard the sentence.
Moncado. If you stay here I'll send thee a shoulder of Venison:
Go home, go home, or if thou wilt disguise,
I'll help thee to a place to feed the dogs.
Pedro. Or thou shalt be special Tailor to the Kings Monkey,
'Tis a fine place, we cannot stay.
Vertigo. No money,
Nor no grace (Gentlemen)?
Tirso. 'Tis too early Taylor. 190
The King has not broke his fast yet.
Vertigo. I shall look for ye
The next Terme, Gentlemen.
Pedro. Thou shalt not misse us:
Prethee provide some clothes, and dost thou hear *Vertigo,*
Commend me to thy wife: I want some shirts too.
Vertigo. I have Chambers for ye all.
Lisauro. They are too musty,

180 ²the] F2; *omit* F1

When they are cleer wee'l come. [*Exeunt.*]

Vertigo. I must be patient
 And provident, I shall never get home els.

 Exit.

 Enter Otrante *and* Florimell. [III.]ii

Otrante. Prethee be wiser wench, thou canst not scape me,
 Let me with love and gentlenesse enjoy that
 That may be still preserv'd with love, and long'd for,
 If violence lay rough hold, I shall hate thee,
 And after I have enjoyd thy Maiden-head,
 Thou wilt appear so stale and ugly to me
 I shall despise thee, cast thee off.
Florimell. I pray ye, Sir,
 Begin it now, and open your dores to me,
 I do confesse I am ugly; Let me go, Sir:
 A Gipsey-girl: Why would your Lordship touch me? 10
 Fye, 'tis not noble: I am homely bred,
 Course, and unfit for you: why do you flatter me?
 There be young Ladies, many that will love ye,
 That will dote on ye: you are a hansome Gentleman,
 What will they say when once they know your quality?
 A Lord, a Miller? take your Toal-dish with ye:
 You that can deal with Grudgins, and course floure,
 'Tis pitie you should taste what manchet means:
 Is this fit Sir, for your repute and honour?
Otrante. I'll love thee still.
Florimell. You cannot, there's no sympathy 20
 Between our births, our breeding, arts, conditions,
 And where these are at difference, there's no liking:
 This houre it may be I seem hansom to you,
 And you are taken with variety
 More then with beauty: to morrow when you have enjoy'd me,
 Your heate and lust asswag'd, and come to examine
 Out of cold and penitent condition
 What you have done, whom you have shar'd your love with,
 Made partner of your bed, how it will vex ye,

*17 Grudgins] Sympson (*qy*), Coleman; Gudgins F1–2

How you will curse the devil that betrayd ye: 30
And what shall become of me then?
Orante. Wilt thou hear me?
Florimell. As hastie as you were then to enjoy me,
As precious as this beauty shew'd unto ye,
You'll kick me out of dores, you will whore and ban me:
And if I prove with child with your fair issue,
Give me a pension of five pound a yeer
To breed your heir withall, and so good speed me.
Otrante. I'll keep thee like a woman.
Florimell. I'll keep my self Sir,
Keep my self honest Sir; there's the brave keeping:
If you will marry me——
Otrante. Alas poor *Florimell.* 40
Florimell. I do confesse I am too course and base Sir
To be your wife, and it is fit you scorn me,
Yet such as I have crown'd the lives of great ones:
To be your whore, I am sure I am too worthy,
(For by my troth Sir, I am truly honest)
And that's an honour equal to your greatnes.
Otrante. I'll give thee what thou wilt.
Florimell. Tempt me no more then:
Give me that peace, and then you give abundance,
I know ye do but try me, ye are noble,
All these are but to try my modestie, 50
If you should find me easie, and once coming,
I see your eies already how they would fright me;
I see your honest heart how it would swell
And burst it self into a grief against me:
Your tongue in noble anger, now, even now Sir,
Ready to rip my loose thoughts to the bottom,
And lay my shame unto my self, wide open:
You are a noble Lord: you pity poor maids,
The people are mistaken in your courses:
You, like a father, try 'em to the uttermost. 60
As they do gold: you purge the drosse from them,
And make them shine.
Otrante. This cunning cannot help ye:

I love ye to enjoy ye: I have stolne ye
To enjoy ye now, not to be fool'd with circumstance,
Yeeld willingly, or else——
Florimell. What?
Otrante. I will force ye.
I will not be delay'd, a poor base wench
That I in curtesie make offer to,
Argue with me?
Florimell. Do not, you will lose your labour,
Do not (my Lord) it will become ye poorly;
Your curtesie may do much on my nature, 70
For I am kind as you are, and as tender:
If you compell, I have my strengths to fly to,
My honest thoughts, and those are guards about me:
I can cry too, and noise enough I dare make,
And I have curses, that will call down thunder,
For all I am a poor wench, heaven will hear me:
My body you may force, but my will never;
And be sure I do not live if you do force me,
Or have no tongue to tell your beastly Story,
For if I have, and if there be a Justice—— 80
Otrante. Pray ye go in here: I'll calme my self for this time,
And be your friend again.
Florimell. I am commanded. *Exit.*
Otrante. You cannot scape me, yet I must enjoy ye,
I'll lie with thy wit, though I misse thy honesty:
Is this a wench for a Boors hungry bosom?
A morsel for a Peasants base embraces?
And must I starve, and the meat in the mouth?
I'll none of that.

Enter Gerasto.

Gerasto. How now my Lord, how sped ye?
Have ye done the deed?
Otrante. No, pox upon't, she is honest.
Gerasto. Honest? what's that? you take her bare deniall, 90
Was there ever wench brought up in a mill, and honest?

That were a wonder worth a Chronicle,
Is your belief so large? what did she say to ye?
Otrante. She said her honesty was all her dowry,
And preach'd unto me, how unfit, and homely
Nay how dishonourable it would seem in me
To act my will; popt me i'th' mouth with modestie.
Gerasto. What an impudent Quean was that? that's their trick ever.
Otrante. And then discours'd to me very learnedly
What fame and loud opinion would tell of me: 100
A wife she touch'd at.
Gerasto. Out upon her Varlet.
Was she so bold? these home-spun things are devils,
They'll tell ye a thousand lies, if you'll beleeve 'em,
And stand upon their honours like great Ladies;
They'll speak unhappily too: good words to cozen ye,
And outwardly seem Saints: they'll cry down-right also,
But 'tis for anger that you do not crush 'em.
Did she not talk of being with child?
Otrante. She toucht at it.
Gerasto. The trick of an arrant whore to milk your Lordship
And then a pension nam'd?
Otrante. No, no, she scorn'd it: 110
I offer'd any thing, but she refus'd all,
Refus'd it with a confident hate.
Gerasto. You thought so,
You should have taken her then, turn'd her, and tew'd her
I'th' strength of all her resolution, flattered her,
And shak't her stubborn will: she would have thank'd ye,
She would have lov'd ye infinitely, they must seem modest,
It is their parts: if you had plaid your part Sir,
And handled her as men do unmand Hawks,
Cast her, and malde her up in good clean linnen
And there have coyed her, you had caught her heart-strings: 120
These tough Virginities they blow like white thornes
In Stormes and Tempests.
Otrante. She is beyond all this,
As cold, and harden'd, as the Virgin Crystal.

Gerasto. Oh force her, force her, Sir, she longs to be ravishd,
Some have no pleasure but in violence;
To be torne in pieces is their paradise:
'Tis ordinary in our Country, Sir, to ravish all;
They will not give a penny for their sport
Unlesse they be put to it, and terribly,
And then they swear they'll hang the man comes neer 'em, 130
And swear it on his lips too.
Otrante. No, no forcing,
I have an other course, and I will follow it,
I command you, and do you command your fellows,
That when you see her next, disgrace, and scorn her,
I'll seem to put her out o'th' dores o'th' sodain
And leave her to conjecture, then seize on her.
Away, ready straight.
Gerasto. We shall not fail, Sir.
Otrante. *Florimell.*

Enter Florimell.

Florimell My Lord.
Otrante. I am sure you have now consider'd
And like a wise wench weigh'd a friends displeasure,
Repented your prowd thoughts, and cast your scorn off. 140
Florimell. My Lord, I am not proud, I was never beautifull.
Nor scorn I any thing that's just and honest.
Orante. Come, to be short, can ye love yet? you told me
Kindnes would far compell ye; I am kind to ye,
And mean to exceed that way.
Florimell. I told ye too, Sir,
As far as it agreed with modestie,
With honour, and with honesty I would yeeld to yee:
Good my Lord, take some other Theam: for Love,
Alas, I never knew yet what it meant,
And on the sudden Sir, to run through volumes 150
Of his most mystick art, 'tis most impossible;
Nay, to begin with lust, which is an Herisie,

135 I'll] F2; Ill F1

A foul one too; to learn that in my childhood:
O good my Lord.

Otrante. You will not out of this song,
Your modestie, and honestie, is that all?
I will not force ye.

Florimell. Ye are too noble, Sir.

Otrante. Nor play the childish fool, and marry ye,
I am yet not mad.

Florimell. If ye did, men would imagine.

Otrante. Nor will I woo ye at that infinite price
It may be you expect.

Florimell. I expect your pardon, 160
And a discharge (my Lord) that's all I look for.

Otrante. No, nor fall sick for love.

Florimell. 'Tis a healthful year Sir.

Otrante. Looke ye, I'l turn ye out o' dores, and scorn ye.

Florimell. Thank ye my Lord.

Orante. A proud slight Peat I found ye,
A fool (it may be too).

Florimell. An honest woman,
Good my Lord think me.

Otrante. And a base I leave ye,
So fare-ye-well.

Florimell. Blessing attend your Lordship; *Exit* [Otrante].
This is hot love, that vanisheth like vapors;
His Ague's off, his burning fits are well quench'd,
I thank heaven for't: his men, they will not force me? 170

Enter Gerasto, *and* Servants.

Gerasto. What dost thou stay for? dost thou not know the way,
Thou base unprovident whore?

Florimell. Good words, 'pray ye Gentlemen.

1 Servant. Has my Lord smoak'd ye over, goodwife Miller?
Is your Mill broken that you stand so uselesse?

2 Servant. An impudent Quean, upon my life she is unwholsome;
Some base discarded thing my Lord has found her,
He would not have turnd her off o'th' sudden else.

Gerasto. Now against every sack (my honest sweet-heart)
 With every *Smig* and *Smug.*
Florimell. I must be patient.
Gerasto. And every greasie guest, and sweaty Rascall 180
 For his Royal hire between his fingers, Gentlewoman.
1 Servant. I feare thou hast given my Lord the pox thou damn'd
 thing.
2 Servant. I have seen her in the Stewes.
Gerasto. The knave her father
 Was Bawd to her there, and kept a Tipling house,
 You must even to it again: a modest function.
Florimell. If ye had honesty, ye would not use me
 Thus basely, wretchedly, though your Lord bid ye,
 But he that knows——
Gerasto. Away thou carted impudence,
 You meat for every man: a little meal
 Flung in your face, makes ye appear so proud. 190
Florimell. This is inhumane. Let these tears perswade you
 If ye be men, to use a poor girle better:
 I wrong not you, I am sure I call you Gentlemen.

Enter Otrante.

Otrante. What busines is here? away:
 [*Exeunt* Gerasto *and* Servants.]
 are not you gone yet?
Florimell. My Lord, this is not well: although you hate me,
 For what I know not: to let your people wrong me,
 Wrong me maliciously, and call me——
Otrante. Peace,
 And mark me what we say advisedly;
 Mark, as you love that that you call your credit;
 Yeeld now, or you are undone: your good name's perish'd, 200
 Not all the world can buy your reputation;
 'Tis sunk for ever els, these peoples tongues will poison ye;
 Though you be white as innocence, they'll taint ye,
 They will speak terrible and hideous things,
 And people in this age are prone to credit,

179 *Smig*] F2; *Sim* F1 182 pox] Coleman] —— F1–2 *201 buy] *stet* F1

They'll let fall nothing that may brand a woman,
Consider this, and then be wise and tremble:
Yeeld yet, and yet I'll save ye.
Florimell. How?
Otrante. I'll show ye,
Their mouthes I'll seal up, they shall speak no more
But what is honourable and honest of ye, 210
And Saintlike they shall worship ye: they are mine,
And what I charge 'em *Florimell.*
Florimell. I am ruind,
Heaven will regard me yet, they are barbarous wretches:
Let me not fall (my Lord).
Otrante. You shall not *Florimell*:
Mark how I'll work your peace, and how I honour ye.
Who waits there? come all in.

 Enter Gerasto *and* Servants.

Gerasto. Your pleasure Sir.
Otrante. Who dare say this sweet beauty is not heavenly?
This virgin, the most pure, the most untainted,
The holiest thing?
Gerasto. We know it (my dear Lord)
We are her slaves: and that proud impudence 220
That dares disparage her, this sword (my Lord)——
1 Servant. They are rascals, base, the sons of common women
That wrong this vertue, or dare owne a thought
But fair and honourable of her: when we slight her,
Hang us, or cut's in pieces; let's tug i'th' Gallies.
2 Servant. Brand us for villains.
Florimell. Why sure I dream: these are all Saints.
Otrante. Go, and live all her slaves.
Gerasto. We are proud to do it. *Exeunt.*
Otrante. What think ye now? I am not I able *Florimell*
Yet to preserve ye?
Florimell. I am bound to your Lordship,
Ye are all honour, and good my Lord but grant me 230
Untill to morrow leave to weigh my Fortunes,
I'll give you a free answer, perhaps a pleasing

Indeed I'll do the best I can to satisfie ye.

Otrante. Take your good time, this kisse, till then farewell, Sweet.

Exeunt.

Enter Antonio, Martine, Bustofa. IV.i

Martine. By all means discharge your follower.

Antonio. If we can get him off: Sirrha *Bustofa,*
Thou must needs run back.

Bustofa. But I must not unlesse you send a Bier, or a Lictor at my
back, I do not use to run from my friends.

Antonio. Well, go will serve the turne: I have forgot——

Bustofa. What Sir?

Antonio. See if I can think on't now.

Bustofa. I know what 'tis now!

Antonio. A Pistolet of that. 10

Bustofa. Done, you have forgot a device to send me away, you are
going a smocking perhaps.

Martine. His owne, due, due i'faith *Antonio,*
The Pistolet's his owne.

Antonio. I confesse it, [*Gives coin.*]
There 'tis: now if you could afford out of it
A reasonable excuse to mine Uncle.

Bustofa. Yes I can: But an excuse will not serve your turn: it must be
a lie, a full lie, 'twill do no good else: if you'll go to the price of that?

Antonio. Is a lie dearer then an excuse?

Bustofa. Oh, treble; this is the price of an excuse; but a lye is two 20
more: look how many foyles go to a fair fall, so many excuses to a
full lye, and lesse cannot serve your turn, let any Tailor i'th' Towne
make it.

Martine. Why, 'tis reasonable, give him his price; [*Another coin.*]
Let it be large enough now.

Bustofa. I'll warrant you, cover him all over.

Antonio. I would have proof of one now.

Bustofa. What? stale my invention before hand? you shall pardon
me for that: well, I'll commend you to your Uncle, and tell him
you'll be at home at supper with him. 30

6 the] *omit* F1–2 24 Why] F2; Wie F1 28 stale] Sympson; scale F1–2

624

Antonio. By no means, I cannot come to night (man).

Bustofa. I know that too, you do not know a lye when you see it.

Martine. Remember it must stretch for all night.

Bustofa. I shall want stuffe, I doubt 'twill come to the other Pistolet.

Antonio. Well, lay out, you shall be no loser Sir.

Bustofa. It must be faced, you know, there will be a yard of dissimulation at least (City-measure) and cut upon an untroth or two: Lyned with Fables, that must needs be, cold weather's coming; if it had a galloon of hypocrisie, 'twould do well: and hooked together with a couple of conceits, that's necessity; well, I'll 40 bring in my bill: I'll warrant you as fair a lye by that time I have done with it, as any gentleman i'th' Town can swear too: if he would betray his Lord and Master. *Exit.*

Antonio. So, so, this necessary trouble's over.

Martine. I would you had bought an excuse of him
Before he went: you'll want one for *Ismenia.*

Antonio. Tush, there needs none, there's no suspition yet,
And I'll be arm'd before the next encounter,
In a fast tye with my fair *Isabel.*

Martine. Yes, you'll find your errand is before you now. 50

Enter Bustofa.

Bustofa. Oh Gentlemen, look to your selves, ye are men of another world else: your enemies are upon you; the old house of the *Bellides* will fall upon your heads: Signior *Lisauro*——

Antonio. *Lisauro?*

Bustofa. And Don what call you him? he's a Gentleman: yet he has but a Yeomans name, Don *Tirso, Tirso,* and a dozen at their heels.

Antonio. *Lisauro, Tirso,* nor a dozen more
Shall fright me from my ground, nor shun my path,
Let 'em come on in their ablest fury.

Martine. 'Tis worthily resolved: I'll stand by you Sir, 60
This way, I am thy true friend. [*They draw.*]

Bustofa. I'll be gone Sir, that one may live to tell what's become of you. Put up, put up, will you never learn to know a lye from an *Esop's* fables? there's a taste for you now. *Exit.*

*47 *Antonio.* Tush] F1 *c.w.* In

625

Enter Ismenia *and* Aminta.

Martine. Look Sir, what time of day is it?
Antonio. I know not, my eies go false, I dare not trust 'em now,
 I prethee tell me (*Martine*) if thou canst,
 Is that *Ismenia*, or *Isabella*.
Martine. This is the Lady, forget not *Isabella*.
Antonio. If this face may be borrowed and lent out, 70
 If it can shift shoulders, and take other tyres,
 So, 'tis mine where ere I find it.
Ismenia. Be sudden:
 I cannot hold out long. *Exit* Aminta.
Martine. Beleeve't she frowns.
Antonio. Let it come, she cannot frown me off on't:
 How prettily it wooes me to come neerer?
 How do you (Lady) since yesterdaies pains?
 Were you not weary? of my faith——
Ismenia. I think you were.
Antonio. What Lady?
Ismenia. Weary of your faith, 'tis a burthen
 That men faint under, though they bear little of it.
Martine [*aside*]. So, this is to the purpose.
Antonio. You came home 80
 In a fair hour I hope?
Ismenia. From whence Sir?

Enter Aminta.

Aminta. Sir, there's
 A Gentlewoman without desires to speak with you.
Antonio. They were pretty homely toyes: but your presence
 Made them illustrious.
Ismenia. My Cosen speaks to you.
Aminta. A Gentlewoman Sir, *Isabella*
 She names her self.
Martine. So, so, it hits finely now.
Antonio. Name your self how you please: speak what you please,
 I'll hear you cheerfully.
Ismenia. You are not well,
 Request her in: she may have more acquaintance

With his passions, and better cure for 'em. 90
Aminta. She's nice in that (Madam) poor soul it seems
 She's fearfull of your displeasure.
Ismenia. I'll quit her
 From that presently, and bring her in my self. *Exit.*
Martine. How carelesly do you behave your self?
 When you should call all your best faculties
 To councell in you: how will you answer
 The breach you made with fair *Ismenia?*
 Have you forgot the retrograde vow you took
 With her, that now is come in evidence?
 You'll die upon your shame, you need no more 100
 Enemies of the house, but the Lady now:
 You shall have your dispatch.

 Enter Ismenia *like* Juno.

Antonio. Give me that face,
 And I am satisfied upon whose shoulders
 So ere it growes: *Juno* deliver us
 Out of this amazement: Beseech you Goddesse
 Tell us of our friends, how does *Ismenia?*
 And how does *Isabella?* both in good health
 I hope, as you your self are.
Ismenia [*aside*]. I am at farthest
 In my counterfeit:—— my *Antonio*
 I have matter against you may need pardon, 110
 As I must crave of you.
Antonio. Observe you Sir,
 What evidence is come against me? what think you
 The Hydra-headed jury will say to't?
Martine [*aside*]. 'Tis I am foold,
 My hopes are pour'd into the bottomles tubs,
 'Tis labour for the house of *Bellides*:
 I must not seem so yet:—— but in sooth (Lady)
 Did you imagine your changeable face
 Hid you from me? by this hand I knew you.
Antonio. I went by the face: and by these eies
 I might have been deceived.

 627

Ismenia. You might indeed (*Antonio*) 120
For this Gentleman did vow to *Isabella*,
That he it was that lov'd *Ismenia*,
And not *Antonio*!
Martine. Good, and was not that
A manifest confession that I knew you?
I else had been unjust unto my friend:
'Twas well remembred, there I found you out
And speak your conscience now.
Antonio. But did he so protest?
Ismenia. Yes, I vow to you, had *Antonio*
Wedded *Isabella*, *Ismenia*
Had not been lost, there had been her lover. 130
Antonio. Why much good do you friend, take her to you:
I crave but one, here have I my wish full,
I am glad we shall be so neer Neighbours.
Martine. Take both Sir, *Juno* to boote: three parts in one,
St. *Hilarie* blesse you. [*Aside*] Now oportunitie
Beware to meet with falshood, if thou canst
Shun it, my friends faith's turning from him.
Imenia. Might I not justly accuse *Antonio*
For a love-wanderer? you know no other
But me, for another, and confesse troth now? 140
Antonio. Here was my guide, where ere I find this face,
I am a Lover, marry, I must not misse
This freckle then, I have the number of 'em,
Nor this dimple: not a silk from this brow,
I carry the full Idea ever with me;
If Nature can so punctually paralel,
I may be cozened.
Ismenia. Well, all this is even:
But now, to perfect all, our love must now
Come to our Enemies hands, where neither part
Will ever give consent to't.
Antonio. Most certain: 150
For which reason it must not be put to 'em:
Have we not prevention in our owne hands.
Shall I walk by the tree? desire the fruit,
Yet be so nice to pull till I ask leave

Of the churlish Gardner, that will deny me?
Ismenia. O *Antonio.*
Antonio. 'Tis manners to fall to
 When grace is said.
Ismenia. That holy act's to come.
Martine. You may ope an oyster or two before grace.
Antonio. Are there not double vows, as valuable
 And as well spoke as any Frier utters? 160
 Heaven has heard all.
Ismenia. Yes: but stayes the blessing,
 Till all dues be done: heaven is not serv'd by halfs.
 We shall have ne'r a fathers blessing here,
 Let us not lose the better, from above.
Antonio. You take up weapons of unequal force,
 It shows you cowardly: heark in your ear. [*They whisper.*]
Aminta [*aside*]. Have I lost all imployment? Would this proffer
 Had been made to me, though I had paid it
 With a reasonable pennance.
Martine [*aside*].
 All thy fore-lock (Time)? I'll stretch a long arm 170
 But I'll catch hold again: Doe but look back
 Over thy shoulder, and have a pull at thee.
Ismenia. I hear you (Sir) nor can I hear too much
 While you speak well: You know th'accustomed place
 Of our night parley: if you can ascend,
 The window shall receive you. You may finde there
 A corrupted Church-man to bid you welcome.
Antonio. I would meet no other man.
Ismenia. *Aminta*, you hear this.
Aminta. With joy (Madam) 'cause it pleases you.
 It may be mine own case another time! 180
 Now you go the right way: ask the Banes out,
 Put it past father, or friends, to forbid it,
 And then you're sure. Sir, your *Hymen* Taper
 I'll light up for you: the window shall show you
 The way to *Sestos.*
Antonio. I'll venture drowning.
Martine. The Simile holds not; 'tis hanging rather.
 You must ascend your Castle by a ladder;

To the foot I'll bring you.
Antonio. Leave mee to climb it.
Martine. If I do turn you off?
Antonio. Till night fare-well:
Then better.
Ismenia. Best it should be; 190
But peevish hatred keeps back that degree.

Exeunt. [*Manet* Martine.]

Martine. I never look'd so smooth as now I purpose:
And then beware: Knave is at worst of knave
When he smiles best, and the most seems to save.

Exit.

Enter Julio. [IV.ii]

Julio. My mind's unquiet ; while *Antonio*
My Nephew's abroad, my heart is not at home,
Only my fears stay with me; bad company;
But I cannot shift 'em off. This hatred
Betwixt the House of *Bellides* and us,
Is not fair war: 'tis civill, but uncivill.
We are neer neighbours, were of love as neer,
Till a crosse misconstruction ('twas no more
In conscience) put us so far asunder:
I would 'twere reconcil'd; it has lasted 10
Too many Sun-sets: if grace might moderate,
Man should not lose so many dayes of peace
To satisfie the anger of one minute.
I could repent it heartily. I sent
The knave to attend my *Antonio* too,
Yet he returns no comfort to me neither.

Enter Bustofa.

Bustofa. No: I must not.
Julio. Hah; hee's come.
Bustofa. I must not: 'twill breake his heart to hear it.
Julio. How? there's bad tidings: I must obscure and hear it; 20

*11 Sun-sets: ... moderate,] Coleman; ~ , ... ~ : F1–2

He will not tell mee for breaking of my heart,
'Tis half split already. [*Goes apart.*]

Bustofa [*aside*]. I have spi'd him: Now to knock down a Don with a
lie, a silly harmlesse lie; 'twill be valiantly done, and nobly perhaps.

Julio. I cannot hear him now.

Bustofa. Oh the bloody dayes that wee live in; the envious,
malitious, deadly dayes that we draw breath in!

Julio. Now I hear too loud.

Bustofa. The children that never shall be born may rue it; for men
that are slain now might have liv'd to have got children, that might 30
have curs'd their fathers.

Julio. Oh, my posterity is ruin'd.

Bustofa. Oh sweet *Antonio*.

Julio. Oh deer *Antonio*.

Bustofa. Yet it was nobly done of both parts: When hee and *Lisauro*
met——

Julio. Oh, death has parted 'em.

Bustofa. Welcome my mortall foe (sayes one), Welcome my deadly
enemy (sayes th'other): off go their doublets, they in their shirts,
and their swords stark naked; here lies *Antonio*, here lies *Lisauro*: 40
hee comes upon him with an *Embroccado*, that hee puts by with a
puncta reversa; *Lisauro* recoils mee two paces and some six inches
back, takes his career, and then, oh.

Julio. Oh.

Bustofa. Runs *Antonio* quite thorow.

Julio. Oh villain.

Bustofa. Quite thorow between the arme and the body: so yet he had
no hurt at that bout.

Julio. Goodnesse be praised.

Bustofa. But then, at next encounter, he fetches me up *Lisauro*; 50
Lisauro makes out a Long at him, which he thinking to be a
Passado, *Antonio's* foot slipping: down: oh down.

Julio. O now thou art lost

Bustofa. Oh, but the quality of the thing: both Gentlemen, both
Spanish Christians, yet one man to shed——

Julio. Say his enemies blood.

Bustofa. His hair may come by divers casualties, though he never go

into the field with his foe: but a man to lose nine ounces and two
drams of blood at one wound, thirteen and a scruple at another, and
to live till he die in cold blood: yet the Surgeon (that cur'd him) 60
said, if *Pia-mater* had not been perish'd, he had bin a lives man til
this day.

Julio. There hee concludes: he is gone.

Bustofa. But all this is nothing: now I come to the point.

Julio. I the point, that's deadly: the ancient blow
Over the buckler ne'r went half so deep.

Bustofa [*aside*]. Yet pitie bids mee keep in my charitie: for mee to
pull an old mans ears from his head with telling of a Tale: oh fowle
Tale! No, be silent Tale.——— Furthermore, there is the charge of
Buriall; every one will cry Blacks, Blacks, that had but the least 70
finger dipt in his blood, though ten degrees remov'd when 'twas
done. Moreover, the Surgeon (that made an end of him) will be
paid: Sugar-plums and sweet breads; yet I say, the man may recover
again, and die in his bed.

Julio. What motley stuffe is this? [*Comes forward.*]
 Sirrha, speak truth;
What hath befallen my deer *Antonio?*
Restrain your pity in concealing it;
Tell mee the danger full; take off your care
Of my receiving it: kill me that way,
I'll forgive my death: what thou keepst back from truth 80
Thou shalt speak in pain; doe not look to find
A limb in his right place, a bone unbroke,
Nor so much flesh unbroil'd of all that mountain
As a worm might sup on; dispatch, or be dispatch'd.

Bostofa. Alas Sir, I know nothing, but that *Antonio* is a man of Gods
making to this hour, 'tis not two since I left him so.

Julio. Where didst thou leave him?

Bustofa. In the same clothes he had on when he went from you.

Julio. Does he live?

Bustofa. I saw him drink. 90

Julio. Is he not wounded?

Bustofa. He may have a cut i'th' leg by this time; for Don *Martine*
and he were at whole slashes.

Julio. Met he not with *Lisauro?*

632

My Lady is my Cosen; I, my self,
Which is neerest then? My desires are mine,
Say they be hers too, is't a hanging matter?
It may be ventur'd in a worser cause,
I must go question with my conscience:
I have the word; Centinel, do thou stand,
Thou shalt not need to call, I'll be at hand. *Exit.*

Enter Antonio *and* Martine.

Antonio. Are we not dog'd behind us, thinkst thou friend?
Martine. I heard not one bark, Sir.
Antonio. There are that bite 30
And bark not (man) me-thought I spy'd two fellows
That through two streets together walk'd aloof,
And wore their eies suspiciously upon us.
Martine. Your Jealousie, nothing else; or such perhaps
As are afraid as much of us, who knows
But about the like busines? but for your fears sake
I'll advise and entreat one curtesie.
Antonio. What's that friend?
Martine. I will not be denyed, Sir,
Change your upper garments with me.
Antonio. It needs not.
Martine. I think so too, but I will have it so, 40
If you dare trust me with the better Sir.
Antonio. Nay then.
Martine. If there should be danger towards,
There will be the main mark I'm sure.
Antonio. Here thou tak'st from me.
Martine. Tush, the General
Must be safe, how ere the Battel goes:
See you the Beacon yonder?
Antonio. Yes, we are neer shore.
Martine. Come, Land, land, you must clamber by the cliffe,
Here are no staires to rise by.

28 be] F2; he F1

637

Enter two Gentlemen with weapons drawn; they set upon Martine.

Antonio.	I, are you there?

Fight and Antonio *pursues them out in rescue of* Martine.

Exeunt.

Enter Aminta *above, and* Martine *return'd again, ascends.*

Aminta. Antonio?
Martine. Yes *Ismenia.*
Aminta. Thine owne.
Martine. Quench the light, thine eies are guides illustrious. 50
Aminta. 'Tis necessary. *Exeunt* [above].

Enter Antonio.

Antonio. Your legs have sav'd your lives, who ere you are.
 Friend? *Martine?* where art thou? not hurt I hope:
 Sure I was farthest in the pursuit of 'em:
 My pleasures are forgotten through my fears:
 The light's extinct, it was discreetly done:
 They could not but have notice of the broile,
 And fearing that might call up company,
 Have carefully prevented, and closed up:
 I do commend the heed; oh, but my friend, 60
 I fear his hurt: friend? friend? it cannot be
 So mortal, that I should lose thee quite, friend?
 A groan, any thing that may discover thee:
 Thou art not sunk so far, but I might hear thee:
 I'll lay mine ear as low as thou canst fall:
 Friend, Don *Martine,* I must answer for thee,
 'Twas in my cause thou fell'st, if thou beest downe,
 Such dangers stand betwixt us and our joyes,
 That should we forethink ere we undertake,
 Wee'ld sit at home, and save. What a night's here? 70
 Purpos'd for so much joy, and now dispos'd
 To so much wretchednes? I shall not rest in't:
 If I had all my pleasures there within,
 I should not entertain 'em with a smile.

52 *Antonio.*] Sympson; *Mar.* F1—2 56 light's] Langbaine; lights F1—2

638

Good night to you: Mine will be black and sad,
A friend cannot, a woman may be bad.

Exit.

Enter Ismenia *and* Aminta. V.i

Ismenia. O thou false.
Aminta. Do your daringst, he's mine owne,
 Soul and body mine, church and chamber mine,
 Totally mine.
Ismenia. Darst thou face thy falshood?
Aminta. Shall I not give a welcom to my wishes
 Come home so sweetly: farewell your company
 Till you be calmer, woman. *Exit.*
Ismenia. Oh what a heap
 Of misery has one night brought with it.

Enter Antonio.

Antonio. Where is he? do you turn your shame from me?
 You'r a blind Adultresse, you know you are.
Ismenia. How's that *Antonio*?
Antonio. Till I have vengeance, 10
 Your sin's not pardonable: I'll have him,
 If hell hide him not: y'have had your last of him. *Exit.*
Ismenia. What did he speak? I understood him not,
 He calld me a foul name, it was not mine,
 He took me for another sure.

Enter Bellides.

Bellides. Hah? are you there?
 Where's your sweet heart? I have found you Traytor
 To my house: wilt league with mine enemie?
 You'll shed his blood, you'll say: hah? will you so?
 And fight with your heels upwards? No Minion,
 I have a husband for you, since y'are so ranck, 20
 And such a husband as thou shalt like him,
 Whether thou wilt or no: *Antonio*!
Ismenia. It thunders with the storm now.
Bellides. And to night

I'll have it dispatch'd: I'll make it sure, I,
By to morrow this time thy Maiden-head
Shall not be worth a Chicken, if it were
Knockt at an out-cry: go, I'll ha' ye before me:
Shough, shough, up to your coop, peay Hen.

Ismenia. Then I'll try my wings. *Exit.*

Bellides. I, are you good at that? stop, stop thief, stop there. 30

 Exit.

 Enter Otrante *and* Florimell *singing.* [V.]ii

 1. Song.

Florimell. *Now having leisure, and a happy wind,*
 Thou maist at pleasure cause the stones to grind.
 Sayles spread, and grist here ready to be ground,
 Fie, stand not idely, but let the Mill go round.

Orante. Why dost thou sing and dance thus? why so merry?
 Why dost thou look so wantonly upon me?
 And kisse my hands?

Florimell. If I were high enough,
 I would kisse your lips too.

Otrante. Do, this is some kindnes,
 This tastes of willingnesse, nay, you may kisse
 Still, but why o'th' sudden now does the fitt take ye, 10
 Unoffered, or uncompell'd? why these sweet curtesies?
 Even now you would have blush'd to death to kisse thus:
 Prethee let me be prepar'd to meet thy kindnes,
 I shall be unfurnish'd else to hold thee play, wench:
 Stay now a little, and delay your blessings:
 If this be love, me-thinks it is too violent:
 If you repent you of your strictnesse to me,
 It is so sudden, it wants circumstance.

Florimell. Fy, how dull?

 2. Song. 20
 How long shall I pine for love?
 how long shall I sue in vaine?

 *26 Chicken] stet F1

 640

> *How long like the Turtle-Dove*
> *shall I heavily thus complain?*
> *Shall the sayles of my love stand still?*
> *shall the grist of my hopes be unground?*
> *Oh fie, oh fie, oh fie,*
> *let the Mill, let the Mill go round.*

Orante. Prethee be calme a little,
 Thou mak'st me wonder, thou that wert so strange,
 And read such pious rules to my behaviour 30
 But yesternight: thou that were made of modestie,
 Shuldst in a few short minutes turn thus desperate.
Florimell. You are too cold.
Otrante. I do confesse I freeze now,
 I am another thing all over me:
 It is my part to wooe, not to be courted:
 Unfold this Riddle, 'tis to me a wonder,
 That now o'th' instant ere I can expect,
 Ere I can turn my thoughts, and think upon
 A separation of your honest carriage
 From the desires of youth, thus wantonly, 40
 Thus beyond expectation.
Florimell. I will tell ye,
 And tell ye seriously, why I appear thus,
 To hold ye no more ignorant and blinded:
 I have no modestie, I am truly wanton:
 I am that you look for Sir; now come up roundly:
 If my strict face and counterfeited staiednesse
 Could have won on ye, I had caught ye that way,
 And you should ne'r have come to have known who hurt ye.
 Prethee (sweet Count) be more familiar with me.
 How ever we are open in our natures, 50
 And apt to more desires then you dare meet with,
 Yet we affect to lay the glosse of good on't:
 I saw you toucht not at the baite of chastity,
 And that it grew distastefull to your palate

*25 grist] MS BL; grists F1–2 54 your] F2; pour F1

To appear so holy, therefore I take my true shape:
Is your bed ready Sir? you shall quickly find me.

3. Song.

On the bed Ile throw thee, throw thee downe;
Down being laid, shall we be afraid
to try the rights that belong to love?
No, No, there Ile wooe thee with a Crown, 60
crown our desires, kindle the fires,
when love requires we should wanton prove:
We'll kisse, we'll sport, we'll laugh, we'll play,
If thou com'st short, for thee Ile stay,
If thou unskilfull art, the ground
Ile kindly teach, we'll have the Mill go round.

Otrante. Are ye no maid?
Florimell. Alas (my Lord) no certain:
I am sorry you are so innocent to think so,
Is this an age for silly maids to thrive in?
It is so long too since I lost it Sir, 70
That I have no belief I ever was one:
What should you do with maiden-heads? you hate 'em,
They are peevish pettish things, that hold no game up,
No pleasure neither, they are sport for Surgeons:
I'll warrant you I'll fit you beyond Maiden-head:
A fair and easie way men travel right in,
And with delight, discourse, and twenty pleasures,
They enjoy their journey; mad men creep through hedges.
Otrante. I am metamophosed: why do you appeare,
I conjure ye, beyond belief thus wanton? 80
Florimell. Because I would give ye pleasure beyond belief.

4. Song.

Think me still in my Fathers Mill,
where I have oft been found-a
Thrown on my back, on a well-fill'd sack,
while the Mill has still gone round-a:

Prethee sirrha try thy skill,
and again let the mill go round-a.

Otrante. Then you have traded?
Florimell. Traded? how should I know else how to live Sir,
And how to satisfie such Lords as you are, 90
Our best guests, and our richest?
Otrante. How I shake now?
You take no base men?
Florimell. Any that will offer,
All manner of men, and all Religions Sir,
We touch at in our time: all States and Ages,
We exempt none.

5. Song.

The young one, the old one, the fearful, the bold one,
the lame one, though nere so unsound,
The Jew or the Turk, have leave for to work,
the whilest that the Mill goes round.

Otrante. You are a common thing then. 100
Florimell. No matter since you have your private pleasure,
And have it by an Artist excellent,
Whether I am thus, or thus, your men can tell ye.
Otrante. My men? Defend me, how I freeze together,
And am on ice? do I bite at such an Orange?
After my men I am preferr'd?
Florimell. Why stay ye?
Why do we talk my Lord, and lose our time?
Pleasure was made for lips, and sweet embraces,
Let Lawyers use their tongues: [*aside*] pardon me Modestie,
This desperate way must help, or I am miserable. 110
Otrante. She turns, and wipes her face, she weeps for certain,
Some new way now, she cannot be thus beastly,
She is too excellent fair to be thus impudent:
She knows the elements of common loosenesse,

643

The art of lewdnesse: that, that, that——

Enter a Servant.

how now, Sir.

Servant. The King (and't please your Lordship) is alighted
Close at the gate.

Ortante. The King?

Servant. And calls for ye Sir.
Means to break-fast here too.

Florimell [*aside*]. Then I am happy.

[*Attempts to leave.*]

Otrante. Stolne so suddenly? go lock her up,
Lock her up where the Courtiers may not see her, 120
Lock her up closely, sirrha in my closet.

Servant. I will (my Lord) what does she yeeld yet?

Otrante. Peace:
She is either a damnd divel, or an Angel,
No noise (upon your life Dame) but all silence.

Exit [Servant *with* Florimell].

Enter King, *Lords*, Vertigo, Lisauro, Tirso.

Otrante. Your Majesty heaps too much honour on me,
With such delight to view each several corner
Of a rude pile: there's no proportion in't, Sir.

Philippo. Me-thinks 'tis hansom, and the rooms along
Are neat, and well contriv'd: the Gallery
Stands pleasantly and sweet: what rooms are these? 130

Otrante. They are sluttish ones.

Philippo. Nay, I must see.

Otrante. Pray ye do Sir,
They are lodging-chambers over a homely garden.

Philippo. Fit still, and hansom; very well: and those?

Otrante. Those lead to the other side o'th' house, and't like ye.

Philippo. Let me see those.

Otrante. Ye may, the dores are open.
[*Aside*] What should this view mean? I am half suspicious.

*125 Otrante.] stet F1

Bustofa. I doe not know her.

Julio. Her? *Lisauro* is a man, as he is.

Bustofa. I saw ne'r a man like him.

Julio. Didst thou not discourse a fight betwixt *Antonio*
 And *Lisauro?*

Bustofa. I, to my self; I hope a man may give himself the lie if it 100
 please him.

Julio. Didst thou lie then?

Bustofa. As sure as you live now.

Julio. I live the happier by it: when will he return?

Bustofa. That he sent me to tel you, within these ten daies at farthest.

Julio. Ten daies? he's not wont to be absent two.

Bustofa. Nor I think he wil not: he said he would be at home to
 morrow; but I love to speak within my compasse.

Julio. You shall speak within mine Sir, now. Within there:

Enter Servants.

Take this fellow into custodie, keep him safe 110
I charge you.

Bustofa. Safe? do you hear? take notice what plight you find me in,
 If there want but a collop or a steak o' me, look to't.

Julio. If my nephew return not in his health to morrow,
 Thou goest to th' Rack.

Bustofa. Let me go to th' manger first; I had rather eat oats then hay.

 Exeunt [Bustofa *and Servants*].

Enter Bellides *with a Letter.*

Bellides. By your leave, Sir.

Julio. For ought I know yet, you are welcom Sir.

Bellides. Read that, and tell me so: or if thy spectacles
 Be not easie, keep thy nose unsadled, and ope 120
 Thine ears; I can speak thee the contents, I made 'em;
 'Tis a challenge, a fair one, I'll maintain't:
 I scorn to hire my Second to deliver't,
 I bring't my self: Dost know me, *Julio?*

Julio. Bellides?

Bellides. Yes: is not thine hair on end now?

Julio. Somwhat amaz'd at thy rash hardines;

How durst thou come so neer thine enemie?

Bellides. Durst?

 I dare come neerer: thou'rt a fool, *Julio.*

Julio. Take it home to thee with a knave to boot.

Bellides. Knave to thy teeth again: and all that's quit: 130

 Give me not a fool more then I give thee,

 Or if thou dost, look to hear on't again. [Julio *reads.*]

Julio. What an encounter's this?

Bellides. A noble one:

 My hand is to my words, thou hast it there,

 There I do challenge thee, if thou dar'st be

 Good friends with me; or I'll proclaim thee coward.

Julio. Be friends with thee?

Bellides. I'll shew thee reasons for't:

 A pair of old coxcombs (now wee go together)

 Such as should stand examples of discretion,

 The rules of Grammar to unwilling youth 140

 To take out lessons by; we that should check

 And quench the raging fire in others bloods,

 We strike the battell to destruction?

 Read em the black art? and make 'em beleeve

 It is divinitie? Heathens, are we not?

 Speak thy conscience, how hast thou slept this month,

 Since this Fiend haunted us?

Julio. Sure, some good Angell

 Was with us both last night: speak thou truth now, 150

 Was it not last nights motion?

Bellides. Dost not think

 I would not lay hold of it at first proffer? 150

 Should I ne'r sleep again?

Julio. Take not all from me;

 I'll tell the doctrine of my vision.

 Say that *Antonio* (best of thy blood)

 Or any one, the least allyed to thee,

 Should be the prey unto *Lisauro's* sword,

 Or any of the house of *Bellides*?

Bellides. Mine was the just inversion: on, on.

Julio. How would thine eys have emptied thee in sorrow,

And left the conduit of Nature drie?
Thy hands have turn'd rebellious to the balls, 160
And broke the glasses, with thine own curses
Have torn thy soul, left thee a Statue
To propogate thy next posterity.

Bellides. Yes, and thou causer! so it said to me,
They fight but your mischiefs: the yong men were friends,
As is the life and blood coagulate
And curded in one body; but this is yours,
An inheritance that you have gatherd for 'em,
A Legacie of blood, to kill each other
Throughout your Generations. Was't not so? 170

Julio. Word for word.

Bellides. Nay, I can go farther yet.

Julio. 'Tis far enough; Let us attone it here.
And in a reconciled circle fold
Our friendship new again.

Bellides. The signe's in *Gemini*,
An auspicious house, 't has joyn'd both ours again.

Julio. You cannot proclaim me coward now, Don *Bellides*.

Bellides. No: thou'rt a valiant fellow: so am I:
I'll fight with thee at this hug, to the last leg
I have to stand on, or breath or life left.

Julio. This is the salt unto humanity, 180
And keeps it sweet.

Bellides. Love! oh life stinks without it.
I can tell you news.

Julio. Good has long been wanting.

Bellides. I do suspect, and I have some proof on't,
(So far as a Love-Epistle comes to)
That *Antonio* (your nephew) and my daughter
Ismenia are very good friends before us.

Julio. That were a double wall about our houses,
Which I could wish were builded.

Bellides. I had it
From *Antonio's* Intimate, Don *Martine*:
And yet (me thought) it was no friendly part 190

159 conduit] F2 (Conduit); condiment F1

635

 To show it me.
Julio. Perhaps 'twas his consent:
 Lovers have policies as well as Statesmen:
 They look not alwaies at the mark they aime at.
Bellides. Wee'll take up cudgels, and have one bowt with 'em,
 They shall know nothing of this union:
 And till they find themselves most desperate,
 Succour shall never see 'em.
Julio. I'll take your part Sir.
Bellides. It grows late; there's a happy day past us.
Julio. The example I hope to all behind it.

 Exeunt.

 Enter Aminta (*above*) *with a Taper.* [IV.]iii

Aminta. Stand fair, light of Love, which epithite and place
 Adds to thee honour, to me it would be shame,
 We must be weight in love, no grain too light;
 Thou art the Land-mark, but if love be blind,
 (As many that can see have so reported)
 What benefit canst thou be to his darknesse?
 Love is a Jewel (some say) inestimable,
 But hung at the eare, deprives our owne sight,
 And so it shines to others, not our selves.
 I speak my skill, I have onely heard on't, 10
 But I could wish a neerer document,
 Alas, the ignorant desire to know:
 Some say Love's but a toy, and with a but,
 Now methinks I should love it ne'r the worse.
 A toy is harmlesse sure, and may be plaid with,
 It seldom goes without his adjunct, pretty,
 A pretty toy we say, 'tis meeter to joy too.
 Well, here may be a mad night yet for all this,
 Here's a Priest ready, and a Lady ready:
 A chamber ready, and a bed ready, 20
 'Tis then but making unready, and that's soone done:

 17 meeter] *i.e.,* metre *or* rhyme

 636

To be your friend, that have preservd your honor?
Otrante. You are, and thus I take ye: thus I seal ye
Mine owne, and onely mine.
Philippo. Count, she deserves ye,
 And let it be my happines to give ye,
 I have given a vertuous maid, now I dare say it,
 'Tis more then blood; I'll pay her portion Sir,
 And't shall be worthy you.
Franio. I'll sell my Mill,
 I'll pay some too: I'll pay the Fidlers,
 And we'll have all i'th' Country at this wedding. 200
 Pray let me give her too, here my Lord take her,
 Take her with all my heart, and kisse her freely,
 Would I could give you all this hand has stolne too,
 In portion with her, 'twould make her a little whiter.
 The wind blows fair now, get me a young Miller.
Vertigo. Shee must have new clothes.
Tirso. Yes.
Vertigo. Yes marry must she.
 If't please ye (Madam) let me see the state of your body.
 I'll fit you instantly.
Philippo. Art not thou gone yet?
Vertigo. And't please your Grace, a gown, a handsome gown now,
 An orient gown.
Philippo. Nay, take thy pleasure of her. 210
Vertigo. Of cloth of Tissew I can fit ye (Madam)
 My Lords, stand out o'th' light, a curious body,
 The neatest body in Spain this day: with embroidred flowrs,
 A clinquant Petticoat of some rich stuffe,
 To catch the eye: I have a thousand fashions.
 O sleeve, O sleeve: I'll study all night (Madam)
 To magnifie your sleeve.
Otrante. Do, superstitious Tailor,
 When yee have more time.
Florimell. Make me no more then woman,
 And I am thine.
Otrante. Sir, haply my Wardrobe with your help

207 your] F2; you F1

May fit her instantly: will you try her? 220

Vertigo. If I fit her not, your Wardrobe cannot.
But if the fashion be not there, you marre her.

[*Exeunt* Otrante, Florimell, Vertigo]

Enter Antonio, Constable, *Officers.*

Antonio. Is my offence so great, ere I be convict,
To be torn with Rascals? If it be Law,
Let 'm be wild horses, rather then these.

Philippo. What's that?

Constable. This is a man suspected of murder, if it please your Grace.

Philippo. It pleases me not (friend). But who suspects him?

Constable. We that are your Highnes extraordinary officers, we that
have taken our oaths to maintain you in peace.

Philippo. 'Twill be a great charge to you. 230

Constable. 'Tis a great charge indeed; but then we call our
neighbours to help us. This Gentleman and another were fallen out
(yet that's more then I am able to say, for I heard no words between
'em, but what their weapons spoke, Clash, and Clatter) which we
seeing, came with our Bils of government, and first knock'd down
their weapons, and then the men.

Philippo. And this you did to keep the peace?

Constable. Yes, and't like your Grace, we knock'd 'em down to keep
the peace: this we laid hold on, the other we set in the stocks. That I
could do by mine own power, without your Majestie. 240

Philippo. How so, Sir?

Constable. I am a Shoo-maker by my Trade.

Enter Aminta.

Aminta. Oh my husband!
Why stands my husband as a man endanger'd?
Restore him to me, as you are mercifull,
I'll answer for him.

Antonio. What woman's this? what husband? hold thy bawling,
I know thee for no wife.

Aminta. You married me last night.

Antonio. Thou lyest: I neither was in Church nor house

648

Last night, nor saw I thee: a thing that was my friend, 250
I scorne to name now, was with *Ismenia*,
Like a thief, and there he violated
A sacred trust. This thou maist know (*Aminta*).
Aminta. Are not you hee?
Antonio. No; nor a friend of his:
Would I had kill'd him: I hope I have.
Aminta. That was my husband (Royall Sir) that man,
That excellent man.
Antonio. That villain, that theefe.

Enter Bellides.

Bellides. Have I caught you Sir? well overtaken.
This is mine enemie: pardon (my Soveraigne).
Philippo. Good charitie, to crave pardon for your enemie. 260
Bellides. Mine own pardon (Sir) for my joyes rudenesse:
In what place better could I meet my foe,
And both of us so well provided too?
Hee with some black blood-thirstie crime upon him,
That (ere the horse-leech burst) will suck him dry:
I with a second accusation,
Enough to break his neck, if need should be,
And then to have even Justice self to right us:
How should I make my joyes a little civill,
They might not keep this noyse?
Antonio. Here is some hope. 270
Should the ax be dull, the halter's preparing.
Philippo. What's your accusation, Sir? We have heard the former.
Bellides. Mine (my Lord)? a strong one.

Enter Julio

Julio. A false one, Sir.
At least malicious: an evidence
Of hatred and despight: He would accuse
My poor kinsman of that he never dream'd of,
Nor waking saw; the stealing of his daughter,
She whom, I know, he would not look upon.
Speak *Antonio*, Didst thou ever see her?

Antonio. Yes Sir, I have seen her.
Bellides. Ah ha, friend *Julio.* 280
Julio. He might, but how? with an unheedfull eye,
An accidentall view, as men see multitudes
That the next day dare not precisely say
They saw that face, or that amongst 'm all.
Didst thou so look on her?
Bellides. Guilty, guilty:
His looks hang themselves.
Philippo. Your patience (Gentlemen).
I pray you tell me if I be in errour,
I may speak often when I should but hear:
This is some Show you would present us with,
And I do interrupt it: 'Pray you speak, 290
(It seems no more) Is't any thing but a Show?
Bellides. My Lord, this Gentlewoman can show you all,
So could my daughter too, if shee were here;
By this time they are both immodest enough:
Shee's fled me, and I accuse this thief for't.
Don *Martine*, his own friend's my testimony:
A practis'd night-work.
Philippo. That *Martine*'s the other
In your custodie; he was forgottten:
Fetch him hither.
Constable. Wee'll bring the Stocks and all else, and't please your 300
Grace. [*Exeunt* Constable, *Officers.*]
Aminta [*aside*]. That man's my husband certain, instead of this:
Both would have deceiv'd, and both beguil'd. [*Exit.*]

Enter Bustofa *and* Ismenia [*as* Isabella].

Bustofa. Soh hoh, Miller, Miller, look out Miller: is there nere a
Miller amongst you here, Gentlemen?
Tirso. Yes Sir, here is a Miller amongst Gentlemen,
A Gentleman Miller.
Bustofa. I should not be far off then; there went but a pair of sheers
and a bodkin between us. Will you to work Miller? Here's a maid

286 Gentlemen] Langbaine; Gentleman F1–2

650

has a sack full of newes for you: shall your stones walk? will you 310
grind Miller?

Philippo. This is your son, *Franio?*

Franio. My ungratious, my disobedient,
My unnaturall, my rebell son (my Lord).

Bustofa. Fie, your hopper runs over, Miller.

Franio. This villain (of my own flesh and blood) was accessary
To the stealing of my daughter.

Bustofa. Oh mountain, shalt thou call a molehill a scab upon the face
of the earth? Though a man be a thief, shall a Miller call him so? Oh
egregious! 320

Julio. Remember Sirha, who you speak before.

Bustofa. I speak before a Miller, a thief in grain; for he steals corn:
He that steals a Wench, is a true man to him.

Philippo. Can you prove that? you may help another cause
That was in pleading.

Bustofa. I'll prove it strongly. He that steals corn, steals the bread of
the Common-wealth; he that steals a wench, steals but the flesh.

Philippo. And how is the bread stealing more criminall then the
flesh?

Bustofa. Hee that steals bread, steals that which is lawfull every day: 330
he that steals flesh, steals nothing from the fasting day. *Ergo,* To
steal the bread is the arranter theft.

Philippo. This is to some purpose.

Bustofa. Again, He that steals flesh, steals for his own belly full: He
that steals bread, robs the guts of others: *Ergo,* The arranter theef
the bread-stealer.

 Again, He that steals flesh, steals once, and gives over; yes, and
often payes for it: the other steals every day, without satisfaction.
To conclude, Bread-stealing is the more capitall crime: for what he
steals hee puts it in at the head: hee that steals flesh (as the Dutch 340
Author sayes) puts it in at the foot, (the lower member). Will you
go as you are now, Miller?

Philippo. How has this satisfied you, Don *Bellides?*

Bellides. Nothing (my Lord), my cause is serious.

I claim a daughter from that loving theefe there.

Antonio. I would I had her for you, Sir.

Bellides. Ah ha, *Julio.*

Julio. How said you (*Antonio*)? Wish you you had his daughter?

Antonio. With my soul I wish her; and my body
Shall perish, but I'll enjoy my souls wish.
I would have slain my friend for his deceit, 350
But I do find his own deceit hath paid him.

Julio. Will you vex my soul forth? no other choice
But where my hate is rooted? Come hither Girl,
Whose pretty maid art thou?

Ismenia. The child of a poor man, Sir.

Julio. The better for it. With my Soveraigns leave,
I'll wed thee to this man, will hee, nill he.

Philippo. Pardon me, Sir, I'll be no Love enforcer:
I use no power of mine unto those ends.

Julio. Wilt thou have him?

Ismenia. Not unlesse he love me.

Antonio. I do love thee: Farewell all other Beauties: 360
I settle here: [*to her*] You are *Ismenia*?

Ismenia [*apart*]. The same I was: better nor worse (*Antonio*).

Antonio. I shall have your consent here, I'm sure, Sir.

Bellides. With all my heart, Sir, Nay, if you accept it,
I'll do this kindnesse to mine enemie,
And give her as a Father.

Antonio. Shee'll thank you as a Daughter.
Will you not, *Ismenia*?

Bellides. How? *Ismenia*?

Ismenia. Your daughter, Sir.

Bellides. Is't possible? Away you feeble witted things,
You thought you had caught the old ones: You wade, you wade 370
In shallow fords: Wee can swim, we: look here,
We made the match: we are all friends, good friends;
Thin, thin: why the fool knew all this, this fool.

Bustofa. Keep that to your self, Sir; What I knew I knew: this Sack is
a witnesse. Miller, this is not for your thumming. Here's gold lace:
you may see her in her holiday-clothes if you will; I was her ward-
robe-man.

Enter Martine, Aminta, Constable, *Officers.*

Antonio. You beguil'd me well, Sir.
Martine. Did you speak to me, Sir?
Antonio. It might seem to you (*Martine*), your conscience
 Has quick ears. 380
Martine. My sight was a little dim i'th' dark, indeed,
 So was my feeling cozen'd; yet I'm content:
 I am the better understander now,
 I know my wife wants nothing of a woman;
 There y'are my *Junior.*
Antonio. You are not hurt?
Martine. Not shrewdly hurt; I have good flesh to heal, you see;
 Good round flesh: these cherries wil be worth chopping,
 Crack stones and all; I should not give much to boot
 To ride in your new, and you in my old ones now.
Antonio. You mistake the weapon: are you not hurt? 390
Martine. A little scratch: but I shal claw it off wel enough.

Enter Gillian.

Gillian. I can no longer own what is not mine
 With a free conscience: My Liege, your pardon.
Philippo. For what? Who knows this woman?
Franio. I best (my Lord),
 I have been acquainted with her these fortie Summers,
 And as many Winters, were it Spring agen;
 She's like the Gout, I can get no cure for her.
Philippo. Oh, your wife, *Franio?*
Franio. 'Tis oh my wife indeed (my Lord),
 A painfull stitch to my side; would it were pick'd out.
Philippo. Well Sir, your silence. 400
Bustofa. Will you be older and older every day then other? the
 longer you live the older still? Must his Majestie command your
 silence ere you'l hold your tongue?
Philippo. Your reprehension runs into the same fault:
 'Pray Sir, will you be silent.
Bustofa. I have told him of this before now (my Liege) but age will

have his course, and his weaknesses——

Philippo. Good Sir, your forbearance.

Bustofa. And his frailties, and his follies (as I may say) that cannot
hold his tongue ere he be bidden. 410

Philippo. Why Sirha?

Bustofa. But I beleeve your Majestie will not be long troubled with
him: I hope that woman has something to confesse will hang 'em
both.

Philippo. Sirha, you'll pull your destinie upon you
If you cease not the sooner.

Bustofa. Nay, I have done, my Liege; yet it grieves me that I should
call that man Father, that should be so shamelesse, that being
commanded to hold his tongue——

Philippo. To th' Porters Lodge with him. 420

Bustofa. I thank your Grace, I have a friend there.

Philippo. Speak woman, if any interruption meet thee more,
It shall be punish'd sharply.

Gillian. Good my Liege, (I dare not)
Ask you the question why that old man weeps.

Philippo. Who? Count *Julio?* I observ'd it not.
You hear the question Sir, will you give the cause?

Julio. Oh my Lord, it hardly will get passage,
It is a sorrow of that greatnesse grown,
'Lease it dissolve in tears, and come by parcels.

Gillian. I'll help you Sir, in the delivery, 430
And bring you forth a joy. You lost a daughter.

Julio. 'Twas that recounted thought brought forth these sorrows.

Gillian. Shee's found again. Know you this mantle Sir?

Julio. Hah?

Gillian. Nay leave your wonder, I'll explain it to you.
This did enwrap your childe (whom ever since
I have call'd mine) when Nurse *Amaranta*
In a remove from *Mora* to *Corduba*
Was seiz'd on by a fierce and hungry Bear,
She was the Ravins prey, as heaven so would;
He with his booty fill'd, forsook the babe: 440

429 'Lease] *i.e.,* 'Less

All this was in my sight: and so long I saw,
Untill the cruell creature left my sight,
At which advantage I adventur'd me
To rescue the sweet Lamb: I did it Sir,
And ever since I have kept back your joy,
And made it mine: but age hath wearied me,
And bids me back restore unto the owner
What I unjustly kept these fourteen yeers.

Julio. Oh, thou hast ta'n so many yeers from mee,
And made me young, as was her birth-day to me. 450
Oh (good my Liege) give my joyes a pardon,
I must go powre a blessing on my child,
Which here would be too rude and troublesome. *Exit.*

Philippo. *Franio*, you knew this before.

Bustofa. Oh, oh; *Item* for you Miller.

Franio. I did (my Liege) I must confesse I did,
And I confesse, I ne'r would have confess'd,
Had not that womans tongue begun to me:
We poor ones love, and would have comforts, Sir,
As well as great: this is no strange fault, Sir, 460
There's many men keep other mens children
As though they were their own.

Bustofa. It may stretch farther yet, I beseech you (my Liege) let this
woman be a little farther examin'd; let the words of her conscience
be search'd. I would know how she came by me: I am a lost childe, if
I be theirs: though I have been brought up in a mill, yet I had ever a
minde (me thought) to be a greater man.

Philippo. Shee will resolve you sure.

Gillian. I, I Boy: thou art mine own flesh and blood,
Born of mine own body. 470

Bustofa. 'Tis very unlikely that such a body should bear me; there's
no trust in these millers. Woman, tell the truth: my father shall
forgive thee, whatsoever he was, were hee Knight, Squire, or
Captain; lesse he should not be.

Gillian. Thou art mine own child, Boy.

Bustofa. And was the Miller my Father?

Gillian. Wouldst thou make thy mother a whore, Knave?

Bustofa. I, if she make me a Bastard. The rack must make her

confesse (my Lord) I shall never come to know who I am else. I
have a worshipfull mind in mee sure: mee thinks I do scorn poor 480
folks.

 Enter Otrante, Florimell *and* Julio, [Vertigo,] *&c.*

Philippo. Here comes the brightest glory of the day:
 Love yoak'd with love, the best equality,
 Without the levell of estate or person.
Julio. You both shall be rewarded bountifully,
 Wee'll be a-kin too; Brother and Sister
 Shall be chang'd with us ever.
Bustofa. Thank you (Unkle) my sister is my cosen yet at the last
 cast: Farewell sister foster. If I had known the Civill law would
 have allowed it, thou hadst had another manner of husband then 490
 thou hast: but much good doe thee; I'll dance at thy wedding, kisse
 the Bride, and so.
Julio. Why, how now sirha?
Bustofa. 'Tis lawfull now, she's none of my Sister.
 It was a Miller and a Lord
 That had a scabberd and a sword,
 He put it up in the Country word
 The Miller and his daughter.
 Shee has a face, and she can sing,
 Shee has a Grace, and she can spring, 500
 Shee has a place with another thing
 Tradoodle.
Franio. A knavish Brother of yours (my Lord).
Bustofa. Would I were acquainted with your Tailor (Noble
 Brother).
Otrante. You may, there he is; mine, newly entertain'd.
Vertigo. If you have any work for me, I can fit you Sir,
 I fitted the Lady.
Bustofa. My Sister (Tailor), what fits her wil hardly fit me.
Vertigo. Who fits her may fit you Sir, the Tailor can do both. 510
Bustofa. You have a true yard (Tailor)?
Vertigo. Ne'r a whit too long, I warrant you.
Bustofa. Then (Tailor) march with me away,

I scorn these robes, I must be gay,
My Noble Brother, he shall pay
 Tom Tailor.
 Exeunt [Bustofa, Vertigo].

Philippo. Your recovered friendships are sound, Gentlemen?
Bellides. At heart, at heart (my Lord) the worm shall not
Beyond many ages find a breach to enter at.
Philippo. These Lovers unities I will not doubt of: 520
How happy have you made our Progresse then,
To be the witnesse of such fair Accords?
Come, now we'll eat with you (my Lord *Otrante*),
'Tis a charge sav'd: You must not grudge your guest,
'Tis both my Welcome, and your Wedding-Feast.
 Exeunt.

 FINIS.

TEXTUAL NOTES

I.i

54–55 Make ... | *Ismenia.*] It is clear from the dialogue that in F1 the prefix '*Ism.*' has been set one line above its proper location.

96 case] The justice of F2's emendation of F1 'cause' may be observed in various parallels such as II.ii.316 'It may be any mans case', III.ii.171 'A King is not exempted from these cases', and IV.i.180 'It may be mine own case another time!'

I.iii

101 *Aminta.*] However the error may have arisen, Dyce was certainly correct to emend the speech-prefix '*Ism.*' to give lines 101*d*–102 to Aminta instead of Ismenia. The pert interjection is in character for Aminta but vastly out of character for Ismenia.

II.i

56 Brother? 'tis] The F1 pointing is important for an actor's delivery. Gerasto and Otrante enter and converse apart about the plan to abduct Florimel. Gerasto, indicating Bustofa, tells Otrante that he will work on Bustofa. Otrante identifies the object of 'Yonder's the subject' as 'Her Brother?' and then confirms that Bustofa is indeed a subject 'with advantages' by the agreement ''tis'. The F2 reading 'Her Brother, 'tis,' with its loss of the query quite changes the sense, and in following F2 Langbaine and Sympson were mistaken.

140 The rest (*Gerasto*) and I hunt my prey.] The sense here is obscured at first by the convention of the round brackets for the vocative replacing other pointing, though Gerasto is not on stage at this time. Weber quotes Mason, 'My business is half accomplished; the rest I leave to Gerasto, with whose aid I shall hunt down the object of my pursuit.' Somewhat more precisely, one may interpret 'The rest (*Gerasto*)' as turning Bustofa over at this point to Gerasto while Otrante himself deludes Franio by the hunt.

II.ii

40 eyes] The singular 'eye' of F1–2 is in error. The image is strained, but Antonio is saying that both of his eyes would be pleased by Isabella's face, whereas, apparently, one eye alone would be pleased by Ismenia's.

72 *Julio*] The sequence of this scene as it appears in the Folio and in this edition is not coherent. A logical sequence would begin the scene with lines 72–308 (the cross meeting of the four lovers) followed by lines 1–71 (the discussion of the likeness of

Isabella to Ismenia) followed by lines 309–46 (the receipt of the letter from Ismenia). In the present text, Antonio and Martine discuss the likeness of Isabella to Ismenia before they have seen 'Isabella'. As the segments beginning at line 72 and line 309 are both introduced by an entry for Julio, it is conceivable that lines 72–308 were misplaced (though if the manuscript were the prompt-book, it is not easy to see how this could be). It is difficult to imagine an earlier scene of deception with Isabella, now lost, this one being so intricate and complex. The entire scene is attributed to Rowley.

120 Gods mercy] The F1–2 censorship evidenced by the reading '—— Mercy' is one of two examples in this play, both seemingly rather casual. Colman's 'God's' (followed by Weber) is perhaps more likely to have offended than Dyce's 'Heaven's'. The other example occurs at III.iii.182, where the dash substitutes for the word 'pox', used there as the name of a disease, not an expletive.

128–129 way: then ∧] This is an interesting semi-substantive reading in which all editors have followed the Folios' 'stand further out o'th' way then:' which makes no sense. The meaning is, if Martine will stand off farther from Bustofa (physically and perhaps verbally) the result will be that Bustofa's lines, will alight wherever they fall without being impeded by Martine's obstruction. The simple transfer of the colon straightens out the sense.

130 sport] The verb 'sport' is needed for F1–2 'sports' as Weber (after Mason) was the first to observe. 'We should read *sport*, meaning, that he hath an ape [rather apes] to sport and make faces.'

214 Why] The curious F1 form 'Wie', also at IV.i.24, was emended, respectively, by Sympson and F2. Since the word is an interjection, not an interrogative, in both instances, 'Wel' (for 'Well') might be a more appropriate emendation.

III.i

46 *Meg*] F1–2 end the line with 'Roring' and a comma, with deficient sense as well as metre, a reading followed by all editors before Dyce. 'Roaring' as a means of forceful persuasion certainly suggests Moll the Roaring Girl (brought on the stage in 1611 by Dekker and Middleton), a by-word for canting bluster. Whether the missing word was '*Meg*' or 'Girl' is not to be determined, but it should have been one or the other. Dyce's footnote provides several persuasive examples of '*Meg*'.

III.iii

17 Grudgins] F1–2 'Gudgins', which is a species of small fish (among other things), is obviously corrupt, and the Sympson edition was correct to query 'Gurgeons', the modernized spelling, which is a coarse meal, or the coarse refuse from flour. *O.E.D.* lists such spellings as 'gurgins', but also 'grudgeons' and 'grudgings'. Since in the forms with 'dg' the 'r' precedes the 'u', the nearest emendation here is 'Grudgins'.

201 buy] In the usual sense of 'purchase', 'Not all the world can buy your reputation' makes perfect sense; but if the continuation of the image comes in the

next line with "'Tis sunk for ever els', then – as the Sympson editor saw in a query – the question arises whether the reading is 'buoy'. However, the image need not be all of a piece, and 'purchase' and 'sunk' can be independent statements. The case is complicated by the *O.E.D.* listing of 'buy' and 'boy' (the latter more common) as variant spellings of 'buoy'. There seems to be no demonstrable means of determining whether 'buy' is intended here as 'purchase' or 'buoy'.

IV.i

47 *Antonio.* Tush] This heads the first column of sig. 4B4, but the catchword on 4B3v is 'In'. The discrepancy has no textual significance and can be satisfactorily resolved by the observation that the third line on sig. 4B4 is 'In a fast tye with my fair *Isabel.*', suggesting that IV.i.47–8 initially ended the second column on 4B3v, so that the catchword would indeed be correct for IV.i.49.

IV.ii

11 Sun-sets: ... moderate] As Colman was the first to observe, the F1–2 pointing produces wrong modification: 'The words "if grace might moderate" apply not to the lasting of the feud through too many sunsets but instead that man should not lose so many days of peace if grace would moderate the enmity.' A simple exchange of punctuation corrects this semi-substantive.

V.i

26 Chicken] The substitution of 'Chequin' first suggested in Sympson and adopted by Weber and Dyce, destroys the parallel between the loss of a maidenhead and the sale of a (worthless?) chicken, knocked down to a bidder at an auction ('knockt at an outcry'). The poultry image continues in lines 28–9.

V.ii

25 *grist*] The reading of Harleian MS 3991 for F1 '*grists*' is here adopted in the assumption that the unusual 'plural' results from contamination by '*hopes*' later in the line. The expected 'singular' appears in line 3 of the scene. Though the *O.E.D.* admits a pluralized form, the sole instance it gives (before 1865) occurs in a context describing several farmers bringing their several lots of grist to the mill. The singular form appears proverbially (though the *O.E.D.* cites this passage as 'proverbial').

125 *Otrante.*] Some lines of text are evidently missing at this point, for here Otrante already knows details of the King's intention which he has not been told in the text as we have it.

EMENDATIONS OF ACCIDENTALS

The Persons Represented

1–32 *from* F2; *omit* F1
1 MEN] *omit* F1–2
7 Tirso] Terzo F2; *omit* F1
9 Martine] Martino F2; *omit* F1

12 *Two*] *omit* F1–2
27 *competitrix*] *competrix* F2; *omit* F1
31 Wenches] *Maids* F2; *omit* F1

I.i

I.i] *Actus primus, Scæna prima.* F1–2 ±
5 methinks] F2; me thinks F1
15 pleasures:] F2; ~ , F1
20 (*Ismenia*)?] F2 [(~ ?)]; (~)∧ F1
22.1 *Enter . . . Martine.*] F1–2 *opp. lines*
22–3
22.1 *et seq.* Martine] Martin F1–2 (*see Introduction*)
26 Company?] ~ : F1–2
29 stay:] ~ ∧ F1–2
32 *Bellides*] *Belides* F1–2
36 Gentlewomen——] ~ . F1–2

37 Gin. 'Pray] F1–2 *line:* Gin. | 'Pray
42,59 'Pray] ∧ ~ F1–2
43 whistling, . . . all:] ~ : . . . ~ , F1;
~ : . . . ~ : F2
49 fight, arm'd ∧] F2; ~ ∧ ~ , F1
63 Gentleman——] ~ , F1; ~ . F2
70 Our . . . it.] F1–2 *line:* Our . . . this,
| We . . . it.
75 *Exeunt*] F1–2 *opp. line* 74a
97 rancle ∧ Cosen;] ~ ; ~ ∧ F1; ~ ,
~ ∧ F2

I.ii

I.ii] *Scæna Secunda.* F1–2
16–17 open, . . . judge:] ~ : . . . ~ ,
F1–2
22 (Friend);] (~)∧ F1–2
24 ignorance:] ~ ; F1–2
30 drives,] ~ ∧ F1–2
52 Belive] F2; Belive F1

65 *Martine*)——] ~). F2; ~)∧ F1
67 self——] ~ . F1–2
69 *Enter . . . Letter.*] F1–2 *below line* 67
104 choked: . . . devotions,] ~ , . . . ~ :
F1; ~ ∧ . . . ~ : F2
108 infamy,] F2: ~ : F1

I.iii

I.iii] *Scæna Tertia.* F1–2
1 Yes] F2; *Yes* F1
24 Cosen.] ~ , F1–2
33 *Exeunt.*] *Exit.* F1–2
35 close: here?] ~ ∧ ~ . F1–2
37 times ∧] ~ . F1–2

49.1 *Enter . . . Taper.*] F1–2 *below line*
43a
50 Sir——] ~ , F1; ~ . F2
56 him: Sir——] ~ , ~ . F1–2
65 Sir)?] ~ .) F1–2
77 (*twice*) 'Pray] ∧ ~ F1–2

105 Heaven——] F2; ~ . F1
111 promise] F2; promile F1
115 (friend).] (~) ∧ F1–2
116 freedom——] ~ : F1–2

117 love——] ~ . F1–2
125 admiration:——] ~ : ∧ F1–2
129 Exeunt.] F2; Exeunt. | Six Chaires
placed at the Arras. F1

II.i

II.i] Actus secundus. | Scæna Prima.
F1–2 ±
1–2 The ... tops.] F1–2 line: The ...
washes | The ... -mops: | The ...
fell | Flies ... tops.
4 thundring——] ~ . F1–2
6 am——] ~ , F1–2
6 whale——] ~ . F1–2
9 (man)?] (~) ∧ F1–2
14 Seas——] ~ . F1–2
17 Sirrha.] ~ , F1–2
26 Whale——] ~ . —— F2; ~ . F1
36 does!] ~ ? F1–2
50.1 Enter ... Gerasto.] F2; F1 opp.

line 49
74–75 Oh ... him.] F1–2 line: Oh ...
you, | He ... him.
93 sake,] ~ . F1–2
108, 121 Lord).] ~) ∧ F1–2
110 Nimph] F2: Nimp F1
110–111 ——The ... fell:——] ∧ ~
... ~ : ∧ F1–2
118 ——The] ∧ ~ F1–2
134 her——] ~ . F1–2
135 What,] ~ ∧ F1–2
142 Exit.] F1–2 opp. line 140
150 Diego: stay,] ~ , ~ : F1–2
162 (girl),] (~) ∧ F1–2

II.ii

II.ii] Scæna secunda. F1–2 ±
32 falshood] F2: falshod F1
48 more.——] ~ . ~ F1–2
61 is——] ~ . F1–2
68 'Twill] F2; 'T will F1
71.1 Enter Julio.] after line 70 F1–2
85 Livery] F2; Livory F1
88 absurd ∧ ... shalbe.] ~ , ... ~ ∧
F1–2
93 Bellides] Belides F1–2
102.1 Enter ... Gentlemen.] F1–2 below
line 99
104 Gostanʒo] Gostanso F1–2
104.1 Enter ... Cupid.] F2: F1 opp. line
104
122 tops,] ~ . F1–2
126 -Apes——] ~ . F1–2
129 light.] ~ , F1–2
130 -Apes ∧] ~ , F1–2
132 blind——] ~ . F1–2
134 be] Be F1–2

135 Nimphs] F2 (Nymphs); Nimps F1
137.1 Ismenia] Ismena
142–143 If ... it?] one line in F1–2
167 Enter ... Mars).] F2; F1 opp. line
167a–b
170 he?] ~ : F1–2
173 thorough] through F1–2
176 'has] has F1–2
179 Help, help, help.] Italic F1–2
180 Sir,] F2; ~ ∧ F1
182 What,] ~ ∧ F1–2
197.1 Enter Bustofa.] F2; F1 opp. line
197
207 Stone-horse] F2; ~ – | ~ F1
218 'Tis] F2; ∧ ~ F1
221 beauties,] ~ ∧ F1–2
240 beauty?] ~ : F1–2
254, 330, 333 'Pray] ∧ ~ F1–2
256 Counsellor.)] ~ ∧) F1–2
269 her:——] ~ : ∧ F1–2
272 methinks] F2; me thinks F1

277 And] F2; and F1
285–286 Tush ... wayes.] F1–2 *line:*
 Tush ... art | I ... wayes.
286 me.] ∼ , F1–2
307 Sir?] ∼ . F1–2

308.1 *Enter* Julio.] F2; F1 *opp. line* 307*b*
335 *Exit.*] *Exeunt.* F1–2
336 Sir,] ∼ . F1–2
346.1 *Exit.*] *Exeunt.* F1–2

III.i

III.i] *Actus tertius.* | *Scæna Prima.* F1–2
15 thiefe?)] ∼) ? F1; ∼ ? ∧ F2
39–40 And ... me.] F1–2 *line:* And ...
 pay: | Horse- ... me.

44 now?] ∼ . F1–2
63 her:] ∼ , F1–2
65–66 foundling ∧ ... too),] ∼ , ...
 ∼) ∧ F1–2

III.ii

III.ii] *omit* F1–2
6 french ∧ demi-launce] F2; ∼ – ∼ .
 ∼ F1
18 him? for ∧] ∼ ∧ ∼ ? F1–2
24 *Enter* Vertigo.] F1–2 *opp. line* 24*a*
25 us,] ∼ ∧ F1; ∼ . F2
38 glory——] ∼ . F1–2
44 belief ∧] ∼ , F1–2
47 suit——] ∼ . F1–2
63 time——] ∼ . F1–2
70 (Tailor)——] (∼) ∧ F1–2
71 leg, Monsieur;] ∼ ; ∼ , F1–2
76 hereafter——] ∼ . F1–2

86 Sir:] ∼ , F1–2
97 Majesty——] ∼ . F1–2
106–107 Trappings; ... bodies ∧] ∼ ∧
 ... ∼ , F1–2
121 *1 Lord.*] *Lord.* F1–2
130 us:] ∼ , F1–2
139 man,] ∼ ∧ F1–2
150 'Tis] F2; ∧ ∼ F1
153 'twill] F2; 't will F1
175 her:] ∼ , F1–2
185 If ... Venison:] F1–2 *line:* If ...
 here | I'll ... Venison:
197.1 *Exit.*] *Exeunt.* F1–2

III.iii

III.iii *Scæna Secunda.* F1–2
40 me——] ∼ . F1–2
65 else——] ∼ . F1–2
69 poorly:] F2; ∼ ∧ F1
80 Justice——] ∼ . F1–2
81 time,] ∼ . F1–2
88 *Enter* Gerasto.] F2; F1 *opp. line* 88*a*
97 i'th'] i'th F1–2
103–104 'em, ... Ladies;] ∼ ; ... ∼ ,
 F1–2
117 Sir,] ∼ . F1–2
119–120 linnen ∧ ... -strings:] ∼ : ...
 ∼ ∧ F1; ∼ , ... ∼ ∧ F2

124 ravishd,] ∼ ∧ F1–2
127 all;] ∼ ∧ F1–2
136 her.] ∼ ∧ F1–2
170 me?] ∼ . F1–2
172 'pray] ∧ ∼ F1–2
187 basely,] F2; ∼ ∧ F1
188 knows——] ∼ . F1–2
194 away:] ∼ , F1–2
197 me ∧——] ∼ .——F2; ∼ ∧ ∧
 F1
200 perish'd,] ∼ ∧ F1–2
202 ye;] ∼ ∧ F1–2
221 Lord ∧)——] ∼ .) ∧ F1–2

IV.i

IV.i] *Actus quartus.* | *Scæna Prima.*
 F1–2 ±
2 *Bustofa,*] ~ . F1; ~ ∧ F2
6 forgot——] ~ . F1–2
7 Sir?] F2; ~ , F1
9 now!] ~ ? F1; ~ . F2
38 coming;] ~ , F1–2
39 'twould] F2; 't would F1
53 *Lisauro*——] ~ . F1–2
56, 57 *Tirso*] Tarso F1–2
73 *Exit* Aminta.] F1–2 *opp. line* 72*b*
77 faith——] ~ . F1–2
81 *Enter* Aminta.] F1 *opp. line* 81*a*

81–82 Sir ... you.] *one line in* F1–2
106 does] F2; dos F1
115 'Tis] F2; ∧ ~ F1
109 counterfeit:——] counterfeit: ∧
 F1–2
116 yet:——] ~ : ∧ F1–2
119–120 eies | I] F1–2 *line:* eies I |
123 *Antonio!*] ~ ? F1–2
126 'Twas] F2; ∧ ~ F1
135 St.] S. F1–2
135 you. Now] ~ , now F1–2
180 time!] ~ : F1–2

IV.ii

IV.ii] *Scæna Secunda.* F1–2
16.1 *Enter* Bustofa.] F2; F1 *opp. line* 15
36 met——] ~ , F1–2
55 shed——] ~ ∧ F1–2
63 concludes:] ~ ∧ F1–2
69 Tale.——] ~ . ∧ F1–2
75 truth;] ~ ∧ F1–2
98–99 Didst ... Lisauro?] *one line in*

F1–2
116.2 *Enter ... letter.*] F2; F1 *opp. line*
 118
119–121 Read ... 'em;] F1–2 *line:* Read
 ...easie, | Keep ... ears; | I ... 'em;
164 causer!] ~ ? F1; ~ : F2
191 'twas] 't was F1–2

IV.iii

IV.iii] *Scæna Tertia.* F1–2
13–14 but, ... worse.] ~ ~ ∧
 F1–2
14 methinks] F2; me thinks F1
48 *Enter ... Martine.*] F1–2 *below line*
 46*b*

48 Martine.] ~ : F1–2
48.1 *Fight*] fight F1–2
48.1–2 Antonio *pursues* ... Martine.]
 follows s.d. at line 48 *in* F1–2
52 are.] ~ , F1–2
53 Friend?] ~ . F1–2

V.i

V.i] *Actus Quintus.* | *Scæna Prima.*
 F1–2
6 calmer,] ~ ∧ F1–2

7.1 *Enter* Antonio.] F2; F1 *opp. line* 7
15 Hah?] F1 *c.w.* Hah,
22 *Antonio!*] ~ ? F1–2

664

V.ii

V.ii] *Scæna secunda.*] F1–2 ±
25 *shall*] Shall F1–2
43 blinded:] ~ , F1–2
65 *art, the ground*ᴧ] ~ ᴧ ~ ~ ,
 F1–2
81 Because ... belief.] F1–2 *line:*
 Because ... ye | Pleasure ... belief.
105–106 Orange? ... men ᴧ ... pre-
 ferr'd?] ~ ᴧ ... ~ ? ... ~ . F1–2
115 that———] ~ ᴧ F1–2
115 *Enter a* Servant.] *on line above line*
 116 *in* F1–2
124.1 *Exit.*] F1–2 *opp. line* 120a
137 'Tis] F2; ᴧ ~ F1
142 Sir———] ~ , F1–2
143 one———] F2; ~ ᴧ F1
147 she;] F2; ~ ᴧ F1
155 dishonourable,] ~ : F1–2
168 temptations,] ~ ᴧ F1–2
180 me———] ~ . F1–2
180 power,] ~ . F1–2

228–229 We ... peace.] F1–2 *line:* We
 ... officers, | We ... peace.
242.1 *Enter* Aminta.] F1 *opp. line* 240;
 F2 *centres as line* 240.1
257.1 *Enter* Bellides.] F1–2 *after line*
 257a
273 *Enter* Julio.] F1–2 *after line* 272
290 'Pray] Pray F1–2
303.1 *Enter* ... Ismenia.] F1–2 *after line*
 301
325 That] that F1–2 (*as prose*)
361 *Ismenia?*] ~ . F1–2
369 Is't possible] F2; ssiPoble F1
407 weaknesses———] ~ , F1; ~ . F2
419 tongue———] ~ . F1–2
423 Liege,] F2; ~ , F1
439 would;] ~ , F1–2
487 Shall] F2; shall F1
504 Would] F2; would F1
511 (Tailor)?] (~ .) F1–2

[NOTE: The following editions are herein collated for substantives, various semi-substantives, and selected points of especial interest: F1 (Folio 1647), F2 (Folio 1679), L (*Works*, 1711, with introduction by Gerard Langbaine the younger and others), S (*Works*, 1730, ed. Theobald, Seward and Sympson), C (*Works*, 1778, ed. George Colman the younger), W (*Works*, 1812, ed. Henry Weber), and D (*Works*, rev. ed. 1877, ed. Alexander Dyce). The only Quarto edition of the play was that printed in 1718 by Tonson; but as it is a reprint of the play from his collected edition of 1711, it is not included in this Collation. The Collation also includes for the song at II.i.143–9, 168–74, MS Drexel 4041.22, 23 (NYPL), and for the song at V.ii.1–99, MS Harleian 3991 (BL).]

I.i

37 moves] mopes F1
37 off. ∧ Ladies——] ~ ∧ ∧ ~ :
 F1–2, L; ~ , ∧ ~ . S; ~ .—— ~
 —— C–D
49 from] for W
54–55 Make ... | *Ismenia.* Brother,]
 Ism. Make ... | Brother, F1 +

57 the belly] *omit* F2, L–C
79 our] your W
82 difference] deference S, C
85 I ... leggs;] *omit* F2, L, S
93 affright] a fright F2, L–D
96 case] cause F1

I.ii

10 Dazled my sense] Baffled my Fence
 S (*qy*)
16 see] saw D
16 have] had S–D
23 Dost] Didst S–D
23 stone] soon F1–2, L
27 she] he L
32 see] not see F2, L–W
46 but] not S (*qy*)
59 arrant] errant F2, L

76 were] are W
97 *Cupids*] Cupid L
104 laughing,choked:]laughing-chok'd,
 S (*qy*), C–D
104 choked:...devotions,] ~ ∧ ... ~
 ; F1; ~ ∧ ...~ : F2, L, S
106 May] 'T may S
109 things.] ~ —— S–W
114 we are] are we F2, L

I.iii

33 Load-star] Land-star F1–2, L, S
 (Load-star *qy*)
37 this] this is W
42 fair] far F1–2, L

58 prop] propt F1
83 word] work L
101 *Aminta.*] *Ism.* F1–2, L–W

II.i

2 Mountain] Mountains F1–2, S–W
8 mountains] Mountains S, C; mountains' W
11 wash! mops?] ~ ∧ ~ ! F1–2, L
22 mother-wit] Mother's wit S
51 gun] game F2, L–D
54 advantages] all Advantages S
56 Brother? 'tis] ~ , ~ , F2, L, S
57 That] For [*or* Sure] S (*qy*)
71 of] for S
86 o'] o'th' F2, L, S
94–95 true-man, Miller] true ∧ man-Miller F1–2, L–W; ~ ∧ ~ , ~ D

110 sister] Sister's S
119 thou] we S
139 my] *omit* L
140 prey.——] F1; ~ , —— F2
149 *Come . . . follow me.*] Come . . . follow, &c. F2 + (− NYPL); *Come follow me, &c.* F1
150 *Diego*: stay,] ~ , ~ : F1–2, L, S; ~ ! ~ . C; ~ ! ~ —— W, D
169 *honey-maker*] honnes maker NYPL
169 *grazes*] *gazes* F1–2, L
171 -*Chamber*] -*Chambers* S
172 *fruit*] *fruits* S–W

II.ii

15 Altogether] All together S
17 speak . . . Form] from the Form speak S
20 ¹millions] Millions S, W
28 wherefore] whereof S, W
40 eyes] eye F1–2, L
42 case] cause F1, S (*qy* case), W
44 staid] stray'd W
50 Estate] Estates F2, L–D
63 The] What S (*qy*)
104 *Gostanzo*] Gostanco F1–2, L
107 can] may S (*qy*)
112 see, see ∧] ~ ∧ ~ , S
120 Gods mercy]——Mercy F1–2, L, S; Heaven's mercy D
120 looks] look S–D

122 mountain] Mountains S
128–129 way: then ∧] ~ ∧ ~ : F1–2, L–D
130 sport] sports F1–2, L–C
132 Blind] Bloud F1
135 Nimphs] Nimps F1
162 ³or her,] *omit* F2, L, S
163 altogether] all together C–D
176 fellow's] follows F1
210 is it] it is L
214 Why,] Wie ∧ F1; *omit* F2, L
215 thus abus'd] abus'd thus D (*qy*)
226 presenter] Representer S (*qy*)
237 you're] your F1
249 ²me ∧] ~ ? S–D
268 in] upon S
288 ready] and ready S, C

III.i

2 me] *omit* F2, L
14 stoln] *omit* F2, L

46 Meg] *omit* F1–2, L–W
56 flitches] flotches F1, D

III.ii

1 saies] say S–D
18 do] did S (*qy*)
18 him ∧ for?] ~ ? ~ ∧ S–D
26 Makes] Make S–W

38 glory.] ~ —— S–D
42 'em] him F1–2, C, W; them S
53 yeer] years F2, L–W
77 unto] to S

80 *Vertigo*.] *King*. F1
89 mother] mauther S (*qy*)
100 foolishly,] ∼ ? S–D
127 lord] load F2, L
129 whoop'd] whop'd F1–2, L, C;

136 when] but when S
156 Horse-] Horses ∧ S, C
173 she] that she W
180 ²the] *omit* F1

III.iii

14 are] *omit* F2, L
17 Grudgins] Gudgins F1–2, L; Gur-
 geons S (*qy*), C–D
17 floure] flower F2, L, S
21 our breeding] or breeding F2, L, S
27 cold] a cold F2, L–D
37 good] God W
63 enjoy ye] enjoy F2, L
83 me, yet] ∼ ∧ ∼ , S–D
88 sped] speed F2, L, D
90 take] took S

91 wench] a wench S
102 devils] evils F2, L
105 too:] ∼ ∧ C–D
135 I'll] Ill F1
157–158 Nor ... imagine.] *omit* F2, L
158 yet not] not yet S
167–170 Blessing ... me?] *omit* F2, L
179 *Smig*] *Sim* F1
182 pox] —— F1–2, L, S
201 buy] buoy S (*qy*), C–D

IV.i

6 the] *omit* F1 +
24 Why] Wie F1
26 cover] to cover S
28 stale] scale F1–2, L, C
40 necessity] necessary S (*qy*)
56 (*twice*) *Tarso*] Terzo S, W, D
57 *Tirso*] Tarso F1–2, L; *Terʒo* S–D
59 in] in all S

76 do you] do you do F2, L
111 pardon] a pardon S
123 and] *omit* F2, L
135 Now] *Antonio*. Now S (*qy*)
144 to] as not to S (*qy*)
158 ope] open F2, L
191 degree] decree C, W

IV.ii

11 Sun-sets:... moderate,] ∼ ,... ∼ :
 F1–2, L, S
29 never] ever F2, L
43 oh] on F2, L
47 body: so ∧] ∼ ∧ ∼ ; S
47 yet] that C, W
51 Long] lunge C–D
52 slipping:] ∼ ∧ C, W
63 concludes:] ∼ ∧ F1–2, L–D
69 Furthermore] Farthermore F2, L, S

92 a] *omit* L
99 *Lisauro*] *Lis.* F1–2; *Lisander.* L
113 steak] Stake L
153 *Antonio*] *Lisauro* F2, L, S
153 thy] all thy S
155 *Lisauro's*] *Antonio's* L, S
157 on, on] on, on, on S
159 conduit] condiment F1
188 builded] built L

668

IV.iii

1 of] *omit* S (*qy*)
8 deprives] is depriv'd S (*qy*)
17 meeter] metre S–D
28 be] he F1
52 *Antonio.*] *Mar.* F1–2, L

56 light's] lights F1–2
61 his] he's S–W
63 any] or any S
76 bad] had S, W

V.i

26 Chicken] Chequin S (*qy*), W, D

V.ii

25 *grist*] *grists* F1 + (− BL)
46 staidnesse] statelyness F2, L, S, W
53 toucht] touch F2, L, S
54 your] pour F1
65 *the*] *on the* F2, L, C, W
73 pettish] petty F2, L
97 *unsound*] *unsound-a* BL
98 or] *and* BL
99 *round*] *round-a* BL
109 me] my F2, L
115 The art] Not the art S (*qy*)
136 should] would F2, L
156 be] be now S

160 *Philippo.*] *omit* F1
196 maid, now ₐ] ∼ ₐ ∼ , S–D
207 your] you F1
235 knock'd] knock L
268 self] it self F2, L
285 Didst] Didst not *S(qy)*
286 Gentlemen] Gentleman F1–2
303 both] both are S (*qy*)
312 This is] S'this S; This F1–2, C–D
346 Ah] Ha S, C
464 words] wounds S; wards C, W
473 Knight] a Knight S
484 person] portion S (*qy*)